MAKING MODERN PARIS

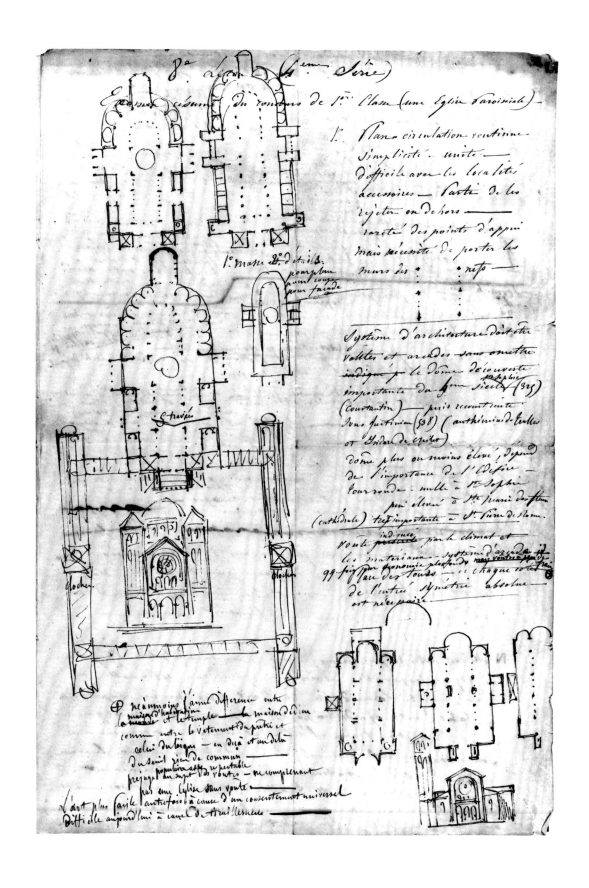

8.ᵉ Leçon (1.ᵉʳᵉ Série)

Esquisse résumant un concours de 1.ᵉ Classe (une Église paroissiale) —

1.° Plan — circulation continue — simplicité — unité —
difficile avec les localités accessoires — Parti de les rejeter en dehors — rareté des points d'appui mais nécessité de porter les murs des ... nefs —

1.° Manière d'étails.
pour plan
pour coupe
pour façade

S.ᵗᵉ travée

Clocher. Clocher.

Système d'architecture doit être voûtes et arcades sans omettre indiqué par le dôme découverte importante du ??? siècle (325) (Constantin) — puis recouvert toute sous Justinien (538) (Anthémius de Tralles et Isidore de Milet) dôme plus ou moins élevé, dépend de l'importance de l'Édifice — leur ronde — nulle à S.ᵗᵉ Sophie peu élevé à S.ᵗᵉ Marie des fleurs (cathédrale) très importante à S.ᵗ Pierre de Rome.

voûte ... indiquée par le climat et les matériaux — système d'arcades 99 ... de l'entrée — symétrie absolue est nécessaire —

Il n'en moins d'une différence entre la maison d'habitation et le temple — la maison de Dieu commun entre le vêtement du prêtre et celui du laïque — en deçà et au delà du seuil — rien de commun — préjugé populaire ... respectable au sujet des voûtes — ne comprenant pas une Église sans voûte —

L'art plus facile autrefois à cause d'un consentement universel — Difficile aujourd'hui à cause d'... nouvelles —

MAKING MODERN PARIS

Victor Baltard's Central Markets and
the Urban Practice of Architecture

 Christopher Curtis Mead

THE PENNSYLVANIA STATE UNIVERSITY PRESS

UNIVERSITY PARK, PENNSYLVANIA

This book was supported by funds from a Regents'
Professorship at the University of New Mexico.

Library of Congress Cataloging-in-Publication Data

Mead, Christopher Curtis.
 Making modern Paris : Victor Baltard's Central Markets
and the urban practice of architecture / Christopher Curtis
Mead.
 p. cm.—(Buildings, landscapes, and societies ; 7)
Includes bibliographical references and index.
Summary: "Investigates how architecture, technology, politics,
and urban planning came together in French architect Victor
Baltard's creation of the Central Markets of Paris. Presents
a case study of the historical process that produced modern
Paris between 1840 and 1870"—Provided by publisher.
ISBN 978-0-271-05087-4 (cloth : alk. paper)
1. Halles centrales (Paris, France).
2. Baltard, Victor, 1805–1874—Criticism and interpretation.
3. Architecture and society—France—Paris—History—19th
century.
4. City planning—France—Paris—History—19th century.
5. Paris (France)—Buildings, structures, etc.
I. Baltard, Victor, 1805–1874.
II. Title.
III. Title: Victor Baltard's Central Markets and the urban
practice of architecture.

NA6275.F7M43 2012
720.92—dc23
2011026162

for MMP

CONTENTS

IN 1991, WHEN I began my investigation of Victor Baltard and the Central Markets of Paris, I did not imagine that the projected book would take twenty years to complete. Other publications and the administrative load that came with serving as a college dean slowed my progress, but the primary reason this book has taken so long is that I rethought its structure and contents after finishing a first draft. The experience has both made me sympathetic to Baltard's own prolonged and fraught history with the Central Markets and deepened with time my understanding of nineteenth-century French architecture and urbanism, as I have continued to learn from the field's steadily growing body of scholarship. Throughout, I have enjoyed the support of the University of New Mexico: my primary research in France was made possible by two sabbaticals, in 1991 and 1997–98, and the award of a Regents' Professorship in 2009 has helped fund the book's publication. Roger Schluntz, dean of architecture and planning at the University of New Mexico, was instrumental in securing the Regents' Professorship.

I am equally thankful to the institutions and individuals who have assisted me with my research over the last two decades. The staffs of the Archives nationales de France, the Archives de la Seine, the Bibliothèque nationale de France, the Bibliothèque historique de ville de Paris, the École nationale supérieure des Beaux-Arts, the Musée Carnavalet, the Getty Research Institute, and the Riviera Library at the University of California, Riverside, all provided me with courteous and prompt access to their collections. Members of the Baltard family allowed me to see private papers still in their possession. Thérèse de Puylaroque—who wrote her master's thesis on Victor's father, Louis-Pierre Baltard, and who always encouraged me during my visits to her elegant apartment in the Faubourg Saint-Honoré—cleared a path to those papers when she accompanied me by train to Sceaux to meet Albert and Colette de Sainte-Marie at their home in the Villa Baltard. Opening up the villa to me, they gave me a sense of what it was like to live there, over the course of several Sunday lunches, and the time I needed to study and photograph the collection of Victor Baltard's sketches and drawings stored away on the villa's top floor. Thérèse de Puylaroque and Albert de Sainte-Marie have since passed away, but if I can no longer thank them in

person for their generosity and kindness, they nonetheless have my lasting gratitude, which I extend as well to Mme de Sainte-Marie and the entire Baltard family. Philippe Cocatre Zilgien provided me with the several apartments around Paris in which I landed during many of my stays in the city. I am likewise grateful for the hospitality of Ian Robertson Smith.

To shape my research into a coherent thesis, I have depended upon the advice, knowledge, and criticism of several respected colleagues. David Van Zanten, under whose direction I wrote my doctoral dissertation on Charles Garnier's Paris Opéra, has been my most steady and important critic, reading multiple drafts of the manuscript, clarifying my argument by pointing out overlooked sources or flawed interpretations, and inviting me to Northwestern University on several occasions so that we could engage in more extended discussions. At various stages in its genesis, the book has benefited immensely from the rigorous critiques of Geoffrey Batchen, Barry Bergdoll, and Katherine Fischer. Frank Paul Bowman, emeritus professor of romance languages at the University of Pennsylvania as well as my godfather, read and commented on a draft of the book before his death in 2006. Early on, I was fortunate to have several productive conversations with Neil Levine about the book's proposed focus and scope, and I have similarly taken advantage of subsequent conversations with Karen Bowie in Paris.

Penn State Press has proved to be a delightful partner through every phase of publication. I received both welcome support and perceptive suggestions from its advisory board for the series Buildings, Landscapes, and Societies: Jesús Escobar, series editor, and board members Cammy Brothers, David Friedman, Diane Ghirardo, and Volker Welter. The two outside readers selected by the press submitted positive yet thoughtfully considered reviews that helped me strengthen the book at several key points; because one of those readers, Helen Tangires, identified herself, I can thank her directly for her comments. Eleanor Goodman, executive editor for art and humanities; Danny Bellet, editorial assistant; Jennifer Norton, assistant director and design and production manager; Laura Reed-Morrisson, managing editor; Patricia Mitchell, production coordinator; and Keith Monley, copyeditor—all were consummate professionals as they shepherded the book into print.

This book is dedicated to my wife, Michele M. Penhall. She has been with me every step on the long path that began in early 1991 during those first frigid winter months in Paris, led through the protracted and sometimes frustrating process of organizing my research into a coherent narrative, and has now finally reached its happy end. I could not have written this book without her patience, trust, and confidence.

Reconsidering Victor Baltard

The reputation of Victor Baltard (fig. 1) is inseparable from the Halles centrales, or Central Markets, of Paris (fig. 2), the complex of iron-and-glass pavilions built to his plans between 1854 and 1874 in the historic heart of the city.[1] And yet, starting with accusations that he stole ideas from rival projects by the radical architect Hector Horeau and the engineer Eugène Flachat, his ability to design one of the defining works of nineteenth-century Paris has been subject to persistent skepticism and doubt.[2] As Charles Garnier observed in the perceptive obituary he delivered in 1875 as Baltard's successor at the Académie des Beaux-Arts, the architect's accomplishment would be forgotten precisely because he had realized in the markets such a self-evident and widely imitated solution to a fundamental problem of his times:

> Thanks to the Central Markets, the name of Mr. Baltard should never be forgotten; and yet one can fear that, because of its very excellence, this building will be powerless to preserve the memory of its builder, at least for the crowd. . . . I have said that the markets have already been copied many times. . . . This sort of plagiarism is becoming common, and indeed almost necessary, since the practical solution is actually found through this way of understanding a market. But this abundance of similar buildings . . . is destined to overwhelm the original monument. The creation of one man will seem one day to be the creation of everyone, and when in the future one admires these great constructions, one will perhaps no longer be able to distinguish the first monument or recognize then the name of the eminent architect who created the original type.[3]

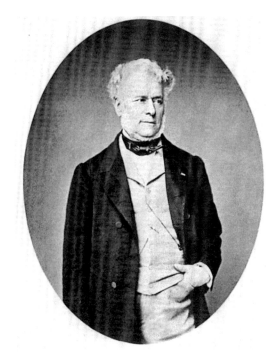

FIGURE 1
Paul Berthier, photograph of Victor Baltard (1805–1874), circa 1865. Private collection of the Baltard family.

In 1928, Sigfried Giedion validated this judgment when he identified Baltard as the accidental

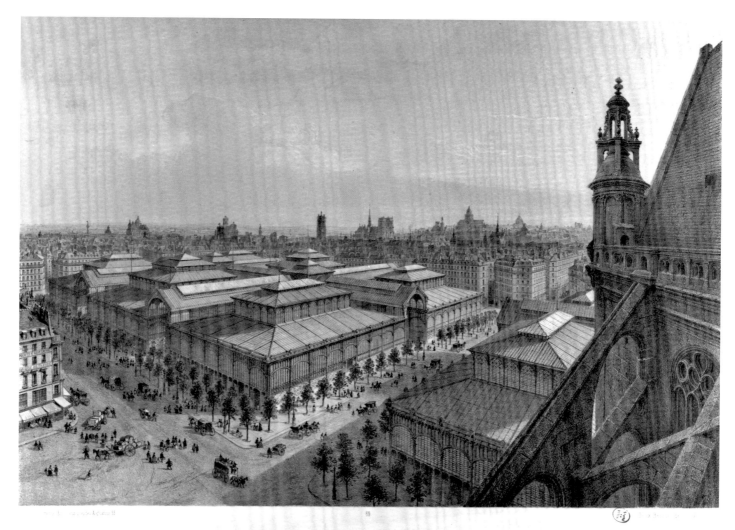

LES HALLES CENTRALES.

author of his most famous work: neither "a great architect nor a great constructor," Baltard, according to Giedion, "laboriously had to patch his buildings together from the ideas of others."[4] But if Garnier proved to be presciently on target, both in grasping the ease of reproduction made possible by the Industrial Revolution and in anticipating Baltard's future reputation, he was also making a larger—at once more substantive and discriminating—point. Suggesting that Baltard could as easily have become "an excellent doctor or a remarkable politician . . . a scholar or an industrialist, a poet or a businessman," while observing that his versatility as "a distinguished writer, prolific speaker, skillful designer, wise administrator, and ingenious builder" made him seem a jack-of-all-trades, "condemned never to surpass in the arts what is usually called a respectable average," Garnier acknowledged that other criteria were needed to evaluate an architect who had been brought by the nineteenth century and its new methods of production to practice architecture outside the conventions and traditions of his art.[5] The present book unpacks this nuanced

argument, which Garnier condensed into twelve deceptively short pages, in order to make the case that the circumstances and significance of the markets' construction, and the parallel circumstances of architectural training and professional experience that equipped Baltard for the task of designing them, both need to be reconsidered.

Historically, there have been two ways to think of the Central Markets. The earlier one looks to the fact that these were the first public buildings in Paris to be assembled entirely from a standardized and prefabricated structure of iron, brick, wood, and glass. Constituting an important moment in architecture's industrialization, the markets turned the decayed medieval quarter of the Halles into an orderly grid of pavilions and streets, and they were recognized from the start as important instruments in Prefect Georges-Eugène Haussmann's renewal of the city between 1853 and 1870. The ten original pavilions and connecting covered streets functioned as specialized spaces of marketing and distribution for a rapidly growing metropolis, at once zoned for different categories of food and integrated by their streets into an efficient transportation network. Part of the same circulatory system that circled nineteenth-century Paris with boulevards and railroad stations, the Central Markets concentrated in one place daily arriving foodstuffs in order to disperse them again throughout the city. Émile Zola appropriated a metaphor already in use by 1854 to name them the belly of Paris in his novel of 1873, *Le ventre de Paris*. But this was the mechanized belly of an industrial age, "a vast modern machine, some kind of steam engine, some kind of boiler serving the people's digestion, a gigantic metal belly, bolted, rivetted, made of wood, of glass, and of iron, with the elegance and power of a mechanical motor."[6]

Where the sumptuous decoration and stone façades of state monuments like Hector Lefuel's New Louvre or Charles Garnier's Opéra (fig. 3) stood for the nation's continuity with its classical past, the skeletal metal frame of the municipal markets signified the city's transformation from cultural artifact into object of utility (fig. 4). Abandoning the opaque, if permeable, boundaries of a masonry wall, which had acted until the Industrial Revolution to shape the city into a dense hierarchy of public and private spaces, the markets' immaterial curtains of brick and translucent glass, held in place by a filigree of cast and wrought iron beneath continuous roofs, seemed socially as much as architecturally to propose another urban identity and order for Paris. Transparent and rational, the markets displaced the familiar differences of building and street, inside and outside, private and public, with the functional abstraction of a scientifically conceived and technically realized theory of the city. Space could now be organized programmatically without being bounded physically. At the markets, architecture was reformulated from its classical conception as a unified, bounded, and self-contained whole, to become instead an additive and open-ended system of repeating, interchangeable units, which, from the structure to the spaces, could be extended indefinitely until a program's quantitative demands had been met.

A century after their construction, the decision in 1971 to demolish the Central Markets produced a second reading of their significance. At the time, the destruction of the markets touched off a fierce debate between functionalists, who argued that the pavilions had outlived their singular purpose, and preservationists, who claimed that the pavilions, far from being narrowly utilitarian structures, were instead wonderfully flexible spaces that could be adapted to a wide variety of needs.[7] Built on a site reserved for the markets since the Middle Ages, their central location in an increasingly populous and crowded city had complicated the distribution of foodstuffs from

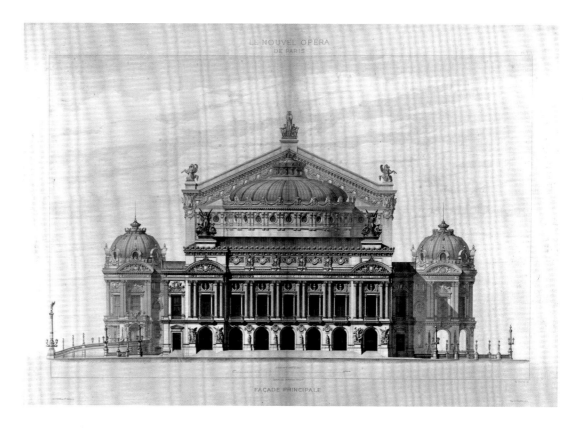

the start and doomed them to obsolescence once refrigeration eliminated the need to supply perishable foods to the city on a daily basis. By the 1950s, the Halles quarter was being targeted by planners intent on eradicating what they saw as a site of drug trafficking and prostitution. The Situationists Guy Debord and Abdelhafid Katib celebrated the Halles in "psychogeographical" maps that delineated the quarter as a place of vibrant, if unpredictable, cultural (rather than purely commercial) exchange, but only nostalgia delayed until 1969 the removal of the markets' functions to the transportation hub of Rungis, on the city's periphery.[8] From 1969 until 1971, the Halles actually became a site of cultural exchange, with performances, exhibitions, and events that turned the pavilions, according to the sociologist Henri Lefebvre, "into a gathering place and a scene of permanent festival—in short, into a centre of play

rather than of work—for the youth of Paris."[9] Their demolition left behind a void stretching for blocks and filled, incompletely and unconvincingly, with the clutter of a subway station, a shopping mall, and a park.[10]

While the debate over their usefulness came too late to save the markets, it did prompt scholars to reexamine their history. First, in the pathbreaking *Système de l'architecture urbaine* (1977), Françoise Boudon and a team of scholars placed the markets within an "urban tissue" of housing blocks, aristocratic mansions, churches, and other public buildings, which had shaped the Halles quarter as a "system of urban architecture" since the twelfth century.[11] Next, in *Les Halles de Paris* (1980), Bertrand Lemoine complemented Boudon's urban history with an architectural history of the markets' design, tracing the sequence of eighteenth- and nineteenth-century projects

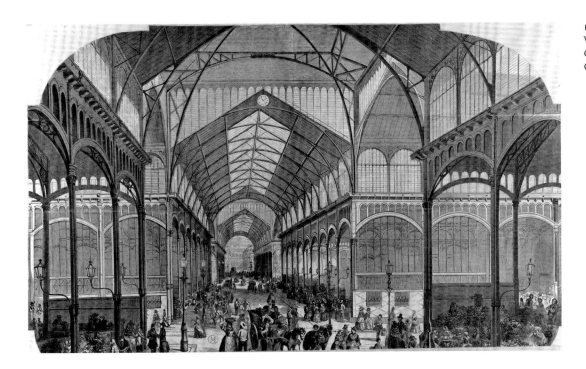

that led up to Baltard's definitive project of 1854.[12] And third, in *Building Paris* (1994), David Van Zanten plotted how a new kind of "commercial urbanism" was formulated between 1845 and 1854 through three phases of planning based in the speculative logic of property lines, lot plans, and real-estate transactions.[13] Even though all three continued to define the markets in Haussmannian terms, as instruments of renewal that radically transformed the existing historic quarter, Boudon, Lemoine, and Van Zanten demonstrated in their research how the gridded layout of pavilions had been generated through a historical process of urban development, negotiation, and compromise rather than from a single predetermined master plan. In so doing, they opened the way to the typological, rather than functional, definition of the markets to be considered here. Fundamentally indebted to Aldo Rossi's argument for the "complexity of urban artifacts" in his seminal study *The Architecture of the City* (1966/1978), this typological approach to the city and its buildings is further informed by Anthony Vidler's critical formulation in 1976 of a "third typology" aimed at understanding "the nature of the city itself, emptied of specific social content from any particular time and allowed to speak simply of its own formal condition."[14]

The shift in critical perspective resulting from the markets' destruction did not, however, close the interpretative divide that continues to separate the buildings from Baltard. At issue are not the facts of his involvement, at least since Lemoine straightened out the project's design chronology, but rather the specific content of his contributions within the context of an otherwise conventional career (as outlined in the appendix).[15] Following in the footsteps of his father, the Neoclassical architect Louis-Pierre Baltard, and encouraged by family friends who included Charles Percier and Pierre Fontaine, Baltard studied under his father at the École des Beaux-Arts, where he won the Prix de Rome in 1833. He went on to spend thirty years working for the municipal administration of

Paris, from the July Monarchy through the Second Republic and Second Empire, climbing the bureaucratic ranks until 1860, when Haussmann appointed him director of the newly reorganized architectural service in the Prefecture of the Seine. During the 1840s and 1850s, Baltard decorated, restored, and modified the city's medieval and Renaissance parish churches. Engaging Ingres's students among other artists to decorate these churches with cycles of mural painting, he also adjusted their building fabric to the planning realities of Haussmann's Paris, most notably when the Boulevard de Sébastopol truncated the apse of Saint-Leu-Saint-Gilles. In the 1850s, Baltard modified the Hôtel de Ville, adding a grand staircase and iron-and-glass roof to its central courtyard, and designed the two Neo-Renaissance annex buildings that face city hall from either side of the new Avenue Victoria. Finally, in the 1860s, he built the church of Saint-Augustin for a triangular wedge of land at the intersection of the Boulevard de Malesherbes and the Rue Portalis: responding volumetrically to a site shaped by its streets, the church's masonry shell is reduced to an eclectic curtain of stone draped over an exposed structure of iron. If these works collectively tended toward pragmatic adjustments of historic precedents to the dictates of modern planning and industrial production, in none of them did Baltard seem able to break free of nineteenth-century historicism to imagine the frank embrace of modernity realized so exceptionally at the Central Markets.

More interested in the markets than their architect, Lemoine documents Baltard's projects without addressing the professional or critical context of their design. Van Zanten considers the architect's career more generally in a chapter from *Building Paris* titled "Haussmann, Baltard, and Municipal Architecture." Surveying the operations and employees of the city's architectural service, whose sphere of action expanded exponentially under Haussmann, Van Zanten credits a new kind of authority to Baltard, one at odds with the traditional responsibilities of a Lefuel or Garnier to represent the city or state in conventional forms, because Baltard controlled the conventionally invisible yet finally more consequential realm of "the city's functions and texture."[16] Faced with the apparent contradictions in Baltard's work between historicism and industrial commercialism, Van Zanten concludes that he was an architect of "unresolved juxtapositions," who accepted "the loosening of the consistencies of art in the face of anonymous technology . . . empowered by the concrete needs of municipal architecture and made plausible by the shadow of adherence to the niceties of traditional design."[17]

Pierre Pinon, in his 2005 biography of Louis-Pierre and Victor Baltard, argues that father and son alike merit study precisely because they were each so typically "representative of their times."[18] Steering clear of "polemics," Pinon believes that the unfounded if rancorous accusations of plagiarism launched against the architect are "explained by the fact that everything had been too easy" for this privileged member of the architectural and municipal elite: at the markets, Baltard was simply doing his job, producing a work whose metal structure demonstrated his technical competence yet that finally lacked the intellectual substance found in the more thoughtful architecture of a Henri Labrouste or Eugène-Emmanuel Viollet-le-Duc.[19] Proving by contrast the eclectic norm of his practice, the markets were Baltard's single excursion into "the realm of experimentation," the one exception to the architectural "bricolage" of ad hoc and ultimately indiscriminate assemblages of historical styles, building technologies, and functional programs characterizing the rest of his work.[20] Baltard is credited with the Central

Markets' design but remains surprisingly irrelevant to their conception in any sense beyond the very narrow one of specialized expertise.

More than any other source, the testimony of Georges-Eugène Haussmann, prefect of the Seine and the administrator to whom Baltard answered as architect of the markets, explains this historical skepticism. Though Baltard's commission predated the prefect's arrival on the scene, Haussmann appeared at a crucial moment in the markets' history, and he claimed years later in his *Mémoires* (1890–93) to have salvaged the architect's appointment.[21] Construction of an earlier design, mixing stone walls with a cast-iron roofing structure, had started in 1851, but this project carried with it political expectations that, while outside Baltard's control, complicated his task. Laying the cornerstone on 15 September 1851, President Louis-Napoléon had pronounced the project to be in the entire nation's interest: "In setting the first stone of a building whose purpose is so eminently popular, I confidently yield to the hope that, with the support of all good citizens and the protection of heaven, we will be able to place on the soil of France some foundations on which will be raised a social edifice solid enough to offer a shelter against the violence and mobility of human passions."[22] Instead, in 1853, the first pavilion provoked a storm of protest: the austere and monumental mass of stone that had been praised in 1851 was now being attacked in the press for seeming more like a fortress than a market hall.[23] Market employees submitted a petition of complaint to Napoléon III, who returned as emperor on 3 June 1853 to a site he had last visited as president, and ordered that work be stopped.[24]

Haussmann intervened sometime after he was sworn in as prefect, on 29 June. As recounted in his *Mémoires,* Haussmann went to Napoléon III for instructions: "The emperor, enchanted by the Gare de l'Est . . . conceived the Central Markets as being this type of hall roofed with an iron-and-glass structure. . . . 'What I want are vast umbrellas, nothing more,' he told me one day, charging me with receiving, organizing, and submitting to him the counterprojects that he had provoked [by dismissing Baltard], and sketching for me, in a few pencil strokes, the silhouette he had in mind."[25] Sketch in hand, the prefect returned to his office in the Hôtel de Ville, where he coordinated the imperial silhouette with his master plan of the market as two groups of pavilions divided by a main central street. Haussmann then summoned Baltard and told him to produce a new scheme based on the emperor's sketch and his master plan: "Quickly, make me a project that follows these guidelines. Iron, iron, nothing but iron!" Baltard supposedly protested that iron "was fine for engineers; but what did an architect, 'an artist,' have to do with this industrial metal?"[26] When, however, Haussmann made it clear that Baltard's career was at stake, the architect capitulated and developed the requisite iron structure. Taking this scheme to Napoléon III, Haussmann presented it as his solution to the imperial command: "I told His Majesty that I, trying to follow his ideas, had had a project drawn up that I hesitated to place before his eyes. . . . 'Let me see,' the emperor said. And as soon as he saw it, he cried: 'But that's it, that's exactly it!'"[27] In May 1854, the emperor viewed a model of the markets at the Hôtel de Ville, fabricated on orders from Haussmann, and used the occasion to reinstate Baltard by decorating him with a Legion of Honor cross, at the prefect's suggestion though supposedly without realizing this was the architect of the original pavilion. Confessing his deception, Haussmann mollified the emperor with an epigram: "It is the same architect; but it is not the same prefect."[28] Haussmann accused Baltard of "ingratitude" when

the architect failed to acknowledge his crucial role by dedicating to him the *Monographie des Halles centrales.*[29]

Seamlessly self-aggrandizing, Haussmann presents himself as an adroitly manipulative administrator able to outwit a naive, if enthusiastic, emperor, who was so inattentive as to be duped into honoring a disgraced architect whom he had already met several times before. Haussmann's account, however, contradicts what actually happened in the summer of 1853.[30] On 5 July, Baltard did in fact submit three alternative schemes to the prefect, two of which were either entirely or predominantly in iron.[31] But these variant designs are dated 13 June and had already been presented to the emperor a week before Haussmann arrived in Paris on 28 June; the project described by Haussmann in his *Mémoires,* incorporating the new master plan, was not drawn up until the following October. Redating this later project to his arrival in Paris several months earlier, the prefect collapsed two distinct events in June and October— only the second of which took place when he was present—into a single fabricated moment of

decisive intervention. Far from being the main actor at a pivotal juncture in the history of Paris, saving Baltard's career even as he pushed him to redesign one of the most important public works of the Second Empire, Haussmann turns out to have turned up too late, nearly a month after the emperor communicated his desires on 3 June, and two and a half weeks after the architect had seized the initiative—on his own volition, not Haussmann's orders—by radically revising the markets' design.

Acknowledging only a "few words," Baltard never specified the imperial criticism he received on 3 June.[32] Napoléon III might have mentioned the Gare de l'Est, completed by François Duquesney and Pierre Cabanel de Sermet in 1852, though he was more probably thinking of the Gare Saint-Lazare, whose train shed had just been expanded by Eugène Flachat in 1851–53 (fig. 5): visiting Saint-Lazare after his inspection of the markets, the emperor was reportedly struck by the contrast between the pavilion's massive stone construction and the shed's light iron structure, which "allied boldness and elegance with the advantage of great economy."[33] Either way, train stations were presented to Baltard as models of industrial modernization, causing him to write defensively to the emperor in mid-June that "as for the system of construction [of the original pavilion], we wanted, it is true, to distinguish it from what is generally employed in railroad stations."[34] Yet both the Gare de l'Est and the Gare Saint-Lazare, with their iron-and-glass halls held behind Neo-Renaissance masonry façades, were fundamentally similar in conception to Baltard's market pavilion. If, as Haussmann later claimed, the emperor really did demand "umbrellas," it could have been with the more radical example of the Crystal Palace in mind (fig. 6). Inaugurated on 1 May 1851 (not long before Louis-Napoléon's coup d'état of 2 December 1851 and the plebiscite that legitimized

his Second Empire on 1 December 1852), this factory-manufactured iron-and-glass exhibition hall had been designed by Joseph Paxton under the patronage of Prince Albert, the royal consort of Napoléon III's political ally Queen Victoria. To the anglophilic emperor, whose desire to modernize Paris was inspired by the example of London, the significance of this building, produced by the world's leading industrial nation, must have been obvious. National chauvinism dictated the rhetorical substitution of a French for an English example, with Flachat's shed providing a timely analogue, but the fact remains that the Crystal Palace was more like the emperor's "umbrellas" than the train stations of Paris.

What, then, was Haussmann up to when he recast as historical fiction an actual series of events? According to Eugène Rouher, a frequent political adversary of Haussmann, the prefect had "an ability to assimilate information so highly developed that in the wink of an eye he made his own—and believed to be his own—all the ideas of his collaborators."[35] Haussmann's fable is so cavalier in its disregard for a verifiable set of dates because he really did believe what he published in 1890, a story he had probably been telling and polishing for years, from the moment he reached Paris in late June 1853. To him, the story was true because it dramatized his appointment and measured the administrative distance between the cautious decisions of his predecessor, Jean-Jacques Berger, and his own vigorous push for change: "It is the same architect; but it is not the same prefect." Haussmann was going to transform Paris.

This psychological truth needs to be kept in mind when trying to understand why histories of Second Empire Paris, from the classic studies by André Morizet (1932), Brian Chapman (1957), and David Pinkney (1958) to the recent biographies of Haussmann by Jean des Cars (1988), David Jordan (1995), Georges Valence (2000),

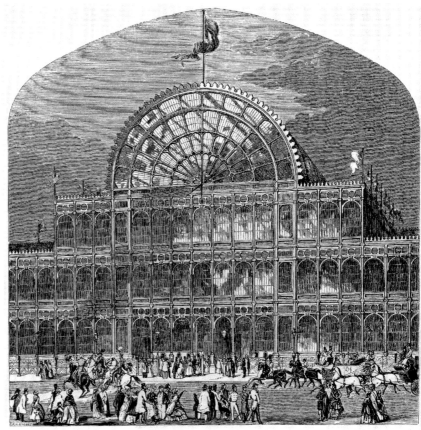

FIGURE 6
Joseph Paxton, Crystal Palace, London, 1849–51. South transept. From *The Art Journal Illustrated Catalogue* (1851).

and Michel Carmona (2000), have all accepted the prefect's account of what happened in 1853. Correcting a few dates, as Lemoine did in 1980, and proving in the process that Baltard took the initiative to save his own career, has not shaken the conviction that, without Haussmann, this architect could never have rethought his design of the markets in the emphatically industrial terms demanded by Napoléon III. After the fact, Baltard seemed to corroborate this judgment. In his *Monographie des Halles centrales,* he noted drily that the markets' original design had been rejected because "a pronounced enthusiasm for metal constructions, of which railroad stations offered interesting examples, dominated public taste, alienating it from stone constructions."[36] Ten years later, in his supplement to that monograph,

Baltard came bluntly to the point: "As far as we are concerned, we have always thought that the true system of construction for public markets in our climate is to be found today in a reasoned combination of stone for the surrounding walls and iron and wood for the interior supports and roofs."[37] In thought, if not in actual deed, Baltard had resisted the command to redesign the markets in "iron, iron, nothing but iron!"

To Haussmann, Baltard was a man of contradictory parts, an architect whose "talent, like his character, presented some singular contrasts." On occasion, "this intransigent classicist by birth . . . this knowledgeable and faithful imitator of past masterpieces," showed glimmers of originality as a "decorator full of imagination and taste." Yet Baltard's regard for an artist's prerogatives put him at odds with the hierarchy of a municipal bureaucracy and made him at best a "functionary in spite of himself." In a closing barb, Haussmann regretted that the architect's "character as a whole . . . lent itself poorly to sympathetic abandon, to generous transports, to [the] disinterested self-sacrifice" that the prefect expected from his employees.[38] Because he was academically trained, Baltard seemed ill equipped to grasp the progressive industrial potential and urban scope of the markets and so had to be forced to act. As Baltard's other critics implied when they accused him of plagiarizing the projects of Flachat and Horeau, the job seemed better suited to an engineer, or at least to an architect who recognized the need to forsake classicism's aesthetic conventions and reinvent architecture according to quantitative criteria of economy, structure, and function.

This portrait justifies the conclusions reached by Van Zanten and Pinon that Baltard was an architect of "unresolved juxtapositions" and "bricolage." But defining Baltard by the supposed contradictions between his academic training and his principal work is as limiting historically as identifying the Central Markets as uniquely utilitarian products of industry and planning. Just as the markets have been rehistoricized in studies that look beyond clichés of utility to recover their actually complex urban development, so the circumstances of Baltard's professional training, experience, and career must be reconsidered before any conclusions are drawn about his role, conservative or otherwise, in a history of nineteenth-century French architecture and urbanism. The issue needs to be rephrased, from the negative assumption that Baltard, despite his technical expertise, lacked the requisite depth of intellect to conceptualize the markets, to an acceptance of the possibility that he did possess that depth, for the simple reason that he proved this as their architect. The question in this case is no longer whether Baltard should be credited with the markets' design but rather what he meant as their architect when he insisted that, having conceived their frankly industrial metal structure, he had always preferred a "reasoned combination of stone . . . and iron."

ENGINEERS AND ARCHITECTS

The engineer's challenge to the architect was already an established truism by the start of the nineteenth century. Jean-Nicolas-Louis Durand, professor of architecture at the École polytechnique, lectured that "architects are not the only ones who construct edifices; engineers of every class . . . frequently experience this obligation; one could even add that at present engineers have more occasions to carry out large undertakings than do architects."[39] By midcentury, architects as otherwise opposed as the Gothicist Eugène-Emmanuel Viollet-le-Duc and the classicist Charles Garnier could voice remarkably similar concerns about the need to maintain skills now claimed by engineers. If Garnier protested the modern scission of the once-unified classical art of

architecture, while Viollet-le-Duc looked ahead to the reconvergence of architecture and engineering according to Gothic principles of structure, both resisted the architect's professional restriction to what Viollet-le-Duc called "the functions of a designer-decorator."[40]

As Antoine Picon explains in *French Architects and Engineers in the Age of Enlightenment,* the two professions were informed by basic conceptual differences between architecture's classical theories of *convenance,* or propriety, and engineering's rational theories of utility.[41] Applying the physics of Newton and the calculus of both Newton and Leibnitz, engineers rationalized the art of architecture as the science of building, replacing traditional notions of stability, based in perception, with a modern notion of construction, based on mathematical calculation. The architect's design of visually coherent forms, shaped by artistic intuition and validated by historic experience, was countered by the engineer's rational analysis of programmatic factors, ordered by technology and determined by natural laws. By the end of the eighteenth century, it was possible in theory to comprehend architecture either in traditional terms, as the physically discrete and self-contained object, or in modern terms, as a rationalized process of form production. This difference is measured in the distance from the mid-eighteenth-century teaching of Jacques-François Blondel at the Académie d'architecture to Durand's instruction at the École polytechnique a half century later (fig. 7): Blondel's classical ideal of unity, of a coherently hierarchical subordination of the parts to the whole, is rethought in Durand's descriptive geometry and diagrammatic grids to become the systematic assembling of repetitive units.[42] To be sure, Durand's compositional method preserved analogies to classical proportions, justifying his own continued loyalty to the language of classicism and obscuring his threat to architecture's

customary conception as a closed system of design. Yet his diagrams anticipated the shift, realized at midcentury in works like the Crystal Palace and the Central Markets, from making a singular object to the process of production itself, in which the part became as important as the whole.

The alternatives between architecture and engineering remained more potential than actual in the eighteenth century, when the practices of architects and engineers continued to overlap. Eighteenth-century building treatises like Jean-Baptiste Rondelet's *Traité théorique et pratique de l'art de bâtir* (1802) still considered materials and structures in mostly empirical terms of experience that were as accessible to architects as to engineers. After 1820, however, engineering's differences from architecture became increasingly explicit. In 1824, Louis Navier, a professor at the École des ponts et chaussées, published one of the first mathematically specialized texts on the science of statics, *L'application de la mécanique à l'établissement des constructions et des machines.* Importing technology developed in England, France began using cast-iron columns and beams for shop windows and commercial arcades in the 1820s; rolled and wrought iron in L and T sections became available during the same decade, while I sections were first used in 1845 by Eugène Flachat for the construction of railroad sheds. Between 1837 and 1853, the engineers Camille Polonceau and Flachat exploited both the compressive strength of cast iron and the tensile qualities of wrought iron to develop a variety of triangular truss frames that revolutionized the ability to span large spaces with economically light and standardized structures.[43]

The scientific and technological thinking that rationalized building also rationalized space and in the process extended the engineer's domain from individual structures to entire cities,

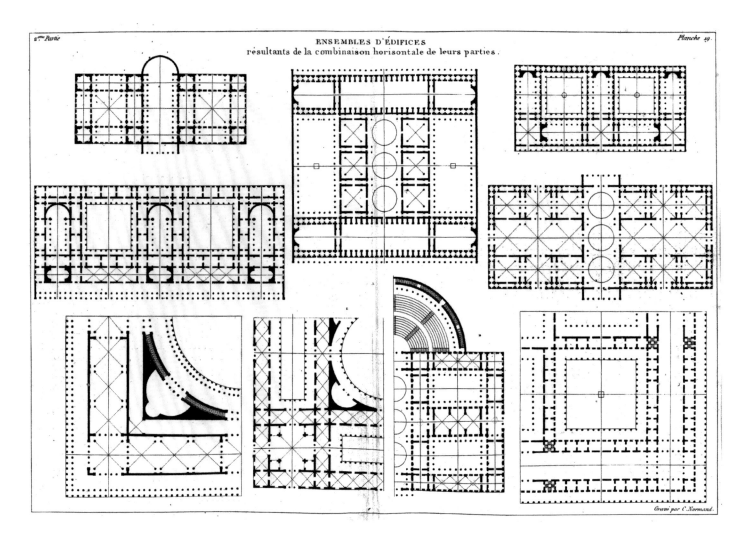

résultants de la combinaison horisontale de leurs parties.

Gravé par C. Normand.

FIGURE 7
Jean-Nicolas-Louis Durand,
buildings resulting from the
horizontal combination of their
parts, from *Précis des leçons*
(1802–5).

territories, and countries. Picon observes that eighteenth-century cartography replaced the "traditional space" of human experience with the geometric abstraction of a "quantified universe," which both obliterated distance through measurement and equated that measurement with time.[44] Space could now be instrumentalized, by coordinating the mapping of a city or a territory with such modern tools of state control as statistics and taxation.[45] Paul Rabinow notes that statistics, formulated in the early nineteenth century as a "'science of facts' concerned with collecting the data of civil society," was itself a form of mapping: "the invention of statistical tools dependent

on and made possible through a conception of social regularity, which could be mapped along a continuum from the normal to the pathological, represented an important shift in social understanding."[46] Tools like statistics translated the eighteenth-century Enlightenment project of rationality into the nineteenth-century project of industrialization and produced the utopian socialism of Saint-Simon and his followers from the 1820s onward. Without the idealism but with an ideology of science and technology fully intact, Saint-Simonian bankers, financiers, and railroad magnates would fund Haussmann's rebuilding of Paris.[47]

The model of circulation was one way to rationalize space. Eighteenth-century medical science, attributing disease to the infectious properties of bad air, applied the physiology of human circulation to the problem of public health and prescribed the free circulation of air as the best antiseptic.[48] Hygiene configured the modern city as coordinated systems of circulation: of air, water, people, vehicles, and goods, whose well-being could be analyzed and quantified in simultaneously physical, economic, and social terms.[49] Cholera epidemics, which struck Paris in 1832, 1847, 1848, and 1849, encouraged the physical and social modernization of the city, with Saint-Simonian theorists leading the way.[50] Complementing the instrumental mapping of society, the circulatory theory of hygiene assumed the skills of engineers to build the roads, bridges, quays, sewers, and water systems needed for a healthy city. Reconceived as open-ended systems of circulation, this modernized city would be extended into and integrated with the rest of the country through the national system of railroads legislated in 1842.[51]

By 1853, the scientific, technological, economic, and industrial pieces were all in place for the transformation of Paris. Entering into office, Haussmann was given as his starting point an imperial plan with new streets marked in colors by Napoléon III.[52] Logically, the first step was to send surveyors out to triangulate the city, reducing the historical and physical complexity of Paris to a tidy grid of coordinates. To translate this survey back into the practical realities of street clearances, parks, water, sewage, and gas lines, Haussmann depended less on architects proper than on his municipal engineers and surveyors, the *architectes-voyers* for whom "geometry and drafting played a more important role than architecture properly speaking."[53] The prefect's classicizing sensibilities, the axial streets and connecting squares of his

plan, were at best a gloss on his resolutely practical outlook: "For us, in the appreciation of a public undertaking, utility beats magnificence."[54] To him, the city was not a work of art but an economic work of industry where the efficiency of systems overrode the beauty of appearances.[55] Haussmann saw the city primarily as a technical process to be regulated, not as a historical object to be shaped: if history and its architectural correlate, the monument, had a continued role to play, it was exceptional, something to be set apart in majestic isolation like the cathedral of Notre-Dame or the Opéra.[56] The Central Markets are immediately understood in the prefect's utilitarian terms. Built with industrial materials, the pavilions fell outside the customary definition and practice of architecture as a historical discourse expressed through conventional forms, to constitute instead a rational space of surveillance and circulation, where goods could both be inspected and exchanged in properly hygienic conditions as part of a program of social control in an explosively growing city. Less a traditional building than an urban system, the markets consequently shared with the larger city the same diffusion of boundaries through transportation networks.

Like the emperor's command in 1853 to redesign the Central Markets as iron "umbrellas," Haussmann's approach to Paris exposed the architect's tenuous position when it came to realizing the modern city: someone else, an engineer, could do the job just as well, if not better. Victor Baltard's uncertain reputation is an extreme instance of the trivialization that nineteenth-century architects generally seemed to suffer in the wake of the Industrial Revolution.[57] It would, however, be a mistake to conclude that architects were unwilling or unable to acknowledge the changes brought about by the utilitarian and technological thinking practiced so confidently by contemporary engineers. Binary oppositions of engineering,

science, and rationalism to architecture, aesthetics, and historical memory fail to consider how an architect like Baltard actually practiced his profession, integrating through his work contradictions that only become irreconcilable when abstracted as a dialectics of progress. Architectural education and practice alike had been absorbing new theories of social and industrial progress since the eighteenth century, with the result that, by the 1840s, architects had formulated the means to address society's utilitarian needs even while they upheld their discipline's aesthetic objectives.

Pierre Baltard was an early proponent of utility in architecture. Even if he is now remembered for the Palais de Justice in Lyon (1828–46), whose Neoclassical façade of twenty-four Corinthian columns echoed his conservative pronouncements at the École des Beaux-Arts as its professor of theory (1818–46), Baltard started out in 1794 as Durand's predecessor at the École polytechnique.[58] Charged with reporting on prisons as a member of the Conseil des bâtiments civils in 1813–18 and appointed architect of prisons for the Department of the Seine in those same years, Pierre Baltard drew as much on theories of penal reform and panopticon design as on classical models when drawing up the plans he published in the *Architectonographie des prisons* (1829).[59] His position as a municipal architect assigned to the markets of Paris in 1831–36, anticipating his son's appointment a decade later, engaged him in equivalently practical tasks.

In the next generation, a string of younger architects focused systematically on the architectural consequences of both utilitarian programs and new building technologies. Émile Gilbert, who started at the École polytechnique before completing his education at the École des Beaux-Arts, kept to a simplified classical language indebted to Durand and executed in stone. But over the course of a career running from the 1830s

through the 1860s, he incorporated current theories of penal, mental, and medical science into the design of a prison, an insane asylum, a morgue, a prefecture of police, and a hospital.[60] Abel Blouet, succeeding Pierre Baltard at the École des Beaux-Arts (1846–53), updated Rondelet's *Traité théorique et pratique de l'art de bâtir* by analyzing new materials, especially iron, in a two-volume *Supplément* (1847–48): "our purpose has been to show what effect the use of different materials and their combination can have on architectural forms."[61] François Jäy, Pierre Baltard's son-in-law, who taught construction at the École des Beaux-Arts from 1824 until 1864, regularly considered industrial materials in his courses as they became available: his three-year, seven-part course on construction presented cast iron, wrought iron, steel, and other metals in part two, on materials; part three, on preparing those materials for use in architecture; part four, on structural elements; and part five, on building types.[62] And Léonce Reynaud, Durand's successor at the École polytechnique (1836–66) as well as architect of the first Gare du Nord in Paris (1845–47), published his two-volume *Traité d'architecture* (1850–58) with a similar purpose of correcting the omissions in Durand's *Précis des leçons,* announcing enthusiastically in the *Traité*'s first volume: "For the new material [of iron] being offered to us, we will need new forms and new proportions, because it differs essentially from all others used until now. What was appropriate to stone could not in any way be appropriate to iron. There is therefore, in this industrial fact, the principle, not of a complete renovation of art, but of new elements, of a new branch."[63] In the second volume, Reynaud praised Baltard for realizing just such a "new element" at the Central Markets.[64]

Victor Baltard's realization of the Central Markets was not the extraordinary accomplishment for an academically trained architect that

Haussmann would have us believe. Baltard's education as much as the general evolution of architectural practice and theory in France since the eighteenth century had equipped him with the ideas and skills needed to undertake such a project. That he was only doing what any number of his contemporaries might have done cannot diminish his qualifications; accusations of who plagiarized whom miss the point that every professional architect or engineer, from Flachat to Horeau to Baltard, had equal access to a common set of nineteenth-century conditions and preparation. Baltard proved his ability both through the design itself and through his efficient cooperation with the Joly ironworks in calculating and producing the standardized elements of the markets' metal structure. While not groundbreaking, the construction of the Central Markets made intelligent use of recently developed materials and building systems. The conjunction of cast-iron columns with a predominantly wrought-iron roofing structure took advantage of sheet-iron trellis girders, available only since 1845, in tandem with I-section beams and spandrel brackets to link the structure together and limit the use of tensioning tie-rods to stabilize the two-story lantern that spanned the thirty-meter-wide central nave. Even Haussmann acknowledged that the result, simplifying the structural clutter found overhead in contemporary train sheds, emphasized a new continuity of architectural space by opening up the interiors visually.[65]

This formal objective, rather than Baltard's technical competence, is paradoxically why his design of the markets has been subject to such enduring skepticism. As the architect admitted, he was not satisfied with the markets' utilitarian premise:

What a central provisioning market requires is the easy circulation of vehicles and

pedestrians; spaces proportioned to deliveries; vast shelters where air without the inconvenience of wind, and light without the heat of the sun, penetrate everywhere.

Many markets of Paris more or less answer these conditions; but it can perhaps be regretted that, under the heading of art and embellishment, a more elevated taste did not preside over their general layout as well as the form of their details. It has been claimed that this excessive simplicity was determined by the question of money. But who does not know that in architecture there is always a way to vary the physiognomy of objects, to impress on buildings without great expense the cachet of art and taste, even with the simplest forms? In any case, *halles* and markets are public establishments. They must be, in appearance as in reality, solid and durable constructions. There is an economy to such a system, but a well-understood economy, an economy for the future.[66]

He reiterated this point in his supplement to the *Monographie:* "a public edifice, whatever its use might be, for the very reason that it is public, must present a certain dignity of form, must go beyond the vulgarity of its material nature."[67] What interested architects and made them argue as much among themselves as with rival professions were the aesthetic consequences of the scientific, technological, and industrial phenomena affecting architecture in the nineteenth century. Baltard—like Blouet, Jäy, and Reynaud—accepted the "industrial fact of iron" not as an end in itself but rather as part of a more general argument for the ongoing modernization of the classical tradition in France: speaking to the tensions confronting architects between tradition and modernity, Baltard's rhetorical insistence on the architectural conjunction of stone and iron articulated their

shared desire to reground the disruptive conditions of utilitarian programs and industrial structures in deeper patterns of historical artistic development.

Architects like Lefuel, at the Louvre, or Garnier, at the Opéra, tempered the challenges of modernity by designing state monuments whose appearance, if not structural fact, preserved the illusion that architecture might remain a representationally stable art informed by tradition and unaffected by industrial change.[68] The municipal town halls, churches, and theaters built by Baltard's colleagues in the Prefecture of the Seine likewise concealed their use of modern materials and structures behind typically Neo-Romanesque

or Neo-Renaissance façades.[69] In exposing his use of iron, not only at the Central Markets but also at Saint-Augustin, Baltard avoided this subterfuge and looked instead to the precedent of Henri Labrouste's Sainte-Geneviève Library (figs. 8, 9). The first public building in Paris to boast a revealed iron structure behind its masonry shell, this library proposed a way to recognize modernity without denying history, join science to art, and mediate the abstract techniques of rationalism with a concern for traditional forms.[70] Bringing together stone and iron into a coherent architectural expression, Labrouste rebutted Victor Hugo's argument in *Notre-Dame de Paris* (1832) that modern technology had reduced

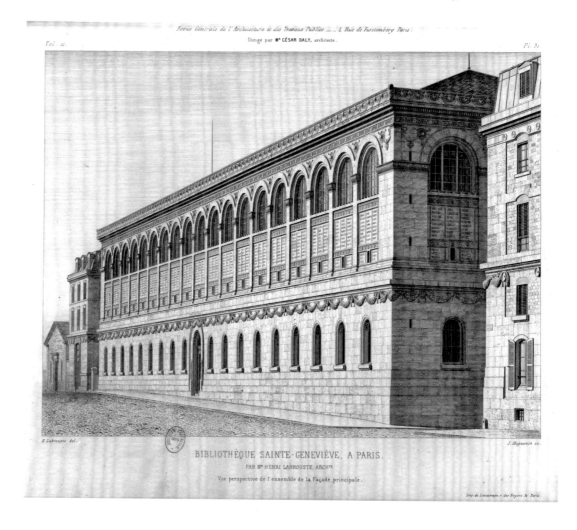

FIGURE 8
Henri Labrouste, Sainte-Geneviève Library, Paris, 1838–50. Exterior perspective, from *Revue générale de l'architecture* (1853).

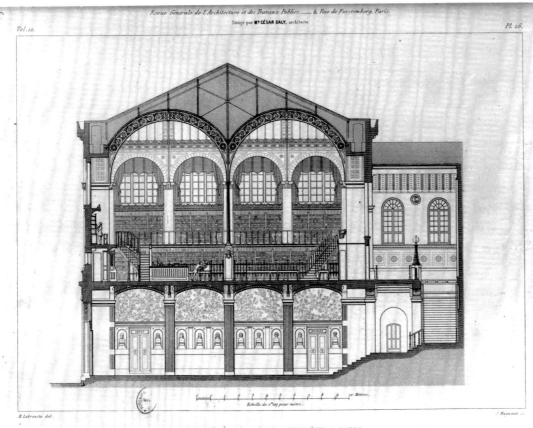

Revue Génerale de l'Architecture et des Travaux Publics.——4, Rue de Furstemberg, Paris.

Dirigé par Mr CÉSAR DALY, architecte.

Vol. 10.

Pl. 26.

B. Labrouste del.

J. Hussenot sc.

Echelle de 0",005 pour mètre.

BIBLIOTHÈQUE SAINTE-GENEVIÈVE, A PARIS.

PAR M. HENRI LABROUSTE, ARCH.te

COUPE TRANSVERSALE.

Imp. de Lemercier, r. de la Sorbonne, 6. Paris

FIGURE 9
Henri Labrouste, Sainte-
Geneviève Library, Paris, 1838–50.
Transverse section through the
entrance vestibule and reading
room, from *Revue générale de
l'architecture* (1853).

architecture to a state of culturally mute utility.[71] Granted, Labrouste acknowledged the erosions effected by modernity, stripping the library's exterior to a structural minimum and then inscribing it with names as if the façade were a printed page for the newly literate public. But like Baltard after him, Labrouste meant to bridge the gap opened up in the nineteenth century between crafting an individual monument in the classical sense and ordering the elements of industrial production in the modern sense.

Labrouste's library provided the conceptual foundation to Baltard's first executed design for the Central Markets, which analogously slipped a cast-iron structure inside a stabilizing masonry shell. He then transgressed this solution in his final project. Looking at the pavilions (fig. 10), it is still possible to see a schematic similarity to Labrouste's library in the arcuated bays screened opaquely at their base with brick walls and opened translucently above with louvers and frosted glass. Yet the similarity makes it even more apparent how foreign the markets were in their spatial diffusion and material ephemerality to the sense of lithic containment and legibility that, for all of its radical modernity, continued to present Labrouste's library in reassuringly traditional terms. With only Paxton's Crystal Palace of two years earlier to provide a point of reference, the Central Markets had apparently stepped beyond

FIGURE 10
Victor Baltard and Félix Callet,
Central Markets, Paris, 1854–74.
Photograph by Charles Marville
of the east group of pavilions from
the roof of pavilion 2 from the
1851–53 markets, after 1859. Private
collection of the Baltard family.

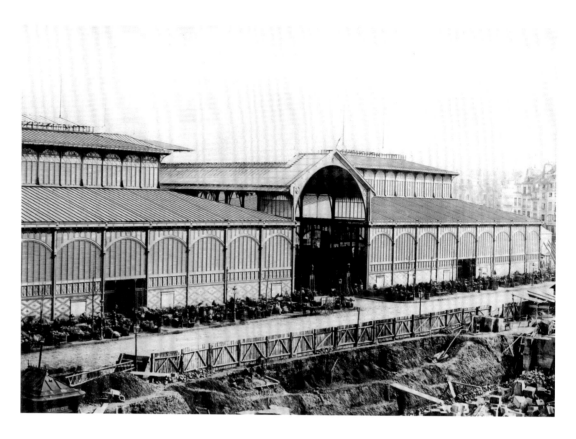

the very history of architecture that Baltard
believed in and meant to effect in his practice.

A HISTORY OF BALTARD'S CITY

This paradox is why we still accept Haussmann's
portrayal of Baltard as little more than a techni-
cian instructed to carry out the ideas of others
who, like the prefect, were better prepared to seize
upon modernity's imperatives. Such a portrayal
can only be answered with a detailed, if necessarily
modest, history of the immediate circumstances
of architectural practice in the nineteenth century,
as those circumstances are documented by one
architect's work over the course of his professional
career. Baltard's design of the markets should be
considered, not as the reflection of an ideologi-
cally fixed position, either for or against moder-
nity, but as the result of his ongoing accommoda-
tion to the developing city of Paris and its effects

on architecture. Against Haussmann's metanarra-
tive of master plans and transformation, Baltard's
career offers a case study of the actually diffuse
historical process that, between 1840 and 1870,
incrementally produced modern Paris.

Organized topically by chapters that study
specific historical issues over time, this book
reconstructs the complexity of Baltard's career,
not as a single synchronous whole, but in dia-
chronic pieces that record the multiple, daily
synchronies of professional practice that came
together in his work. Chapter 2, "Classicism and
the Architect's Education," ties Baltard's academic
formation, from his training at the École des
Beaux-Arts and the Académie de France in the
1820s and 1830s through his activities as a member
of the Académie des Beaux-Arts in the 1860s, to
the nineteenth-century reformulation of classical
doctrine in response to contemporary Romantic

theories of art and history. Chapter 3, "Representing Paris," documents Baltard's complementary bureaucratic formation as a municipal architect from the 1840s through the 1860s, identifying not only the language of civic architecture he helped articulate during those decades but also the forces of political, social, and industrial change that undermined architecture's traditional codes of representation and shifted its justification from functional to urban typologies of monumental public and private domestic building. Chapter 4, "Decorated Construction," takes up a subject raised in previous chapters to consider how Baltard, responding to the fatal separation of ornament from structure posited in Romantic theory, treated decoration as a discursively contingent exegesis on the historically mutable uses of buildings in the city. Chapter 5, "An Urban History of the Central Markets," locates Baltard's pivotal role in the project within concentrically narrowing fields of administrative regulation, urban planning, and architectural design, in order to connect his conception of the markets as integrated works of urban architecture both to the city's historic patterns of development and to its modernization in the nineteenth century. Chapter 6, "Housing the City," compares Baltard's church of Saint-Augustin with the Central Markets to demonstrate how these functionally distinct buildings were informed by their common identity as works of urban architecture, which were therefore treated interchangeably as decorated sheds that interiorized the city and its spaces beneath great sheltering roofs. The book concludes with an epilogue on interpreting Victor Baltard's work in terms of the typological reading of the city proposed by Aldo Rossi and Anthony Vidler.

Deeply invested in the traditions of his art, Baltard was brought by experience and his own intelligence to adjust the inherited paradigms to new criteria of municipal administration, urban

planning, and building technology. Two concerns run through his practice, connecting in a single body of work projects otherwise as varied as the industrial Central Markets, the Neo-Renaissance annexes to city hall, the alterations and additions to the medieval church of Saint-Leu-Saint-Gilles, and the eclectic church of Saint-Augustin: first, the attempt to derive a coherent architecture from conditions of urban siting and context at a time when the city's accelerating physical and social changes were calling into question the functional conventions of Beaux Arts composition; and second, the attempt to formulate an architectural language able to carry architecture's historical burden of representation at a time when technological innovation had severely compromised the classical idea of decoration as the inherent expression of a building's structural order. Out of this came an urban architecture that mediated the differences produced by modernity between the historic city and its nineteenth-century transformation, including its translation from a city of stone into one of iron. Baltard would prove at once stubbornly determined and remarkably patient in his effort to grasp modernity and its effects on architecture from all sides, confusing conservative and progressive critics alike with his willingness to expose the contradictions of his age in a sequence of works that looked back to the past and forward to the future simultaneously.

As Charles Garnier recognized, this left Baltard vulnerable to misinterpretation, particularly when it came to defining the content—both technical and aesthetic—of his architectural work. Not everyone, however, accepted the testimony of Haussmann. Writing to Auguste Perret in December 1915 to ask his advice on compiling an "album" comparing the architectural progress of France and Germany, Le Corbusier cited Baltard's church of Saint-Augustin as one of a few noteworthy French precedents to contemporary

architecture. He went on to ask, "Where are the masters? Where is the vital line of transmission?"[72] A month later, Perret answered:

> The important buildings, marking definitive dates in the history of nineteenth-century architecture, are few, but their value is decisive with respect to the point we want to make. There is [Henri Labrouste's 1869] reading room of the National Library; the Central Markets; [Jean Viel's 1855] Palace of Industry; [Jean Formigé's] Palace of Fine and Liberal Arts at the 1889 Exposition . . . at the same exposition [Ferdinand Dutert's] Gallery of Machines certainly. The church of Saint-Augustin of which you speak and which presents us with the first great dome of iron is not in my opinion as important as the Central Markets by the same architect (Victor Baltard).[73]

Le Corbusier and Perret differed on the value of Saint-Augustin relative to that of the Central Markets yet agreed that Baltard figured prominently in any history of modern French architecture. Perret, who was born in 1874 and had studied at the École des Beaux-Arts, possessed like Garnier an intuitive understanding of Baltard's significance. More surprising, perhaps, is Le Corbusier's reciprocal respect for the architect, until one realizes that his question to Perret was rhetorical: the "vital line of transmission" he sought was actually a pedagogical filiation of education and training well known to both architects. It went back five generations to Victor Baltard, who taught Charles Garnier at the École, who trained Julien Guadet in the Opéra construction office, who taught Auguste Perret at the École, who trained Le Corbusier in his office.

Le Corbusier's correspondence with Perret shows him trying to determine his historical relationship to the nineteenth-century city and its architects in advance of his own projects for remaking Paris, most notably by razing and then rebuilding with a grid of cruciform towers much of the Right Bank, including the Central Markets, in his Voisin Plan of 1925. Anthony Vidler, in an essay on "posturbanism" illustrated with an image of the Central Markets' demolition, suggests that "urbanism . . . might be defined as the instrumental theory and practice of constructing the city as a memorial of itself" and traces its history from the sixteenth-century plan of Sixtus V for Rome to the nineteenth-century transformation of Paris under Haussmann and from there to its modernist rethinking by Le Corbusier in the twentieth century. But where the Renaissance "perspective city proposed a delicate balance between . . . the city as such and its monuments," the "figure-ground city of modernism was founded on erasure" in an act of forgetting: "Such a forgetting would, in Le Corbusier's case, take the form of erasure, literal and figural, of the city itself, in favor of a tabula rasa that reinstalled nature as a foundation for a dispersed urbanism and made its monuments out of the functions of modern life—the bureaucratic skyscrapers."[74] The Central Markets, by turning a medieval quarter of Paris into a rational grid of industrial metal sheds, prefigured Le Corbusier's projected erasure of the city in the 1920s. While Perret, however, did not hesitate to recognize the markets in a genealogy of modernist architecture and urbanism, Le Corbusier's counterintuitive selection of Saint-Augustin speaks to a more ambiguous and ambivalent interpretation of the markets' relevance. His preference for the overtly monumental church over the supposedly utilitarian markets was less a statement of categorical differences between these works than it was a critical indication of their fundamental similarity as products of the Industrial Revolution that were nonetheless deeply indebted to the city's historical

form. In seeking to preserve the historically "delicate balance" between a city and its monuments, the markets as much as the church resisted the very process of erasure that, through the instrument of Haussmann's urban renewal of Paris, had paradoxically made their construction possible in the first place and prepared the way in turn for Le Corbusier's urbanism.

These ambiguities perhaps explain why Le Corbusier soon lost interest in the church and markets alike, erasing both from Paris with his Voisin Plan, and why Sigfried Giedion was then so harsh in his 1928 judgment of Baltard as an architect who "laboriously had to patch his buildings together from the ideas of others." Now, however, the polemics of modernism have come to seem as archaic as the nineteenth-century's experiments with industrial building seemed to Le Corbusier and his contemporaries in the 1920s. The demolition of the Central Markets in 1971—justified by a plan for the second transformation of Paris in the 1960s and 1970s according to Le Corbusier's principles of towers, green spaces, zoning, and expressways—marked a historical turning point reflected in the methodological shift found in Françoise Boudon's investigation of the Halles in the *Système de l'architecture urbaine* and paralleled by the theoretical formulation of a typological city by Rossi and Vidler.[75] Looking back on both the nineteenth- and the twentieth-century cities from the perspective of Vidler's "posturbanism," we are less taken with heroic narratives of instrumental planning than interested in the diffuse and finely grained historical process by which a city is produced through the material, social, and ideological interactions of multiple individuals over time. This inclusive and necessarily tentative approach to the city complicates any history of the "vital line of transmission" connecting Baltard to Le Corbusier. But in positing a more comprehensive, if less linear, method for understanding how architects contribute to making the city, such a history might identify Baltard alongside more canonic figures like Henri Labrouste and Viollet-le-Duc as a seminal participant in architecture's nineteenth-century reformulation in response simultaneously to the material possibilities of the Industrial Revolution and to the urban conditions that, by 1870, had made Paris into a capital of modernity.

Classicism and the Architect's Education

When Georges-Eugène Haussmann called Victor Baltard an "intransigent classicist" and accused this "Prix de Rome" of never "introducing into his work the smallest detail that was not justified by authorized examples," he was making a broader point about the architect's education at the École des Beaux-Arts.[1] In suggesting that Baltard's classicism had kept him focused myopically on the past, blinding him to modern programs and industrial conditions, Haussmann implied that his education was as conservative in theory as he claimed the architect later proved to be in practice. This bias against the École des Beaux-Arts, appearing in print shortly before the start of the twentieth century and codified by modernist historians like Sigfried Giedion, went largely unchallenged until the 1970s, when an exhibition at the Museum of Modern Art in New York systematically reexamined French academic architecture.[2] As Neil Levine argued in an accompanying essay on Henri Labrouste, the identity of classicism as a singular and reactionary tradition was now in question:

> There is no longer any use in considering any of the products of nineteenth-century architecture classical. To designate some as classical and some as not involves the same kind of historical schizophrenia as trying to understand such a building as the Bibliothèque Sainte-Geneviève without taking account of its deliberately applied, historically derived decorative forms. . . . The Beaux-Arts is neither as monolithic a structure nor as homogeneous a system of design as its classical appearance would lead one to believe.[3]

Since then, a generation of scholars have tested Levine's thesis by recovering the actually multivalent aims, agendas, and alliances of nineteenth-century French architects.[4] Like so much else in his *Mémoires,* Haussmann's identification of Baltard as an "intransigent classicist" turns out to be historically inaccurate and critically misleading.

Henri Delaborde and Charles Garnier offered more nuanced readings of Baltard's classicism in the obituaries that each wrote after the architect's death, in 1874. Both noted Baltard's tolerance for complexity in addressing the challenges facing architecture in an age of industrial revolution, and neither characterized him as an "intransigent classicist." Indeed, according to Delaborde, Baltard avoided "taking a stand in the quarrels between the disciples and the adversaries of the doctrine called classical, neither escaping from nor submitting to either the traditions of the old school or the exigencies of the new."[5] Writing shortly before he became secretary of the Academy in May 1874, Delaborde was referring to battles of the 1830s, when aging Neoclassicists like Antoine-Chrysostome Quatremère de Quincy and Pierre Baltard were pitted against young Romantics like

Félix Duban, Henri Labrouste, Louis Duc, and Léon Vaudoyer in noisy debates about the role of history, culture, and technology in shaping modern architecture.[6] Coming of age at this time, Baltard inevitably had a take on classicism different from that of his father, one less committed to the classical orders, more accepting of the diversity of historical precedents, more willing to rationalize architectural forms in an age of technological change. Caught between the principled adherence of his Neoclassical elders to Greco-Roman models and the historicism of his Romantic peers, Baltard seemed to Delaborde to advocate a reasonable middle ground that anticipated the historicized classicism formulated by Charles Garnier at the Paris Opéra (1861–75), which Julien Guadet, as professor of the theory of architecture at the École des Beaux-Arts (1894–1908), then codified.[7] Baltard was encouraged in this compromise by Charles Percier and Pierre Fontaine, two Neoclassicists who first liberalized academic doctrine in the early nineteenth century by offering up the Renaissance alongside antiquity as a more relevant model for contemporary architecture.

As both Donald Drew Egbert and David Van Zanten have shown, this liberal doctrine informed the system of composition taught at the École des Beaux-Arts.[8] Based in rational principles of spatial planning and codified in Prix de Rome projects that refined those principles over the course of the nineteenth century, Beaux Arts composition combined functional programming with an increasingly varied use of history. Because the particular style chosen remained secondary to formal paradigms and to what Pierre Pinon terms, in his monograph on Pierre and Victor Baltard, "the architectural genius of the nineteenth century . . . [for] typological invention," Beaux Arts composition gets one from the Neoclassicism of the father to the eclecticism of his son without losing the thread of their common education.[9] This thesis of

an evolving classical tradition, characterized by its flexible accommodation of historical precedents to functional types, justifies Delaborde's conclusion that Baltard proved "the liberal breadth of his doctrines" at the markets by reconciling the interests of the engineer with those of an artist in a work of architecture that responds to "our immediate needs and modern ideas," as if he finally had no doctrine at all beyond an infinite adaptability to circumstance.[10]

Charles Garnier, who attended the École des Beaux-Arts in the 1840s, when Baltard substituted for his father as the adjunct professor of theory, provided a slightly different take on the architect in his obituary. While complimenting Delaborde for his "remarkable article," Garnier avoided the cliché of opposing schools of Neoclassicists and Romantics.[11] Instead, he spoke of Baltard as someone who "liked a little what was complicated." Where Delaborde saw equivocation, Garnier found independence, suggesting that Baltard had played a "sometimes dangerous game; a mind less clear, a less serious nature, would have lost its way, and our colleague might then have become one of the race of subversive dreamers who think that architecture has as its purpose making stones speak." Absent any clear choices, Baltard had to think things out for himself: "He was a searcher, not in the vague sense of the word, but a searcher with a definite purpose, reached by force of will. He reasoned his art all the way through; implacable logic led him sometimes to formulate artistic expressions that sentiment alone would have abandoned."[12] Aiming to solve problems logically in their own terms, Baltard proved at the Central Markets his ability to respond to a radically altered program with an original solution that made convincing use of iron.[13] Garnier's point was more than a rhetorical sleight of hand deployed to rationalize an inconsistency at the heart of the architect's career. Beaux Arts composition was set

up for projects like the Paris Opéra, not the Central Markets, whose generically gridded layout of prefabricated iron-and-glass pavilions apparently dispensed with the need for functionally elaborated spaces informed by a history of monumental precedents. In attributing Baltard's work to his problem-solving logic, Garnier refused to limit the architect by the conventions of his training, or at least a conventional understanding of what that training entailed. This at once neutralized any supposed contradiction between his education and his most famous work and recognized that his intellectual formation was more intricate and dynamic than Haussmann assumed.

In fact, Baltard's thinking evolved over the course of his career, from his early focus on the rules of composition while at the École in the 1820s to the attention paid in subsequent decades to articulating a language of architecture at a time when developments in both society and technology had called into question the relevance of the classical orders: Baltard broached the problem during the 1830s while at the Académie de France in Rome and then examined its implications at length in the 1840s through a dialectic of construction and decoration addressed in his École lectures. Neil Levine, David Van Zanten, and Barry Bergdoll have each connected this dialectic to a historicist theory of art formulated in the 1830s by a circle of Romantic writers and architects around Léonce Reynaud and Léon Vaudoyer.[14] Seeking to reconcile tradition with industrial progress, these Romantics refused to choose categorically between classical and medieval styles but looked instead to the Renaissance as the starting point for a new historical synthesis in modern architecture. Baltard incorporated this historicism into his École lectures and used it to support his argument for an architecture of decorated construction.

Like Labrouste and his peers, Baltard was searching for a language of architecture in a

century when the norms of classicism no longer held. A remarkable letter written to Baltard in June 1871 by the architect Simon-Claude Constant-Dufeux, when he was a candidate to succeed Félix Duban at the Académie des Beaux-Arts, speaks to the difficulties of this historical project: "Everything tells me that, if we are not on the same grain of sand, we are at least *since Rome* on the same ground, in the good company of Gilbert, Labrouste, Duc, Vaudoyer, etc., of, finally, this pleiad of 1830, truly *classical* and *academic,* in the strict good sense, in the true meaning, of the word."[15] If, like Delaborde after him, Constant-Dufeux recognized the ambiguities that always seemed to accompany Baltard, he was also wrestling with the contradictions faced by every architect of his generation. Claiming Baltard's allegiance yet recognizing that his friend had kept his own counsel, as he joined the Romantics "on the same ground" without yielding that "grain" of loyalty to his father, Constant-Dufeux at the same time located the Romantics on the same "*classical* and *academic*" ground already occupied by the Neoclassicists. Tellingly, he never defined those terms except by association: it was no longer possible to fix the "true meaning" of "*classical* and *academic*" in any way other than the contingent ones of experience and history. If classicism meant anything by 1871, it was the ability of academically trained architects like both Constant-Dufeux and Baltard to work things out for themselves on the ground as they responded to the shifting needs of their practice in an age of unprecedented change.

THE EDUCATION OF VICTOR BALTARD, 1815–1833

Victor Baltard's formal training, first under his father at the École des Beaux-Arts and then under Ingres at the Académie de France, prepared him for his career by inculcating the habits of logic admired later by Garnier. Reflective rather than

polemical, his mind constantly, if carefully, at work, inflecting his father's heritage in the light of his own experience, Baltard was initially more intent on mastering the fundamentals of his discipline than on asserting an independent intellectual position. As a student at the École des Beaux-Arts, he answered to multiple, distinct, yet interdependent institutions, which cumulatively decided his future: a family aspiring to, or seeking to keep its place in, the middle class; a studio master, who was expected to have both the connections and the experience to help his students move ahead at the École; the École itself, with its professors and their monthly competitions; the Académie des Beaux-Arts, whose academicians wrote and judged the Prix de Rome competitions; the Académie de France in Rome, whose director answered like the pensioners to the Académie des Beaux-Arts in Paris; and finally the official careers granted to those select few who made it all the way through. Every architect who studied at the École, especially those who won the Prix de Rome, belonged to an elite world of professionals where everyone knew everyone else, shared the same objectives, and spoke the same language.

Families like the Mansarts, Blondels, Gabriels, and Miques had already specialized in architecture over several generations during the seventeenth and eighteenth centuries, and this tendency only accelerated in the nineteenth century, when institutions like the École des Beaux-Arts made an education in the arts democratically accessible: the 1907 edition of *Les architectes élèves de l'École des Beaux-Arts* lists 309 entries with two or more French architects from the same family (fathers, sons, brothers, nephews, and grandsons) who were active from the mid–eighteenth century onward.[16] Seven of Pierre Baltard's children either studied or married into the arts.[17] Besides Victor, the elder son, Prosper (1796–1862), pursued a career in architecture, enrolling in the École spéciale

d'architecture in 1813 and subsequently working as the architect of the Gobelins manufactory (1849–52) and as an inspector under Visconti and Lefuel on the Louvre and Tuileries (1852–58).[18] Victor's older sister Adèle (born 1798) was betrothed in 1820 to François Jäy, the architect and future professor of construction at the École des Beaux-Arts. His younger sister Constance (born 1812) married the architect Paul-Eugène Lequeux (1806–73) in 1833, three months before Victor wedded Lequeux's sister, Adélaïde. Lequeux, who entered the École in 1822, would, like his brother-in-law, go on to a municipal career, as architect of the suburb of Saint-Denis, while the sons of both Jäy and Lequeux also became architects. A younger brother, Jules Baltard (born 1807), became a painter, and two other sisters married artists: Caroline (1801–1886) wed the engraver Jean Bein in 1826, and Amélie (born 1809) wed the painter and lithographer Pierre Lacroix in 1833. Because these families of professionals shared their skills liberally with any qualified applicant, they often grew more diffuse genealogically with each succeeding generation, as schoolmates and colleagues became relatives through marriage.[19]

As the fifth of ten or eleven children and the second son after the firstborn Prosper, Victor found himself in the middle of a large family ruled with patriarchal authority.[20] Recollections handed down through the family portray Pierre Baltard as a stern father who commanded respect as well as affection and who could answer disobedience with wrath.[21] Typically for the age, his sons felt that authority more directly than the daughters, since they bore the weight of his professional expectations. In 1842, Pierre Baltard praised his younger son as "my disciple, my soldier without pay," crediting his achievements to a sense of duty and obedience.[22] Charles Timbal, a painter and Victor's friend, wrote after his death that he "never resisted his father," to whom he "had

submitted completely as a youth" and "owed, he said, all the successes of his career."[23] Early dreams of becoming a mathematician or medical doctor were abandoned in face of his father's insistence that he become an architect, though Victor was considering alternatives as late as 1831, when he briefly contemplated a military career, before his mother dissuaded him in time to keep this plan from reaching his father.[24] According to Timbal, Baltard learned to present to the world a mask of compliance, which could sometimes be misread: "What the public will never know sufficiently well is the great warmth of temperament that he liked to hide behind a manner that the affairs of men had made a little bantering and cold."[25]

Victor Baltard was born on 19 June 1805 in his father's house, a pavilion behind 637 (now 108bis) Rue du Bac, on the grounds of the former Hôpital des Convalescents, in what was then the xe Arrondissement of Paris. His infancy is largely undocumented, although the multiplying siblings and an already extended family that included the maternal grandfather (the musician Romain de Brasseur) must have challenged the capacity of Amélie de Brasseur to cope as wife, mother, and household manager. First Prosper, then Victor, and finally Jules were sent off to boarding schools at the age of ten. For eight years, from November 1815 until November 1823, Victor attended the Collège Henri IV, where a municipal stipend paid half of his tuition and board.[26] Founded in 1796 in the wake of the Revolution, named the Lycée Napoléon in 1804, and renamed the Collège Henri IV in 1815, this preparatory school for the French elite occupied the conventual buildings of the former Abbaye de Sainte-Geneviève, just behind the Panthéon. Baltard received a classical education that left him fluent in Latin and, in Timbal's words, with "a certain aristocracy of manner and language that for a long time placed him at a higher station than his modest fortune."[27]

Neatly filled notebooks in chemistry, geometry, algebra, trigonometry, equation theory, and statics testify to his scientific aptitude, substantiating alike Timbal's assertion that Baltard was headed for a career in mathematics or medicine and the claim of Ferdinand Deconchy that he was preparing to enter the École polytechnique.[28] Though the school was within easy walking distance of the Rue du Bac, Victor only went home on Sundays, to report his academic progress to his father.

Shortly before he left the Collège Henri IV, Victor wrote his catechism of Lutheran faith on 29 September 1823.[29] A history of ecumenical tolerance in the Baltard family suggests that this was a private, if devoutly held, matter of personal belief: Pierre Baltard was a Lutheran, but Victor's mother had been raised a Catholic, only converting to Lutheranism after the birth of Prosper, who was raised a Catholic; Victor's own child Pauline, baptized a Lutheran, would convert to Catholicism at the age of fourteen. Haussmann, an adherent of the doctrinally stricter Calvinist sect, later attributed a political dimension to Baltard's faith, crediting his "sympathy" for the architect to these years when, as *coreligionnaires* attending the same school, they "formed part of the group of Protestant students who were sent to services at the Temple Sainte-Marie in the Rue Saint-Antoine."[30] Yet Baltard's Lutheran moderation, as much as his reserved temperament and the public careers for which the Collège Henri IV was preparing all of its students regardless of creed, makes it unlikely that these Sunday excursions to the Calvinist Temple Sainte-Marie signaled any conscious resistance on his part to the Catholic majority of France: he was simply getting along with his more radical Protestant peers, just as he would later serve Catholic clients.

Graduating in 1823, Victor Baltard returned home to become his father's student at the École des Beaux-Arts. Installed in 1816 on the grounds

of the former Couvent des Petits-Augustins, the school remained a ramshackle site, its courtyard littered with architectural fragments left from Alexandre Lenoir's Musée des Monuments Français, while François Debret's unfinished Palais des Études (begun in 1819) rose like a ruin in the gardens beyond. Baltard lived next to the school, in the house and studio at 16 Rue des Petits-Augustins to which his father had brought the family by 1828. The circumscribed orbit of Baltard's life, where contingent spaces of domesticity and pedagogy overlapped and blurred, was captured years later in his letter of candidacy to the Académie des Beaux-Arts: "I had my father for a teacher, and as guides, from my earliest studies, his colleagues and friends Percier and Fontaine."[31]

Coached by Percier, he successfully took the École entrance exams in mathematics on 17 February, in perspective on 3 March, and in architecture on 3 April 1824.[32] Bound to his father at every step, Baltard attended his father's theory lectures, participated in monthly competitions written by his father, and composed projects in his father's studio. This instruction was complemented by François Jäy, just named the École's adjunct professor of construction in 1824 (formally replacing Rondelet in 1829), whom Baltard recalled in 1871 as having worked "in concert with . . . his father-in-law, my worthy and venerated father . . . at a better organization of the École, by giving, for his part, to the teaching of construction a development and a rational foundation that it never before had to the same degree."[33] He advanced quickly through the second class in architecture (1824–26), mostly on the basis of technical merits: he earned consistent first mentions and medals in mathematics, perspective, and construction but never got more than a second mention in the monthly *concours d'émulation* in architectural composition.[34] In 1827, Baltard entered as well the second class in painting, as a student of his father's

friend and colleague Guillaume Guillon, called Lethière, for whom he produced competent, if uninspired, figure studies.[35] Victor only began to show real promise after he entered the first class of the architectural section in November 1826. A string of first and second medals from 1827 onward, for both sketched and rendered *concours d'émulation* projects, culminated in 1832 with the *prix départemental* for the greatest number of points earned that year.[36] Baltard competed the first time for a Prix de Rome in architecture in 1831, without advancing beyond the preliminary stage. He competed again in 1832, this time placing fourth behind the winner, Jean-Arnould Leveil. He won the Prix de Rome on his third attempt, in 1833.

Projects like his rendering of a water circus (fig. 11) hold to a beautifully delineated, if conservative, Neoclassical vocabulary indebted to imperial Rome by way of eighteenth-century Paris. Reflections of the programs written by his father, these fantasies suspend, at least for a moment, one's skepticism about something as alien to the nineteenth-century as a water circus. Subsequent projects like the maritime prefecture (fig. 12) responded to more topical programs with updated quotations of Italian Renaissance architecture. Often treating public buildings with complex programs, the *concours d'émulation* were preparatory exercises for the Prix de Rome.

Meeting on 3 May 1833, the eight members of the architectural section of the Académie des Beaux-Arts proposed a public treasury, a gymnasium, an athenaeum, a zoo (*ménagerie*), a veterinary school, a military school, a preparatory school (*lycée*), and a pantheon as the program for that year's Prix de Rome competition. After editing this list to a pantheon, a gymnasium, or a military school, the school was selected in a drawing by lots.[37] All three programs were new to the competition and were topical in the cases of the

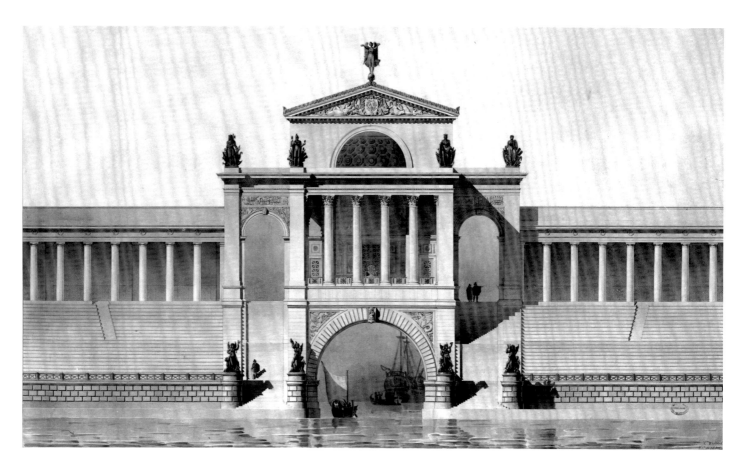

FIGURE 11
Victor Baltard, project for a water circus, *concours d'émulation,* 1830. Elevation.

FIGURE 12 *(opposite)*
Victor Baltard, project for a maritime prefecture, *concours d'émulation,* 1832. Section and elevations.

pantheon and the military school: Louis-Philippe had renationalized the Panthéon in 1830, and in 1833 the July Monarchy publicized its decision to surround Paris with fortifications.[38] Intended for four hundred students, the military school subdivided into (1) a dormitory and refectory for students; (2) apartments for the administration and faculty; and (3) teaching facilities, including a chapel, classrooms and amphitheaters, a library, a cabinet of natural sciences and mineralogy, and a gallery for plans, maps, and models.[39] A riding school, swimming school, and artillery park were also required.

When the eight finalists were judged, on 21 September 1833, Victor Baltard came in first, ahead of Hector Lefuel (a student of Huyot's) in second and Pierre-Philippe-Claude Chargrasse

(a student of A.-M. Chatillon's) in third. Baltard's project (fig. 13) was praised for an "ingenious" plan that "fulfills the conditions of the program."[40] Intersecting rectangles unfold along a central axis that extends to swimming and riding schools to either side of the main building. This building is organized by a forward block of student and faculty wings that frame a central courtyard, and a rear teaching block around a chapel with nine amphitheaters lining the perimeter. Starting with functionally directional projects like Louis Duc's 1825 Prix de Rome for a town hall (fig. 14), which distributes spaces discursively along a principal axis, Baltard avoided the resulting spatial diffusion by restoring the paradigm of modularly gridded and cross-axial planning perfected in Charles Percier's classic project of 1786 for a building to

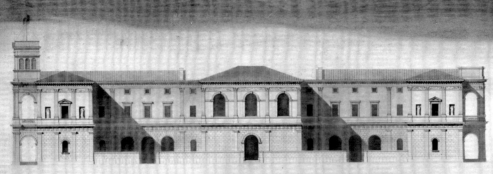

FACADE LATERALE

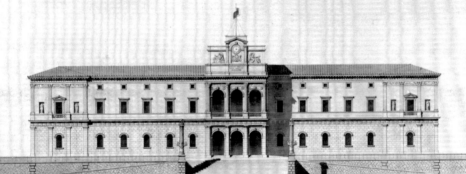

FACADE SUR LE PORT
CÔTE DE L'ADMINISTRAT.

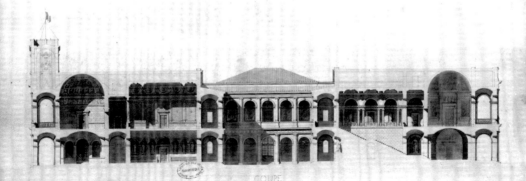

COUPE

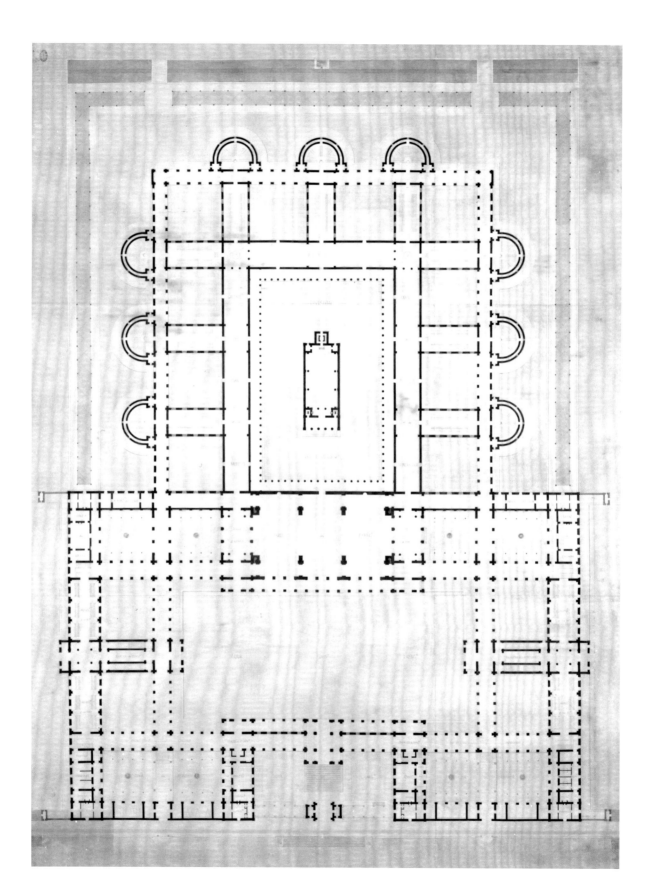

assemble the academies (fig. 15). Baltard's teaching block refers directly to Percier's project, in a variation on a theme that preserves the formal logic of a subdivided equilateral square yet reverses its spatial rhythm by shifting the grid from three to four squares on a side. Despite the allusion to the proposed fortifications for Paris, this Prix de Rome was an academic exercise, utopian in its detachment from the practical world and concerned principally with recomposing a tradition of precedents. Baltard assisted his father in preparing the 1834 edition of the *Grands prix d'architecture* and had clearly internalized its lessons.[41]

By 1833, however, this tradition was under attack. In 1828, two pensioners at the Académie de France in Rome had sent back provocative *envois* to Paris: Henri Labrouste's fourth-year restoration of the temples at Paestum, which challenged the accuracy of authors on whom Neoclassical doctrine was based, and Felix Duban's fifth-year project, whose modern if modest program for a Protestant temple questioned the relevance of antiquity to contemporary social and political conditions. *Envois* submitted the following years by Henri and Théodore Labrouste, Louis Duc, Léon Vaudoyer, Antoine Delannoy, and Simon-Claude Constant-Dufeux continued to test the limits of Neoclassicism. The Académie des Beaux-Arts responded moderately in its reports, but the situation was exacerbated by personal differences between Quatremère de Quincy, who as perpetual secretary took the lead in critiquing the *envois,* and Horace Vernet, who as director of the Académie de France defended the pensioners' work. Matters came to a head in 1830, when Vernet refuted Quatremère de Quincy by offering himself to verify Labrouste's measurements of the temples at Paestum.[42]

Dissension in the academy mirrored the contemporary political turmoil in Paris as mounting opposition to the Bourbon Restoration exploded

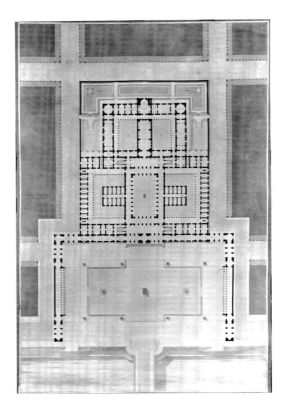

FIGURE 13 (*opposite*)
Victor Baltard, project for a military school, Prix de Rome, 1833. Plan.

FIGURE 14
Louis Duc, project for a hôtel de ville, Prix de Rome, 1825. Plan.

FIGURE 15
Charles Percier, project for a building to assemble the academies, Prix de Rome, 1786. Plan.

in 1830 with the revolution that brought in the constitutional July Monarchy of Louis-Philippe; François Guizot, Victor Cousin, and Victor Hugo were simultaneously promoting a ferment of

Romantic ideas in history, philosophy, and literature. Prix de Rome pensioners, motivated by anxiety about their careers, returned to Paris demanding equivalent reform in the arts in a campaign that took aim at the teachings of Quatremère de Quincy and Pierre Baltard. In 1831, the elder Baltard opened his course by asserting the most uncompromising Neoclassicism imaginable:

> Despite the unprecedented excursions outside the field of architecture, antique as well as modern; despite the succession of new fashions that have appeared one after another from within the school over the last fifty years; despite the falsified imitations of Greek architecture and the temples of Paestum; despite the introduction of a semi-Gothic manner dignified by the name of Tuscan architecture; and despite the recent fashion for paintings and embroideries imitating the ruins of Pompeii, it is the masters [of the antique] who, in the midst of so many deviations, have upheld the taste of the only two forms of architecture that are worthy of imitation—such as the Propylaea of Athens or the Parthenon, or Roman monuments of the time of Augustus and Trajan—and that should be considered as the only types of good architecture.[43]

Quatremère de Quincy reiterated this prejudice categorically the following year, insisting in the *Dictionnaire historique* that modern architecture emulate that of ancient Greece and Rome.[44]

Younger architects equated this doctrinal rigidity with the system of seniority they saw tyrannizing the profession. On 20 January 1831, architecture students interrupted an awards ceremony at the École, refusing to accept their medals and disrupting the presentation of medals in painting and sculpture with whistling and foot shuffling. Five days later, on 25 January,

the minister of the interior, Marthe-Camille de Montalivet, named a commission charged with reporting on possible reforms, whose work was to include a review of the Academy's authority to control and judge the Prix de Rome.[45] The fifteen academicians appointed along with Quatremère de Quincy refused to participate, and the attempted reform died in 1832, after the École des Beaux-Arts ignored the commission's report. Thwarted pedagogically, institutional reform went ahead in other ways, most notably through a 1832 decree that opened up government job opportunities by restricting architects' sinecures to a single state building and agency.

Baltard's victory in 1833 came in the midst of continuing unrest: a cholera epidemic that decimated the city from March to October of 1832; martial law imposed in June 1832 in response to Saint-Simonian, Republican, Royalist, Bonapartist, and workers' threats to the government; a protest in July 1833 by students of the École polytechnique, who believed that the proposed fortifications of Paris were really an instrument to control the city's population. Yet Baltard triumphed with an academic exercise whose respect for tradition is matched only by its detachment from current events. Reviewing the Prix de Rome in September 1833, Tiburce Morisot worried that

> our architects are trained to produce works of magnificence and luxury, when the economy in building that will later be asked of them should be the basis and the rule for both the exercises and the instruction that constitute their studies. To be sure, neither ideas of monumentality nor a knowledge of antiquity should be abandoned, since we believe that these alone can form true artists; but without forsaking this important part of education, one could join to it an understanding of more

common and certainly just as useful types of building.[46]

Dazzling in its mastery of the past, Baltard's project seemed irrelevant to the present.

Baltard was inescapably aware of the events unfolding in 1830–32, and his attempt to enter military service in 1831 suggests one last crisis of commitment before he put aside his doubts and gave himself to architecture. While others protested, Baltard took the entry-level jobs granted to better students at the École: in 1827, he was named a supernumerary, and then in 1831, the titulary *conducteur* supervising workers and the delivery of materials at Hippolyte Lebas's church of Notre-Dame-de-Lorette (1822–36); in 1831, he was named an inspector under Louis Visconti for the Fête de Juillet celebrating the July Revolution of 1830; in 1832, the year of reform, he was named in recognition of his *prix départemental* a *sous-inspecteur* assisting Paul Lelong at the Archives, Victor Dubois at the Conservatoire des Arts et Métiers, and Jean-Antoine Alavoine at the Colonne de Juillet, where he worked alongside Louis Duc.

Pierre Baltard had ambitions but no wealth for his son, and therefore gave to Victor the only things he could: his training and connections. To regret that Victor Baltard did not import into his education the strife then affecting France is to mistake his purpose, which was to demonstrate his competence in academic works of composition. Baltard won the Prix de Rome because his project, at once erudite and original, contributed a formal invention to the tradition it upheld. While his subsequent career in municipal architecture would cause him to rethink those conventions, especially when it came to applying the abstract and self-referential principles of Beaux Arts composition to the practical needs of real buildings in the city, Baltard's focus in 1833 was on winning

the Prix de Rome. In its own way, this purpose was just as practical, because it brought the objective of a career one step closer.

IN ROME, 1834–1838

According to Timbal, the five years spent by Victor Baltard at the Académie de France in Rome were "the most beautiful time in his life."[47] Baltard wrote lyrically of the Villa Medici in a book of engravings published in 1847 (figs. 16, 17):

> Happy is he to whom is given the chance to claim the past with memories of places where the contemplation of artistic and natural beauties ennobles thought, where we especially feel ourselves living through our affection for the things and the men who have contributed to our education, to the exercise and development of our faculties! After home come the schools, places of study, classical countries. Among these, the best is the place where one has experienced the most, intellectually and emotionally: that is to say, Rome . . . that is to say, the Villa Medici.[48]

Distanced from his father's demanding presence and the confusion of Paris, in a country that was then more profoundly foreign to France than in our homogeneous present, Baltard found the time and space to mature intellectually. J.-A.-D. Ingres, director of the Académie de France from 1835 until 1841 and the man to whom Baltard dedicated his book, was instrumental. Mentor and teacher, Ingres freed Baltard from his father's tutelage and gave this obedient son his first real opportunity to think for himself.

On 8 October 1833, two and a half weeks after receiving the Prix de Rome in architecture in a public ceremony at the Institut de France, Victor Baltard married Adélaïde Lequeux, called Adèle. The following March, the newlyweds left Paris,

FIGURE 16
Victor Baltard, general view of the
Villa Medici from the city, from
Villa Médicis à Rome (1847).

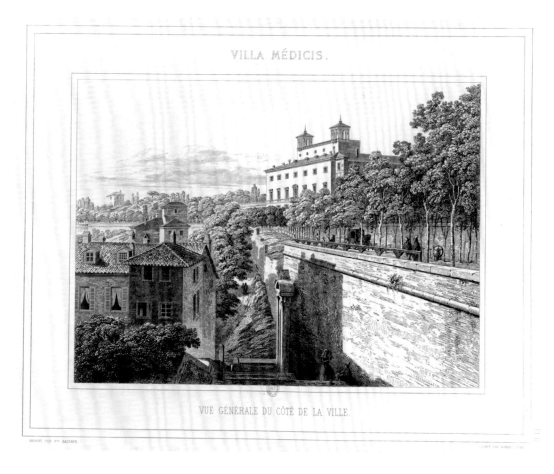

VILLA MÉDICIS.

VUE GÉNÉRALE DU CÔTÉ DE LA VILLE.

traveling south by way of Lyon and Marseille, from whence they took a steamship to Civitavecchia, landing on the coast of Italy some eighty kilometers from Rome.[49] They moved into rented rooms on the Via Sistina, at the foot of the Pincian Hill, on which the Villa Medici stood. Nearing thirty years in age, Baltard came to Rome as a married man and, in 1834, the father of his only child, Pauline (called Paule).[50] The young family lived on the Via Sistina because only a director's wife was permitted to reside in the Villa Medici. The regulations of the Académie de France, revised and approved by royal ordinance in 1821, stipulated that pensioners be housed and fed at the villa, presuming without specifying that they be bachelors.[51] This left a loophole through which Émile Signol (winner of the 1830 Prix de Rome

in painting), Pierre Garrez (1830 Prix de Rome in architecture), Jean-Arnould Leveil (1832 Prix de Rome in architecture), and Victor Baltard all slipped as married pensioners. Before leaving Paris, Baltard wrote to Adolphe Thiers, minister of commerce and public works, requesting an additional stipend for room and board outside the Villa Medici, which was granted in a report citing Signol as its precedent.[52] Baltard was the last pensioner to benefit from the oversight: his married brother-in-law, Lequeux, won the Prix de Rome in 1834 but could not afford to go, and when the regulations were again revised in 1846, they explicitly disqualified "married artists."[53]

Baltard spent his days at the Villa Medici before returning home in the evening. Letters to Eugène Roger (1833 Prix de Rome in painting)

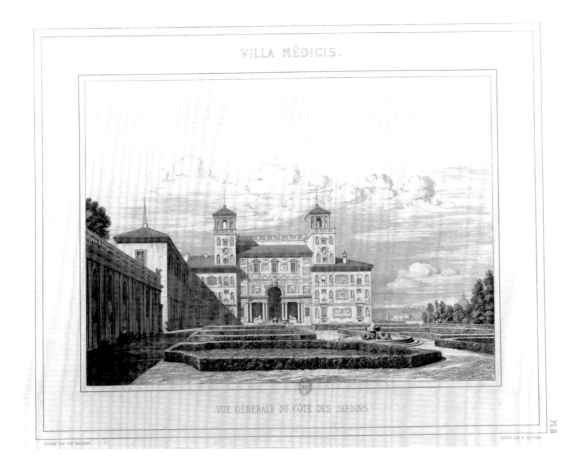

VILLA MÉDICIS.

VUE GÉNÉRALE DU CÔTÉ DES JARDINS.

FIGURE 17
Victor Baltard, general view of
the Villa Medici from the gardens,
from *Villa Médicis à Rome* (1847).

record Baltard's candid views of the other pen-
sioners.[54] He was closest to Ingres's students, espe-
cially Hippolyte Flandrin (1832 Prix de Rome)
and his brother Paul (arriving independently in
1834), along with Paul Jourdy (1834 Prix de Rome)
and Roger. In February 1836, Baltard wrote to
Roger that the "Flandrin pair" "come often to see
us, and their visits are the only recreation in the
evening to which we attach any value; they are
excellent friends. Then comes Jourdy, who is at
least equal to the two Flandrins in weight. More-
over, he is very well known . . . in Roman soci-
ety."[55] Among the architects, Baltard singled out
Constant-Dufeux (1829 Prix de Rome) and Gar-
rez, writing wistfully to Roger in August 1835 that
"I have just seen Dufeu [sic] leave, the only one of
my architectural colleagues whose talent and good

friendship could have compensated me for what
I am soon to lose with the departure of my good
comrade Garrez."[56] After Garrez left in 1836, Pros-
per Morey (1831 Prix de Rome) became his com-
panion by default, although their relations were
uneasy: "Morey is always the same, very chatty
and very amiable with those who put up with his
answering north when one tells him south."[57] Bal-
tard's patience had worn thin by the time Morey
left for France in 1837: "It is very difficult to speak
of a colleague when one wants to be severe in
principle and indulgent by circumstance."[58] He
ignored Jean-Arnould Leveil, who had defeated
him for the 1832 Prix de Rome, and kept his
distance from the younger pensioners: Charles-
Victor Famin (1835), François Boulanger (1836),
Jean-Jacques Clerget (his father's student, granted

a three-year pension in 1836), and François-Jean-Baptiste Guénepin (1837). When squabbles disrupted the peace in July 1838, he wrote to Roger:

> I will tell you in confidence, my dear Roger, that with you and the Flandrins gone, the rest of our fellow academicians do not amuse me at all; fortunately, in my situation I hardly have to deal with them, and I give them little cause to deal with me. I am sure that they are all very good and very nice; but I believe that one must give up making new friends at my age: one already feels old and one becomes intolerant. There is only that good fellow Simart [Pierre-Charles Simart, 1833 Prix de Rome in sculpture] . . . with whom I might be friends.[59]

Baltard kept to a small, at once restricted and familiar, circle of acquaintances. When companions like Constant-Dufeux or Garrez left for Paris, the circle simply got smaller.

Ingres was the heart of this circle. Named to replace the controversial Horace Vernet in July 1834, Ingres reached the Villa Medici at the dramatic hour of two in the morning on 4 January 1835.[60] Taking control some three weeks later, on 24 January, he reformed the rhythms of life at the Villa Medici, turning the place inward after the extroverted tenure of Vernet. Eugène-Emmanuel Amaury-Duval witnessed the transition from Vernet's last days, when the Villa Medici was a glittering salon for the elite of Rome, to the sober regime instituted by Ingres: "Everything was somber and gloomy: a lamp in each corner of this immense room, made even darker by the tapestries decorating it; a lamp on the table and, near this table, Madame Ingres knitting; Monsieur Ingres, in the middle of a group, conversing gravely. But not the shadow of a woman, black suits only, nothing that might distract the eye."[61] Foreigners were mostly excluded, although Frenchmen,

especially artists, could visit by invitation. During the week, Ingres and his wife entertained select pensioners in their private quarters, and on Sunday, received all of them for dinner, followed by a concert at which Ambroise Thomas (1832 Prix de Rome) and others would play, according to Amaury-Duval, "the virtuous music, as Ingres called it, of Mozart, Beethoven, and Gluck."[62]

The image cultivated for the Villa Medici was one of bourgeois propriety, with the director and his wife acting in *loco parentis* to ensure at once the good behavior and welfare of their extended family of artists. Despite the irregularity of his married status, Baltard won the director's affection, aided by his studious temperament and the recommendations of mutual friends: besides the Flandrin brothers, these included Jacques-Édouard Gatteaux, a medalist and engraver who was equally close to Ingres and Pierre Baltard and who remained in regular contact with Ingres from Paris. Victor's Sunday visits home while a student at the Collège Henri IV now gave way to Sunday evenings at the Villa Medici, where the paternal figure of Ingres replaced Pierre Baltard. In 1836, Ingres drew a pair of portraits, one of Victor with Saint Peter's in the background (fig. 18), and the other of Adèle and Paule under the garden loggia of the Villa Medici, inscribed "to his friend Mr. Victor Baltard." Baltard answered with devotion, exclaiming to Roger in August 1835: "Mr. Ingres . . . is a man one cannot love by half measures, and in truth he has conquered me."[63] He wrote again in 1836: "After the flock [of pensioners] I come to the shepherd [Ingres], always good, always sublime in his lessons, which is to say, in his conversations, which are rich in beautiful precepts."[64]

Eugène-Emmanuel Viollet-le-Duc, in Rome from late October 1836 through May 1837 during his tour of Italy, offered an outsider's perspective of the pensioners in letters written home to

FIGURE 18 (*opposite*)
J.-A.-D. Ingres, portrait of Victor Baltard, 1836.

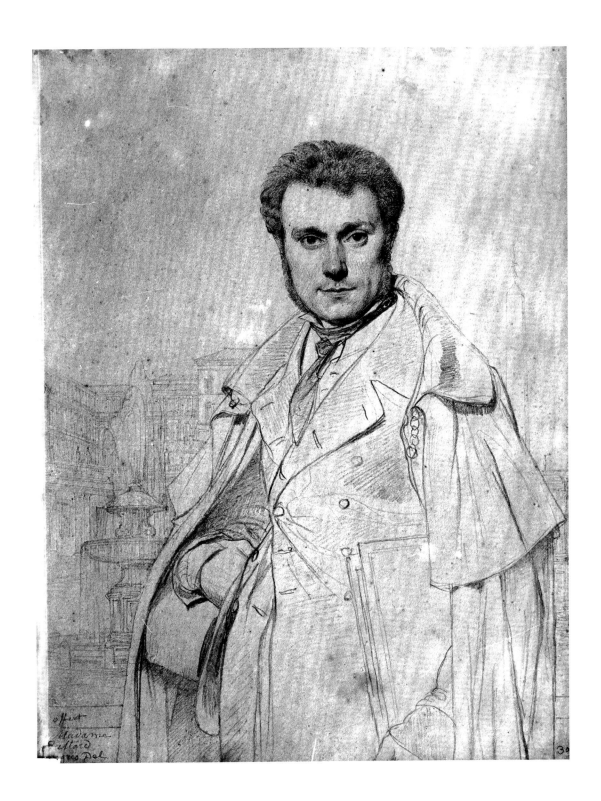

his father.[65] Received warmly by Ingres in late November, Viollet-le-Duc became a regular guest at the Villa Medici, boasting that he soon got to know "all the students of the Academy" and inviting them in turn to Monday salons at his apartment on the Via delle Carrozze.[66] He met up again with Prosper Morey, with whom he had studied in the studio of Achille Leclère and who gossiped with him about the Academy's three factions: the "Etruscans," obsessed with "the tombs of Corneto"; the faithful "students of Mr. Ingres"; and "the independents, who form the last pit from the seditious fruit that Mr. Horace [Vernet] had let grow at the Academy."[67] In January 1837, Viollet-le-Duc announced to his father that he was "fine with the entire Academy," only to see his happy situation sour after Victor Baltard returned to Rome that same month from a three-months' absence in southern Italy: writing to his father on 26 March, Viollet-le-Duc told a convoluted tale of intrigue in which he accused Baltard, acting through an unnamed third party, of warning him away from the Villa Medici after he and his family became too friendly with Ingres and his wife.[68] Viollet-le-Duc stopped holding his Monday salons and cut off all ties with the pensioners, except for a few friends like "Morey, the excellent Morey, who still loves us."[69]

It should be remembered that Viollet-le-Duc was famously skeptical of the Academy long before he tried to reform the École des Beaux-Arts in 1863. The same letter that boasts of his intimacy with the pensioners also complains: "I am more than ever convinced . . . of the unfortunate influence that this sort of academic corporation has on the youth, which gives to all of them a uniform character, a pedantic manner of solemnity that seems a sort of illness in young men. With them, no originality, no individual personality; one is neither Pierre nor Paul nor François; one is a *Student of the Academy*."[70] In siding with the garrulous Morey, rather than the reserved Baltard, Viollet-le-Duc was trying to have it both ways, keeping his intellectual distance from the Villa Medici even as he accepted flattering invitations from Ingres. The sense of superiority that comes through in Viollet-le-Duc's letters vis-à-vis the pensioners (including Morey, who was the unwitting subject of tart remarks) is condensed in his passing reference to Baltard as "a charming boy": at thirty-two, Baltard was actually eight years older than Viollet-le-Duc, who had just turned twenty-four in January 1837.[71] What Viollet-le-Duc casts as malicious interference may well have been motivated by Baltard's desire to protect Ingres and the Academy from the attentions of someone who was not nearly as well intentioned as he seemed.

The Villa Medici was meant to be a haven where pensioners could study quietly, away from mundane cares and needs. Ingres restored the villa, remodeling its library, installing an architecture gallery of fragments and casts, replanning the gardens and planting them with umbrella pines. To encourage a privileged sense of mission, Ingres called on the archaeologist Antonio Nibby, who had excavated the Forum Romanum in 1827–35, to teach a course on classical Rome. First offered in the winter of 1836–37, the course surveyed the city's ancient topography and monuments from the contemplative distance of the Pincian Hill.[72] When cholera epidemics ravaging Italy reached Rome in 1837, the Académie de France literally became a place of refuge. On 18 August of that year, the painter Xavier Sigalon (in Rome to copy Michelangelo's *Last Judgment*) died of cholera while staying at the Villa Medici. Baltard wrote to Roger in September that Sigalon's death had thrown the pensioners into a state of panic, until Ingres calmed their fears by quarantining the villa,

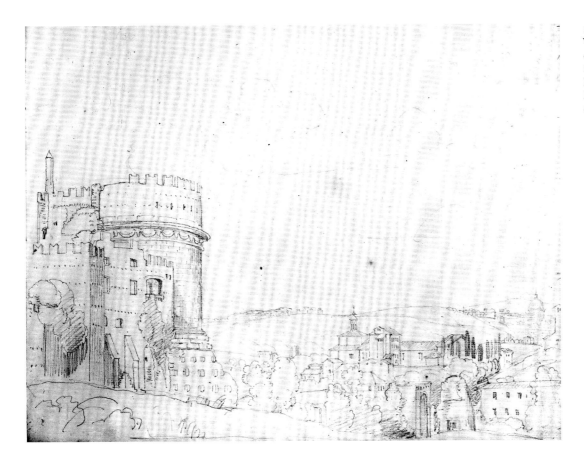

FIGURE 19
Victor Baltard, sketch of the tomb
of Cecilia Metella with Rome
in the distance, circa 1834–35.
Document held at the Centre
historique des Archives nationales
de France, Paris.

prophylactically sealing its doors and preventing further deaths: "Perhaps it is because of this unhappy event that everyone in the academy now enjoys perfect health . . . everyone . . . follows with scrupulous exactitude the most severe laws of hygiene."[73]

Still, the rest of Italy beckoned outside the villa's walls. Broken into a puzzle of states, overrun by highway brigands who made it prudent to travel protectively in groups, littered with ancient sites and medieval towns, Italy in the nineteenth century was an exotic, if dangerous, land. Rome and the surrounding countryside were explored on foot, while longer trips were taken by coach, with fares that often included meals and beds at inns along the way. Before railroads reduced to hours journeys that had once taken days, one dis-

covered the country at the leisurely pace described by Amaury-Duval:

the slow trot of the horses . . . leaves you perfectly indifferent; one knows that one will do ten leagues in a day, that one will arrive at fixed hours for eating and sleeping; one therefore need only admire the countryside, climb the hills on foot, and often descend them on foot as well; almost a walking trip in the end, with the possibility of resting in the carriage that follows you, when it gets too hot. . . .

I traversed Italy in this way, in every direction, and I could really see it. Since then, I have done in a few hours what once took me four days, and I congratulate myself for having visited Italy before the invention of these

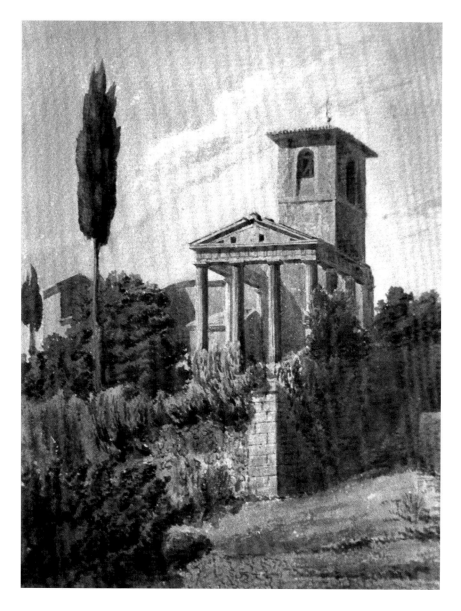

For the first two years, Baltard kept to Rome and nearby sites like Veii, Cerveteri, Tarquinia, Viterbo, Orvieto, Tivoli, and Cori. He sketched what he saw topographically, as the layering of history in a place: the tomb of Cecilia Metella with Rome looming in the distance (fig. 19), the Temple of Hercules at Cori jostling with its transformation into the church of San Pietro (fig. 20).[75] From June to December of 1836, Baltard visited southern Italy. With Naples serving as his base camp, he first explored Pompeii, Herculaneum, and Paestum, and then embarked on longer tours, through Puglia and Calabria on his own, and to Sicily in the company of Morey and Joseph Nicolle (a student of Henri Labrouste's).[76] Sicily, with its ancient Greek and medieval sites, overwhelmed Baltard, as he wrote to Roger in September: "too many companions, too many mountains, and too many beautiful things to see in the time I could consecrate to them."[77] Another cholera outbreak delayed Baltard's return to Rome by three months, from October until he finally made it back with his family on 10 January 1837 after a harrowing journey.[78] Baltard stayed put until he left Rome for good in the fall of 1838, visiting Florence, Bologna, Perugia, Venice, and Rimini before returning to France in December.

The trip to Puglia and Calabria in the summer of 1836 was on a commission from the duc de Luynes. Writing to Ingres on 22 December 1835, the duke had offered to pay a pensioner 2,000 francs to illustrate a book on the history of Norman architecture of southern Italy.[79] Ingres gave the commission to Baltard, along with an itemized list of the sites to be visited: the pensioner checked off each item with a "Done" when he had finished the meticulously measured and detailed pencil studies that, interspersed with picturesque views of the countryside and *in situ* monuments, became the book's thirty-five plates (fig. 21).[80] Reflecting the duc de Luynes's particular

marvelous means of transport that deprive you of a thousand charming details, make you pass like an arrow by small towns that a few hours would have been enough to visit but that would take too much time if you had to wait until the next day's train.[74]

Preindustrial and premodern, Italy in the 1830s was a country removed from the changes already affecting France.

Coupe sur l'axe

Plan de l'encadrement de la fenêtre du milieu.

Encadrement de la fenêtre du milieu.

CATHÉDRALE DE BARI.
Détails de la façade postérieure.

interest in the influence of Arabic traditions on the architecture of southern Italy and Spain, the book updated the eighteenth-century topographic tradition of the *voyage pittoresque* by looking beyond the world of classical antiquity to consider the Middle Ages even as it continued to emphasize directly observed empirical evidence. The technical training and widening historical horizons of Villa Medici pensioners made them logical candidates for the job; in 1853, the duc de Luynes commissioned another pensioner, Charles Garnier, to delineate the funeral monuments of the House of Anjou in southern Italy and Sicily.[81] Though Baltard complained to Roger that the trip through Puglia was "tedious, laborious, and flat," he was paid a considerable sum to use skills already in hand to survey buildings in the field.[82] Grumbling aside, the task was familiar and one that Baltard easily completed in time to send the final drawings back to Paris with the *envois* in July 1837.

Determined to dedicate himself to the affairs of the Villa Medici and hampered by poor health, Ingres slighted his own work while in Italy. He did bring two projects from Paris. The first was a rather naïve request from Adolphe Thiers that he copy works by Raphael: Ingres handed this off to his students Raymond and Paul Balze, who labored from 1836 to 1840 duplicating the cycle of fifty-two frescoes in the Vatican Loggie, while Baltard traced their decorative frames and borders.[83] The other project was a commission from the duc

FIGURE 23
Victor Baltard, study of wall
paintings and architectural details
from the House of Sallust in
Pompeii, 1836. Private collection
of the Baltard family.

d'Orleans to paint a pendant to Paul Delaroche's *Death of the duc de Guise:* between 1835 and 1840, Ingres fitfully executed his diminutive canvas of *Antiochus and Stratonice* (fig. 22), working with the Balze brothers and Baltard, who designed its polychromatic Pompeiian setting.[84] Early in 1836, Baltard confided to Roger that Ingres "does nothing, nothing except for his little picture, on which I work every day."[85] Ingres's decision to move the story of Antiochus and Stratonice, told in Plutarch's *Lives,* from the ancient Near East to Rome led Baltard to elide Greek and Roman imagery by situating the bedroom scene in a Corinthian atrium: known from Pompeii, this Hellenized form of atrium had four, instead of the usual two, columns on a side.[86] Pompeii and nearby Herculaneum had been subjects of archaeological and artistic interest ever since their rediscovery in 1738 and 1748,

and they remained obligatory sites to be visited and sketched by pensioners across the nineteenth century. When Baltard first visited Pompeii during the summer of 1836, recording examples of its painted architectural decoration in meticulous watercolor studies (fig. 23), he saw in person what he had already absorbed at second hand through publications like *Les ruines de Pompeii* (1813–38) and from the drawings by other pensioners that circulated the Villa Medici studios as a valued, if informally constituted, visual archive.[87]

Assisting the director of the Academy in Rome on a painting's classical setting seems a respectable pastime for a Prix de Rome pensioner. Pompeii, however, posed a problem for the academicians back in Paris. Although the city was ancient, its value lay more in artifacts of daily domestic life than in public buildings that seemed, at best, to

be provincial variants of grander models found elsewhere, and that were therefore deemed poor examplars of the classical monumentality pensioners were expected to analyze in their *envois.* Pierre Baltard voiced the concern of many Neoclassicists when he protested in 1831 "the recent fashion for paintings and embroideries imitating the ruins of Pompeii."[88] Amaury-Duval, on the other hand, spoke for his contemporaries when he confessed: "The long and frequent visits that I paid to Pompeii did not only engage my aesthetic interests: the art of the ancients, which differs so completely from our own, also awoke in me a lively curiosity to know the material and practical sides of life."[89] By 1836, the troubling fashion was entrenched: seven *envois* of public Pompeiian buildings were produced between 1818 and 1836, and even though no one had as yet dared choose a Pompeiian house for his *envoi,* Baltard's erudite interior for *Antiochus and Stratonice* anticipated François Boulanger's 1839 *envoi* of the House of the Fawn.[90]

Worries about Pompeii were exacerbated by the parallel debate over architectural polychromy. Since the 1820s, Jacques-Ignace Hittorff had argued that ancient temples were completely and boldly painted, against Désiré Raoul-Rochette, who defended a more restricted use of color in keeping with Quatremère de Quincy's purist ideal.[91] The evidence of Pompeii supported Hittorff's argument for polychromy and encouraged young Romantics to draw the radical conclusion that a building's decoration, rather than being determined by the constituent orders, as Quatremère insisted, was an independent overlay of accretive ornament added to the separate facts of a building's structure. As both Levine and Van Zanten have shown, this rethinking of architecture as a system of decorated construction was informed by Villa Medici *envois* like Labrouste's 1828–29 restoration of the three Greek temples at Paestum: treating them as straightforward stone structures, Labrouste tied their functional and cultural meaning to ephemeral schemes of painted decoration (along with attached objects such a shields).[92] If the Pompeiian setting invented by Baltard for *Antiochus and Stratonice* remains classical, it does so heretically, much like Ingres's own eccentric classicism. Writing to Baltard in September 1838, Lequeux observed that "you threaten us in a letter to Garrez with *Classicolisme* [*sic*]," an apparent pun on "Catholicism" and "alcoholism" alike to suggest the fervid classicism that Ingres inculcated in his protégés. Lequeux, however, was uncertain how, or how far, to take its meaning, concluding it would be "wise to come to an understanding on the word."[93] For Baltard, the term spoke to the freedom granted by Ingres to push beyond orthodox Neoclassical doctrine into experimental (and implicitly Romantic) realms of artistic practice where a decorative concern for detail, color, and form provided its own logic and justification. The license to experiment that came from the opportunity to work with Ingres on "his little painting" is one reason why Baltard would look back on the Villa Medici as the place "where one has experienced the most, intellectually and emotionally."

Freedom, however, was not what the Academy had in mind, especially in the wake of Vernet's permissive regime. The regulations were now to be stringently enforced. For each of their first three years, architects had to execute four "studies of details from the most beautiful antique monuments" and additionally, in the third year, include "a portion either of the antique edifice from which these details are chosen, or of another edifice." Pensioners were not permitted to travel beyond the immediate environs of Rome until the third-year *envoi* had been completed. In their fourth year, architects were to submit "measured drawings of an antique monument of Italy," in its present state and in a restoration, accompanied

by a historical essay. Finally, in the fifth year, "the pensioner designs a public monument of his own composition and conforming to the usages of France."[94]

For his first *envoi,* of 1834–35, Baltard analyzed the interior decoration of the Pantheon, rendered in nine sheets.[95] For his second *envoi,* of 1835–36, he submitted eight sheets of details of the Theater of Marcellus in Rome, along with a comparative parallel of ancient tombs in and around Rome, which documented at once their pictorial and sculptural decoration and their modification over time.[96] As always, careful sketches in the field preceded the finished ink-and-watercolor renderings.[97] The Pantheon and the Theater of Marcellus were canonical and repeatedly studied examples of Roman architecture: the Pantheon seventeen times by 1834 (starting with J.-F.-J. Ménager in 1807), and the Theater of Marcellus fourteen times by 1835 (starting with A.-L.-T. Vaudoyer's classic restoration of 1786). The Académie des Beaux-Arts approved of both *envois,* though the Pantheon's polychromatic details prompted criticism for the "exaggeration of colors and the pretension of the marble veining[, which] in some parts fundamentally negates the lines and relations of the architecture."[98] The comparative study of tombs was similarly deemed an exercise more applicable to the "history of art" than to architecture properly speaking.[99]

By 1835, Baltard was chafing against the regulations. Acting without Ingres's approval, he took the extraordinary step of petitioning Thiers, now minister of the interior, for permission to visit Greece, before he had even begun his third-year *envoi* and a full decade before Théodore Ballu in 1844 became the first architectural pensioner to get there.[100] Prompted by a growing sense that the architectures of Greece and Rome were not the ideally continuous tradition posited by Quatremère de Quincy but were in fact historically

distinct forms of classicism, pensioners had been looking since the 1820s to the colonial examples of Greek architecture in southern Italy and Sicily: Émile Gilbert led the way in 1826 with his third-year *envoi* of the Temple of Concord at Acragas (Agrigento), followed by Henri Labrouste in 1828 with his fourth-year restoration of the temples at Paestum.[101] The publication of Abel Blouet's *Expédition scientifique de Morée,* whose first two volumes, on the Peloponnesus, appeared in 1831 and 1833, further contributed to the desire to see the Greek mainland. An astonished Quatremère de Quincy dismissed Baltard's petition out of hand in letters of 24 December 1835 to Thiers in Paris and to Ingres in Rome.[102]

With Greece off limits, Baltard turned instead to Sicily for his third-year *envoi,* of 1836–37: six sheets of details analyzing the Temples of Concord and of Castor and Pollux at Acragas, and Temple B (called the Little Temple) on the Acropolis of Selinus (Selinonte); and a seventh sheet offering a partial restoration of the Temple of Concord (fig. 24).[103] Baltard was stretching the rules by venturing outside Rome for his third-year *envoi,* and he risked the same displeasure that the Académie des Beaux-Arts had voiced in reviewing the *envois* of Sicily sent back by Gilbert, Duc (1829), Antoine Delannoy, and Constant-Dufeux (1831).[104] He did so, however, with the support of Ingres, who, like Vernet, sided with pensioners in their minor rebellions against Paris. Bored with Rome, whose novelty had been exhausted, the pensioners pushed outward, to southern Italy in the 1820s, to northern Italy in the 1830s, and finally to Greece in the 1840s, as they looked for opportunities to study unfamiliar sites and monuments. This desire for novelty needs to be kept in mind when deciphering whether pensioners meant their *envois* to dismantle the entire edifice of Neoclassical doctrine or merely to remodel it along lines already plotted by Percier

FIGURE 24
Victor Baltard, restored elevation
detail of the Temple of Concord
at Acragas, third-year *envoi,* 1836.
Private collection of the Baltard
family.

and Fontaine. The Greek temples of Sicily were
central to Hittorff's thesis of antique polychromy,
and they furnished young architects from Gilbert
to Baltard with evidence for a classical tradition
outside the cramped boundaries imposed by
Quatremère de Quincy. Baltard was temperate in
his partial restoration of the Temple of Concord,
avoiding the Pompeiian excess of *Antiochus and
Stratonice* while keeping its polychromy within
the limits illustrated by Blouet in the *Expédi-
tion scientifique,* where color is applied selectively
to architectural details in the upper zone of the
frieze, cornice, and pediment. The Académie des
Beaux-Arts was pleased: "The whole of this proj-
ect gives an idea of the character that the archi-
tectural polychromy of one of the most beautiful
Greek temples of Sicily could have had."[105]

Only the vignette tucked into the restora-
tion's lower left corner reveals that Baltard's use
of polychromy signaled more than archaeological

knowledge in the service of Neoclassical doctrine.
As Baltard wrote to Roger, this "perspective view
in natural colors, with the antique town, the sea,
and the mountains in the background," related
the Temple of Concord to the immediate cultural
and geographic circumstances of its construction.
Alluding to a Romantic belief in local color, the
vignette explains the temple's polychromy as a
historically specific and therefore applied gloss of
decoration, not the universal and inherent articu-
lation of the orders demanded by Quatremère
de Quincy. Baltard went on to boast that "the
novelty of this provoked the interest and chatter-
ing of connoisseurs" when the *envoi* was displayed
at the Villa Medici before being sent on to Paris.[106]
The critique was there to be noticed, if one looked
carefully at the margins.

In 1837–38, for his fourth-year restoration
envoi, Baltard turned to the Theater of Pompey,
built in 55 B.C.E. on the Campus Martius as
Rome's first permanent theater.[107] He was the first
and last pensioner to do so: unlike well-preserved
and well-studied monuments like the Theater of
Marcellus and the Colosseum (studied in *envois* of
1809 and 1828 and restored by Louis Duc in 1830),
little of the Theater of Pompey remained, and it
had consequently been ignored. Exploring and
excavating the surviving traces of its foundations
and the base of its *cavea* in the later fabric of medi-
eval houses and streets, Baltard confirmed the the-
ater's location and orientation. But he relied just
as much on the Forum Urbis, the marble map of
Rome made in the third century under Septimus
Severus and rediscovered in the fifteenth century
beneath the church of Santi Cosma e Damiano.
Installed in the Capitoline Museum since 1742,
the Forum Urbis mixes original fragments with
facsimiles of lost pieces reproduced after engrav-
ings published by G. P. Bellori in 1673, copied in
turn from ink drawings of the map in a sixteenth-
century manuscript given to the Vatican by Fulvio

Orsini. To supplement this problematic evidence, Baltard consulted the ancient authors Vitruvius, Seneca, Pliny, Plutarch, Cassius Dio, and Tertullian, and the modern antiquarians and archaeologists Vacca, Piranesi, Nardini, Canina, and Nibby.[108] The Theater of Marcellus and the Colosseum provided him with comparative examples, as did the theaters of Pompeii, Herculaneum, Arles, Nîmes, Orange, and Verona.

Baltard studied the Theater of Pompey on nine sheets rendered in ink with washes of gray and rose (figs. 25–28). The first two sheets present documentary texts and plans: on the first sheet, a lengthy excerpt from Baltard's historical essay is paired with details from the Orsini manuscript that reproduce relevant pieces of the Forum Urbis; the second sheet copies fragments from the map that show the Hecatostylum built on axis with the theater. The third sheet records physical remains of the *cavea* foundations in plan, sections, and details. Finally, six meticulously detailed sheets restore the complex in plans (2), elevation, and sections (3). The semicircular and freestanding *cavea,* with engaged Doric, Ionic, and Corinthian orders on the three stories of its arcuated façade, abuts a central podium and temple of Venus Victrix. Inside, seating climbs three levels to a colonnade and faces a lavishly decorated stage, which is flanked by monumental vestibules on two floors. The Hecatostylum, a public peristyle whose two-story portico wraps a court planted with trees and fountains, extends behind the stage.[109]

Carefully researched, scrupulous in its evaluation of the textual and artifactual evidence, both primary and secondary, Baltard's restoration was received favorably by the Académie des Beaux-Arts and by archaeologists from Ernest Beulé to Ernest Nash.[110] The project, however, was more than an archaeological exercise. As Pierre Pinon and François-Xavier Amprimoz argue in their

study of Villa Medici *envois,* such restorations belonged to a tradition "at the frontier of architecture and archaeology," where an architect's aesthetic interest in form came into conflict with the archaeologist's scientific interest in data.[111] At its simplest level, this conflict originated in the same desire for novelty that took pensioners to southern Italy in search of unfamiliar subjects, with consequences that Julien Guadet summarized in 1867: "So many restorations of antique monuments have now been done that everything has been done, often as well as possible, and new discoveries are rare. At first one could choose as a subject fairly complete monuments whose restoration is nearly certain. . . . It is left to the latecomers to choose between monuments that are too ruined to restore with conviction."[112] Baltard chose the Theater of Pompey, less to advance the field of archaeology than to make his mark as an architect, even if that meant restoring a poorly preserved monument. Writing to Roger in 1837, Baltard had noted of his third-year *envoi* that "composition plays a very small role in such a project and its execution has no other merit than to show if one understands what one draws." His restoration *envoi,* on the other hand, promised "a real composition, given that the actual condition of the monument I have chosen is limited to a few substructures that one rediscovers with difficulty in the cellars of some houses."[113] The Academy agreed with this judgment. Questioning whether "the restoration of a monument for which so few traces remain" was truly a restoration, the Academy instead praised Baltard "for the talent he has proved in a work where his imagination has played the greatest role."[114]

The *envoi*'s tension between material and textual evidence, especially between the theater's surviving foundations and a map of Rome that had been inscribed, copied, and reinscribed into a composite of variously authentic and facsimile

FRAGMENS ESTAMPÉS
SUR·LE·PLAN·ANTIQUE·DE·ROME.

HECATOSTYLVM

THÉÂTRE DE POMPÉE.

FIGURE 25 (*opposite*)
Victor Baltard, fragments of the
Forum Urbis showing the Theater
of Pompey in Rome, fourth-year
envoi, 1837.

FIGURE 26
Victor Baltard, plan, sections, and
details of the surviving structure
of the Theater of Pompey in Rome,
fourth-year *envoi,* 1837.

fragments, speaks as much to architecture's disciplinary relationship of drawing to construction, invention to imitation, and originality to reproduction as it does to any scientific attempt to correlate facts. Quatremère de Quincy's definition of restoration informed this dialectic between originality and reproduction: "Restoration is said, in architecture . . . to be the work that an artist undertakes and that consists in rediscovering, from the remains, debris, or descriptions of a monument, its original form, complemented by its dimensions, its proportions, and its details. One knows that a few fragments of columns, entablatures, or capitals of Greek architecture are very often enough to restore at least the entire order of the temple."[115] The architectural, rather than archaeological, purpose of restoration was to emulate classical monuments as ideally complete types, not analyze them as physically real,

if imperfect, artifacts. As Quatremère explained to Ingres when refusing Baltard's request to visit Greece, "One knows that, for every kind of architecture, only a small number of works can become models for successive generations, because it is less a question of having the student strictly reproduce these works than one of thoroughly investigating the reasons, the sentiment, and the taste that produced them."[116] For the Academy, the value of a restoration *envoi* lay, not in its actual degree of material and hence archaeological authenticity, but rather in its application of universal principles of classical (Greek) architecture to a historically specific (Roman) building.

Baltard, however, played off the purposes of archaeology against those of architecture in order to justify the necessary independence of his restoration from any a priori abstractions. On the one hand, he exploited the tension between textual

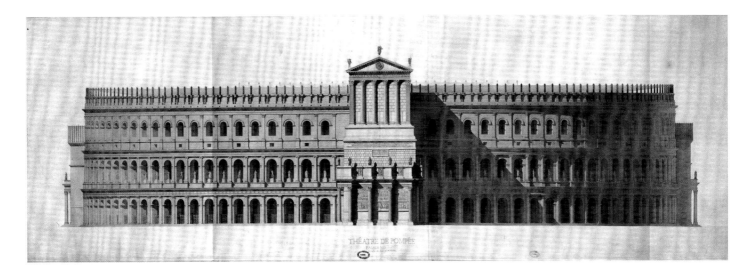

THÉATRE DE POMPÉE

and material evidence to question the possibility of Quatremère de Quincy's ideally coherent type. On the other hand, even as he employed archaeological evidence to undermine the theater's typicality, Baltard corrupted its archaeological value by recognizing a compositional objective in his restoration. He cited Vitruvius to justify his failure to follow this Roman authority, precisely because the monument's "actual state imposed certain obligations that first had to be satisfied": "It is up to the architect to judge at what point it is necessary to submit and in what conditions these rules can be modified according to the circumstances and the importance of the monument."[117] Vitruvius, claiming that architectural "expertise is born both of practice and of reasoning," had likewise subordinated when necessary compositional principles of symmetry and proportion to practical requirements of site, appearance, and function.[118] Quatremère de Quincy's stipulation that a restoration demonstrate typical forms is refuted by the very authority whose text was presumed to establish such norms in the first place. Thinking like an architect, Baltard agreed with Vitruvius that the abstract ideals of theory were always subject to the concrete realities of practice. In the end, Baltard presented his *envoi,* and the

original monument it ambiguously represents, in the obdurate terms of their own circumstances. The universality upheld by Quatremère de Quincy is acknowledged, only to collapse in face of architecture's material specificity, whether in the form of an actual building or its reproduction.

After the effort of the restoration *envoi,* the fifth-year requirement for a public building "conforming to the usages of France" could seem a redundant exercise, revisiting the Prix de Rome at a time when pensioners were looking ahead to a professional career back home. Still, Baltard took the obligation seriously and spent nearly two years mulling over possible programs in letters to his father. In November of 1836, he was considering a palace of industry, which by 1837 had become a museum for public expositions, sketched with both arcaded and colonnaded elevations in a letter soliciting his father's "good advice."[119] He went so far as to develop this project in plan and elevation (fig. 29), before settling in 1838–39 on a conservatory of music for Paris.[120] Rendered in five sheets, this *envoi* has not been found, but its character can be inferred from the stripped classicism of the alternate museum project. The Protestant temples, commemorative monuments, frontier bridges, and belfries submitted by pensioners in previous years

FIGURE 27 (*opposite*)
Victor Baltard, plan, over the existing site, of the restored Theater of Pompey in Rome, fourth-year *envoi,* 1837.

FIGURE 28
Victor Baltard, façade elevation of the restored Theater of Pompey in Rome, fourth-year *envoi,* 1837.

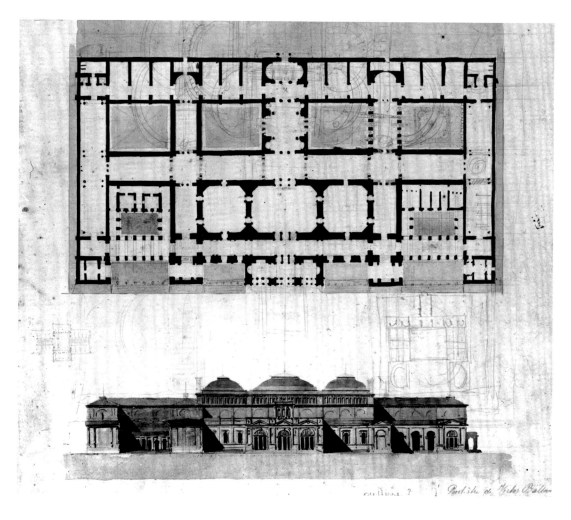

had provoked the Académie des Beaux-Arts with programmatically polemical, if modest, buildings. Baltard's conservatory (reprising an 1831 *concours d'émulation* project for a music school) offered an apparently conventional program and design. The Academy responded with audible relief: "the importance that Mr. Baltard has given to his project is an attainment for which pensioner-architects have until now shown too little concern in their work for the fifth year, and for which the Academy is pleased to give to Mr. Baltard a particular expression of its satisfaction."[121]

Yet this dutiful project prompted antithetical readings from the Academy and from Henri

Labrouste in a review for the *Revue générale*. If both praised its plan, the Academy regretted "that the character of the elevations lacks unity and . . . would have liked more of this simplicity, demanded by a building destined for study," while Labrouste observed that it is "easy to recognize, from the simplicity of the façades and the richness of the sections, that Mr. Baltard attaches more importance to the interior decoration than to the exterior aspect of buildings."[122] What the academicians saw as too busy (Romantic?), Labrouste saw as too simple (Neoclassical?), suggesting that each may have missed the point by only finding what they were looking for. Baltard had gone his own

way, explaining himself in terms that were consistent with his own logic rather than faithful to either Neoclassical or Romantic expectations.

PROFESSING ARCHITECTURE

Baltard's formal education ended with his return to Paris in December 1838. As he stated in his 1863 letter of candidacy to the Académie des Beaux-Arts, he now turned his attention to a municipal career.[123] But even as he secured the positions that led to his becoming architect of the Central Markets in 1845 and chief architect of Paris in 1860, he continued to engage the academy, substituting for his father at the École in 1842–46 and running an *atelier* from 1840 until 1852.[124] Though he had abandoned teaching for full-time practice by 1852, these years at the École helped him articulate ideas with direct relevance to his municipal work. The arts in general and architecture in particular were facing interconnected challenges from the 1830s onward. On one side was an ongoing debate about the status and relevance of the arts in modern society, which in the case of architecture focused after 1840 on the controversy over a proposed Neo-Gothic design for a new parish church of Paris. On the other side was a campaign begun by the government in 1831 to regulate the traditionally autonomous institutions of fine-arts education, which culminated in 1863 with the reorganization of the École des Beaux-Arts. First at the École and then in the Académie des Beaux-Arts, Baltard proved to be a voice of moderation whose appeals to the logic of evolutionary reform tempered calls for more radical change. Professing the pragmatic view of architecture he had formulated in Rome, Baltard looked beyond his father's pronouncements to find in the Renaissance common ground between Neoclassicists and Romantics: classicism's real legacy, he argued, was its history of modernization.

By 1840, aged and infirm, Pierre Baltard was finding it difficult to meet his teaching obligations in Paris as he spent more and more time in Lyon supervising the construction of the Palais de Justice.[125] He had, however, more in mind than expedience when he called on his son to fill in for him at the École. César Daly suspected nepotism and huffed that "a professor's chair is not like a notary's license, to be passed on as an inheritance."[126] Indeed, Pierre Baltard had written to his son that the death of Jean-Nicholas Huyot in August 1840 presented them with a double opportunity by clearing the way for "you to enter the École and me to enter the Institut": "you must follow the path that was taken and given to us by your brother Jäy. He first substituted for Rondelet—well, you must become my substitute; then you must become the titular professor. In three years, I pass by right to the rank of emeritus [professor], and from adjunct you become a [faculty] member of the École."[127] In the end, Pierre Baltard's plans went no farther than getting his son named *professeur suppléant* from January 1842 until January 1846.[128] Huyot's chair at the Académie went to Augustin Caristie, while Victor was abruptly replaced after his father's death, in January 1846, at first on an interim basis from February to April by Hippolyte Lebas, Huyot's successor as professor of history, and then by Abel Blouet, who was named the École's next professor of theory in May of that year.

Baltard applied for the permanent appointment. One can only speculate on the reasons for his failure: his lecture notes document his seriousness yet cannot say whether he was an effective speaker; more probably, since his publications all came after 1846, he lacked Blouet's stature as the author of a three-volume work on Greek architecture, though this does not explain why he was first replaced on an interim basis by the

unpublished (and conservative) Lebas. Pinon, noting the fluctuation in Baltard's lecture notes between theory and practical commentary, argues that the architect's thinking lacked clarity and concludes that he "did not have the necessary grounding in theory" to teach at the École.[129] Given his father's tutelage, this is an extraordinary assertion. Because Baltard left behind a complete set of handwritten notes, the record of his thinking is inevitably more discursive than the few, published and polished, introductory lectures that document Pierre Baltard's teaching. And if the younger Baltard was dismissed for this reason, then his succession by Blouet makes little sense: according to Robin Middleton, while Blouet's two-volume *Supplément* to Rondelet's *Traité de l'art de bâtir* demonstrated his awareness of current Romantic theories, his attempt to formulate a coherent theory of architecture was limited at once by his imperfect grasp of those theories and by his inability to "give convincing form to his ideas."[130] The real reason for Baltard's dismissal may well have been the content of his course: though he strove to be temperate, he was the first to introduce Romantic theory systematically into the body of Neoclassical doctrine that had been taught until then, and may well have pushed the École too rapidly forward into a new generation of ideas.[131] Despite the demands of his municipal practice, Baltard applied again for the position when Blouet died, in 1853, only to lose this time to the safely conventional J.-B.-C. Lesueur.

Pierre Baltard may have had a further motive for stepping down at the École besides obtaining a sinecure for his son. In December 1840, the Conseil municipal had ratified Prefect Rambuteau's proposal to build the new parish church of Sainte-Clotilde in a Gothic style, based on Franz-Christian Gau's project of 1839 (fig. 30).[132] This decision and Gau's Neo-Gothic design prompted immediate fire from the elder Baltard, along with

FIGURE 30
Franz-Christian Gau and Théodore Ballu, Sainte-Clotilde, Paris, 1846–57. Photograph by Édouard Baldus.

bitter opposition from the Conseil des bâtiments civils and a protracted debate until the project was finally approved for construction by royal ordinance in July 1846. Elaborating on objections voiced in 1839, Baltard used his opening lecture in January 1841 to attack the Gothic as a period of decadence and ignorance.[133] Innovation was impossible, he said, because the "elements generally accepted" in architecture had all been foreseen by Greece and Rome, even though the Renaissance deserved praise for recovering those ancient precedents and principles.[134] He ended by delineating three factions in contemporary architecture: the Neoclassicists, who, "in their orthodoxy, hold rigorously to the precepts of Vitruvius"; the Romantics, who, "less absolute . . . overload buildings, furniture, and every precious object with ornaments that, taken separately and placed with discernment, would seem to be in good taste but

whose abuse destroys their grace and happiness of invention"; and finally the Gothicists, who, "claiming they can only find mysterious effects and religious inspiration in Gothic churches, attempt . . . to rehabilitate among us the vicious architecture that a sort of barbarism has borrowed from various regions."[135]

Baltard returned to the attack at year's end, announcing to the second class in architecture on 8 December a *concours d'émulation* for a parish church. He stipulated that the church be "composed of a single nave, or in imitation of ancient basilicas flanked by side aisles." Warning that "any composition having the character of late Roman or medieval buildings or of forms called Gothic will be disqualified," Baltard insisted that "this rigor is founded on the necessity of opposing the retrograde movement given to our art by a powerful influence that is completely foreign to informed and rational studies."[136] One month later, in January 1842, Pierre Baltard handed over his teaching responsibilities to his son. César Daly had savaged the elder Baltard's final *concours* as "a sort of classical barbarism . . . an unintelligent protest against every kind of progress in the art of building," and he now speculated that the son's appointment was in reaction to this attack.[137] Indeed, Pierre Baltard's parting shot left his son in an awkward position and caused Victor to admit in his inaugural lecture that he owed "the honor of appearing before you to a perhaps excessively paternal presumption."[138]

Caught between filial loyalty and the expectation that he bring a fresh perspective, Baltard settled on a strategy of nuance that requires a double reading of his lectures. On the one hand, those lectures obediently pick up where his father's left off. Defining theory to be "the science of declaring principles and deducing the rules that derive from them," he grounded architecture in "immutable principles" of truth and reason

(relating to architecture's material condition), beauty (relating to its moral condition), and taste (regulated by the authority of models), a formula that he pared down in following years to reciprocal rules of reason and taste.[139] Where Pierre had declared in 1841 that "nothing is good except that which has the property of being useful, and beauty can only exist in what is natural," Victor stated in 1842 that the first sensible principle of architecture is "Everything must tend to a useful purpose" and that its first intellectual principle is "Do not contradict the laws of nature."[140] Arguing that art is "simple in its origin" even if it was "today complicated because of the complexity of civilization," he claimed that the superiority of Greek over Gothic lay in a simplicity of principle that made its architecture universally relevant.[141] Though he recognized medieval architecture as a legitimate alternative to the classical tradition, because justified by Christianity, Baltard nonetheless compared the trabeated coherence of the Greek orders and the constructive solidity of the Roman arch to the disturbing fragility of Gothic structures, whose use of the pointed arch "cannot be considered an invention," since "it does not increase the resources of the art of building."[142] It is as if the elder Baltard were looking over his son's shoulder, parsing his lectures and vetting their doctrine.

The correctness, however, is deceptive, or was at least less faithful than is suggested by the Neoclassical rhetoric. Even as he paraphrased his father, Victor diverted his father's certitudes to Romantic possibilities. This difference, of intent as well as argument, is revealed in both the thematic structure and actual content of his course, which over the course of four years shifted the premise of classical theory from universally valid principles based in nature to culturally relative ones based in history. Organized around a dialectic of construction and decoration, the lectures

analyze walls in the first year, point-support sys-
tems and the classical orders in the second year,
building elements (cornices, pilasters, buttresses,
roofs, doors, and windows) in the third year, and
the composition of coordinated systems of con-
struction and decoration in the fourth year. The
sequence of topics derived from Durand's *Précis
des leçons* (1802–5), while the criteria of analysis
returned to the triad of decoration, distribution,
and construction codified in Blondel's *Cours
d'architecture* (1771–77).[143] As Baltard noted, this
triad was consonant with the Vitruvian canon
of *firmitas, utilitas,* and *venustas;* with the philo-
sophical categories of the beautiful, the good, and
the true; and with the formal values of eurythmy,
symmetry, and harmony. But in his lectures the
dialectical pairing of construction and decoration
cut across such truisms to address a critical debate
within French classicism about the nature of the
classical orders and their relevance to contempo-
rary architecture.[144]

From François Blondel in the seventeenth
century to Jacques-François Blondel in the eigh-
teenth century and Charles Normand in the
nineteenth century, successive attempts had been
made to rationalize the orders with measurable
canons of proportion regulated by rules of good
taste.[145] Yet the orders' empirical character and
changeable forms had been recognized ever since
Claude Perrault questioned the classical canons
of proportion in his *Ordonnance des cinq espèces
de colonnes* (1683). The discovery that ancient and
Renaissance treatises were often contradicted by
the buildings themselves led Perrault to propose a
pragmatically straightforward and easily applied
arithmetic sequence of modules in place of the
platonic system of harmonic proportions favored
by François Blondel. Positing that beauty was
either the positive result of materials and execu-
tion or an arbitrary expression of cultural conven-
tion, Perrault relied on normalizing (rather than

normative) rules of taste based in habit and educa-
tion to explain how an architect fit his work to
the aesthetic preferences of his time.[146] Perrault's
progressive advocacy of the moderns, against
Blondel's conservative defense of the ancients,
opened up the fissure within French classical
theory that continued to divide Neoclassicists and
Romantics in the nineteenth century.

Because the orders, as forms of constructed
decoration, were distinguished by their ornamen-
tal differences rather than their uniform struc-
tures, Jacques-François Blondel had emphasized
decoration and distribution over construction in
his *Cours.*[147] Durand reversed the formula in his
Précis, rejecting both decoration and distribu-
tion in favor of a reductively practical definition
of architecture as the art of construction, which
was the "only idea that is sufficiently general to
apply to all buildings."[148] Rebutting Durand in
his *Dictionnaire historique* (1832), Quatremère
de Quincy had categorically rejected "the material
part" of construction for "the combinations of
order, intelligence, and moral pleasure," positing
a cyclical history of eternal return to an unchang-
ing, fixed ideal that controlled the imitation of
the forms and proportions realized in the classical
Greek orders.[149] This thesis was in turn critiqued
by a circle of Romantic writers and architects
who were active from the early 1830s onward.[150]
Léonce Reynaud laid out the basic argument in
his essay "Architecture" published in the *Ency-
clopédie nouvelle* in 1834. Drawing at once on a
dialectical theory of progress popularized by the
Eclectic philosopher Victor Cousin and on the
Saint-Simonian belief in the primacy of evolution
and scientific progress in shaping society, Reynaud
defined architecture as a simultaneous product of
art, science, and industry: "architecture is an art
on which science and industry exert an immediate
influence, because it owes to them both its means
of existence and part of its expressive identity;

and it is precisely from this dependence on the laws of matter, from this effect of art, science, and industry, that architecture draws its particular character. . . . In effect, there exists a clear relation between human customs, knowledge, and opinions at the various stages of architectural development."[151] As a history of "different ways of building" determined by structural laws, architecture was a matter of decorated construction, not constructed decoration. Ornament, Reynaud stated, "[is] not indispensable to architecture: architecture has its own expression and could exist without ornament; ornament is only an accessory to the monument, even if an accessory one cannot neglect."[152] Neither inherent nor natural, ornament articulated a building's structural and formal logic in historically inflected ways that spoke to its time of construction. The history of architecture was therefore about the evolution of structural forms in response to changing technological and social conditions, from the trabeated principle of classical antiquity to the arcuated principle of the Middle Ages. The Renaissance had combined these principles but left the synthesis unfinished, and it was then abandoned when Neoclassical architects returned to exclusively classical forms. Concluding that it was up to present architects to realize the promised synthesis, Reynaud identified two camps engaged in this task: eclectic architects, who were recovering architecture's full historical diversity, and those who, more positively, were "applying artistically to our constructions the new materials made available by industrial progress."[153]

Baltard betrayed his Romantic sympathies from the start, in his lectures on walls. Pointing out that walls, unlike the orders, cannot be reduced to an a priori system of proportioned forms that dictate their ornament and structure, he attributed their decoration to three conditions: (1) physical construction; (2) mediating ideas of order that abstract construction into hierarchies

of detail; and (3) cultural representations, such as murals, which remain independent of construction.[154] Turning next to the orders, Baltard argued that there was no single, universal, and normative form to be copied, since their proportions and details had been successively shaped and reshaped in Greece, Rome, the Renaissance, and the eighteenth century in an ongoing history of stylistic modification.[155] While subject to "rules of taste, propriety, and moral correspondences," the classical orders resulted from the properties of particular materials chosen because of climate and use, and from the customs differentiating one country from another.[156] It was pointless to expect a nineteenth-century French architect to imitate the Greek Doric order, despite its "beauty, truth, and rationality," because "we are neither Greeks nor even Romans— . . . the nature of our ideas, our laws, our religions, our customs, is no longer the same . . . our materials, our climate, do not allow the same demeanor, the same forms, the same processes."[157] In the end, classicism was simply a "spirit of system" to practice as one chose: "Every architect makes his own method—is right if he has his own method."[158]

In the third year, Baltard extended his analysis of construction and decoration to a more general dialectic of science and art.[159] Translating his father's Vitruvian pairing of utility and beauty into modern equivalents that spoke to an industrial age, Baltard noted that theory itself had split into a positive theory of scientific facts and a metaphysical theory of artistic forms. The plurality of styles produced alike by different technologies and different traditions proved again the historic necessity of choice and rendered impossible the Neoclassical objective of a unified theory of architecture dictated by a priori ideals. It was left to each architect to reconcile the antithetical demands imposed on the discipline by scientific knowledge and artistic imagination.

In his final lecture, on 1 December 1845, Baltard applied this dialectic to a structurally rational history of architecture shaped by technologies that ran from the ancient use of stone to the "immense resources" made available by the modern industrial materials of cast and wrought iron. From antiquity to the Renaissance and the present, science and art were seen to play complementary roles that benefited art in "every age when scientific conquests are attached to the advantage of art." Still, the nineteenth century was recognized to be "an age of transition" in which "facts have outstripped theories" and "the science obtained has yet to be sorted out." Calling for "synthetic spirits" who could overcome the current tendency to reproduce "archaeological formulations" based on pedantic imitations of the past, Baltard concluded that only through a new synthesis between art and science could three types of unity be restored to architecture: "(1) Unity of system, of principle, and of style. (2) Unity of conception and of composition. (3) Unity of decoration and ornamentation."[160] The rhetoric of unity was consistent with French classical theory, and Baltard quoted Quatremère de Quincy among other Neoclassicists at length to prove this point. Along the way, however, the premise had shifted from a cause to a consequence, from the singular unity of an original and natural principle to the variable unity of historically specific results. French architecture, and beyond that the entire classical tradition, were shown to be, not an object of inherent truths, but instead the subject of a mutable and ongoing historical dialectic between construction and decoration, building and architecture, matter and form, fact and idea, nature and culture, science and art, practice and theory, past and present, ancients and moderns, Neoclassicists and Romantics.

Baltard concretized this argument in the monthly *concours d'émulation* programs that he wrote as adjunct professor of theory.[161] Excepting the occasional Roman house or circus, these programs abandon antique models to focus on nineteenth-century types: the second class was typically given markets, train stations, town halls, schools, and bourgeois houses, as well as in 1845 an athenaeum for the Société centrale des architectes français (founded in 1843); those for the first class ranged from colleges, veterinary schools, theaters, libraries, museums, cemeteries, and public fountains to topical subjects like a funerary chapel for the duc d'Orleans (assassinated 13 July 1842), a palace of industry, and a monument to honor three eighteenth-century inventors of the steam engine (Denis Papin, Thomas Newcomen, and James Watt). Projects were often for Paris, on real sites or in hypothetical but urban locations: a public swimming pool (*piscine publique*) for a working-class district; a waterworks on the Rue Saint-Honoré or the Place de Breteuil (ceded, with its artesian well, to the city in 1838); a hotel facing a train station on a trapezoidal parcel of ground. On 4 November 1844, Baltard announced to the first class in architecture the *concours d'émulation* for a parish church. Returning to the still-simmering controversy over Sainte-Clotilde and a problem last posed by his father in 1841, Baltard avoided formal proscriptions to offer instead a simple list that left the choice of style wide open: "A parish church must contain a porch, a nave, a choir, a sanctuary, side aisles, chapels."[162]

He reviewed the projects in his eighth lecture (fig. 31), sketching plans and elevations of successful solutions: skeletal structures of columns or piers supporting vaults and domes on the interior, within arcuated envelopes. He explained that "the system of architecture must be vaults and arcades without omitting the dome," and cited as precedents the Byzantine church of Hagia Sophia in Constantinople, the Gothic cathedral of Florence,

FIGURE 31 (*opposite*)
Victor Baltard, notes for a course on the theory of architecture at the École des Beaux-Arts, eighth lecture, 1844–45. Plans and elevations of successful projects in the competition for a parish church. Document held at the Centre historique des Archives nationales de France, Paris.

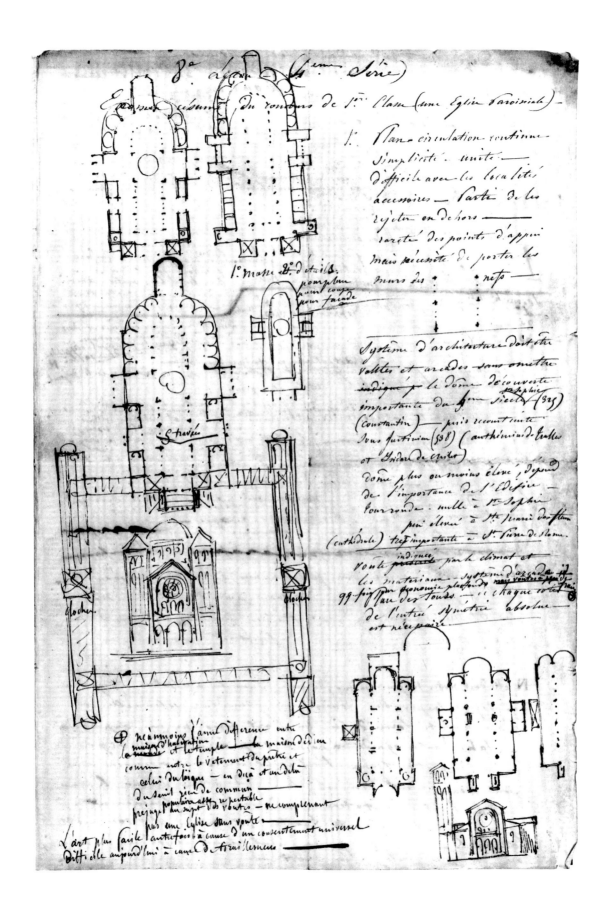

8e Leçon (1ère Série)

Esquisses raisonnées du concours de 1re Classe (une Eglise paroissiale) —

1. Plan — circulation continue —
simplicité — unité —
difficile avec les localités
accessoires — Partie de les
rejeter en dehors —
rareté des points d'appui
mais nécessité de porter les
murs des ⋮ ⋮ nefs —

1r. travée 2d. détails.
pourplein avant coupe
pour façade

Système d'architecture doit être
voûtes et arcades sans omettre
indiqué p le dôme découverte
importante du 4e siècle (325)
(Constantin) — puis reconstruite
sous Justinien (538) (Anthémius de Tralles
et Isidore de Milet) —

dôme plus ou moins élevé, dépend
de l'importance de l'édifice —
tour ronde — nulle à Ste Sophie
peu élevé à Ste Marie des fleurs
(cathédrale) très important à St Pierre de Rome

voûte indiquée par le climat et
les matériaux — système d'arcades
99 fig pour économie plafonds mais voûtes pas chère
Plan des fonds — et chaque côté frais
de l'entrée — Symétrie absolue
est nécessaire —

5 travées

clocher clocher

① néanmoins l'énorme différence entre
la maison d'habitation et le temple — la maison de dieu
comme entre le vêtement du prêtre et
celui du laïque — en deçà et au delà
du seuil peu de commun —
préjugé populaire assez respectable — ne comprenant
pas une église sous voûte —
L'art plus facile autrefois à cause d'un consentement universel
Difficile aujourd'hui à cause d'Arui Herneus —

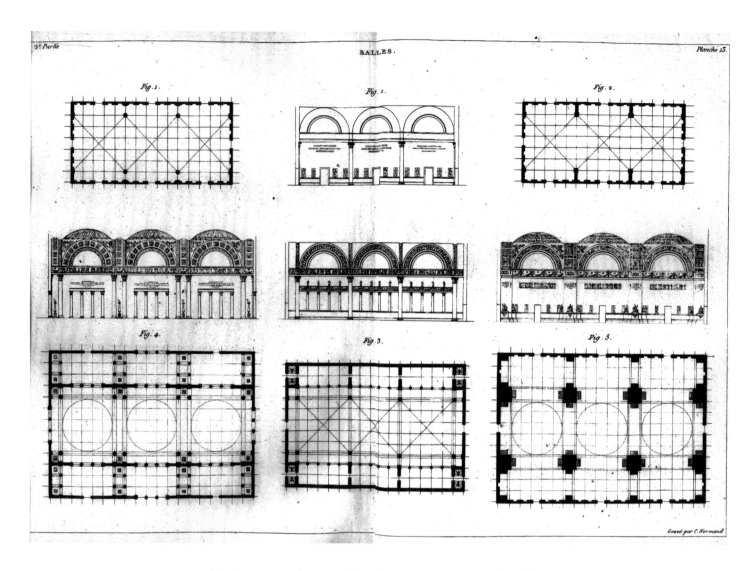

FIGURE 32
Jean-Nicolas-Louis Durand, *Salles,*
from *Précis des leçons* (1802–5).

and the Renaissance basilica of Saint Peter in
Rome.[163] His fourth through seventh lectures,
in 1844–45, on arcuated and vaulted systems of
construction, had identified the round arch as
the defining structural type of Western archi-
tecture from ancient Rome to the Renaissance:
placed on piers with engaged classical orders in
Roman architecture; placed on columns and liber-
ated structurally in Early Christian, Byzantine,
and Romanesque architecture; modified in the
Gothic as the pointed arch; and finally restored
in the Renaissance, when the Roman arch was
synthesized with medieval principles of structure.

Introduced by Léonce Reynaud in 1834, this
structurally progressive history of architecture
was termed "the emancipation of the arch" by
Léon Vaudoyer and Albert Lenoir in their "Études
d'architecture en France," published in the *Maga-
sin pittoresque* from 1839 to 1852.[164] Refuting the
emphasis placed by Quatremère de Quincy on the
restoration of the classical orders in the sixteenth
century, Reynaud and Vaudoyer looked instead to
the synthesis between medieval and classical types
of structure realized between the thirteenth and
fifteenth centuries in the cathedral of Florence,
first by Arnolfo di Cambio and then by Filippo

Brunelleschi (neither of whom used correct classical orders).[165]

For Baltard, as he strove to reconcile his father's thinking with that of a younger generation, this Romantic synthesis was anticipated by the adaptation of medieval structures to classical forms in Soufflot's Panthéon, the diagrammatic buildings of Durand's *Précis des leçons* (fig. 32), and the vaulted entry hall of his father's own Palais de Justice in Lyon: as a practical matter, the theoretical differences between Neoclassical orthodoxy and Romantic revisionism came down to a question whether consistency of decoration was more important than consistency of construction and, by extension, whether architecture could stray outside the classical norms preferred by Quatremère de Quincy to admit the transformations of the Middle Ages and the reinventions of the Renaissance.[166] In 1841, Pierre Baltard had answered this question in the negative when he separated French architecture into the three camps of Neoclassicists, Romantics, and Gothicists. As the Conseil municipal prepared to give final approval to Gau's design for Sainte-Clotilde, the Gothicists Jean-Baptiste Lassus and Viollet-le-Duc weighed in with a series of articles for the *Annales archéologiques* (1844–45).[167] Adopting the elder Baltard's categories but not his prejudices, Lassus and Viollet-le-Duc reformulated the argument, distinguishing between a national Gothic school, characterized by its unity of principle and cultural relevance; a "traditional school" of Neoclassicists, deemed culturally irrelevant if consistent in its principled adherence to the classical orders; and a "rationalist school" of Romantics, who had abandoned principle for "the most complete eclecticism in the arts."[168] Intent on isolating Neoclassicists from Romantics, Viollet-le-Duc and Lassus expected the Academy to uphold the arguments of Quatremère de Quincy, and they were therefore caught off guard when their attack was rebutted, not only by Vaudoyer and Lenoir in 1844, but also by the Academy's next secretary, Désiré Raoul-Rochette, in 1846.[169] Alluding to the city's decision to build Sainte-Clotilde in a Neo-Gothic style, Raoul-Rochette cited the precedent of Rome to refute the notion that only the Gothic was suitable for a Christian edifice, since the churches of Rome demonstrated a classical continuum from antiquity to the Renaissance. Having already suggested in his 1840 obituary of Percier that eclecticism was justified by the liberalization of academic doctrine initiated decades earlier by Percier and Fontaine, Raoul-Rochette went on to argue that the Renaissance showed how one could modernize the classical tradition from within, through the adaptation of past models to present needs and conditions.[170] Without contradicting either Quatremère de Quincy or Pierre Baltard, who favored the Renaissance for its revival of classical principles, Raoul-Rochette promoted a tacit historicism that advanced the Renaissance over antiquity as a culturally more relevant model for modern France.[171]

Victor Baltard's École lectures echoed this revisionist argument, and he twice corroborated Raoul-Rochette after the fact. The first instance came in the obituary he delivered as Caristie's successor at the Academy. As a member of the Conseil des bâtiments civils, Caristie had stubbornly opposed Gau's Sainte-Clotilde, refusing like Pierre Baltard to see in the Gothic any value to the present. Although an obituary's eulogistic etiquette discouraged open criticism, Baltard let the evidence speak for itself when comparing Caristie's intransigence to the "tolerant eclecticism" displayed by Raoul-Rochette on the same occasion: "while the Academy is used to finding the clearest expression and most constant application of the true principles of architecture in the antique form, it cannot fail to recognize the virtuality of the arts of the Middle Ages or the great effects achieved

by the artists of this age."[172] Never was the point to promote a Gothic revival. Rather, it was simply to admit, especially in the case of France, that a thousand years of medieval architecture came between antiquity and the Renaissance. Three years later, Baltard returned to this point in his address on "the school of Percier." Praising Percier for a liberalism that his disciples sometimes neglected, Baltard identified both Percier and Fontaine as leaders of a "French school" that continued into the present a tradition of reform launched in the late fifteenth century: "This was the first reform, and from it dates the advent of the charming art of the Renaissance, ingenious and abundant art, lively and well ordered, inspired by, rather than copied after, the antique, supple and at the same time curious about rules, translating Vitruvius, attaching itself more to the spirit than the letter of his work, and not disdaining finally to borrow some characteristic forms from the [Gothic] style that it replaced."[173] Asserting a history of diversity over a theory of consistency, Baltard found in the Renaissance an answer to the narrower views of architecture advanced on either side by orthodox Neoclassicists and polemical Gothicists.

As a means to synthesize conservative with progressive strains of French classicism, the Renaissance addressed the problem of style, which remained for Baltard the stubborn point of difference between his father's teaching and his own. After his father's death, he published with Édouard Gatteaux a set of drawings of the Renaissance Gallery of Diana at Fontainebleau by Charles Percier and Pierre Baltard (fig. 33). In the accompanying text, he compared classicism's historical richness to the limiting perspective imposed by the Gothicists: "Why reject . . . this imperishable filiation of the history of humanity that is reflected and is perpetuated without end in the arts? Why would one want, as some do these days, to box and constrain rigorously all types of

beauty within a limited period of a few centuries?"[174] Allying Neoclassicists and Romantics in mutual resistance to the Gothicists, Victor Baltard here implicated his father, a Neoclassicist whose taste ran like Percier's to Italy, in an unmistakably Romantic appreciation for the stylistically mixed and culturally native forms of the French Renaissance. Pierre Baltard's mistrust of the Romantics is reinterpreted in light of these drawings to become less an admonishment than a tacit acknowledgment that, despite their differences, Neoclassicists and Romantics shared a common tradition that had been both liberalized and radically transformed by its translation to France in the Renaissance.

IN THE ACADEMY

Baltard was the single most important municipal architect in Paris by the time Augustin Caristie died, on 5 December 1862, and his election to the Académie des Beaux-Arts, on 7 February 1863, came easily, in a tally of twenty-four out of thirty-seven votes, despite a field of eleven candidates that included Louis Duc, Henri Labrouste, and Léon Vaudoyer.[175] The honor at once justified Baltard's career by acknowledging his work as architect of the Central Markets and spoke to his position outside recognized camps. Félix Duban, who had opposed his candidacy in favor of Labrouste and Duc, admitted as much when he wrote to congratulate Baltard on his election: "Now that the fight is over, and after having paid to my old friendships a debt of heart and of conscience . . . let me tell you how happy I am to count among our colleagues an artist such as you."[176] In his letter of application, Baltard pretended respect for Caristie and his role in sustaining the institutions and doctrines of classicism.[177] Clearly, however, he felt for his predecessor little of the sympathy that Garnier would show for him in the same circumstance: delivered belatedly in 1870, Baltard's

FIGURE 33 (opposite)
Charles Percier, Gallery of Diana at Fontainebleau. View from the entrance, from Victor Baltard and Édouard Gatteaux, *Galerie de la reine dite de Diane à Fontainebleau* (1858)

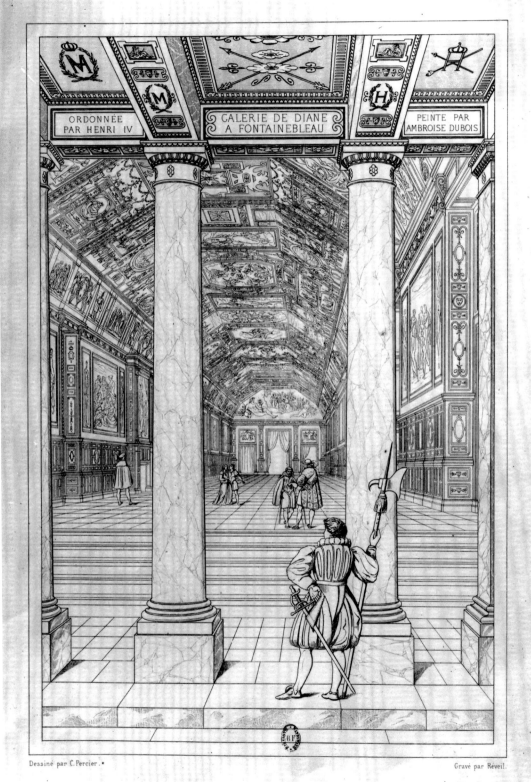

ORDONNÉE
PAR HENRI IV

GALERIE DE DIANE
A FONTAINEBLEAU

PEINTE PAR
AMBROISE DUBOIS

Dessiné par C. Percier.

Gravé par Réveil.

VUE PRISE DE L'ENTRÉE DE LA GALERIE.

obituary of Caristie was cold in tone and surprisingly hostile in content. Impatient with Caristie's reactionary instincts, Baltard complained that his works were restricted "by the more or less blind attachment to the exterior appearances of antiquity without trying sufficiently to penetrate its spirit."[178] The harsh judgment betrays at once Baltard's intellectual differences with Caristie and his visceral sense of vindication at getting the chair that by rights should have gone to his father in 1840.

Baltard's induction into the Academy came shortly before Napoléon III issued his decree of 13 November 1863 ordering a comprehensive reform of the École des Beaux-Arts.[179] The École's institutional independence from the state and its traditional dependence on the Academy were alike to be replaced by a structure of government regulation and supervision. The decree stipulated that the director and faculty of the school be appointed by the minister of fine arts, acting on the advice of a Conseil d'enseignement also named by him; that both the entrance exams and the monthly *concours* be eliminated; that students' progress be evaluated instead in trimonthly reports by the professors of official *ateliers,* replacing the *ateliers libres;* that control of the Prix de Rome be transferred from the Académie des Beaux-Arts to the Conseil d'enseignement, which would write the competition programs and draw up the list of thirty-seven jurors (divided by discipline into sections); and that admission to the Prix de Rome be restricted to students between fifteen and twenty-five years of age.

This was the third time in as many decades that the government had tried to reform fine-arts education in France. Following the first attempt, in 1831, under the July Monarchy, when the Academy refused to cooperate and the École ignored the resulting report, the Second Republic had on 2 March 1848 established yet another commission charged "with examining the reforms to be carried out in the organization of the École française de Rome and the École des Beaux-Arts."[180] Victor Baltard was named along with the architects Théodore Charpentier and Henri Labrouste, the painters Michel-Martin Drölling, Ingres, and Horace Vernet, the sculptor David d'Angers, and the critic Charles Blanc, but this commission soon collapsed in face of the "stand taken to reject all reform."[181] Determined to succeed in 1863, the imperial government avoided committees and relied instead on the advice of two intimates of the court, Viollet-le-Duc and his ally, the Romantic writer and administrator Prosper Mérimée (son of Léonor Mérimée, secretary of the École des Beaux-Arts). The Academy was caught off guard and fruitlessly sought an audience with the emperor, before it resorted to arguing its position in published responses by Ingres and Charles-Ernest Beulé (named perpetual secretary in 1862); simultaneously, it worked to undermine the reforms through the Conseil d'enseignement, on which the academicians secured a majority and where Hector Lefuel proved a tenacious advocate of their interests.[182] By the time new regulations were issued, on 6 January 1864, the entrance exams and the monthly *concours* had been restored, at once ensuring a continued function for the *ateliers libres* and smoothing the way to further compromises that would nullify much of the reform by 1871.[183]

Baltard played a less visible role than Ingres, Beulé, and Lefuel, though he was busy behind the scenes. He petitioned Ingres, as the Academy's most distinguished member, to lead an imperial delegation yet observed privately that Ingres's published response was "too passionate to be convincing."[184] Simultaneously, he drafted his own "Note on the Decree," which he shared with colleagues and sent to the superintendent of fine arts, Nieuwerkerke.[185] Alluding to his (and his

father's) experience at the École, Baltard wrote that he "had for a long time felt that instruction in the fine arts needed some reform" and that he was "happy to find decisions in the report" that matched his own.[186] This did not mean that he accepted every provision of the decree. He insisted, like Lefuel, on keeping the monthly *concours,* since without them the École would lose its standard of evaluation along with the practices of liberty and emulation on which progress in the arts depended. He otherwise sought a reasonable middle ground between continuity and change, proposing that École professors be selected jointly by the Academy and the Conseil d'enseignement; that the Prix de Rome jury be composed equitably of academicians and outside members chosen by the *conseil;* and that the age limit be lowered gradually to twenty-five in order to provide a period of transition.

Eight years later, Baltard drafted a second "Note," this time in response to an invitation from Jules Simon, minister of public education, who was preparing to return control of the Prix de Rome to the Academy in his decree of 13 November 1871.[187] Baltard again defended the École's pedagogical balance between studios and courses and their integration through the *concours d'émulation.* He approved the official *ateliers* that had been instituted alongside the *ateliers libres,* as well as the rationalized administration set up under a term-appointed director (five years); expecting the return of the Prix de Rome to the Academy, he repeated his recommendation that its jury include outside artists in addition to academicians. Even as he recognized the benefits of reform, however, Baltard questioned whether its imposition by the government had been necessary: "The state [of the École] was the result of various successive ameliorations, and it would have been improved further; everyone knew that, everyone thought about it and prepared

themselves for it, when the decree of 13 [November] 1863 suddenly intervened, unexpectedly cutting off all questions related to teaching."[188] By suggesting that the government should leave instructional policy to academicians and professors, Baltard reiterated the interests of professional autonomy and self-determination that had been the real point of contention all along.

Among the many obituaries and lectures that Baltard wrote as an academician, his unpublished essay on Vitruvius best summarizes his view of the architect in the nineteenth century. The touchstone of all modern architectural theory, Vitruvius was the authority to whom everyone had turned since the Renaissance to validate each new strain of classicism. Baltard recognized that this critical function subjected the Roman architect to misinterpretation by conservatives and progressives alike: "Vitruvius is perhaps, of all the ancient authors, the one whose work has been most variously judged and, recently, the most misunderstood. . . . Depending on whether the question of architectonic style vibrates one way or another, one takes a stand either for or against the author. To some he seems neither sufficiently Greek nor sufficiently Roman for one to be able to study [in his work] antique art; to others, too Roman and too Greek for one to find [in him] lessons to be applied to contemporary art."[189] Despite Pierre Baltard's defense of those who, "in their orthodoxy, hold rigorously to the precepts of Vitruvius," there was in fact no orthodoxy, no absolute doctrine, to be found in his theory. Nor did his *Ten Books* provide a universal prescription for the problem of style bedeviling contemporary architecture. This did not mean, however, that Vitruvius was any less worthy of "serious and in-depth" examination or any less relevant to the present.[190] Speaking more to his own modernity than to the antiquity of Vitruvius, Baltard described the ancient architect as a problem solver, someone

who could synthesize in a workable solution the multiple and often contradictory conditions affecting architecture: "Engineer, architect, he was one and the other, as are sometimes certain superior minds who are able to master the matter at hand whatever it might be, to solve all the problems that relate more or less directly to their art."[191] In an age of transition, when so many competing demands tore at the profession, Baltard looked across the polemics of theory to find in the messier evidence of history the proof he sought that architecture had always been conditioned, from antiquity to the present, by its practical obligation to serve the material and social conditions of its time.

Representing Paris

Since 1599, when Henri IV named the duc de Sully his grand voyer of France and charged him with responsibilities that soon included oversight of the roads, façade alignments, and building codes of Paris, the city has been the object of plans to rationalize its space in administrative terms that could be codified legally and supervised bureaucratically.[1] By the time of the Revolution, the royal investiture of individuals with authority over the public domain had been abstracted into a system of state and municipal offices charged with controlling the forms, functions, and development of almost every aspect of modern Paris.[2] The bureaucratic city was fully in place by the mid–nineteenth century, when the municipal services of the Prefecture of the Seine at once rivaled and complemented the state's Service des bâtiments civils in building the Second Empire capital of Napoléon III. Victor Baltard, employed by the prefecture from 1839 until 1870, was both bureaucrat and architect in the practice of his profession. As he adjusted the historic form of Paris to the new imperatives of administrative regulation and planning, he also confronted the forces of political, social, and industrial change calling into question the codes of representation that had shaped the city's public image since the sixteenth century. He responded with a programmatically open-ended language of civic architecture that was premised on urban, rather than functional, typologies of form.

From the start, the administrative regulation of Paris was tied to and complicated by its competing identities as a city and a capital. The establishment of the Prefecture of the Seine in 1800 merely codified a historic overlap between municipal and state interests in the city's governance. On the one hand, the prefecture inherited the mayoral office of *prévôt des marchands,* entrusted since the thirteenth century with the economic interests of Paris. On the other hand, it absorbed state claims to jurisdiction over the city, starting with Sully and further consolidated by Jean-Baptiste Colbert, Louis XIV's superintendent of royal buildings from 1664 until 1683. According to Horace Say, a municipal councilor during the July Monarchy, Paris was shaped politically by the resulting struggle between the state's program of national centralization and the city's effort to preserve its civic independence.[3] Parallel architectural agencies, detailed by David Van Zanten in *Building Paris,* reflected this rivalry.[4] Gourlier and Questel recorded the state's Service des bâtiments civils, while Say, Lazare, Rambuteau, Merruau, Maxime du Camp, and Haussmann spoke for the municipal services of the Prefecture of the Seine.[5] State architects like Hector Lefuel and Charles Garnier, who worked in Paris on national monuments, were celebrated by Biet, Gourlier, Grillon, and Tardieu, while municipal architects like Victor Baltard and Théodore Ballu, who also worked in Paris but on city buildings, were documented by Félix Narjoux.[6]

At their extremes, these state and municipal agencies produced buildings as antithetical as Garnier's monumental Opéra and Baltard's utilitarian Central Markets. These differences would be reflected in the persistent objections of the Conseil des bâtiments civils to the municipal projects by Baltard and his colleagues. This apparently categorical distinction, however, was complicated by an even more fundamental tension between the customs of collegiality and emulation that continued to define the architectural profession, and the bureaucratic structures and technocratic criteria that increasingly regulated architectural practice.[7] The bureaucratic model of a fixed, salaried hierarchy of offices with precise duties had first been applied systematically to architecture in the Service des bâtiments civils, which was organized between 1808 and 1842 into descending ranks of responsibility, from inspectors general (*inspecteurs généraux*) to architects (*architectes*), project managers (*inspecteurs*), construction supervisors (*sous-inspecteurs*), material and labor delivery clerks (*conducteurs*), bid and contract clerks (*vérificateurs*), and accountants (*contrôleurs*).[8] The prefecture's Service d'architecture duplicated this model in 1831, constituting the profession as a service-oriented branch of municipal administration staffed by technicians who were supposed to be as attentive to matters of utility and cost as to traditional concerns like aesthetics and historical precedent. Haussmann's prejudice against the academic training of the architects in his employ, condensed in his complaint against Baltard's classicism, was one expression of this intended shift, as was Horace Say's call in 1846 for municipal architects to break with the classical focus on drawing taught at the École des Beaux-Arts, for a more practical training in physics, chemistry, and mechanics.[9] Yet the architects in question continued to ground their professional identity in habits of artistic emulation and collegial consensus,

where decisions were reached through often protracted negotiations between qualified individuals rather than issued by a higher official. Dating to the foundation of the Académie d'architecture in 1671, these habits were protected by organizations like the Société centrale des architectes, which resisted the attempts of officials like Haussmann to divide the profession into bureaucratic camps according to administrative affiliation.[10]

The representational codes of architecture in Paris were also more layered than is suggested by a simple dialectic of city and state. In *Building Paris,* Van Zanten sets a foreground of national monuments like the Opéra against a background of civic and private buildings that, from the Sainte-Geneviève Library to the apartment building, established the "texture, the flesh, of the living city" in which those monuments were embedded.[11] Through the École des Beaux-Arts, the Académie des Beaux-Arts, and the Bâtiments civils, modern France continued to uphold architecture's traditional status as a monumental art that concretized the nation's political identity. Alongside this centralizing program operated the civil institutions that, justified by their legal, rather than political, authority, served the municipality in more or less democratic ways with city halls, law courts, prisons, schools, and hospitals. These political and institutional conceptions of Paris, both of which imposed instruments of power on the existing city, were supported in turn by the private architecture of the city's economic life. Increasingly synonymous with capitalism, this private city housed and was produced locally by the commercial, professional, and residential interests of its citizens.

These codes are rooted in the history of Paris. Treated consciously since at least the sixteenth century as both a city and a capital, Paris developed a dense urban fabric whose hierarchies of scale and space from the mundane to the

monumental stand for its simultaneously private, civic, and state roles. Like London and Vienna, two other characteristic nineteenth-century capitals, Paris never relinquished its municipal interests to the dictates of a larger national identity.[12] As the city's historic forms were remade by the ordinary as well as ritual needs of contemporary bourgeois society, the state's representational program was mediated by the spatially decisive, if symbolically less explicit, products of daily life. François Loyer proves this point in his exhaustive urban history, *Paris XIXe siècle*. Looking not to its monuments but at its mixed-use apartment buildings, Loyer documents the process by which Paris adjusted "a cultural system defined by classicism . . . to the exigencies of an industrial economy" through the continuous adaptation of its streets and housing blocks to a modernizing city.[13] The evolving typologies of form, improving techniques of construction, and functionally multivalent spaces that shaped Paris from the eighteenth century into the Second Empire are shown to be significant factors in the city's midcentury transformation.

For this very reason, the distinction made by Van Zanten between a representational foreground of state monuments and a background of "unrepresentational" buildings became increasingly blurred during the course of the century.[14] As I have noted elsewhere, Garnier's Opéra (see fig. 3) shared with the surrounding private structures the common elevational scheme of a colonnaded *piano nobile* on an arcaded base.[15] Derived from Perrault's east façade of the Louvre, this type of public architecture became at once so urbanized and democratized during the eighteenth to nineteenth centuries that originally distinct categories of royal (public) and bourgeois (private) building were conflated. Even as Garnier "claimed the appropriateness of a royal palace for the Opéra, he recognized that the type had

by 1860 effectively lost its intended representational function. What he really was imitating in his citation of the Louvre were the bourgeois *immeubles* that those royal façades had become in Second Empire Paris."[16] This radical conflation of representational foreground and supporting background is worth noting for three reasons. The first is that traditional notions of representation ceased to hold in the nineteenth century, especially when it came to the premodern social structures of public and private status that an ongoing process of democratization had discredited.[17] Absent any real system of differences, the city's apparent unity resulted instead from a collage of interchangeable fragments in which uniform façades were wrapped around ever more complex and functionally varied interiors. The second is that architects responded to this loss of iconographic stability by rethinking the conventions of representation that had traditionally informed their work. Whether or not they accepted or even recognized every social or political factor behind the changes affecting Paris, these architects contributed materially to those changes by conceiving new ways of visualizing and experiencing the city. And third, some of them—particularly architects like Baltard, in municipal employ—would be encouraged by this modernization to look beyond functional programs to the underlying urban typologies of form that had fundamentally shaped the city's growth since the sixteenth century.

Victor Baltard was at the center of a process of urban development spanning the middle decades of the century from the July Monarchy through the Second Empire. His response both to the bureaucratic city and to the city's material changes that came to maturity under Haussmann can be traced through two histories: first, a history of the Service of Architectural Works from its inception in 1831 to its operations under Baltard in the 1860s, which documents how architects fought

to preserve their professional autonomy within a growing municipal bureaucracy; and second, a history of Baltard's responsibilities as architect of the Hôtel de Ville, where he was charged with representing the civic identity of Paris in both transient and lasting ways. Faced with the administrative regulations, planning constraints, and often shifting programs that characterized his municipal commissions, Baltard abandoned the Beaux Arts ideal of self-sufficient monuments generated from within by clear and consistent functions, to produce instead hybrid works of architecture that adjusted a project's immediate internal needs to external factors of context, including the city's patterns of development over time. In concert with colleagues like Antoine Bailly and Gabriel Davioud, Baltard articulated a language of civic architecture that was at once indebted to the Renaissance synthesis of classical and medieval models hypothesized in the 1830s and 1840s, and sufficiently flexible to mediate between the traditional city and the forces of modernization reshaping Paris in the present. Baltard's pragmatic acceptance of the contingent—which is to say, the circumstantial—relation between a building's form and use, and his consequent shift from functional to urban typologies of architecture, confused contemporary critics and continue to baffle historians today, who remain critical of programmatically mixed works like Baltard's Bâtiments Annexes for the Hôtel de Ville. In their conflation of public and private types of architecture, however, these modest buildings were among the first to articulate what became, in monuments like Garnier's Opéra, a defining feature of Haussmann's Paris.

THE MUNICIPAL SERVICE OF ARCHITECTURAL WORKS

The impulse, historiographically, is to step back from the confusion of ordinances, decrees, and edicts dictating the operations of the Prefecture of the Seine in search of some overarching administrative order. Victor Baltard lacked this simplifying hindsight: for him, as a functionary employed within that system, the prefecture was a place of personalized and localized experiences tied for the most part to the specifics of his architectural duties and interests. This leaves an interpretative gap between retrospective summations of the prefecture as an ideally coherent bureaucracy and the practical reality that its administration remained an evolving and sometimes contradictory aggregate of offices and people throughout the nineteenth century. While we might rationalize the prefecture and its services as the abstract result of an idea that originated with Henri IV and Sully, Baltard knew the municipality descriptively, from the inside, as an incremental process of negotiation and compromise between competing agendas. This provided vital, if perhaps unintended, opportunities for individual action. Architects before they were bureaucrats, Baltard and his colleagues worked the prefecture to their own ends, maintaining their professional independence even against Haussmann's autocratic reforms.[18]

Paradoxically, the program of centralizing the direction of French public building atomized that direction into competing spheres of authority at both the state and municipal levels. Aesthetic in purpose and collegial in structure, the architectural profession lacked the cohesion of the engineering corps and was consequently prone to the administrative fragmentation that characterized the Bâtiments civils, which recurrently gave up pieces of its mandate to the Palais impériaux (royaux or nationaux) in 1804, the Travaux de Paris in 1811, the Monuments historiques in 1840, and the Édifices diocésains in 1848–53.[19] By imperial ordinance of 11 January 1811, confirmed by royal ordinance of 26 February 1817, a Direction des travaux de Paris (under

the engineer Louis Bruyère) was set up within the Ministry of the Interior to oversee public works in the city. During the First Empire and Bourbon Monarchy, under the prefects Nicolas Frochot (1800–1812) and Gilbert Chabrol (1812–30), the city shared the cost of municipal projects with the state but had no say in their management. This changed with the July Monarchy when, by royal ordinance of 31 December 1830, the Direction des travaux was transferred to the Prefecture of the Seine. Four services were charged with the fabric of Paris: a Service des ponts et chaussées, responsible for department roads and bridges; a Service municipal des travaux publics, responsible for city streets, water, and sewers; a Service de la grande voirie de Paris, responsible for city planning, street alignments, codes, and building permits; and a Service des travaux d'architecture, subdivided into a Service ordinaire, responsible for maintaining municipal buildings, and a Service extraordinaire, charged with new construction. As exterior agencies of the prefecture, whose activities physically took place outside the Hôtel de Ville, these services were each affiliated with interior *bureaux,* which in turn were grouped into the prefecture's second administrative division.

Prefect Pierre-Marie Taillepied de Bondy (February 1831 to June 1833) first systematized the Service of Architectural Works in an edict of 28 February 1831. Attached to the fifth bureau in the second division, this service was organized into five sections, each headed by an architect: section one, under Étienne-Hippolyte Godde, oversaw the Hôtel de Ville, city churches, public squares, and *fêtes* (public ceremonies, parades, and receptions); section two, under François Jäy, oversaw customhouses, warehouses, and slaughterhouses; section three, under Antoine-Marie Peyre, oversaw courts of law, barracks, and schools; section four, under Jean-François-Julien Ménager (or Mesnager), oversaw prisons and the morgue;

and section five, under Pierre Baltard, oversaw markets and the district town halls (*mairies d'arrondissement*). Nominally, the logic was functional, though the mixture of building types in each section indicated the impossibility of reducing the city's complexity to neatly consistent categories. With the notable exception of the Hôtel de Ville, a building whose iconic importance kept it at the head of the first section until 1871, buildings under the oversight of a section could change with each reorganization of the service, as responsibilities were rearranged in a bureaucratic version of musical chairs. Set against the functional indeterminacy was a consistent personnel who stayed put for decades: Peyre and Baltard continued until their deaths in 1843 and 1846, Godde held on until 1848, and Jäy and Ménager both retained their positions for an impressive twenty-nine years before they were finally retired in 1860.

Bondy was succeeded by Claude de Rambuteau, whose long term in office (June 1833 until February 1848) made him the most consequential prefect of the Seine before Haussmann. Rambuteau twice reorganized the Service of Architectural Works. By edict of 16 May 1836, he reduced the service from five to four sections under an inspector general: Godde, Jäy, Peyre, and Ménager remained as architects of four expanded sections, while Pierre Baltard was named inspector, with the "mission . . . of enlightening the administration on the disputes that could occur during the course of construction."[20] A second edict, of 30 November 1840, organized the service into a stratified hierarchy modeled after the Bâtiments civils: *architectes, inspecteurs, sous-inspecteurs, conducteurs, contrôleurs,* and *vérificateurs.*[21] That same year, the service was reshuffled again, adding a de facto fifth section (which became official in 1844), of primary schools, kindergartens, and workshops, under Hippolyte-Louis (?) Durand, and incorporating the two suburbs of Saint-Denis, under

Eugène Lequeux, and of Sceaux, under Claude Naissant. No further reforms were effected during the July Monarchy, although Gabriel Jolivet succeeded Peyre in 1844 and the post of inspector general was discontinued with Baltard's death, in 1846.

After the revolution of February 1848, the prefecture reverted briefly, between February and July, to its revolutionary form as the Mairie de Paris, while a succession of two mayors and two prefects held office between February and December.[22] Stability returned with the appointment of Jean-Jacques Berger, who served as prefect from December 1848 until June 1853, from the Second Republic to the start of the Second Empire. Berger kept in place the administrative restructuring ordered by a mayoral edict of 29 March 1848: now answering to the fourth bureau in the third division of city works, the architectural service was collapsed from five back to four sections. Jäy, Jolivet, and Ménager stayed on with slightly reshuffled second, third, and fourth sections, while Victor Baltard replaced Godde as architect of an enlarged first section, which absorbed the fifth section, of schools, formerly headed by Durand (who became Baltard's *architecte en second*).

Georges-Eugène Haussmann replaced Berger in June 1853. Remaining in office until January 1870, Haussmann at first issued relatively cautious edicts and decrees that followed the example of his predecessors by adjusting, without completely reorganizing, the prefecture's operations and structure. By 1860, however, he was ready to take more radical steps, as he sought once and for all to regulate the municipality's various services in a fixed hierarchy answering directly to him. The law of 16 June 1859, which annexed the city suburbs and nearly doubled the districts of Paris from twelve to twenty, demarcates these two phases of his tenure.

Immediately after his arrival, Haussmann trimmed the prefecture from five to four divisions, transferring public works from the third back to the second division.[23] By edict of 18 May 1854, he increased the architectural service from four to six sections: Baltard, Jäy, Jolivet, and Ménager kept their posts but lost responsibilities to a fifth section, of schools, under Joseph Uchard and a sixth section, of universities, town halls, and justices of the peace, under Antoine Bailly.[24] A subsequent decree, of 26 December, reassigned the prefecture's divisions yet again and expanded a new third division, of public works, from four back to five *bureaux:* (1) *ponts et chaussées* (bridges and roads); (2) *eaux et pavé* (water and paving); the former office of *grande voirie* split into (3) *voirie* (codes) and (4) *alignements* (street alignments); and (5) *travaux d'architecture* (architectural works).[25] Multiplying the offices and services of his administration even as he condensed its divisional structure, Haussmann restricted the authority of every functionary besides himself by limiting his employees to increasingly specialized duties. The prefect aimed to instill in architects the same *esprit de corps* that identified the technically minded engineers as "functionaries belonging to a strictly organized hierarchy, exclusively devoted to public service."[26] To his dismay, municipal architects continued to display the independence and divided loyalties that he sought to correct: "Architecture was for all of them a profession; for many, without doubt, an art; but for none of them was it the public duty that could become in the eyes of the truly worthy a sort of priesthood."[27]

To institute this priesthood, Haussmann remade the architectural service in his famous edict of 31 March 1860.[28] Characteristically, bureaucratic elaboration and administrative centralization went hand in hand. The six positions listed in Rambuteau's edict of 30 November

1840 now swelled into eight subdivided ranks in the new Direction du service d'architecture: (1) an architect-director, who would "centralize all the parts" and communicate directly with the prefect on a regularly scheduled basis; (2) four architects-in-chief, first class, to oversee the four divisions of city buildings, and two architects-in-chief, second class, attached to the suburbs of Saint-Denis and Sceaux; (3) one chief accountant, in charge of expenditures; (4) two architects (*architectes ordinaires*) "under the immediate orders of the architect-director, one charged with new work and maintenance of the Hôtel de Ville and its dependencies, and the other with everything involving the fine arts" (city works of art); (5) ten district architects, each assigned to two of the city's twenty districts; (6) twenty-four project managers (*inspecteurs*) to assist both architects-in-chief and district architects; (7) five accountants; and (8) various adjunct accountants, along with numerous construction supervisors (*sous-inspecteurs*), delivery clerks (*conducteurs*), filing clerks (*commis piquers*), and watchmen.[29] The decision to rank an accountant immediately below the senior architects speaks to the bureaucratic logic of this hierarchy, as does its inclusion of filing clerks. With obvious satisfaction, Haussmann remembered that he installed a chief accountant against Baltard's wishes, with explicit instructions that this number cruncher report directly to him without first informing the director.[30] Left to their own devices, architects were not to be trusted:

> It was no small matter to maintain . . . habits of order and punctuality. The bosses did not have enough personal authority over their subordinates, when these were former comrades from the École, or enough severity, when they were former students of theirs. As artists, neither the ones nor the others paid more than mediocre attention to expenses. I add that,

generally, they did not have sufficient knowledge to draw up an estimate, or the attentive and detailed application needed to audit a report.[31]

Salaries were generous when compared to the 4,000 to 5,000 francs paid to senior municipal architects in 1854: the director earned between 12,000 and 15,000 francs, chief architects from 10,000 to 12,00 francs for the first class and 8,000 to 10,000 francs for the second class, and regular architects from 5,000 to 7,000 francs.[32] This munificence came, however, with the stipulation that "no architect or permanent agent of the service can undertake himself, or have executed by others, any work for any other administration or any private commission."[33]

Victor Baltard was named director of the architectural service, with, for the first time, an office in the Hôtel de Ville. He kept supervisory control over both the Hôtel de Ville and fine arts and may even have insisted on this prerogative, since he had long held both positions. Otherwise, daily responsibility for the physical fabric of Paris fell to the ten district architects (increased to twenty by 1865), whose work was supervised by the four chief architects: (1) Émile Gilbert, in charge of barracks, guardhouses, police stations, prisons, jails, the morgue, the Prefecture of Police, markets, warehouses, and slaughterhouses; (2) Louis Duc, in charge of schools, preparatory schools, colleges, universities, the Palais de Justice, and the Institut Eugène Napoléon; (3) Antoine Bailly, in charge of town halls, justices of the peace, the Bourse, customhouses, and cemeteries; and (4) Théodore Ballu, in charge of churches.[34] Except for Baltard, employees in place since the 1840s gave way to a fresh group of faces: Gilbert, Duc, and Ballu joined Bailly (appointed in 1854) as architects-in-chief, while younger professionals filled the lower ranks. The change in personnel,

however, was less drastic than it looked. Gilbert, Duc, and Ballu were Prix de Rome laureates like Baltard, while every architect holding the rank of *inspecteur* or above had trained at the École, and most of them had already worked for the city. Artists before they were functionaries, these new employees came from Baltard's world rather than Haussmann's, and they shared common educational and professional experiences. When Haussmann approved architectural appointments, he acted on nominations put forward by Baltard.[35]

If Haussmann could not control the training of his architects, he could at least dictate their terms of employment. His bureaucratic purpose is measured by the distance between Baltard's responsibilities as director and the office of inspector general held by his father two decades earlier. Pierre Baltard's largely honorific position in a compact architectural service is foreign to his son's charge to coordinate the minutely regulated operations of a large municipal office. Baltard captured those operations in a "circular" issued on 22 September 1865. Acting on instructions from the prefect and citing the edict of 31 March 1860, Baltard in his departmental memorandum enumerates, in tediously comprehensive and footnoted detail, the protocols to be followed by all architects undertaking work for the city. When, for example, the cost of maintaining a municipal building exceeded fifty francs, the supervising architect was required

to transmit to the administration by the intermediary of the architect-in-chief a budget before undertaking any work, stating in the covering letter, through a precise and clear explanation and in numbered order, the urgency of the work to be done. If the building is at risk, the architect must, under his supervision and after having consulted with the architect-in-chief, begin work, while simultaneously addressing to the Direction

[du service d'architecture] a report, a budget, a plan or sketch, and an authorization request.[36]

New construction or major renovations necessitated additional documents; once a project was approved, architects submitted monthly (or, in certain cases, trimonthly) progress reports to the administration. In dictating such policies, Haussmann through Baltard was emulating state agencies like the Bâtiments civils and their equally prolix procedures. The requirement, at every instance and at every level, was for reports, budgets, and authorization requests, in a stream of memoranda that flowed upward into an ever greater flood of paper.

Baltard mitigated the burden of Haussmann's bureaucratic imperatives as much as he could. Letters to Antoine Bailly show Baltard keeping his colleague abreast of prefectoral regulations, soliciting recommendations for appointments and promotions, requesting project reports, and preparing an entrance exam for filing clerks.[37] This exam subtly subsumes the intended bureaucratic qualifications for the position into those of an architect: penmanship, spelling, record keeping, and accounting are balanced by a knowledge of mathematics, drafting, and building materials.[38] While bureaucracy may have been for Haussmann a primary source of political power and social utility, it never carried this value for the architects in his employ. To them, the prefecture remained what it had been from the start: the means to an end, a tool to be brought to bear on the only thing that mattered, architecture. Adapting to a burgeoning bureaucracy and its requirements, these architects went on building as they found ways to integrate into their practice another claim on their attention and time. Baltard secured the commission for Saint-Augustin while other projects, probably on his recommendation and certainly with his approval, went liberally to his municipal

colleagues, including those in senior positions: Bailly undertook the Tribunal de Commerce and the Mairie du IVe Arrondissement; Ballu designed the churches of La Trinité, Saint-Ambroise, and Saint-Joseph; Gilbert began the Préfecture de Police and the Hôtel Dieu (completed by Diet); and Duc worked on the Vestibule d'Harlay at the Palais de Justice.

Haussmann would boast in his *Mémoires* that he personally selected the architects of new buildings, and he claimed credit as well for playing a key role in several designs, notably Ballu's church of La Trinité and Bailly's Tribunal de Commerce.[39] Implying that he coached these architects, telling them how to compose their projects in response to urban conditions and planning constraints that they seemed incapable of grasping on their own, Haussmann confused a building's program, over which he had some control, with its architecture, about which he had less to say. He admitted that all projects were reviewed by a Conseil d'architecture chaired by Baltard and his four chief architects, without realizing that this displaced his asserted authority with a body of experts far more informed in matters of design.[40] Working with his colleagues, Baltard formulated the language of civic architecture seen in the two most common municipal building types from the 1860s, churches and town halls.[41] The eight parish churches and one synagogue commissioned, if not always completed, during the decade, mostly to serve the new districts resulting from Haussmann's expansion of Paris, all share a round-arched vocabulary that rejects the Gothicizing specificity of Sainte-Clotilde while extending stylistically from the Romanesque inspiration of Vaudremer's Saint-Pierre-de-Montrouge to the Renaissance inflections of Ballu's La Trinité.[42] In his own work, Baltard emphasized Renaissance over medieval forms, though he was fluent in other idioms: among his preliminary designs for

Saint-Augustin is a sketch for a Neo-Romanesque church (fig. 34), with a double-towered façade strikingly similar to that of Ballu's church of Saint-Ambroise (fig. 35).[43] The six town halls begun in the 1860s employ a Renaissance idiom derived loosely from the Hôtel de Ville and the Luxembourg Palace: façades have two stories with an engaged order on the upper floor and symmetrical wings framing an entrance pavilion opened by three arched bays; in plan, the buildings typically wrap an inner courtyard reached whenever possible by an axial entrance with an attached stair hall, which serves to conceal the irregular perimeters resulting from splayed sites (figs. 36, 37).[44] If the uniform use of the round arch returns to the Romantic theories that Baltard had professed at the École in the 1840s, the original structural reasoning was now optional, something to be respected or ignored depending on circumstance. What mattered was a syntax that was sufficiently generalized to range from eleventh- to sixteenth-century models without disrupting the uniformity of formal effect, and was sufficiently flexible to resolve complicating factors of site, program, and budget into a recognizable civic image.

Haussmann was removed from office in January 1870; Baltard, believing he was too closely associated with the regime to be effective, resigned soon after the fall of the Second Empire in September of that same year.[45] The next prefect, Léon Say, partly dismantled the architectural service in an edict of 30 June 1871.[46] In his *Mémoires,* Haussmann complained bitterly that the reforms of 1860 "did not survive me, and, I say with regret, some of the very members of the architectural elite, from which I was forced to compose the service, were among the first to undermine the institution, in order to recover, with absolute liberty, the ability to accumulate honor and money."[47] Haussmann's charge is misleading, less for the accusations of egotism and greed that he had so

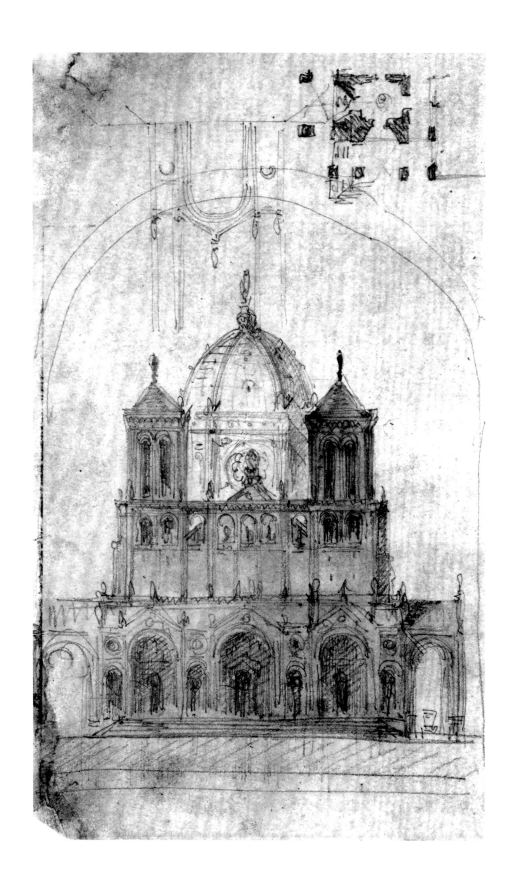

often lodged before than for suggesting that these architects had ever forsaken, however briefly, their professional identity and ambitions when joining the prefect's priestly bureaucrats.

STAGING THE CITY

In March 1848, Baltard succeeded Godde as architect of the first section of city buildings, including the Hôtel de Ville; in 1854, following Louis Visconti's death in December 1853, he became architect of municipal ceremonies. As architect of the Hôtel de Ville, Baltard undertook all modifications to the new building recently completed by Godde and Lesueur, from enclosing the central courtyard with an iron-and-glass roof to designing its Bâtiments Annexes across the facing square. As architect of municipal ceremonies, Baltard supervised the city's public events, planning everything from banquets to the inauguration of new streets. Until 1860, these two positions answered to separate offices within the prefecture, in a bureaucratic parallel to the distinction between architecture proper and stage-set design. Yet the responsibilities were linked historically in urban practice and had in fact been combined when the first section of architectural works was set up, in 1831. Separated in 1836, when Visconti took over public ceremonies from Godde, they were linked again in 1860 in the reorganized architectural service, with its triple responsibility for municipal works of architecture, fine arts, and ceremonies.[48] Working with inherited expectations so familiar that they were mostly taken for granted, Baltard carried out his twinned tasks with a clear sense of their historic interdependence in representing Paris. He also confronted the forces of urbanization, democratization, and industrialization that increasingly called into question those traditions of representation. Apparently unchanged yet profoundly different, informed by precedent yet radically reformed in the present,

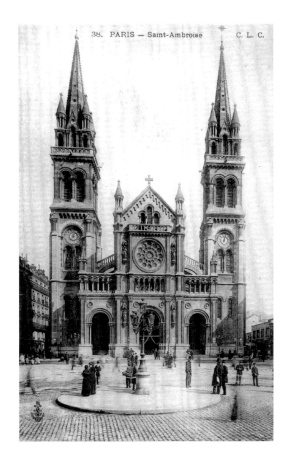

38. PARIS — Saint-Ambroise C. L. C.

FIGURE 34 (*opposite*)
Victor Baltard, project for a church, circa 1860. Partial plan and elevation. Document held at the Centre historique des Archives nationales de France, Paris.

FIGURE 35
Théodore Ballu, Saint-Ambroise, Paris, 1865–76. Contemporary postcard.

Baltard's actions as architect of the city hall and its public ceremonies can only be grasped at their specific level of modernity when measured against a history of urban practices originating in the Middle Ages.

By the middle of the thirteenth century, the city's status as an independent municipality led to the formal incorporation of an elected municipal tribunal, headed by a *prévôt des marchands* (provost of merchants), seconded by four *échevins* (aldermen), and advised by twenty-four *prud'hommes* (councilors).[49] At the same time, the parallel status of Paris as a royal capital was codified through three types of public spectacle that, as Roy Strong explains in *Art and Power,* projected a king's domain over the city: the royal entry, the tournament, and entertainments, including the banquets, balls, and ballets associated with royal

FIGURE 36
Antoine Bailly, Mairie du IVe Arrondissement, Paris, 1862–67. Exterior perspective, from Félix Narjoux, *Paris: Monuments élevés par la ville* (1880–83).

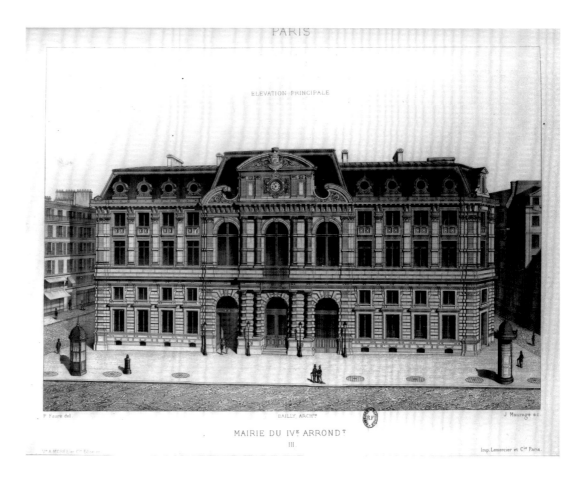

births, baptisms, and marriages.[50] The royal entry, when the king was handed the keys to the city and then made a solemn procession through its streets to his palace, dramatized at once the city's subordination to the prince and the rights granted in return to the bourgeoisie. Innovations imported from Italy in the sixteenth century included the emulation of antique classical models (particularly the Roman imperial triumph), the application of single-point perspective as a tool for rationalizing space, and the humanistic belief that "truth could be apprehended in images."[51] By the Renaissance, the principal streets, squares, and buildings of Paris were being actively figured as a physical setting for events like the royal entry, in a collaborative process that brought together ceremony and urban space, scenography and architecture,

the ephemeral and the permanent, in making the city.[52] From the entry of Henri II and Catherine de Médicis into Paris on 16 June 1549 to the entry of Louis XIV on 26 August 1660, these events helped codify the public spaces of Paris.[53] Architecturally, the institutional coordination between the king's political authority and the merchants' commercial interests was concretized in the pairing of the Louvre with the Hôtel de Ville; after François Ier authorized their joint reconstruction in 1528, these two buildings came to represent their shared public status through similar façades of an arcaded base and engaged classical orders on the main floor (fig. 38).[54]

The establishment of absolute monarchy in seventeenth-century France, beginning with Henri IV and culminating with Louis XIV,

solidified the identity of Paris as the nation's capital and prompted the creation of the royal squares documented by Hillary Ballon and Richard Cleary.[55] The first was the Place Royale (des Vosges), undertaken in 1605 as part of an ambitious building program encouraged by Henri IV in order to consolidate his reign in the wake of the destabilizing religious wars that brought him to power. Stamped as a royal square by its regular space and façades, along with the soon-to-be-obligatory equestrian statue of a king (Louis XIII, added in 1639), the Place Royale prefigured Jules Hardouin-Mansart's two masterpieces of Parisian urbanism, the Place des Victoires and the Place Louis-le-Grand (Vendôme), both commissioned by Louis XIV in 1685 to celebrate his military victories and framed with buildings modeled after Perrault's new east façade for the Louvre (1667–74). Mansart's two squares led to the last *place royale* created before the Revolution, the Place Louis XV (de la Concorde). Proposed in 1748 and fitfully realized to designs by Ange-Jacques Gabriel, the square was closed on its north side with two monumental façades based on Perrault's Louvre, though with humbler functions: the Garde Meuble to the east, completed by the city in 1774, warehoused royal furniture, while the western building was ceded to the city in 1775 for private development. Situated between the Champs-Élysées and the gardens of the Tuileries Palace, at the opposite edge of Paris from the Place Royale, the Place Louis XV served as a point of entry into the city from the king's residence at Versailles. While each square was treated as a separate intervention into the fabric of Paris, without regard to more systematic patterns of circulation, they collectively structured the city with an arc of public spaces that reached around the Hôtel de Ville and Louvre, from the Place Royale, to the Place des Victoires, to the Place Louis-le-Grand, to the Place Louis XV. By the end of the

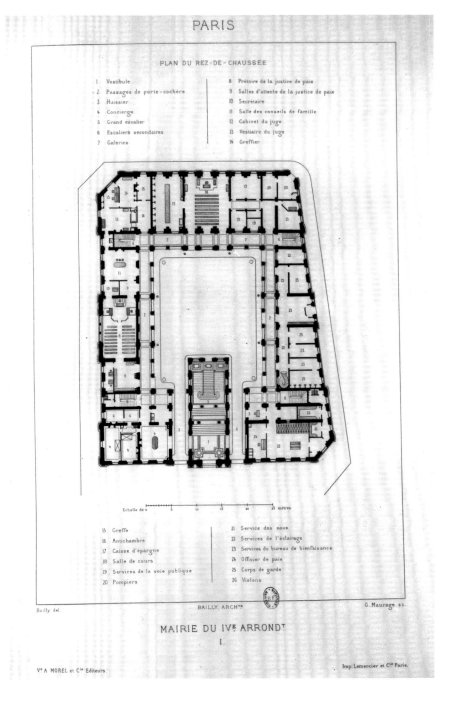

eighteenth century, the city was at least implicitly acquiring an urban scope and scale.

Roy Strong argues that the Renaissance shifted royal spectacles away from the medieval dialogue between classes to a liturgy of absolute state power

FIGURE 37
Antoine Bailly, Mairie du IVe Arrondissement, Paris, 1862–67. Plan, from Félix Narjoux, *Paris: Monuments élevés par la ville* (1880–83).

FIGURE 38
Domenico da Cortona, Hôtel
de Ville, Paris, 1533–1609,
with additions of 1837–46 by
Hippolyte Godde and Jean-
Baptiste-Cicéron Lesueur.
Photograph by E. Dontenville.

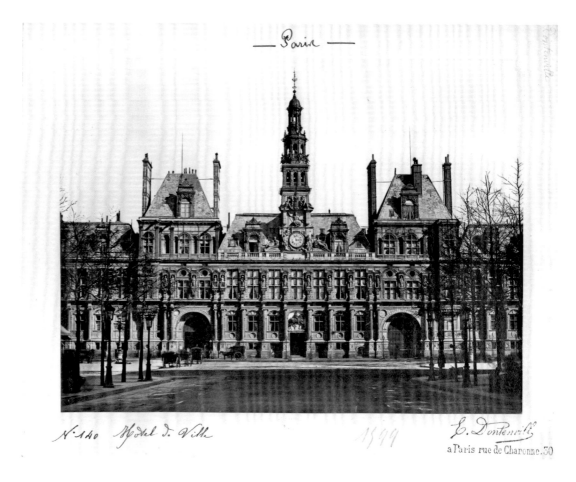

that, by the seventeenth century, was focused on the king at the expense of the bourgeoisie.[56] Yet the joint contributions of crown and municipality to the spatial production of Paris indicate the more complex reality of a city caught between its competing identities, in which formal consistency, rather than uniformity of program, defined its urban order. Indeed, the coherent image of these squares stands in marked contrast to their functional mutability, as well as to the confusing mix of state, municipal, and private interests that went into their realization. In her study of the Place Vendôme, Rochelle Ziskin reveals how this square "served a domestic program at the expense of its public character" as a result of its redesign by Hardouin-Mansart for private residential

development after 1698: the upwardly mobile but uncertain social status of the financiers who inhabited the square was reflected in the shifting iconography and typology of its architecture.[57] Politically, the public image of these royal squares justified their appropriation by subsequent regimes, employing the past to confer legitimacy on the present. Yet the ease with which they could be adapted and renamed, for new uses and for new regimes, indicates they were representationally less stable than is usually assumed: the Place Royale (minus its statue) became successively the Place des Fédérés in 1792, de l'Indivisibilité in 1793, and des Vosges in 1800; the Place Louis-le-Grand, renamed the Place des Piques in 1793 and Place Vendôme in 1799, was then identified with

Napoléon I by the column erected in his honor in 1806–10 (replacing one of Louis XIV, torn down in 1792); the Place Louis XV (minus its statue) was turned into the Place de la Révolution in 1792 and the conciliatory Place de la Concorde in 1795.

Applying royal formulas to modern political purposes, Percier and Fontaine staged the successive events commemorating Napoléon I's accession to imperial power, most famously his coronation at Notre-Dame on 2 December 1804.[58] As in the Paris of Henri IV and Louis XIV, these rituals paralleled permanent works, including the new Rue de Rivoli, whose design was ordered in 1801.[59] The street's open arcade and regular fenestration reflect the Place des Vosges, although mixed brick-and-stone façades give way to a uniform limestone ashlar that renders explicit their common Italianate inspiration. Because the Rue de Rivoli elevations lack the classical orders found on the facing Louvre and Tuileries Palaces, Van Zanten identifies the street and its municipal buildings as an "unrepresentational" background that sets off a representational foreground of royal (and imperial) architecture.[60] The distinction is confused, however, by the Rue de Rivoli's kinship with the Place des Vosges, built by another ruler eager to establish his legitimacy. Perhaps because it was originally intended for bourgeois housing, the Place des Vosges also lacks engaged orders (except on the two royal pavilions), yet this did not obviate its status as a royal space. The Rue de Rivoli exploits this representational ambiguity in order to shape another public space in which municipality and state, bourgeoisie and ruler, were not so much juxtaposed as made to mirror each other in a composite image of the city.

The Bourbon Restoration systematized the management of state ceremonies in a Royal Administration of Entertainments (*menus-plaisirs*), overseen by the architect François-Joseph Bélanger until his death in 1818, when the position was split between Joseph Lecointe and Jacques-Ignace Hittorff.[61] The July Monarchy at first abolished the position, relying instead on ad hoc appointments, but after Visconti became the municipal architect of ceremonies in 1836, the Ministry of the Interior named him the state architect of ceremonies in 1839. Given the overlapping interests of city and state, Visconti's dual offices at once made practical sense and recognized the historic partnership between city and state in staging public spectacles. Inheriting political claims from both the Bourbon Restoration (reprising the Ancien Régime) and the Revolution (producing Napoléon I), the July Monarchy manifested the resulting ideological synthesis in the Fête de Juillet. This national holiday—first celebrated in 1831 to commemorate the "three glorious days" of 27, 28, and 29 July 1830—was memorialized year-round by the Colonne de Juillet erected in the Place de la Bastille. Like the column honoring Napoléon I in the Place Vendôme, the one projected by Alavoine (assisted by Louis Duc and Victor Baltard) emulated ancient Roman rostral columns; in 1834, Duc took over the commission, and his revised iron column mounted on a sarcophagus base and topped by Auguste Dumont's Genius of Liberty was inaugurated on 28 July 1840.[62] As an analogue to the royal statue, the Colonne de Juillet identified the Place de la Bastille as a revolutionary successor to the earlier *places royales.* Yet the column's significance, substituting an impersonal abstraction for the personal specificity of a royal statue, is fundamentally ambiguous, just as the square's amorphous border is at odds with the formal clarity of earlier squares.

Similar ambiguities characterize the Place de la Concorde, which Hittorff completed in 1833–36 by erecting an Egyptian obelisk at its center.[63] In 1831 (after Charles X proposed in 1826 to erect an expiatory statue of Louis XVI on the site of

the king's execution and a competition in 1829 to complete Gabriel's original design failed to yield results), Louis-Philippe had accepted the smaller of two obelisks of Rameses II from Luxor offered by the Viceroy of Egypt, designating it for the Place de la Concorde with this justification: "I have another reason for placing the obelisk in the center [of the square], which is that it will not recall any political event and is therefore sure to remain, otherwise you might someday see there an expiatory monument or statue of liberty."[64] In place of an explicit message for the square, Hittorff formulated a blandly generic, if highly elaborate, program of "national triumph in the industrial age."[65] Despite the king's pointed reference to a "statue of liberty," the Colonne de Juillet in the Place de la Bastille was equally without specific meaning. When the Second Republic was proclaimed from its base on 27 February 1848, the column was left unharmed because this free-floating symbol was so easily recontextualized: unlike the statue of a king in a royal square, but like the obelisk in the Place de la Concorde, its destruction was no longer needed to legitimize a revolution.[66]

By 1848, public architecture in Paris had reached a state of representational crisis. The new Hôtel de Ville (fig. 39), built by the July Monarchy though still unfinished when Baltard took over as its architect, was the city's largest and most expensive project before the Second Empire. In 1832, faced with a burgeoning administration that was rapidly outgrowing its Renaissance quarters, Prefect Bondy charged Godde with expanding the existing building. After the Conseil municipal rejected the preliminary design, Rambuteau appointed Lesueur to assist Godde on a joint project that was mostly realized between 1837 and 1846 at a cost of 12 million francs (excluding interior furnishings and decorations).

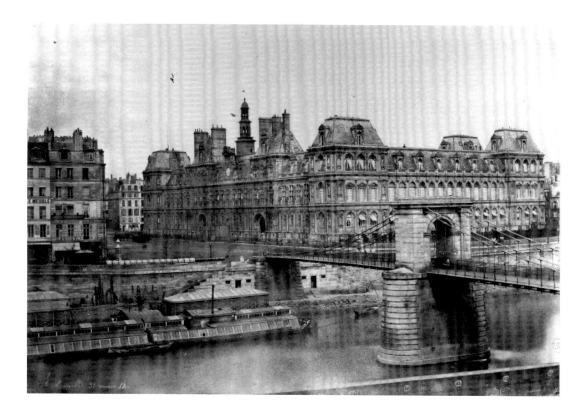

FIGURE 39
Hippolyte Godde and Jean-Baptiste-Cicéron Lesueur, Hôtel de Ville, Paris, 1837–46. Photograph by Charles Marville, 1852.

Faithful to the Renaissance original, down to the smallest architectural detail, the additions nonetheless transformed the building, doubling the length of its façade, encasing the central block and its single courtyard (the Cour Louis XIV) within new wings organized around flanking courtyards, and adding an enfilade of reception rooms that ran along the Rue Lobau in back.[67] Godde and Lesueur treated the building scenographically, unrolling as on a sheet of canvas an open-ended vocabulary of arcades, engaged orders, pedimented windows, and mansarded pavilions that could be repeated ad infinitum until the requisite volume of functional space had been provided. Their solution anticipated the even more gigantic New Louvre, projected by Visconti and Lefuel in 1848–54 and undertaken at a cost of 31 million francs in order to furnish the Second Empire with a suitably grandiose political seat.[68] The Hôtel de Ville and the New Louvre each elided existing historical structures conceived for other purposes in the past with new structures conceived for more complex purposes in the present. The illusion of historical continuity and architectural coherence glossed over real discontinuities in both political identity and functional program: representationally, form and content (figurative as well as real) were radically disconnected in these monuments.

When Baltard succeeded Godde as architect of the first section in 1848, Lesueur stayed on as the Hôtel de Ville's architect of record, since many of its interiors awaited decoration.[69] Whether, however, the building was still under construction, and thus properly the charge of Lesueur, or a finished monument whose maintenance was Baltard's responsibility became less clear with each passing year, particularly after Lesueur began restoring the Cour Louis XIV in 1851.[70] As early as 1849, Baltard was proposing projects (for the Salle de la République), and he made his move for full

control soon after Haussmann replaced Berger as prefect of the Seine in June 1853. In a letter from 1854, Lesueur stiffly refused Baltard's request for assistance:

> I would agree with your scruples, but I find myself in a very awkward position. Honestly, I had been promised, on the resignation of Berger, the work of completing the Hôtel de Ville; but insofar as it will involve only work of adjustment of little importance, I will remain silent. Moreover, I would be afraid of failing in my objection, which would be quite disagreeable for me. Knowing neither the nature nor the importance of the work of completion to which you refer, I would not know how to offer an opinion. If it is a matter of the monumental fireplaces in the two square rooms, I would certainly object, if only for the fees due to me for my compositions and studies.[71]

Professional niceties had been brushed aside by Haussmann's impatient demands for prompt action, and Baltard obliged by quickly finishing the building's interiors in 1854–55.[72]

At the same time, Baltard completed Lesueur's restoration of the Cour Louis XIV, covered the courtyard with an iron-and-glass roof, and added a formal grand staircase leading to the first-floor reception spaces at the rear of the building (fig. 40).[73] Construction was well along when the Conseil des bâtiments civils reviewed the project in May 1855, causing Charles-Auguste Questel to huff that the *conseil*'s opinion was moot, since the alterations were nearly done. The city was usually punctilious about consulting the state, but Baltard was trying to beat a deadline, and in any case, the *conseil* was less distressed by this breach of protocol than by the iron-and-glass roof. Rejecting as unacceptable this alteration to "the character of

FIGURE 40
Cour Louis XIV, Hôtel de Ville,
Paris, as remodeled by Victor
Baltard, 1854–63. General view by
Félix Benoist and H. Clerget, from
Paris dans sa splendeur.

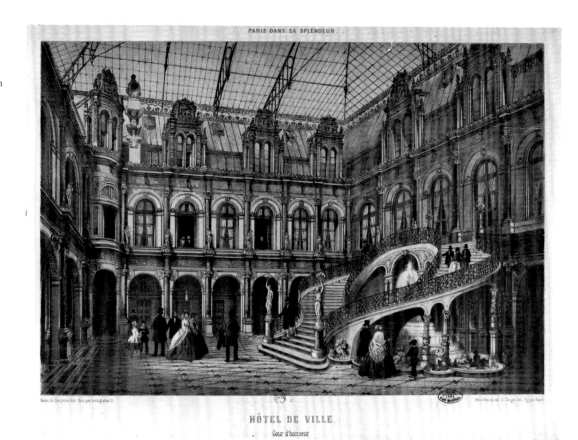

PARIS DANS SA SPLENDEUR.

HÔTEL DE VILLE.
Cour d'honneur

the edifice, one of the most beautiful monuments of the Renaissance," the *conseil* complained "that the projected iron roof is fundamentally offensive because of the heaviness and the vulgarity of its design" and concluded "that the details of the ironwork cover cannot in any way be adopted."[74] Baltard considered curvilinear and rectilinear alternatives (figs. 41, 42) before going ahead with a rectilinear scheme whose graceful wrought-iron structure hardly justified the *conseil*'s stinging rebuke.[75] In 1855, however, exposed iron-and-glass roofs were still the exception, a feature of utilitarian, rather than monumental, architecture: except for Labrouste's Sainte-Geneviève Library and its formally unrelated barrel vaults of cast iron and ceramic tile, the only precedents were industrial constructions like the shed of Duquesney's Gare de l'Est, Paxton's Crystal Palace, or Baltard's own

designs for the Central Markets. If his iron-and-glass roof seems modest when compared to the Hôtel de Ville's massive expansion of 1837–46, its evident contrast with the material form of the Cour Louis XIV made it stand out in ways that Godde and Lesueur's scenographic historicism did not. Instead of papering over the differences between past and present, Baltard had made them all too apparent.

When it came to the staircase, Baltard first considered a straight flight in two sections with a middle landing, before settling on horseshoe ramps that swelled up from a lower fountain and basin (fig. 43). Modeled after the Renaissance stairs added by Jean Ducerceau to Fontainebleau in 1634, the staircase made the expected historicist gesture so disturbingly absent from the iron-and-glass roof. Thrown up hastily in 1855 on

FIGURE 41
Victor Baltard, project to roof the Cour Louis XIV, Hôtel de Ville, Paris, 1854. Perspective sketch of circular scheme. Document held at the Centre historique des Archives nationales de France, Paris.

FIGURE 42
Victor Baltard, project to roof the Cour Louis XIV, Hôtel de Ville, Paris, 1854. Perspective sketch of rectilinear scheme. Document held at the Centre historique des Archives nationales de France, Paris.

an arched base of wood and plaster, the staircase was rebuilt in 1861–63 as a lithe freestanding structure of limestone and white Italian marble with a wrought-iron railing. The remodeled Cour Louis XIV mitigated the labyrinthine path taken by dignitaries, upon their arrival by carriage, from the Place de l'Hôtel de Ville to the reception rooms along the Rue Lobau at the rear. By turning the courtyard into a comfortably enclosed stair hall that could be used year-round as a vestibule to the spaces beyond, Baltard answered Haussmann's desire to stage this space for an ongoing series of political and ceremonial functions. Framed by the restored masonry façades of a royal past, sheltered overhead by the iron roof of an industrial present, the Neo-Renaissance staircase was deployed as a piece of political theater that associated the present regime of Napoléon III with those of François

Ier and Louis XIV. The emperor made systematic use of architecture to validate his rule, and he found in Haussmann a willing collaborator in his efforts to represent Paris as a suitably imperial capital.[76]

This stage was conceived and first used for a reception held in honor of Queen Victoria at the Hôtel de Ville on 23 August 1855.[77] The emperor had allied France with Britain in the Crimean War, of 1854–56, and celebrated this alliance in 1855 through reciprocal imperial visits that took Napoléon III and Eugénie to London in April and brought Queen Victoria and Prince Albert to Paris the following August. Amid the state ceremonies, including a banquet at Saint-Cloud, the royal couple was invited to an evening at the Hôtel de Ville. The event began at ten o'clock, when Victoria and Albert arrived from the Tuileries by way of Haussmann's newly extended Rue de Rivoli. Descending from their carriage, beneath a tent set up in the brilliantly illuminated

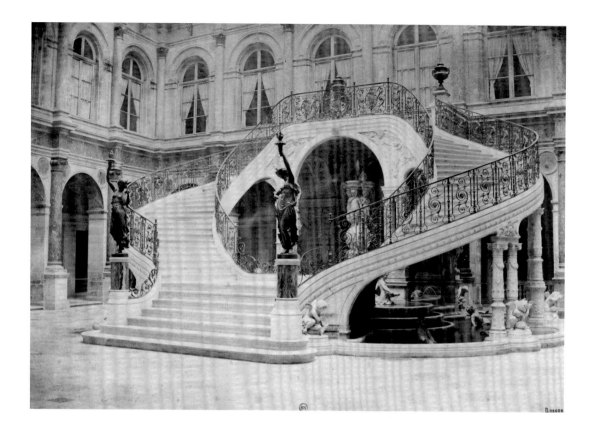

Place de l'Hôtel de Ville, the two were received by Baron Haussmann and his wife, who escorted them inside to the Cour Louis XIV. In this "newly covered and restored" vestibule, members of the Conseil municipal had assembled with an honor guard and other officials to greet Victoria: "In order to reserve for the Queen . . . a passage where no one had walked before Her Majesty, a large double staircase had been erected at the end of this courtyard, recalling in design and style the staircase of Fontainebleau and looking as if suspended over a nymphaeum, in the midst of which appeared the two united statues of England and France."[78] As indicated, paired statues of France and England, flanked by personifications of the Seine and Thames Rivers in the central basin, signaled Napoléon III's close ties with Queen Victoria. Banners with the interlaced monograms of Victoria and Albert, Napoléon and Eugénie,

hung from the first-floor windows, while "a purple velarium . . . hid the crystal vault covering the courtyard."[79] Moving from space to space in a meticulously choreographed performance, Queen Victoria and Prince Albert climbed the stairs to join Napoléon III in the Salle des Cariatides (Eugénie had stayed at home), attend a ball in the Salle des Fêtes, and tour the prefect's apartments, before departing at 11:30 sharp.

The reception of Queen Victoria explains at once the Anglo-French program of sculpture, the royal connotations of the stair's design, and a fast-tracked construction schedule that left barely enough time to erect the temporary staircase. The stair hall remained provisional in 1855, simulating a condition of permanence that did not yet exist, and the initial justification for its program was then effectively erased by the stair's success and regular use in subsequent receptions:

without compromising the still-legible allusions to François Ier and Louis XIV, the substitution in the permanent construction of adolescent putti (by J.-A.-B. Lechesne) for the statues personifying France and England eliminated the original references to Queen Victoria. Shorn of any fixed referent, the stair became a representationally open-ended, if elegantly detailed, stage, which now acquired its significance indiscriminately from each passing circumstance of its use. The efficiency with which the remodeled Cour Louis XIV lent itself to clockwork events like the reception for Queen Victoria depended upon the realization that meaning, at least in architecture, could only be concrete if it were also ephemeral.

Next year, Baltard orchestrated on Haussmann's command the ceremony to celebrate the baptism of the emperor's son and heir, Eugène.[80] The Conseil municipal had already, in December 1855, charged Baltard with designing a cradle shaped like a ship and decorated with Sèvres porcelain enamels of the cardinal virtues by Hippolyte Flandrin, a cast silver figure of the City of Paris by Charles Simart at its head, and a cast silver imperial eagle by Alfred Jacquemart at its foot. Fabricated at an extravagant cost of 161,751 francs, the cradle was displayed in the Salle du Trône at the Hôtel de Ville on 13 and 14 March, before being rushed over to the Tuileries Palace on the fifteenth, after the start of Eugénie's labor preempted plans for a formal presentation on the sixteenth. A few days later Napoléon III sent to Haussmann a large Sèvres vase as a *"personal souvenir"* of thanks for the gift.[81]

The baptism was scheduled for three months later, on the afternoon of 21 June 1856. Gathering in the Place de l'Hôtel de Ville, the imperial cortege left by carriage at 5:30 for Notre-Dame, crossing over to the Île de la Cité on the newly rebuilt Pont d'Arcole (1854). This straight line to the cathedral and back made the square a logical staging point for the ceremony, even if the site was undergoing renovations: the new Avenue Victoria, planned in 1854 to connect the Place de l'Hôtel de Ville on axis to the Place du Châtelet, remained an unpaved path flanked by empty lots. To mask this fact while publicizing the coming urban improvements (fig. 44), Haussmann instructed Baltard to face the east side of the Place de l'Hôtel de Ville with "a simulacrum of the projected buildings, in the manner of theater decorations. The imitation of depth and the hue of stone was done with such exactitude that many people . . . did not immediately notice the artifice employed to complete in an instant the Place de l'Hôtel de Ville."[82] Fronted by a triumphal arch, the unfinished Avenue Victoria was turned into a garden, with allegorical sculptures, basins, and fountains in imitation of André Le Nôtre's landscapes at Versailles. Returning from the cathedral around 7:00 P.M., the emperor and empress were received by the prefect and escorted into the Cour Louis XIV (fig. 45), festooned as it had been for Queen Victoria with banners, monograms, and another velarium overhead. There they were met by "a group of young ladies, at the head of which was Miss Henriette Haussmann," who presented Eugénie with a basket of flowers in reference to her fertility.[83] Ascending the stairs, they retired to a private apartment until it was time to enter the banquet hall around eight o'clock to the applause of the seated multitude.[84] Dinner was followed by a tour of the Hôtel de Ville, and the imperial couple then departed for the Tuileries Palace at 10:30. During the evening, the garden in the Avenue Victoria was illuminated with a fireworks display.

The baptism of the Prince Impérial in 1856 emulated the baptism of the Roi de Rome in 1811, which likewise took place at Notre-Dame and was followed by a reception at the Hôtel de Ville.[85] The two Napoléons were represented and related

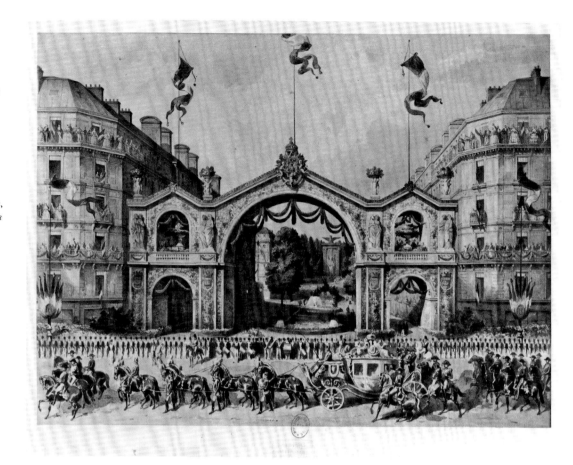

in a spectacle of dynastic perpetuation that staged the city along with the cathedral and the Hôtel de Ville as a site of imperial triumph. As the re-created gardens of Versailles on the Avenue Victoria made clear, the ceremony laid simultaneous claim to Louis XIV: just as the nineteenth-century renewal of Paris was seen to build upon a tradition of urbanism that ran from Henri IV and Louis XIV to Napoléon I and Napoléon III, so the emperor and his heir were placed in a line of succession that reached back before the Revolution. Reinforcing the political associations were the continuities of practice that recycled in the present ceremonial forms and settings invented in the past. As in the Paris of Louis XIV, so in the Paris of Napoléon III, the ephemeral and the permanent were made interchangeable through

simulated triumphal arches and buildings that projected onto the city the image of a new political order in advance of its material fact: like Mansart's Place des Victoires, whose façades were projected by canvas mock-ups when the square was inaugurated in 1681, the simulacra thrown up on the Place de l'Hôtel de Ville in 1856 prefigured the two Bâtiments Annexes to be erected in 1857–62.

These continuities of practice connecting Second Empire Paris with a history of pre-Revolutionary precedents masked but could not prevent the inexorable erosion of the Renaissance belief in the emblematic truth of such representations. Even if the images looked familiar, their content was becoming increasingly abstract. Ostensibly about the emperor and his family, the ephemeral ceremonies and street decorations

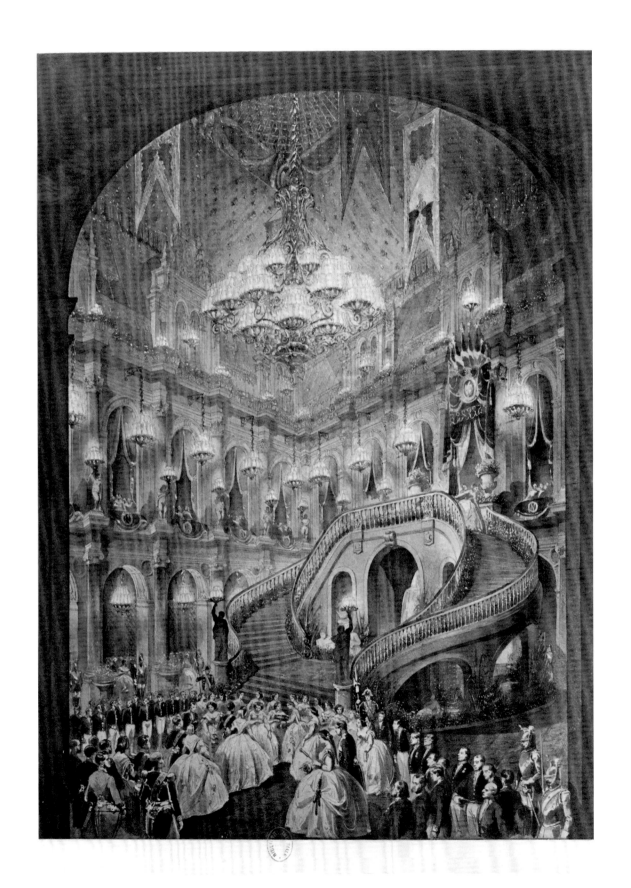

choreographed by Baltard simultaneously addressed Haussmann's transformation of the city. The inauguration of the Boulevard de Sébastopol on 5 April 1858, the Boulevard des Malesherbes on 15 August 1861, the Fontaine Saint-Michel on 15 August 1860, and the Boulevard du Prince Eugène (Voltaire) on 5 December 1862 all provided instances where the emperor and his prefect rode the length of avenues still largely unfinished and delivered speeches about the promise of these streets to improve the economic, social, and physical well-being of the city's inhabitants.[86]

The opening of the Boulevard du Prince Eugène (to commemorate the son of Empress Joséphine, after whom the younger Prince Eugène was named) prompted the last and most elaborate ceremony of its kind; Max Vautier had taken over the position of architect of ceremonies in 1860, but Haussmann personally charged Baltard with decorating the boulevard and the Place du Trône at its head.[87] At the foot of the boulevard, a triumphal arch with flanking obelisks in gilded latticework focused a perspective lined with Venetian masts and banners. Midway, the Place

du Prince Eugène (Léon Blum) was punctuated by Auguste Dumont's bronze statue of the elder prince, for which Baltard designed a granite base with chamfered corners, imperial eagles, and palm fronds. The climax to this mise-en-scène came in the Place du Trône (fig. 46), where Baltard projected in wood and painted plaster the maquette for a permanent monument to the emperor's military campaigns, especially the war of 1859 against Austria in support of Italian unification. Circled by arcaded porticos, the vast square centered on a fountain with a statue of Glory by Théodore Gruyère and was anchored at one end by a grandiose triumphal arch, located just inside Ledoux's Barrière du Trône and dedicated to Napoléon III and his military victories. As Haussmann explained at the dedication, "We do not pretend to have resolved, in the hasty works of a temporary decoration, the very complex artistic questions raised by such a conception; but we are certain to have been faithful interpreters of popular sentiment when we think to dedicate this very spot with a triumphal arch dedicated to the victor of Solferino and to his valiant soldiers where Your

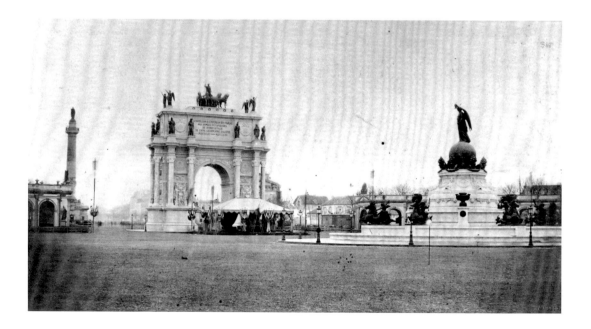

FIGURE 46
Victor Baltard, Place du Trône, Paris, 1862–63. Dedication ceremonies on 5 December 1863. Photograph by Richebourg.

FIGURE 47
Claude-Nicolas Ledoux, Barrière
du Trône, Paris, 1788, and a
project for its completion by
François Jäy, 14 December 1839.
Elevation. Private collection of the
Baltard family.

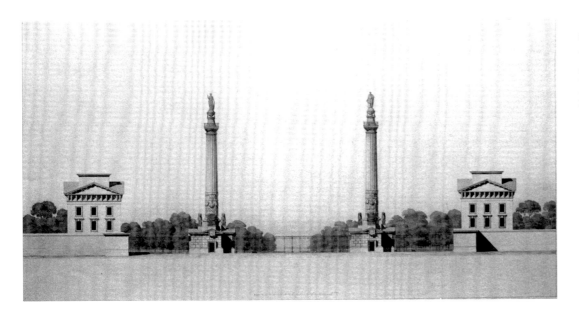

Majesty, returning from Italy, reentered Paris at the head of Your troops."[88]

Haussmann meant to realize an urban project dating to the reign of Louis XIV. After the square was first laid out, on the occasion of the king's royal entry into Paris in August 1660, Claude Perrault had in 1670 begun construction of a permanent triumphal arch to replace the temporary one erected ten years before. This project was abandoned, leaving only foundations and a base so massive that they would not be removed until 1716. In 1788, on the eve of the Revolution, Ledoux began the Barrière du Trône (also called the Barrière de Vincennes after the destination of this gate) on the east side of the square: a pair of austere cubical pavilions, adorned with giant arched portals and flanked by two Doric rostral columns on cruciform bases (fig. 47).[89] Like the Barrière de l'Étoile at the opposite edge of Paris, the Barrière du Trône marked a royal point of entry into the city, and this status at once set these gateways apart from the other, more strictly practical *barrières* and made their design subject to the king's personal approval. Left unfinished at the start of the Revolution, Ledoux's two rostral

columns were completed in 1842–45 by François Jäy with the help of Baltard, when they were given capitals and crowned by statues of Saint Louis and Philippe Auguste by Antoine Etex and Auguste Dumont.[90]

Haussmann's program for and Baltard's design of the Place du Trône were informed by this history. The proposed arch in honor of Napoléon III evoked Perrault's aborted arch for Louis XIV, even if its decoration referred more directly to Percier and Fontaine's Napoleonic Arc du Carrousel at the Louvre (1806). Its construction would have confirmed the formal and symbolic linkage of the Place du Trône with the Place de l'Étoile as the city's two royal gates and translated that linkage into post-Revolutionary terms through the pairing of Chalgrin's Arc de Triomphe, commissioned by Napoléon I in 1806, with Baltard's arch in the Place du Trône, projected on behalf of Napoléon III in 1862. Extended into Paris by the Boulevard du Prince Eugène, whose length is nearly equal to the distance down the Champs-Élysées from the Étoile to the Tuileries, the Place du Trône would have been the latest *place royale* added to the city, except that this was to be a *place*

impériale, as firmly associated with Napoléon III as the Étoile already was with Napoléon I.

The project was abandoned, a victim alike of Haussmann's shifting priorities and the emperor's attempt after 1860 to refashion himself from an autocratically imperial into a liberally democratic ruler. Despite its image of monumental permanence, the Place du Trône proved as temporary as the first staircase of wood and plaster built for Queen Victoria in the Cour Louis XIV: because each was designed to serve a specific political event, both became irrelevant the moment the event in question had taken place; unlike the staircase, whose generic ceremonial utility justified a permanent replacement, the decoration of the Place du Trône had no purpose except to remind the public of an emperor's pretensions. Ignoring lessons of the Colonne de Juillet in the Place de la Bastille and the obelisk in the Place de la Concorde, the personalized specificity of the triumphal arch to Napoléon III made it an immediate anachronism. In 1880, the square was rebaptized the Place de la Nation, and in 1899, it received a fountain dedicated to the Triumph of the Republic by Aimé-Jules Dalou.[91] By 1903, when the Paris Baedeker recorded the square's history for tourists, Baltard's plaster arch, arcades, and fountain had all vanished from memory as well as space: the square's origins and original name were remembered, but nothing was said about the ambitious plans of 1862.[92] The boulevard alone remains to record what Haussmann intended, except that the renamed Boulevard Voltaire is an abstracted spatial gesture, stripped of its original dedication and statue and therefore of its dynastic connection to the Place du Trône. Conceived for a moment in time, Haussmann's political program proved as transitory as Baltard's festival architecture, two kinds of ephemera that left no trace outside forgotten photographs and newspaper articles.

According to David Van Zanten, the Place du Trône is symptomatic of a fundamental shift in how Napoléon III treated Paris between the first and the second decades of his reign: "At first the emperor imposed Napoleonic imagery on the city, to appropriate it for his own representation, but by 1860 it was the city itself and its transformation that had become the subject of this theater, with the emperor increasingly appearing merely the instrument of its self-realization."[93] Van Zanten's point is that there is a telling difference between a ceremony whose subject is a royal rite or the dedication of a palace and one whose subject is an urban project.[94] If the former casts the ruler in the traditional role of personal agency, the latter turns that ruler into a quasi-bureaucratic facilitator of plans for which he can no longer claim direct credit. The first legitimizes the ruler through precedents like Louis XIV, while the second betrays his likeness to Haussmann.

In practice, however, this distinction was blurred, especially in projects like the Place du Trône, where the emperor's heavy-handed political message went hand in hand with the prefect's urban planning. The emphasis upon the personal that runs so insistently through the events considered here, as when Napoléon III sent to Haussmann a vase as his *"personal souvenir"* of thanks on the occasion of Eugène's birth, suggests how the emperor hoped to shore up his post-Revolutionary reign with pre-Revolutionary props of personalized authority. The ceremonies staged by the city in his honor repeatedly conflated categories of individual and urban, royal and bureaucratic representation. Indeed, both the baptism of the Prince Impérial in 1856 and the inauguration of the Boulevard du Prince Eugène in 1862 actively tied imperial ritual to urban planning, combining the two in such a way as to leave it finally unclear whether the prefect's urbanism

was being called upon to justify the emperor's authority or vice versa. In part, this confusion can be attributed to the ambivalent identity of Napoléon III, about whom Karl Marx said that "just because he was nothing, he could signify anything."[95] The emperor's loss of meaning paradoxically identifies him, and the ambiguous ceremonies staged in his name, as typical signs of their times. More generally, his ability to "signify anything" points to the accumulating inability of any public representation in nineteenth-century Paris (whether by a politician, a ceremony, a space, or a building) to convey a conventional iconographic program with any consistency or permanence.

Behind the transience of projects like the Place du Trône lay the widening gap dividing the political intentions of Napoléon III and Haussmann from the architectural intentions of Baltard and his colleagues. As demonstrated by his transformation of the Cour Louis XIV into a ceremonially efficient, if representationally open-ended, space, Baltard adopted a pragmatic, rather than emblematic, approach to architecture. Treating representation as a consequence instead of the determinant of use, Baltard was able to work fluently in the moment, without having to assume that his decorations carried any lasting political content. The very conditions conspiring to undo architecture's iconographic conventions were turned to constructive advantage and provided the tools to create a new kind of urban architecture that could address the emerging social and spatial realities of modern Paris. Baltard's answer to those realities, already hinted at in his mixture of historical and industrial idioms in the Cour Louis XIV, was further developed in his design of the municipal annex buildings facing the Hôtel de Ville.

The Bâtiments Annexes (fig. 48, 49) resulted from two distinct, if interdependent,

requirements. The first was the functional need for office space to house the prefecture's relentlessly spreading bureaucracy. The second was the urban need to solidify Haussmann's redevelopment of the center of Paris with a series of new municipal buildings. Extending west to east from the Louvre to the Hôtel de Ville, and south to north from the Left Bank across the Seine and the Ile de la Cité to the Rue de Rivoli and the Central Markets, this plan was organized in its eastern half around the intersection of two streets at the Place du Châtelet: a street running past the Square Saint-Jacques and ending on axis at the Place de l'Hôtel de Ville, which was decreed on 29 July 1854 and named the Avenue Victoria in 1855 in honor of the queen's visit; and the Boulevard du Centre, connecting the Place du Châtelet to the Gare de l'Est, which was decreed on 25 September 1854 and renamed Sébastopol in 1855 after the French and English siege of that city in the Crimean War.[96] The resulting spatial grid was anchored by the two Bâtiments Annexes, on either side of the Avenue Victoria; by Gabriel Davioud's two theaters, framing the Place du Châtelet; and by Antoine Bailly's Tribunal de Commerce, built across the Seine on the Ile de la Cité with its dome aligned to the Pont au Change and the Boulevard de Sébastopol. Both the streets and the buildings necessitated by this plan reflected a new, modern approach to organizing urban space, one based less on Renaissance constructions of a framed and contained perspectival space than on the abstract logic of circulation networks.

Financed by the law of 2 May 1855, the expropriation of properties for the Avenue Victoria cleared the way for municipal use of the leftover parcels of space. In July of 1855, the city approved Baltard's preliminary scheme for two office buildings, one to the south on a rectangular lot and

FIGURE 48
Victor Baltard, Bâtiments Annexes
de l'Hôtel de Ville, Paris, 1855–58.
Façade elevation, from Félix
Narjoux, *Paris: Monuments élevés
par la ville* (1880–83).

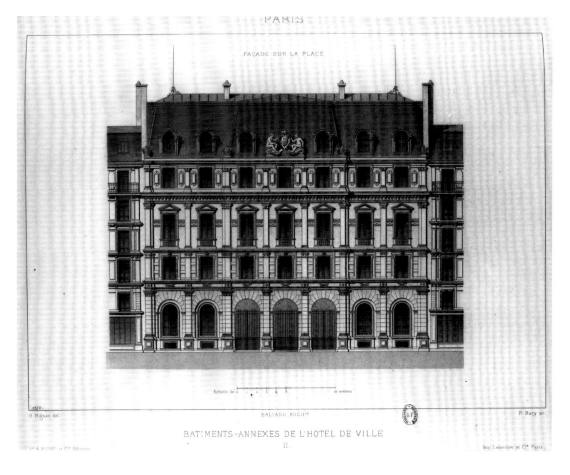

one to the north on a triangular lot that backed
against the Rue de la Coutellerie. The larger,
south building was budgeted at 1,059,589 francs in
October 1855 and rebudgeted at 1,325,926 francs
in July 1856, after it was revised in the spring of
1856 to serve an expanding, though still indefi-
nite, hodgepodge of bureaucratic functions.[97] In
the end, the south building erected by Baltard in
1857–58 would house the city's tax and revenue
offices, the office of public works, and the munici-
pal archives. The smaller, north building, housing
the welfare offices of the Assistance Publique, was
realized in 1860–62 by Théodore Labrouste, who
was required to keep Baltard's elevations. Gutted
by fire in 1871, both were rebuilt in 1873–76 to
substantially the same design by the municipal

architect Félix Roguet, Baltard's second on the
original project.[98]

The Bâtiments Annexes completed the regu-
lated civic square fronting the Hôtel de Ville, from
which they borrowed both their apparent sym-
metry and their vocabulary of arcades, engaged
orders, and pedimented windows. In fact, they
were asymmetrical in form, function, and layout.
Bits of infill on differently sized and shaped lots,
they were configured externally by the surround-
ing streets rather than internally by their use, just
as those streets were being laid out according
to the abstract dictates of a circulation network
rather than their own internal, perspectival order.
Despite a program that continued to evolve in
response to the prefecture's growing needs, each

annex was expected to provide functionally planned spaces, adequate light and ventilation, and efficient systems of vertical and horizontal circulation, while also housing such specialized equipment as Baltard's ingenious cast- and wrought-iron storage racks for the municipal archives on the upper floor of the south building.[99] All of this had to fit into predetermined exteriors that incorporated apartment buildings with ground-floor shops into the corners of each four- and three-sided municipal annex, with the result that their central façades mirroring the Hôtel de Ville pushed against residential elevations modeled after those approved in 1854 for the final extension of the Rue de Rivoli to the Place de l'Hôtel de Ville. Haussmann later criticized the low relief of the annex façades, suggesting that they "would have had a better character if the pilasters and moldings had projected more." Clearly, however, Baltard was trying to coordinate the municipal with the residential elevations by giving them equally weighted surfaces despite their evident differences of floor heights, fenestration, and detailing.[100]

Early in 1858, when the south annex was nearing completion, a journalist observed that Baltard had managed to effect a "transition between the character proper to residences and what is appropriate to public constructions with a utilitarian purpose. . . . As for the interior layout of the building, it will answer all the needs of the offices to be installed there."[101] César Daly was less complimentary by the time Théodore Labrouste finished the north annex in 1862: "It was required, mistakenly in our opinion, that the façades of the two buildings be treated identically, in spite of the great differences of purpose and essential character."[102] Daly's objection echoed concerns raised by the Conseil des bâtiments civils in 1855 in its review of the preliminary project:

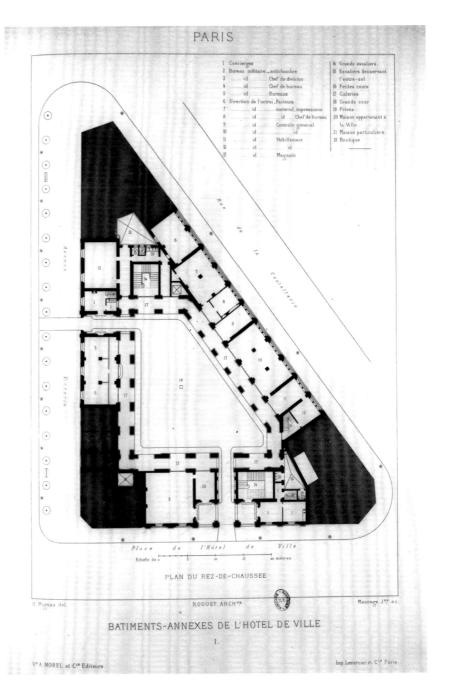

That, at a time when the efforts of the government are tending in other places to detach public edifices from neighboring private residences, this disposition, adopted for an edifice that is destined for the municipal

FIGURE 49
Victor Baltard, Bâtiments Annexes de l'Hôtel de Ville, Paris, 1855–58. Plan of the north Bâtiment Annex as rebuilt by Félix Roguet in 1873–76, from Félix Narjoux, *Paris: Monuments élevés par la ville* (1880–83).

administration, erected on grounds belonging to the city, cannot be easily explained;
That the adopted solution is all the more regrettable because it deals with buildings located on the Place de l'Hôtel de Ville. . . . That it is to be desired that the administration buildings, which do not in any case require a monumental style for their purpose, of an appearance that is contrary to that of offices, do not so obviously distance themselves from the style of private houses, even while distinguishing themselves.[103]

Like Daly, the *conseil* expected explicit functional typologies that, codified in the system of Beaux Arts composition, stipulated a clear correspondence between a building's use and its architectural form, so that every program resulted in coherent and functionally expressive elevations. These typologies, moreover, were to follow a clear hierarchy of public monuments, civic structures, and private residences. Instead, Baltard had generalized the building program through an urban typology of public and private architecture that

identified the Bâtiments Annexes indeterminately and variously as public buildings fronting a square, as office buildings serving administrative functions, and as mixed-use residential buildings housing the city's inhabitants and their commercial interests.

Anticipating the other municipal buildings to go up around the Place du Châtelet, Baltard's Bâtiments Annexes were among the first to subordinate, so blatantly and explicitly, functional programming to urban planning.[104] Next came Bailly's lopsided Tribunal de Commerce (fig. 50), which visibly adjusts its split program—requiring commercial shops along with offices—to the stipulation that its dome and main façade align with the Boulevard de Sébastopol. The Conseil des bâtiments civils worried that "the layout adopted by the entrance to the Tribunal from the *quai,* the construction of the dome, and the placement of shops will entail numerous disadvantages for the interior circulation," while Daly wondered at "the singular necessity of creating a plan to justify a predetermined architectural form, instead of looking for the architectural form best suited at once to satisfy the needs of the program and to express the building's character."[105] When Davioud followed Bailly by wedging the Châtelet theaters (fig. 51) between thin slabs of apartments over ground-floor commercial spaces, the *conseil* complained that "it would be regrettable to include shops in institutions of this kind."[106] By the time that Daly collaborated with Davioud in 1865 on a book documenting the theaters, however, he was sanguine about what he called a "good idea": "It was decided that the new theaters would be surrounded by private constructions . . . whose ground floors would be occupied by shops and whose upper floors would be divided into apartments rented to private individuals."[107] Daly cited the precedent of ground-floor cafés and stores in Théodore Charpentier's unbuilt project for a

Théâtre Lyrique but attributed to Haussmann the idea of integrating public and private building in Daviouds's theaters.[108] No mention was made of Baltard or the Bâtiments Annexes. Daly also noted the prefect's decisive role in the design of Bailly's Tribunal de Commerce.[109] Again, Baltard was ignored. After Haussmann took credit in his *Mémoires* for the conception of both projects, the claim became historical fact.[110] Overlooking Baltard and the Bâtiments Annexes, Van Zanten concludes in *Building Paris* that Daviouds and Bailly were working from a formula developed entirely, if unsuccessfully, by Haussmann: "The shapes they were given were indecisive . . . the masses inarticulate and pressed hard up against the street lines; the decoration desired was finicky."[111] If these architects were not to blame for Haussmann's urbanism, this is because they were little better than draftsmen, carrying out solutions they neither generated nor controlled.[112]

Haussmann's claim merits some skepticism. Bailly and Daviouds's final project designs were only approved in 1860, after Baltard had been named director of the architectural service and all municipal projects were reviewed by a Conseil d'architecture chaired by Baltard along with the city's four chief architects (Bailly among them). By then, these three municipal colleagues must already have discussed shared issues of design that went back five years, starting with Baltard at the Bâtiments Annexes in 1855 and continuing with both Bailly at the Tribunal de Commerce in 1857 and Daviouds at the Châtelet theaters in 1859. While the prefect certainly had his say in dictating the programs of municipal buildings, he had much less control over their design, which stayed in the hands of his architects: they composed solutions to problems he may have posed yet lacked the formal training to solve. Rather than accidental and inexpressive, the urban architecture formulated by Baltard, Bailly, and Daviouds

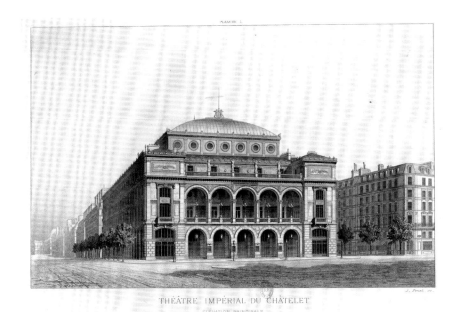

THÉÂTRE IMPÉRIAL DU CHÂTELET
ÉLÉVATION PRINCIPALE

should be recognized as their deliberate response to Haussmann's planning edicts.

As François Loyer has shown, the mixed-use apartment building is the typological key to nineteenth-century Paris.[113] Characterized by its transposition of monumental onto vernacular types of architecture, this type originated in the 1840s and came of age in the 1860s, when it defined such typical spaces of Second Empire Paris as the Place de l'Opéra. Ignoring distinctions of functional zoning and social categories alike, the monumentalized apartment building was consistent with Haussmann's planning emphasis on "embellishing public space" through a pragmatic adaptation of existing urban forms and types to the exigencies of "concrete situations."[114] The conflation of the monumental and public with the private and residential posed, however, a challenge to architects as they wrestled with the inversion of traditional urban hierarchies and the consequent disruptions of architectural scale. Shortly after Baltard began work on the Bâtiments Annexes, Daviouds addressed this problem at the Place

FIGURE 51
Gabriel Daviouds, Théâtre Impérial du Châtelet, Paris, 1859–62. Perspective view, from Gabriel Daviouds and César Daly, *Les théâtres de la place du Châtelet* [1865]. Photo: Bibliothèque nationale de France.

FIGURE 52
Gabriel Davioud, Place Saint-Michel, Paris, 1856–60. Façade elevations and sections, from M.-L. Taxil, *Ville de Paris: Recueil des actes administratifs* (1905). Bibliothèque historique de la ville de Paris.

Saint-Michel (1856–60). To shape an awkward intersection of streets into a symmetrical square facing the Seine, neatly deflecting the Boulevard de Sébastopol on axis across the Ile de la Cité toward the Boulevard Saint-Michel, Davioud integrated a monumental fountain into an armature of apartment buildings (fig. 52). According to Loyer, "This extraordinary collage is enriched even more by the reintroduction of classical proportions and the traditional writing of the orders: to the pure volumes of the imperial Neoclassicism of Percier and Fontaine['s Rue de Rivoli], Davioud applies the monumental pilasters, channeled masonry bases, and abundant window frames of the Louis XIV façades on the Place Vendôme."[115] Loyer notes how the Place Saint-Michel façades anticipated Davioud's subsequent Place du Châtelet project, where two theaters framed by apartment buildings organize a similarly scaleless

void into a coherent space, though he (like Van Zanten) ignores the precedent to both works in Baltard's Bâtiments Annexes.

The fact that Baltard's buildings were the first municipal structures to mix the monumental public and the private residential types in a calculated urban collage has been obscured by the judgment, originating with the criticisms of Daly and Haussmann, that the Bâtiments Annexes failed as works of architecture. This conclusion misses the larger historical point. The perfected congruence between monument and apartment building that would be realized in the 1860s at the Place de l'Opéra depended on experiments dating to the 1850s, including Baltard's initial contribution to the type. Because these experiments, as experiments, necessarily broke with well-tested paradigms, evaluations of their relative success or failure are subjective: what Loyer calls an "extraordinary collage" of the monumental and the vernacular at the Place Saint-Michel, Van Zanten complains is "indecisive monumentally."[116] If Baltard and Davioud proposed differing decorative treatments, particularly in the contrast between the low relief of the Bâtiments Annexes and the ponderated façades on the Place Saint-Michel, this was because both architects, like Bailly at the Tribunal de Commerce, were working on a new problem without a predetermined or even an immediately apparent solution.

As quickly as Haussmann worked to erase the city's urban density and history with his surgical new streets, Baltard and his colleagues reinscribed that history onto Paris by admitting into their architecture the play of public and private, political and commercial, institutional and residential interests that had shaped the city since the sixteenth century. These architects recognized how the representational significance of the city's public spaces and monuments had been eroded, historically, by its urban undertow of commercial

and residential use. Faced with the loss both of the Renaissance belief in emblematic forms and of the iconographic conventions that had maintained for architecture a coherent image in prerevolutionary France, they had no choice but to treat the inherited forms in radically modern and pragmatic ways. As the Conseil des bâtiments civils suspected, the municipal structures designed by Baltard, Bailly, and Davioud were indeed illegible in the traditional terms. Yet their hybrid compositions, at once experimental and flexible in their accommodation to the modern city, made those buildings paradoxically expressive of the new urban realities affecting Paris and its architecture.

POSTSCRIPT ON THE HÔTEL DE VILLE

Though he had retired from municipal service in September 1870, the competition for a new Hôtel de Ville, announced by Prefect Léon Say on 23 July 1872, presented Baltard with one last chance to design a monument for the city.[117] The Hôtel de Ville had burned to the ground on 24 May 1871, in the last days of the Paris Commune, and its rebuilding signaled a rededication to middle-class values and social order under the Third Republic, after the successive disruptions of the Second Empire and Commune. To represent this figurative return to an idealized age of bourgeois self-government, to a time when the *prévôt des marchands* still spoke with authority before the seventeenth-century absolutism of Henri IV and Louis XIV and (more to the point) its nineteenth-century reinvention by Napoléon I and III, the program stipulated a Renaissance style for the new building. In what may be emblematic of the program's contradictions, the surviving façades of Domenico da Cortona's original building (with Godde and Lesueur's additions) were to be replaced with replicas rather than restored.[118]

Reticent as always in his public comments, Baltard kept silent on the Commune's traumatic upheaval—though family stories did record his distress at the damage inflicted to his villa at Sceaux by the eighty Bavarian soldiers who were bivouacked there during the preceding Siege of Paris.[119] The destruction of the Hôtel de Ville—on which he had worked for sixteen years, which had housed his own office since 1860, and whose incineration extended to the Bâtiments Annexes—must have affected him as well, since the material evidence and documentary record of his municipal career had gone up in flames. Charles Garnier claimed that Baltard entered the competition "to fulfill a duty": "He had long been architect of the Hôtel de Ville, he knew everything needed for the composition of such a monument, and he would have thought it a failure had he not put forward his ideas, not so much in the hope of victory as in the hope of seeing them used in part by the winner of the competition."[120] After Théodore Ballu was declared the winner, Baltard observed diplomatically that Ballu "will know how to make of the new Hôtel de Ville a work that will answer to the grand memories of the past, to the anxious expectation of the present, and to the thoughtful admiration of the future."[121]

Baltard's project, detailed on thirteen sheets of rendered plans, sections, and elevations (fig. 53), was scrupulously obedient to the program: he kept to the footprint of the ruined structure, re-creating Cortona's original building even as he discreetly juxtaposed the flanking new wings to the Renaissance central block through varied rhythms of fenestration and a typically flattened scheme of decoration.[122] The Cour Louis XIV, stripped of the stairs and iron roof he had added in 1855, was restored to its historic form, while the Salle des Fêtes was again reached directly by straight flights of stairs from the Rue Lobau, at the rear. Recognizing that Haussmann's imperial theatrics were unsuited to the polemics of a republican present, Baltard systematically subordinated

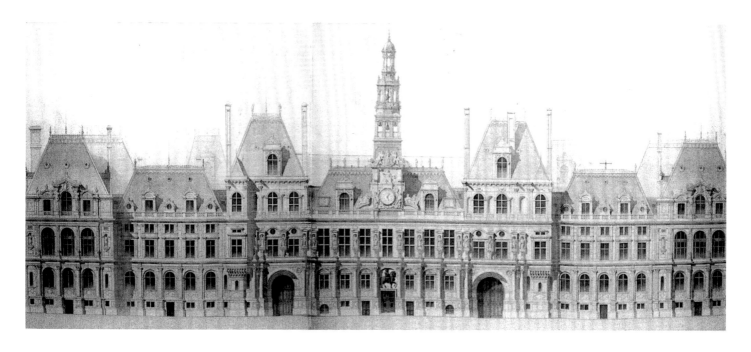

FIGURE 53
Victor Baltard, competition project for the Hôtel de Ville, Paris, 1872–73. Façade elevation. Private collection of the Baltard family.

the prefecture's ceremonial spaces to its bureaucratic services. The press reported favorably on his project, and it was supported on the competition jury by Garnier, who joined the press in praising its adherence to the program.[123] A subcommittee of the thirty-one-member jury under Say (composed equitably of ten architects selected by the contestants, ten officials from the prefecture and allied artistic institutions, and ten members of the Conseil municipal) cut the submissions to thirty-six, and the jury (divided into three mixed groups) then progressively reduced the pool to twenty and then eight submissions through a process of negative voting: in the final round, Baltard got fifteen votes against his project, whereas the winning project, by Théodore Ballu and Édouard Deperthes, received none.[124] Baltard's respectable eighth-place finish earned him an indemnity of 2,500 francs but ranked him well behind the six premiated finalists.

Despite his elimination, the contest was effectively between municipal employees: Ballu, placing first, was former architect of the fourth section

(1860–71) and was now head of the first inspection; Gabriel Davioud, placing third, was the architect of the Châtelet theaters and now headed the second inspection; Émile Vaudremer, placing fourth, had been a district architect since 1860 and was the architect of Saint-Pierre de Montrouge; and Auguste-Joseph Magne, placing fifth, was the architect of the Théâtre de Vaudeville (1867–69) and now headed the third inspection.[125] In the top five, only Jean-Eugène Rouyer, placing second, had no prior municipal experience, though he had studied with Victor Baltard in the 1840s and would build the Mairie du Xe Arrondissement in 1893–96.[126] (The team of Constant Moyaux and Charles Lafforgue came in sixth, and Baltard's former assistant Félix Roguet won seventh place in partnership with Achille Menjot.) These architects all knew how to package the prefecture's complex needs within a coherent Renaissance dress that signified the restoration of bourgeois order. Most contestants kept their designs to the existing foundations, although Ballu and Deperthes (fig. 54), like Magne, broke with the

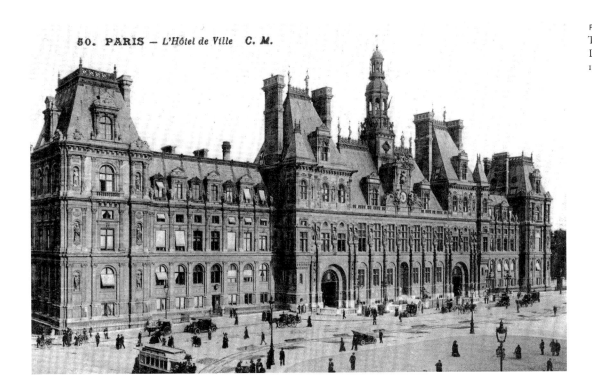

50. PARIS — *L'Hôtel de Ville* C. M.

FIGURE 54
Théodore Ballu and Édouard
Deperthes, Hôtel de Ville, Paris,
1872–82. Contemporary postcard.

alignment of the main elevation by recessing the side wings of their projects: this at once framed the "original" structure and distanced the new city hall from any direct correlation with the planar façade of Godde and Lesueur's building.

Precisely because the Third Republic was socially and economically continuous with the Second Empire, the competition program tried to divorce the new city hall from recent events through an appeal to a more distant past of mythologized Renaissance origins. This political, rather than architectural, brief suggests why Baltard never had a chance at winning, regardless of the merits of his project. Architect of the Hôtel de Ville and director of its architectural service under Haussmann, Baltard was intimately connected with the Second Empire and was therefore

disqualified a priori from the revisionist task of representing the city's restoration of republican virtue. Ballu, like the other premiated finalists and despite his own municipal career, did not bear this onus of appearances. Having spent his career serving political bosses, Baltard understood this fact even if he thought it irrelevant. His project for the Hôtel de Ville offered what he had always provided as a municipal architect, most notably in his design of the Bâtiments Annexes: an ability to package diverse functions within a recognizable type of civic architecture whose forms and details spoke to the city's ongoing historical development from the sixteenth century to the present. Baltard's work was informed by this history even if his architecture relied indeterminately for its meaning on the passing circumstances of its use.

Decorated Construction

CHAPTER 4

In the very decades when new productive methods and materials of the Industrial Revolution called into question architecture's identity as the ancient art of stonecutting, the Neoclassical unity of constructed decoration split into a Romantic dialectic of decorated construction, sundering the traditional coherence of structure and ornament realized in the classical orders into a modern duality of building and architecture. The rupture is apparent in the difference between Pierre Baltard's Palais de Justice (1828–46), whose integrated Corinthian order and details suppose a naturally inherent logic of proportioned forms, and Labrouste's Sainte-Geneviève Library (1838–50), whose decoration reads as an interpretative gloss applied to the separate material facts of the building's stone-and-iron construction. As Neil Levine has explained, the library's boxy form and arched stone shell (see fig. 8), stripped of columns yet inscribed with decoration, defined a new idea of architectural legibility, one that replaced ideals of classical homogeneity with facts of structural differentiation and reconstituted meaning through the "discursive application" of ornament to structure.[1] Victor Baltard explored this discursive practice in his own work, looking beyond antiquity to consider the Middle Ages and especially the Renaissance in his search for a system of detailing that could at once mediate classical and medieval traditions, reconcile those traditions with the new conditions and technologies of modernity, and

bridge the gap opened up in Romantic theory between construction and decoration. But where Labrouste made ornament answer to the facts of building in his architecture, Baltard concluded that ornament's fatal separation from structure meant that construction alone was no longer a sufficient pretext for decoration, even when applied discursively. Guided by his experience as a municipal architect, Baltard looked increasingly to the city and its history of urban development to justify and inform his use of ornament.

As has already been noted with respect to the Bâtiments Annexes, Baltard's solution could subject his architecture to an unhappy combination of criticism and dismissal for its characteristic flatness of effect, combining low relief with understated, if tightly delineated, details that sit uneasily on the surface. If, however, his ornament is hard to appreciate, its consistency speaks to the seriousness of purpose that Charles Garnier recognized in all of Baltard's work when he wrote that "implacable logic led him sometimes to formulate artistic expressions that sentiment alone would have abandoned."[2] His search for an effective language of ornament was persistent and can be traced through a series of programmatically varied, if critically related, projects from the 1840s through the 1850s: his premiated project in the 1841 competition for Napoléon's Tomb, along with his more modest funerary commissions; a police station on the Boulevard de Bonne Nouvelle and

his completion of the Hôtel du Timbre, begun by Paul Lelong; and his decoration, restoration, and alteration of the parish churches of Paris in his overlapping positions as inspector of fine arts and architect of the first section of municipal buildings. Baltard found what he was looking for at the medieval church of Saint-Leu-Saint-Gilles. Radically truncated to make way for the Boulevard de Sébastopol, the reconfigured church was finished with a scrim of Neo-Renaissance decoration that spoke at once to the historic conflation in Paris of public monument and private house and to the city's urban transformation in the nineteenth century.

In 1857, while he was at work on Saint-Leu-Saint-Gilles, Baltard built a villa for himself in the suburb of Sceaux, some ten kilometers south of Paris (fig. 55).[3] The Villa Baltard stands at the site's southwest corner, backed against the Rue Bertron and overlooking a picturesque garden that slopes down a hill toward the distant city. Its two-story cubical mass—originally faced with stucco and still ornamented with architectural fragments, bracketed eaves, hipped tile roof, and terra-cotta belvedere—evokes the castellated farmhouses that Baltard had seen in the Roman countryside some twenty years earlier (fig. 56). Inside, facing the garden through a pergola on the villa's north side, the adjacent dining room and salon were decorated by Ingres's students. Charles Timbal frescoed the dining room, its walls formerly a rich Pompeian red, with six vignettes of putti bearing Latin exhortations: "AGE QUOD AGIS" (Do what you will); "VIRES ACQUIRIT EUNDO" (He gets stronger as he goes). In the salon, with its Louis XVI wainscoting and furniture, Jean-Louis Bézard painted four panels depicting the villas of Rome, including the Villa Medici, and Jean Brémond sketched allegories of music and architecture over the two main doors. Canvases by Paul Flandrin, Hippolyte Flandrin, and Alexandre Desgoffes

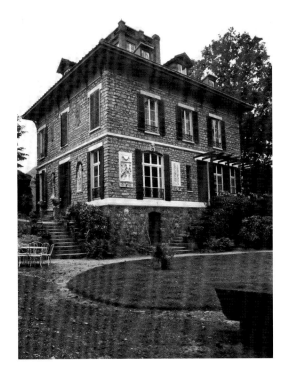

FIGURE 55
Victor Baltard, Villa Baltard, Sceaux, 1857. View from the garden.

FIGURE 56
Victor Baltard, sketch of an Italian farmhouse, 1834–38. Private collection of the Baltard family.

hung on the walls, as did Ingres's pencil portraits of Victor and Adèle. Here, in the evening, Ambroise Thomas might play the piano, after a dinner served on blue Sèvres china with a set of silverware given by Ingres to Baltard in gratitude for his help on *Antiochus and Stratonice*. Figuratively, the trip by train from the Baltard apartment

at 4 Rue de l'Abbaye in Paris to the suburban villa in Sceaux became an escape, in time as well as space, to a place that recovered past Sundays at the Villa Medici.[4]

Piled up in niches and stuck on the walls, the decoration of the Villa Baltard alludes to the Villa Medici, whose garden façade (see fig. 17) was covered with a profusion of sculptural reliefs arranged in imitation of Roman monuments like the Arch of Constantine. But what aims at the Villa Medici to be an integrated composition has become at the Villa Baltard a visibly ad hoc collage of ornamental spolia. Just as Ingres had installed a gallery of architectural fragments and casts at the Villa Medici, or Félix Duban had organized the fragmentary remains of Lenoir's Musée des Monuments Français into a scenographic history of French architecture at the École des Beaux-Arts (1833–40), so Baltard treated his villa as a museum, though now a private one, finishing it inside and out with ornamental details and works of art acquired from disparate sources. If, as Baltard wrote in reviewing an exhibit of Duban's drawings after his death, architecture was an art of human invention rather than an art of imitating nature like the other visual arts, this was because it was fundamentally a product of history: every work of architecture began with a creative reinterpretation of the past to serve present interests and needs.[5] At the Villa Baltard, the architect recast ornament as autobiographical souvenirs of Rome, indulging a private investigation of decoration's temporal dimension and allowing him greater license for experimentation than was permissible in his public commissions. In using his villa to reveal the effort required to invest architecture with a present relevance that was always slipping into the past, assembling a formal language from bits and pieces of decoration that could no longer claim any inherent ground in a building's construction, Baltard identified what he saw as the fundamental

challenge facing architecture in the nineteenth century. In an age when the norms of classicism (natural, constant, universal) had given way to the vicissitudes of historicism (social, changing, local), it was no longer possible to posit a language of architecture in any other terms than the contingent ones confessed to at the Villa Baltard.

REPRESENTING MODERNITY IN NAPOLÉON'S AND OTHER TOMBS

When Baltard returned from Rome to Paris in December 1838, he was thrown from the idyll of his academic studies into the mundane urgency of getting a job. A decade of uncertainty lay ahead as he dealt with the frustrations, familiar to any young professional, that came from the gap between big dreams for the future and modest prospects in the present. The competition for Napoléon's Tomb nearly gave him the break he needed, though hope turned to disappointment when the premiated finalist of 1841 was pushed aside the next year for the more experienced Louis Visconti. Charles Garnier, whose better fortune in the 1861 competition for the Opéra vaulted an equally junior architect to sudden prominence, would suggest reasonably that a "competition reserves its benefits for the young above all," since, not yet having a reputation to lose, those "contestants risk little except lost time."[6] Baltard, however, felt he had lost more than time, and sold his gold medal in 1842 to dramatize his impoverished state.[7] Still, the challenge of commemorating in architecture the defining political figure of modern France had its own value. In trying to house the radically modern subject of Napoléon within the conventionally symbolic object of a tomb, the competition brought the contestants face to face with the fatal slippage in modernity between architectural form and cultural content.

First told by César Daly, the competition's tangled history has since been meticulously

reconstructed by Michael Driskel.[8] Daly described nineteen projects, supplementing his descriptions with statements provided by the contestants, but illustrated only three: by Félix Duban, Henri Labrouste, and the sculptor Louis Auvray. This has forced subsequent historians, including Driskel, to consider Visconti's executed design without knowing what the leading counterprojects by Louis Duc and, most pertinently, Victor Baltard actually looked like. The discovery of Baltard's project in a private collection restores a crucial piece of evidence to the competition.[9] Compositionally less original than one might imagine, this project suggests that Baltard got as far as he did, despite his supposed inexperience, because he was just as shrewd as Visconti at mobilizing his allies while having a good grasp of the issues in play.

Politically, the tomb marked an attempt by the July Monarchy of Louis Phillipe, led by his prime minister Adolphe Thiers (March to October 1840), to absorb the Napoleonic myth and with it the support of Bonapartists into the *juste milieu* synthesis of a constitutional monarchy. Announced on 12 May 1840, when Charles de Rémusat, minister of the interior, requested funding from the Chamber of Deputies, the project was approved by the law of 10 June 1840 mandating both the return of the emperor's ashes to France from Saint Helena and the creation of a tomb within the Dome of the Invalides in Paris. On 15 December the funeral cortege reached the Invalides, in an elaborate ceremony with decorations designed by Louis Visconti with the assistance of Henri Labrouste. The decision to entomb Napoléon I in the Invalides—a site that at once seemed peripheral to Paris and was less explicitly identified with Bonapartism than locations like the Place Vendôme (with its Napoleonic column)—inaugurated an ongoing controversy that Alphonse de Lamartine summarized in a speech to the Chamber of Deputies on 26 May 1840. Before the

project had received official approval, Thiers commissioned on his own initiative the transplanted Italian sculptor Charles Marochetti to produce a monumental equestrian statue of Napoléon I for the Invalides courtyard. Then, in June, Rémusat named Félix Duban architect of the tomb: Duban sketched a saucer-shaped tumulus representing the globe and surmounted by a sarcophagus, only to resign in July in the midst of an ongoing struggle with Marochetti for control of the project. Opposition mounted against the decision to grant such an important national commission to a foreigner, especially after a full-scale wood-and-canvas maquette of Marochetti's original design for the Invalides courtyard was unveiled in July to unanimous ridicule from the press. By the fall of 1840, calls were being made for a public competition to decide the matter. On 13 April of the following year the new minister of the interior, Tanneguy Duchâtel, finally presented to the Chamber of Deputies a bill authorizing such a contest, which passed into law on 25 June 1841.

Anticipating the Opéra competition in its collision of political agendas with aesthetic choices, the competition for Napoléon's Tomb ostensibly accepted the need to consult public opinion when selecting for the state something as subjective as a work of art.[10] The state, however, was ambivalent about a competition that might escape its control: Hygin-Auguste Cavé, director of fine arts, asserted, "It is not a competition that we want; it is an open consultation that we are asking for from artists!"[11] When announced by Duchâtel in the *Moniteur universel* on 17 June 1841, with a submission deadline of 1 September, the competition was published without any stated criteria, program, or jury. In order to admit late submissions, the deadline was pushed back in phases to 15 October, nine days before the scheduled exhibition of projects at the École des Beaux-Arts, and the twelve-member selection committee was not named until after the

exhibition's end, on 23 November. The committee, in keeping with the government's *juste milieu* policies, was at least equitably balanced between officials like Rémusat, Cavé, and Ludovic Vitet; critics like Louis Peisse and Théophile Gautier; and artists like the architect Pierre Fontaine, the painter Ingres, and the sculptor David d'Angers. This jury successively cut submissions from 81 to 23 to 10: in the final scrutiny, Victor Baltard and Louis Visconti tied at twelve votes each, followed closely by Louis Duc with eleven, Félix Duban with ten, and Henri Labrouste with nine. Instead of naming a winner, however, the committee deferred the matter back to Duchâtel along with a recommendation for a simple binary program whose terms favored Visconti: "An open crypt on the interior, an equestrian statue on the exterior."[12] In March 1842, the minister charged Visconti with the design of Napoléon's Tomb in the Dome of the Invalides.

The selection of Visconti confirmed the suspicions of many that the contest had been rigged from the start. Daly accused Visconti of benefiting both from the extended submission deadline and from inside information leaked by Cavé; he further insinuated that Visconti was a functionary who was better versed in the ephemera of street decorations than in the conception of lasting monuments.[13] Visconti certainly was well connected through his municipal and state positions, and he probably seemed to Duchâtel like just the sort of official on whom the state could rely to realize the politically sensitive project of Napoléon's Tomb.[14] Yet the implication that Visconti and Baltard brought critically opposed visions of architecture to their projects ignores the professional proximity of these two finalists.[15] Baltard had served under Visconti for the 1840 Fête de Juillet and worked alongside him in the prefecture, where Visconti, as architect of municipal ceremonies, and Baltard, as inspector of fine

arts, both answered to the second bureau of the General Secretariat. And Baltard was at least as much the insider as Visconti when it came to a competition committee that included such family friends and mentors as Ingres and Fontaine, who presumably played an instrumental role in ranking Baltard alongside Visconti and ahead of Duc, Duban, and Labrouste.[16]

Appropriating the Dome of the Invalides to its new purpose of housing a dictator's tomb, the competition asked that the Baroque, Catholic, and royalist space of Jules Hardouin-Mansart's church be reconciled with the classicizing, secular, and politically modern subject of Napoléon I. Daly distinguished two solutions to this formal and symbolic incongruity: tombs placed above ground directly beneath the dome, as in Duban's monumental sarcophagus of white marble (fig. 57) or Duc's still-missing design for a raised porphyry sarcophagus; and tombs placed below ground in a crypt, as in the projects by Labrouste (fig. 57), Visconti (fig. 58), and Baltard (figs. 59–61).[17] If submerged crypts tempered the iconographic discontinuity between church and tomb, their removal from the church presented the opposite problem of invisibility. Labrouste, Visconti, and Baltard each solved this problem in slightly different ways: Labrouste shrouded the sarcophagus beneath a great bronze shield raised by eagles at the corners just enough to allow glimpses into the shadowed crypt below; Visconti opened the sunken circular crypt with its sarcophagus (initially granite, later porphyry) to the church above; Baltard enclosed his red granite sarcophagus within a domical crypt decorated with mosaics representing the cities of France, a crypt that swelled upward through the floor above into a stepped cenotaph bearing a recumbent effigy of Napoléon in gilded bronze. This crypt was reached by a long subterranean corridor run beneath the church of Saint-Louis out to the

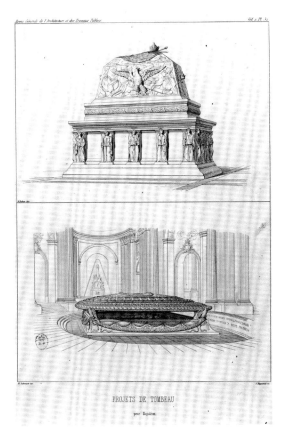

PROJETS DE TOMBEAU
pour Napoléon.

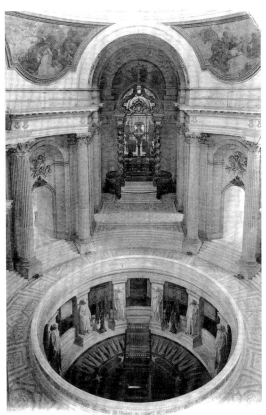

264. PARIS — Les Invalides - Tombeau de Napoléon Ier

FIGURE 57
Félix Duban and Henri Labrouste, competition projects for Napoléon's Tomb, Paris, 1840. Perspectives, from *Revue générale de l'architecture* (1841).

FIGURE 58
Louis Visconti, Napoléon's Tomb, Dôme des Invalides, Paris, 1840–53. Contemporary postcard.

FIGURE 59
Victor Baltard, competition project for Napoléon's Tomb, Paris, 1840. Plan detail of upper and lower levels. Private collection of the Baltard family.

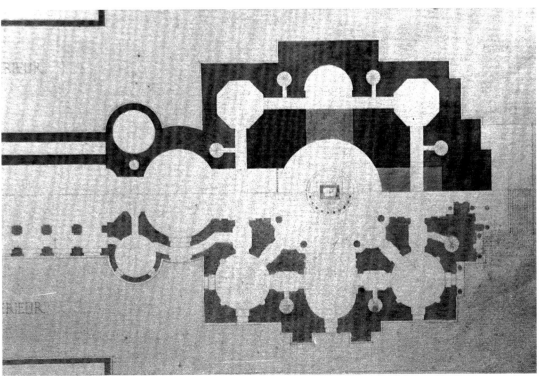

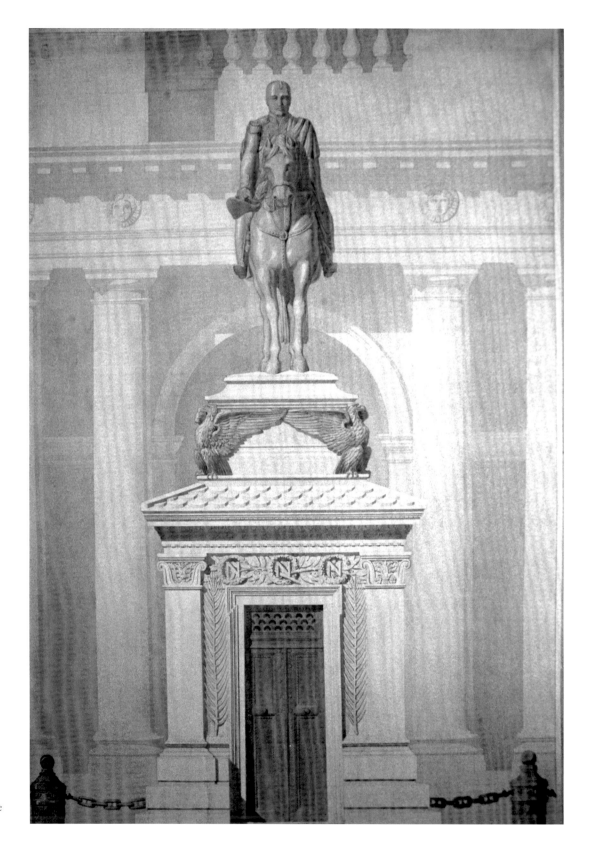

FIGURE 60
Victor Baltard, competition
project for Napoléon's Tomb,
Paris, 1840. Elevation of the
equestrian monument and tomb
entrance. Private collection of the
Baltard family.

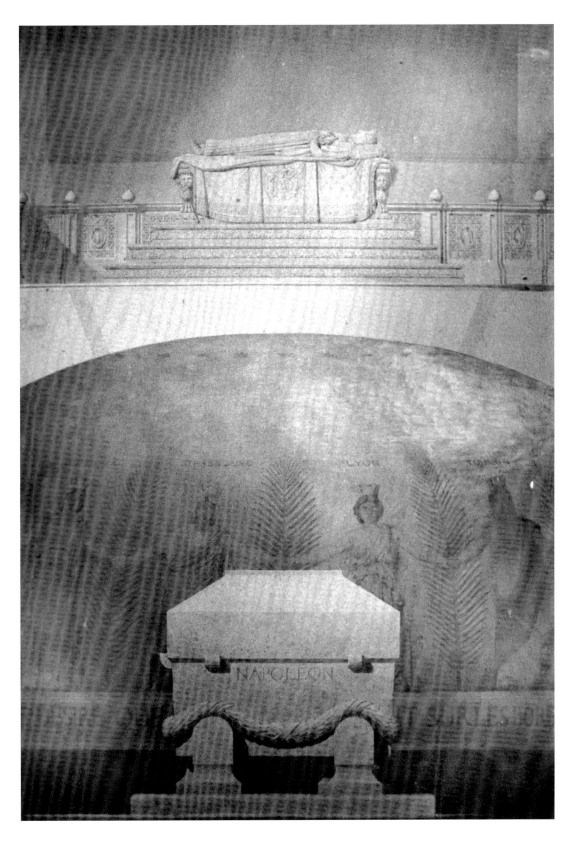

FIGURE 61
Victor Baltard, competition
project for Napoléon's Tomb,
Paris, 1840. Section and elevation
of the tomb and effigy. Private
collection of the Baltard family.

Invalides courtyard, where it was entered through bronze doors in the base of an equestrian statue to Napoléon.

The same idea found its way into Visconti's project, where an identical passage led from the crypt out to Marochetti's statue. Because Baltard completed his project by the original deadline, it has generally been assumed that Visconti cribbed this idea for his late submission, perhaps on the advice of Cavé. If so, Baltard was not in the end disadvantaged by the supposed plagiarism, since the committee ignored the passageway in his project while specifically criticizing its inclusion by Visconti: "his subterranean corridor . . . has the disadvantage of turning a funerary monument into a necropolis."[18] This corridor, along with Marochetti's statue, disappeared from Visconti's executed design, where the crypt is reached directly by stairs inside the dome. Here again Baltard may have anticipated Visconti with an alternate version of his project that likewise eliminates the corridor in favor of stairs descending directly to the crypt, a version perhaps executed after the competition in response to the committee's criticism. In a letter to an unidentified member of the committee, Baltard implied that he as much as Visconti was privy to inside information: because he expected the committee's conclusion that "none of the exhibited projects are susceptible of immediate execution," Baltard assumed that the winning project would need revision, and he advised protecting its author against the inevitable accusations of plagiarism; it would, he said, "be a good idea to distinguish a certain number of projects that one might think of using, indemnifying the authors . . . [and] acquiring at the same time the right to put their ideas at the disposition of the artists who will be charged with the monument."[19] In other words, questions of who cribbed from whom were finally beside the point in a project that called for synthesis as much as invention.

Daly concluded his review by criticizing a tendency in the competition projects to treat monuments as inscribed tablets, reducing architecture's expressively plastic poetry to a descriptive form of literature.[20] This criticism might allude to Labrouste's contemporary design for the Sainte-Geneviève Library, which was then working its way through a protracted process of approval between 1839 and the start of construction in 1843. As Neil Levine explains, Labrouste's conception of the library as a book answered Victor Hugo's claim in *Notre-Dame de Paris* (1832) that literature, by means of the printing press, had supplanted architecture as culture's principal medium of expression: the inscribed names running in columns of text across the library's upper façade suggested that the textualization of building was architecture's fate in modernity.[21] In an age when words seemed to have preeminence over things, Baltard's perceptive critique of his project for Napléon's tomb admitted the obstacles to creating a monument where meaning might again be embedded in material form, instead of being a merely literary gloss of applied decoration:

> I swear that it was not without recognizing the drawbacks that I resorted to allegory; reflecting on it, I believe I would now prefer a gold ground [in the crypt], ornamented solely with laurel wreaths and palm fronds arranged with ordered symmetry. Finally, in the church, I would have wanted to put nothing except the name of Napoléon in bronze letters, encrusted into the marble over the sepulchre. But I fear that this simplicity might have been insufficient for those coming from all over to visit the tomb of the emperor. . . . Thus, for the gilded bronze cenotaph that I placed in the church, I had only the pretension of tracing, hieroglyphically so to speak, but nonetheless with magnificence, the great name of the emperor.[22]

These regrets acknowledged the committee's judgment that the upper part of his project was "not as satisfying" as its crypt, and echoed the evaluations of other schemes, like the criticism of Félix Duban's ornamentally busy tomb for lacking "the austere and monumental aspect suited to the emperor's sepulchre."[23] Baltard's project is in fact as anxiously overscripted as Duban's, even if he did figure the sarcophagus as two minimally adorned blocks of granite, presenting a literally lithic and metaphorically solid image of Napoléon I's political heritage that is conveyed as well in Visconti's executed design.

If, as Garnier claimed, Baltard was not "one of those subversive dreamers who think that architecture has as its purpose making stones speak," he was like the other leading contestants in being acutely aware of the silence that threatened architecture in modernity.[24] The difficulty they faced was that the symbols and conventions of commemoration called upon were clearly inadequate, if not irrelevant, to the task of representing Napoléon I. Attempts to get around the problem by inscribing the tomb with explanatory texts and images only exacerbated the loss of meaning. Visconti succeeded where Baltard failed, not because he cheated or had better connections or even because his project was more coherent, but because its voided space came closest to solving the fundamental problem of representation. Eloquent precisely because it is mute, Visconti's design, by leaving it to each passing spectator to provide, individually and indeterminately, the tomb's absent meaning, answered the July Monarchy's ambiguous purpose in commissioning the project in the first place.

The more modest tombs and funeral monuments designed by Baltard after 1841 mirror these ambiguities. The tombs fall into three groups: nearly identical copies of the third-century B.C.E. Roman sarcophagus of Scipio Barbatus, with its

FIGURE 62
Victor Baltard, tombs of Victor Cousin (right) and of Jules Barthélemy Saint-Hilaire (left), Père Lachaise Cemetery, Paris, 1848 and 1895.

FIGURE 63
Victor Baltard, competition project for the monument to Monseigneur Affre, 1848. Plaster maquette.

characteristic Doric frieze and lid raised in volute scrolls at each end, as seen in the tomb of Victor Cousin (fig. 62); aediculae in both classicizing and medievalizing variants, as seen in the competition project for the tomb of Monseigneur Affre (fig. 63); and stelae, usually with a portrait bust of the deceased and extended horizontally at the base by a gabled sarcophagus lid, as seen in the

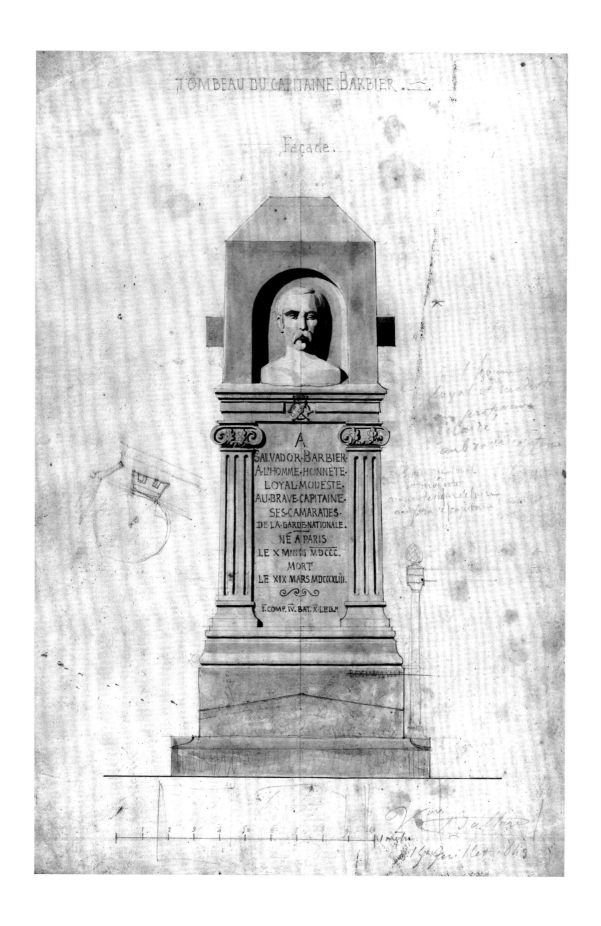

TOMBEAU DU CAPITAINE BARBIER.

Façade.

A.
SALVADOR·BARBIER·
A·L'HOMME·HONNÊTE·
LOYAL·MODESTE·
AU·BRAVE·CAPITAINE·
SES·CAMARADES·
DE·LA·GARDE·NATIONALE·
NÉ A PARIS
LE X M... M·DCCC·
MORT
LE XIX MARS M·DCCC·XLIII.

I·COMP·IV·BAT·X·LEG·N·

tombs of National Guard Captain Salvador Barbier (fig. 64) and of Ingres (fig. 65).[25] Collectively, these tombs reflect a century of change in the perception of death in modern France. Richard Etlin explains in *The Architecture of Death* that the medieval custom of burying the dead in and around parish churches was displaced between 1744 and 1804 by reforms that revived the ancient practice of interring the deceased in cemeteries located outside the city.[26] Adopting new ideas of health and sanitation, along with a decisive shift from a spiritually transcendent Christian view of death to pantheistic celebrations of nature and natural law, modern cemeteries like Père Lachaise on the edge of Paris were conceived as picturesque fields of Elysium. The practical and ideological rethinking of death embodied in these cemeteries paralleled a democratic emphasis upon the personal merits and individual accomplishments of the deceased.

Quatremère de Quincy was closely involved in the development of Père Lachaise Cemetery, planned by Alexandre Brongniart in 1803–4, and he codified the architectural consequences of the reform in burial practices in his entries for the *Encyclopédie méthodique* on cemeteries, sepulchres, and tombs.[27] Looking to antiquity for his models, especially to sites like the Via Appia outside Rome, Quatremère distinguished private tombs from those of important public figures, which should "in a sense be temples, from which their enlightened shadows still look out for the country's welfare."[28] He divided those public monuments into two types: large sarcophagi elevated on high platforms, and templelike "square structures ornamented with sculptural reliefs on each side and, raised above on a pedestal, a statue of the person buried in the sepulchral chamber of the base."[29] The classifications provided Baltard with a point of departure, despite the mutation of Quatremère's two types of tomb

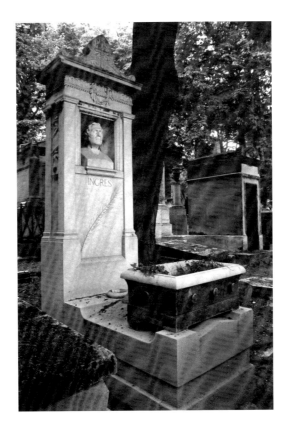

FIGURE 64 (*opposite*)
Victor Baltard, project for the tomb of Salvador Barbier, Montparnasse Cemetery, Paris, 1843. Elevation. Document held at the Centre historique des Archives nationales de France, Paris.

FIGURE 65
Victor Baltard, tomb of J.-A.-D. Ingres, bust by Jean-Marie Bonnassieux, Père Lachaise Cemetery, Paris, 1867.

into at least three. The copies of the sarcophagus of Scipio Barbatus belong to Quatremère's first type. Derived in turn from antique altars, these tombs specified a pantheistic and humanistic message that was suited to subjects like Victor Cousin, whose philosophy of Eclecticism helped popularize a similarly secularized spirituality in midcentury France.[30] The aediculae tombs relate to Quatremère's second type, although here the typologies start to unravel: the monument to Monseigneur Affre, intended for Notre-Dame and modeled after cenotaphs in the royal abbey church of Saint-Denis, is set apart from the classical forms that Quatremère had in mind, both in its mixture of medieval and Renaissance idioms and in its recumbent, rather than standing, figure.[31] The third group, of stelae, further deformed Quatremère's taxonomy by condensing the freestanding aedicular structure into emblematic

column piers attached in antis to a stone slab. An archaizing form of gravestone that harks back to ancient Greece, the stela had been revived by Léon Vaudoyer in his monument to Nicolas Poussin (1828) in the church of San Lorenzo in Lucina in Rome and constituted a Romantic alternative to Quatremère's Neoclassical models.[32] Combining stela, aedicula, and sarcophagus while appropriating such additional motifs as the obelisks and Roman household shrines alluded to in Barbier's tomb, Baltard individuated the tombs of Barbier and Ingres, freely manipulating and recombining elements from a common set of sources.

The typological slippage undid the very distinctions codified by Quatremère de Quincy in response to the eighteenth-century reform of cemeteries and funeral practices. Socially and economically, the stelae stood for the ongoing democratization of death in an age when every member of the middle class laid claim to a career worthy of commemoration, whether as a doctor, artist, National Guard captain, or leader of the country. Transgressing Quatremère's restriction of funeral "temples" to a national elite, Baltard mediated and absorbed the previously exclusive types of sarcophagus and aedicula tomb, even as he collapsed private graves and public monuments into a single all-encompassing category. The dilemma of restoring meaning to conventional forms emptied of their significance by modernity, already traced in Napoléon's Tomb, ruptures these memorials into a visible dialectic of construction and decoration, producing a pictorial, rather than tectonic, logic where architecture, sculpture, and text compete for figurative space as each seeks to animate the mute stone and speak for the dead.

TWO BUILDINGS IN THE CITY

In the 1840s, Baltard was charged with building two instruments of social control in Paris: a municipal police station on the Boulevard

de Bonne Nouvelle and the government Stamp Office on the Rue de la Banque. Addressing the same complications of bureaucratic process, shifting programmatic requirements, and irregular sites that would characterize his work for the city in the 1850s, Baltard resolved these contradictions through unified schemes of decoration whose apparent coherence masked the rupture between the interior spaces and exterior forms of these buildings.

The Corps de Garde was a piece of urban infill on the renovated Boulevard de Bonne Nouvelle: already lowered and straightened by a royal ordinance of 15 May 1832, the boulevard was further leveled and paved in 1842–43, when sidewalks and sewers were added, along with stairs on the steep south side climbing the Butte de Ville-Neuve-les-Gravois.[33] The modest project was commissioned late in 1842 by the prefect of police, Gabriel Delessert, but supervised by Prefect Rambuteau, to whom Baltard reported and who approved his fees.[34] He first proposed a two-story domed octagon, perhaps for a site on the boulevard's more open north side, with wedge-shaped offices ranged around a central octagonal hall.[35] After Delessert rejected this disproportionately monumental and costly project in December 1842, the architect developed, reluctantly and only after urging from Rambuteau, an alternative scheme by April 1845 (figs. 66, 67). This second scheme was estimated at 34,059 francs, funded in the amount of 29,672 francs by municipal edict on 23 July 1846, and built for an even more modest 22,763 francs.[36] Working now with a skewed, rhomboidal plot of ground on the boulevard's south side, Baltard wedged a two-story structure into the sloping site against a rear retaining wall. Instead of symmetrical plans and elevations, he uncoupled these two parts of the building, dissembling the utilitarian spaces behind a façade whose variant elevations of engaged pilasters over an arcaded ground

FIGURE 66 (*opposite*) Victor Baltard, revised design for the Corps de Garde on the Boulevard de Bonne Nouvelle, Paris, 1845. Plan and elevation. Document held at the Centre historique des Archives nationales de France, Paris.

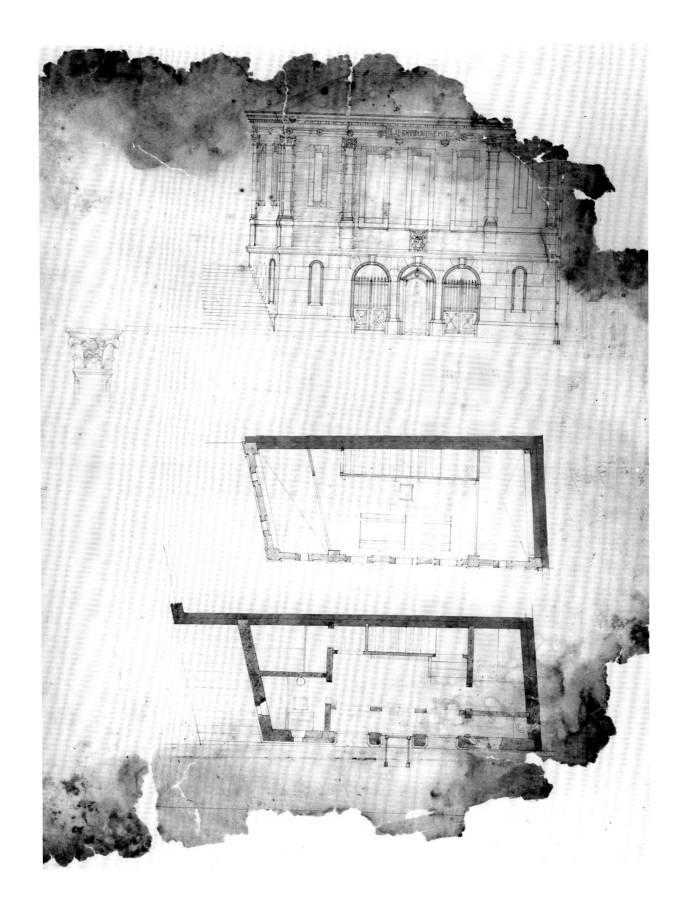

FIGURE 67
Victor Baltard, final design for the
Corps de Garde on the Boulevard
de Bonne Nouvelle, Paris, 1846.
Elevation. Document held at the
Centre historique des Archives
nationales de France, Paris.

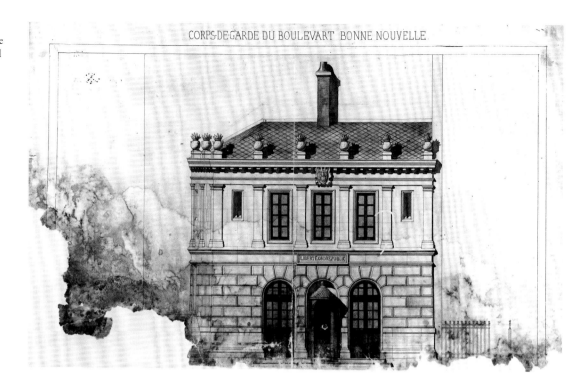

CORPS·DE·GARDE DU BOULEVART BONNE NOUVELLE.

floor (probably unexecuted, given the budget) were derived from the Hôtel de Ville. Smoothing over the internal disjunctions to present an image of architectural, and therefore social, order to the city, this police station prefigured Baltard's Bâtiments Annexes in its urban specificity and flexible accommodation to the constraints of site and program.

The Hôtel du Timbre (fig. 68) was, as a contemporary guidebook explains, an instrument of state surveillance and censorship: "The Stamp Office is open every day, from nine until four o'clock, except for holidays; the number of sheets of paper that enter this vast establishment to exit with a government stamp is incalculable. Not only bills of exchange and account books, posters, tracts, judicial acts, and stock certificates, but also political newspapers are subjected by law to the formality of being stamped, which requires [im]printing more than two hundred thousand pages every day."[37] The building's severe exterior is

consistent with this program. Stretched along the Rue de la Banque as a series of planar blocks that step forward slightly to frame a central courtyard and entrance pavilion, the building runs from outer wings opened by classically framed windows over ground-floor arched windows to uniformly arcuated façades at the center. The classical colonnade that would have fronted such a public building in the eighteenth century has been reduced to the abbreviated giant order of pilasters bracketing the corners of the four-story inner pavilions along with the central entrance pavilion; an even more schematic form of pilaster articulates the piers that organize each of the three upper floors of those pavilions into a structural grid between arched windows. The conjunction of pilasters and piers in combination with round arches is analogous to the elevation of the new wing that Léon Vaudoyer designed in 1848 for the Conservatoire des Arts et Métiers and similarly points to the detailing of the buttresses on the south side of the Renaissance

church of Saint-Eustache (see fig. 78), which Baltard was restoring in those same years. But where, as Barry Bergdoll has shown, the Conservatoire carefully diagrams the building's interior structure and spaces, the Hôtel de Timbre presents a mask to the street and reveals little of what lies behind.[38]

The curiously blank Hôtel du Timbre conceals a vexed history of programming, design, and construction. Begun by Paul Lelong in 1844 and completed by Baltard in 1852, this project introduced multiple voices into nearly every decision, in a protracted bureaucratic process that compromised the architect's authority and limited his control over the building's final form.[39] Preparations date to 1841, when the minister of finances, Humann, appointed a committee to study moving both the Stamp Office and the administratively separate Registry Office out of the quarters they had jointly occupied since 1806 in the former Couvent des Capucines on the Rue de la Paix (near the Place Vendôme).[40] Nothing happened until the next minister, Jean Lacave-Laplagne, set up a second committee in 1844, which selected a site just off the Rue des Petits Pères in the area of the former Couvent des Petits Pères.[41] Paul Lelong was named the architect by Pierre-Sylvain Dumon, who as minister of public works supervised state constructions through the Service des bâtiments civils. In November 1844, Lelong submitted his preliminary design for a building budgeted at 780,000 francs and organized programmatically around three courtyards facing onto a new street: the Stamp Office in the middle, its print shops spreading into the left wing, and the Registry Office occupying the right wing.[42] Reviewing this project on 25 and 28 November, the Conseil des bâtiments civils recommended that the side courts be given street façades, "as much to give more presence to the building" as to bring more air and light into the back of the building.[43] Lelong's revised project (figs. 69, 70), now budgeted at

990,330 francs, internalized the side courts and screened the central court behind a ground-story wall and pavilion; the elevations mixed blind arcades with Doric pilasters.[44] The *conseil* reviewed and approved this design in meetings on 3 and 6 February 1845, stipulating only that Lelong remove the blind arcade from the principal elevations.[45] Meanwhile, a royal ordinance of 8 December 1844 had extended the new Rue de la Banque from the existing Passage des Petits Pères (widened from seven to twelve meters) up to the Bourse.[46] Construction funds of 1,298,000 francs (including 240,000 francs for the acquisition of additional properties) were approved on 15 July 1845, and city contracts for clearing the site of existing structures were adjudicated on 24 September 1845. Groundbreaking took place the following spring, and Lelong immediately set

FIGURE 68
Paul Lelong and Victor Baltard, Hôtel du Timbre, Paris, 1844–52. View of the main façade.

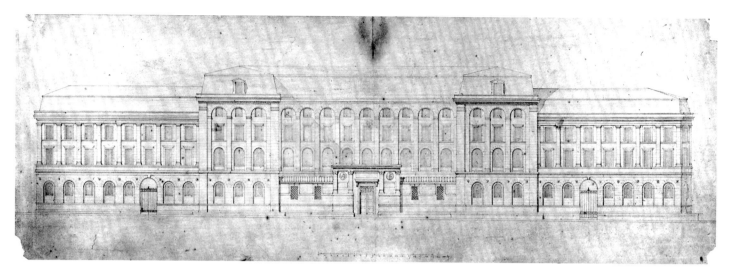

FIGURE 69
Paul Lelong, revised design for
the Hôtel du Timbre, Paris, 1845.
Elevation. Document held at the
Centre historique des Archives
nationales de France, Paris.

FIGURE 70
Paul Lelong, revised design for the
Hôtel du Timbre, Paris, 1845. Plan.
Document held at the Centre
historique des Archives nationales
de France, Paris.

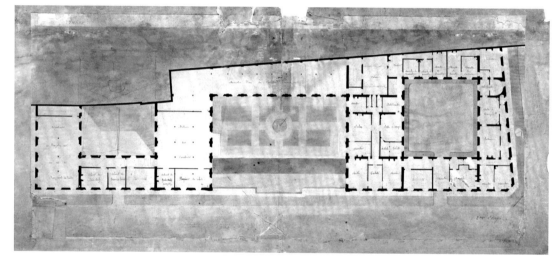

to work excavating the foundations. Problems
with the ground (including substructures from
earlier buildings) slowed the expected progress,
but the foundations for the middle section and
left workshop wing were finished by 4 September
1846.[47] Lelong died that same month, leaving his
inspector, Lemonnier de la Croix, temporarily in
charge.[48]

Baltard replaced Lelong on 14 November
1846.[49] He got the job through François Guizot,
the influential politician and minister of foreign
affairs, who reportedly was impressed by the
young architect's diligence in assisting Gisors as

an inspector at the École normale (1842–46).[50]
His promise to complete Lelong's design without
substantial changes was probably another factor,
although this promise proved impossible to keep:
the problematic foundations had already increased
construction costs by some 160,000 francs, while
the Registry Office, echoing concerns raised
previously by the Bâtiments civils, was soon
complaining that its spaces were inadequate.[51]
In January 1847, Baltard proposed slipping a
separate Hôtel de l'Enregistrement (fig. 71) into
a narrow site across the street from the Hôtel du
Timbre, between Alphonse Girard's Mairie du IIe

Arrondissement (1846–49) and a future municipal barracks (planned in 1845 though not built until 1857).[52] Its Neo-Renaissance design was presumably closer to Baltard's tastes and would have presented a clear contrast to the inherited Neoclassicism of Lelong's building across the street, with a façade and courtyard inspired respectively by the Palazzo della Cancelleria and the Palazzo Farnese in Rome, inflected by a French mansard roof opened by dormer windows on the façade and bulls-eye windows in the court. When its estimated budget of 400,000 to 500,000 francs was rejected as too costly, Charles Rohault de Fleury recommended to the minister of finances in February 1847 that the Hôtel du Timbre be expanded by another 1,720 square meters in order to satisfy the Registry Office needs.[53] Because any expansion had to fit the existing foundations, Baltard proposed (1) raising the main elevation two meters in order to squeeze a fourth floor into the building's central section, (2) subdividing the second story of the workshop wing to create another floor, and (3) converting the attics into usable space by adding dormer windows to the mansard roofs.[54] This captured an extra 1,907 square meters of space at a projected additional cost of 54,700 francs; the actual cost overrun would climb to 300,000 francs by April 1849.[55] In September of that year, Baltard received permission from the Ministry of the Interior to ornament the entrance pavilion with two medallion busts representing Law and Security, by Eugène-André Oudiné, and two recumbent lions flanking the coat of arms of France, by Alfred Jacquemart.[56] Construction was finished by July 1850, although tasks of decoration and furnishing dragged on for another two years and the various services would not fully occupy the building until November 1852.

César Daly ignored the Hôtel du Timbre, except to offer an invidious comparison in his review of Girard's facing town hall:

I looked a long time at these two structures with this thought, that one was the work of a [Prix de Rome] laureate and the other of an architect who had never set foot in Rome. . . . I believe nonetheless that I prefer the appearance of the town hall by Mr. Girard over the Stamp Office by Mr. Baltard. Both buildings are born from reminiscences of antiquity, reminiscences that are perhaps imperfectly founded in Mr. Girard's town hall, but with a certain love for the *accent* and an obvious attempt at independence; reminiscences that are a little more coordinated . . . in Mr. Baltard's Stamp Office, but borrowed in a lump and with a heavy somnolence.[57]

While Daly might have been responding to the greater relief of Girard's façade, which otherwise is stylistically similar to Baltard's, his opinion is less noteworthy for its aesthetic judgment than for his confident assertion that the Hôtel du Timbre was the "more coordinated" of the two. Remarkably, the Hôtel du Timbre *looked* coherent even though this appearance contradicted the building's ad hoc realization by two different architects answering to diverse politicians, state ministries, bureaucrats, and advisors, whose own priorities and recommendations evolved in response to a fight over space caused by the fateful decision to continue housing two separate government offices in a single structure on an awkward site.

Like the uncoupling of plan from elevation at the Corps de Garde, the interior and exterior of the Hôtel du Timbre were developed independently of each other, in this case largely because of a program of growing and unpredictable complexity (fig. 72): the regular façade hides an asymmetrical plan and warren of spaces that have ingeniously been made to fit the irregular perimeter. Baltard's role, at once sweeping and modest, was to reorganize the interior functions

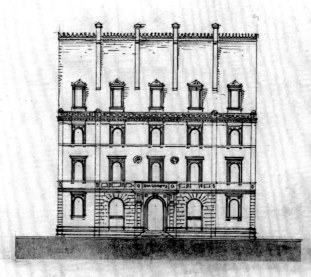

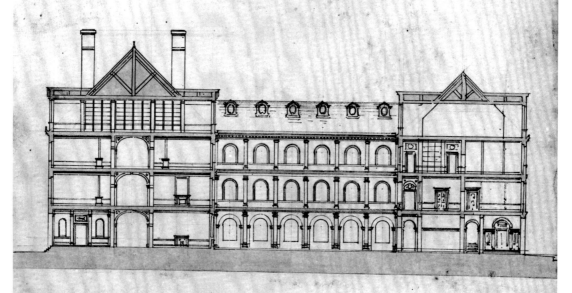

within largely predetermined exterior volumes; he could heighten the façade with a new attic story, add dormers to the mansard roof, and rationalize the detailing of Lelong's elevations, but at no point could he start over and propose another solution. Demonstrating at once his practical skill and a deft touch, Baltard reconciled the building's actual disjunctions of form and function in a work that looked unified even when it was not. The Hôtel du Timbre hides its internal contradictions behind an impassive mask, in a paradoxically forbidding image of the building's use as an instrument of state censorship.

The entrance pavilion gave Baltard his single opportunity for creative expression. He first sketched a three-bay triumphal arch (fig. 73) that, like his later arch for the Place du Trône, evokes the detailing and proportions of Percier and Fontaine's Arc du Carrousel. Then, between 1849 and 1852, he redesigned the pavilion as a pedimented portal (fig. 74). Effectively tracking the nation's political mutation from Second Republic in 1848 to Second Empire by the end of 1852, Baltard turned the entrance from an open passageway into an authoritarian point of control and replaced the Republican dedication to "liberty, fraternity, and equality" with what finally became an imperial emphasis on law and security. Now layered with a more overtly Romantic and discursive system of ornament that spoke to the difference between construction and decoration, the entrance juxtaposed arches articulated with moldings that carve into the surface to emphasize their structural mass and depth, to a trabeated temple frame that sits on the surface as a visibly thin, if elaborately delineated, appliqué. Here again the Conservatoire des Arts et Métiers comes to mind, whose similarly pedimented entrance, in this case with caryatids by Elias Robert, was built to Vaudoyer's evolving design between 1846 and 1850.[58] Vaudoyer's ponderated ornament, however, has been

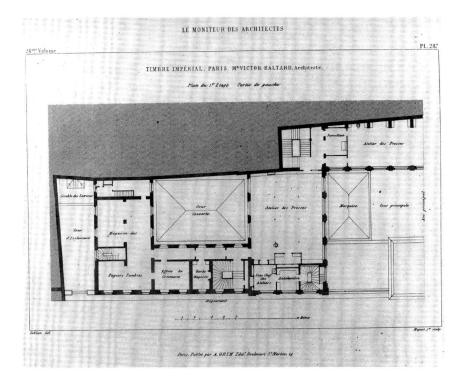

FIGURE 71 (*opposite*)
FIGURE 71 (*opposite*)
Victor Baltard, project for the Hôtel de l'Enregistrement (Registry Office), Paris, 1847. Elevation and section. Document held at the Centre historique des Archives nationales de France, Paris.

FIGURE 72
Paul Lelong and Victor Baltard, Hôtel du Timbre, Paris, 1844–52. First-floor plan, left half, from *Moniteur des architectes* (1854). Document held at the Centre historique des Archives nationales de France, Paris.

FIGURE 73
Victor Baltard, preliminary design for the entrance pavilion of the Hôtel du Timbre, Paris, 1848. Elevation sketch. Document held at the Centre historique des Archives nationales de France, Paris.

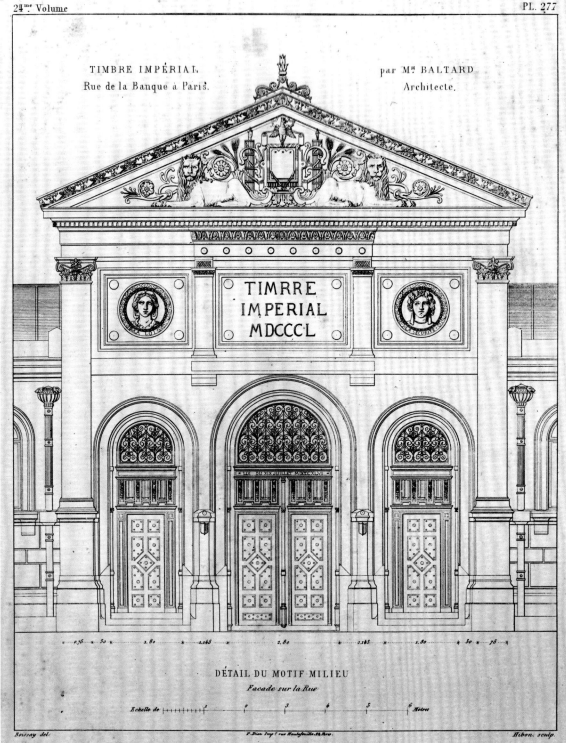

TIMBRE IMPÉRIAL,
Rue de la Banque à Paris.

par Mr. BALTARD
Architecte.

DÉTAIL DU MOTIF MILIEU
Façade sur la Rue

Echelle de

Boissay del.

F. Dien Imp.ᵉ rue Hautefeuille, 32, Paris.

Hibon, sculp.

Paris, Publié par A. GRIM Edit.ᵉ Boulevart St. Martin, 19.

flattened out with tightly drawn details that barely project from the surface. Baltard's attic frieze, and its inscription between Oudiné's two medallions of Law and Security, seems at once pinned to the façade and hung from a classical armature of pilasters, cornice, and pediment, so that the entire elevation reads like a poster on a wall, with its censor's stamp of approval in the central panel. If the language is classical, it is also unorthodox, both in the mixture of Roman and Renaissance motifs (including the Renaissance conflation of triumphal arch and temple) and in its filtering of those sources through a decorative sensibility based in Baltard's investigations of architectural polychromy while at the Villa Medici in Rome. This entrance suggests how Baltard might have treated the entire Hôtel du Timbre had he been a truly free agent. Since he was not, he could only add, hieroglyphically, this intense moment of detailing to a workable yet otherwise mute building.

THE CHURCHES OF PARIS

For much of his career, Baltard tended to the churches of Paris, first as the inspector of fine arts charged with supervising religious works of art (1840–60) and then also as the architect charged with the first section of municipal buildings, including its churches (1848–60).[59] Excepting Saint-Augustin, realized after he stepped down as architect of the first section, his duties were limited to the maintenance, decoration, restoration, and alteration of extant structures. Even so, or perhaps precisely because these duties were at once so modest and diffuse, Baltard's cumulative impact on the churches of Paris was extensive: by 1860, he had put his hand to at least twenty-seven churches, affecting their fabric in ways both prosaic and transformative, from the installation of sewer systems to the decoration and restoration of Saint-Germain-des-Prés, Saint-Eustache, and Saint-Étienne and the radical adjustments of

churches like Saint-Leu-Saint-Gilles to the new streets of Haussmann's Paris.[60]

Constrained by administrative regulations, planning edicts, and artistic commissions, Baltard's responsibilities engaged him in a collaborative practice of architecture that makes it easy to miss his determining role in the process itself as he coordinated multiple programs and agents to remake the churches of Paris during the middle decades of the nineteenth century. Besides addressing immediately practical needs, his interventions in these churches also reflected contemporary debates about the role of decoration in architecture, the proper scope of restoration, and the status of both the historic monument and religious art in modernity. His restoration especially of the two Renaissance churches of Saint-Eustache and Saint-Étienne-du-Mont, along with his Neo-Renaissance additions to the Gothic church of Saint-Leu-Saint-Gilles, turned these churches into narratives of artistic evolution that identified the sixteenth century as a simultaneous point of connection and transition in the history of Paris from its premodern to its modern forms. This aesthetic project recovered the historic significance of these churches by challenging the technocratic rationality of Haussmann's urbanism at the material level of the buildings themselves. Instead of utilitarian order, Baltard found in these churches evidence of an incremental and densely accretive urban history that challenged the prefect's clinical view of the city as an abstract system in which monuments could be surgically isolated and preserved like artifacts in a museum.[61]

The history of religion in France since the Revolution explains why a municipal architect was charged with these churches. In his study *Paris, capitale religieuse sous le Second Empire,* Jacques-Olivier Boudon documents the political and administrative program of religious centralization that, starting with Napoléon I and culminating

FIGURE 74 (*opposite*) Victor Baltard, final design for the entrance pavilion of the Hôtel du Timbre, Paris, 1849–50. Elevation, from *Moniteur des architectes* (1854). Document held at the Centre historique des Archives nationales de France, Paris.

with Napoléon III, consolidated control of the French Catholic Church in the capital through a campaign of modernization, allying the diocese of Paris with the state's political aims and making the church an active partner in the city's urban transformation under the Second Empire.[62] In 1789, the Revolution had legalized the state seizure of church properties and freed local communities from the obligation (dating to Louis XIV) to fund their parish churches and presbyteries. In 1801, Napoléon Bonaparte signed the concordat that reestablished formal relations with the church, at once recognizing religious tolerance in a modern, secular France and turning the church into a quasi-official part of the state: clergy were regulated by civil lists, while the cost of erecting, maintaining, and decorating the nation's churches was restored to municipal governments. The Paris diocese, reestablished in 1802 as a result of the concordat, was organized into thirty-nine parishes that, along with the city's three Protestant temples, were subsidized by the Caisse municipale. Reduced to thirty-seven in 1808 and increased again to thirty-eight in 1843, the city parishes otherwise remained remarkably stable from 1802 until 1850. Fitfully supported by the empire, the institutional restoration of the church was stimulated into activity with a series of projects initiated by the Bourbon Monarchy and completed by the July Monarchy: between 1815 and 1830, the municipality financed the reacquisition of five churches for the cult, the enlargement of another four, the restoration of three, and the construction of Saint-Denis-du-Saint-Sacrement (1823–35, by Godde), Notre-Dame-de-Lorette (1823–36, by Lebas), and Saint-Vincent-de-Paul (1823–44, by Lepère and Hittorff).

After 1850, the ongoing program of church restoration and construction acquired the consciously national objective of aligning Paris, as the religious capital of France, with the state's agenda of political centralization, justifying what Boudon

terms the "religious Haussmannization" of the city in response to its "galloping urbanization."[63] Five new parishes were created between 1850 and 1854, raising the total to forty-three, while a joint committee of clerical and administrative officials was appointed in 1853 to formulate sweeping reforms, announced in 1856: to correct population disparities between different parishes and a parallel decline in regular religious observance, problems compounded by the weak ties of many parishioners to their own parish and their itinerant tendency to worship at other churches, the 1856 reform redrew parish boundaries and raised the total to forty-seven (one parish was never instituted, leaving an effective total of forty-six).[64] The annexation of the city's suburbs in 1860 brought the number of parishes to sixty-three and, in conjunction with the 1856 reform, led, under Baltard's direction, to the eight new churches and one synagogue that were erected over the next decade in a coordinated program of religious building and municipal planning. The protracted debate over the Neo-Gothic design of Sainte-Clotilde opened the way for the eclectic variety of Romanesque, Gothic, and Renaissance styles employed during the Second Empire (concentrating on Romanesque and Renaissance idioms by the 1860s).[65]

With this political, administrative, and fiduciary commitment to the ecclesiastical architecture of Paris came a burgeoning bureaucracy. By 1811, the city's churches had been brought under the control of the state-run Direction des travaux. Alexandre Brongniart, head of the *direction*'s second section, served as the *architecte des édifices du culte de la ville de Paris* until his death in 1813, when he was succeeded by his inspector, Godde. Godde retained this office from 1813 to 1848, after 1831 as architect of the first section of municipal buildings. The fall of the July Monarchy brought in Victor Baltard, who held the position until 1860, when he in turn was replaced by Théodore

Ballu as part of Haussmann's reorganization of the architectural service. Almost from the start, oversight of churches was shared with the municipal Bureaux des beaux-arts et des cultes that Prefect Chabrol set up in 1816 and that was advised by a Commission des beaux-arts chaired by Chabrol and composed primarily of members of the Académie des beaux-arts along with Godde.[66] Aiming to assume functions still controlled by the Direction des travaux, the bureau claimed responsibility for maintaining the churches of Paris, decorating them, and regulating the city's cemeteries. In fact, it focused narrowly on procuring works of art: by 1830, the city had commissioned 219 paintings and 125 statues for the churches of Paris, with 178 paintings and 110 statues completed.[67] Odilon Barrot disbanded both office and commission at the start of the July Monarchy yet kept their operations under Augustin Varcollier in the prefecture's General Secretariat. Granted a separate budget line for the first time in 1834, those operations were formally reestablished by Rambuteau in 1835, when a second division of the General Secretariat was assigned to the Beaux Arts and the Commission des beaux-arts was revived. The office itself was reinstated in 1839 (headed by Buffet and later Baudot), and Baltard was named the city's first inspector of fine arts the following year.[68] Baltard stepped down as inspector when he became director of the Service d'architecture in 1860, keeping an honorary appointment but leaving the day-to-day job to the newly named *architecte des beaux-arts,* Marie-François Péron.

Three state agencies with a say in the churches of Paris further complicated the bureaucratic situation: the Édifices diocésains, the Bâtiments civils, and the Monuments historiques. The city's diocesan buildings (cathedral, bishopric, and seminary) came under the Service des édifices diocésains, administered through the Ministry of Justice and Cults.[69] Before 1848, care for these buildings

usually went to local architects appointed by the bishop in consultation with the prefect, which meant in the case of Paris that Godde was both diocesan and municipal architect of churches. In 1842, however, the minister of justice, Martin du Nord, removed Godde as diocesan architect of Notre-Dame. A limited competition for the cathedral's restoration was opened in 1843 and won in 1844 by Jean-Baptiste Lassus and Viollet-le-Duc.[70] When Baltard replaced Godde in 1848 as municipal architect, he became diocesan architect as well, except that Lassus and Viollet-le-Duc retained control of Notre-Dame. Restricting his activities to stabilizing the structure of Godde's Saint-Sulpice Seminary (especially its chapel), Baltard left the completion of this task to Lassus and Viollet-le-Duc after they formally replaced him as diocesan architects in 1854, as a result of administrative reforms that restructured the service into a centralized corps of architects supervised by three general inspectors (Reynaud, Vaudoyer, and Viollet-le-Duc).[71] The Bâtiments civils, answering to the parallel Ministry of the Interior, extended its control over state monuments to include ecclesiastical edifices of national significance, among them the royal abbey of Saint-Denis (restored by François Debret in 1816–46) and the Sainte-Chapelle in Paris (restored by Félix Duban in 1836–49).[72] François Guizot introduced a rival to both services in the 1830s when, as minister of the interior, he set up both the Inspection and the Commission des monuments historiques.[73] Charged with reporting on medieval structures, the first two inspectors, Ludovic Vitet (1830–34) and Prosper Merimée (1834–53), pushed as well for the advisory commission established in 1837. After this commission was transferred in 1840 from the Bâtiments civils to the Ministry of Public Works, the Monuments historiques asserted its independence as a powerful voice for reform in the preservation practices of the other services.

A final interested party was the Catholic Church, which could employ its own architects alongside those designated by the city or state. From 1838 to his death, in 1857, Lassus was charged by the church with the restoration of Saint-Germain-l'Auxerrois, even as he continued until 1848 to serve as Godde's municipal inspector.[74] In those same years, Baltard worked alongside Lassus, first supervising the church's decoration with murals in 1840–56 as the inspector of fine arts and then directing its interior restoration as Godde's successor in 1848–58.[75] His past difficulties with Viollet-le-Duc notwithstanding, this devout Protestant seems to have minimized the potential for friction with the equally devout Catholic Lassus over the restoration of Saint-Germain, just as he forged alliances with parish priests on behalf of the churches under their mutual care. Credited by Paul Sédille with an artist's tolerant appreciation for Catholic pomp, Baltard avoided the dissensions that had characterized his father's relations with the clergy as architect of the Panthéon.[76]

As the inspector of fine arts, Baltard oversaw the installation of religious works in the churches of Paris. The Commission des beaux-arts liberally acquired paintings on canvas and statues from a wide variety of artists, with little regard—beyond a generic concern for iconographic propriety—either for an artist's aesthetic or a work's stylistic fit with its destination.[77] Baltard expanded and significantly rethought this objective with an ambitious program to decorate these churches with cycles of mural paintings.[78] Saint-Sulpice, where three chapels were painted with frescoes in 1822–24, and Notre-Dame-de-Lorette, sumptuously decorated with both murals and canvases by thirty different artists between 1828 and 1835, offered important precedents, as did La Madeleine: after Paul Delaroche, commissioned to decorate the interior in 1833, withdrew in 1835, the project was divided between seven painters.

Compared, however, to the frequency with which site-specific works were commissioned after 1840, these remained isolated instances with mixed results. Attitudes changed as young artists like Hippolyte Flandrin and Victor Mottez pushed for reviving traditions of mural painting that extended from antiquity to the seventeenth century but had since largely been abandoned.[79] Flandrin obtained his first commission in 1839, for the Chapelle Saint-Jean in Saint-Sèverin: Édouard Gatteaux, as a city councilor (1834–43), petitioned Rambuteau to give Flandrin the job, just as he would intervene again the following year to secure Baltard's appointment to coordinate the nascent campaign of mural painting.[80] Starting at Saint-Sèverin and Saint-Germain-l'Auxerrois in 1840, following in 1841 with Sainte-Elisabeth, Saint-Louis-d'Antin, and Saint-Louis-en-l'Île, and continuing through the 1850s and 1860s with a host of other churches, this program found its defining, if exceptional, example at Saint-Germain-des-Prés, which was painted in its entirety with compositions by Flandrin between 1842 and 1865.[81]

According to his biographers, Baltard preferred and called whenever possible on the followers of Ingres: Mottez, Amaury-Duval, Paul Jourdy, and Adolphe Roger were important contributors along with Flandrin.[82] Yet the so-called school of Ingres, as Bruno Foucart points out in his history of religious art in nineteenth-century France, actually covered a wide range of artists who were at best loosely associated by their common admiration for the master's example.[83] Baltard's criteria of selection were necessarily more catholic than is suggested by singling out a few artists from the many who worked with him during the 1840s and 1850s. To the extent that these commissions indicate any real bias, it was for artists educated at the École des Beaux-Arts. Anticipating Charles Garnier's reliance on École painters and sculptors to

decorate the Paris Opéra in the 1860s and 1870s, Baltard drew on a usefully large pool of candidates whose individual temperaments and talents were balanced by their common academic training and experience.[84] Instead of aspiring to an impossible uniformity of style, Baltard sought artists who were sympathetic to the challenge of integrating paintings with their architectural settings. The challenges were both technical and formal. Mottez struggled to restore techniques of fresco painting used previously at Saint-Sulpice in the 1820s, but his attempts at Saint-Germain-l'Auxerrois (1840), Saint-Sèverin (1845), and Saint-Sulpice (1860) soon disintegrated in the damp conditions of Paris, on stone walls that at Saint-Germain and Saint-Sèverin had been impregnated with saltpeter from the Revolutionary use of these churches to manufacture and store gunpowder. Flandrin established a viable alternative by using encaustic to produce murals that mimicked fresco yet proved at once easier to work and more durable.[85] Driving this search for a viably permanent medium was the formal conviction that murals, as images affixed to walls and thus dependent on the architecture, should employ textures, colors, and compositions that held to the pictorial surface and collapsed the illusion of depth found in easel painting. Indebted to Italian artists, especially the Pre-Raphaelites from Giotto to Fra Angelico, this concern for flatness both reinforced the academic stress on line over color taught at the École and looked to the example of Ingres, at work in 1843–50 on a pair of murals in the Château de Dampierre.

The bias for murality and line over spatial illusion and color suited Baltard's intention to keep works of painting within the architectural frame. Lecturing at the École in 1845, Baltard argued that "when painting is called upon to decorate a building, this art cannot operate with complete compositional independence. The architect cannot cease

being the organizer and regulator of everything that, being accessory, must conform with the taste and the conventions of the principal object." He went on to explain that mural paintings must always "maintain the essential principle, which is [the building's] at least apparent, if not real, solidity, and to this end one must avoid distant views, perspectives, multiplied planes, in a word, anything that produces the effect of void where the appearance of the solid is necessary."[86] Watercolor studies of *in situ* murals, including the sanctuary of Saint-Louis-d'Antin to be painted by Émile Signol (fig. 75), record the attention paid by Baltard to grounding these murals with painted wainscoting, revetments, and ornamental borders.[87] The system was perfected at Saint-Germain-des-Prés, where Baltard collaborated with Hippolyte Flandrin and the ornamental painter Alexandre Denuelle on an integrated program of murals and decoration (figs. 76, 77). The ornamental chevrons, rinceaux, and banded fields that cover the church's medieval structure serve at once to hold Flandrin's murals in place and turn that structure from an articulated skeleton into a uniform series of continuously painted fields in muted tones of red, green, yellow, brown, blue, and gold.

Behind the technical and formal issues lay critical questions about the status and role of religious art in architecture. For some, the decoration of the churches of Paris launched by the Bourbon Monarchy carried both a generally religious and an explicitly Catholic charge.[88] Originating in arguments put forth in Chateaubriand's *Génie du christianisme* (1802), the theory for a revival of Christian art was articulated at length in works like François-Alexis Rio's *De l'art chrétien* (1836) and Charles de Montalembert's *De l'état actuel de l'art religieux en France* (1837). Paralleling the apologies for a revival of Gothic architecture put forth by Lassus and others in Adolphe-Napoléon Didron's *Annales archéologiques,* proponents

Fig. 11

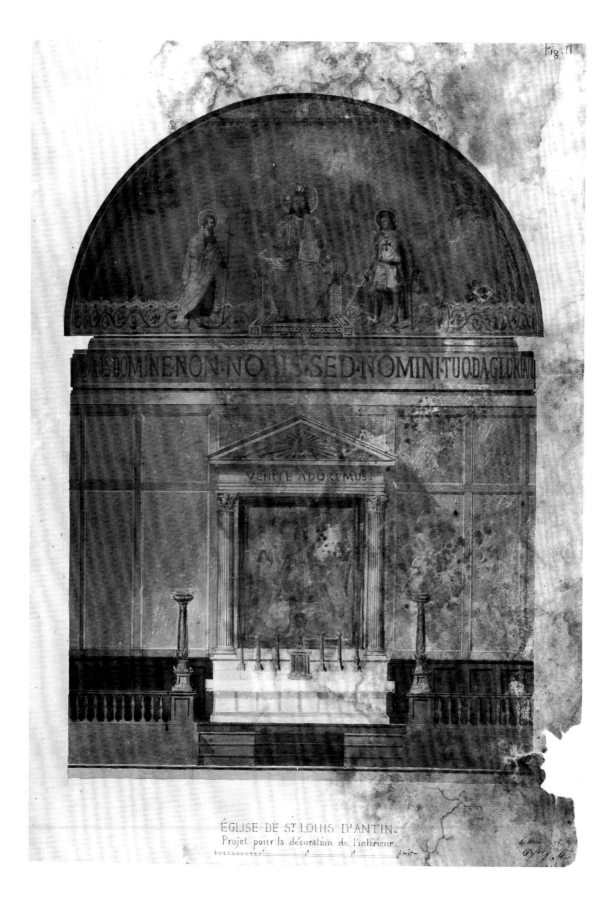

ÉGLISE DE St LOUIS D'ANTIN.
Projet pour la décoration de l'intérieur.

sought a return to Pre-Raphaelite (i.e., pre-Renaissance and pre-modern) models in order to restore to religious art its properly Catholic liturgy and iconography: the *Annales archéologiques,* founded in 1844, polemically identified archaeology with medieval art and architecture instead of classical antiquity.[89] Despite the efforts of apologists, however, the alignment of Catholicism with religious art was neither inevitable nor even expected. Napoléon I's concordat had secularized religion in nineteenth-century France, inaugurating a process that, though slowed by the pro-Catholic policies of the Bourbon Monarchy, gained momentum with the anticlerical July Monarchy and was consolidated under the Second Empire, when the French Catholic Church collaborated with the government of Napoléon III in a program of social modernization that sometimes brought them into conflict with the religiously conservative interests of the Holy See.[90]

Ecumenical tolerance, moreover, was necessarily the rule in municipal programs like the decoration of parish churches, where painters of Catholic subjects were supervised by a Protestant inspector and commissions could go to Jewish artists like Henri Lehmann (at Saint-Merry). Even a pious Catholic like Hippolyte Flandrin, popularly canonized at his premature death as the very model of the Christian artist, was more immediately concerned with aesthetics than theology in his commissions.[91] Rather than respect Pre-Raphaelite models, his murals at Saint-Germain-des-Prés evolve stylistically from the medievalism of the sanctuary to the eclecticism of the nave, where Cimabue and Giotto mix with Raphael and Nicholas Poussin, in an unmistakable nod to Flandrin's mentor, Ingres. According to Foucart, religious art in nineteenth-century France was justified less by some renascent Catholic orthodoxy than by the blend of historicism and spiritualism found in Victor Cousin's contemporary philosophy of

FIGURE 75 (*opposite*)
Victor Baltard, project for the decoration of the sanctuary in Saint-Louis-d'Antin, with murals by Émile Signol, 4 May 1841. Document held at the Centre historique des Archives nationales de France, Paris.

FIGURE 76
Victor Baltard, Hippolyte Flandrin, and Alexandre Denuelle, decoration of the choir in Saint-Germain-des-Près, 1846–48 and 1853–54. View of bays on the north side.

Eclecticism.[92] Cousin's most influential work, the compact *Du vrai, du beau et du bien,* published in 1836, condensed and popularized lectures he had delivered at the Sorbonne in 1815–20 and again in 1828–30 (after intermittent repression by the Bourbon Restoration for his pantheistic views).[93] Claiming eclecticism as his method and spiritualism as his principle, Cousin outlined a history of philosophy that progressed in loosely Hegelian and dialectical terms toward a psychologically defined and hence subjective ideal of truth. Eclecticism's fuzzy logic blurred the intellectual boundaries between previously distinct categories of thought, both eliding Neoclassical idealism with Romantic historicism and rationalizing religious art as a form of spiritualized yet doctrinally vague aesthetics acceptable to Catholic and non-Catholic, Christian and non-Christian, alike.

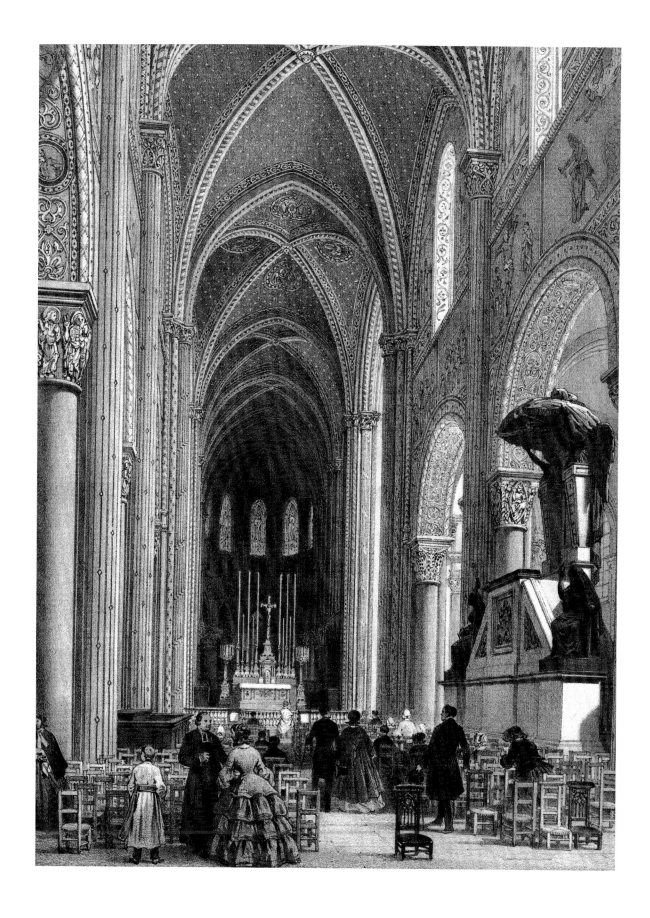

Prudently eclectic in form and content, religious art in midcentury France was a tool to restore historical meaning, at least as a visual expression of culture, to a world being stripped of such meaning by modernity.[94] Much the same preoccupation informed the contemporary enthusiasm for architectural polychromy. Prompted by the discovery in 1811 of traces of color on the Temple of Aphaia on Aegina, architects led in France by Jacques-Ignace Hittorff speculated from the mid-1820s onward that ancient temples had been lavishly decorated with murals along with painted sculptures and ornaments. Hittorff's thesis provoked opposition, most notably from Désiré Raoul-Rochette, who worried correctly that such an extensive system of applied ornament threatened the classical unity of constructed decoration with a modern dialectic of decorated construction. Yet this debate only questioned the extent, never the premise, of polychromy, and the idea had won general acceptance by the time Hittorff published his definitive monograph on the polychromatic Temple of Empedocles at Selinus in 1851.[95]

Religious art and architectural polychromy intersected in the practice of mural painting. In 1851, Pierre-Jules Jollivet and Prosper Mérimée published a lengthy series of technical and aesthetic articles on "mural painting and its use in modern architecture."[96] Broadening the subject from ancient to medieval (as well as Renaissance) precedents, while moving its sphere from the bright marble exteriors of sunny Greece to the dim limestone interiors of cloudy France, Merimée advocated mural painting for its potential to protect architectural surfaces, enliven architectural interiors, and articulate the logic of architectural structures. Merimée's thesis was informed by Hittorff's publications as well as by a report submitted by Ludovic Vitet to the Monuments historiques in 1831 detailing the role of painted decoration in the medieval monuments of northern

France.[97] Just as relevant, if unacknowledged, were the lessons learned during a decade of experimentation on the churches of Paris, beginning with Saint-Sèverin, Saint-Germain-l'Auxerrois, Saint-Merry, and especially Saint-Germain-des-Près. In 1841, the critic Théophile Gautier cited the first three of those churches as evidence of a general shift from construction to decoration in contemporary architecture.[98] Jean-Philippe Schmit, an ally of Didron's as well as a functionary in the Édifices diocésains from 1827 until 1840, lamented in his 1845 *Nouveau manuel complet de l'architecture des monuments religieux* that murals had not made greater advances in the decoration of churches.[99] By 1859, however, he was ready to admit in the manual's second edition that "the movement is done, at least for Paris, where the walls are being covered with paintings."[100]

Baltard was a key agent in turning architectural polychromy into a viable practice during the 1840s and 1850s. Interested in its use since his days at the Villa Medici, when he both composed the vividly Pompeiian interior for Ingres's *Antiochus and Stratonice* and applied local color to his 1836 *envoi* of the Temple of Concord, Baltard treated the churches of Paris experimentally, as blank surfaces awaiting inscription, wiped clean of historical exegesis until the artists working under his direction painted new readings, a new history, on their walls. Despite the principle of integration, the murals did not emerge inherently out of a building's architecture. Instead, even as they acknowledged their context, these paintings remained contingent, circumstantial additions that were applied to a structure as expressions of culture rather than nature and were consequently subject in time to their own historical erasure.

Inevitably, given the necessary work of cleaning, resurfacing, and plastering that prepared these churches to be painted, their decoration overlapped with their restoration.[101] Baltard's

FIGURE 77 (*opposite*)
Saint-Germain-des-Près, Paris, eleventh-twelfth centuries, with decoration by Victor Baltard, Hippolyte Flandrin, and Alexandre Denuelle, 1842–65. View of the interior by Chapuy and Philippe Benoist, from *Paris dans sa splendeur.*

FIGURE 78
Saint-Eustache, Paris, 1530–1637
and 1754–72. View of the
south side, with the Central
Markets construction site in
the foreground, circa 1860.
Photograph by Édouard Baldus.

joint appointments as inspector of fine arts and
architect of the first section facilitated this practi-
cal elision between decoration and restoration
and encouraged a process of creative reinven-
tion that was first realized comprehensively at
Saint-Eustache (fig. 78). Except for its Neoclas-
sical façade, added in the eighteenth century,
this church is a characteristic example of French
Renaissance architecture, erected between 1530
and 1637 and defined stylistically by the period's
conflation of a Gothic structure with classical
details. Baltard spent eighteen years, from 1842
to 1860, restoring Saint-Eustache, and as he came
to know the church inside and out, it both con-
firmed his belief in the historical relevance of the
Renaissance to the evolution of French architec-
ture and provided him with a valuable precedent
to his own work.[102] He began, in 1842–43, with a
commission for a new high altar, funded by the

parish and carried out in consultation with the
Ministry of the Interior, which submitted Bal-
tard's designs to the Commission des monuments
historiques for review: two initial projects were
rejected for "presenting a mixture of styles without
any relation to the church," before a revised, third
project was approved in February 1843.[103] A sur-
viving rendering (fig. 79; for which preliminary
project is not clear) combines Renaissance details
with a medievalizing frieze of apostles, carved in
low relief from panels of white marble and high-
lighted with gold; by the time it was finished in
1847, the altar had acquired a baldachin over the
ciborium, its gilded ornaments had grown more
elaborate, and the frieze of apostles had disap-
peared, presumably in answer to objections of the
Commission des monuments historiques.[104] After
a fire extensively damaged the church interior on
16 December 1844, Baltard received two further

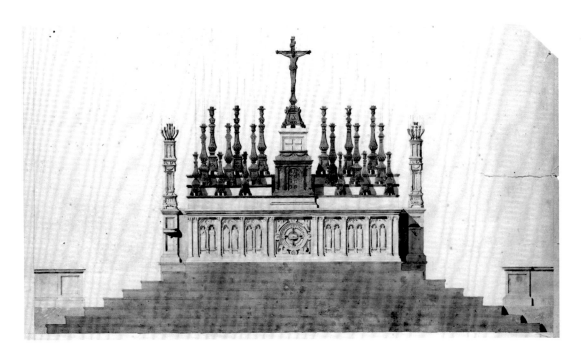

FIGURE 79
Victor Baltard, high altar of
Saint-Eustache, Paris, 1842–47.
Preliminary project rendering.
Document held at the Centre
historique des Archives nationales
de France, Paris.

commissions, for a new pulpit (completed in 1849, with ornamental sculpture by Victor Pyanet) and an organ case (fig. 80). Drawing directly, if freely, on the architecture of Saint-Eustache, the pulpit and organ case were more consistently Renaissance (as well as more sculptural) in their detailing than the first versions of the high altar.

In 1846–48, still answering to the Ministry of the Interior and the Bâtiments civils, Baltard rebuilt the vaults of the first two bays of the nave (above the new organ); in 1849, now reporting to the Prefecture of the Seine as architect of the first section, he supervised a general repair and cleaning of the interior, which included the restoration in 1853–54 of the walls and vaults in four side chapels. This led in 1850 to the discovery of seventeenth-century murals in five ambulatory chapels, prompting at once their restoration and the decision to decorate the remaining chapels with new murals by Félix Barrias, Jean-Louis Bézard, Thomas Couture, Auguste-Barthélemi Glaize, Pierre-Auguste Pichon, Isidore Pils, and Émile Signol among others. Reflecting their

seventeenth-century precedents, these murals play with the sort of perspectival effects that Baltard and Flandrin had rejected at Saint-Germain-des-Près, and they were criticized in 1856 by Claudius Lavergne for "the singular dissonances that disconcert the painter and shock the view[er]."[105] The painted architectural ornament, developed in collaboration with Denuelle though carried out with revisions by Charles Séchan, similarly shifted from medievalizing to Renaissance motifs that associated the immediate context of Saint-Eustache with Italian sources like Raphael's Stanze at the Vatican (whose decorative borders Baltard had copied while in Rome).[106] Between 1856 and 1860, Baltard turned his attention to commissioning and installing enameled terra-cotta reliefs in the transept arms. Finally, he proposed in 1862 to replace the existing eighteenth-century façade with a new west end that re-created the transitional mixture of Gothic structure and Renaissance style found in the body of the church: despite rumored imperial approval, this project was never realized.[107]

FIGURE 80
Victor Baltard, organ case, with
an organ by Ducroquet, statues
by Eugène Guillaume and
J.-M.-A. Pollet, and ornamental
sculpture by Victor Pyanet, Saint-
Eustache, Paris, 1849–54.

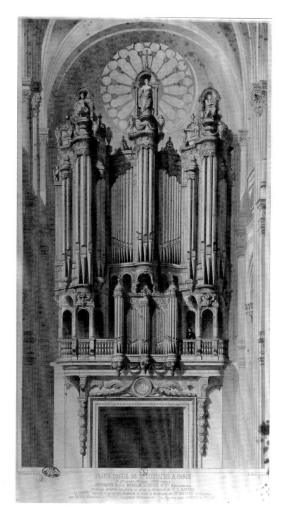

Just as Viollet-le-Duc's contemporary restoration of the cathedral of Notre-Dame (1844–64) justified his structurally rational theory of architecture, Baltard used Saint-Eustache to prove the Romantic synthesis between classical and medieval traditions advocated in his École lectures. Félix Duban had organized the École des Beaux-Arts, completed in 1840, around the late Gothic and early Renaissance fragments of French architecture remaining from Lenoir's museum, most prominently two sixteenth-century façades from the châteaux of Gaillon and Anet.[108] Between 1842 and 1845, Léon Vaudoyer argued in the "Études d'architecture en France" that the

French Renaissance contained "the seeds of an original style that could have given birth to a truly national architecture" had its inventive potential not been interrupted by the return to exclusively antique models in the Baroque and Neoclassical periods.[109] Though he criticized Saint-Eustache for its "lack of harmony," resulting from the conflation of a Gothic structure with Renaissance details, Vaudoyer nonetheless borrowed its pilaster piers for his new wing at the Conservatoire des Arts et Métiers.[110] Baltard had already referred to Saint-Eustache in the elevations of the Hôtel du Timbre, and it would subsequently inform his designs of both the Central Markets (on which he was officially at work by 1845) and Saint-Augustin.

Saint-Étienne-du-Mont (1491–1622) traces an equivalent evolution from its late Gothic choir to its Renaissance nave. Starting in 1856, Baltard restored the choir and nave buttresses and simultaneously designed a new Chapelle des Catéchismes (fig. 81) on the far side of the cloister, behind the choir.[111] Dedicated in 1858, this chapel was detailed in a loosely Renaissance style that incorporated late Gothic elements into its ribbed plaster vaulting. By 1857, Baltard was at work cleaning and reconditioning the interior (fig. 82), which led in 1859 to a general restoration project for the church; reviewed by the Conseil des bâtiments civils on 20 September 1859, this project was unfinished when Baltard stepped down as architect of the first section the following year.[112] In 1860, the nave-vault pendentives were refaced, and the church façade (fig. 83) was then completely reconstructed between 1860 and 1864, taken apart stone by stone and reassembled with new sculptures by de Bay, Dubray, Hébert, Félon, Millet, Pascal, Ramus, Schroeder, Thomas, and Valette. Decoration, restoration, and construction overlapped in a campaign of modernization that made the church look as clean, as bright, and as whole as a monument built yesterday.

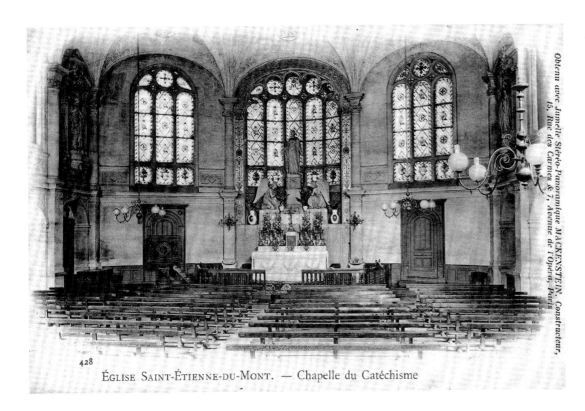

428

ÉGLISE SAINT-ÉTIENNE-DU-MONT. — Chapelle du Catéchisme

FIGURE 81
Victor Baltard, Chapelle des Catéchismes, Saint-Étienne-du-Mont, Paris, 1856–58. Contemporary postcard.

FIGURE 82
Saint-Étienne-du-Mont, Paris, 1492–1622, as restored by Victor Baltard, 1856–64. View of the interior by Philippe Benoist, from *Paris dans sa splendeur.*

Rather than stratified into distinct periods, past and present were related in a historical continuum of the old made new and the new made old. Treating both Saint-Eustache and Saint-Étienne as works of art whose historical significance lay as much in their aesthetic value as in their sacred function, Baltard identified these churches as historic monuments. The idea, as Françoise Choay notes in *The Invention of the Historic Monument,* is modern. Conflating the ancient type of the monument with the modern discipline of history, including a history of art, the "historic monument" was coined by the antiquarian Aubin-Louis Mullin in 1790 and was then institutionalized in 1830 by François Guizot through the Commission des monuments historiques. Paraphrasing Alois Riegel, Choay explains that "the monument is a deliberate (*gewolte*) creation whose purpose is established *a priori* and at the outset, while the historic monument is . . .

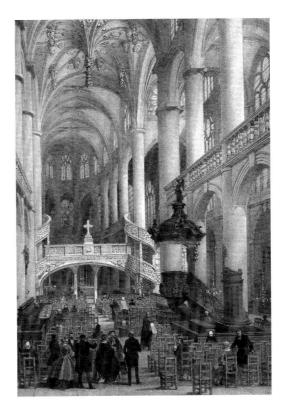

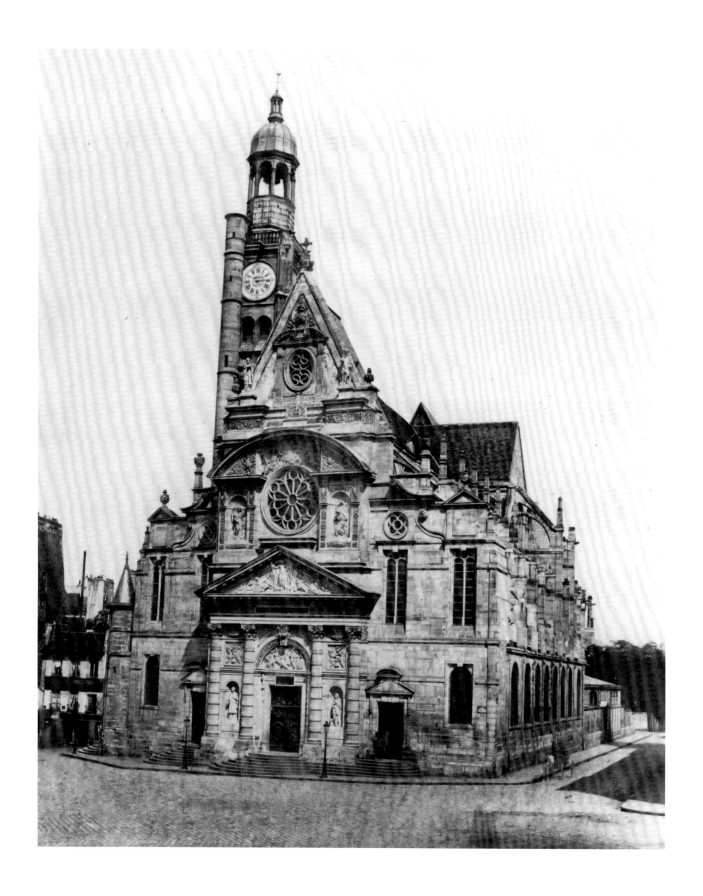

constituted *a posteriori* by the converging gazes of the historian and the *amateur,* who choose it from the mass of existing edifices, of which monuments constitute only a small part."[113] This identity of the historic monument as any building that has acquired meaning through the passage of time makes its significance fundamentally unstable and subjects it to parallel historical and artistic criteria: the historic monument can be valued both as an object of knowledge from the past that documents a linear construction of time and as an aesthetic experience that remains directly relevant to the present despite the passage of time. Choay credits the break in traditional modes of production brought about by the Industrial Revolution with forcing the perceptual rupture in time between "a 'before,' to which the historic monument was relegated, and an 'after,' where modernity began."[114] Whether through systematic historiographic analysis or scenographic aesthetic experience, the (urgent, if never realized) desire was to close that rupture by treating the historic monument as a spatiotemporal bridge from the present back to the past (and vice versa).

The degree to which the restoration of Saint-Étienne visibly placed this Renaissance church within the present space of nineteenth-century Paris can be gauged both by the Édouard Baldus photograph of the just-reconstructed façade and by the Philippe Benoist lithograph of the reconditioned interior. The historical as much as technological distance between the photograph and the Renaissance façade it records is at once measured and collapsed in an image that observes the entire church in a single, comprehensive, and comprehensible glance.[115] The elevated vantage point, perspectival corrections, and shadowy blurs of passing figures are evidence not only of photography's technical capacities and limitations at the time but also of the viewer's removal from the scene: we see everything yet remain strangely removed from the ground of the actual church, which now returns weightlessly as a piece of paper in our hands. The juxtaposition of one medium of representation to another, an albumen print regarding sculpted stone, sets up and frames for the viewer the cliché of a city suspended between its premodern, craft-based, and traditional past and its suddenly modern, increasingly industrialized, and nearly instantaneous present. Like Baltard's restoration of the church, the photograph reconstructs Paris around a narrative of continuity and change between old and new.[116] The Benoist lithograph of the interior (see fig. 82), drawn for the series *Paris dans sa splendeur,* offers parallel insights. Unconstrained by long exposure times, this lithograph reinhabits the image with the people missing from the Baldus photograph: in the foreground, a circle of Parisians attend the guide's lecture, making us, the viewers, figurative eavesdroppers on his narrative. Like the photograph, however, the lithograph assumes that the restoration has made this splendid artifact from the past newly relevant to us in the present; other lithographs from the series, like the one of Saint-Germain-des-Prés with its Flandrin murals (see fig. 77), reiterate this point of cultural renewal through historical reinvention. Because the material fabric of a building actually spans the temporal space between past and present, eliding history and modernity in the same object, we are offered the hope that our removal from the past (as from the object) can be overcome by replacing the artifact with its representation: a photograph, a lithograph, or a restoration.

The ambiguous status of the historic monument, as a work that belongs at once to past and present, was played out in debates over the scope and purpose of preservation. Surveying nineteenth-century preservation practices, Choay recognizes two antithetical responses to the historic monument, the first articulated in England by John Ruskin and William Morris as the

conservation of monuments in their existing state, and the second articulated in France by Viollet-le-Duc as the restoration of monuments in an ideally complete state: Choay attributes the first to a nostalgia for the past and the second to a nostalgia for the future.[117] Between those ideological extremes, as Choay admits, lay not only the elusive historical present but also preservation practices that more often advanced through experimental compromises than by fixed principles. Working in this middle ground, Baltard mixed conservation and restoration in a practice that was informed by experiences dating to his days in Rome. His 1837 *envoi* of the Theater of Pompey, whose fragmentary remains justified a project that was an exercise simultaneously in archaeological documentation and in architectural composition, anticipated the inventive, rather than strictly curatorial, assumptions at work in Baltard's restorations of the churches of Paris. If those churches led Baltard to extrapolate the potential of restoration to modernize a monument, it was because they confirmed his conclusion, already reached in 1837, that any act of restoration was at once constrained and liberated by the tension between a building's material specificity and its mutable aesthetic form.

During the 1840s and 1850s, Baltard explored the idea of restoration primarily through practice rather than words. He did, in his opening lecture at the École for 1845–46, protest the Neoclassical habit of modifying Gothic churches with "Greek" elements (like the classicized piers of Saint-Médard or Saint-Nicolas-des-Champs) as a confusion between systems and principles belonging to different times.[118] He was attracted rather to the subtler changes effected by history's evolutionary alterations. Returning to this idea in his obituary of Augustin Caristie, Baltard drew a crucial distinction when analyzing the architect's meticulous restorations of the Roman Arch and Theater of Orange: "In praising the

method followed by Caristie for the restoration of an antique monument, it is not necessary to remark that this method cannot be applied to any monument, no matter how ancient, that we still use, such as the churches of the Middle Ages. For these, one must repair them day by day in such a manner as to maintain them in their natural living state."[119] Neither restoration nor conservation, conventionally understood, justified Baltard's ongoing and incremental, "day by day" process of adjusting buildings to a society's developing needs and perceptions. If this incremental approach ran counter to Caristie's Neoclassical absolutism, it was equally at odds with Viollet-le-Duc's categorical definition of "restoration" in the *Dictionnaire raisonné* (1866): "To restore an edifice is not to maintain it, repair it, or remake it; it is to reestablish it in a complete state that can never have existed at a given moment."[120] Both Baltard and Viollet-le-Duc understood architecture to be a system of decorated construction, and both agreed that restoration modernized a monument. But where Viollet-le-Duc premised restoration on the rational establishment of an ideally consistent structural form, Baltard explicitly rejected the expectation that a restoration could ever reestablish a consistent whole, rather than effect another in a long history of ad hoc adjustments. He conflated the very terms separated by Viollet-le-Duc, equating a building's restoration with its maintenance and repair on behalf of its continued social relevance.[121] Their differences came to the fore in the 1840s, when Baltard was remaking the churches of Paris and Viollet-le-Duc was engaged in his seminal reconstruction of the Burgundian church of La Madeleine at Vézelay (1840–50).[122]

After 1853, when the ongoing restoration of the churches of Paris was coordinated with Haussmann's transformation of the city, Baltard was increasingly called to adjust their structures to the prefect's planning dictates. Several churches

were altered by the new streets being cut through the city: at Sainte-Elisabeth, the Virgin's Chapel was demolished and the choir modified in 1854–58 to make way for the Rue de Turbigo; at Saint-Nicolas-du-Chardonnet, both the Virgin's Chapel and the choir were rebuilt in 1860–62 to make way for an extension of the Boulevard Saint-Germain. When the conventual buildings of the Temple de l'Oratoire (fig. 84) were demolished to make way for an extension of the Rue de Rivoli in 1854–55, Baltard wrapped the rear of the church in a freestanding gallery that duplicates the ground-story arcade of Percier and Fontaine's façade elevation for the street.[123] More than a device to conceal the misalignment of the Rue de Rivoli and the temple, this gallery is simultaneously a piece of historical shorthand and a bit of urban furniture that connects the seventeenth-century monument to the nineteenth-century street through a succinct ornamental gesture.

In 1858, after the early eighteenth-century church of the Barnabites was torn down to make way for the Boulevard du Palais, Baltard reerected its façade on the late seventeenth-century church of Notre-Dame-des-Blancs-Manteaux, whose own façade had never been realized.[124] Given the similarities between these nearly contemporary churches, and the approximate relation that Baroque façades usually have to the interior, this pairing of unrelated monuments would probably escape notice if Baltard had not drawn attention to the discrepancy with a new Chapelle des Catéchismes built at the same time along the south side of the church (figs. 85, 86). Placed at the juncture between two Baroque works of architecture, and for that reason finished exceptionally with Baroque, rather than Renaissance, details, this chapel presents two apparently unrelated elevations, one along its flank, which duplicates the rhythm of arched bays in the nave elevation above, and a blank end wall whose diagrammatic classical

FIGURE 84
Temple Protestant de l'Oratoire, Paris, 1621–1745, with a gallery arcade on the Rue de Rivoli added by Victor Baltard in 1854–55.

FIGURE 85
Notre-Dame-des-Blancs-Manteaux, Paris, 1685–90. Reused façade from the former church of the Barnabites (left) and the new Chapelle des Catéchismes added by Victor Baltard in 1858–63 (right).

order pulls its lines (but not mass) from the adjacent borrowed façade. A calculated collage, the chapel at once reflects the typical break between façade and interior of Baroque architecture and comments on the composite historical identity of a church assembled from different buildings.

What Baltard learned from working on the churches of Paris is summarized at Saint-Leu-Saint-Gilles. The Boulevard du Centre, ordered

by imperial decree of 29 September 1854 and renamed Sébastopol in 1855, was realized in sections from the Place du Châtelet to the Gare de l'Est.[125] In 1857, when the middle portion of the boulevard, between the Rues de Rambuteau and Greneta, sliced through the rear of Saint-Leu-Saint-Gilles, Baltard fit the church to the new thoroughfare according to the dictates of a detailed municipal program.[126] He truncated the apse, demolished three ambulatory chapels (including a central Virgin's Chapel), and boxed the now-exposed choir behind a parapet wall on the boulevard (fig. 87). To the south, on the Rue de la Grande Truanderie, he sandwiched a new Virgin's Chapel (vaulted with experimental concrete arches spanning twelve meters) between symmetrical building blocks for a presbytery toward the boulevard and service lodgings on the Rue Saint-Denis; he also slipped four small chapels and two sacristies between the Virgin's Chapel and the church proper and wedged a Salle des Catéchismes into the chapel attic. Eight narrow

chapels were strung along the church's north side, toward the Rue du Cygne. Facing the Rue Saint-Denis (fig. 88), Neo-Renaissance additions were distinguished from the original Gothic façade in a stylistic contrast that simultaneously related the two in a narrative of ongoing modification: the thirteenth-century church had already been remodeled with Italianate elements in the sixteenth century (and was restored in 1823–34 and again in 1847–49 by Godde and Baltard, when stalls against the façade were torn down).[127]

Located a stone's throw from the Central Markets, where Baltard was in those same years reconstructing Paris as an architecture of the rationally gridded void, Saint-Leu-Saint-Gilles is similarly compressed into a cubical footprint dictated by its street alignments. David Van Zanten concludes that Baltard meant the church "to mediate with its new Haussmannian situation urbanistically and stylistically," and indeed Haussmann was uncharacteristically complimentary of Baltard, praising him for the skill with which he carried out this "very difficult and very delicate operation."[128] The result, however, is not some radically simplified image of urban order. Developed three-dimensionally, the church unfolds with four different façades around a labyrinthine interior that contradicts the abstract clarity of the street alignments. Typologically complex, as much a neighborhood as a church, it presents two linked yet distinct systems of architectural detailing. The regularly fenestrated residential buildings at the corners are drawn with stylized drip moldings that pull their façades into compact blocks. These blocks push tightly up against the perimeter to frame the recessed and more varied volumes that the church proper presents to the Rue Saint-Denis (façade), the Rue de la Grande Truanderie (Virgin's Chapel), and Boulevard de Sébastopol (choir). Beneath their raised roof lines, the church elevations open through great arched windows,

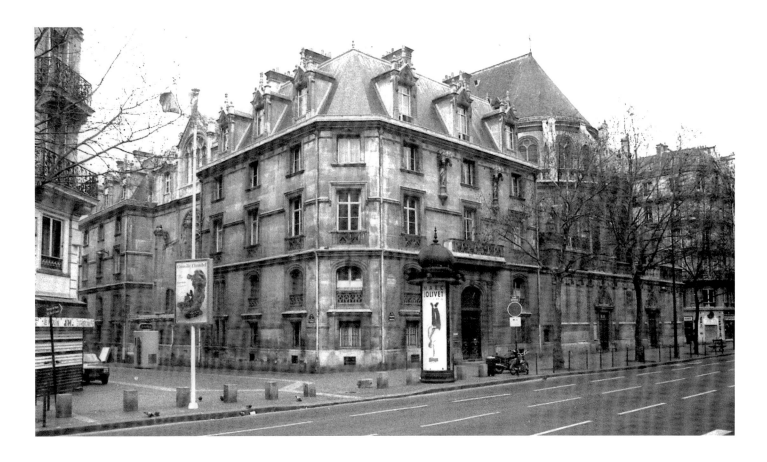

both pointed and round, whose curvilinear trac-
ery forms an expressive counterpoint to the linear
moldings of the residential blocks. The urban
dialog between domestic and monumental archi-
tecture comes together in the wall placed along
the Boulevard de Sébastopol at the foot of the
choir. Arranged in a five-part composition, from
outer towers to middle portals to central aedicula,
this wall is detailed with low-relief decoration
that fades into a nearly smooth surface when seen
obliquely from down the boulevard, yet remains
sharp and precise when viewed frontally from the
sidewalk. Stressing the perimeter alignment that
runs without interruption around the entire base
of Saint-Leu-Saint-Gilles, it holds the building's
complex pieces in place, as if preserving their his-
torical contradictions from the boulevard's mute
singularity of purpose.

After the project was approved by the Com-
mission municipale, on 9 August 1857, it was
reviewed by the Conseil des bâtiments civils, on
30 September.[129] In his report, Charles Questel
took the stylistic linkages for granted and praised
the ingenious layout of spaces. But he was harshly
critical of both the decision to flatten the choir
against the Boulevard de Sébastopol and the
failure to express the new Virgin's Chapel as a
separate volume: preferably, this should have
been placed next to the choir on the boulevard.
Ignoring the programmatic constraints placed on
Baltard, Questel wanted a conventional solution,
with orderly relations between distinct building
elements whose exterior masses were consis-
tent with their interior spaces. Instead, Baltard
developed the exteriors as much in answer to
their context as to the building's internal logic,

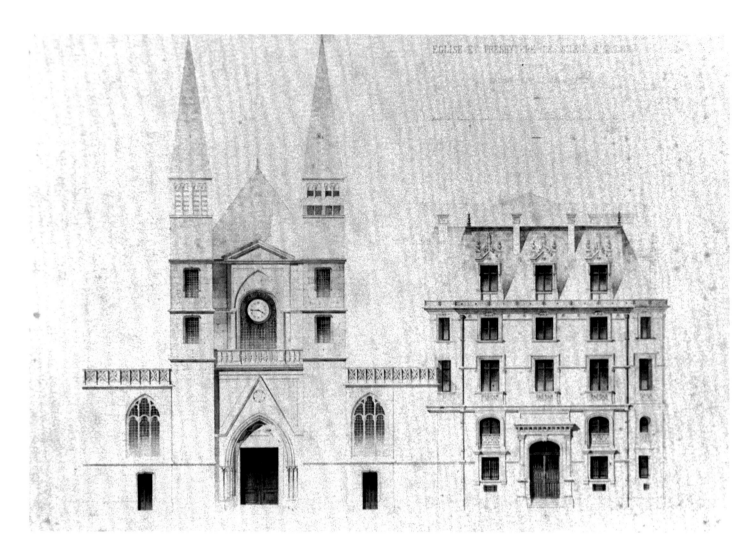

FIGURE 88
Victor Baltard, restoration project
for Saint-Leu-Saint-Gilles, 1857.
Façade elevation. Photograph
by Charles Marville. Private
collection of the Baltard family.

violating the rules of Beaux Arts composition by
adapting the choir to the boulevard while burying
the Virgin's Chapel within residential blocks. The
conseil concluded that Baltard's project "cannot be
adopted and . . . must be restudied in terms of the
preceding observations."[130]

Obviously, the utilitarian program mandated
by the prefecture contradicted the conventions of
architectural representation upheld by the Bâti-
ments civils. Just as obviously, another perspective
was at work in Baltard's effort to give to the historic
fabric of Saint-Leu-Saint-Gilles renewed relevance
in the modern city. Arguing for the city's density

of form and multiple uses, Baltard reinvented
Saint-Leu-Saint-Gilles as a piece of urban infill
whose deceptively unified massing holds a jumble
of monumental spaces embedded within a resi-
dential framework. Rather than confirm a neatly
legible dialectic between past and present, between
the isolated historic monument and the regulated
city of modernity, Saint-Leu-Saint-Gilles blurs the
two by reconstructing the block as a rehistoricized
quarter that brings into view the passage of time.
From the restored façade to the reconfigured apse,
this church traverses an interval in history between
the old Rue Saint-Denis, down which medieval

kings rode on horseback when entering the city, and the new Boulevard de Sébastopol, up which modern Parisians headed when leaving the city by train from the Gare de l'Est. Like the other churches under Baltard's supervision, Saint-Leu-Saint-Gilles was located at the city's intersection with modernity, its fabric provisionally reshaped into a sign at the crossroads between past and present histories of Paris. Treating the project as another historical collage, Baltard recorded on the building's surfaces the disruptions to which the church had been subjected by Haussmann's planning. His alterations, additions, and decorations restored the very thing threatened by the surgical gesture of the Boulevard de Sébastopol: the church's urban, and therefore messy, history.

Baltard's sympathies went to transitional works like Saint-Étienne, Saint-Eustache, and Saint-Leu-Saint-Gilles, whose hybridities of style were heightened, rather than muted, by his eclectic restorations and alterations of each building. Subsuming the Gothic while adjusting classical architecture to the cultural and climatic particularities of France, the Renaissance constituted for Baltard a validly national alternative to the impasse of stylistic rigidity proposed by the municipality when it commissioned the church of Sainte-Clotilde. Prefiguring the new churches built under his direction in the 1860s, these theoretically impure but physically real buildings concretized history for Baltard as the provisional adjustments of abstractly consistent styles to the determining, if inconsistent, conditions of culture, place, and need. His interventions in the churches of Paris paradoxically compromised their historical worth as artifacts of a past period or style in order to recover their ongoing relevance to the present. Contingent and incomplete in both form and content, the churches of Paris confirmed his understanding of the city as a mutable site where cultural meaning is continuously inscribed, erased, and reinscribed through decoration onto architecture's obdurate matter in response to the changing circumstances of daily life.

An Urban History of the Central Markets

The history of a building and that of a city coincide in the Central Markets of Paris. Proposed under Napoléon I in 1811, projected under Louis Philippe in 1834–47, built mostly under Napoléon III in 1854–74, and demolished under President Pompidou in 1971–73, the markets span the same two centuries of modernity that saw the physical and social transformation of Paris into the capital of an industrialized nation.[1] Whether they were indeed industrial machines or were instead works of art, whether they proved an instrumental rationalization of space or demonstrated the cultural persistence of place, the markets remain specific to modern Paris: they at once built upon and stood apart from earlier historical forms and ideas of the city. Like an urban microcosm to its urban macrocosm, the markets' material and ideological relations to Paris require that any history of the buildings be construed from a history of the city of which they were a part. At the same time, the markets were specific to Victor Baltard, who worked on them longer and more persistently than any other individual, from circa 1843 until 1870, when their crucial phases of conception and construction were carried out. Baltard's contribution to the making of the markets, and through them to the making of Paris itself, can be located in a concentrically narrowing historical field, from the city and the regulation of its spaces, to the pavilions and their planning, to the architect and his professional practice.

The competing interpretations of the Central Markets noted in chapter 1—as either utilitarian works of planning or aesthetic works of architecture—relate in turn to competing readings of the city as either a unified work of urbanism or a more diffuse work of urban history. Urbanism treats the city structurally, with primarily economic criteria to be applied through rational theories of urban planning that were first postulated in the nineteenth century to regulate the city at a time when its traditional patterns of growth were being disrupted by extensive social change. As Françoise Choay has pointed out, urban planning itself did not exist as a named discipline until 1867, when Ildefonso Cerdá defined it in his *Teoría general de la urbanización,* partly in response to Haussmann's Paris.[2] The discipline's antecedents have been traced, by Pierre Lavedan and other scholars, back to a group of politicians, social reformers, and critics who theorized Paris during the 1830s and 1840s in a debate over the city's perceived population shifts: Jacques-Séraphin Lanquetin, Ernest de Chabrol-Chaméane, A. Perreymond, and Hippolyte Meynadier among others interpreted Paris as variously demographic, spatial, economic, and aesthetic systems to be coordinated in a comprehensive urban plan that invariably included new Central Markets.[3] Prefigured in the fragmentary Plan des Artistes of 1794–97, such a plan was requested of Prefect Rambuteau by the municipal council in 1839 and would be

realized by Prefect Haussmann, who claimed to have derived his plan for Paris from a sketch given to him in 1853 by Napoléon III.[4] By 1854, Albert Lenoir and Pierre Landry could outline a *théorie des villes,* organized into spontaneous and planned types of city, and in 1864 César Daly credited Haussmann's modernization of the city to his reliance on a "general plan for the rectification of the circulation routes of Paris."[5]

Haussmann came along at precisely the right moment to take advantage of a newly theorized understanding of the city as systems of circulation. Marcel Royancolo and Françoise Choay have analyzed the prefect's emergent administrative practice in complementary essays on the industrial city for the multivolume work *Histoire de la France urbaine.*[6] Under the heading of "haussmannization," they explain how the city was progressively conceptualized as systems of spatial, social, and economic circulation in response to the Industrial Revolution and the triple crisis it supposedly provoked: the need to adapt the city to capitalist modes of production, transportation, and exchange; the need to adapt the city to the dislocations of population growth; and the need to adapt the city to industrial materials, methods, and systems of building. Haussmannization inverted the traditional hierarchies, putting streets before buildings and engineers before architects as municipal alignments took precedence over property lines, the regulation of public space invaded the private domain, and the city's quantification in a survey plan became more significant than aesthetic codes and traditions. From the theoretical formulations of the 1830s and 1840s to the plans anticipated under Rambuteau and executed by Haussmann, to the analyses by Armand Husson, Maxime du Camp, Charles Merruau, and other observers of the city's midcentury transformation, the argument was made for a systematic treatment of the city. This mentality was fundamentally

different from the journalistic view of the city presented in Louis-Sébastien Mercier's *Tableau de Paris* of 1781–88 and revived successively by Paul de Kock in his *Nouveau tableau de Paris* of 1842 and Edmond Texier in his *Tableau de Paris* of 1852–53.

Armand Husson—Saint-Simonian economist, municipal functionary, and regular participant in planning the Central Markets—advocated Haussmann's circulatory theory of the city in his *Consommations de Paris* of 1856 (with a second edition of 1875).[7] Documenting the rapid growth of Paris from 547,756 inhabitants in 1800 to 1,174,346 by 1856 and 1,851,792 by 1872, Husson connected this demographic "transformation de la Cité" to the expansion of the city's "population industrielle" with both workshops and factories; to the city's parallel mechanization through vehicular systems of transportation, including the eight train stations that replaced city gates as the principal means of arrival and departure; and to the city's consequent ability to meet the surging demand for goods that by 1872 had reached 4,879,674 kilotons delivered daily by rail.[8] He calculated that by the later 1860s the city consumed each year an average of 1,042,437,738 kilos of solid foods and 590,980,363 liters of liquids.[9] Reinforcing these facts was not only a positivist's conviction that the needs of Paris could accurately be quantified through statistical analysis but also the utilitarian conclusion that they could efficiently be addressed by planning the city's circulation. The Central Markets formed part of any plan: Husson estimated that each day an average of 4,500 vehicles, from handcarts to horse-drawn wagons, were used to distribute food in Paris, delivering it first to the markets and from there to local markets, shops, and restaurants spread across the city.[10]

Against urbanism's vision of the city as a singular object of master planning, urban history offers an alternative view of the city as the ad hoc

consequence of diverse conditions, decisions, and actions. As explained in chapter 1, the demolition of the markets in 1971 prompted the methodological shift found in Françoise Boudon's *Système de l'architecture urbaine,* from a story of instrumental planning to a more diffuse and finely grained history of how a city is shaped by the material, social, and ideological interactions of multiple individuals over time. François Loyer broadened this methodological premise in his 1987 survey of the city's streets and buildings in order to demonstrate that Haussmann's plan for Second Empire Paris was the outcome of sequential developments originating under Prefects Chabrol and Rambuteau during the Bourbon Restoration and the July Monarchy.[11] The implications of Loyer's research have been extended by Cars and Pinon in their reappraisal of Haussmann's Paris, by Van Zanten in his account of building Paris between 1830 and 1870, and by Nicholas Papayanis in his analysis of the antecedents to Haussmann's urbanism.[12] These works and others indicate the critical turn recognized by Loyer in his introduction to a collection of essays on the formation of Paris before Haussmann in the earlier nineteenth century: "Crossroad of disciplines, the study of cities ceased thirty years ago being purely prospective (as the instrumental practice of *urbanism,* described as a simple method of economic planning, had been for so long) to orient itself to the field of urban history."[13] Instead of the familiar claim, captured in Armand Husson's statistics and justifying Haussmann's master plan, that the city was in crisis, scholars are finding that Paris remained in an ongoing and provisional state of self-correcting physical and social adjustment to the conditions of modernity.[14] Urban theorists and planners were claiming credit for a process they could only reflect, never control.

Yet even as urban history has opened Paris to the renewed aesthetic appreciation found in studies like Donald Olsen's *The City as a Work of Art,* historians have continued to see the Central Markets in Haussmannian terms, as fundamentally utilitarian and economic interventions into the fabric of Paris that broke at once with the city's historical patterns of development and with its building traditions. Boudon interprets the markets as a radical transformation of the Halles quarter: "Haussmannian urbanism would take up, with the diagonal tracing of streets, the parcellary system of organizing lots from the late eighteenth century. This system would coexist with the simplest type of orthogonal organization, of regularly formed blocks, relatively few in number at the Halles, where the ancient topography resisted at every turn the systematization of the new urbanism."[15] Extending Boudon's thesis, Lemoine treats the markets in *Les Halles de Paris* as industrial machines that "inscribe themselves . . . as an autonomous system, complete, independent of the city on which they implant themselves like a foreign body."[16] In *Building Paris,* Van Zanten concludes that Baltard, caught between "the concrete needs of municipal architecture" and the "the niceties of traditional design," built a work that "was neither one thing nor another" but was instead a hyphenated "architectural-urbanistic artifact."[17] More recently, in "Paris Space: What Might Have Constituted Haussmanization," he writes of the final plan of 1853–54 for the Halles quarter around the Central Markets: "This is our first glimpse of Haussmann's urbanism, and it is not an aesthetic but an economic system—one in which private space coalesces into tight airless *'massifs'* floated in a grid of continuous broad streets."[18]

Falling into an interpretative gap between urban history and the history of architecture, the Central Markets have been left posthumously without grounding either in the city for which they were built or in the professional experience

of their designer. As a result, two questions have gone unanswered: how, exactly, was the systematic urbanism of the markets "resisted" (to borrow Boudon's term) or, more constructively, *informed* by the existing topography of the Halles; and what, exactly, was the connection in the markets' design between urban planning and architecture? Four points can be made in answer to those questions. First, the markets' design and the related plan for the Halles quarter were both largely in place by the time Haussmann arrived in office: the story of decisive intervention told in his *Mémoires* was a piece of political theater staged in 1853 to legitimize his authority as prefect over Second Empire Paris, but most of the actual work had already been done by Baltard and other municipal officials. Second, the project was the result of a protracted process of collaboration, justified by a series of legal, administrative, and planning instruments that were incrementally formulated from the 1830s onward. Third, the markets were the logical extension, rather than exception, to Baltard's other municipal commissions and addressed many of the same urban conditions. And fourth, as designed by Baltard between 1844 and 1854, the markets at once synthesized the city's historical patterns of growth with its spatial regularization in the nineteenth century and reconciled its historic identity as a city of stone with its industrial transformation into one of iron.

According to Baltard, the new Central Markets originated neatly in two edicts: Napoléon I's edict of 24 February 1811, which authorized a Grande Halle on the site of the existing markets; and Prefect Rambuteau's edict of 14 July 1842, which set up a Commission administrative des Halles to plan their construction.[19] In fact, the markets resulted from a lengthy and often contentious process of urban development dating back to the twelfth century and continuing at least until 1854. The actually uncertain, dynamic and

evolving, history of the markets was less about two autonomous moments of origin than overlapping events that cluster in three phases: a preparatory phase from circa 1137 to 1845, when the markets' administrative, urban, and architectural conditions were incrementally formulated; an initial phase of design and construction from 1845 to 1853, when Baltard's official project faced numerous counterprojects, including most famously those by the radical architect Hector Horeau and the engineer Eugène Flachat; and a definitive phase of design and construction from 1853 to 1874, when Baltard's iron-and-glass pavilions were finally realized. With a lag of just a few years, Baltard's work on the Central Markets tracks his career from 1840 to his retirement in 1870. Where Haussmann approached the Central Markets from the outside, bringing with him what he claimed was a fresh perspective in 1853, Baltard knew the project intimately from the inside, as an ongoing responsibility in which he repeatedly adjusted his design to the administration's evolving priorities. Instead of looking at the markets to see how their conception changed in 1853, the focus here will be on determining the degree to which that redesign was consistent with ideas that Baltard had been formulating all along. What distinguishes the final project was less a new set of criteria, at least for Baltard, than a distillation of ideas developed over a decade of activity into a work of urban architecture that was at once profoundly historical and radically modern.

PLANNING THE CENTRAL MARKETS, 1137–1845

The history of planning the markets is really two histories. The first is a history of the accumulating legal and administrative decisions by which the municipality of Paris defined the Central Markets as a public category of urban space subject to municipal regulation and policing, in which food

was to be distributed to the city from a centralized location and in a centralized system that coordinated wholesale and retail trade.[20] The second is a history of how Baltard adjusted the inherited architectural conventions to new constraints of municipal regulation and planning, and new industrial materials and methods of construction, by formulating an urban typology at the markets that synthesized the historic development of the Halles quarter as a spatial system of housing blocks and monuments like the church of Saint-Eustache with the vernacular model of the open-air market hall, whose modular and flexible construction in wood was translated into a structure of iron.[21] Experimental and contingent, both histories worked toward new criteria of urban administration and architecture, rather than from received ideas that were fully articulated at the start. Three men made telling contributions. Administratively, Prefect Rambuteau consolidated municipal authority over the markets and formalized the bureaucratic practices that later permitted Haussmann to realize the project. Urbanistically, the municipal councilor Jacques-Seraphin Lanquetin led a debate in the late 1830s and early 1840s that theorized the link between the markets and urban planning. And architecturally, Victor Baltard visualized the markets' urban typology, projecting by 1844 the principle of what would finally be built despite the many revisions still to come.

Inheriting and reconfiguring a history of legal and urban precedents starting in the Middle Ages, the markets were gradually transformed from an ad hoc and largely unregulated site of commercial exchange into an ordered public space. State and municipal interests in the markets of Paris had overlapped at least since 1137, when Louis VI instructed that existing marketplaces on the Île de la Cité and the Place de Grève be moved to a field outside the city called the Marché

des Champeaux. After Philippe Auguste decreed in 1183 the construction of a Halle aux Drapiers (for drapers) and a Halle aux Tisserands (for weavers), this commercial quarter became known as the Halles, fixing the distinction between the generic term for any market hall and what was now a specific place-name for an area of Paris. The Halles were officially incorporated into the city by the walls erected around Paris in 1190–1213. In the thirteenth century, three more market halls were added to the Halles, while shops proliferated along the surrounding streets. In 1543, François Ier issued an ordinance to rebuild the Halles (in a state of dilapidation after the Hundred Years' War) and to embellish the quarter with aristocratic mansions, confirming its status as a regulated, if still organically shaped, public space (fig. 89).[22]

In the eighteenth century, the municipality commissioned a grain market, the Halle au Blé. Erected in 1763–69 on the site of the Renaissance Hôtel de Soissons (1572), the Halle au Blé was designed by Nicolas le Camus de Mézières within a coherent urban scheme that coordinated the circular market with a surrounding network of radial streets (fig. 90).[23] On the eve of the Revolution, in 1780, the notoriously putrid Cemetery of the Innocents at the southeast corner of the Halles was closed: by order of Louis XVI, its charnel house was removed and replaced with an open-air fruit and vegetable market, the Marché des Innocents; simultaneously, Jean Goujon's Fontaine des Innocents (1547–49) was moved from its original site on the Rue Saint-Denis and reerected in the market's center on a base designed by the architects Jacques-Guillaume Legrand and Jacques Molinos. This transformation of a site of decay into one of social utility and health identified the markets as an urban counterpoint to the picturesque cemeteries that, starting with Père Lachaise, would soon be established at the city's edge.

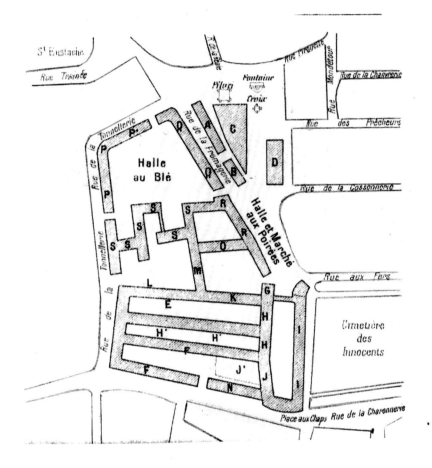

PLAN RESTITUÉ DES ANCIENNES HALLES DE PARIS
au seizième siècle (1543 à 1572).

Légende

A La Harengerie . Halle à la Saline
B Halle à la marée.
C Place aux marchands . Parquet de la Marée
D La Morue . Vente au détail du poisson de mer
E Halle aux draps (détail) et halle aux toiles
F Halle aux Tisserands . Halle de Beauvais Boucherie de Beauvais.
G La Ganterie.
H Basses Merceries.
H' Appentis des basses Merceries transformé en Jeu de Paume.
I Halle aux Lingères . Halle aux sueurs et Merciers sur les sueurs.
J Halle au Cordouan
J' Dépendances de cette Halle
K Etaux ou Halle aux Tapissiers
L Etaux ou Halle aux Chaussiers et Etaux à toile
M Halle aux Merciers . Entre la Halle aux Tapissiers et la halle aux Fripiers.
N Halle aux Chaudronniers.
O Halle aux Fripiers.
P Halle de St Denis.
P' Halle de Gonesse
Q Halle de Douai et au-dessus les greniers à Coustes (garde)
R Halle de Malines
S Halle du commun

(En 1786, suppression du Cimetière des Innocents)
(Inauguration du marché des Innocents le 14 Février 1789.)

If, however, it was now theoretically possible to comprehend the Halles as a public realm of commerce and hygiene subject to regulation and control, the markets themselves remained an eccentric agglomeration of buildings and stalls clustered around the Carreau de la Halle and spread along a weaving diagonal of streets that ran from the Pointe Saint-Eustache down to the Marché des Innocents. This irregularity reflected their largely spontaneous growth since the twelfth century. The Halle aux Draps, rebuilt in 1787 by Legrand and Molinos on the site of the earlier Renaissance hall, was the markets' single symmetrical and fully roofed structure, although the adjacent Halle au Blé and its streets suggested how they might be developed as a more systematic urban space.[24]

The law of 17 February 1800 that split control of Paris between a prefect of the Seine, charged with municipal administration, and a prefect of police, charged with municipal safety, health, and the regulation of commerce, reflected the premodern pairing of a *prévôt des marchands,* representing the merchants, with a *prévôt de Paris,* appointed by the king to maintain public order. This division of responsibilities had direct consequences for the Halles.[25] On 30 June 1800, the Prefecture of Police was charged with inspecting both markets and foodstuffs in Paris, which allowed the

FIGURE 89
Plan of the Central Markets, Paris, 1543–72, from Jules Vigneau, *Halles centrales de Paris* (1903).

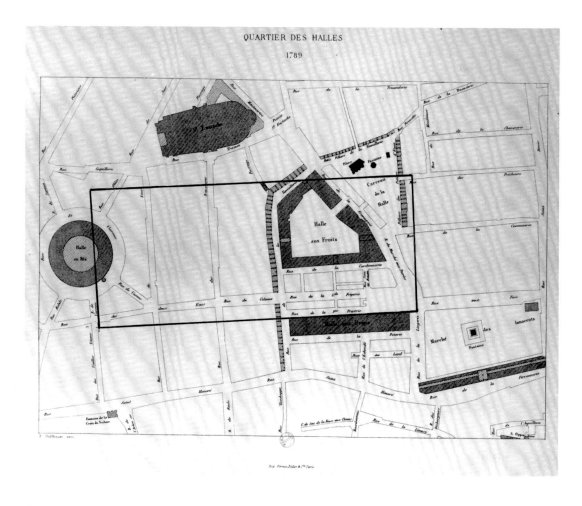

FIGURE 90
Plan of the Halles quarter, Paris, 1789, by F. Hofbauer after Edme Verniquet, *Atlas du plan général de la ville de Paris* (1791), with perimeter added of Central Markets as decreed in 1811.

first two prefects of police, Louis-Nicolas Dubois (1800–1810) and Étienne-Denis Pasquier (1810–14), to assert their jurisdiction over the markets against the rival claims of the prefect of the Seine, Nicholas Frochot (1800–1812). Another decree, of 21 September 1807, confirmed the markets' regulatory supervision by the police even as it granted to the Prefecture of the Seine the right to collect rental fees and tariffs in return for erecting covered sheds. Further decrees, of 26 March 1806 and 30 January 1811, ceded those markets to the city, briefly resolving a historically muddled matter of ownership in favor of the Prefecture of the Seine and its claims of authority to plan the markets. Despite the objections of subsequent prefects, from Rambuteau to Haussmann, the Central

Markets were realized under these competing structures of surveillance and planning.

In 1811, Napoléon I proposed replacing the existing Central Markets with a Grande Halle that would be, not "a monument, but a useful establishment . . . a large regulatory market."[26] The emperor ordered its construction in an edict of 24 February and then fixed its perimeter in a second edict, of 19 May, plotting a vast rectangle that cut through the quarter from the Halle au Blé to the Marché des Innocents (fig. 90).[27] Pierre Baltard prefigured and may even have determined this perimeter in three projects he submitted to the Ministry of the Interior in 1809; François Bélanger, Louis Bruyère, and perhaps Pierre Fontaine followed with designs for four to six large

open halls that, in the case of Belanger's project, featured metal roofs.[28] Bruyère and Fontaine both had close ties to the current government, and Bruyère had just been named the *directeur des travaux* in January 1811, which suggests that the basic scheme was nearing approval. Municipal revenues, however, did not match the projected scope of the work: besides the Grande Halle, four local markets, five slaughterhouses, and a wine warehouse on the Quai Saint-Bernard were planned. To finance the estimated construction costs of nearly 19.5 million francs, including 6 million francs for the Grande Halle, the edict of 24 February transferred ten municipal markets (among them the Marché du Légat and the Marché des Innocents) to the Administration des hospices. A semiautonomous municipal agency charged with welfare services, the Administration des hospices funded its activities in part through rental income from real-estate holdings: in exchange for the right to collect fees from the markets, the *administration* agreed to lend 12,330,577 francs toward the costs of new construction by selling off its residential properties; the prefecture was obligated to fund the balance of 7,116,000 francs.[29]

In 1813, the Marché des Innocents was enclosed with wooden porticoes, and work began on the four neighborhood markets. But plans for a Grande Halle had stalled, a victim, according to Lemoine, of Napoléon I's distraction with his failing empire after 1812.[30] Jean-Marc Léri suggests another, perhaps more immediate reason for the delay when he notes that the edict of 24 February 1811 had exacerbated an already confused situation by ceding ownership of the markets to the Administration des hospices, which now assumed responsibility for tasks of surveillance and planning attributed since 1800 to the Prefectures of Police and the Seine.[31] In a situation of such uncertain and fragmented authority, ambitious plans for a Grande Halle became unfeasible.

Compounding the confusion, a subsequent royal ordinance of 30 October 1818 confirmed the power of the municipality to set tariffs at the markets, even though revenues went to the Administration des hospices.[32] Consequently, only modest projects were undertaken during the Bourbon Monarchy. A royal ordinance of 24 November 1817 instructed the Administration des hospices to erect five markets, four of them at the Halles: a Halle au Beurre (dairy) and Halle au Poisson (fish) by Hubert Rohault, a Marché des Prouvaires (meat) by Huvé, and a Marché à la Verdure (greens). Completed by 1824 and built entirely of wood, these covered stalls and hangars filled the remaining open space in the Carreau de la Halle with fish and dairy halls and extended the public markets west toward the Halle au Blé, past the stalls for greens to the meat stalls set up between the Rue des Prouvaires and the Rue du Four (fig. 91). Any regularization of space remained internal to these modular wooden structures, which were simply wedged into the existing jumble of streets without any thought given to a general plan.

Rambuteau revived Napoléon's project for a Grande Halle, thanks to a series of laws that authorized the prefecture to realize large public projects.[33] The royal ordinance of 31 December 1830, transferring responsibility for municipal works from state to city management, was followed by successive laws of 7 July 1833 and 3 May 1841 justifying the expropriation of private property for reasons of public utility—although those laws also strictly limited the expropriated property to the area immediately affected by a project and its related street alignments. Complementary royal ordinances of 7 March 1834 and 1 September 1835, subsequently absorbed into the definitive law of 3 May 1841, stipulated the public review of all proposed expropriations: plans were to be displayed for eight days at a district town hall, followed by

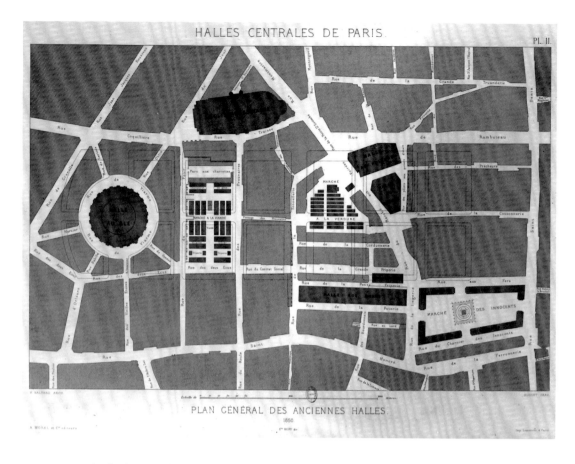

FIGURE 91
Plan of the Central Markets, Paris, 1850, from Victor Baltard and Félix Callet, *Monographie des Halles centrales* (1863).

an inquest and a final report from a municipal commission, before the prefect could take action. Effectively, this subjected public projects to the often parochial interests of property owners and their elected representatives from each district of Paris, a situation reinforced by laws of 21 March 1831 and 20 April 1834 that replaced the previously appointed Conseil municipal, of twenty-four members, with an elected council of thirty-six members representing the city's twelve districts. (The councilors and the two prefects, plus the twelve district mayors and their adjuncts, formed the "municipal corps" of city government.) Faced with such a structure of vested interests, Rambuteau adopted a Solomonic strategy as he negotiated his way between multiple claims to the city. On the one hand, as he later explained in his *Mémoires,* he cast himself as a neutral civil servant

in his dealings with the state: "I do not so much want to say that the King never asked me to speak frankly as to say that by this time [the 1840s] I hardly exercised the right: I was nothing more than an administrator, having nothing to do with politics, and no one thought to consult me." On the other hand, the prefect acted as a check of reasoned reflection and fiscal prudence on the impulsive Conseil municipal: "That was my system to prevent my elected municipal council from throwing itself headlong into every reform for the sake of innovation and from seeking popularity while demolishing the budget and the government."[34]

Within, however, the limits imposed alike by law and his own cautious temperament, Rambuteau worked to increase the prefecture's reach over all aspects of the city, including its markets. Between 1834 and 1842, he recovered control and

then ownership of the municipal markets, removing obstacles that Napoléon I had placed in the way of the Grande Halle when he ceded those markets to the Administration des hospices.[35] After the Conseil municipal proposed to buy back the markets in 1834, Rambuteau asserted the prefecture's claim by careful degrees. He first, in an edict of 14 November 1834, extended the jurisdiction of municipal tax collection, performed by the Service d'inspection des perceptions, to those markets ceded to the Administration des hospices in 1811; a second edict, of 18 September 1838, extended this to the new markets built by the Administration des hospices since 1811. On 1 January 1835, the prefecture regained direct responsibility for managing the markets, which it now rented from the Administration. After the Conseil municipal, on 22 July 1842, approved the cost of repurchasing the markets and the Administration des hospices, on 24 August, accepted the city's offer, Rambuteau, on 23 December, signed a treaty agreeing to pay to the Administration a thirty-year annuity at 5 percent (for yearly payments of 615,526 francs until 1874).

In those same years, the prefecture began to investigate the Halles as a public space of utility subject to planning. In the first of many planning studies to come, a municipal surveyor (*architecte-voyer*) named Lahure completed an *Études sur les Halles* in January 1837.[36] Perhaps prepared in consultation with the similarly named Louis-Auguste Lahure, city councilor and adjunct mayor for the fourth district, this study was submitted for review to the municipal Commission de la grande voirie, on which Councilor Lahure served.[37] The architect Lahure calculated that the current markets (including the Marchés des Prouvaires and Innocents) occupied 17,945 square meters, of which only 8,290 were covered; when the 18,680 square meters of surrounding streets were included, the total area measured

36,625 square meters. He advised more than doubling the markets proper to a total of 39,367 square meters through 18,527 square meters of street and property alignments at an estimated cost of 9,253,500 francs. All affected streets were to be regularized at a width of thirteen meters, in an early instance of Prefect Rambuteau's emphasis on the "plan d'alignement," on straightening streets over widening them or opening new ones. This recommendation to enlarge and regularize the markets asserted a nascent program of urban planning whose first concrete expression would be the Rue de Rambuteau: extrapolating from the precedent of the Rue de Rivoli (authorized by an edict of 21 April 1802), this street was ordered by royal ordinance on 5 March 1838 to run from the Rue des Francs-Bourgeois in the Marais to the Pointe Saint-Eustache at the Halles.[38] Criticized for its miserly width of thirteen meters yet cut in a straight line right through the heart of medieval Paris, the Rue de Rambuteau was cautious and forward-looking in equal measures.

That same March, the Conseil municipal began deliberating street alignments around the markets. As the councilors became more involved in the planning process, they began to challenge Rambuteau for greater say over the decisions being made. On 1 August 1839, the *conseil* requested "that a general study be done . . . and a master plan be drawn up" for the city so that the administration's funding priorities for public works could be evaluated accurately.[39] This request came at the instigation of Jacques-Séraphin Lanquetin, a wholesale wine merchant who had been elected to represent the ninth district in November 1834; like his colleague Lahure, Lanquetin was a member of the Commission de la grande voirie, where he made it his business to scrutinize every "work executed or proposed by the administration."[40] When Rambuteau ignored the call for a master plan, the Conseil générale de la Seine asked, on

28 October 1839, that the administration study the migration of people and industry from the center to the western edge of Paris and correct this demographic and economic displacement with "large thoroughfares and the suppression of unhealthy streets by the reconstruction of the blocks they cross."[41] On 20 November, Interior Minister Tanneguy Duchâtel preempted Rambuteau and established a commission to study the "question of the displacement of the population of Paris."[42] Beside the prefects of police and the Seine, seven municipal councilors were named to this commission: Lahure and Lanquetin, along with Édouard-James Thayer (second district), the architect Edme-Jean-Louis Grillon (fifth), the lawyer Antoine-Jean Galis (ninth), the artist and engraver Édouard Gatteaux (tenth), and the lawyer Jean-Denis-Marie Cochin (twelfth). The commission first met on 11 May 1840 under Charles de Rémusat (who had succeeded Duchâtel as interior minister) and convened twice again in 1840–41.

The question of displacement got its urgency from Parisian elites' mounting fear that the city's center and Left Bank were being abandoned to an urban underclass of working poor, who crowded into increasingly inadequate and unhealthy housing while wealthy professionals, businessmen, and property owners relocated to new districts under development on the Right Bank.[43] The perceived threat of a growing working class to the city's social order, and the apparent inequities in municipal services going to the two parts of Paris, prompted an extensive public debate over the city's "displacement," which in turn generated a set of proposals that directly anticipated Haussmann's planning after 1853.[44] At the commission's first meeting, in May 1840, Lanquetin asserted the "necessity for a new systematic study of works of city planning."[45] Claiming that Paris was being transformed from a "city of consumption" into a "city of commerce, factories, and manufacturing,"

he used a comparative analysis of census figures from 1817, 1831, and 1836 to argue that this transformation had disproportionately favored the first, second, and third districts on the city's Right Bank.[46] During a period when the city had grown from 713,966 to 868,438 inhabitants, those three districts had each shown vigorous rates of growth, accompanied by extensive new construction and rising property values. Conversely, seven districts exhibited only modest or depressed rates of growth: the fourth, seventh, eighth, and ninth in the center; and the tenth, eleventh, and twelfth on the Left Bank.

To counter the continuing displacement of people and wealth, from their historic concentrations in the center and Left Bank to the newly fashionable Right Bank districts on the northwest side, Lanquetin proposed a three-pronged solution that hinged on moving the Central Markets. First, congestion in the center would be alleviated by creating an "immense square" on the site of the Halles, with wide streets "radiating from this point to the extremities" of Paris.[47] Second, a new wholesale general market would be built across the Seine, in the twelfth district on the Left Bank (fig. 92): drawn up by the architect Victor Grisart in 1843, this project took advantage of cheap land on the largely vacant grounds of the former Couvent des Bernardins, just off the Quai de la Tournelle and adjacent to the Halle aux Vins; the nearby Boulevard de l'Hôpital provided convenient access to the ring of boulevards circling the city.[48] Third, a series of new or widened streets, linked across the Seine by toll-free bridges (including one at the Quai de le Mégisserie), would facilitate the fluid movement of people, vehicles, and goods from the periphery back through the center and onto the Left Bank. According to Lanquetin, the growing city had absorbed the Halles into an increasingly congested center of narrow streets, negating

FIGURE 92 (*opposite*)
Victor Grisart, project for the Central Markets on the grounds of the former Couvent des Bernardins, Paris, 20 March 1843. Plans, section, and elevation. Document held at the Centre historique des Archives nationales de France, Paris.

PROJET DE HALLES GENERALES

A ELEVER SUR LES TERREINS DES BERNARDINS ET DU CARDINAL LEMOINE

COUPE SUR LA LARGEUR

ELEVATION GEOMETRALE DE L'UNE DES HALLES

PLAN GENERAL

A. Fourrières pour remiser les voitures.
B. Escaliers desservant les bureaux établis
C. Colonne de garde.
D. Centrale.
E. Latrines publiques.
F. Ecuries pour 40 chevaux.

SUPERFICIES

HALLE AUX VINS

PLAN GENERAL

PROJET DE HALLES GENERALES

PLAN DETAILLÉ
DE L'UNE DES HALLE AUX LEGUMES

PLAN DETAILLÉ
DE LA MOITIÉ DE LA HALLE
AUX FRUITS

Paris ce 20 Mars 1845

FIGURE 93
A. Perreymond, plan for the center
of Paris, from *Revue générale de
l'architecture* (1843).

the advantages of its once-peripheral location
in the twelfth century. Moreover, its dual use
as combined wholesale and retail markets had
been rendered obsolete by the numerous local
markets built around the city, particularly in the
nineteenth century. Because the quarter's retail
needs could be met by the Marchés des Innocents
and Prouvaires, the wholesale markets could be
removed from their present location.

Lanquetin's arguments were seconded by
Édouard Gatteaux, who also reported to the com-
mission in May 1840: "It is evident that there
is a displacement of population in Paris." Less
troubled than his colleague by a phenomenon
he believed to be "commanded by the prosperity
of our age," Gatteaux recommended mitigating
its effects by "forming squares and gardens in the
center of the city," "reconstructing the Halles in an
appropriate place" (he did not specify where), and
"multiplying and enlarging" the main thorough-
fares of Paris.[49] Probably at this same meeting,

Ernest de Chabrol-Chaméane then spoke on
behalf of the three Left Bank districts. Concep-
tualizing Paris as a mechanism of interdependent
functional parts, Chabrol-Chaméane claimed that
the city's displacement could be stopped, and bal-
ance between its various districts restored, with a
coordinated plan of streets that reconnected the
periphery to the center, itself organized around a
core of municipal institutions and services.[50]

A subcommittee charged with verifying the
city's population shifts through a review of census
figures from 1817 to 1836 confirmed Lanquetin's
analysis when it reported to the commission at
its next meeting, later in 1840.[51] The hypothesis
of displacement had meanwhile gathered public
support.[52] Following Chabrol-Chaméane, the
pseudonymous Fourierist and engineer A. Perrey-
mond formulated a general urban plan for Paris
in nine articles published in the *Revue générale
de l'architecture* in 1842–43 (fig. 93).[53] Adopt-
ing a biological metaphor, Perreymond argued

that the unequal effects of the city's social and economic displacement from the center to the northwest proved that "Paris lives an abnormal life."[54] To cure its urban pathology, he prescribed rebuilding the center of the city as a "foyer of action capable of reestablishing equilibrium" between the Right and Left Banks.[55] The Île de la Cité and the Île Saint-Louis, connected to each other and the Left Bank by filling in the Seine's left channel, were transformed respectively into a Nouvelle Lutèce, for the city's administrative, judicial, and cultural institutions, and a National Bazaar, for new central markets along with other municipal warehouses and depots.[56] A cross-axial network of streets integrated both the city's railroad stations and the Seine into a comprehensive urban system of circulation.[57]

Where Chabrol-Chaméane and Perreymond defined the city in functional and organic terms, Hippolyte Meynadier presented an aesthetic and empirical perspective in his 1843 study, *Paris sous le point de vue pittoresque et monumental.* A former bureau chief of theaters in the Direction des Beaux-Arts, Meynadier was closer temperamentally to Gatteaux than to Lanquetin, and he took the similarly qualified view that the city's displacement should be tempered rather than stopped, because it reflected inevitable consequences to the growth of Paris. Even so, he called for "a system of new main thoroughfares of communication" and "a general master plan" to coordinate the city's unequal development between its Left and Right Banks.[58] Believing that any plan for Paris had to be based on its patterns of daily life, Meynadier avoided the social engineering advocated by Lanquetin, Chabrol-Chaméane, and Perreymond, emphasizing instead the aesthetic potential of new streets and other embellishments to "regenerate" declining quarters of Paris by making them more attractive.[59] Because of the fourth district's established economic interests, Meynadier rejected the

idea of moving the Halles and suggested instead that new markets be built within a vast rectangle covering forty thousand square meters along the axis of a "Boulevard du Centre" that he predicted (accurately) would run between the Place du Châtelet and the Rue Aubry-le-Boucher.[60]

Lanquetin's thesis of displacement seemed to carry the day. Rambuteau, however, was skeptical from the start, resisting the petitions of the municipal council and writing in protest to Duchâtel in November 1839: "Paris is not displacing itself, Paris is growing."[61] Indeed, Louis Daubanton, a former *inspecteur général de la voirie* under Chabrol, observed in 1843 that current statistics on the growth of Paris contradicted Lanquetin's demographic analysis.[62] Three years later, on the basis of the 1846 census and a population of 1,053,897 inhabitants, Rambuteau categorically denied the city's displacement: "There is nothing abnormal in the direction of this population growth; every district has grown notably, and no part of the city has become poorer. There is therefore no question, as had often been said, of a population displacement and the abandonment of the Left for the Right Bank."[63] As Horace Say explained that same year, Lanquetin had mistaken the actual growth of each district of the city for the apparent displacement of population from the center to the periphery.[64] Ignoring the fact that the population of Paris had historically been driven, not by its birthrate, but by immigration from the countryside, Lanquetin failed to consider that expansion occurs opportunistically where land is available. What the councilor mistook as the displacement of people and wealth from one part of the city to another was instead the difference between rapid growth in less developed districts bordering the city and necessarily slower growth in the built-up central districts.[65]

Rambuteau's opening in the debate over displacement came in the fall of 1840, when the

subcommittee to the ministerial commission turned to remedying the displacement it had supposedly proved. On instructions from Rambuteau, the bureau chief of the prefecture's Service de la grande voirie, Hourdequin, prepared a new study of the Halles in October of that year.[66] Accepting Lahure's recommendations from 1837, Hourdequin rejected any need to move the Halles from the Right to the Left Bank. He did acknowledge two points made by Lanquetin: the Halles should become a dedicated wholesale market; and higher-than-anticipated costs for the Rue de Rambuteau proved that Lahure's preliminary estimate of 9,235,500 francs to acquire property (at an average of 500 francs per square meter) had been too low. But whereas Lanquetin calculated the cost at 1,453 francs per square meter, for an exorbitant total of 26,887,339 francs, Hourdequin brought this estimate down to 16,656,300 francs by recalculating the average cost at 900 francs per square meter. Because this figure was still too high, he revised Lahure's evaluation of how much property would be needed for the project. Noting that of the 18,680 square meters of area covered by streets, 10,628 were already contained within the Halles, Hourdequin reasoned that only 8,000 of the 18,527 square meters required by Lahure had to be purchased, at a cost of 9,492,300 francs: 4,887,900 francs for the markets proper and 4,604,400 francs for the surrounding streets. This provided an area of 20,908 square meters between the Rue de Rambuteau to the north, the Rue de la Tonnellerie to the west, and the Rues des Piliers Potiers and Mondétour (straightened and extended) to the east.[67]

Lanquetin counterattacked in March 1841, accusing Hourdequin (and, by implication, Rambuteau) of failing to recognize how his "new idea" for the markets transcended the self-interest of individual districts, and looked instead to the future with a plan for the entire city.[68] That same

month, the commission discussed his report along with that of Hourdequin in its third and final meeting, and then disbanded without issuing any conclusions. By the time Lanquetin published another report of protest, in April 1842, he had lost the initiative.[69] Rambuteau moved quickly to regain control of the process. On his instructions, Lahure had in May 1841 already drawn up a second iteration of his plan for the Halles, which led to a final revision of July 1842 (fig. 94).[70] Approaching the perimeter set by Napoléon I in 1811, Lahure's plan hypothesized the renewal of an entire quarter with a market complex covering 41,843 square meters in two parts: (1) a regularized and enlarged Marché des Prouvaires, with pairs of covered markets to either side of an aligned Rue des Prouvaires (14,942 square meters); and (2) the Carreau des Halles, framed by four covered markets between a straightened Rue de la Tonnellerie to the west and a new Rue des Piliers Potiers pushed farther to the east (26,901 square meters). Like Hourdequin, Lahure suggested moving the Fontaine des Innocents to the center of the Carreau des Halles. The Marché des Innocents, measuring 8,424 square meters, brought the total area to 50,267. Now estimating property expropriations at 674 francs per square meter, he calculated it would cost 10,256,080 francs to purchase the additional 15,215 square meters that were needed. That same July, an inspector of municipal weights and taxes named Daniel confirmed the economic and functional viability of the markets in their current location, repeating Lahure's recommendations while arguing (against both Lanquetin and Hourdequin) that the Halles continue to serve both wholesale and retail needs.[71]

By edict of 14 July 1842, Rambuteau established a Commission administrative des Halles to plan the new Central Markets.[72] Making it clear he was in control, the prefect appointed twelve

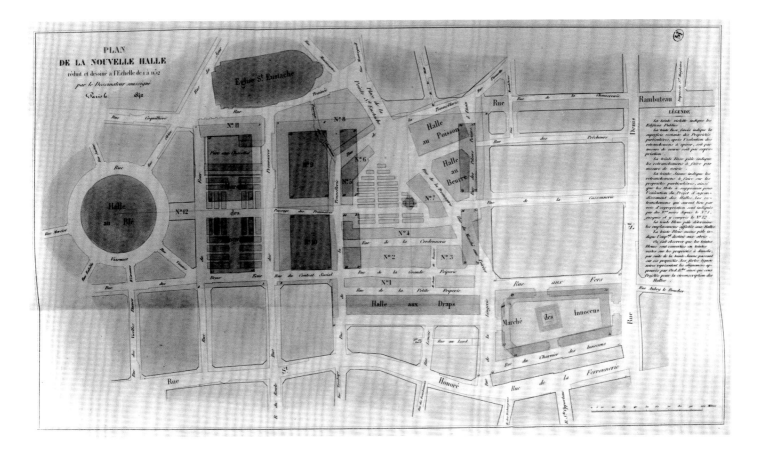

members of his staff, mostly bureau chiefs, to serve alongside (and outnumber) the seven municipal councilors named to the commission: Gatteaux, Lahure, and Lanquetin, along with Louis-Édouard Besson, Auguste Ganneron (second district), Claude Etignard de Lafaulotte (first), and André Périer (seventh). At the commission's first meeting, Rambuteau confirmed that the markets were staying put: "their central position, with respect to every part of the population in our great city, the advantage that they offer for the concentration of the most necessary products and foodstuffs, finally the customs that have been developed and maintained by the markets for many centuries, are powerful reasons why the administration will respect the present situation."[73] Rambuteau presented Lahure's project verbatim to the commission and predicted confidently that the new

markets would be realized in five to six years at a total cost of 14 to 15 million francs: the 10,256,080 francs estimated by Lahure for property expropriations plus another 4 million francs for construction.

In the end, Lanquetin failed to make his case either for the displacement of Paris or for moving the Halles. Because the pragmatic Rambuteau proved more adept than the utopian Lanquetin, both at reading statistics and in getting his way, he ensured that a respect for the historical persistence of place won out over an instrumental master plan. Nonetheless, Lanquetin made a lasting contribution to the debate over planning the city. One of the first to conceptualize Paris as a "work of urbanism," Lanquetin catalyzed the city's theorization during the 1840s by Chabrol-Chaméane, Perreymond, Meynadier, and others.[74] Relating the

FIGURE 94
Lahure, site plan for the new Central Markets, Paris, 5 July 1842.

Lanquetin altered the terms to every future plan for the markets, because his proposal for Paris, however impractical, had translated a conventional project of architecture into one of urban planning.

Meeting on 20 April 1843, the administrative commission concluded a heated debate between Lanquetin and the prefect of police, Gabriel Delessert, by voting "unanimously, less one vote," to keep the Halles in their current location as mixed-use wholesale and retail markets.[75] Soon afterward, the architect Auguste Magne exhibited a design for the markets, which he inscribed to Rambuteau in the apparent hope of securing the commission.[76] Described in the press, Magne's project laid out a symmetrical complex on a site of thirty thousand square meters run along an axis from the Halle au Blé to the Rue de la Cosson-nerie: two markets with 230 stalls for dairy and fish toward the Rue du Four; a large market in the middle, organized cross-axially by four cast-iron sheds with 824 stalls wrapping the corners around an open square focused on the Fontaine des Inno-cents; and two more markets with 496 stalls for meat and poultry toward the Rue de la Lingerie. The Marché des Innocents was designated a "parc aux charrettes," with space for 410 carts sur-rounded by stables for 300 horses.

When exactly Victor Baltard entered the plan-ning process is uncertain, though he was presum-ably encouraged to do so both by his father and by Édouard Gatteaux: Gatteaux gave Baltard a copy of his report on the displacement of Paris and was well positioned to pass on to him relevant infor-mation as a member first of the original ministe-rial commission and then of the prefect's admin-istrative commission. Like Magne, Baltard was possibly stirred to action by the decision in April 1843 to move ahead with a design for the Cen-tral Markets at their present site. Whatever the impetus, what is probably his first ink-and-pencil sketch of the markets (fig. 95) corresponds closely

FIGURE 95
Victor Baltard, project for the Central Markets, Paris, after April 1843. Sketch site plan and perspectives. Document held at the Centre historique des Archives nationales de France, Paris.

markets to the greater growth of Paris, he shifted the focus from planning buildings to planning streets: what began as a narrowly practical scheme now answered to a theoretical need to compre-hend the city as coordinated systems of circulation.

enough to published descriptions of Magne's project to indicate they were addressing a common set of criteria.[77] There are differences: Baltard added two more (octagonal) pavilions toward the Halle au Blé, reshuffled the pavilion functions, and ran the markets all the way to the Rue Saint-Denis. The two perspectives included in Baltard's sketch show him thinking of a composite construction, with masonry walls and metal roofs. In 1843, the use of iron was still fairly precocious, a gesture of modernity anticipated by Labrouste's Sainte-Geneviève Library and contemporary with the original shed of Armand and Flachat's Gare Saint-Lazare (projected in 1843). The justification, however, was probably closer to hand in the utilitarian architecture of market halls and their own evolution from traditional constructions of wood and masonry into industrial structures of iron. The Halle au Blé, visible at the back of Baltard's perspectives, was an obvious model: after fire destroyed the Halle au Blé's wooden dome, it was replaced in 1808–13 with one of iron and copper by François Belanger (who also proposed metal roofs in his 1811 project for the Grande Halle). More recently, two local markets in the city had also received metal roofs: Gabriel Veugny's Marché de la Madeleine, projected in 1824 and finally realized in 1838, and the Marché des Blancs-Manteaux, rebuilt in 1837–40 by Antoine-Marie Peyre and Louis-Ambroise Dubut with a new roof of iron, zinc, and glass dropped atop the original masonry walls.[78]

Baltard's preliminary sketch led next to a pair of rendered plans (fig. 96).[79] Though signed and dated 1844, these conform to Lahure's master plan of July 1842 and were almost certainly drawn up before a major rethinking of the site in November 1843.[80] The two plans proposed a phased development of the site, which when complete would extend the markets from the Rue du Four to the Rue Saint-Denis with four octagonal and two oblong paired pavilions to either side of the Carreau des Halles. This square is enclosed by sheds and has a central clock tower (seen as well in the earlier sketch); the Halle aux Draps to the south of the *carreau* is mirrored by another rectangular building to the north, in a line of administrative pavilions run along the Rue de Rambuteau. Residential blocks on the Rue du Contrat Social have notched corners that mirror the spatial footprint of the two square pavilions on the Rue Trainée (de Rambuteau), while a fountain turns the corner of the Pointe Saint-Eustache between the Rues Montmartre and Montorgueil. Despite these urban gestures, however, Baltard at this stage still conceived the markets as a monumental complex of freestanding and formally distinct pavilions that interrupted the texture of the surrounding quarter. Their strong geometry echoes that of the Halle au Blé, whose circular form and radial streets similarly broke with the quarter's quadrangular housing blocks.

Another pair of plans, sketched in ink on tracing paper (fig. 97), investigates an alternate solution that shifts attention from formalizing the markets proper to coordinating the entire Halles quarter through a system of streets.[81] Framed by the Rues des Prouvaires, de Rambuteau, Saint-Denis, and du Contrat Social, the market pavilions (separated from a smaller Marché des Prouvaires) are distributed around the diagonal intersection between an extended Rue Montmartre and a projected second street; in the second project, this new street runs all the way from the Rue Saint-Honoré to the Rue de Rambuteau. Other streets are either eliminated (Rue de la Poterie) or extensively straightened (Rue Saint-Honoré), and the Marché des Innocents is replaced by a public square. Adopting Lanquetin's suggestion that the Halles be turned into an "immense square" with streets "radiating from this point" to the rest of Paris, Baltard not only picked

FIGURE 96
Victor Baltard, general project
for enlarging the Central Markets,
Paris, after April 1843. Site plan.
Bibliothèque historique de la ville
de Paris.

FIGURE 97
Victor Baltard, project for the
Central Markets, Paris, after April
1843. Sketch site plan. Document
held at the Centre historique des
Archives nationales de France,
Paris.

FIGURE 98
Victor Baltard (attributed)
for Gabriel Delessert, site plan
for the Central Markets, Paris,
30 November 1843. Bibliothèque
historique de la ville de Paris.

up the historic diagonal of squares and streets crossing the Halles in line with the Rue Montmartre (see fig. 91) but also anticipated two streets planned under Haussmann: the Rue des Halles, authorized in 1854 from the markets down to the Place du Châtelet, and the Rue de Turbigo, authorized in 1858 from the markets up to the Place de la République. The pavilions, however, are still developed conventionally from the inside out as geometrically distinct and largely self-referential forms that are imposed on the quarter's grid of housing blocks.

The markets were then completely rethought in a plan presented by the prefect of police to the Commission des Halles on 30 November 1843 (fig. 98).[82] Though unsigned, the plan was almost certainly drawn up by Baltard: he was already working for Gabriel Delessert in those same years on the Boulevard de Bonne

Nouvelle police station, and this initial scheme leads directly to his signed and nearly identical plan of 17 July 1844 (fig. 99).[83] An irregular grid weaves four approximately rectangular and four approximately square pavilions into an urban fabric drawn directly from the quarter's network of streets. The grid subdivides into two types of street to organize the circulation of people and goods: public thoroughfares circle the perimeter and cut across the markets at the Rues des Prouvaires and de la Tonnellerie, while service alleys run contiguously around each pavilion. Double rows of trees separate alleys from thoroughfares and signal a decisive conceptual shift from building to street: the sectionally zoned architecture (detailed at upper right of the 30 November plan) erases the traditional distinction between inside and outside by layering space continuously from pavilion to covered sidewalk to service alley to

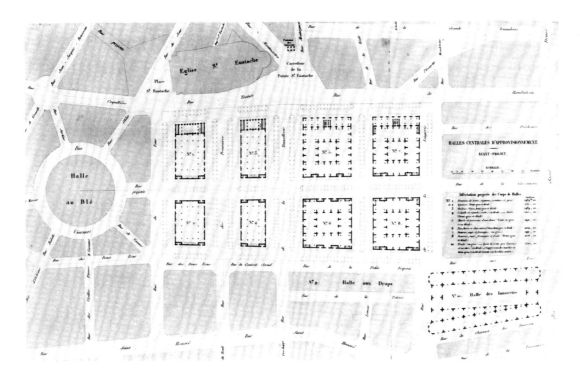

FIGURE 99
Victor Baltard, preliminary
project for the Central Markets,
Paris, 17 July 1844. Site plan.
Bibliothèque historique de la ville
de Paris.

rows of trees to public thoroughfare. At the same time, the adjacent streets and housing blocks have been straightened and aligned. The markets now cover 44,366 square meters (excluding the Marché des Innocents), and the total area has increased to some 52,000 square meters: an extended Rue de la Lingerie (from the Marché des Innocents to the Rue Mondétour) is pushed fifteen meters east toward the Rue Saint-Denis; to the south, the Rue de la Grande Friperie is eliminated, and the Rues du Contrat Social and de la Petite Friperie are straightened. Instead of trying to urbanize the site through the Baroque device of a monumental square, with or without diagonal avenues, Baltard drew the form of the markets from the quarter's historic growth as an incrementally more coherent fabric of roughly quadrangular blocks woven together by a cross-axial grid of streets. Baltard treated the markets generically by taking his cue from this evolving urban pattern rather than a normative idea of architectural order, and by modeling the resulting grid of pavilions after the mixed-use housing block: their form derived less from internal programmatic factors than from criteria of urban context and circulation. Dissembling the plan's radical urban conception, however, the architecture of the pavilions retreated from the use of iron to traditional timber roofs resting on masonry arcades.

On 18 July, Rambuteau presented Baltard's project to the Conseil municipal, along with a memorandum comparing it favorably to Lanquetin's counterproposal (see fig. 92), and the following day the councilors named a Commission municipale to examine both plans.[84] Reporting on 10 September, the commission reviewed the history of the Halles since 1811 and concluded in support of Baltard's project, noting that Lanquetin's alternative "had found . . . few advocates among the members of the administrative commission."[85] The Conseil municipal accepted the gridded circulation system organized into two types of street, and explicitly rejected the more monumental idea of having "any large public thoroughfare" cross

the markets, since this was incompatible with the function of the markets and with "the nauseating odor exhaled by an establishment of this type."[86] Rambuteau followed up with a second memorandum, on 16 October, listing sixteen streets that needed either to be opened or aligned in order to realize this plan.[87] The commission submitted its final report on 28 February 1845, and the Conseil municipal formally adopted Baltard's project on 18 April.[88] Costs were estimated at 13,968,126 francs for property acquisitions and 5,010,000 francs to construct the eight pavilions, for a total of 18,978,126 francs; the separate expense of roofing the Marché des Innocents added another 1,650,00 francs, for a total combined budget of 20,628,126 francs. The municipal commission floated the idea of securing a loan, though Rambuteau intended to finance the project entirely from public funds, including 820,000 francs in anticipated annual revenues from the new markets.

OFFICIAL PROJECTS AND COUNTERPROJECTS, 1845–1853

If Victor Baltard thought municipal approval of his project signaled the start to construction, he was mistaken. The next eight years would turn out to be the most contentious in the markets' history, as both the plan for the Halles and Baltard's design of its buildings were subjected to an interminable and inconclusive process of public review whose principal effect was to encourage Hector Horeau and others to submit counterprojects. Baltard continued to develop his design with further projects of 1848 and 1851 but was put on the defensive by criticisms that undermined his credibility as the markets' architect. The fall of the July Monarchy, followed by the proclamation of the Second Republic in February 1848 and of the Second Empire in December 1852, further complicated Baltard's standing, as he was forced to reestablish his qualifications with the new

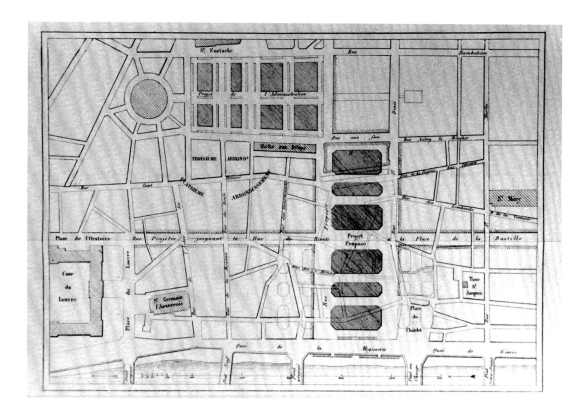

FIGURE 100
Hector Horeau, project for the Central Markets, Paris, October 1845. Site plan comparing his project with the official project. Bibliothèque historique de la ville de Paris.

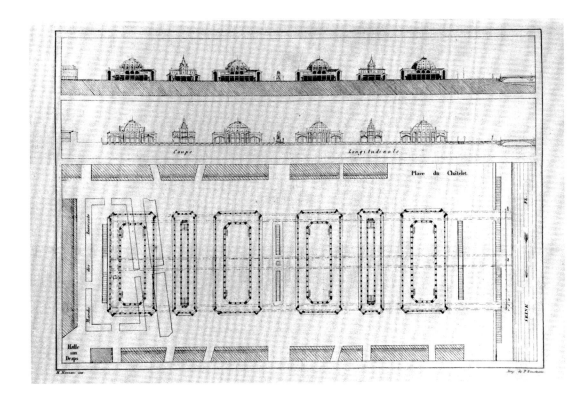

FIGURE 101
Hector Horeau, project for the
Central Markets, Paris, October
1845. Plan, section, and elevation.
Bibliothèque historique de la ville
de Paris.

prefects and officials brought in by each successive government. Work finally began on one of the eight planned pavilions in September 1851, only to be halted two years later in the face of continuing public scrutiny and opposition.

The trouble started almost immediately. After the Conseil municipal approved Baltard's project, Rambuteau ordered a public review of the site plan that identified the private properties to be expropriated for the sixteen proposed street alignments.[89] The inquest, conducted at the Hôtel de Ville from the second to the twentieth of June 1845, was meant to solicit comments from property owners and other interested members of the public, but its larger effect was to reopen to debate the city's decision to rebuild the markets at their present site. Hector Horeau led the way with a brochure comparing his counterproject to the official one; he would follow up with eight more iterations between October 1845 and June 1853 (figs. 100, 101).[90] Criticizing the administration's

plan for its irregular grid and the inevitable problems of circulation in such a congested area of housing blocks and narrow streets, Horeau proposed a work of radical urban renewal: moved to a new site of sixty-three thousand square meters running from the Marché des Innocents down to the Seine, the markets were reoriented to the river as the principal delivery point for goods, incorporated the planned extension of the Rue de Rivoli as a central square between two groups of three pavilions in alternating widths to either side, and justified the demolition of the Chevalier du Guet quarter, a slum lying behind the Quai de la Mégisserie on the Seine that had seen especially high mortality rates in the 1832 cholera epidemic. A vast basement substructure facilitated the delivery of foodstuffs and the removal of garbage via a system of handcarts run on rails and connected to barges on the Seine, which also ventilated the markets with fresh air. To complement these efficiencies of circulation, transportation, and

hygiene, Horeau projected the pavilions as single-span halls of cast iron within outer masonry walls.

From the start, Horeau's approach was alien to Baltard's in one important respect. If, as Françoise Boudon has pointed out, Horeau was in fact fairly conventional in both his layout of the Central Markets as a series of monumental pavilions and his design of cast-iron structures that were technically more conservative than those to be developed by Baltard, he consistently claimed for his projects the sort of broader social and political significance that Baltard, as a municipal official, avoided.[91] While both projects proposed to rebuild whole quarters of the city, Baltard (at least after November 1843) worked consistently with the existing fabric of streets and housing blocks so that the quarter's historic patterns of development were reflected in the markets' architecture. Horeau, on the other hand, asserted a program of sweeping urban renewal that conceived the markets as a rationally autonomous machine whose organization was largely independent of the surrounding city. The systematic urbanism of Baltard's designs for the markets may have prefigured the gridded regularity of Le Corbusier's Voisin Plan, but Horeau's proposal to demolish an entire quarter in the heart of Paris more directly anticipated Le Corbusier's treatment of the city as a utopian *tabula rasa* where history could be erased with an efficiently self-referential plan. Abstract and categorical, Horeau's project is equivalent in this sense to Perreymond's equally visionary plan of 1843 (see fig. 93), which similarly cleared huge tracts of ground while tying Paris to the Seine as its principal transportation artery.

Born in 1801, Horeau, like Baltard, had studied at the École des Beaux-Arts, entering the second class in 1819 and advancing to the first class in 1821, before he dropped out after losing the Prix de Rome to Léon Vaudoyer in 1826. The sense of injustice nursed from that time forward was compounded by subsequent defeats, most notably in 1839, when he won the competition but lost the commission for a covered market in Versailles, and again in 1849, when he was premiated in the competition only to be denied the commission for the Crystal Palace in London. Where Baltard's failure to win the competition to design Napoléon's Tomb caused him to concentrate on a municipal career, Horeau dealt with defeat by gravitating instead to a career in architectural polemics, building little yet publicizing a steady stream of schemes and manifestoes.[92]

Reacting swiftly to the threat, Baltard scribbled tart retorts on the handbill publicizing Horeau's counterproject: the claimed urban improvements were destined to happen "in any case" or would be "blocked by the new pavilions"; the proposal to use the Seine to remove garbage via an underground railroad was a "fiction"; the proximity to fresh air from the river also exposed the markets to deleterious "effects of the sun"; the assertion that costs would not exceed those calculated by the administration was "hardly believable."[93] Baltard settled down to a calmer evaluation in the report he sent to Rambuteau by the end of June 1845:

1. The siting on the quay would be preferable with respect to the regular perimeter and by making it easier to give a more monumental appearance to the market halls, but the service needs would be no better guaranteed.
2. Mr. Horeau's indications and descriptions add no new ideas that have not already been applied or could be applied to the administration's project.
3. The cost would be augmented by 7,540,00 [francs] by the necessity of acquiring 13,400 additional [square meters] of private property, without in the end making the available area noticeably larger.[94]

Report in hand, the prefect addressed the Conseil municipal on 26 June, summarizing the results of the public inquest and comparing the two projects. On 11 July, the council confirmed its approval of Baltard's project, and on 4 August Rambuteau issued an edict naming Victor Baltard and Félix Callet "architects of the work of enlarging and improving the Central Markets." The edict went on to state that the architects would "eventually be given instructions for drawing up the definitive project," until which time "Mr. Callet [would] continue to carry out his duties as *commissaire voyer*."[95]

Félix-Emmanuel Callet (1791–1854) was an older and presumably more experienced architect than either Baltard or Horeau. Trained at the École des Beaux-Arts in 1809–19, he had won the Prix de Rome in 1819 and in 1823 submitted a restoration *envoi* of the Forum of Pompeii that was received favorably by the Academy.[96] By 1845, Callet had established a modest reputation as architect of the original Gare d'Orleans in Paris and a related train station at Corbeil (1835–40), both built in collaboration with the engineer Adolphe Jullien.[97] In those same years, he completed the Neo-Renaissance Hôtel des Commissaires-Priseurs, an auction house with a glass-roofed hall on the Place de la Bourse, and the Hôtel Casimir Leconte, a private mansion on the Rue Saint-Georges.[98] Lemoine suggests that Rambuteau chose Callet because of his technical expertise, although the two train stations were simple structures realized largely by Jullien, to which Callet added little beyond the same classical detailing that characterizes the hotels.[99] A more probable reason was the one given in Rambuteau's edict: Callet was a *"commissaire voyer,"* which is to say, a municipal architect-surveyor who (like Lahure, the author of preparatory plans for the markets) was charged with regulating street alignments and the façades of new buildings.[100] More than works

of architecture, the new Central Markets would be works of urban planning, and Callet's appointment ensured that this criterion was in qualified hands.

Baltard and Callet cooperated amicably until Callet's sudden death from cholera, on 1 August 1854. Callet's father, Antoine, a municipal architect himself, was a contemporary and friend of Pierre Baltard's, and it is likely that their sons already knew each other before their joint appointment in 1845. After Callet died, Baltard scrupulously calculated that his partner's heirs were due 25 percent of the architectural fees, and he was similarly careful to credit Callet in his monograph on the Central Markets.[101] Still, it remains unclear what, exactly, Callet brought to their partnership beyond an aura of seniority and municipal experience. Callet boasted no advantage in either education or training that Baltard did not himself possess, from a sensibility for classical traditions to an understanding of how industrial materials like iron and glass could be applied to architecture. In 1854, César Daly wondered at Callet's invisibility, explaining that if he had failed to cite Baltard's associate, it was because he shared this oversight with the public at large: "the name of Baltard is usually said alone when the public speaks of the Halles."[102] After 1845, Baltard continued to take the lead in developing the project, just as he continued to draft the reports that were then issued in both their names.[103] Unlike Horeau, who challenged Baltard at every turn, Callet accepted the supporting role he had been assigned and kept quietly in the background.

On 18 August 1845, Rambuteau appointed Baltard, along with Armand Husson (representing the Prefecture of the Seine as head of the Office of Departmental Administration) and one Anger (representing the Prefecture of Police as inspector general of markets), to a commission charged with studying the markets of England, Belgium,

Holland, and Germany.[104] The commission visited some twenty-five markets and consulted with the architects Thomas Donaldson and Charles Fowler in London, Friedrich Stüler in Berlin, and Friedrich von Gärtner in Munich. Singling out London as "the only city in Europe one can compare to Paris," they noted such recent examples of market design as Fowler's Covent Garden (1830) and Hungerford (1835) Markets in their report of 30 November 1845. But the new market in Birkenhead, built in 1845 by the Birmingham firm of Fox and Henderson, made the greatest impression: "the market that seemed the most remarkable to us, and was undeniably set up the best, was that of Birkenhead, a new town being erected on the other side of the Mersey River [from Liverpool]. . . . This market occupies 8,000 square meters; it . . . consists of three aisles . . . formed from two rows of wrought-iron point supports, very light and beautiful in effect."[105] The report concluded that contemporary markets, like train stations, typically had masonry walls of stone or brick and wooden roofs supported by wrought-iron trusses on cast-iron columns.[106]

On 9 February 1846, Rambuteau personally presented the administration's master plan to the Conseil des bâtiments civils, smoothing the way for its approval on 23 March with only minor recommended changes.[107] Horeau fought back, reissuing his counterproject in April and again in May 1846 and writing on 12 August: "My dear Baltard, I will not consider myself beaten until I have been told officially what are the disadvantages of my project and until these have been compared equitably to those of the administration's project."[108] Rambuteau pressed ahead, announcing to the Chambre de commerce in December that the markets had been "the object of extended study, both under the heading of food distribution and from the point of view of circulation," and that he expected to finalize their design in the coming

year.[109] After Louis-Philippe declared the new Central Markets to be a work of public utility on 17 January 1847, based on the plan approved in the inquest of June 1845, Rambuteau on 12 February presented to the Conseil municipal his comprehensive plan for the city in the form of an itemized list of projects budgeted at 50 million francs: "It comprised the Central Markets, the town halls of the third, tenth, and twelfth districts, the church of Sainte-Clotilde, the completion of wharves and bridges [along the Seine], the new Opéra, the Place du Palais Royal, the extension of the Rue de Rivoli, the improvements of streets, paving, sewers, sanitation, etc. All this was supposed to be completed by 1 January 1853: it was in a sense my last will and testament, and the time had come to sign it."[110] Despite the business slump and gathering fiscal crisis of 1847 (resulting from a poor harvest in 1846), the prefect was optimistic about the city's finances. Calculating that half of his plan could be funded from existing municipal revenues, he believed that the remaining 25 million could be borrowed without negative effects: in 1847, the city had reserves of 22 to 24 million francs, and by 1848 it would retire all but 24.5 million of the total debt of 150 million incurred since 1807.[111] The Central Markets constituted the largest single item in his plan and were budgeted at just over 16 million francs: 9,362,126 francs for property acquisitions (down from the 13,908,126 francs estimated in 1845) and 6,660,000 francs for construction (the same 5,010,000 francs estimated in 1845, plus an additional 1,650,000 francs for the Marché des Innocents).

The Conseil municipal approved the prefect's budget on 26 February 1847, the requisite loan of 25 million francs was enacted into law by the Chamber of Deputies on 1 August, and on 21 October Rambuteau issued an official program for the markets.[112] Calling for eight pavilions of "a monumental character," the program plotted

a site between the Rue de Rambuteau to the north, the Rue du Four to the west, the Rue de la Lingerie to the east, and the Rues des Deux Ecus, du Contrat Social, and de la Petite Friperie to the south. Double rows of trees were to separate public thoroughfares from service alleys, a water reservoir and clock tower were specified for the center of the site, and pavilion entrances had to be raised seventy centimeters above the surrounding sidewalks and limited in width as much as possible in order to leave "the largest area possible available for sidewalks" (reserved for vegetable wholesale).[113]

To develop their project, Baltard and Callet also relied on a contemporary master plan for the Halles quarter (fig. 102).[114] Reaching from the Quai de la Mégisserie up to the Rue Monconseil and from the Halle au Blé over to the Rue Saint-Martin, this plan incorporates the perimeter of the Napoleonic Grande Halle (traced in blue) along with two phases of street alignments: those approved by the ordinance of 17 January 1847 (in black) and the next round recommended by the municipal Commission des alignements though not yet adopted by the Conseil municipal (in red). The eight pavilions of Baltard and Callet's project are hatched in pencil on the plan. Since November 1843, Baltard had thought of the markets in urban terms as a series of city blocks crossed by a network of streets on axis with the Halle au Blé, and he now petitioned Rambuteau on 17 November 1847 for "modification of the general massing plan that had been imposed on them" by the irregular lots plotted in 1843, in order to regularize both the markets and the adjacent streets with a consistently rectangular grid: the architects "called for . . . a regular and symmetrical plan for the eight islands prescribed by the program, with a rectified [central] axis with respect to the Halle au Blé and the extension of the perimeter 50 meters beyond the Rue de la Lingerie."[115] The Commission des alignements

denied their request, since the modifications would "change in a notable fashion the alignments approved by royal ordinance."[116]

Baltard and Callet focused instead on articulating the markets' architecture in their first complete set of drawings (figs. 103–6).[117] Finalized in August 1848, these drawings detail a mixed structure of stone and iron: groin-vaulted basements of stone and brick; granite pavements and exterior walls of limestone ashlar; and a cast- and wrought-iron roofing structure sheathed with wood and zinc. The pavilions have beveled corners rising to hexagonal towers, with entrances either through or adjacent to those corners as well as centered on one or more sides. As required by the program, those entrances are narrow and raised above the surrounding sidewalks. To the west, four smaller pavilions (numbers 1 to 4) take the form of elongated rectangles, extended in the case of pavilions 1 and 3 with attached administration buildings that fill out each block. To the east, four larger and nearly square pavilions (numbers 5 to 8) are extended in the case of pavilions 5 and 7 with administration buildings on the Rue de Rambuteau. Their façades dissolve from solid to void as the elevations climb from masonry bases with punched basement windows, past metal awnings cantilevered over the sidewalks, to a superstructure above opened by paired windows between pilaster piers and generous clerestory lanterns. The administration buildings have full two-story elevations, articulated with segmental arches and Doric pilasters. Inside, roofs spanning twelve meters are framed with curved trusses of cast and wrought iron that rest on a stacked structure of attenuated cast-iron columns, segmentally arched struts, and round arches. To address lateral forces of shear (as critical in such a light construction as vertical loads of dead weight), the structure is tied together by the lower segmental struts and by rows of curved purlins between the trusses above.

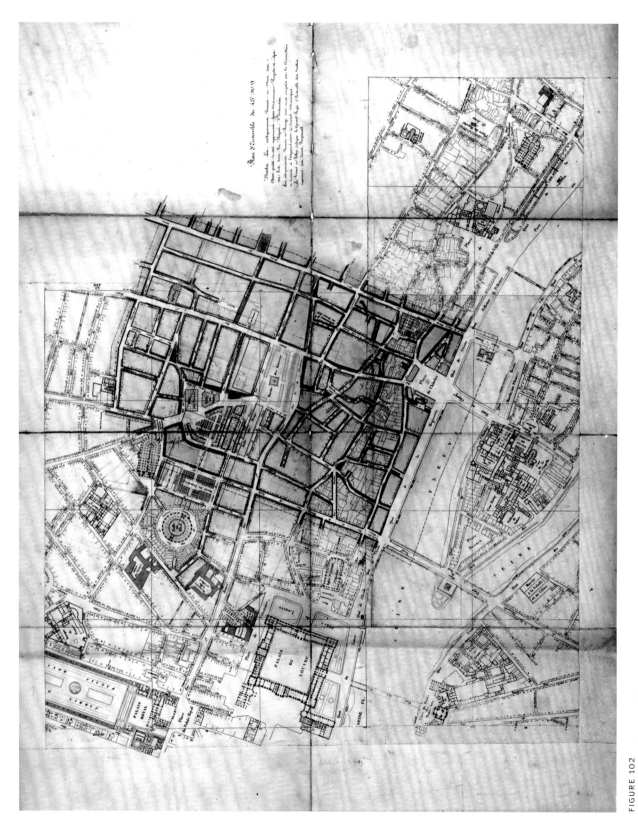

FIGURE 102

Alignment plan for the Halles quarter, Paris, 1846–47, from
Théodore Jacoubet, *Atlas général de la ville de Paris* (1836).
Document held at the Centre historique des Archives
nationales de France, Paris.

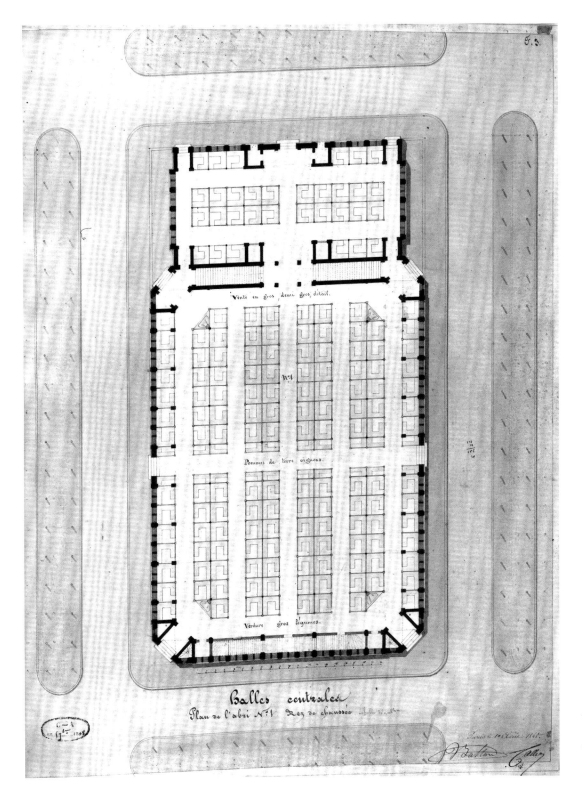

F. 3.

Vente en gros, demi gros, détail.

N.º1

Pommes de terre oignons.

Verdure gros légumes.

Halles centrales
Plan de l'abri Nº1 Rez de chaussée échelle...

Paris le 10 Août 1848.

FIGURE 103
Victor Baltard and Félix Callet,
project for the Central Markets,
10 August 1848. Ground-floor
plan of pavilion 1. Archives de la
Seine.

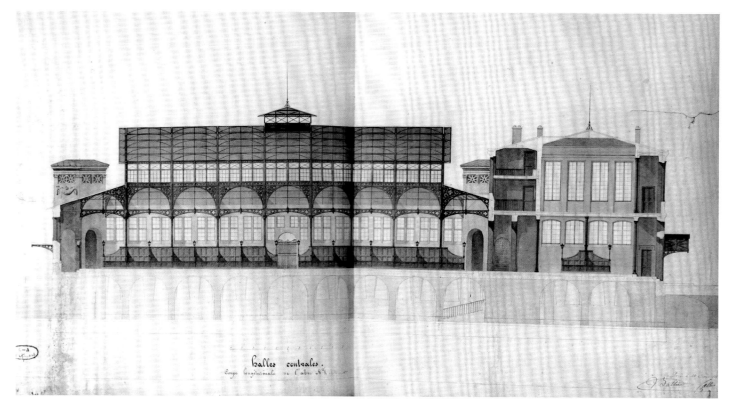

Halles centrales.
Coupe longitudinale de l'abri N°1

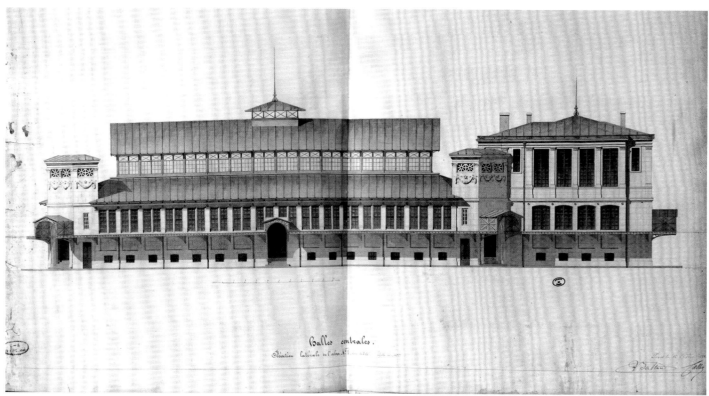

Halles centrales.
Élévation latérale de l'abri N°1

The architects calculated that the pavilions alone would cost 9,185,548 francs to build, up significantly from the previously estimated 5,010,000 francs and raising the total construction budget to 12,060,059 francs. If the original estimate, figured on the basis of schematic designs, had been less an objective evaluation of what the markets might actually cost than an instance of bureaucratic calculation justified by political expedience, Baltard and Callet's more realistic budget in 1848 obviously looked beyond the markets' utilitarian program to factor in their aesthetic value as works of architecture. These differences of purpose between the administration and its architects would remain an ongoing source of tension.

Except for the separate Marché des Innocents, whose metal roof rests awkwardly on historicizing stone arcades, the pavilions are coherent statements of progressive architectural thinking at midcentury. The architects justified their embrace of iron by citing the markets visited in England and Germany, as well as "the progress that industry puts every day at the disposal of art."[118] Classicizing yet industrial, the pavilions' combination of stone and iron is consistent with the theory of technological progress professed by Baltard at the École earlier that same decade, and invites comparison with Labrouste's Sainte-Geneviève Library, then nearing completion.[119] Indeed, the garland swags decorating the corner towers and the paterae atop the pilaster piers, marking bolt connections for the metal structure inside, repeat two telling motifs from the library façade. Where, however, Labrouste conjoined those details, turning them into an eloquent metaphor for the indexical complexity of decorated construction by comparing a fictional stone garland with a literal referent to the building's metal structure on the interior, Baltard set them apart as unrelated categories of decoration, each having its own material

FIGURE 104 (*opposite top*) Victor Baltard and Félix Callet, project for the Central Markets, 10 August 1848. Longitudinal section through pavilion 1. Archives de la Seine.

FIGURE 105 (*opposite bottom*) Victor Baltard and Félix Callet, project for the Central Markets, 10 August 1848. Lateral elevation of pavilion 1. Archives de la Seine.

FIGURE 106 Victor Baltard and Félix Callet, project for the Central Markets, 10 August 1848. Elevation of the administration building for pavilions 5 and 7, on the Rue de Rambuteau. Archives de la Seine.

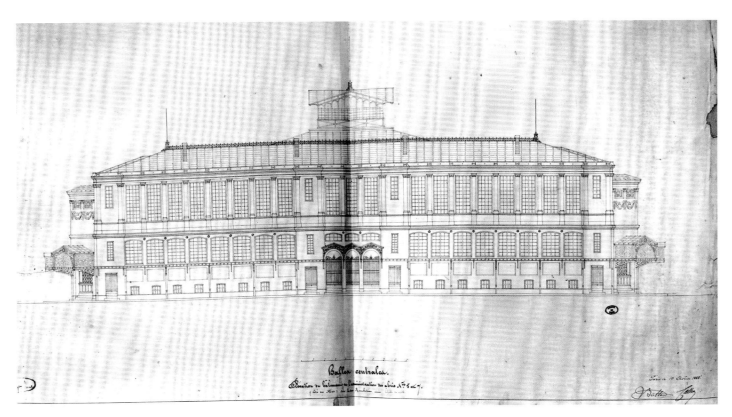

and therefore ornamental character. The difference between Baltard's prosaically descriptive and Labrouste's poetically interpretative ornament is one of intention, however, not a failure of imagination: the matter-of-fact character of Baltard's decoration draws attention to the real originality of his industrial structure, which is not only more sophisticated than Labrouste's in its technically elegant balance between dynamic forces of gravity and shear but is also directly expressed on the exterior in the visible dissolution of each pavilion from solid masonry below into a light and nearly transparent parasol of metal roofs and lanterns above.

At the same time, without pretending to Horeau's polemics, Baltard and Callet's design implemented an instrumental rationalization of space. Organized by the uniform modules of individual market stalls (see fig. 103), the pavilions duplicate in microcosm the gridded pattern of blocks crossed by circulation axes that was planned for the markets as a whole. Together, the structure and space of the markets plotted an open-ended system of urban architecture: "It is to be observed, moreover, that the system of isolated pavilions, numbering eight, makes it possible to carry out this vast operation successively and fractionally, and that it could be interrupted at any time, when one or more of the pavilions had been constructed, without any obstacle to the future and with real advantages for the present."[120] In effect, the architects were advocating a conceptual shift from the classical composition of self-contained and closed objects to the reproduction of standardized and interchangeable units. Returning to the historic example of the open-air market hall, with its modular wooden structure, while looking forward to industrial methods of construction, this proposed shift to an additive and open-ended system remained implicit in the project designed in 1848 but would directly

inform the repetitive metal structure of Baltard's final project in 1853.

The architects singled out for "special study the means to deliver provisions and remove waste by tunnels that must indubitably be linked some day to a beltway railroad connecting the principal train stations of Paris."[121] Horeau's project, with its basement system of rail handcarts, could have been on Baltard's mind, but where Horeau still looked to the Seine as the city's historic artery of commerce, Baltard recognized the promise of railroads to reinvent the transportation infrastructure of Paris. Capping a public debate launched in 1837, the "Charter of French Railroads" had established a national system of railroads with the law of 11 June 1842 and inaugurated the mechanization of Paris during the 1840s and 1850s with a chain of train stations circling the city. By 1845, two civil engineers had already proposed underground lines to bring both people and goods into the center of Paris: in 1837, Louis Vallée suggested running such a line to the Hôtel de Ville; in 1845, F. de Kérizouet published his plan for a partially subterranean railroad run round Paris at the perimeter of the inner boulevards, with a branch line run to the Central Markets along the Rue Mondétour.[122] Kérizouet's plan, like Baltard and Callet's contemporary proposals for the Central Markets, anticipated the construction of a ring railroad linking the city's stations, the Chemin de fer de la petite ceinture authorized by presidential decree on 10 December 1851 and realized in 1852–67.

The economic crisis of 1847 and the following collapse of the July Monarchy, in February 1848, derailed any hope that work on the markets might soon begin. Rambuteau and Delessert resigned on 24 February, to be succeeded by Louis-Antoine Garnier-Pagès as the mayor of Paris and by Marc Caussidière as prefect of police. On 9 March, Armand Marrast replaced Garnier-Pagès as mayor, and it was to him that Baltard

and Callet on 15 June initially addressed their project. By the time the architects had finalized their project in August, they found themselves answering to Ariste Trouvé-Chavel, who had been appointed prefect of the Seine on 19 July (having already replaced Caussidière as prefect of police on 18 May, to be followed in that position by François-Joseph Ducoux). The situation was still in flux when, on 20 December, Louis-Napoléon named Jean-Jacques Berger as prefect of the Seine and Colonel Rebillot as prefect of police, ten days after his own election as president of the Second Republic. By then, any understanding that Baltard and Callet might have established with the previous administration had evaporated. Although the financial crisis stabilized in 1848, ensuring credit for projects like the Central Markets, the architects now faced a new set of officials, whose allegiance was to a new regime with a new set of priorities.

Pierre Carlier replaced Rebillot as prefect of police in November 1849. Berger hung on as prefect of the Seine until June 1853, though he lacked, according to Charles Merruau, Rambuteau's ability to reconcile the competing agendas that came with his job:

> on one side the government of Louis-Napoléon desired, prepared, demanded great enterprises; on the other, the representatives of the city of Paris resisted, retrenched, delayed, and held on, as much as they could, to continuing projects that had already been adopted by some of them under the government of Louis-Philippe. The prefect, Mr. Berger, wanted to please the government, and not displease the municipal commission. He quite readily rallied to the prince-president.[123]

After the elected Conseil municipal was dissolved on 27 February 1848, the interim national government provisionally set up an appointed Commission municipale by decree on 3 July. This commission remained provisional through the Second Empire, as a supposedly more tractable alternative to the independent councilors with whom Rambuteau had worked under the July Monarchy. Still, several councilors survived the transition, including Lanquetin (president of the Commission municipale in 1850–52). Even after Louis-Napoléon consolidated political control with the coup d'état of 2 December 1851, followed a year later by his proclamation of empire, vested interests from the previous regime retained a say in municipal affairs. Soon enough, Baltard and Callet would be caught up in the ensuing political struggle between these vested interests and those of Napoléon III.

Public-works projects including the markets made modest progress in 1848. Broadening the right of eminent domain while ignoring the limits set by the law of 3 May 1841, the interim government allowed the city to expropriate entire properties when it ordered the extension of the Rue de Rivoli from the Louvre to the Rue Saint-Antoine on 3 May 1848: this edict prepared the way for Louis-Napoléon's sweeping presidential decree of 26 March 1852.[124] On 5 May 1848, the minister of the interior, Alexandre Auguste Ledru-Rollin, modified the royal ordinance of 17 January 1847 to order the alignment of twelve streets around the Central Markets and the Marchés des Innocents.[125] On 24 July, the Assemblée nationale reauthorized the municipal loan of 25 million francs for projects in Paris, including the Rue de Rivoli and the markets. The adjudication and demolition of properties in the Halles continued uninterrupted from 1848 through 1849.[126]

Noting that "the definitive projects and budgets had already been submitted to the city's Commission d'architecture and for review by

the Prefecture of Police," Baltard and Callet petitioned Berger on 23 January 1849 to set aside two houses at the Halles for their use as architectural and construction management offices.[127] Instead, on 19 February, the prefect of police issued a highly critical review of their project. Since many of Rebillot's criticisms addressed requirements of the official program, Baltard and Callet were in effect being blamed for decisions made by the previous administration. They responded as best they could in their report of 23 March: the central reservoir and clock tower could be eliminated; housing for market inspectors had not been requested but could be added along the Rue de Rambuteau; given their internal flexibility, the pavilions could easily accept other layouts for the market stalls (as the architects demonstrated with a revised scheme for pavilion 5); though they had included basement plans, they could justify in greater detail the organization and circulation of the entire basement substructure of the markets; the admittedly awkward Marché des Innocents could be redesigned. Only once did the architects express real dismay, in response to Rebillot's insistence that the subterranean rail system be abandoned, since its elimination meant the continued "barbarous use of filthy garbage carts running through the streets of Paris."[128]

The possibility that decisions reached under Rambuteau might now be subject to change encouraged Baltard and Callet to renew their earlier petition from 1847 for a fully regular set of streets around the markets.[129] Berger ignored this request yet soon proved open to far more radical revisions to the markets' siting and program. Auguste Magne, whether or not he knew of Baltard and Callet's difficulties with the new administration, had already proposed in September 1848 turning the Halles into a dedicated retail market, while erecting a new wholesale market along the right bank of the Seine on the grounds of the

former Île des Louviers.[130] Horeau followed suit in 1849. In the midst of labor unrest exacerbated by another cholera epidemic, and probably aware that the official project was in jeopardy, Horeau reissued his project from 1845, presenting it to the prefect of the Seine on 29 May and publishing two further iterations the following July and September (fig. 107).[131] For good measure, in October he sent a copy of his project to the minister of public works: estimating it would cost 11,000,000 francs to build, (plus another 36,000,000 francs for property acquisitions), he teamed up with two contractors, Callou and Lacasse, to prove the feasibility of his design.[132] By year's end, Horeau was at work on comparative models of the official project and his counterproject.

According to Horeau, Berger received the project "with marked interest" and sent it for immediate review to a special commission "that he himself chaired and on which the prefect of police served."[133] Baltard responded in June 1849 with a written supplement to his earlier evaluation of Horeau's project in 1845. Alluding to Rebillot's criticisms of his own project, Baltard concentrated on debunking Horeau's basement rail delivery system, which he said was neither new nor practical: the idea, he argued, "has been studied, and if it has been decided not to follow through on it, that is because this system posed very grave difficulties, if not impossibilities," of circulation, grade changes, and cost.[134] Still, the tide continued to turn in favor of Horeau. After Berger summarily denied Baltard and Callet's request in January 1850 for funds to build a model of their project, Horeau was left unchallenged in March, when he put his comparative models on display at the Palais Royal.[135] His campaign of publicity was picked up in both the daily and professional press and found an especially articulate advocate in Jules Senard, a well-connected lawyer and politician who had served as minister of the

NOUVELLES HALLES CENTRALES POUR LA VILLE DE PARIS

PAR HECTOR HOREAU, architecte.

interior from June to October 1848.[136] In April
1850, Senard compared Horeau's spacious layout
by the Seine to the crowded site of the Halles:
"What can one say about the tumult, the disorder,
the crush of people, in the midst of which the
unloading, laying-out, sale, and removal of goods
takes place; and what can one say of the accumula-
tion of debris, of putrefaction, of waste of all sorts,
that litters the path of this strange whirlwind!"[137]
Noting that 7 million francs had by February
1848 already been spent expropriating properties
at the Halles and that another 12 million francs
might still be needed, Senard argued that the
city should stop wasting its money "and adopt a
project that is better planned and more suited to
its true interests."[138] Because the economic sphere

of the Central Markets extended beyond Paris to
every department of France, from which came not
only the foods to be sold but also the materials
and labor to be used in their construction, Senard
claimed that their design was a matter of national
importance, and he therefore called on the state to
organize a public competition.[139]

Earlier that same month, Pierre-Jules Baroche,
minister of the interior, wrote to Berger promis-
ing a state subsidy if the city adopted Horeau's
project.[140] On 30 April, the prefect charged a
subcommittee to the Commission administra-
tive (set up in 1842) with deliberating whether
the Halles should become a dedicated wholesale
market or continue to serve mixed wholesale
and retail needs.[141] Next, on 19 June, he asked the

Commission municipale to form a special committee to study the relative merits of the official project and Horeau's counterproject. In his supporting memorandum, Berger argued that the viability of the official project was compromised by its incompatible functions as a site of food distribution and as a public circulation network. Horeau's counterproject not only offered a more "accessible" site but promised to facilitate the extension of the Rues de Rivoli and Montmartre while transforming an area "now occupied by narrow, tortuous, badly laid-out streets, and by old, unhealthy, and uninhabitable houses."[142] The only obstacles, according to Berger, were the current occupants and property owners of the Halles, who had a vested interest in the administration's project. Pierre Carlier followed up on 15 March 1851 with a report that similarly concluded that Horeau's site offered greater advantages than the official one in terms of both circulation and distribution.[143]

On the face of it, Berger's embrace of Horeau's project over that of Baltard and Callet is extraordinary. The latter architects were experienced municipal employees, well versed in the prefecture's bureaucratic ways, and they had based their project faithfully on the prescribed site and program. Horeau, on the other hand, was an outsider whose project promised to undo at least five years of preparatory legal, economic, and physical planning by the city. He succeeded because, as Charles Merruau tells us, his project "had charmed the president of the republic when he first saw it."[144] Even if the advantages of his site were speculative and his spanning arches of cast iron were technically less sophisticated than Baltard and Callet's integrated structure of cast and wrought iron, Horeau had shrewdly promoted his project as more progressive than the alternative. To a politician like Louis-Napoléon, the appearance of progress mattered more than mundane facts

of professional expertise or structural ingenuity. Since the president's interest was accompanied by a promise of state funding, it—along with pressure on Berger—initially proved convincing. Direct interference by the state in municipal projects had been rare since the prefecture gained control over public works in 1830, but it was prophetic of the increasingly active role that Louis-Napoléon would take in remaking Paris as the nation's capital, especially when this reinforced dynastic associations with his uncle. The task of building the Central Markets, first proposed by Napoléon I, was at once a personal and a state responsibility: at the ceremony to lay the cornerstone for the new markets in September 1851, the prince-president would deploy the same rhetoric of national significance employed by Seynard, proclaiming that the project begun "forty years earlier" was more than "just a municipal work, because Paris is the heart of France."[145]

Expedient rather than principled, the interests of Louis-Napoléon would prove to be subject to the changing winds of public opinion. In 1850, however, Horeau's success with the state encouraged others to put forward proposals of their own. Théodore Vacher, after viewing the models on display at the Palais Royal, wrote to Berger in April to suggest rotating Horeau's design, running the markets from the Pont au Change to the Pont Neuf between the Rue de Rivoli and the Quai de la Mégisserie, in order to segregate this utilitarian space of food distribution from the Rue de Rivoli.[146] That same month, the architect Jean-Baptiste Dédéban submitted a project to house the markets in a domed rotunda identical in shape and size to the Halle au Blé and facing it across a large open square.[147] Léon Marie, though a critic of Lanquetin's theory of displacement, proposed in May to turn the present Halles into a public square and to erect two new wholesale markets on opposite sides of the city, along the line of the

barrières.[148] Augustin Chevalier, a member of the Commission municipale and of its special committee on the Halles, picked up on Marie's argument in late December, reasoning that the Central Markets should be decentralized as a series of large markets distributed across Paris.[149]

To rein in the threat unleashed by Horeau and his political patrons, Baltard's allies rallied to his defense. Some five hundred residents of the fourth district set up a nine-member commission chaired by H. Grenet, a civil engineer in the Service des ponts et chaussées, to represent the interests of the Halles shopkeepers and property owners. Contacting Baltard on 16 April 1850, in the first of twenty letters sent by May 1851, Grenet explained that he hoped to counter Horeau's hallucinatory effect on "public opinion, so easy to lead astray, [which] has been taken in by misleading appearances that could also seduce the administration."[150] Baltard answered with a detailed comparative analysis of the two projects, which the residents of the fourth district used to turn the tables on Senard in their rebuttal of 30 April: Horeau's placement of the markets, across the Rue de Rivoli and blocking the Rue Saint-Honoré, would complicate, rather than facilitate, circulation in the city center; the subterranean delivery system had already been shown to be impractical and would in any case necessitate raising the entire site several meters to lie above the flood plain of the Seine.[151] Claims about size and cost were questioned as well. When both sites were plotted to the center of the bordering streets, rather than to the outer edge as Horeau had done, the official plan at 52,800 square meters compared favorably with Horeau's at 49,000. Adding another four pavilions increased the official site to 69,000 square meters; including the basements raised that figure to 80,160, against the 88,950 meters generated by Horeau's vast substructure. Where Horeau's project would cost 47 million francs (11 for

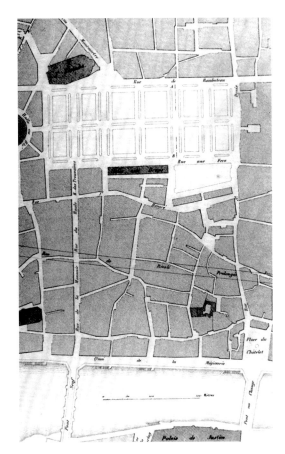

FIGURE 108
Victor Baltard and Félix Callet, expanded site plan for the Central Markets, Paris, April 1850, from [Blondel et al.], *Halles centrales* (1850). Bibliothèque historique de la ville de Paris.

construction and 36 for property), the official project came in at a relatively economical 34 million francs: an estimated 15 million francs for construction (including another 3 million for the extra pavilions) and 19 million francs for property. Taking advantage of the opportunity offered by Grenet, Baltard published a symmetrical site plan that added four pavilions and extended the markets all the way to the Rue Saint-Denis (fig. 108).

Further support came from the administrative subcommittee on the Halles. In its report of 7 May 1850, written by Armand Husson, the subcommittee insisted that the "long and laborious discussion" had ended with the royal ordinance of 17 January and the program of 21 October 1847.[152] Noting that they had consulted Lanquetin, who rehearsed his theories yet conceded the official

program, the subcommittee rejected once again the notion that Paris was displacing itself and reaffirmed the need for mixed-use Central Markets. Just as critically, they questioned whether any plan could dictate the city's demographic growth: "we believe that the administration has no power, in this matter, other than an action of protection, surveillance, and policing."[153] At a time when Berger, under pressure from Louis-Napoléon, was pushing for a return to the instrumental urbanism theorized by Lanquetin in 1839–41, the prefect's subordinates were justifying Rambuteau's policy of incremental planning.

Baltard's allies kept up the pressure. The contractor Auguste Lenoir (who had worked on the Hôtel du Timbre) offered to erect four pavilions in four years, payable in a 1:2 ratio of public and private funding to be reimbursed at 5 percent over ten years.[154] After the *Journal des débats* announced, in June 1850, that the administration was considering Horeau's design, the commission representing the Halles issued, in July, a second defense of the official project.[155] The next month, they arranged an inquest to determine whether the city was obligated to honor its commitment to keep the markets at the Halles: conducted by a lawyer named Langlois, this inquest concluded that the city was under a "double obligation" of both ethics and equity and that, if it abrogated those commitments, then it was required (under the terms of the law of 3 May 1841 regulating works of public utility) to return all expropriated properties to the original owners along with full compensation for the value of demolished buildings.[156] Senard countered in December, refuting Langlois while repeating his arguments for Horeau's project, and was immediately answered in January 1851 with another rebuttal from Grenet.[157]

Step by step, Berger and Carlier were put on the defensive. Reporting to the Commission municipale on 15 March 1851, the prefect of police

was forced to recognize that Horeau's project, despite its "incontestable advantages," had shortcomings of its own.[158] Though Carlier professed to be untroubled at the prospect of placing the markets across the Rue de Rivoli, he now rejected as unworkable Horeau's elaborate underground delivery system. Because this formed such a distinguishing feature of the project, a municipal engineer named Dupuit was called in to investigate whether the risk of flooding was as serious as claimed. In September 1850, a civil engineer at the École des ponts et chaussées named Bélanger had corroborated Horeau's contention that floods could be prevented with minimal adjustments to the site. But Dupuit concluded that, to avoid flooding, much of the site would in fact have to be raised from one to two meters. Since this would substantially increase the construction costs and necessitate awkward ramped grade changes between the markets and the surrounding streets, Dupuit suggested lowering the basement clearances by 640 centimeters in order to raise their floors by the same amount, at which level they might only be flooded eight times a century![159]

By 1851, the steady stream of projects and counterprojects had generated a de facto version of the competition called for by Senard. On 27 November 1850, capitalizing on his fame in the 1850 competition for the Crystal Palace, Horeau sent to Berger a new design for the markets (see fig. 119), which the prefect presented to the Commission municipale on 18 December.[160] The site of Horeau's project now extended all the way to the Rue de Rambuteau, while the six pavilions had been condensed into three gargantuan halls, spanned by segmental cast-iron arches measuring 86 meters across by 33 meters high. In April 1851, Charles Duval published a variant of Dedeban's circular market at the Halles, now inflated to a megalomaniacal 270 meters in diameter and divided into eight wedge-shaped pavilions

(fig. 109).[161] In May, Félix Pigeory appropri-
ated Vacher's suggestion and developed another
rotated variant of Horeau's project between the
Quai de la Mégisserie and the Rue de Rivoli
(see fig. 118).[162] That same month, Berger sent the
projects by Dédéban, Duval, and Pigeory to the
Commission municipale for review by its special
committee.[163]

On 10 June 1851, Baltard and Callet submitted
a new project to the prefect (figs. 110–12).[164] The
pavilions, with carefully detailed groin-vaulted
basements, still have the canted corner entrances
proposed in 1848 and gridded interiors organized
by the market stalls. Their decorative treatment,
however, has been simplified: the stone garlands
are gone from less ornate, rectangular corner
towers, as are the telltale paterae from the stream-
lined elevations, which now rise directly from
the gabled bays of segmentally arched windows

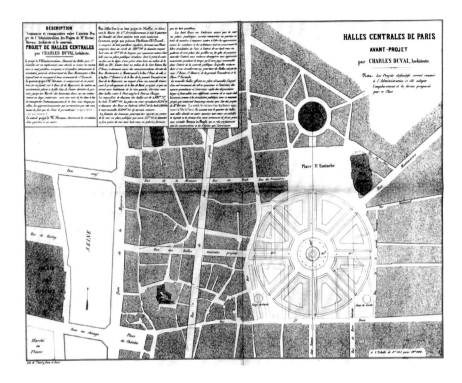

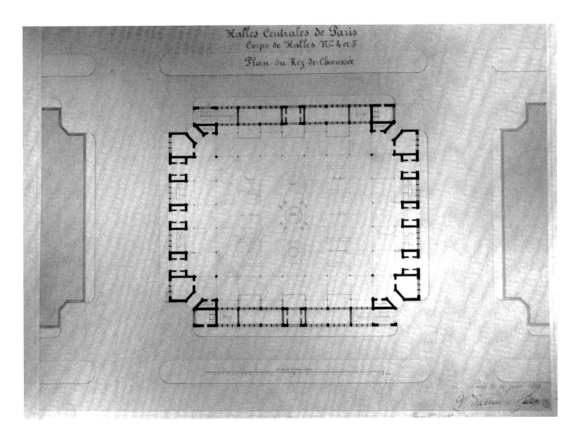

FIGURE 109
Charles Duval, preliminary
project for the Central Markets,
Paris, 1851. Site plan. Document
held at the Centre historique des
Archives nationales de France,
Paris.

FIGURE 110
Victor Baltard and Félix Callet,
project for the Central Markets,
Paris, 10 June 1851. Ground-
floor plan of pavilions 4 and 5.
Bibliothèque historique de la ville
de Paris.

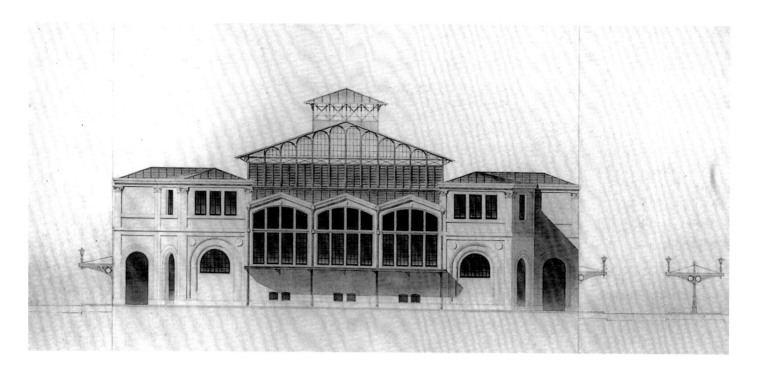

FIGURE 111
Victor Baltard and Félix Callet,
project for the Central Markets,
Paris, 10 June 1851. Elevation of
pavilions 4 and 5. Bibliothèque
historique de la ville de Paris.

(evoking the thermal windows of Roman baths) to generous clerestory lanterns. On the interior, an efficient iron framework uses a curved variant of the Polonceau truss to delineate its structural equilibrium between vertical forces of gravity and lateral forces of shear.

The site plan (fig. 113), modifying alignments in place since 1843, is consistently symmetrical and rectangular. The markets have been increased to sixty thousand square meters by their extension toward the Rue Saint-Denis, though only to the center line of the Marché des Innocents, in answer to Carlier's objections to the more ambitious scheme published in 1850. Rectangular end pavilions, toward the Rue du Four to the west and the future Rue des Innocents to the east, bracket six interior pavilions that cluster along a single transverse street on axis with the Halle au Blé, an axis that cuts through the end pavilions to create what are in effect covered streets. The inner core, assembled from pairs of smaller pavilions to either side of two larger, nearly square pavilions

in the middle, is framed by two thoroughfare streets and crossed by two service alleys between the Rue de Rambuteau to the north and the Rue du Contrat Social to the south. Addressing the criticism that earlier schemes had confused food distribution with public circulation, this layout at least partly segregates the markets' internal functioning from the surrounding network of streets. Whether or not it would in fact have solved the problem, this plan expressed Baltard's ongoing effort to organize the markets into a comprehensive urban system: the tightly integrated weave of pavilions and streets plots a regular yet continuously inflected grid that is carefully coordinated with the surrounding quarter.

Chaired by Lanquetin, the special committee of the Commission municipale had shifted its allegiance over the course of the past twelve months, since it had first been charged by Berger with comparing the competing projects by Baltard and Horeau. In July 1850, Grenet calculated that opinion was evenly divided between the

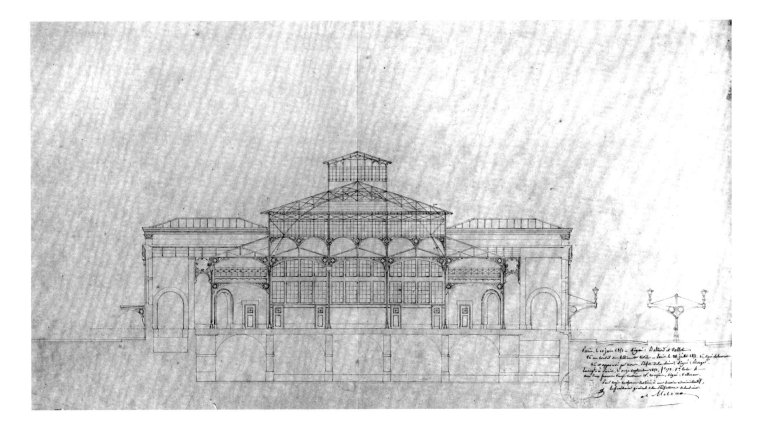

FIGURE 112
Victor Baltard and Félix Callet,
project for the Central Markets,
Paris, 10 June 1851. Section of
pavilions 4 and 5. Archives de la
Seine.

two, but by February 1851 he could report that "if Mr. Lanquetin is not completely favorable to us, he is perfectly hostile to the Horeau project, and that's enough for us."[165] The following April, when Léon Faucher replaced Baroche as minister of the interior and asked to see the projects, Horeau lost the government's support as well.[166] By the time Faucher reported his opinion to Berger on 21 May, word had already leaked out: on 10 May, Grenet wrote to Baltard to say that Faucher had come over to their side.[167] The special committee followed suit in its final report, of 11 June, rejecting the counterprojects by Horeau, Pigeory (and Vacher), Dédéban, and Duval to come down decisively on the side of the official site, program, and project: "The conscientious study of the programmatic needs and the in-depth study of every question has convinced your committee to reject every project to displace the

Central Markets, not only because the utility of the change had not seemed to answer the exigencies of the program but also because the other sites designated would present as many and even greater problems than the current site, enlarged at such great expense."[168] The committee recommended that the amount of covered space along the service streets be increased and that the 1847 alignments be modified by extending the site fifty meters toward the Rue Saint-Denis, straightening the Rue Saint-Denis from the Place du Châtelet to the Marché des Innocents, opening a new street fifteen meters in width from the Quai de la Mégisserie to the center of the Marché des Innocents, and widening to fifteen meters four other streets to the south (Boucher, Estienne, Tirechappe, and des Déchargeurs). Despite Baltard and Callet's repeated requests, however, the committee kept in place the skewed alignment of streets along the

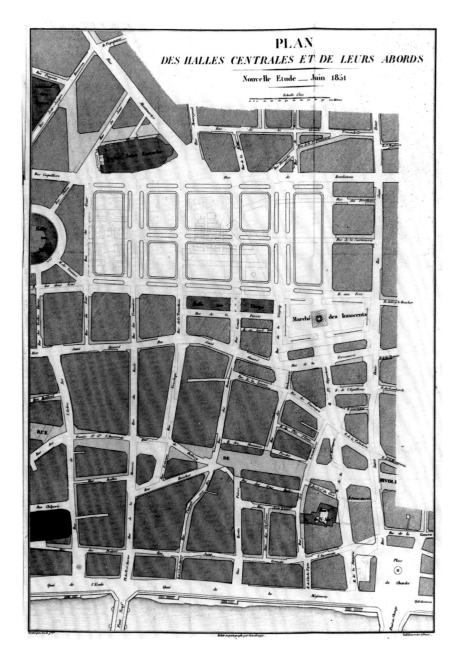

PLAN
DES HALLES CENTRALES ET DE LEURS ABORDS
Nouvelle Etude — Juin 1851

FIGURE 113
Commission municipale, site plan
for the Central Markets, Paris,
June 1851. Document held at the
Centre historique des Archives
nationales de France, Paris.

markets' south flank, so that these paralleled the
existing Halle aux Draps rather than the projected
pavilions.

On 11 June, by a vote of twenty-one out of
thirty-six, the Commission municipale adopted
the committee's recommendations and, conse-
quently, the work of Baltard and Callet. Horeau

protested in July, laying out the municipal report
and his rebuttal in parallel columns, but the gov-
ernment and the prefecture had both lost interest
in his counterproposal after the tide of public
opinion swept back to the administration's proj-
ect.[169] Nor is it surprising that, in the end, Lanque-
tin came around to supporting Baltard and Callet,
even though his arguments for displacing the mar-
kets had both provoked and justified the search
for alternative sites in the first place. As *Le siècle*
observed, the official project was the result of a
collective municipal effort, realized through a
series of administrative actions and decisions that
had been deliberated since at least 1842.[170] By 1851,
the city had spent 10,395,671 francs expropriating
and clearing property at the Halles, based on a
program that Rambuteau had formalized in 1847:
legally and fiscally, it had become impossible to
abandon the official site.[171]

Louis-Napoléon was eager for work to begin
before his term expired in 1852, the National
Assembly having refused, in June 1850, to lift the
ban on presidential reelections set in the Consti-
tution of November 1848. On 18 July, the Com-
mission municipale adopted a combined budget
of 58 million francs for the Central Markets and
Rue de Rivoli: 11 million francs to build the eight
new pavilions (4 million less than Baltard had esti-
mated in 1850); 20 million francs to acquire prop-
erty for an area now measuring sixty-eight thou-
sand square meters (including perimeter streets);
another 6 million francs for the six streets listed
by the special committee; and 21 million francs
to extend the Rue de Rivoli from the Louvre to
the Hôtel de Ville.[172] Abandoning the hope of
a direct state subsidy, promised in 1850, when
Louis-Napoléon was taken with Horeau's counter-
project, the councilors doubled the loan approved
in 1847 and voted to borrow 50 of the required
58 million francs at 5 percent. On 28 July, the
Conseil des bâtiments civils approved the revised

project for the markets after a lively discussion in which the eight architects present disagreed with Prosper Mérimée's objection that the "elevations do not in his opinion present at all the character appropriate either to their purpose or to the construction of the exterior in stone and the interior in iron."[173] (It is not clear whether the project in question was the one drawn up in June 1851 or a subsequent revision that more closely corresponded to what was actually built in 1851–53.)

The municipal bond was passed into law by the National Assembly on 4 August.[174] Two days earlier, Berger opened a public inquest into a new master plan for the entire Halles quarter between the Rue de Rambuteau and the Seine (fig. 114): by 1851, it was understood that the Central Markets were part of a comprehensive project of urban renewal in the center of Paris.[175] This included the Chevalier du Guet quarter, which Horeau had correctly targeted as a slum, even if the administration's solution was to rebuild, rather than raze, the existing housing stock. The south flank of the markets (but not the south side of the Rue du Contrat Social) had finally been aligned to permit the fully rectangular perimeter requested by Baltard and Callet since 1847, though the centerline of the markets remained off-axis to the Halle au Blé. Baltard and Callet were ignored when they wrote to the prefect in September asking that the entire site be shifted south in order to line up with the Halle au Blé.[176] Rehearsing arguments from a decade before, representatives of the tenth, eleventh, and twelfth Left Bank districts argued for Horeau's project on the Seine, or at least for a direct connection via a new street between the Halles and the Quai de la Mégisserie.[177] Their petitions also fell on deaf ears, as did a proposal from the architect A.-F. Mauduit to coordinate Horeau's project with a variant of the Rue de Rivoli, which he argued should be extended on axis from the center of the east façade of the

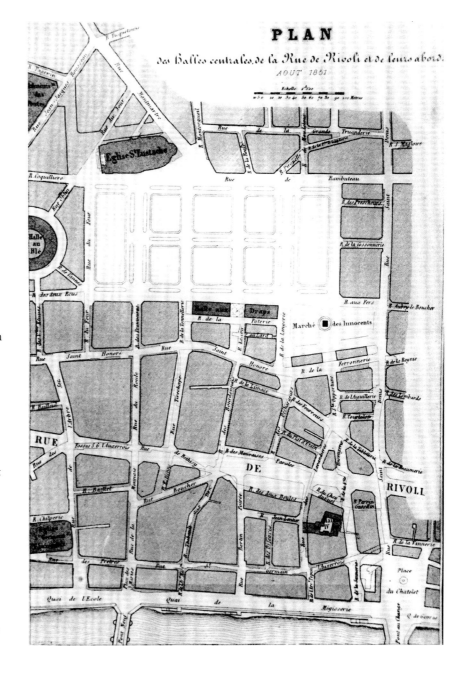

Louvre to the Hôtel de Ville.[178] As far as Berger was concerned, "The question of the siting of the Central Markets having been definitively resolved, the issue will be considered moot and closed to further discussion."[179]

Louis-Napoléon laid the markets' cornerstone on 15 September 1851, at a ceremony attended

FIGURE 114
Préfecture de la Seine for Jean-Jacques Berger, inquest plan for the Central Markets and the Rue de Rivoli, August 1851. Bibliothèque historique de la ville de Paris.

by Faucher, Berger, Carlier, and the municipal council. The prefects of the Seine and police were each decorated with the Légion d'Honneur, while the "Dames de la Halle" presented the prince-president with bouquets of flowers, including an enormous one of violets bearing his monogram. Until Carlier let word slip out prematurely, Louis-Napoléon had intended to overthrow the National Assembly and arrest the opposition two days after this ceremony. While the indiscretion of his prefect of police forced the president to postpone his coup d'état until 2 December, his presence at the markets was nonetheless calculated for its political effect, as Merruau explains: "At the moment of undertaking an abrupt change in government, Prince Louis wanted to demonstrate, one more time, his preoccupation with the needs of the people and his efforts to provide them with work."[180] Louis-Napoléon had abandoned Horeau yet remained sensitive to the project's political connotations, with consequences that would again directly affect Baltard and Callet two years later.

The revised site plan was not formally authorized until 10 March 1852, when a presidential decree superseded the royal ordinance of 17 January 1847.[181] Construction, however, began immediately after the inquest in August 1851. Baltard calculated at 2,593.47 francs the cost of setting up on site the necessary storage sheds, workshops, and construction offices.[182] The masonry work for pavilion 2, across from the church of Saint-Eustache and the first to be built, was adjudicated in September to the builder Labouret, who bid a 15 percent discount on the contract of 600,000 francs.[183] That same month, Baltard contacted Pierre Joly about his qualifications to fabricate ironwork for the markets.[184] By October 1851, the office was preparing the working drawings for pavilion 2.[185] Drawings for pavilion 8, at the eastern edge of the Halles, on the Rue des Innocents, were produced between January and May of 1853,

and bids in the amount of 341,835.97 francs were contracted in early June for its ironwork, woodwork, marble work, roofing, and painting.[186]

By then the project was in serious trouble. Over budget and behind schedule, its roof only half finished, pavilion 2 had already cost 850,000 out of a budgeted 994,758 francs by May 1854; Baltard and Callet recalculated the costs for all eight pavilions at 12,862,058 francs.[187] As the structure rose slowly from the ground, the public also discovered that the light and open pavilions promised in earlier designs had been exchanged for something unexpectedly massive and closed (figs. 115, 116). In January, a newspaper article observed that the masonry "walls are built with such solidity that one would almost call it a fortress."[188] Later that same year, César Daly elaborated on the apparent incongruity between the pavilion's form and its function: "The masonry is treated with luxury; the cut stone presents everywhere sharp quoins and displays carefully dressed faces. . . . But it is hard to see what this heap of stones has to do with the vending of vegetables and flowers."[189] Inside, the graceful metal framework proposed in June 1851 had given way to sturdy iron arches that rested directly on stone piers set into the perimeter walls, and that were assembled in voussoir-like sections from pierced ornamental panels of cast iron screwed to each face of sheet-iron I-beams. Daly noted that the effect of solidity was achieved at the expense of any real economy or efficiency of structure.[190]

Bertrand Lemoine suggests that pavilion 2, especially its cast-iron arches, was conceived with Labrouste's Sainte-Geneviève Library in mind.[191] If he is right, then the intelligent commentary demonstrated in the 1848 project had been abandoned for an exercise in willful misquotation. A more likely reason is that Baltard, the ever-responsible and responsive municipal employee, had answered to yet another official directive: defending the

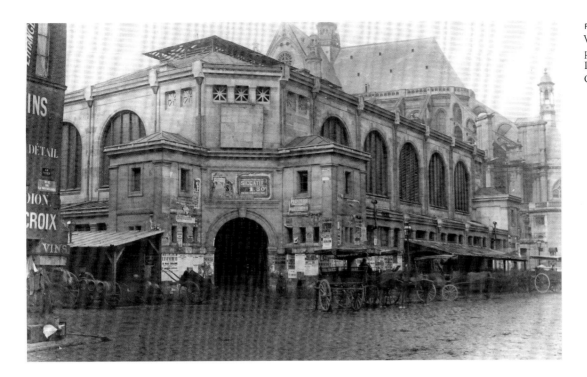

FIGURE 115
Victor Baltard and Félix Callet,
pavilion 2 of the Central Markets,
Paris, 1851–53. Photograph by
Charles Marville.

project to Napoléon III in June 1853, he insisted on "the complete submission [the architects] had always demonstrated with respect to the programs and the direction they received from the administration."[192] Though César Daly was skeptical, observing that we should "accept this excuse for what it is worth," the pavilion's stolid monumentality was in fact a significant departure from the elegantly transparent structures of the two previous designs.[193] The "monumental character" stipulated for the markets in October 1847 could well have acquired added urgency in 1851, when Louis-Napoléon was eager to prove his political legitimacy and therefore stability as he laid the foundations for his coup d'état: the same politician who would insist on iron "umbrellas" in 1853 lavished praise in 1851 on the projected stone pavilions for representing "a social edifice solid enough to offer a shelter against the violence and mobility of human passions."[194]

The adjacent church of Saint-Eustache (see fig. 78), which Baltard was restoring in those very same years and whose looming bulk became ever more apparent as the foreground clutter of shops and houses was cleared to make way for the new markets, offered an appropriate model. Visual continuities between the rhythm of the pavilion's round-arched bays and the south façade of Saint-Eustache coordinated the two buildings through a shared architecture that extended to their interchangeable use of stone and iron in systems of arcuated compression. This equivalence, and the consequent retreat to a more conservative structure, marked a return in Baltard's thinking to his preliminary projects, which had similarly treated the markets as monumental works of architecture, before he reformulated them in November 1843 as urban elements in a grid of housing blocks. To this extent the pavilion built in 1852–53 was an unresolved pastiche of old and new, as Baltard struggled to reconcile the traditional signifiers of public buildings with their industrial transformation in the nineteenth century. And yet, by directing his attention to Saint-Eustache, the redesigned

Revue Générale de l'Architecture et des Travaux Publics — 4, Rue de Furstemberg, Paris

Dirigé par M. CÉSAR DALY, architecte.

Pl. 5.

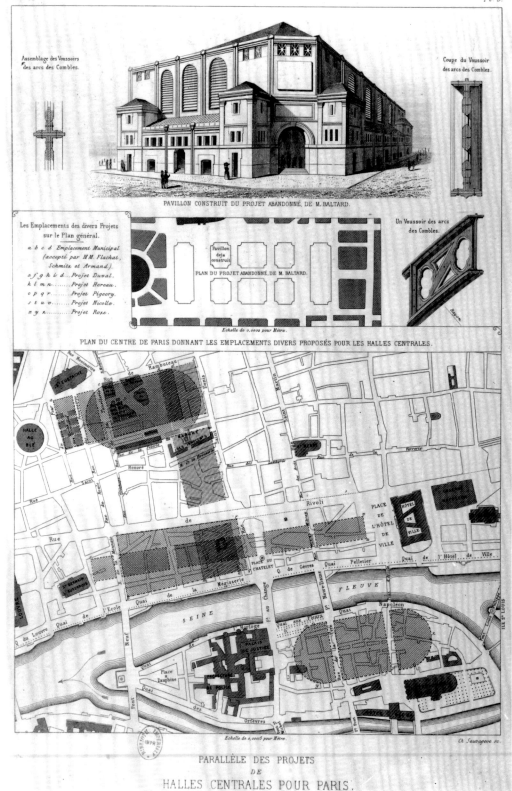

Assemblage des Voussoirs des arcs des Combles.

Coupe du Voussoir des arcs des Combles.

PAVILLON CONSTRUIT DU PROJET ABANDONNÉ, DE M. BALTARD.

Les Emplacements des divers Projets sur le Plan général.

a b c d Emplacement Municipal (accepté par MM. Flachat, Schmitz et Armand).

e f g h i d ... Projet Duval.

k l m n Projet Horeau.

o p q r Projet Pigeory.

s t u v Projet Nicolle.

x y z Projet Rose.

Pavillon deja construit

PLAN DU PROJET ABANDONNÉ, DE M. BALTARD.

Un Voussoir des arcs des Combles.

Echelle de o,ooo2 pour Mètre.

PLAN DU CENTRE DE PARIS DONNANT LES EMPLACEMENTS DIVERS PROPOSÉS POUR LES HALLES CENTRALES.

Echelle de o,ooo5 pour Mètre.

Ch. Sauvageot sc.

PARALLÈLE DES PROJETS
DE
HALLES CENTRALES POUR PARIS.

pavilion also pointed a way out of this dilemma by making Baltard look beyond the material dialectic of stone and iron that he had already and more successfully addressed in the two previous projects, to address the fundamental urban dialectic between monumental and residential types of architecture. This dialectic not only defined his final project of 1853–54 but would also inform both his design of the Bâtiments Annexes in 1855 and his rebuilding of Saint-Leu-Saint-Gilles in 1857–60.

Impregnable in appearance, pavilion 2 was quickly dubbed the "Fort de la Halle," in a play of words on the market porters called the *forts de la halle*.[195] As required by the program, its narrow entrances had been raised four steps above the surrounding sidewalks. This made circulation difficult and alienated the porters and shopkeepers, who submitted a petition of complaint to the emperor.[196] Alert to the problem, Baltard and Callet had already revised the plan of pavilion 8 (fig. 117) between January and May 1853, replacing the corner entrances with a continuous arcade that wraps the perimeter on grade with the sidewalk. But this came too late and in any case did not affect the existing pavilion. On 3 June, Emperor Napoléon III returned to a site he had last visited as president and ordered that work be stopped. The decision became official on 11 June, when Berger wrote to the architects and told them "to suspend immediately all work on the pavilion under construction at the Central Markets."[197]

The immediate result was another flood of counterprojects, in a second iteration of the competition that Senard had called for in 1850. According to Daly, forty-two schemes were sent to the prefecture, ten of which were published (figs. 118–20).[198] Most incorporated iron and glass into their structures, and all addressed issues of urban planning, though only two were a direct threat to the official project. Four projects chose

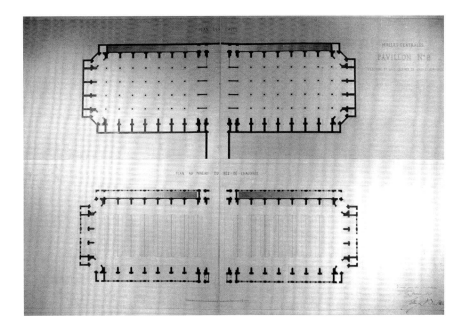

alternate sites along the Seine (see fig. 116). Hector Horeau and Félix Pigeory reissued their earlier designs. Joseph Nicolle (echoing Maudit's solution in 1851) proposed a vast Place du Peuple, 705 meters long on axis from the Louvre to the Hôtel de Ville, whose light and open metal sheds would span an ambitious forty-eight meters. The builder Henry Roze and his son, the civil engineer A. Roze, leveled half of the Île de la Cité to make way for a gigantic elliptical structure covering fifty-eight thousand square meters, with masonry façades emulating Percier and Fontaine's Rue de Rivoli and three iron-and-glass halls linked by two covered streets. Six projects accepted the official site. Charles Duval, whose earlier scheme for a circular market hall had been received with apparent favor by Napoléon III in June 1852, proposed an elliptical building measuring 305 by 165 meters and reaching from the Rue des Prouvaires to the Rue Saint-Denis: behind Neo-Renaissance exteriors, this megastructure divides internally into six iron-and-glass pavilions, with connecting covered streets that converge on a central roofed hangar. Maurice-Sidoine Storez, a former inspector of

FIGURE 116 (*opposite*)
Victor Baltard and Félix Callet, perspective rendering of pavilion 2 and site plan of the Central Markets, Paris, 1851–53, with compared site plans for projects by Baltard and Callet, Armand, Flachat, Duval, Horeau, Pigeory, Nicolle, and Roze. Perspective, details, and site plans from César Daly, "Halles centrales," *Revue générale de l'architecture* (1854).

FIGURE 117
Victor Baltard and Félix Callet, Central Markets, Paris, 1851–53. Revised basement and ground-floor plans for pavilion 8, January–May 1853. Bibliothèque historique de la ville de Paris.

Revue Générale de l'Architecture et des Travaux Publics. — 4 Rue de Furstenberg Paris.

Dirigé par M.r CÉSAR DALY, architecte.

Vol 12

Pl 2

PROJET DE M. F. PIGEORY.

Elévation du Carreau couvert.

PROJET DE M. STOREZ.

PROJET DE MM. ROZE.

PARALLÈLE DES PROJETS
DE
HALLES-CENTRALES POUR PARIS.

municipal works, returned to an idea explored by Baltard in 1843 (see fig. 97) to cluster variously sized pavilions around a central square crossed by diagonal streets and framed by apartment

buildings over ground-floor shops. Thorel, a self-identified architect collaborating with a butter merchant named Chirade, widened the site from the Rue de Rambuteau down to the Rue Saint-Honoré: eight pavilions of conservative design, with iron-and-glass roofs resting on arcaded masonry walls, surround a large empty square with an administration building at its center. The otherwise unknown Schmitz laid out a complex of five elaborate masonry pavilions divided internally into double aisles beneath paired metal roofs between connecting covered streets, on a site that also ran all the way to the Rue Saint-Honoré.

The projects submitted by the architect Alfred Armand and the engineer Eugène Flachat were solicited by the prefecture, perhaps on instructions from Napoléon III.[199] Armand and Flachat had worked together from 1836 until 1846 on the construction of train stations for the Compagnie des chemins de fer de l'Ouest, and they replaced Horeau as Napoléon III's new (if equally transient) favorites after the emperor visited Flachat's iron-and-glass shed, spanning an impressive forty meters, at the Gare Saint-Lazare in June 1853 (see fig. 5).[200] Asked to submit jointly, the architect and the engineer presented competing projects when they failed to agree on a common design. Both, however, understood that the emperor had embraced railroads as an industrial model for the modernization of France, and each proposed exclusively iron-and-glass structures. Armand drew up two variants for a single hall with arcuated façades and closely spaced rows of cast-iron columns flanking four transverse covered streets: the first scheme parallels those streets with paired aisles; the second, evoking Saint-Eustache, crosses those streets with three broad naves within a perimeter ambulatory. Armand's attention to the niceties of historical context contrasts with Flachat's stress on his structural expertise as one of France's leading engineers. After considering, like

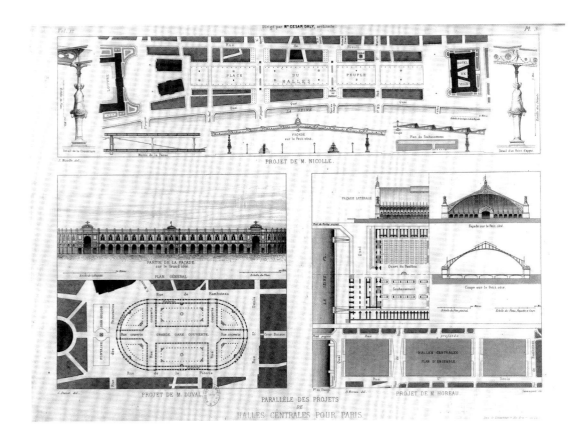

PROJET DE M. NICOLLE.

PARTIE DE LA FAÇADE sur le Grand côté.
PLAN GÉNÉRAL

PROJET DE M. DUVAL.

FAÇADE LATÉRALE
Coupe sur le Petit côté.

PROJET DE M. HOREAU.

PARALLÈLE DES PROJETS DE HALLES CENTRALES POUR PARIS.

FIGURE 118 (*opposite*)
Félix Pigeory, Maurice-Sidoine Storez, and Henry and A. Roze, projects for the Central Markets, Paris, 1853. Plans, elevation, and section, from César Daly, "Halles centrales," *Revue générale de l'architecture* (1854).

FIGURE 119
Joseph Nicolle, Charles Duval, and Hector Horeau, projects for the Central Markets, Paris, 1853. Plans, elevations, and sections, from César Daly, "Halles centrales," *Revue générale de l'architecture* (1854).

Armand, a single hall covering forty-two thousand square meters, Flachat opted for three detached pavilions (one large, two small) on advice from the municipal administration. As at the Gare Saint-Lazare, Flachat spanned these pavilions with a variant of the Polonceau truss, in which the compression struts are set perpendicular to the rafters above rather than to the tension rods below. The proposed span of eighty-two meters in the central hall of the large pavilion advertised the scope of Flachat's engineering ambitions, since it doubled his own record and exceeded anything that had been constructed to date. Whether or not Flachat's markets could have been built as designed, they visualized the expectation articulated by César Daly: "Under vast coverings . . . under elegant and light roofs held up by svelte columns, the individual markets are grouped without difficulty at the most convenient points,

expanding and contracting according to need and the lessons of experience . . . the umbrella has become the collective monument."[201]

DESIGNING THE CENTRAL MARKETS, 1853–1854

By 1853, Baltard had worked nearly ten years on the Central Markets, eight of those officially since his appointment as their architect in 1845. By 1853, he was also a seasoned municipal employee, whose service since 1840 as the *inspecteur des Beaux-Arts* had led to his promotion in 1848 as architect of the first section of city buildings. No longer the novice who saw his hopes dashed in the competition for Napoléon's Tomb, Baltard responded aggressively to the threat posed by Armand and Flachat. He and Callet immediately drew up three variant projects for the markets, which they sent to Berger on 13 June and presented to

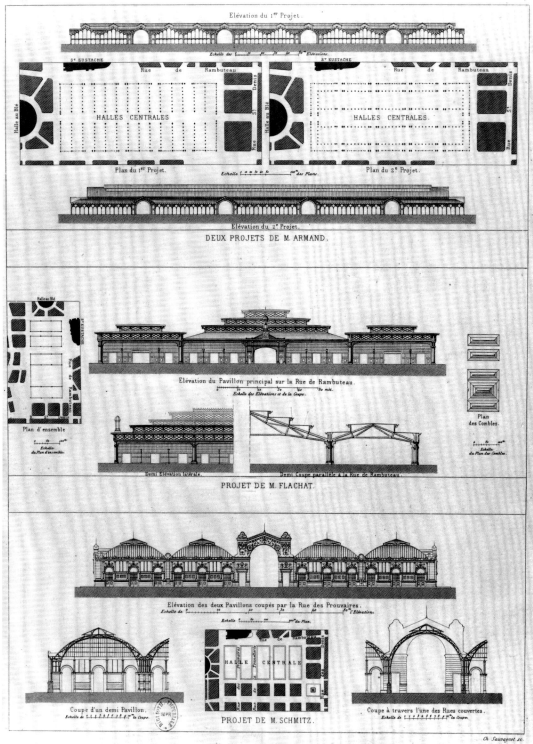

Elévation du 1^{er} Projet.

Echelle des ⊢⊢⊢⊢⊢ Elévations.

S^t EUSTACHE Rue de Rambuteau S^t EUSTACHE Rue de Rambuteau

Halle au Blé HALLES CENTRALES Rue S^t Denis Halle au Blé HALLES CENTRALES. Rue S^t Denis

Plan du 1^{er} Projet. Echelle ⊢⊢⊢⊢⊢ des Plans. Plan du 2^e Projet.

Elévation du 2^e Projet.

DEUX PROJETS DE M. ARMAND.

Halle au Blé

Plan d'ensemble

Echelle du Plan d'ensemble.

Elévation du Pavillon principal sur la Rue de Rambuteau.

Echelle des Elévations et de la Coupe.

Demi Elévation latérale. Demi Coupe parallèle à la Rue de Rambuteau.

Plan des Combles.

Echelle du Plan des Combles.

PROJET DE M. FLACHAT.

Elévation des deux Pavillons coupés par la Rue des Prouvaires.

Echelle de ⊢⊢⊢⊢⊢ l'Elévation. Echelle ⊢⊢⊢⊢⊢ du Plan.

Coupe d'un demi Pavillon. Coupe à travers l'une des Rues couvertes.

Echelle de ⊢⊢⊢⊢⊢ la Coupe. HALLE CENTRALE Echelle de ⊢⊢⊢⊢⊢ la Coupe.

PROJET DE M. SCHMITZ.

Ch. Sauvageot sc.

PARALLÈLE DES PROJETS

DE

HALLES CENTRALES POUR PARIS.

Napoléon III a week later: one "almost exclusively of iron," a second of "iron with stone piers," and a third "mixed construction of stone and iron" based on the existing pavilion.[202] All three further regularized the 1851 site plan, while the latter two introduced covered streets that cluster the pavilions into superblocks. By October, Baltard and Callet had refined their design for ten pavilions built entirely of iron and organized into two superblocks with connecting covered streets. By December, they had finalized this design, and the project was then reviewed and approved for construction in the spring of 1854.

The three schemes of June 1853 are differentiated by their budgets, structures, and plans. The first, budgeted at 5 million francs, is cautious despite its extensive use of iron. Rows of cast-iron columns subdivide the pavilions into two or three interior aisles that measure a relatively timid twelve meters across, set within a perimeter circulation gallery and anchored by stone towers at the corners. The site plan keeps the layout approved in 1851, with two thoroughfares cutting across the markets between the Rue de Rambuteau and the Rue du Contrat Social. In the only change of note, short internal streets bisect the rectangular pavilions at either end: these internal streets effectively raise the number of pavilions from eight to ten and establish a continuous cross-axis aligned with the Halle au Blé, as Baltard and Callet had requested since 1847. The second scheme (figs. 121, 122), budgeted at 6.5 million francs, is structurally and urbanistically bolder. Curtain wall façades of iron and glass, opened at their base through segmental arches resting on triads of thin cast-iron columns, are bracketed between masonry arcades run from corner towers down the flank of each pavilion. Inside, the umbrella-like pavilions are roofed with Polonceau trusses to permit a clear span of thirty meters in the nave of the largest central pavilion; these support ingenious girders that incorporate

segmental arches to create a ventilated double roof. Covered streets connect the middle three pavilions and pull the site together into a spatially unified system of urban superblocks, while an internal transverse street cuts through every pavilion on axis with the Halle au Blé. The third project, budgeted at 8 million francs, adapts the layout of the second project to a mixed structure of stone and iron, derived from the existing pavilion but modified to permit the revisions suggested for pavilion 8 (see fig. 117). In every case, the budgets of 5, 6.5, and 8 million francs promised dramatic economies over the earlier designs. Even the 8 million francs budgeted for the stone-and-iron pavilions was markedly less than the 11 million francs approved for nearly the same design in 1851 (and recalculated at 12.5 million francs in 1853). The expectation, partly justified by the 40 percent decline in prices for cast and wrought iron between 1815 and 1848, was that industrialized and standardized structures could reduce building costs.[203] In 1853, however, these estimates still answered more to political than to economic realities, and they would prove to be substantially less that the actual costs of construction.

If Baltard clearly had the technical expertise to engineer an iron structure, he just as clearly preferred the second scheme, integrating iron and stone, over the first, using iron alone. To his way of thinking, the juxtaposition of stone to iron was a material indicator of how a city is made over time: signs of modernity like covered streets or iron roofs spanning thirty meters became more remarkable, more significant, when compared to signs of tradition like a masonry arcade. Technically and conceptually, the second project picks up the tectonic dialogue between stone and iron that Baltard had previously explored in August 1848 and June 1851, even if he now greatly increased the interior spans in response to the public clamor for more striking displays of structural ingenuity and

FIGURE 120 (*opposite*) Alfred Armand, Eugène Flachat, and Schmitz, projects for the Central Markets, Paris, 1853. Plans, elevations, and sections, from César Daly, "Halles centrales," *Revue générale de l'architecture* (1854).

FIGURE 121
Victor Baltard and Félix Callet,
project 2 for the Central Markets,
in iron with stone piers, 13 June
1853. Site plan. Bibliothèque
historique de la ville de Paris.

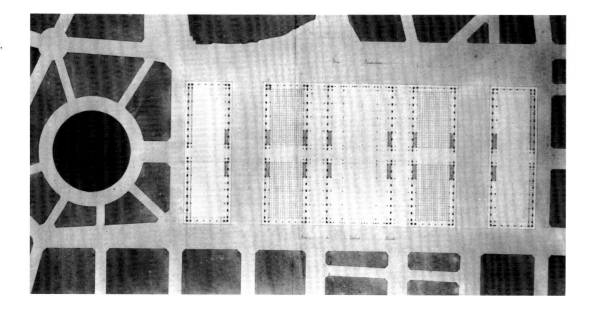

industrial prowess. At the same time, he looked again to Saint-Eustache, whose example he had emulated so unsuccessfully in pavilion 2. Where the quadrangular footprint and volumes of the pavilions mirrored the quarter's housing blocks, their elevations and dramatic interiors reflected the arched forms and monumental spaces of Saint-Eustache. At work is the same logic that Baltard would apply when adjusting the nearby church of Saint-Leu-Saint-Gilles to the imperatives of Haussmann's planning. Avoiding easy distinctions between a work of industrial utility and one of historic preservation, Baltard transposed the circumstances of each project in a densely layered urban hybrid: the industrial modernity of the markets was compromised by their location in a quarter dating to the Middle Ages, just as the premodern authenticity of the church was compromised by Haussmann's urbanism.

Baltard's use of iron, along with the covered streets and Polonceau truss introduced in his second project, left him vulnerable to charges that he had stolen ideas from Armand and Flachat. Given their quasi-official status as invited contestants, it

is not surprising that Baltard paid close attention to their projects. What he is supposed to have plagiarized remains, however, uncertain, since the ideas in question were neither original nor unique to his rivals. Like Baltard, Armand and Flachat relied on materials, types, and systems that were widely disseminated and commonly shared by 1853: Camille Polonceau's truss had been published in the *Revue générale de l'architecture* in 1840, and covered streets had been known since the development of commercial arcades roofed with iron and glass in the 1820s.[204] If, like Armand, Baltard figured the markets with rhythmic elevations of arches and gables, this was because they were both trained as architects in the rhetoric of historical forms, especially when those resonated with the nearby church of Saint-Eustache. One cannot assume that either was copying the other, any more than either was imitating Flachat, whose rectilinear elevations and latticework detailing are formally distinct from their projects. Armand and Flachat did not so much show Baltard what to do as prompt him to clarify what he had been thinking all along, ever since he realized that streets

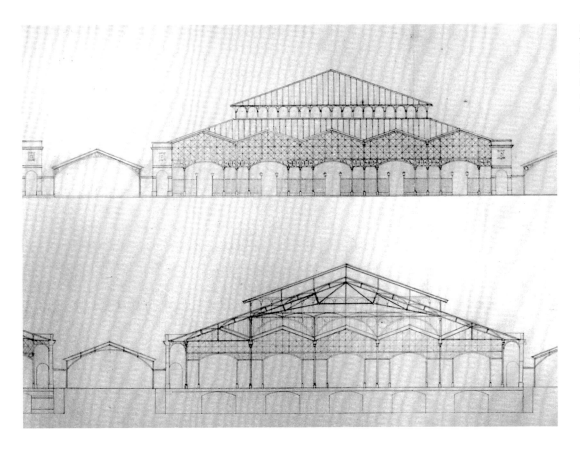

FIGURE 122
Victor Baltard and Félix Callet, project 2 for the Central Markets, in iron with stone piers, 13 June 1853. Detail of elevations and sections. Bibliothèque historique de la ville de Paris.

could precede buildings in the Delessert plan of November 1843, and ever since he seriously investigated the structural potential of iron in his project of August 1848.

Baltard and Callet worked hard to reestablish their authority in June 1853, only to be overrun by events beyond their control. That same month, Napoléon III dismissed Berger and brought in Haussmann as prefect of the Seine. On July 5, the architects resubmitted their projects, noting that these had already been presented to the emperor and that they stood ready "to give to our new plans any development that is called for."[205] There is no record of the prefect's response, though he was certainly paying attention: that same month, the *directeur des bâtiments civils,* J.-É.-M. de Cardaillac, wrote to Haussmann on behalf of the minister of the interior to say that he

had received and reviewed two counterprojects by Eugène Flachat and M.-S. Storez but that it was up to the prefect to decide which project best met the needs of Paris.[206] In August, Baltard and Callet petitioned Haussmann for permission to complete pavilion 2 with a modified design that they recommended applying as well to pavilions 3, 6, and 7.[207] This sensible desire (perhaps advocated by other administration officials) to preserve a building on which so much money had already been spent would encourage Haussmann to claim that Baltard resisted the imperial command to design the markets in "iron, iron, nothing but iron!" On 8 August, he fired the architects and suspended all salaries and fees to their office as of 1 September.[208]

Haussmann did not mention Baltard and Callet when he presented their projects to the

Commission municipale on 26 August, along with new site plans and revised budgets of 67,456,517 and 29,722,051 francs respectively for the historically related Rue de Rivoli and Halles projects.[209] The street and markets were further associated by the charge of incompetence leveled against the previous administration, since surveying mistakes in the alignment of the projected extension of the Rue de Rivoli meant that the street, like the markets, had to be replanned. Haussmann set the final property costs for the Halles at 20,722,051 francs, plus another million to engineer new streets: with 14,688,000 francs already spent demolishing 147 houses and expropriating 17,493 square meters of ground, an additional 6,030,000 francs were needed to demolish the remaining 180 houses on another 12,052 square meters. Insisting that economies could be realized by building the markets with "less massive masonry and lighter roofs," the prefect fixed the construction budget at 8 million francs and prescribed "new studies."

Obviously, the actions taken by Haussmann upon assuming office in July 1853 were humiliating for the municipal officials and architects who, like Baltard and Callet, had been responsible under Berger for planning the city's streets and public works. Such concerns, however, mattered less to Haussmann than his desire to consolidate his own authority as prefect, at a time when his administration's control over Paris was under threat from the state in the wake of the emperor's direct intervention in the Central Markets in June, first by halting work and then by inviting counterprojects from Armand and Flachat. Having named Haussmann to replace Berger, the emperor then pivoted in the opposite direction by setting up a separate commission charged with developing a plan for Paris: on 2 August 1853, Fialin de Persigny wrote as minister of the interior to Henri de Siméon, asking him to chair a Commission des embellissements de Paris.[210] A prominent

politician and prefect under the July Monarchy, Siméon had hoped to replace Berger, whose administration seemed as ineffectual to him as it did to both Persigny and Napoléon III. Advised by Théodore Jacoubet (author of the 1836 atlas of Paris), Hippolyte Meynadier, and the brothers Louis and Félix Lazare, the Siméon commission in effect constituted a shadow administration that reported directly to the emperor, was headed by a rival for Haussmann's job, and was critical of the prefecture's operations and employees. As David Van Zanten points out, Haussmann's first order of business was therefore "less one of opening things to innovation than one of closing things to outside interference so as to achieve efficient, effective authority."[211] This meant getting municipal projects safely back in the hands of city officials, which is why Haussmann—having first fired them— reinstated Baltard and Callet as architects of the Central Markets on 9 October.[212]

Ten days later, they completed their "Project for the Central Markets According to a New Layout of the Pavilions" (figs. 123, 124).[213] Entirely of cast and wrought iron, the markets are planned on a building module of eight meters, with a clear span of twenty-four meters for the central nave in the two largest pavilions. Perimeter galleries still circle each pavilion, but the elevation proposed in June is simplified to become a continuous arcade of segmental arches on thin columns, which rise directly to roofs capped with clerestory lanterns. The most significant change is in the site plan. Abandoning the symmetrical scheme proposed in June 1853 (going back to 1851), Baltard and Callet adopted the new master plan that Haussmann presented to the Commission municipale in August: a minor group of four pavilions toward the Halle au Blé, connected by covered streets fifteen meters across; and a major group of six pavilions and covered streets toward the Rue des Innocents, with pairs of smaller pavilions

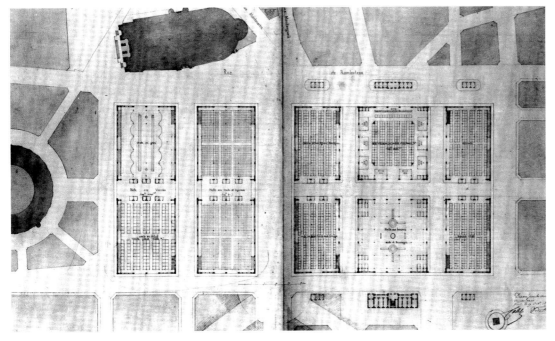

FIGURE 123
Victor Baltard and Félix Callet, project for the Central Markets according to a new plan, 19 October 1853. Site plan. Bibliothèque historique de la ville de Paris.

FIGURE 124
Victor Baltard and Félix Callet, project for the Central Markets according to a new plan, 19 October 1853. Bird's-eye view. Document held at the Centre historique des Archives nationales de France, Paris.

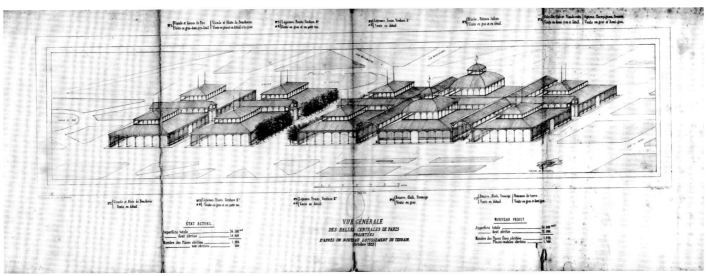

framing two larger pavilions in the middle. A wide transverse thoroughfare, the future Rue Baltard, separates the two groups of pavilions. Measuring thirty-one and a half meters across, this street links the Rue Montmartre to the north with three projected streets that radiate from a semicircular square on the markets' south side. The site remains at the 60,000 square meters fixed in 1851, but now some 32,500 square meters are roofed by pavilions and covered streets, up from the 26,000 meters of enclosed space in previous projects.

This is substantially what would be built, despite the refinements to come in the structural module, the interior layout, and the final elevations. The plan and perspective suggest a light and relatively simple system of construction: faced

with Haussmann's equal insistence on economy and iron, Baltard and Callet put aside the sophisticated structural investigations that had defined the earlier projects—in 1848 and 1851 as much as 1853—and turned instead to the vernacular model of the open-air-market shed, whose modular and repeating system of wooden construction they now translated into an industrial vernacular of cast and wrought iron. The prefect took credit for the revised master plan, with its organization of the markets as clusters of four and six pavilions to either side of a cross street.[214] Nearly identical to the one used by Flachat in June 1853 on advice from the previous administration (see fig. 120), this plan was actually formulated over the course of three months, from June through August, by municipal personnel working for both Berger and Haussmann. In Baltard's diplomatically nuanced account, Haussmann joined with the architects "in perfecting a project that the emperor had already approved in principle, and admitted a new plat of the site, more rational and judicious than that of the earlier projects."[215] The deliberative process of consultation and revision that had informed the design's development all along did not end with Haussmann's arrival.

Baltard and Callet finalized their project by December 1853, when it was reviewed by a special municipal committee set up (like the one in 1851) to evaluate competing proposals for the Halles. Approved by the Commission municipale on 16 January 1854, the project was then displayed in February at the fourth district's town hall.[216] By March, drawings of the basement were ready for inspection by the Conseil des bâtiments civils. In a contentious meeting on the twenty-seventh, every architect except Henri Labrouste attacked its composite structure of brick groin vaults resting on cast-iron ribs and columns.[217] Reconvening on 12 and 13 April to examine a finished set of drawings, the *conseil* continued to question the basement structure while voicing doubts about the pavilions as well. Félix Duban captured the majority sentiment—again except for Labrouste—when he complained that "the cast and wrought iron employed for the pavilions is spindly in appearance and in reality; he believe[d] that, given the hypothesis, one should have been able to adopt a more accentuated architectural system."[218] The meeting minutes suggest that Labrouste alone defended Baltard's design and may have been instrumental in securing the *conseil*'s reluctant approval of the project, along with its budget of 8,254,997.29 francs.

On instructions from Haussmann, Baltard and Callet also fabricated a detailed model of the markets in metal and plaster in the spring of 1854. Predictably, the prefect overlooked the comparative models exhibited by Horeau in 1850, to claim that the idea was entirely his own. He described this model as presenting "the two groups of projected pavilions, and everything around them, monuments and houses, sidewalks and street lights, executed with scrupulous attention to the proportions of everything, and even offering the spectacle of activity in the streets, so that one could judge the grandeur of the edifice by the smallness of the vehicles and the pedestrians."[219] Shown unfinished to the Commission municipale in mid-April, the completed model and a plan of the Halles quarter were then put on display at the Hôtel de Ville in May, where both were viewed by throngs of people, including Napoléon III, who personally approved the new design on May 19.[220] If Baltard and Callet were now beneficiaries of the imperial favor shown previously to Horeau, Armand, and Flachat, this had everything to do with a new perception of their project. Marking Haussmann's real contribution to the process, the model and its display were acts of political theater that divorced the iron-and-glass markets from unfortunate associations with the project's origins

in the July Monarchy and the Second Republic and reimagined them as signs of Napoléon III's promise to industrialize France under the Second Empire. Ironically, Baltard and Callet were allowed to design the markets because their invention had now been claimed by the emperor and his prefect. Following on, and in a sense completing, the events of July and August 1853, when Haussmann fired the architects and asserted his control over the design process, this dramatic re-presentation of the markets as instruments of imperial planning fostered the enduring myth that Baltard was nothing more than a technician who, in Giedion's words, "laboriously had to patch his buildings together from the ideas of others."[221]

The plan for the Halles quarter, exhibited along with the model at the Hôtel de Ville, was drawn up in the same months that saw Baltard and Callet finalize their project (fig. 125). Ready by January 1854, it was examined by the Conseil des bâtiments civils on 16 and 20 February, published on 1 March, submitted to public inquest from 22 March to 8 April, adopted by the Commission municipale on 12 May, and authorized by imperial decree on 21 June 1854 (superseding the presidential decree of 10 March 1852).[222] The Central Markets were to be coordinated with a tight network of streets, housing blocks, and public buildings that included a new Hôtel des Postes on the nearby Place du Châtelet. As the architects had requested since 1847, this newest plan bisects the markets with a street on axis with the Halle au Blé. To permit the markets' alignment with the Rue du Contrat Social on the south side, the Halle aux Draps has been removed and the Marché des Innocents replaced on its western side by a massive, five-story housing block (soon named the "Massif des Innocents") that faces to the east onto a small urban park organized around Goujon's relocated Fontaine des Innocents. Three streets radiate from a semicircular square at the foot of

the Rue Baltard, linking the markets with both the Rue de Rivoli and the Seine; these include the future Rue des Halles, leading on the right to the Place du Châtelet and the Pont au Change, and the future Rue du Pont Neuf, leading in the center to a projected square and extant bridge of the same name. Two more streets, authorized in separate decrees of 1854, bracket the quarter to the west and east: the Rue du Louvre, extending north from the Place du Louvre, and the Boulevard de Strasbourg (Sébastopol), starting at the Place du Châtelet. Another projected street, authorized in imperial decrees of 15 and 22 November 1853, runs at lower left from the Place du Louvre, past the church of Saint-Germain-l'Auxerrois, to the Place du Pont Neuf. In the plan's far right corner, the future Avenue Victoria, decreed on 29 July 1854, connects the Place du Châtelet to the Hôtel de Ville. Proposing to rebuild an entire district, this plan was never fully executed: the two radiating streets to the west of the Rues du Pont Neuf and des Halles, extending toward the Louvre, went unrealized; the street on axis with the Place du Louvre was blocked in 1860–62 by Théodore Ballu's belfry between Saint-Germain-l'Auxerrois and J.-I. Hittorff's Mairie du 1er Arrondissement; and the Hôtel des Postes was moved to the Rue du Louvre, to be replaced by Davioud's Théâtre Impérial du Châtelet. Even so, it fixed the footprint of the markets and the grid of the surrounding Halles quarter, coordinating both with a series of new streets.

The architects of the Bâtiments civils were deeply troubled when they saw this plan on 16 February 1854. They criticized its apparent confusion between utilitarian streets, serving the markets, and public streets, serving the city. More violently, they questioned its organization of the quarter into a grid of housing blocks crossed by diagonal streets. Alphonse de Gisors spoke for his colleagues when he deplored "the small lots

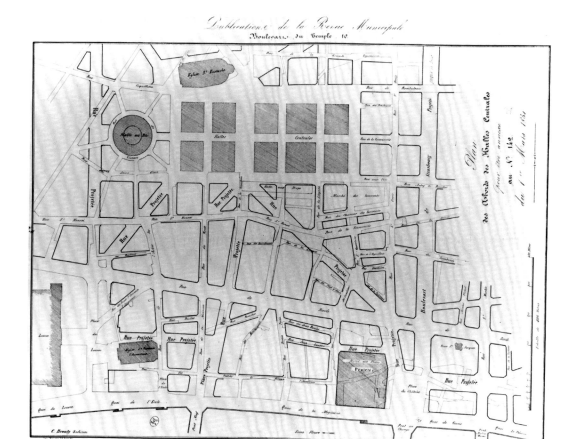

of unhappy shape that are to be constructed, as well as the diagonal or oblique direction of the various small streets abutting the markets; he does not understand why, demolishing everything, one does not proceed with regularity, that is to say, with parallel streets."[223] Unable to reach consensus, the architects adjourned until 20 February. At this second meeting, they were joined by Trémisot, head of the prefecture's second division and responsible for municipal works of planning and architecture. Claiming to speak for the emperor as well as the prefect, Trémisot explained that

> the prefect of the Seine wanted this work, first of all, to free up the church of Saint-Eustache, and then to group all the market pavilions,

including the Halle au Blé, and to develop their circulation to the fullest: he explained to the *conseil* that, to serve the markets, there is a double cycle of circulation specific to certain hours [of delivery and departure] that is independent from the circulation that takes place in the regular streets; and it is for the purpose of not obstructing this circulation that a large space has been set aside, destined for a boulevard alongside the first group of pavilions, by which one can reach every point from the Bourse [on the Right Bank, via the Rue Montmartre] to the Faubourg Saint-Jacques [on the Left Bank, via the Rue des Halles]. . . . He announced, moreover, that the emperor participated with the prefect in the study of

this project and even traced several circulation paths himself.[224]

Questioned by de Gisors on the "small lots," Trémisot replied that "the lots are not so small, and their appearance is not so troubling as it seems in plan, because the least of these lots will have façades of 5 meters, which is enough to give them regularity, with an entry and a window to either side."[225]

The *conseil* backed down and approved the plan, but only after it had recorded its distress at the break with Renaissance conventions of planning based in perspectival constructions of space, as had earlier been demonstrated in the Place des Vosges, the Place des Victoires, and the Place Vendôme, and had more recently informed Percier and Fontaine's effort to set off the Louvre with the Rue de Rivoli. Even though they lacked any systematic coordination with the rest of the city and therefore remained isolated interventions in the urban fabric, those squares and street had presented an immediately apparent spatial order that was carefully coordinated with the framing façades or facing monuments. The Halles plan abandoned those conventions, subordinating traditional notions of perspectival order and spatial hierarchy to a system of densely plotted streets and building blocks that were understood to be continuous with the city's larger patterns of circulation and that consequently collapsed the expected differences between foreground and background into a uniform spatial network.

Coinciding with Haussmann's arrival in office, the formulation of such a radically modern plan seems to corroborate the story of how a prefect collaborated with his emperor to transform Paris. Already in place when Trémisot spoke to the Conseil des bâtiments civils in February 1854, this story identifies the Halles plan as the first iteration of Haussmann's program to bisect the city with the Rue de Rivoli, the Boulevard de Sébastopol, and the Boulevard Saint-Michel:

> In effect, it was for me to penetrate the Sovereign's initial thought in the conception of the first regime of new streets to be opened, according to his plan; to recognize the modifications required for the direction of some of those by a more accurate survey map of the city's topography . . . ; to signal certain important gaps to be filled in, and to foresee everything in the way of work, often thankless and always costly, that might be called for by the connection of these new streets with the old ones.[226]

Like the story of the markets' redesign, however, the plan's attribution to the decisive intervention of emperor and his prefect in 1853–54 ignores the multiple authors who were responsible for its historically protracted development. At issue is both the immediate factual record and the larger point that the transformation of Paris launched in 1854 actually began with an inherited plan based on an inherited set of ideas.

Three presidential decrees from March 1852 prepared the way: a decree of 10 March fixing the perimeter of the Central Markets; a decree of 22 March extending the Rue de Rivoli from the Louvre to the Hôtel de Ville; and a decree of 26 March formalizing the intent of the preceding decree by authorizing the expropriation of entire properties affected by the widening, straightening, or opening of streets in Paris.[227] Replacing the law of 3 May 1841, which limited expropriations to property directly affected by street improvements, the decree of 26 March facilitated the shift from Rambuteau's incremental "plan d'alignement" to the more ambitious "plan de percement" that

characterized Haussmann's planning. In April of 1852, Berger authorized a municipal loan of 50 million francs to finance these works, which was passed into law the following August, and in November of that year a contract was issued for the construction of the northern section of the Boulevard de Strasbourg (Sébastopol), between the Gare de l'Est and the Grands Boulevards. Work was under way when Haussmann replaced Berger in June 1853.[228]

The Siméon commission codified this preparatory work in the report it submitted to Napoléon III on 27 December 1853.[229] Summarizing two decades of planning, the report proposed a comprehensive plan for Paris that itemized twenty-four new streets and organized the city into a system of circulation tied to its train stations. The report also recognized that its ambitious program of urban renewal could not plausibly be completed within ten years unless the conservative fiscal practices employed by Rambuteau and Berger to fund public-works projects were replaced by more aggressive methods of speculative financing that exploited both the excess private capital and the huge pool of surplus labor that were then accumulating in Paris. The Siméon commission thus provided both the urban template and the economic instrument for Haussmann's transformation of the city.[230] Clearly threatened by the commission's challenge to his authority, the prefect suppressed its report; in his *Mémoires,* he implied that the charge of this "Commission spéciale chargé par l'Empereur" had been limited to making recommendations to rebuild the Pont Notre-Dame.[231] This did not, however, prevent him from absorbing the report's recommendations into the plan drawn up by the prefecture between December 1853 and January 1854.

The larger historical point of this record is that the plan for the Halles quarter—and the Central Markets that were its primary

justification—resulted from an extended process of collaboration going back to the 1840s. Rambuteau and Berger had instituted the legal and administrative instruments that authorized its realization. Lanquetin, Perreymond, and other urbanists had formulated a theory of the city as coherently planned systems of circulation that coordinated individual districts with the larger dynamics of physical, social, and economic exchange affecting the city. And Baltard had articulated an urban architecture that generated a building's forms and spaces as much from the city's fabric of streets, housing, and monuments as from the internal requirements of its functional program. Organized by uniform modules of space and structure, the orthogonal grid of the markets systematized the evolving pattern of housing blocks that had shaped the quarter at least since the Renaissance—just as the diagonal linkage of the Rue Montmartre to the new Rues Baltard and des Halles, anchoring the network of diagonal streets that so troubled the architects of the Bâtiments civils, rationalized the crooked path that had wended its way across the site since the Middle Ages. The Delessert plan of November 1843 (see fig. 98), the alignment plan of January 1847 (see fig. 102), and the inquest plan of August 1851 (see fig. 114) were key precedents to the plan approved in 1854. What historians have tended to see as the first demonstration of Haussmann's modernization of Paris according to a model of utilitarian and speculative economy was in fact ready made for the prefect when he arrived in 1853, something that could be quickly implemented precisely because it was not in fact a new idea worked out in a short period of seven months from July 1853 to January 1854 but was instead something that had been formalized incrementally over the previous two decades.

The Central Markets at the core of this plan were not only consistent with its organizing logic but were in fact its principal impetus (fig. 126).

FIGURE 126 (*opposite*) Victor Baltard and Félix Callet, Central Markets, Paris, 1854–74. Bird's-eye perspective, from Victor Baltard and Félix Callet, *Monographie des Halles centrales* (1863).

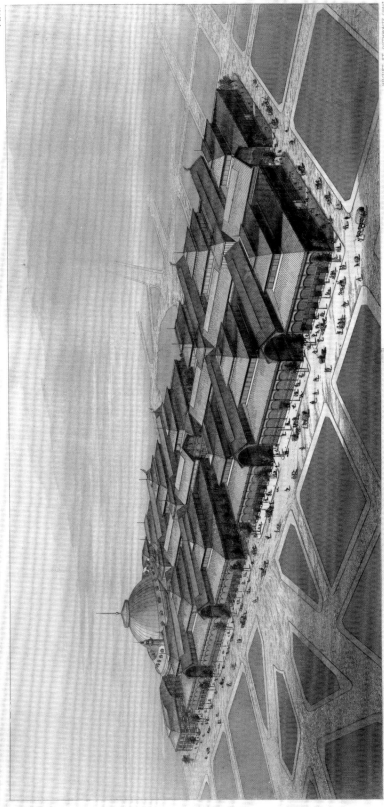

HALLES CENTRALES DE PARIS.

VUE PERSPECTIVE À VOL D'OISEAU

V. BALTARD ARCH.ᵗᵉ

HIQUET ET OUTHWAITE GRAV.ᵗ

Cᵗᵉ BURY dir.

A. MOREL et Cᵗᵉ Éditeurs

Imp. Lemercier à Paris.

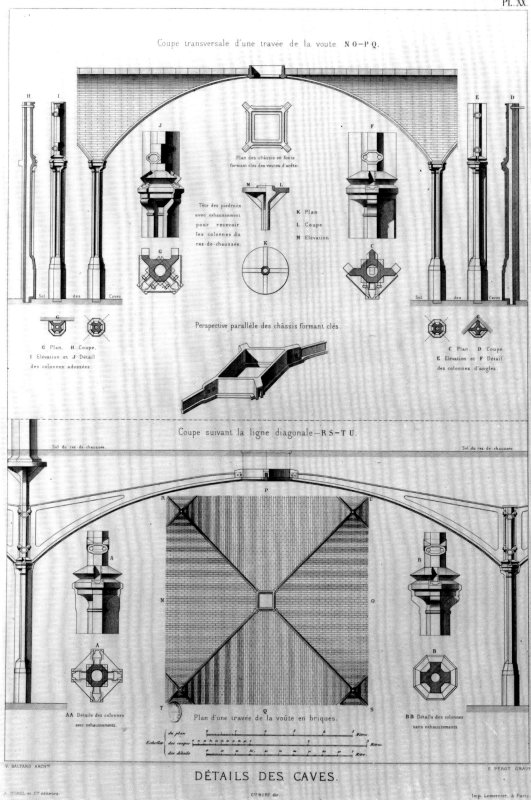

FIGURE 127
Victor Baltard and Félix Callet,
Central Markets, Paris, 1854–74.
Details of the basement vault
structure, from Victor Baltard
and Félix Callet, *Monographie des
Halles centrales* (1863).

This explains why the Conseil des bâtiments civils, having attacked the plan in February, reacted with similar hostility when it reviewed the project drawings in March and April: like that plan, this project seemed to have abandoned conventions of design based in the Renaissance and in formal values of perception in favor of something weirdly abstract and indifferent to "the more accentuated architectural system" that the *conseil* architects wanted to see. According to Baltard, the markets' construction had the advantage of being "simple, economical, and solid; easily applicable to any large space to be covered, it is susceptible to being divided into similar squares requiring only one model."[232] A simple unit of space organized the plan into regularly expanding, additive increments: "A market cannot be anything else, according to our needs, than a rectangular parallelogram divisible by compartments of 2 meters; each stall requires 2 by 2 meters; the passageways require 2 meters . . . which leads to a spacing of 6 meters, multiple of 2 meters, between the columns or point supports of the Halles, in order to create two rows of stalls with a passageway in between."[233] Producing the "regular and symmetrical plan of the eight blocks prescribed by the program," the modular organization of the markets provided in turn the urban template for regularizing the surrounding quarter with its network of symmetrical and orthogonal streets.[234] No longer defined in classical terms as a coherent and self-contained composition, the pavilions were determined instead by the open-ended replication of identical units that brought together building and city, architecture and urbanism, in a uniform system of spatial planning.

The entire complex sat on a concrete foundation mat 30 to 60 centimeters thick. Basements (fig. 127) were vaulted by a composite structure of brick groin vaults supported on cast-iron columns and ribs; the ribs, reinforced with a triangular truss, connected at the vault crown to an open

cast-iron frame in place of the keystone, filled either with a glass block or a ventilation grille. Delivery tunnels (fig. 128), run beneath the covered streets, were spanned in three 5-meter increments by segmental brick vaults set on rivetted sheet-iron girders; a grid of girders one meter in depth spanned the 15-by-15-meter intersections of these tunnels. The basement vaulting was then leveled to grade with concrete. Rows of columns, spaced at 6 meters on center, organized the pavilions (figs. 129, 130) into a perimeter aisle 12 meters in width and a central nave 18 meters across for the smaller pavilions and 30 meters for the larger ones. Assembled from a standard elevation module of 6 by 9.5 meters (fig. 131), each pavilion rested on a stone base and was screened by a patterned brick curtain wall, a band of frosted-glass windows, and open wooden louvers above for ventilation; air from below was exhausted through a second range of wooden louvers in the nave clerestory. Cast-iron columns (6 meters in height) framed each bay and supported cast-iron segmental arches, whose spandrels subdivided into blind arcades filled with frosted glass. The smaller pavilions (fig. 132) were spanned inside by lattice girders of riveted sheet iron sprung from anchoring spandrel brackets in the perimeter aisles and braced laterally by I-section beams as well as by a sheet-iron collar around the base of the clerestory. The naves of the larger pavilions (fig. 133) were reinforced by triangular buttresses at the clerestory and by tensioning tie-rods run parallel to the eaves at both the clerestory and lantern levels. Baltard argued that this system was structurally sounder and visually neater than triangular frames like those of the Polonceau truss, which would have stretched tension rods across the nave to support the roof on compression struts.[235] Attenuated trussed arches, assembled from lengths of wrought iron, crossed the covered streets (fig. 134). Zinc roofs laid over double layers of wood planks

PL. XXIII

Coupe suivant la ligne A B.

Coupe suivant la ligne E F.

Détail d'une des poutres. M N.

Détail d'assemblage en a

Détail des grandes poutres suivant C D.

O Détail d'assemblage suivant c d

Q Sections des poutres en tole des rues transversales avec sommiers en fer.

Plan d'ensemble à l'intersection des rues couvertes.

P Détail d'assemblage suivant e f.

R Section des poutres des rues longitudinales.

DÉTAILS DES PLANCHERS.
SOUS LES RUES COUVERTES.

FIGURE 128
Victor Baltard and Félix Callet, Central Markets, Paris, 1854–74. Details of the vaulting structure for the basement-level delivery streets, from Victor Baltard and Félix Callet, *Monographie des Halles centrales* (1863).

produced an internal insulating airspace that protected the markets against the sun as well as rain.

The Central Markets constituted a comprehensive rethinking of architecture according to industrial materials and methods of production. Except for the stone used in the basement walls

and pavilion foundations, the markets were built from concrete, brick, cast and wrought iron, glass, milled lumber, and zinc. The logic of construction shifted from handcrafting materials that typically arrived on site in an unfinished state, to erecting a structural system from a standardized kit of parts that—from the bricks to the cast-iron columns and sheet-iron girders—were mostly prefabricated and delivered to the site ready to assemble. Tellingly, instead of delineating the sculpted ornamental details that would have finished a traditional masonry building, the construction drawings specified instead the multiple bolted or riveted connections and joints that—along with the gas lines, waterlines, and related mechanical systems—now defined the markets' simultaneously standardized and mechanized structure. Paxton's Crystal Palace, like the greenhouses and train sheds of the previous two decades, anticipated this shift, despite some important differences: unlike the Crystal Palace and the related greenhouses, the Central Markets would be permanent structures answering to a complex urban site and program; unlike the mixed building practices still used in railroad stations, the construction of the Central Markets was consistently industrial from start to finish. As has already been noted, this had the effect of recovering the vernacular logic and constructive simplicity of the traditional wooden market hall, within the profoundly different context of the Industrial Revolution.

Functional considerations of use were secondary: beyond a generic concern for ventilation and tempering the heat gain of metal buildings, especially in the hot, summer months, the form of the markets had more to do with criteria of urban planning and industrialized building systems than the logistics of selling food.[236] Reflecting their administrative division between the Prefecture of the Seine, charged with maintaining the buildings, and the Prefecture of Police, charged with

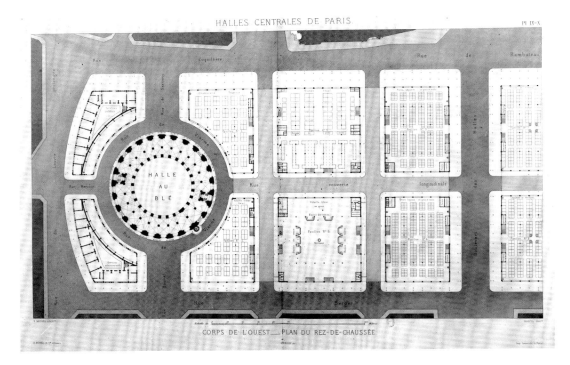

FIGURE 129
Victor Baltard and Félix Callet, Central Markets, Paris, 1854–74. Plan of the west group of pavilions, from Victor Baltard and Félix Callet, *Monographie des Halles centrales* (1863).

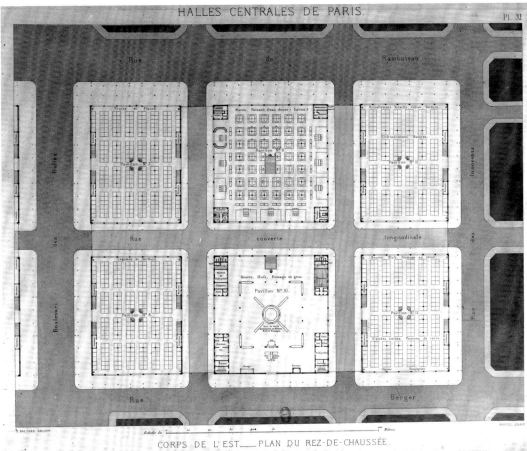

FIGURE 130
Victor Baltard and Félix Callet, Central Markets, Paris, 1854–74. Plan of the east group of pavilions, from Victor Baltard and Félix Callet, *Monographie des Halles centrales* (1863).

FIGURE 131
Victor Baltard and Félix Callet,
Central Markets, Paris, 1854–74.
Details of one exterior bay of the
pavilions, from Victor Baltard
and Félix Callet, *Monographie des
Halles centrales* (1863).

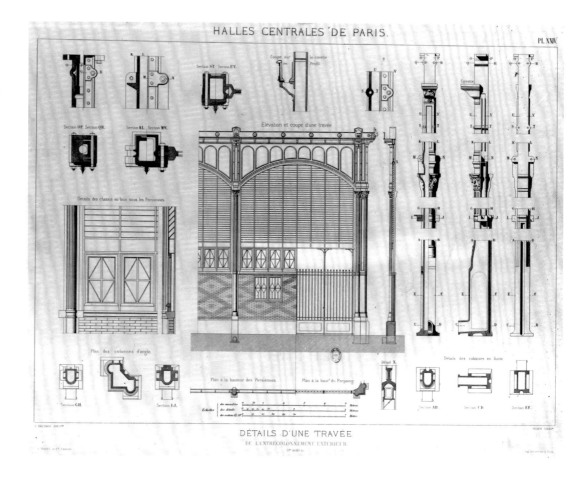

regulating their commerce, the Central Markets were designed as two congruent yet independent spatial systems, each with its own criteria: industrial sheds controlled by the Prefecture of the Seine, which worked at the urban scale of the city, and market stalls controlled by the Prefecture of Police, which worked at the functional scale of commercial exchange.[237] Despite Baltard's careful inventory of the intended purpose of each pavilion, the markets remained an interchangeable set of large covered areas whose particular uses were determined almost entirely by their furniture of stalls and equipment (fig. 135).[238] Functions could easily be reshuffled as other pavilions became available: pavilion 11, for example, was at first used to sell both meats and vegetables but was later reserved for the sale of oysters, after fowl and game

were moved to pavilion 4 and onions, potatoes, and greens moved to pavilion 5. The only fixed condition was a quantitative one of size, since determinations of use were based on equations between the estimated daily volume of a specific category of food and the surface area needed to serve that volume. Otherwise, the pavilions were functionally neutral and therefore multivalent. Like the Bâtiments Annexes, whose complex yet indeterminate program was housed in an architecture conceived primarily in response its urban context, form did not follow function at the markets, if function meant a building's specific use.

And yet, even as Baltard embraced the new industrial realities of architecture, he held to the aesthetic purpose summarized in the supplement to his *Monographie des Halles centrales:* "a public

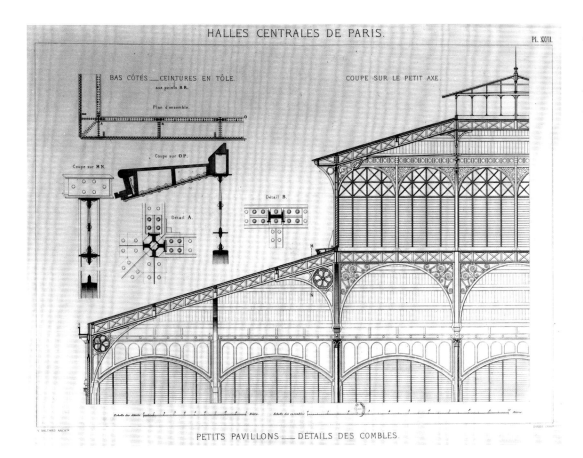

HALLES CENTRALES DE PARIS.

PL. XXVII.

BAS CÔTÉS ___CEINTURES EN TÔLE.
aux points R R.

Plan d'ensemble.

COUPE SUR LE PETIT AXE.

Coupe sur O P.

Coupe sur M N.

Détail B.

Détail A.

Echelle des détails Mètre. Echelle des ensembles

V. BALTARD ARCH.

PETITS PAVILLONS ___ DÉTAILS DES COMBLES.

FIGURE 132
Victor Baltard and Félix Callet,
Central Markets, Paris, 1854–74.
Details of the roofing structure
for the smaller pavilions, from
Victor Baltard and Félix Callet,
Monographie des Halles centrales
(1863).

edifice, whatever its use might be, for the very reason that it is public, must present a certain dignity of form, must go beyond the vulgarity of its material nature."[239] Three interrelated criteria of design informed this purpose: first, a formal and spatial system that organized the markets with modules of two and six meters; second, a structural system that translated the spatial modules into a three-dimensional framework of cast and wrought iron; and third, a system of decoration that, from the patterned brick walls to the cast- and wrought-iron column capitals and spandrel infill of the arches, added articulating tectonic details to the systems of form and structure. Indebted to Claude Perrault's substitution of arithmetic modules for the platonic harmonies favored by François Blondel, the design did not rely on the a priori proportions that had unified construction

and decoration in the classical orders of orthodox theory. Instead, as Baltard had argued at the École in 1845, architectural form was made a consequence of material facts (science) as analyzed by the architect within his time and place (art). Well before Le Corbusier equated the Parthenon with a Delage automobile in *Vers une architecture* (1923), Baltard sought to reconcile classicism with industrial modernity by reinventing the hierarchical and regulated unity of the orders in a system of decorated construction that organized each pavilion, from its parts to the whole, into a consistently ordered yet completely open-ended architecture.[240] The resulting structural juxtaposition of brick screens with an iron frame anticipated by fifteen years Jules Saulnier's famous experiment with skeletal curtain wall construction at the Menier chocolate factory in Noisel-sur-Marne (1871–72).

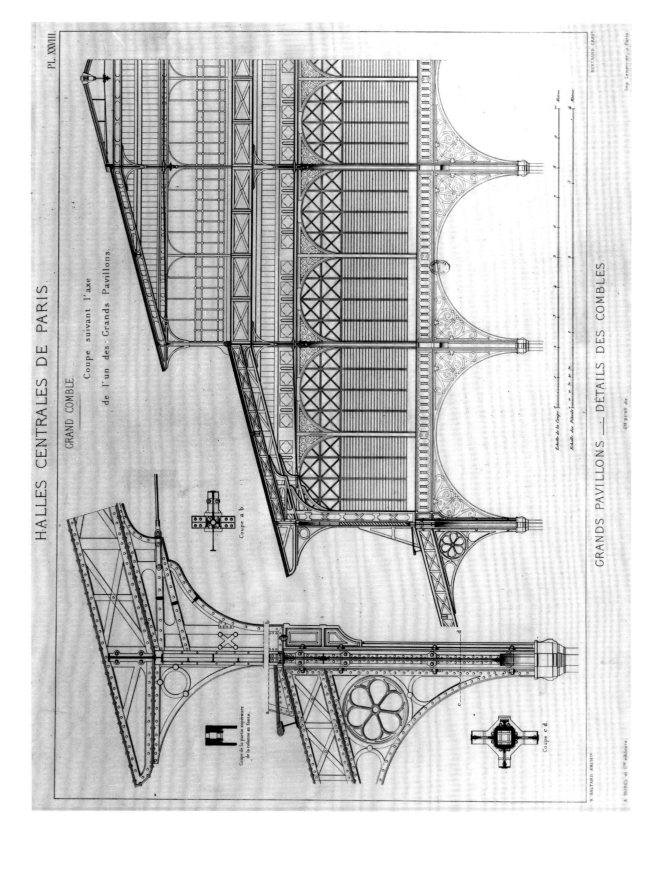

HALLES CENTRALES DE PARIS.

GRAND COMBLE.

Coupe suivant l'axe
de l'un des Grands Pavillons.

Coupe a b.

Coupe de la partie supérieure
de la colonne en fonte.

Coupe c d.

GRANDS PAVILLONS — DÉTAILS DES COMBLES.

V. BALTARD ARCHle.

A. MOREL et Cie éditeurs.

Gle BURY dir.

Imp. Lemercier, a Paris.

BERTRAND GRAVT

As a system of urban form and space (fig. 136), the markets synthesized the residential type of the housing block, shaped by its rectangular footprint, with the monumental type of churches like Saint-Eustache, with its arcuated façades, stepped profile, and gabled transepts echoed in the markets' pavilions and covered streets. Like the housing block, the markets organized the city with a generically repeating module. Like the church, the markets roofed a portion of the city as public space: nave and transepts, side aisles and chapels at Saint-Eustache; covered streets and pavilions with peripheral aisles and central naves at the markets. Sharing fundamental similarities with the church of Saint-Leu-Saint-Gilles, despite the differences of construction and use, the markets' system of decoration reinforced these typologies. First, this decoration was characteristically flat and linear, holding tightly to the architectural surfaces onto which it was drawn with only minimal relief or pressed like a specimen into the structure's thin planes (see figs. 131–33). Second, it originated historically in ornamental motifs drawn from late medieval and early Renaissance architecture: the classicizing fluting and capitals of the markets' cast-iron columns are a case in point, as are the cast-iron rosettes that filled the spandrel brackets inside. And third, these historicizing details coalesced into rectilinear and curvilinear patterns that were woven together in elevation by a grid of horizontal and vertical lines: the horizontal diamonds of the cross-hatched brick curtain wall rotated 90 degrees to run perpendicularly across the band of frosted-glass windows, which aligned in turn with the registers dividing the horizontal wooden louvers into uniform vertical strips, whose ascending rhythm was contained and returned to the framing columns by the cast-iron blind arcade at the top. At Saint-Leu-Saint-Gilles, the rectilinear and curvilinear patterns of decoration correspond to the alternating residential and

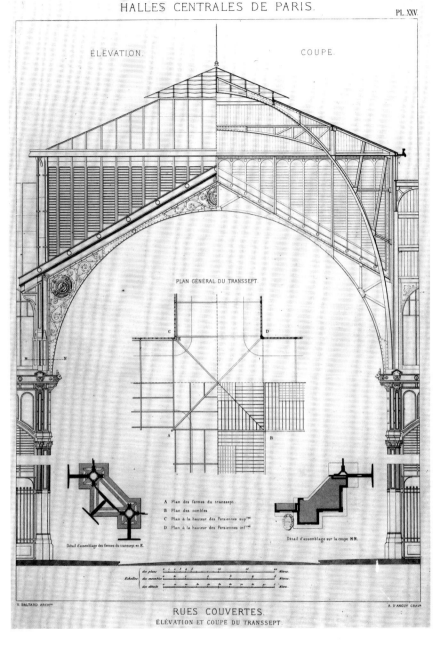

FIGURE 133 (*opposite*)
Victor Baltard and Félix Callet, Central Markets, Paris, 1854–74. Details of the roofing structure for the larger pavilions, from Victor Baltard and Félix Callet, *Monographie des Halles centrales* (1863).

FIGURE 134
Victor Baltard and Félix Callet, Central Markets, Paris, 1854–74. Elevation and section of a covered street, from Victor Baltard and Félix Callet, *Monographie des Halles centrales* (1863).

FIGURE 135
Victor Baltard and Félix Callet,
Central Markets, Paris, 1854–74.
Details of market stalls for beef
in pavilion 3, from Victor Baltard
and Félix Callet, *Monographie des
Halles centrales* (1863).

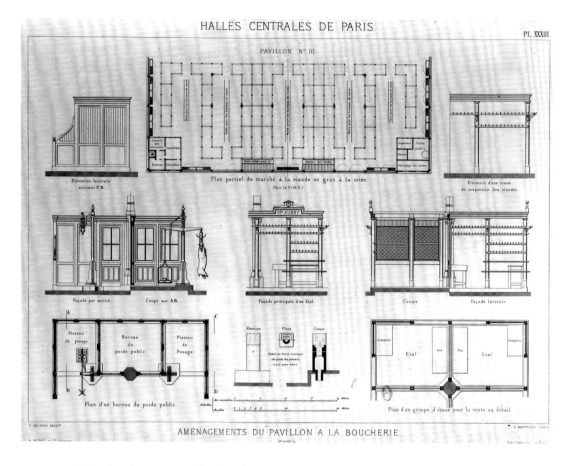

monumental façades that organize the church into
a dialog between these two types of architecture
in the city. At the markets, these patterns were
more tightly integrated by setting the pavilion's
arches within a regulating rectangular frame
both inside and outside. But their dialectic made
the same point of drawing the architecture of
the Central Markets from the forms, spaces, and
details of the city of which it was a part.

BUILDING THE CENTRAL
MARKETS, 1854–1874

Before the markets' design had been fully
approved, the firm of A. Jaffeux was contracted
in February 1854 to excavate foundations and
basements; work began in May, after the old
Halle au Beurre was demolished in April.[241] By

July, construction of the east group of pavilions
was under way, with the firm of A. Dallemagne
contracted for masonry and concrete work.[242]
Yet work on the construction drawings had
barely begun when Félix Callet died of cholera
on 1 August. This task, and site supervision, fell
to a small office headed by Baltard's inspectors:
Veugny, Touchard, and Huillard.[243] In October
1854, the Joly ironwork company was contracted
to carry out structural calculations and assemble
the markets' metal frame. The company was
apparently selected without a bid, through the
intervention of Napoléon III, though at least this
time the interference was consistent with Baltard's
wishes: the architect had corresponded with
Pierre Joly in 1851 about working on the markets
and would praise Joly for his "devoted as well as

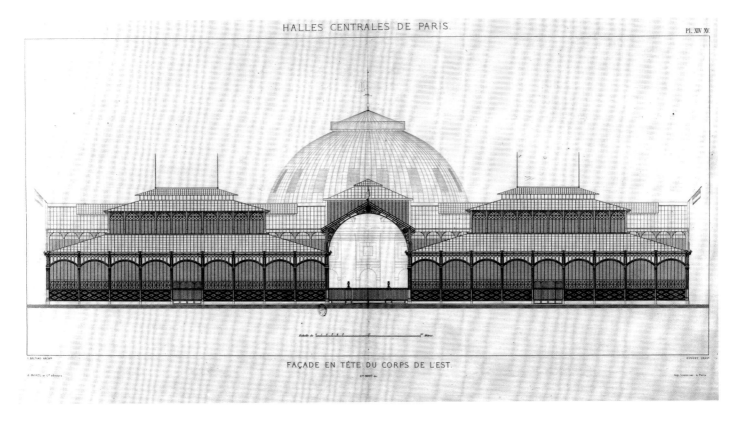

FAÇADE EN TÊTE DU CORPS DE L'EST.

intelligent cooperation in solving the questions raised by the program."[244]

Construction of the six east pavilions (numbers 7 to 12), covering 21,080 square meters, proceeded smoothly.[245] Pavilions 11 and 12 were completed by October 1857, pavilion 9 by December of that year, pavilion 10 by January 1858, and pavilions 7 and 8 were both ready the following October, barely three years after work had begun.[246] Vendors were installed by the Prefecture of Police as each pavilion came on line: retail butter, eggs, and cheeses moved into pavilion 12; retail fowl, game, cooked meats, onions, potatoes, and greens into pavilion 11; wholesale butter, eggs, and cheeses into pavilion 10; retail and wholesale fish into pavilion 9; retail and wholesale vegetables into pavilion 8; fruits and flowers into pavilion 7.[247] As Baltard had predicted in 1848, the open-ended system of construction not only made

it possible to carry out "this vast operation successively and fractionally" but also allowed each section of the complex to be put efficiently to use the moment it was ready.

Baltard and Callet were still finalizing their design when the engineers Édouard Brame and Eugène Flachat proposed to supply the Central Markets via an underground railway system connected to the Petite Ceinture (fig. 137).[248] As chief engineer of the Petite Ceinture, Brame was well positioned to realize an idea dating to the 1840s, while Flachat was of course intimately familiar with the markets themselves. A railroad spur from the beltway to the Gare de l'Est would descend underground at the station to run beneath the Boulevard de Sébastopol through a tunnel 2,333 meters long, 7 meters wide, and 4.3 meters high. The smoke from locomotives would be exhausted through ventilation chimneys connected to sewer

FIGURE 136
Victor Baltard and Félix Callet, Central Markets, Paris, 1854–74. Elevation of the east group of pavilions, looking west toward the Halle au Blé, from Victor Baltard and Félix Callet, *Monographie des Halles centrales* (1863).

FIGURE 137
Édouard Brame and Eugène
Flachat, project for a railroad
serving the Central Markets, Paris,
from *Nouvelles annales de la
construction* (1855).

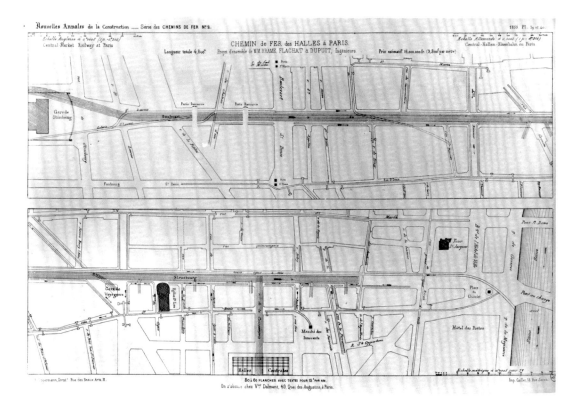

openings and lampposts along the boulevard, while a pressurized "atmospheric system" was proposed for the market tunnels; at the markets, ten turntables would rotate train cars onto secondary lines. Drawn up in June 1853 and published the following December, the plan was reviewed at a public inquest in February 1854 and eventually approved by the Conseil général des ponts et chaussées in June 1857. Brame and Baltard corresponded about its design between January and April of 1854, and delivery tunnels were integrated into the markets' design (fig. 138).[249] When, however, negotiations between the city and a consortium of interested capitalists fell through, the project was abandoned and the tunnels were backfilled with sand.[250]

With the east group of pavilions nearing completion in December 1857, Haussmann named Baltard and Armand Husson to a new Commission des Halles with a charge to "investigate the best

distribution of the various pavilions already built or still to be built at the Central Markets."[251] In seven meetings held from 22 December to 12 January 1858, the committee considered ways to redistribute the designated functions, in order both to make more efficient use of the available space and to increase the revenue obtained from renting stalls.[252] The markets were proving more expensive to build than had been anticipated: the first six pavilions alone would cost the 8 million francs that Haussmann had budgeted for the entire project in 1853.[253] His Second Regime for Paris, borrowing another 180 million francs, included funds for the markets, but their profitability had to be justified.[254] At the same time, the burgeoning population of Paris had outstripped the markets' programmed capacity: following the annexation of its suburbs in 1859, the city grew to 1,696,141 people in 1861 and would reach nearly two million by 1876.[255] After reconsidering the proposal put

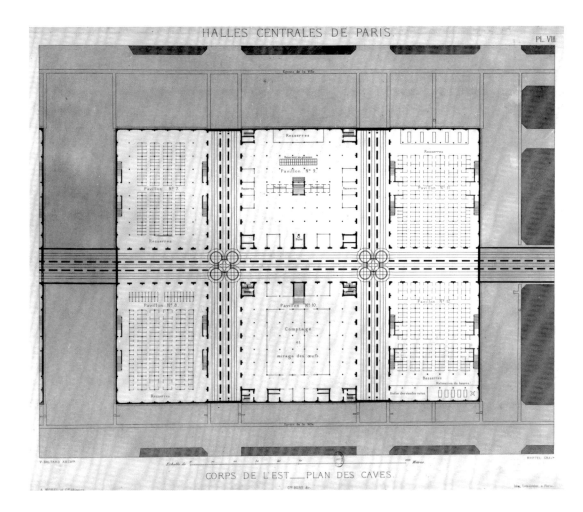

FIGURE 138
Victor Baltard and Félix Callet,
Central Markets, Paris, 1854–74.
Basement plan of the east group
of pavilions, from Victor Baltard
and Félix Callet, *Monographie des
Halles centrales* (1863).

forth in 1850 to extend the pavilions east to the
Rue Saint-Denis, the committee decided it would
be easier and less expensive to expropriate the
semicircular wedge of properties between the Rue
du Four and the Halle au Blé. Baltard drew up a
revised plan that added two curved pavilions to
the west, increasing the markets to 40,390 square
meters on a site now occupying 87,790 square
meters (see fig. 129). After a public inquest in May,
the Commission municipale adopted the plan on
8 July 1859, but the eccentric shape of the pavilions
proved troublesome for the Conseil des bâtiments
civils, which only approved the design after Bal-
tard submitted a written justification of the rea-
sons for subordinating functional considerations

to exigencies of siting.[256] The markets' extension
was authorized by imperial decree on 4 April
1860.[257]

Construction of the west group began on
schedule in 1859, with pavilion 3 ready by Sep-
tember 1860. Progress then slowed dramatically:
because the markets were now in active daily use,
the builders had to work around the merchants
and their needs.[258] Over a year passed before con-
struction of pavilion 4 started in 1862, which was
not completed until December 1866; pavilion 5
(on the site of the earlier stone-and-iron pavilion)
was begun in October 1864 and only finished in
May 1869.[259] After Baltard resigned as architect
of the markets in the fall of 1870, it was left to his

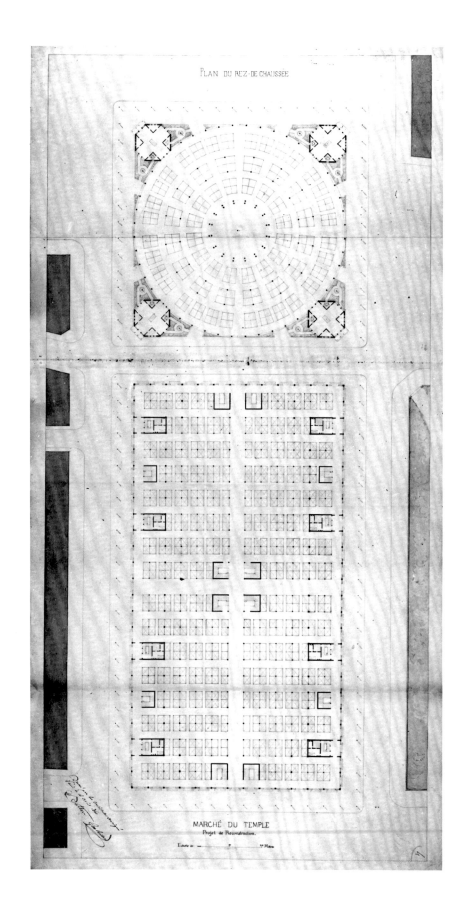

PLAN DU REZ-DE-CHAUSSÉE

MARCHÉ DU TEMPLE

Projet de Reconstruction.

former student Auguste Radigon to build pavilion 6 in 1871–74. The curved pavilions 1 and 2, by the architect Dubois, were finally built of reinforced concrete between 1935 and 1948 at an estimated cost of 86 million francs.[260] The two curved administration buildings, planned for the far side of the Halle au Blé toward the Rue du Louvre, were never built.[261]

In 1859, Baltard estimated that an additional 11 million francs were needed to complete the markets: 8,853,300 francs for the west group of pavilions, another 825,000 francs for the two curved pavilions, plus 3,555,600 francs to acquire the remaining property, less 2,257,000 francs in rebates from the sale of surplus properties (like the Marché des Innocents).[262] In his *Monographie des Halles centrales,* Baltard adjusted the total construction budget from 17.5 million down to 15 million francs: the 8 million already spent and another 7 million francs for the west group of pavilions.[263] Either way, the cost was substantially higher than the figure of 8 million francs set by Haussmann in 1853. Though he knew better, Baltard had gone along, pretending under political pressure that iron construction could produce miraculous economies. Defensively, he noted in the *Monographie* that some 35 million francs had been spent since 1812 acquiring and clearing property for the markets.[264] Against property costs of 321 to 3,168 francs per square meter, average building costs were a reasonable 380 francs per square meter.

As Garnier observed in 1874, Baltard's markets would be so widely imitated that people forgot "the name of the eminent architect who had been the creator of the original type." During the 1860s, they served as a model for the eighteen additional markets built in Paris.[265] Except for the Abattoirs de la Villette, the new slaughterhouse erected at the city's edge by Jules de Mérindol, these were all retail markets serving local needs.

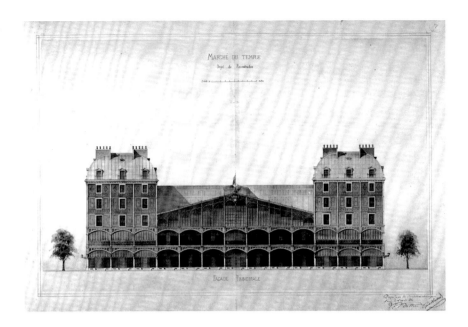

One, the Marché Secrétan in the nineteenth district, is attributed to Baltard, though this cannot be documented. Some, like the Abattoirs de la Villette, were run by the city, though the majority were built by private companies that contracted with the city to construct and operate the markets under municipal supervision.[266] Absent any uniqueness to place, differences between the original and its copies became secondary, because in a very real sense they all reproduced the same idea of the city. Conversely, the idea proved so flexible that every application yielded a different result: the type was less about duplicating the Central Markets than adapting Baltard's urban system to the context of each site.

With Gustave Huillard, Baltard submitted two projects in November 1858 and April 1860 to rebuild the Marché du Temple, on the site of a historic marketplace for rag merchants in the third district (figs. 139, 140).[267] Both projects propose mixed-used structures of iron and brick that wrap the markets with perimeter housing; the second project includes a large domed rotunda evoking the Halle au Blé. The integration of housing

FIGURE 139 (*opposite*)
Victor Baltard and Gustave Huillard, project for the Marché du Temple, Paris, 16 April 1860. Ground plan. Document held at the Centre historique des Archives nationales de France, Paris.

FIGURE 140
Victor Baltard and Gustave Huillard, project for the Marché du Temple, Paris, 16 April 1860. Elevation of the main façade. Document held at the Centre historique des Archives nationales de France, Paris.

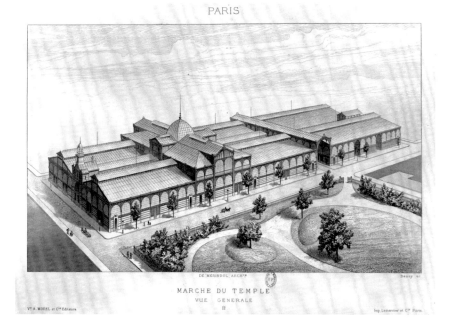

MARCHE DU TEMPLE
VUE GÉNÉRALE
II

FIGURE 141
Jules de Mérindol, Marché du Temple, Paris, 1863–65. Bird's-eye view, from Félix Narjoux, *Paris: Monuments élevés par la ville* (1880–83).

into the markets carries to its logical conclusion Baltard's hybrid typological conception of the Central Markets, along with contemporary works like Saint-Leu-Saint-Gilles and the Bâtiments Annexes. Based on the similar system developed at the Central Markets, the conjunction of a metal frame with patterned brick curtain walls anticipated not only Saulnier's Menier chocolate factory but also Viollet-le-Duc's project of 1871 for an iron-framed apartment house with infill walls of brick and glazed tile over ground-floor shops.[268] If, as Neil Levine argues, Viollet-le-Duc's design is "forward-looking, even radical," because of its "fully integrated and exposed three-dimensional metal structural frame . . . lightweight exterior facing clearly treated as infill panels . . . large, nearly fully glazed shop windows . . . and . . . promise of prefabrication," then the same must be said of Baltard's design, where these ideas had already been formulated and applied.[269] Indeed, the project proved too forward-looking for the city, and after it was rejected, Mérindol reworked the model of the Central Markets into a less

ambitious, if still sizable, complex that clusters pavilions and connecting covered streets into an urban superblock (fig. 141).

CONSIDERING THE CENTRAL MARKETS

Starting in 1857, as the first group of pavilions neared completion, the Central Markets were discussed in reviews that did not so much define their significance as indicate the degree to which Baltard's pragmatic work of design had moved ahead of any critical consensus. How one saw the markets depended on one's point of view. The journalist Édouard Fournier perhaps came closest to putting into words the market's paradoxical balance of tradition and innovation when, borrowing the cliché of cathedrals more commonly applied to railroad stations, he celebrated "these veritable cathedrals of cast iron and glass, svelte and light in their immutable solidity, luminous and aerial, like the Crystal Palace, which they recall without, however, seeming to have taken as their model."[270]

Professional critics had a harder time of it. César Daly negotiated a thicket of carefully qualified remarks in 1857, when he recognized the vernacular model of open-air markets yet sensed that Baltard had more monumental objectives in mind: "The general aspect is very satisfying, and, in this circumstance, one can praise without reservation the use of cast iron. The columns are slender, delicate, light, and the eye is satisfied, because what it looks for is the best, the most economical use of the space. . . . The whole of each pavilion has a sufficiently monumental air, without losing the character of light construction that must belong to a market and that, finally, recalls the memory of an open-air market."[271] In 1863, Eugène-Emmanuel Viollet-le-Duc noted favorably that "if all of our monuments had been built with this absolute respect for use, for the needs of the population, if they indicated so directly the means of construction, then they would have a

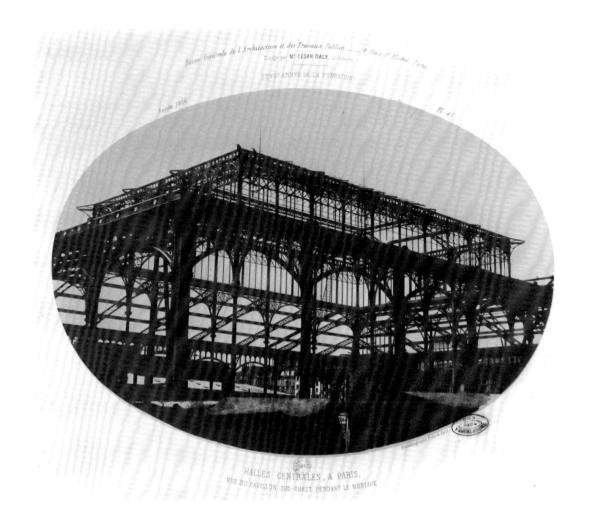

FIGURE 142
Auguste Poitevin,
photolithograph of pavilion 12
under construction at the Central
Markets in 1856, from *Revue
générale de l'architecture* (1856).

character appropriate to their times," but he went
on to complain that the elimination of masonry
from their construction made the markets little
more than "hangars," since a true work of modern
architecture could only result from the structural
integration of stone and iron.[272] For different
reasons, Charles Garnier also regretted the loss of
stone, insisting in 1857 that iron alone could not
create the desired effect of visual solidity found
in masonry constructions, with their propor-
tioned relationships between structural solids and
voids.[273] Nonetheless, he concluded that the pavil-
ions had preserved the sense of lithic containment
that historically had characterized architecture:
"the lower walls, built of bricks in a diamond

pattern, and the frosted glass . . . give to the whole
of the complex an appearance of solidity that sets
off the mass of the pavilions and contrasts happily
with the great openings that terminate the cov-
ered streets."[274] By 1874, in his obituary of Baltard,
Garnier had come around to emphasizing the spa-
tial extension, rather than apparent solidity, of the
markets, noting how "the slender supports that
organized the plan" held up the "elegant roofs" of
what he called "an immense hangar."[275]

The markets' uncertain suspension between
history and industry is captured as well in con-
temporary photographs by Alphonse Poitevin and
Charles Marville. Poitevin's single image (fig. 142),
published in the *Revue générale de l'architecture,*

FIGURE 143
Charles Marville, photograph of
the Rue du Contrat-Social from
the Rue de la Tonnellerie looking
toward pavilion 8, in the west
group of the Central Markets,
after 1859.

recorded the open metal framework of pavilion 12 under construction in 1856, before the structure was enclosed with walls and roofs.[276] Silhouetted against the sky and permeated by light, the pavilion is alienated from the city as an autonomous work of technological reason, to be identified instead with its photographic reproduction as two equivalently transparent products of modern science, each of which has replaced outmoded conventions of artistic representation with the evidence of physical facts drawn directly from nature. Poitevin's photolithograph was only the second to appear in the pages of the *Revue générale,* after the publication earlier that same year of a photograph by François-Alphonse Fortier of the Renaissance staircase of François Ier at the Château of Blois (newly restored by Félix Duban in 1845–48): the spiral staircase at Blois, a structure of considerable ingenuity for its time, was connected by notions of progress to the industrial structure of the Central Markets in a narrative of steadily increasing efficiency and rationality.[277] Photography was

architecture's natural ally in this narrative. The accompanying article by Henri Sirodot, introducing the new medium, credited photography for its specificity of detail and consequent ability to satisfy "our epoch's need for precision" and concluded that only the human eye surpassed the camera as an inherently accurate instrument for seeing.[278]

Marville's photographs of the Halles, taken in the course of his municipal commissions to record the transformation of Paris from the later 1850s until the mid-1870s, offered a more varied and culturally nuanced reading of the markets.[279] Whether looking east (fig. 143) from the Rue de la Tonnellerie to a corner of pavilion 8 at the end of the arcaded Rue du Contrat Social or up the Rue de la Tonnellerie toward Saint-Eustache (fig. 144), between the east pavilions and the housing blocks to the west that would shortly be demolished (along with the old pavilion 2), the images show the markets as standing in a complex, layered relation to the city. On the one hand, the markets'

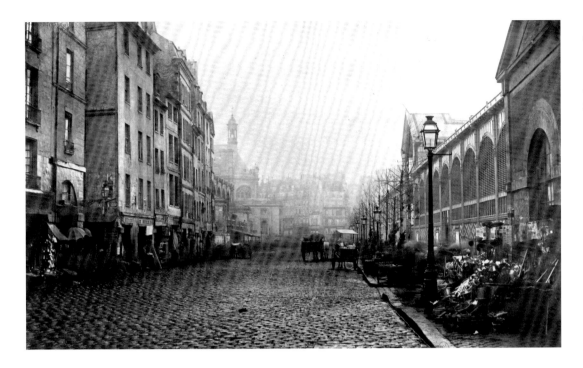

FIGURE 144
Charles Marville, photograph of
the Rue de la Tonnellerie looking
toward Saint-Eustache, with the
east group of pavilions of the
Central Markets on the right, after
1859.

uniformity and newness set them emphatically apart from the quarter's decrepit stock of buildings. Marville often photographed streets low to the ground, in circumstances that exaggerated their dampness and darkness, either in early morning, late afternoon, or when overcast, to validate Haussmann's transformation of Paris from a city of "narrow and twisting streets . . . impenetrable to circulation, dirty, stinking, unhealthy," into one where "space, air, light, greenery and flowers, in a word, everything that dispenses health," would circulate efficiently and rationally.[280] But even as he justified the markets as instruments of utilitarian planning, Marville also grounded them in the very city they were meant to replace. Where the tilted camera angle of Poitevin's photograph divorced pavilion 12 from its context, the low vantage point and raked perspective of Marville's photographs act to embed the markets in the historic fabric of Paris. As Baltard intended, the markets are seen to take visible shape from the surrounding streets and buildings: viewed through the lens

of Marville's camera, the arcuated rhythm and stepped profile of the pavilions and covered streets reflect the spatial and formal logic of the quarter's development since the Middle Ages.

The most evocative photograph taken by Marville peers down the Rue des Prouvaires to glimpse the south transept of Saint-Eustache at the end of a covered street under construction (fig. 145). The arched metal roof of the markets at once completes the vanishing perspective from foreground street to background church and dissolves the opaque city of stone below into luminous space above. Émile Zola, replacing the photographer with a fictional painter named Claude, re-created this image in *Le ventre de Paris:* "In the narrowing perspective of the Rue des Prouvaires, Claude squinted, looking at a side portal of Saint-Eustache that faced him with its rose window and two stories of round-arched windows, at the end of the covered street, framed by this immense vessel of a modern station; he said, defiantly, that all of the Middle Ages and all of the Renaissance

could be held beneath the Central Markets."[281] One hundred pages later, Claude returns to this view, finding there an answer to Hugo's warning in *Notre-Dame de Paris* that Gutenberg's printed book would kill the cathedral's book of stone, that modernity would kill architecture: "It is a curious juxtaposition, he said to himself, this end of a church beneath this avenue of iron. This will kill that, iron will kill stone, and the time is near."[282] Hugo's equation—"This will kill that"—is accepted yet given a new meaning by Zola. Instead of killing architecture, modern technology has instead created a new architecture, picking up history in a new form, at once containing and overcoming its past.

Zola's silence on the role of the architect in creating this work of modernity avoided the question whether Baltard intended the novelist's reading. The architect was still alive, the last full year of his life, when *Le ventre de Paris* was published, in 1873, yet left no record of having read the novel. Ignoring Baltard and his professional intentions, Zola nonetheless assumed that the significance of the markets lay more in their cultural form than in their utilitarian function. Indeed, Zola's description of the odors of ripening and rotting food, emanating like miasmas from the pavilions, reminds us that the markets were in fact smelly and messy places, which neither technology nor administrative regulation could effectively control: "Then, in the scorching afternoons of June, the stench rose up, and weighed down the air with a pestilential reek."[283] Zola's discouraging portraits of the bourgeois shopkeepers who peopled the markets' spaces and venally accepted Napoléon III's repressive government so long as it continued to ensure their prosperity combine with these images of corruption to present the Central Markets less as a rational space of public health than as an instance of social decay. Against this failure to institute a utilitarian utopia, Zola sets

the markets' aesthetic beauty and wonder. Again and again in *Le ventre de Paris,* he returns to the challenge of capturing them in words, of translating their material presence into a metaphor on the page: besides a metal belly, he writes that the Central Markets were like a "row of palaces . . . light as crystal"; that they composed "a strange city, with its distinct quarters, its suburbs, its villages, its promenades and routes, its squares and intersections, all placed under a hangar one rainy day"; that they were "a metal Babylon . . . crossed by suspended terraces, by aerial corridors, by flying bridges thrown across the void."[284] Answering Hugo's *Notre-Dame de Paris,* Romanticism yielding to Realism in literature as in architecture, Zola saw in the Central Markets "an artistic manifesto, positivism in art, an entirely experimental and materialist modern art."[285]

The Central Markets were demolished in 1971–73. Except for the orphaned pavilion 8 (fig. 146), rebuilt with alterations in 1976 to serve as a concert hall in the suburb of Nogent-sur-Marne, the markets survive only as a way of thinking about the urban history of Paris. Yet from 1811 until 1874, in the very decades of the city's modernization, they gave administrators, planners, and architects alike a material point of reference to debate a theory and a practice for transforming Paris. Too many people were engaged for too many years before Haussmann for this prefect to deserve the credit he claimed: his execution of an instrumental master plan, supposedly conceived all at once in 1853–54 on the basis on an imperial sketch, was really the outcome of a protracted process of invention. To this process Baltard contributed an urban architecture whose spaces, structure, and decoration bridged the temporal distance between past and present forms of the city. Aiming to reconcile the historic identity of Paris as a city of stone with its industrial translation into a city of iron, the Central Markets at

FIGURE 145 (*opposite*)
Charles Marville, photograph of the Central Markets and Saint-Eustache from the Rue des Prouvaires, circa 1870.

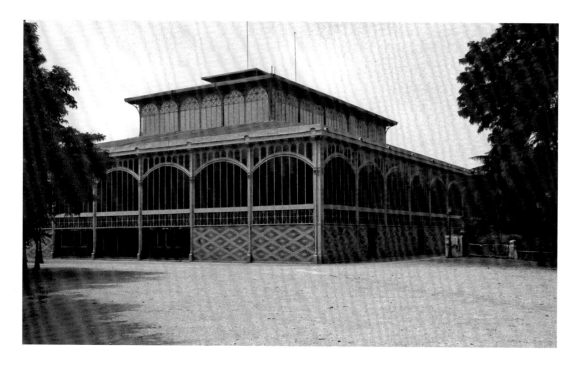

once grew out of the past and radically reshaped that past in the present to reflect modernity's new methods of production. The pavilions were monumental in scale and yet were no longer monuments in the sense that the church of Saint-Eustache was a monument: a self-contained work of architecture that is original to its site. The industrial market sheds replaced crafted specificity to place with off-site prefabrication and standardized assembly of repeating structural units. Siteless and generic, the markets' construction divorced building from its physical place of production, which now became a remote series of foundries

and workshops. What took place at the Halles was the markets' *reproduction* in a series of metal pavilions whose logic derived from the city's own patterns of development. The markets visualized the city in a form that reflected society's industrialization, but did so in terms that were in origin cultural and aesthetic rather than abstract and utilitarian. Hybrid and contingent, type became at the markets a provisional sign of the city's own historicity, of its urban actuality and historical transience, as mutable patterns of political representation, civic regulation, and daily inhabitation shaped and reshaped Paris over time.

Housing the City

In 1859, just before he became director of the Service d'architecture, Victor Baltard secured the commission to design the new church of Saint-Augustin on the Boulevard de Malesherbes (fig. 147).[1] Coming right after the Central Markets, whose first phase of construction ended in 1859, Saint-Augustin summarized ideas that Baltard had formulated over twenty years of municipal practice and concluded his exploration of the urban and industrial conditions that he saw informing architecture in the modern city. Despite their differing programs, the church and the markets addressed the same two fundamentally aesthetic questions of whether the city's historical form and development could be reconciled with its transformation in the nineteenth century and whether architecture's traditions of building and conventions of representation could survive their translation from stone into iron.

Built between 1860 and 1868 at a final cost of 5.7 million francs, the church occupies a trapezoidal wedge of land (fig. 148) created when the imperial decree of 14 March 1854 laid out the Boulevard de Malesherbes in two sections between the Place de la Madeleine and the Parc Monceau, with a break in its axis at the site of Saint-Augustin.[2] To fit the site, Baltard splayed the church by truncating its side chapels at angles run parallel to the flanking boulevard and street, so that the church widens continuously from twenty-two meters at the façade to forty meters at the transept

crossing. To maximize the interior space, Baltard slipped a self-contained vaulting structure of cast and wrought iron inside a minimal envelope of masonry that eliminated the need for buttresses (figs. 149, 150). As he reported to Haussmann,

> the use of stone for the exterior and partition walls, combined with cast iron for the supports and vault ribs, might perhaps be astonishing in the construction of a church but is nonetheless only the rational application of the resources that industry puts at the disposal of builders. If one can find some disadvantages in this, one must also recognize that there are great advantages, particularly that of a simple, economical, and solid combination [of stone and iron], which frees [the structure] from the need for buttresses and flying buttresses by dispensing with the stereometric structure of stone that creates the thrust of vaults.[3]

The plan and composite structure of Saint-Augustin permit a clear interior span of fifteen meters in the nave, while containing the building within crisp volumes that are precisely adjusted to its site. Manipulating the conventions of orthogonal perspective, those volumes shift almost cinematically according to one's vantage point. Seen straight on (fig. 151), Saint-Augustin neatly terminates the axial view up the Boulevard de Malesherbes from the Place de la Madeleine

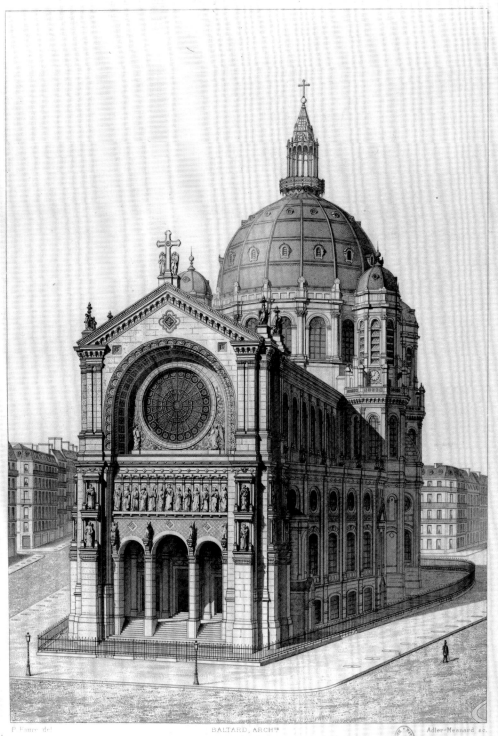

P. Faure del BALTARD, ARCH.TE Adler-Mesnard sc.

EGLISE SAINT-AUGUSTIN
FACADE PRINCIPALE _ VUE PERSPECTIVE
II.

FIGURE 147
Victor Baltard, Saint-Augustin,
Paris, 1860–68. Exterior
perspective, from Félix Narjoux,
Paris: Monuments élevés par la ville
(1880–83).

with a collapsed frontal image of façade and dome. Move to the right or left, and this image unfolds into an asymmetrical assemblage of angled planes that align the church diagonally to the boulevard and street on either side. As the perspective view and photograph make clear, Saint-Augustin is set quite deliberately into this urban framework, with its background of apartment buildings, answering those buildings with similarly planar and horizontally banded elevations even as the crowning gabled façade and crossing dome set the church monumentally apart.

The ironwork is fully exposed inside (fig. 152). In the nave, cast-iron colonettes in three sections support lateral and transverse wrought-iron arches, which carry segmentally curved brick vaults. The limestone walls are independent of the vaulting and rely on the roof's wrought-iron trusses (above the vaults) to tie them together with lateral bracing from side to side. The separation between these two structures is stressed, rather than tempered, by the metal straps that clamp the iron colonettes like so many down spouts to the nave arcade piers. The crossing dome, twenty-five meters across and sixty meters high, is comparable, if more complex, in its construction. Inner and outer domes (and a cast-iron lantern weighing 80,000 kilograms), each with sixteen wrought-iron trussed girders forming ribs, are supported inside the drum by sixteen cast-iron columns, which transfer the load via a gridded web of wrought-iron at the pendentives to eight cast-iron clustered-colonette piers below. As in the nave, the outer stone skin is structurally distinct from the iron skeleton, although the dome ribs brace the rotunda drum, just as the masonry acts throughout the building to stabilize the metal frame. Minimized by this frame, the masonry envelope is noticeably reduced in thickness and approaches the condition of a curtain wall in its independence from vaulting loads.

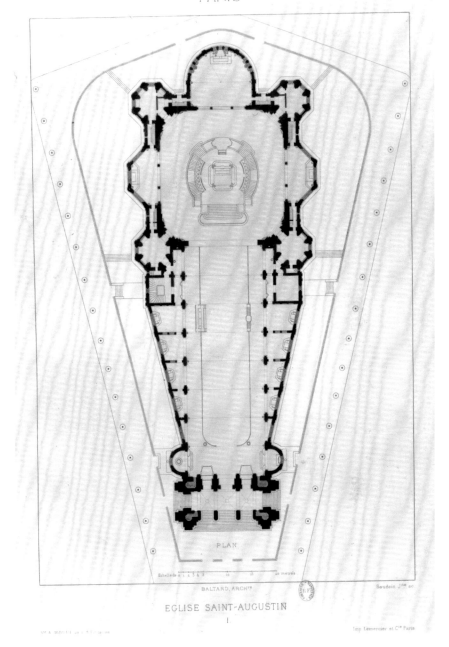

PLAN

BALTARD, ARCH.ᵗᵉ

EGLISE SAINT-AUGUSTIN

For that envelope, Baltard at first considered a Romanesque idiom (see fig. 34), before eliding Gothic with Renaissance models like the cathedral of Florence and Michelangelo's Saint Peter's in the final design.[4] Clearly, he was looking as well at Saint-Eustache (see fig. 78), whose south

FIGURE 148
Victor Baltard, Saint-Augustin, Paris, 1860–68. Plan, from Félix Narjoux, *Paris: Monuments élevés par la ville* (1880–83).

FIGURE 149
Victor Baltard, Saint-Augustin,
Paris, 1860–68. Longitudinal
section, from Félix Narjoux, *Paris:
Monuments élevés par la ville*
(1880–83).

FIGURE 150 (*opposite*)
Victor Baltard, Saint-Augustin,
Paris, 1860–68. Transverse section
and plan of one bay of the nave,
from *Nouvelles annales de la
construction* (1872).

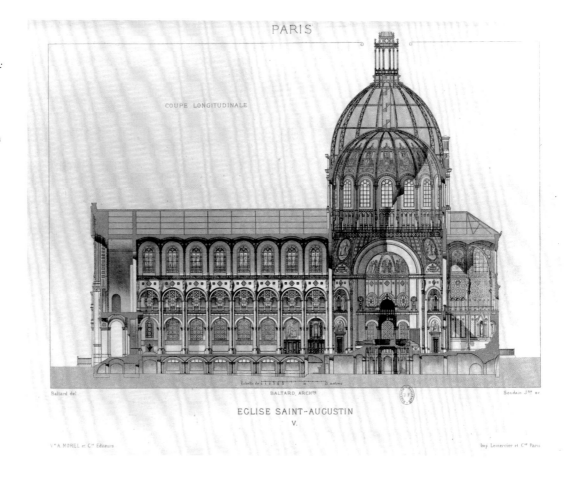

PARIS

COUPE LONGITUDINALE

EGLISE SAINT-AUGUSTIN
V.

flank (minus its buttressing) is suggestively like the sides of Saint-Augustin in its skewed plan and truncated chapels, its volumetric flatness, and its conflation of a medieval structure with Renaissance forms. Reprising the synthesis of classical and medieval traditions considered years before in his lectures at the École (see fig. 31), Baltard posited a similarly skeletal system of columns and piers supporting vaults and domes within an arcuated shell, in line with the structurally rational theory justified by the "emancipation of the arch" that Léonce Reynaud and Léon Vaudoyer had laid out in the 1830s and 1840s. The iron structure of Saint-Augustin, however, not only rendered explicit the fundamental difference between load-bearing skeleton and non-load-bearing shell but also helped liberate both from their historical

models to investigate the possibility of an architecture whose structure and form alike spoke to their time of construction. Pushed by the use of iron beyond the eclecticism of his sources, Baltard became one of those architects who, as Reynaud had predicted in 1834, were "applying artistically to our constructions the new materials made available by industrial progress."[5]

Continuing a practice developed over two decades of working on the parish churches of Paris, Baltard called on thirty-two sculptors and seven painters to decorate Saint-Augustin with encyclopedic thoroughness in the culminating work of his career.[6] The roster of academic artists included François Jouffroy, Jules-Pierre Cavelier, Henri-Alfred Jacquemart, and Alfred-Adolphe-Édouard Le Père, who sculpted the façade statues

EGLISE St AUGUSTIN á Paris

M.ʳ BALTARD Architecte en chef
de la ville de Paris.

Fig. 1 Coupe transversale de la nef, á 0.006.
Portes, Buffet d'orgues, Rosace, Tribunes, Charpente en fer.

M.ʳ TRAIN Architecte Inspecteur

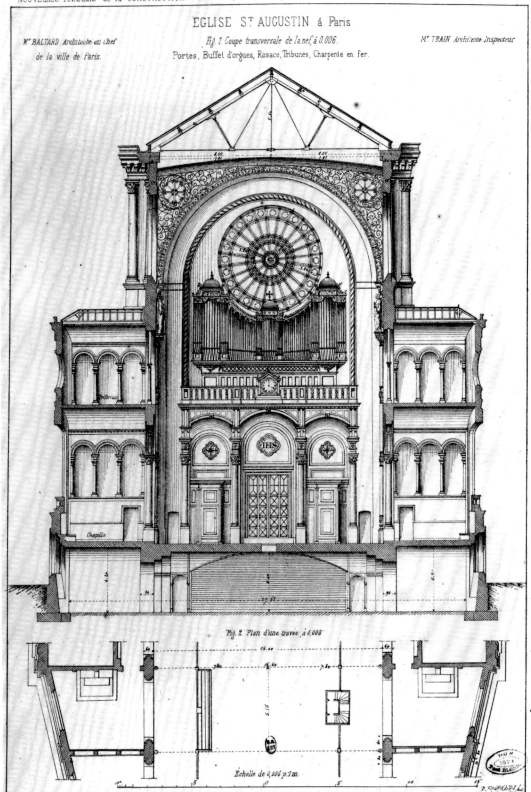

Fig. 2 Plan d'une travée, á 0.006

Echelle de 0,006 p.1m.

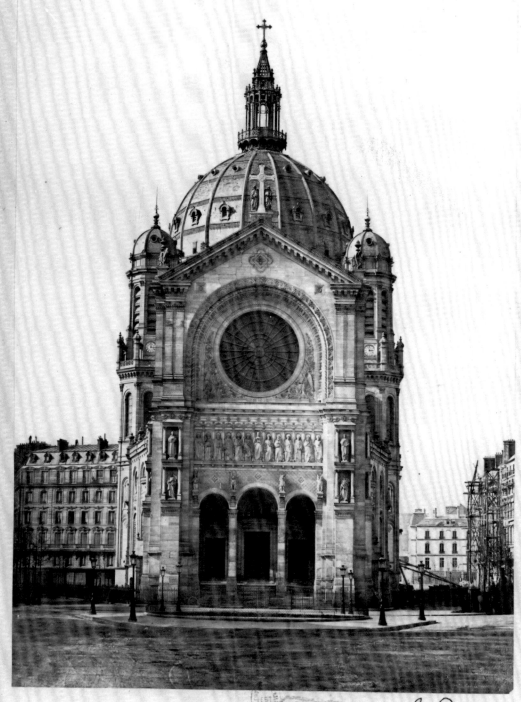

Nᵒ 135 Eglise St Augustin

1334

E. Dontenvill
a Paris rue de Charonne. 30

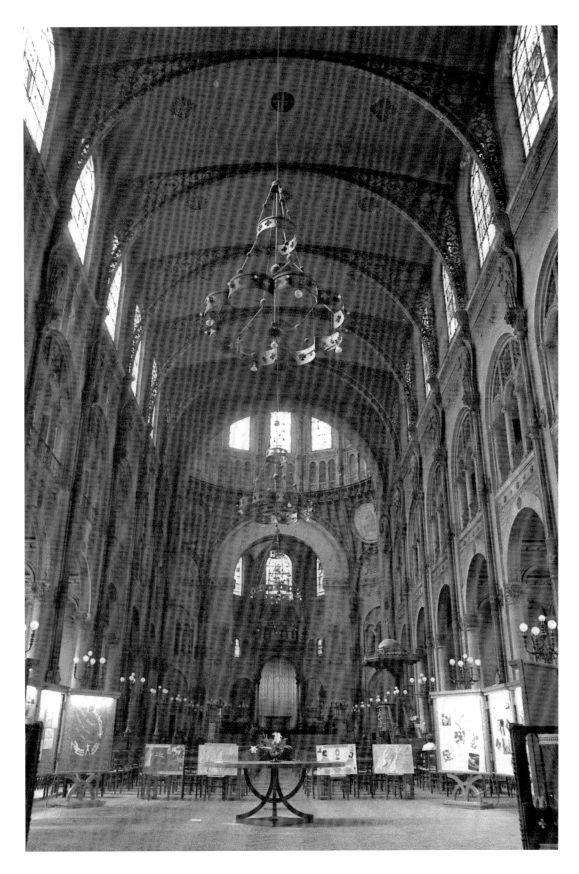

FIGURE 151 (*opposite*)
Victor Baltard, Saint-Augustin,
Paris, 1860–68. Photograph by
E. Dontenville.

FIGURE 152
Victor Baltard, Saint-Augustin,
Paris, 1860–68.

and reliefs; Jean-Louis Bézard, Émile Signol, and William-Adolphe Bouguereau, who painted the canvases pasted in place on the dome, pendentives, and transept vaults of the crossing. Louis Schroeder modeled the cast-iron angels set atop the nave and crossing colonettes, and Alexandre Denuelle, who had worked with Baltard on the decoration of Saint-Germain-des-Prés, executed the painted architectural ornament. The effect, particularly when combined with the generous use of gold highlights on the interior, leads Pinon to characterize the church as having a "Byzantine 'ambience.'"[7] This characterization is justified both by Saint-Augustin's eclectically stylized ornament and by the relevance of Hagia Sophia to the underlying Romantic theory of its structure, yet misses the degree to which the decoration of the church, like its construction, has gone beyond the historical precedents with which Baltard began his design. Certainly the admiration that Le Corbusier professed for this church in his letter of December 1915 to Auguste Perret would be incomprehensible, even for an architect still formulating his own modernism, were there nothing more to its architecture than Neo-Byzantine historicism.[8]

Looking forward, Saint-Augustin's decoration seems rather to anticipate the new understanding of ornament that would be seen after 1890 in the work of architects like Louis Sullivan. As described by David Van Zanten in *Sullivan's City,* this ornament abstracted a few classical motifs into an increasingly inventive and free system that "was cast in deeper or shallower relief to respond precisely and powerfully to [its] situation as well as to the quality of light falling on [it]."[9] Without suggesting that Sullivan owed some special debt to Baltard—Van Zanten credits the English designer Christopher Dresser and the French ornamentalist Victor Ruprich-Robert as Sullivan's sources—the American architect inescapably would have seen Baltard's new church during the

year in 1874–75 he spent studying at the École des Beaux-Arts as a student of Émile Vaudremer's.[10] Saint-Augustin's lavish yet hard-edged program of decoration, deposited in layers on the masonry envelope, either presses against the stone or, in the case of more ponderated elements, is pinned to the surface like some physical specimen: either way, its visibly applied character reinforces the building's taut planarity. As at the Central Markets, the details coalesce into abstractly curvilinear and rectilinear patterns that cover the building surfaces with lacelike ornament, whose qualities of layered relief are mirrored on the interior by the building's weblike iron structure. It is tempting to speculate that Sullivan, like Le Corbusier after him, recognized Baltard's move beyond historical sources as he sought an architectural decoration able to comment on a building's structural conditions and urban context.

Contemporary critics reviewing Saint-Augustin ignored the stylistic references: the quarrel provoked in 1839–40 by the proposed Neo-Gothic program for Sainte-Clotilde had been exhausted by the 1860s, when the eight municipal churches built under Baltard's direction all adopted a round-arched vocabulary that was sufficiently flexible to extend from Romanesque to Renaissance (and even Baroque) inflections.[11] The critics likewise had little to say about Saint-Augustin's decoration, suggesting by omission that they took it for granted along with the building's eclecticism.[12] Attention focused instead on the design's two unusual aspects. The first dealt with the splayed form and complex volumes that resulted from fitting the church so literally to its site. The second dealt with Baltard's abrupt juxtaposition of iron to stone without any attempt to integrate the two either structurally or formally. As Baltard anticipated in his report to Haussmann, his "rational application" to Saint-Augustin of the same "resources of industry" already used

at the Central Markets struck many observers as inappropriate to the traditions of monumentality expected in a church.

Predictably, concerns were raised by the Conseil des bâtiments civils when it reviewed the project on 31 January 1860, at the same meeting in which Bailly's Tribunal de Commerce was discussed. The *conseil* approved the project after hearing a report by Alphonse de Gisors that analyzed both the unusual plan and the unorthodox structure in generally favorable terms, yet attached two objections: "Considering (1) that the walls generally, whether of the nave or of the dome, have too little thickness, (2) that the projecting and returning angles of the side-aisle walls will produce a bad effect, which is unsatisfying, and that it would have been preferable, as the reporter requests, to adopt a straight line from the corner of the façade to the service stairs for the sacristies."[13] These points rehearse complaints voiced about the other municipal works undertaken by Baltard, Bailly, and Davioud in the 1850s and 1860s. Regardless of program, those works demonstrated a troubling disregard for the rules of composition and the principle that exterior forms should result from a coherent development of the interior functions. Instead, these architects each exploited the new flexibility made possible by industrialized building systems to create novel solutions that freely adjusted the architecture to urban factors of context and siting.

As architects responded to the growing precedence of street alignments over building programs, such innovations became increasingly common. Baltard, however, went farther than his peers: from the rhomboidal Corps de Garde to the triangular right Bâtiment Annexe and the trapezoidal Saint-Augustin, he repeatedly abandoned the conventions of orthogonality when fitting a building to its surrounding streets. Starting with a trefoil plan derived from the cathedral

of Florence, Baltard deformed Saint-Augustin into the suggestively streamlined profile of its acutely angled site. Since those conventions of orthogonality continued to inform architecture, especially in the case of religious architecture, Saint-Augustin remained an exception to the norm. Théodore Ballu held La Trinité (fig. 153), for example, to a rectangular volume between parallel side streets, even while he turned its porch into a covered carriageway that spilled across the access street into the facing public square through a connecting fountain and set of stairs.[14] Most of the new churches were in fact located on conveniently rectangular sites, or at least on sites that, like Léon Ginain's Notre-Dame-des-Champs, were easily made rectangular. More unusual sites produced similar results. To rationalize the triangular location of Saint-Pierre-de-Montrouge (fig. 154), whose placement at the intersection of two diagonal avenues is directly comparable to that of Saint-Augustin, Émile Vaudremer followed the contemporary example of Garnier's Opéra, which neatly extended a rectangular building with cross-axial pavilions to fill out its polygonal site: at Saint-Pierre, a Latin-cross basilican plan widens sequentially outward in rectangular units from a narrow façade tower to broad transepts.[15]

Saint-Augustin's iron structure proved more problematic still. Backing up its objection to the thin masonry walls, the *conseil* appended three complaints to its deliberations:

1. That if the use of industrial materials can be imposed on architects, the buildings where these materials are used should assume forms and proportions in keeping with the nature of these materials and the resources they provide,
2. that in the project in question the substitution of cast iron for stone in vertical elements cannot be justified by an

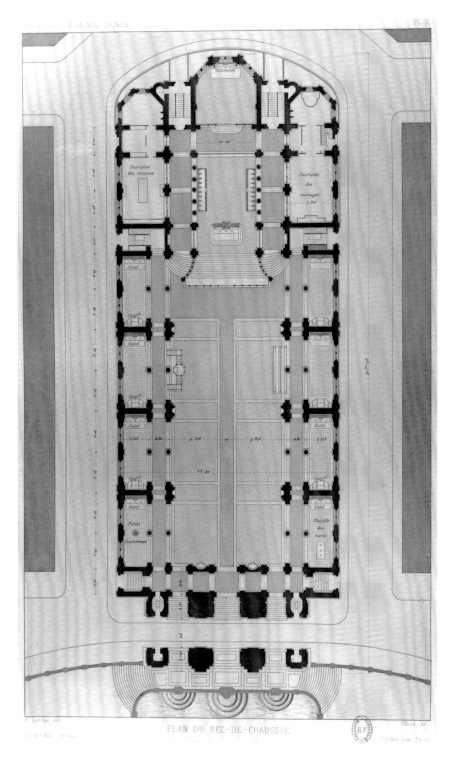

Sacristie des messes

Sacristie des mariages

Autel

Autel

Autel

Autel

Fonts

Baptismaux

Autel

Chapelle des morts

PLAN DU REZ-DE-CHAUSSÉE.

incontestable goal of utility, or by forms that are inherent to this material,

3. that the use of cast iron in place of stone seems to have no motive except economy and that, consequently, the monumental character that is required for a religious building disappears completely.[16]

Reviews of Baltard's design echoed that by the *conseil,* with varying slants. Viollet-le-Duc *fils,* referring to his father's theories for a rational integration of stone and iron based on dynamic principles of Gothic structure, attacked Baltard's engineering, since he had merely used iron to lighten what remained conceptually a classical system of vertical dead weight.[17] While Jules Bouchet appreciated the efficiency of Saint-Augustin's construction, he argued that its attenuated iron skeleton was inappropriate to a church, as did Henri Delaborde in his obituary of Baltard.[18] Paul Sédille likewise admitted the economic utility of Saint-Augustin's industrial structure, but went on to observe that it produced "an interior at once spindly and enormous" and concluded that the spiritual effects sought in a religious monument could only result from the sight of great masses of masonry overcoming gravity and vaulting space.[19]

Alone among his critics, Charles Garnier defended Baltard's premise:

he flanked all the church walls with cast-iron columns, making the real points of support thus look more spindly than the walls of the building. The walls should have torn, the columns should have bent, and the sight of the monument's interior should have troubled observers—but not at all. Mr. Baltard knew how to combine the various elements in such a way that everything was stable and the appearance of the whole harmonious, despite the heterogeneity of its constituent parts.[20]

Garnier, who hid his own extensive use of iron at the Opéra behind a reassuring cloak of masonry, was not suggesting that other architects embrace Saint-Augustin as a model for imitation like the Central Markets. Indeed, the tongue-in-cheek tone in which Garnier couched his defense of Baltard makes it clear that he, too, found the design to be eccentric, if ingenious. But he at least was able to grasp the originality and architectural rigor that went into Baltard's uncompromising juxtaposition of stone to iron: while "the solution was not without risks," it showed "that the artist who took on such a program had in himself the resources needed to overcome the obstacles."[21] More than the Central Markets, Saint-Augustin proved Garnier's assertion that Baltard was an architect whose "implacable logic led him sometimes to formulate artistic expressions that sentiment alone would have abandoned."[22]

Because everyone admitted the utility of iron, the material facts of Saint-Augustin's structure were not themselves at issue, even in a church. Rather, what disturbed almost every critic except Garnier were the dislocations forced on architecture when Baltard introduced the industrial material of iron alongside the traditional material of stone without making any attempt to smooth over the difference by re-creating architecture's conventional effects of structural mass. Ballu's contemporary church of La Trinité showed how easily a metal armature could be dissembled behind plaster simulations of masonry, setting an example that was duplicated by Ballu at Saint-Ambroise, Uchard at Saint-François-Xavier, and Ginain at Notre-Dame-des-Champs. Even when the use of iron was honestly expressed, the objective remained one of formal and structural reintegration. François Jäy upheld this objective from 1836 onward in the competition programs for his construction courses at the École, in that he proposed masonry walls combined with metal roof

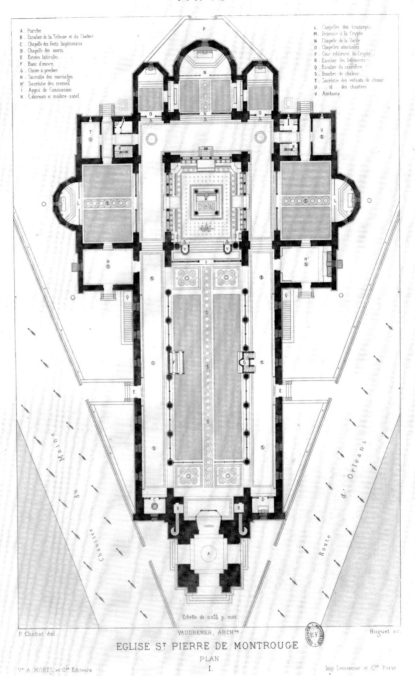

FIGURE 153 (*opposite*)
Théodore Ballu, La Trinité, 1861–67, Paris. Plan, from Félix Narjoux, *Paris: Monuments élevés par la ville* (1880–83).

FIGURE 154
Émile Vaudremer, Saint-Pierre-de-Montrouge, 1863–69, Paris. Plan, in Félix Narjoux, *Paris: Monuments élevés par la ville* (1880–83).

and vaulting structures.[23] The project for a parish church (fig. 155) submitted by Constant-Dufeux's student Édouard Dainville to the 1846 competition in Jäy's course on general construction proves the point by supporting the vaults on engaged stone instead of attached iron colonettes: despite the conjunction of stone and iron, and parabolic arches that signal the progressive metal vaulting, the colonettes in Dainville's project are integral to a masonry fabric with enough mass both to stand on its own and to support the vaults.[24] Conversely, the colonettes of Saint-Augustin dissect the building into heterogeneous constructions of stone and iron, neither of which is structurally stable by itself. Saint-Augustin provoked criticism precisely because the structure's iron skeleton made it possible to reduce the masonry skin to emaciated planes of stone, even while that stabilizing skin made it possible to reduce the iron skeleton to an impossibly thin frame. If this structure demonstrated the engineering efficiencies made possible by industrial materials and more precise calculations, the disconcerting consequence, as Sédille observed, was that the "enormous" void of the church, at once soaring and expansive, lacked the expected and traditional sense of mass: "one feels this immense cube of the central dome enveloped by thin walls, and the void loses its imposing effect because adequate solid masses are not opposed to it."[25]

While working on the Central Markets, Baltard had considered Labrouste's Sainte-Geneviève Library at length (see figs. 8, 9), and its cast-iron structure slipped inside a limestone box certainly remained relevant to his design of Saint-Augustin. His intentions, however, are better explained by comparing Saint-Augustin to the more recent and experimental church of Saint-Eugène (figs. 156, 157). Begun by Louis-Adrien Lusson in 1853 and completed in 1854–55 to a revised design by the

cabinetmaker-turned-architect Louis-Auguste Boileau, this Neo-Gothic church uses a metal structure to address the combined constraints of a constricted site and a tight budget: a web of wrought-iron vaulting ribs, infilled with terra-cotta and plaster and supported by cast-iron columns and arches, eliminates the need for buttressing and turns the masonry exterior into a non-load-bearing shell.[26] From 1853 forward, Boileau publicized the "new architectural form" that resulted synthetically from his "new system of construction" in a series of books: he took Gothic architecture as his logical point of departure but substituted iron for stone in order to correct its "vicious" dependence on external buttressing (and the need for massive timber roofs over the vaults).[27] Coinciding with the decision by Napoléon III to halt construction of the Central Markets in 1853, and reflecting the more general interest in iron architecture stimulated by train stations and the Crystal Palace in London, the publication of Boileau's first book and the example of Saint-Eugène provoked in 1854–55 a polemical exchange of articles between Boileau, the architectural editor Adolphe Lance, the Saint-Simonian critic Michel Chevalier, and Eugène-Emmanuel Viollet-le-Duc.[28]

Lance sparked the debate with a skeptical review that acknowledged Boileau's ingenuity as a builder yet questioned his abilities as an architect: "his *architectural form,* though it may be new, has nothing in common with good architecture . . . there is more true art in one of those awful flying buttresses of the old cathedral of Paris than in all of his *synthetic composition.*"[29] Chevalier was more sympathetic. Praising the material economy in Saint-Eugène's use of iron, which greatly reduced the mass of Gothic structures while still permitting monumental effects of space, he concluded that iron had the added benefit of being easily

Revue Générale de l'Architecture et des Travaux Publics
Paris, Rue de Furstemberg, Nº 6
M. Cesar Daly, arch. Directeur.

Fig. 8.

Fig. 1.

Fig. 3.

Fig. 2.

Fig. 4.

Fig. 5.

Fig. 6.

Fig. 7.

Echelle des Fig. 4, 5, 6 et 8.

Echelle des Fig. 1, 2, 3 et 7.

Echelle des Ensembles.

E. Dainville del. et sc.

PROJET D'ÉGLISE PAROISSIALE.

(Concours de Construction générale — École Roy. des B. Arts de Paris — 2ᵉ Classe).

PAR M. DAINVILLE, ÉLÈVE DE M. CONSTANT-DUFEUX.

FIGURE 155
Édouard Dainville, project
for a parish church, *concours
de construction générale,* 1846.
Plan, sections, elevations, and
details, from *Revue générale de
l'architecture* (1847).

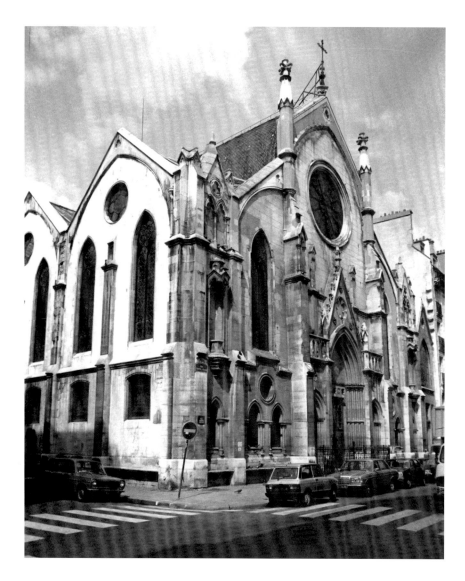

materials, one must change the forms," Viollet-le-Duc looked for a rational integration of stone and iron able to translate Gothic principles, particularly the dynamic balance of loads through the use of diagonal buttressing, into a truly new system of architecture.[32]

Baltard's critics ignored Saint-Eugène in their reviews of Saint-Augustin—although the comments of the younger Viollet-le-Duc with respect to Saint-Augustin echo those of his father with respect to Saint-Eugène. Both churches exploit the relative lightness and vertical loads made possible by iron vaulting, eliminating the need for buttresses, while sheathing the building with a thin envelope of stone that pushes tightly against the perimeter of its site. In this respect, Baltard, like Boileau, was more a builder solving a problem of construction than an architect solving a problem of design. Unlike Boileau, however, Baltard was professionally trained, and he demonstrated his extensive formal and theoretical as much as practical experience in a design whose use of history and of iron is more sophisticated than Saint-Eugène's. Substituting an inventive dialogue between medieval and Renaissance models for Boileau's rather literal reliance on Gothic forms, the architecture of Saint-Augustin considers the analogy between finishing a Gothic structure with Renaissance details and covering an industrial metal frame with a traditional envelope of stone. This dialectic between historical precedent and technological progress, echoing the argument of Baltard's École lectures, explains why the metal structure of Saint-Augustin, unlike that of Saint-Eugène, is consistently revealed through forms that speak directly to the differing material properties and, consequently, to the distinctive aesthetic characteristics of stone, cast iron, and wrought iron. The structural system of Saint-Augustin may not have been the one advocated by Viollet-le-Duc, but it was— as Garnier recognized—rational and consistent in

adapted to different stylistic forms: "cast iron, because of the marvelous ease with which it can be molded, lends itself to taking . . . any form that the rich imagination of our architects might want."[30] Viollet-le-Duc reacted to these claims with critical contempt: neither Chevalier nor Boileau understood the structural principles of Gothic architecture, and their naïve assumption that its forms and details could simply be turned from stone into iron reflected a failure to grasp how those forms were a specific result of the materials used.[31] Asserting that, "in changing the

its derivation of a tectonic language of decorated construction from the materials used.

Whether in the form of chiseled stone walls wrapping a metal frame or a metal frame filled with patterned brick walls, Saint-Augustin and the Central Markets are both examples of decorated construction realized by means of a structural skeleton and an ornamental skin. In 1834, Léonce Reynaud had described the classical details that Renaissance architects drew over Gothic structures as "a foreign veil, a rich and diaphanous veil, which decorated without dissimulating anything."[33] The metaphor is apt and applies with equal accuracy to the markets' curtain walls and to the ornamental veil that decorates without dissimulating the structure of Saint-Augustin. The industrialization of building in the nineteenth century confirmed architecture's transformation since the Renaissance into increasingly contingent fields of representation: freed from primary structural responsibility by its iron frame, and relegated to the secondary role of stabilizing that structure, the building's masonry skin became a decorative medium, able to assume at will a wide variety of historically expressive and therefore ephemeral guises. This dialectic had two implications for the future. On the one hand, it introduced the distinction between structural frame and curtain wall that came to define modernist architecture by the 1920s, providing Le Corbusier with an important precedent to his iconic Dom-Ino House and suggesting a further reason why he considered including Saint-Augustin in his album comparing the architectural progress of France and Germany. On the other hand, the ornamental veiling of architecture turned both markets and church into what the American architects Robert Venturi and Denise Scott Brown termed "decorated sheds" in 1970: generic structures determined by industrial methods and materials of construction, which signify their function and meaning through applied ornament.[34] As decorated sheds,

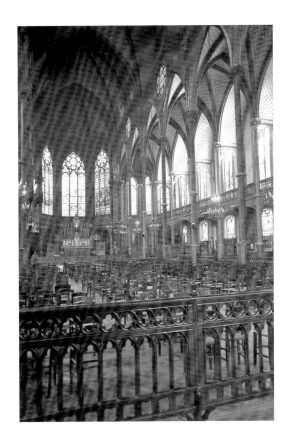

the Central Markets and Saint-Augustin reflect the bias for actual murality over illusionistic depth that Baltard had advocated in his decorative program for the churches of Paris and led in his work to an architecture of hieroglyphically inscribed surfaces stretched across a variety of functions.

Murality coincided with a minimal structure to produce an architecture of volume, line, and surface, without the expected physical mass or depth. The material shift left critics searching for ways to explain what happened, until the architect Louis-Charles Boileau (son of Louis-Auguste) found the words in 1876. The immediate occasion was his design, with the engineer Gustave Eiffel, of an addition to the Bon Marché Department Store in 1872–74, which featured a frankly exposed iron-and-glass interior.[35] Taking up the familiar claim that iron could not be treated like stone, Boileau argued for an equally fundamental per-

ceptual shift in architecture's aesthetic basis from the solid to the void:

> this point of view should attempt to envisage, not the solids of the edifice, but rather the void of the envelope; this is to say that, instead of trying to make light play on plastic forms, light should be played against itself in the ambient air that circulates through the structure and that, by its profusion or its economy, creates highlights, half shadows, or reflections that make the brightness sparkle through the space just as one throws candlelight on a crystal chandelier, cutting it into various prisms.[36]

Boileau, who had studied at the École des Beaux-Arts and placed himself in the classicist camp, was not aiming to replace architecture with engineering.[37] He continued to erect his aesthetic of the void on the architect's traditional interest in perceptible appearances, not the engineer's calculation of rational facts: "I think one would gain a lot in precision and truthfulness by adding that the true, in architecture as in all the arts, is nothing more than the *apparently true;* that is to say, it is not the intrinsic qualities of materials—their true nature—that must determine their forms, but rather the apparent qualities by which they present themselves to the eye—their apparently true nature."[38] Boileau's understanding of appearance, of *vraisemblance,* is consistent with that of every French classicist since the eighteenth century.[39] He meant, not to reject the classical tradition, but rather to justify its transformation in the nineteenth century.

Boileau provided the terms with which to describe Baltard's aesthetic purpose at the Central Markets and Saint-Augustin, each of which wrapped luminous voids with papery building envelopes. From its metal frame to its disturbingly thin walls, Saint-Augustin looked less like the contemporary churches being built in Paris than like the new iron architecture of the Central Markets. This similarity led most critics to assume that the lessons of industrial economy learned at the Halles had been applied directly, without any mediating effort to adjust the utilitarian premise of a markets to the sacred purpose of a church. Called upon to create a monument, Baltard built something that looked suspiciously like a shed. This perception is both factually true and critically misleading. Limiting the comparison to an economic equation of utility, it caused critics to focus on the functional differences between a church and a market and on the associated question of what materials were appropriate to each program. Yet twenty years of municipal practice had taught Baltard that function and form were discrete rather than synonymous criteria in architecture: use was something accommodated in the course of fitting a building to its site and to new means of construction, not something inherent in either a structure or a form. While Saint-Augustin and the Central Markets do speak to their respectively ecclesiastical and commercial programs, those programs were a secondary consideration in their design. What mattered to Baltard, and spoke to the aesthetic, rather than the economic, reasoning of his work, was how a building dealt with the urban and industrial conditions that he saw informing all of architecture, regardless of function, in modernity.

The purpose of both markets and church was to house the city. At Saint-Augustin, because of site constraints, Baltard eliminated the customary side aisles in favor of a single wide nave, segregating its congregational space from circulation zones to either side by wooden railings topped with lampposts. The theatrical effect, staging the spectacle of worship, is comparable to Ballu's

La Trinité, where Paul Sédille noted that religious rituals had been adapted to the social customs of its bourgeois audience.[40] Baltard, however, went farther than Ballu in his articulation of the church as an urban space. To make the interior spatially as well as socially continuous with the city, Baltard turned the nave, with its metal arches, into a covered street that is a direct axial extension of the Boulevard de Malesherbes leading up to the façade outside. Modeled after the connecting covered streets of the Central Markets, and descending from the commercial shopping arcades of the 1820s and 1830s, the nave of Saint-Augustin takes this idea to its logical conclusion: instead of being paired with pavilions or threaded between existing buildings, the nave as covered street becomes the building itself. Figuratively, this integrates the church with the apartment buildings that line the surrounding network of streets, framing the monumental public space of Saint-Augustin within an armature of private spaces. When Hector Horeau proposed, after 1862, to cover the boulevards of Paris with iron-and-glass roofs, he was picking up on an idea that Baltard had already, and more radically, put into practice.[41] Unlike Horeau, however, Baltard had more in mind than the futurist potential of modern building technologies: the covered street of Saint-Augustin looks past the Central Markets to the vaulted naves of churches like Saint-Eustache, bringing full circle a historical precedent that had already been appropriated to justify the form, space, and structure of the market pavilions. Understood historically, the industrial metal of Saint-Augustin was merely a more economical means than the stone of Saint-Eustache to realize a type of urban architecture that had shaped the space of Paris since the Middle Ages.

Like Giovanni Battista Nolli's 1748 map of Rome, whose figure-ground plan connects the city's streets and squares with its churches and monuments in a continuum of figural public space set against the solid ground of the city's housing blocks, the Central Markets and Saint-Augustin internalized the public spaces of Paris beneath generously sheltering roofs—what Zola likened to "a strange city . . . all placed under a hangar one rainy day."[42] Such a figure-ground conception of urban space and form confirms the historical shift away from the perspectival constructions of the Renaissance city and toward the modern city's abstraction in terms of circulation systems. Yet even as Baltard seems again to have anticipated Le Corbusier, not only at the Central Markets but also at Saint-Augustin, there remains a fundamental difference between Le Corbusier's erasure of the city with a matrix of bureaucratic skyscrapers in his Voisin Plan and Baltard's remaking of the city with industrial structures that simultaneously drew on its historic forms and spaces. Where Le Corbusier reversed the figure-ground relationship of Nolli's map, precipitating the city into the isolated black footprints of buildings that float within a white vacuum of public space, Baltard held to the city's traditional hierarchy as it was plotted by Nolli: an urban form shaped by its streets, monuments, and housing blocks, and consequently organized into a coherent network of public spaces woven through the private spaces of inhabitation.[43]

To contemporary eyes, what was most disturbing about Saint-Augustin's likeness to the Central Markets was the challenge this similarity posed to the conventional distinction between monumental and utilitarian types of architecture. Where the monumental church was supposed to be a representationally opaque medium for cultural memory and history, the utilitarian market shed was supposed to be a rationally transparent instrument of economic efficiency. But the iron structure of Saint-Augustin had hollowed out its

masonry shell to the point of transparency, stripping away the expected reading of the church as a monument grounded in tradition and leaving only an evacuated, weightless shell. Conversely, historical patterns of urban form and space had shaped and filled in the metal frame of the Central Markets to the point of opacity. What was meant to be opaque had become disturbingly transparent, while what promised to be transparent had been made strangely opaque. Opacity and transparency converged at the church and markets, in another demonstration of Baltard's pragmatic tendency to bring together modernity's complex pieces in a visible relation of differences through the process of architecture's own material production.

Epilogue on Function and Typology in Baltard's Urban Architecture

The paradox of transparency and opacity in Baltard's urban architecture returns to the methodological distinction between functional and typological readings of the city raised in chapter 1. Whether one thinks of the Central Markets as transparent instruments of utilitarian rationality or as opaque works of culturally informed art depends on whether one sees them through the functionalist lens that largely controlled interpretations of the markets until their destruction in 1971 or views them in the typological terms formulated in the 1960s and 1970s in reaction to the consequences of modernist urbanism. This book has made the case that Baltard addressed modernity's destabilizing effects on the nineteenth-century city by grounding the industrial metal structure of the Central Markets, like the rest of his work, in the deeper patterns of urban development that had historically shaped Paris.

Impatient with the historicizing contingency of nineteenth-century architects, modernists like Sigfried Giedion sought a functionally coherent justification for architecture. Filtered through an ideology of progress, both the physical fact and the intellectual concept of transparency came to stand for the perfected equation between a building's industrial production and its social function: any further need for opaque conventions of representation would be obviated by the ability to see directly through an architectural form to its programmatic use. Judged by this theoretical

project, Baltard could only fail to satisfy the expectations of his twentieth-century critics, since he had designed one of the most important demonstrations of architecture's industrialization in the nineteenth century yet persisted in his commitment to the city's historical forms and spaces. Indeed, the modernist lens through which Giedion observed the nineteenth century is conceptually so powerful that it remains to this day difficult to escape its frame of reference, suggesting why Baltard remains an architect of "unresolved juxtapositions" for David Van Zanten and of "bricolage" for Pierre Pinon.[1]

In his seminal text on modern architecture, *Building in France, Building in Iron, Building in Ferroconcrete* (1928), Giedion described the transparency that became possible when industrial materials of iron and glass replaced the traditional material of stone: "Iron opens the spaces. The wall becomes a transparent glass skin. . . . Through the condensation of material to a few points, there appears an unknown transparency, a suspended relation to other objects."[2] Alfred Gotthold Meyer had already considered this phenomenon in his 1907 study of iron architecture, *Eisenbauten*. Countering the complaint that iron buildings were rendered invisible by their loss of mass, he pointed out the obvious visibility of structures like Gustave Eiffel's 300-Meter Tower and concluded that the reduction of mass and surface to a framework of lines had produced transparency, not

invisibility.[3] Giedion took this argument another step by equating architecture's material transparency with an expectation of social progress: "Architecture is as closely bound to the sociological structure of a country as to its climate, materials and customs."[4] The reluctance of nineteenth-century architects to forsake historical imitation and embrace without reservation the dictates of industry therefore entailed for him a social as much as an aesthetic failure: "Saint Simon never reckoned with the century's divided soul, which in architecture as in society imposed the old formal apparatus on a new system."[5]

What Giedion outlined with polemical efficiency, Walter Benjamin set out to investigate more thoroughly in his *Arcades Project*. Accepting Giedion's history of architecture, Benjamin proposed a parallel social history of transparency in the nineteenth century: "It is a peculiarity of technological forms of production (as opposed to art forms) that their progress and their success are proportionate to the transparency of their social content. (Hence glass architecture.)"[6] In distinguishing technical from artistic forms, Benjamin meant both to recognize modernity's dialectic between industrial forms of production and traditional forms of culture and to claim the need for a new aesthetic, one that was equally transparent to technology and society. Like Giedion, Benjamin concluded that the nineteenth century had failed to formulate such an aesthetic, precisely because it had not responded "to the new technological possibilities with a new social order."[7] To Benjamin, the Paris of Napoléon III and Haussmann had concealed its use of modern technology behind the traditional imagery of stone in order to preserve the existing social order, and so remained in a premature or subconscious state of modernity: "Glass before its time, iron premature. . . . Around the middle of the century, it was not yet known how to build with glass and iron."[8] Despite its

technology, the nineteenth-century city therefore remained socially and politically opaque. The Central Markets, identified by Benjamin as Haussmann's most successful construction, "was itself an interesting symptom" of this opacity.[9]

Giedion's and Benjamin's interpretations of transparency drew on philosophical ideas of the Enlightenment. Founded on Newtonian physics and the natural sciences, the Enlightenment sought to discover the principles of a universal language that could reach from mathematics and physics to psychology and the social sciences and translate knowledge transparently from one field of inquiry to another.[10] This project was given explicit definition by Jean-Jacques Rousseau, who hoped through his political philosophy to restore man's original state of transparent goodness in nature, before society had corrupted his natural honesty of sentiment.[11] As Rousseau explained in "Second Dialogue," this meant getting behind false social masks to recover a person's innate transparency between psychological being and appearance: "His heart, transparent as crystal, can hide nothing of what goes on inside; everything that he feels is transmitted to his eyes and onto his face."[12] Rousseau's thesis of transparency attacked premodern notions of nobility as socially fixed status represented through such artificial signs as dress, manners, and speech.[13] To distinguish natural from social types of nobility, he used a dialectic of appearance whose connotations are subtler in the original French than in English: while *être* fairly simply translates as "being," *paraître* translates variously as "seeming to," "appearing," "making ones appearance," and "becoming visible"; these connotations extend to the related terms *apparaître* and *apparence*. The relevance of these meanings, and the representational play between the being of *être* and the seeming-to-be of *paraître,* become clear when one realizes that the transparency of Rousseau's crystal heart was itself a

psychological state that had to be made apparent, be represented, on a person's face.[14]

French academic architectural theory absorbed this reasoning into the principle that a building's exterior forms should express its interior spaces and functions, establishing the compositional system that was taught at the École des Beaux-Arts, upheld by the Académie des Beaux-Arts through the Prix de Rome, and enforced by the Conseil des bâtiments civils through its review of building projects.[15] From the time of Jacques-François Blondel onward, the representational content of this system was defined under the heading of "character," as when Durand asked rhetorically in his *Précis des leçons,* "If one organizes a building in a way that is suitable to its intended use . . . will it not then naturally have a character, and, what is more, its own character?"[16] This premise continued to hold despite the shift from constructed decoration to decorated construction that accompanied the Romantic rejection of the normative classical orders in favor of structurally rational methods of building. Until the end of the nineteenth century, the transparency of architectural character as an expressive criterion of composition therefore remained largely independent from the actual transparency made possible by iron-and-glass structures. David Van Zanten cites an 1887 necrology of Joseph Nicolle, which observes that Nicolle's teacher, Henri Labrouste, had sought in his design of the Sainte-Geneviève Library "to make the interior show through [*transparaître*] on the exterior of the building."[17] Yet the transparency in question continued to be figurative rather than literal, a matter of representing a building's interior on its exterior as images drawn on opaque stone. When the architect Émile Trélat tried in 1871 to explain how his projected "Sitellarium" would represent its function as the ideal public building housing the voting urn of a perfect democratic society, he turned to

the metaphor of reflection, not transparency: "Its existence is simply the reflection of a beautiful civil aptitude."[18] As Louis-Charles Boileau made clear in 1876, the increased availability of iron and glass, and the literal transparency made possible by those materials, had little effect on the classical preference for perceived appearances over material facts in architectural representation: "I think one would gain a lot in precision and truthfulness by adding that the true, in architecture as in all the arts, is nothing more than the *apparently true;* that is to say, it is not the intrinsic qualities of materials—their true nature—that must determine their forms, but rather the apparent qualities by which they present themselves to the eye—their apparently true nature."[19]

The Industrial Revolution was supposed to have provided a way out of this premodern reliance on verisimilitude and representation.[20] The greenhouses projected by John Claudius Loudon from 1817 onward, followed by those built during the 1830s and 1840s by Joseph Paxton, Decimus Burton, and Richard Turner in Great Britain and by Charles Rohault de Fleury in France, were an early field of technological experimentation that anticipated Paxton's Crystal Palace, Flachat's Gare Saint-Lazare train shed, and Baltard's Central Markets alike at midcentury.[21] The ability of greenhouses to control nature, admitting light while keeping out intemperate weather, suggested two intersecting utopias: an industrial utopia of nature made transparent to the control of modern technology that could serve the political utopia of modern technology made transparent to a program of social reform. Charles Fourier and his follower Victor Considérant theorized a society reorganized on a basis of equality in communal complexes called phalansteries, where collective living spaces, public halls, and industrial workshops would be connected by glass-covered galleries.[22] Like Rousseau's crystal heart, these glass

galleries stood for a phalanstery's absolute transparency between technology, architecture, and society.

The anticipated social transformation did not occur. Instead of producing phalansteries, the Industrial Revolution led to the glass-roofed commercial arcades built in Paris from the 1820s through the 1840s.[23] The arcades introduced a new type of urban space that interiorized the street, eroding the traditional difference between exterior/public and interior/private realms of experience. According to Benjamin, while both Fourier's galleries and the commercial arcades "make the street an interior," the arcades did so in collusion with bourgeois capitalism.[24] This repressed the collective potential of industrial and political revolution at work in the phalanstery in favor of "wishful fantasies."[25] The arcades were an unstable composite of contradictions: their modern materials and production opposing their historicizing imagery and details; their actual status as private properties cut through apartment blocks opposing their mimicry of the traditionally public street; the illusion of social transparency, of classlessness, in the visibly open, light-filled spaces opposing the opaque reality that the arcades were a specialized instrument for the sale of luxury goods to an elite class of consumers. Instead of transparency, the arcades staged a spectacle of consumption, a condition that extended by implication to every urban descendant of the arcades, including Baltard's Central Markets and the church of Saint-Augustin.

If these markets were indeed "an interesting symptom of" Haussmann's Paris, as Benjamin believed, it was because they seemed to fulfill a cycle of development begun with the arcades: appropriating a type of private space that substituted for the public street, the markets instituted a public realm to serve private commerce. This intersection of public and private interests had

been implicit to the history of the markets since at least 1137, when Louis VI claimed the right to determine their location in the city, and it became an explicit criterion of their modern development after 1811, when Napoléon I categorized the projected Grande Halle as a "large regulatory market." By the second half of the nineteenth century, the social and economic categories of public space and private space had become so entangled that any attempt to separate these traditionally distinct spheres became impossible.[26] It made sense, pragmatically, for the prefecture to contract in 1865 with private companies to build and operate the local retail markets attached to each district of Paris: in effect, a public space regulated by the prefecture was to be erected by a private company to serve commercial transactions managed by that same private company.[27] Faced with such contradictions, and the resulting erosion of public civic space in the city, modernists like Giedion and Benjamin theorized a utopian future of aesthetic and social reform that would finally reconcile history with modernity.

But when the principles of modernist urbanism came to be applied systematically to cities like Paris in the 1960s, what resulted was not the predicted reintegration but instead the unexpectedly violent destruction of the physical and social fabric of urban space. While historians like Pierre Lavedan, Françoise Choay, Marcel Royancolo, and Françoise Boudon got to work reexamining the conditions of a city's historical development, paying particular attention to the historic turning point of the nineteenth-century industrial city, other students of the city like Aldo Rossi and Anthony Vidler argued for what Rossi called "a typological reading of the city based on a theory of urban artifacts and their structure."[28] As explained in *The Architecture of the City* (1966), this theory identifies the city as "a gigantic man-made object, a work of engineering and

architecture that is large and complex and growing over time" and that is composed in turn of urban artifacts classified as streets, districts, and building types that house a "multiplicity of functions . . . over time" because those functions "are entirely independent of the form."[29] Borrowing the concept from Marcel Poète and Pierre Lavedan, Rossi attributed the city's complexity of urban artifacts to the persistence of its "basic layout and plans": the focus shifted from the premise of erasure found in the *tabula rasa* of Le Corbusier's Voisin Plan, to understanding how a city's form persists through the process of being rebuilt and remade over time.[30] Persistence applied as much to Haussmann's transformation of Paris as to any other city or historical period: "one may or may not approve of Haussmann's plan when judged solely on the basis of its design . . . but it is equally important to see that the nature of Haussmann's plan is linked up with the urban evolution of Paris."[31]

What Rossi considered at length, Vidler condensed into his short essay "The Third Typology" (1976). Where the first typology of nature is realized in the model of the primitive hut defined by Marc-Antoine Laugier in the eighteenth century, and the second typology of industrial production is realized in the machine for living defined by Le Corbusier in the 1920s, the third typology of the city is realized in the urban artifact defined by Aldo Rossi. All three are based in rational systems of classification, but unlike the other two, the third typology does not look to anything outside itself for validation: "urban spaces, while linked in an unbreakable chain of continuity, refer only to their own nature as architectural elements, and their geometries are neither scientific nor rational but essentially architectural. It is clear that the nature referred to . . . is no more or less than the nature of the city itself, emptied of specific social content from any particular time and allowed to speak simply of its own formal condition."[32] The

city's continuity of "history and form" is therefore not determined by considerations of function, though use remains something made possible by its streets and buildings:

This does not of course mean that architecture in this sense no longer performs any function . . . but simply that the principal conditions for the invention of object and environment do not necessarily have to include a unitary statement of fit between form and use. . . . In the accumulated experience of the city, its public spaces and institutional forms, a typology can be understood that defies a one-to-one reading of function, but which, at the same time, ensures a relation at another level to a continuing tradition of city life.[33]

For Vidler as for Rossi, this typological understanding identifies the city as a work of art that is continually being recomposed from its own formal elements according to three criteria: "the first, inherited from meanings ascribed by the past existence of the forms; the second, derived from the choice of the specific fragment and its boundaries; the third, proposed by a re-composition of these fragments in a new context."[34]

Interpreted in these terms, the Central Markets are seen to be what Émile Zola said they were in 1873: imperfect instruments of social utility and remarkable works of art that recomposed a city and its history into an iron architecture of sheltering pavilions and covered streets. If, ironically, it took the markets' demolition in 1971 to prove this simple point, it has also proved remarkably difficult to undo the consequences of that action. In 2003, the challenge of reurbanizing the resulting void prompted an invited competition between the architects Rem Koolhaas, Winy Maas, David Mangin, and Jean Nouvel.[35] Sensitive to the urban history of the Halles, these architects were all

keenly aware that the removal of the pavilions had interrupted the quarter's continuity and connections with the surrounding city. To "repair" the Halles, Jean Nouvel called for "reconquering" the site with "a new dialogue between our modernity and those that came before us. We can make the dialogue by creating a new Halles quarter that rests on and develops the quarter's qualities today but remembers the lost myth" of its character in the past.[36] Their projects, however, mostly recycle ideas from the 1970s, when the site was first laid out as a park over a subway station, with a shopping center at one end. David Mangin's winning project proposes a large garden between the existing Bourse de Commerce to the west and a new glass-roofed commercial center tied into the subway to the east. Where Baltard had integrated the markets with the Halles quarter by reinventing in modern industrial structures the city's historic elements of streets, monuments, and housing blocks, Mangin's park offers instead a picturesque escape from the city that seems indebted more to Le Corbusier's modernist strategy of erasure than to Baltard's program of typological recomposition. Instead of housing the city, Mangin leaves in place the hole that was opened up in the heart of Paris when the markets were torn down.

The argument of this book has been that the significance of Baltard's work as a whole lies precisely in its attempt to formalize in architecture the historical conditions of nineteenth-century Paris. Rehistoricized—which is to say, freed from the polemics of functionalism—Victor Baltard and his work become subject to interpretation, not for their success or failure in realizing an ideology of progress, but as concrete expressions of their times. True to his Vitruvian understanding of the architect as someone who is able "to solve all the problems that relate more or less directly to

their art," Baltard took on the engineer's challenge by acknowledging the new imperatives of rational necessity, even as he continued to justify those imperatives with aesthetic values.[37] He recognized the need to rethink the classical conception of architecture as a closed system of design in answer to the quantitative conditions and circumstances of the modern industrial city, but did so in terms that held to the historic understanding of the city as something made by its streets, monuments, and houses. His restoration of the city's churches, preserving by reinventing their cultural meaning in ways that were comprehensible to the nineteenth century, are of a piece with his new buildings. Whether apparently in stone, like the Bâtiments Annexes, in a heterogeneous mixture of stone and iron, like the church of Saint-Augustin, or in industrial structures of iron, brick, and glass, like the Central Markets, these works engaged Baltard in the same—typically contingent as well as contradictory—circumstances of the nineteenth-century city, caught as it was between the persistence of its formal and spatial history, on the one hand, and the transformations being effected by the Industrial Revolution, on the other. These circumstances led neither to the utilitarian denial of history feared by Baltard's contemporaries on the Conseil des bâtiments civils nor to the historicist rejection of industry supposed by Haussmann and Giedion, but rather toward successive attempts to describe, in architectural form, the modernity of Paris as directly lived and experienced on an ongoing daily basis. If, in the end, Baltard's buildings remained paradoxically opaque, despite their increasing material transparency, this was because they did not so much reveal universal truths, either of society or of architecture, as they reflected back onto itself the specificity of a city's own history.

1805	Born 19 June in Paris
1815–23	Attends the Collège Henri IV
1824–33	Attends the École des Beaux-Arts:

1824	Admitted into the architecture section, second class, as a student of Louis-Pierre Baltard's
1826	Advanced to the first class
1827	Admitted to the painting section, second class, as a student of Guillaume Guillon's, called Lethière
1832	Awarded the *prix departemental*
1832	Competes for the Prix de Rome, awarded fourth place
1833	Wins the Prix de Rome: military school

1827	Conductor of works at Notre-Dame de Lorette, under Hippolyte Lebas
1831	Inspector for the Fête de Juillet, under Louis Visconti
1832	Underinspector of works at the Archives, under Charles Lelong; at the Conservatoire des Arts et Métiers, under Victor Dubois; and at the Colonne de Juillet, under Jean-Antoine Alavoine
1833	Marries Adélaïde Lequeux, the sister of Paul-Eugène Lequeux
1834–38	Prix de Rome pensioner at the Villa Medici, Rome:

1834	First-year *envoi:* Pantheon, Rome
1835–38	Assists J.-A.-D. Ingres on *Antiochus and Stratonice*
1835	Second-year *envoi:* Theater of Marcellus, Rome, and "Parallel of Ancient and Modern Tombs"
1836	Travels to southern Italy and Sicily
1836	Third-year *envoi:* Temple of Concord and Temple of Castor and Pollux at Acragas, and Temple B at Selinonte, Sicily
1837	Fourth-year *envoi:* Theater of Pompey, Rome
1838	Fifth-year *envoi:* conservatory of music

1839	Interim architect of the District of Saint-Denis, replacing Paul-Eugène Lequeux
1840	Underinspector of works at the Halle aux Vins
1840	Inspector for the Fête de Juillet, under Louis Visconti
1840–41	Appointed an auditor on the Conseil général des bâtiments civils

1840–52	Runs an architecture studio, with Paul-Eugène Lequeux until 1847
1840–60	Inspector of fine arts for the city of Paris
1841	Premiated in the competition for Napoléon's Tomb
1841–46	Inspector of works for the Barrière du Trône, under François Jäy
1841–46	Inspector of works at the École normale, under Alphonse de Gisors
1842–46	Adjunct professor of architectural theory at the École des Beaux-Arts, substituting for Louis-Pierre Baltard
1842–48	Architect of the Corps de Garde, Boulevard de la Bonne Nouvelle, Paris (demolished)
1843	Architect of the tomb of Salvador Barbier, in Montparnasse Cemetery, Paris
1845–70	Architect of the Halles centrales, Paris, with Félix Callet until 1854
1846–52	Architect of the Hôtel du Timbre, Paris, succeeding Paul Lelong (1844–46)
1848	Places second in the competition for the tomb of Monsignor Affre, with sculpture by Jean-Auguste Barre
1848–54	Diocesan architect for the Department of the Seine; responsibilities formally assumed by Jean-Baptiste Lassus and Eugène-Emmanuel Viollet-le-Duc in 1854
1848–60	Architect of the first section of architectural works for the city of Paris
1853–58	Architect of the Temple Protestant, Nérac, after winning an 1852 competition
1853–60s	Architect of municipal ceremonies (*fêtes*) for the city of Paris:

1855	Reception of Queen Victoria, Hôtel de Ville
1856	Cradle of the Prince Impérial, with Hippolyte Flandrin, Pierre-Charles Simart, and Henri-Alfred Jacquemart (Musée Carnavalet, Paris)
1856	Baptism of the Prince Impérial, Hôtel de Ville
1858	Inauguration of the Boulevard de Sébastopol
1861	Inauguration of the Boulevard des Malesherbes
1862	Inauguration of the Boulevard du Prince Eugène/Voltaire, including a pedestal for the statue of Prince Eugène Napoléon, Place du Prince Eugène/Léon Blum, Paris (demolished), and decorations for the Place du Trône de la Nation (demolished)

1854–70	Architect of the Hôtel de Ville, Paris, succeeding Hippolyte Godde and Jean-Baptiste-Cicéron Lesueur (1832–46):

1854–55 } 1861–63 }	Staircase and iron-and-glass roof added to the Cour Louis (demolished)
1855–58	Bâtiments Annexes, Hôtel de Ville (rebuilt by Félix Roguet, 1873–76)

1857	Architect of the Villa Baltard, Sceaux
1859–68	Architect of Saint-Augustin, Paris
1860–70	Director of the Service of Architectural Works for the City of Paris
1863	Officer of the Légion d'honneur

1863 Elected to the Académie des Beaux-Arts, succeeding Augustin Caristie

1864–73 Société centrale:

 1864 Vice president

 1865–67 ⎫
 ⎬ President
 1871–73 ⎭

1865 Architect of the tomb of Hippolyte Flandrin, with a bust by Eugène-André Oudiné, in Père Lachaise Cemetery, Paris

1865–68 Restores and alters the Châteaux de Cestas, Gironde, for Georges-Eugène Haussmann

1866 Architect of the monument to Hippolyte Flandrin, with a bust by Eugène-André Oudiné, in Saint-Germain-des-Près, Paris

1867–68 Architect of the tomb of J.-A.-D. Ingres, with a bust by Jean-Marie Bonnassieux, in Père Lachaise Cemetery, Paris

1868 Architect of the Marché Secrétan, Paris (attributed)

1871–74 Appointed an inspector general of the Service des bâtiments civils

1872–73 Places eighth in the competition for the new Hôtel de Ville, Paris

1874 Dies 14 January in Paris

The following abbreviations appear frequently in the notes.

AN Archives nationales
AS Archives de la Seine
BHVP Bibliothèque historique de la ville de Paris
ENSBA École nationale supérieure des Beaux-Arts
RGA *Revue générale de l'architecture*

All citations of AN, 332 AP 1–26, are to the Fonds Baltard.
All translations are by the author, unless otherwise noted.

Chapter 1

1. See chapter 5, note 1, for the principal architectural, urban, and administrative histories of the markets.
2. Daly, "Chronique," *RGA* 27 (1869): cols. 205–6, with a letter from Victor Baltard; Malo, "Correspondance"; Louis Arnould, in *Le Génie civil* 17 (November 1890), reprinted in BHVP, *Baltard,* 28–29.
3. Garnier, *Baltard,* 7–8.
4. Giedion, *Building in France,* 112, 114. See also Hautecoeur, *Histoire de l'architecture classique,* 7:309–10; Hitchcock, *Architecture: Nineteenth and Twentieth Centuries,* 128; Lemoine, *Architecture in France,* 172–74.
5. Garnier, *Baltard,* 2, 3.
6. Zola, *Ventre de Paris,* 399.
7. See Evenson, "Assassination of Les Halles"; Evenson, *Paris,* 301–9; L. Chevalier, *L'assassinat de Paris.*
8. Sadler, *Situationist City,* 63–66, 88–90.
9. Lefebvre, *Production of Space,* 167.
10. See Michel, *Les Halles;* Large, *Halles.*
11. Boudon et al., *Système de l'architecture urbaine,* 1:56–57, 317–20, and passim.
12. Lemoine, *Les Halles,* 41–159.

13. Van Zanten, *Building Paris,* 218–26.
14. Rossi, *Architecture of the City,* 55–61; Vidler, "Third Typology," 2.
15. See Deconchy, "Baltard"; Magne, "Nécrologie"; Delaborde, "Baltard"; Sédille, "Baltard"; Garnier, *Baltard;* Arnould, *Baltard;* Aimard, "Baltard"; Romane-Musculus, "La famille de l'architecte Victor Baltard."
16. Van Zanten, *Building Paris,* 226.
17. Ibid., 230.
18. Pinon, *Baltard,* 7–8.
19. Ibid., 7, 169, 185.
20. Ibid., 9, 209.
21. Haussmann, *Mémoires,* 2:226–32.
22. "Discours de M. le Président de la République," in BHVP, *Baltard,* 15.
23. News clipping dated 25 January 1853, in BHVP, *Baltard,* Fo. 10375.
24. Daly, "Nouvelles de Paris," *RGA* 11 (1853): col. 224.
25. Haussmann, *Mémoires,* 2:227.
26. Ibid., 228.
27. Ibid., 229.
28. Ibid., 230.
29. Ibid., 235. In fact, Baltard and Callet, *Halles centrales,* 18, did acknowledge both Napoléon III and Haussmann. See correspondence between Baltard and Haussmann concerning this monograph in AN, 332 AP 6.
30. See Lemoine, *Les Halles,* 145–54; Cars and Pinon, *Paris-Haussmann,* 189–210.
31. See chapter 5 for documentation of these projects.
32. Victor Baltard and Félix Callet to Napoléon III, [June 1853], in BHVP, *Baltard,* 18.
33. *Journal des chemins de fer,* 18 June 1853, as quoted in Van Zanten, "Paris Space," 181. See Lemoine, *Les Halles,* 126–27 and n. 10; Bowie, *Grandes gares,* 62–63.
34. Baltard and Callet to Napoléon III, in BHVP, *Baltard,* 17.
35. Eugène Rouher, as quoted in Jordan, *Transforming Paris,* 259.

36. Baltard and Callet, *Halles centrales,* 18.
37. Victor Baltard, *Complément,* in Moncan, *Baltard,* 134.
38. Haussmann, *Mémoires,* 2:236–37.
39. Durand, *Précis des leçons,* 1:5.
40. E.-E. Viollet-le-Duc, *Entretiens,* 2:74–77; Garnier, *À travers les arts,* 72–73.
41. Picon, *French Architects and Engineers,* 1–6 and passim.
42. J.-F. Blondel, *Cours d'architecture;* Durand, *Précis des leçons.* See Picon, *French Architects and Engineers,* 47–98, 322–30, and passim; Fichet, *La théorie architecturale;* Szambien, *Durand;* Szambien, *Symétrie, goût, caractère.*
43. Polonceau, "Pratique," *RGA* 1 (1840): cols. 27–32. See Lemoine, *L'architecture du fer;* Steiner, *French Iron Architecture;* Kahlmaier and Sartory, *Houses of Glass,* 77–137.
44. Picon, *French Architects and Engineers,* 223.
45. Ibid., 250.
46. Rabinow, *French Modern,* 59–60.
47. See Girard, *La politique des travaux publics;* Harvey, *Paris.*
48. See Corbin, *The Foul and the Fragrant.*
49. See Marcel Royancolo, "La production de la ville," in Agulhon, *La ville de l'âge industriel,* 73–155, and Françoise Choay, "Pensées sur la ville, arts de la ville," in ibid., 156–271. See also Etlin, *Symbolic Space,* 9–13.
50. Loyer, *Paris,* 106–12; Rabinow, *French Modern,* 30–39; Papayanis, *Planning Paris,* 141–57.
51. See Beatrice de Andia, "Entre les feux de l'État, de la ville et des compagnies," in Bowie, *Grandes gares,* 2–21; Papayanis, *Planning Paris,* 157–68.
52. Haussmann, *Mémoires,* 1:29. On this map, see Merruau, *Souvenirs de l'Hôtel de Ville,* 363–74; Morizet,

Du vieux Paris au Paris moderne, 129–32; Lavedan, *Nouvelle histoire,* 318–23 and 413ff.; Pierre Pinon, "Le projet d'embellissement de Paris," in Cars and Pinon, *Paris-Haussmann,* 51–56; Van Zanten, *Building Paris,* 199–202.

53. Haussmann, *Mémoires,* 1:3. See Anne-Marie Châtelet, "La conception haussmannienne du rôle des ingénieurs et architectes municipaux," in Cars and Pinon, *Paris-Haussmann,* 257–63.

54. Haussmann, *Mémoires,* 2:18.

55. See François Loyer, "Avant-propos," in Cars and Pinon, *Paris-Haussmann,* 9–14; Sutcliffe, *Paris,* 83–104.

56. Haussmann, *Mémoires,* 1:28–29.

57. See Giedion, *Space, Time, and Architecture,* pt. 3; Le Corbusier, *Vers une architecture,* 1–10.

58. See Puylaroque, "Pierre Baltard, peintre et dessinateur"; Puylaroque, "Pierre Baltard, peintre, architecte et graveur"; Pinon, *Baltard.*

59. See Foucart, "Architecture carcérale"; Pinon, *Baltard,* 47–71.

60. See Abadie, *Gilbert.*

61. Blouet, *Supplément au Traité,* 1:vij. See Lance, *Blouet.*

62. Jäy, *Résumé des leçons de construction.* See V. Baltard, *Funérailles de M. M.-F. Jäy.*

63. Reynaud, *Traité d'architecture,* 1:448.

64. Ibid., 2:451–53.

65. Haussmann, *Mémoires,* 1:231–32.

66. Baltard and Callet, *Halles centrales,* 3–4.

67. V. Baltard, *Complément,* in Moncan, *Baltard,* 139–40.

68. See Mead, *Garnier's Paris Opéra;* Van Zanten, *Building Paris,* 74–121 and passim; Mead, "Urban Contingency."

69. See Narjoux, *Paris.*

70. Neil Levine, "The Romantic Idea of Architectural Legibility: Henri Labrouste and the Néo-Grec," in Drexler, *Architecture of the École des Beaux-Arts,* 325–416; Levine, "The Book and the Building," in Middleton, *Beaux-Arts,* 138–73; Van Zanten, *Designing Paris,* 83–98 and passim.

71. Hugo, *Notre-Dame de Paris,* 209–24.

72. Le Corbusier to Auguste Perret, 14 December 1915, in Le Corbusier, *Lettres*

à Perret, 152. I thank David Van Zanten for bringing this to my attention.

73. Auguste Perret to Le Corbusier, 17 January 1916, in ibid.

74. Vidler, "Posturbanism," in *Architectural Uncanny,* 179–80.

75. See Lavedan, *Nouvelle histoire,* 523–57, on the second transformation of Paris.

Chapter 2

1. Haussmann, *Mémoires,* 2:227.

2. Giedion, *Building in France;* Giedion, *Space, Time, and Architecture.* The 1975 exhibition was followed by a publication of the same title: Drexler, *Architecture of the École des Beaux-Arts.*

3. Neil Levine, "The Romantic Idea of Architectural Legibility," in Drexler, *Architecture of the École des Beaux-Arts,* 329.

4. Middleton, *Beaux-Arts.* See note 6 below for other sources.

5. Delaborde, "Baltard," 789.

6. On the Neoclassicists, see Daly, "Notices nécrologiques," *RGA* 6 (1845–46): cols. 547–52; R. Schneider, *Quatremère de Quincy;* Puylaroque, "Pierre Baltard, peintre et dessinateur"; Puylaroque, "Pierre Baltard, peintre, architecte et graveur"; Rowlands, "Quatremère de Quincy"; Lavin, *Quatremère de Quincy;* Pinon, *Baltard.* On the Romantics, see Blanc, *Artistes de mon temps;* Levine, "Architectural Legibility"; Van Zanten, *Designing Paris;* Bergdoll, *Léon Vaudoyer;* Bellenger and Hamon, *Duban.*

7. Delaborde, "Baltard," 790. See Delaborde, *Académie des Beaux-Arts;* Guadet, *Éléments et théorie;* Mead, *Garnier's Paris Opéra,* 99–134, 199–252, and passim.

8. Egbert, *Beaux-Arts Tradition;* David Van Zanten, "Architectural Composition at the École des Beaux-Arts from Charles Percier to Charles Garnier," in Drexler, *Architecture of the École des Beaux-Arts,* 110–323.

9. Pinon, *Baltard,* 9.

10. Delaborde, "Baltard," 801–5.

11. Garnier, *Baltard,* 8.

12. Ibid., 4.

13. Ibid., 6–7.

14. Levine, "Architectural Legibility"; Van Zanten, *Designing Paris,* 45–68; Bergdoll, *Léon Vaudoyer,* 109–40.

15. Simon-Claude Constant Dufeux to Victor Baltard, 27 June 1871, AN, 332 AP 13.

16. Penanrum, Roux, and Delaire, *Architectes élèves.*

17. Romaine-Musculus, "La famille de l'architecte Victor Baltard"; Puylaroque, "Pierre Baltard, peintre, architecte et graveur," 34–38.

18. "Appointements de l'agence des travaux: Réunion des Tuileries au Louvre; Ministre d'État," AN, 64 AJ 65–66.

19. See Bergdoll, *Les Vaudoyer,* on the professional dynasty founded by A.-L.-T. Vaudoyer.

20. Arnould, *Baltard,* 2, and Romane-Musculus, "La famille de l'architecte Victor Baltard," list ten children; Puylaroque, "Pierre Baltard, peintre, architecte et graveur," 34–38, identifies eleven.

21. Aunay, "Baltard"; Timbal, "Baltard"; Arnould, *Baltard,* 2–4; Puylaroque, "Pierre Baltard, peintre, architecte et graveur," 35–37.

22. Pierre Baltard to Victor Baltard, 10 October 1842, in Puylaroque, "Pierre Baltard, peintre, architecte et graveur," 37.

23. Timbal, "Baltard."

24. Puylaroque, "Pierre Baltard, peintre, architecte et graveur," 35–36.

25. Timbal, "Baltard."

26. Letter from the Préfecture de la Seine to Pierre Baltard, 31 October 1815, naming Victor Baltard a "Boursier de la ville de Paris au Lycée de Henri IV," AN, 332 AP 2.

27. Timbal, "Baltard."

28. Deconchy, "Baltard," 236. See Baltard's notebooks, AN, 332 AP 2.

29. AN, 332 AP 2.

30. Haussmann, *Mémoires,* 2:226–27. Romane-Musculus, "La famille de l'architecte Victor Baltard," notes that Baltard's family attended the Temple des Billettes in the Rue des Archives.

31. Draft from Victor Baltard to the Académie des Beaux-Arts, 24 January 1863, AN, 332 AP 2.

32. AN, AJ 52 174.

33. V. Baltard, *Funérailles de M. M.-F. Jäy.*

34. Victor Baltard's awards for the second class are recorded in AN, 332 AP 2.

35. See forty-five studies of male nudes, anatomical details, and statues in AN, 332 AP 23.

36. "École royale des Beaux-Arts: Section d'architecture; Résultats des jugements de 1ère classe; Commencé 1831," AN, AJ 52 180; many of Baltard's *concours d'émulation* projects and his Prix de Rome project are in the ENSBA archives.

37. David Van Zanten kindly shared his notes from the Registre des Concours, Archives de l'Institut, 1833: 1H2, 131–58.

38. On the topicality of these programs, see Neil Levine, "The Competition for the Grand Prix in 1824," in Middleton, *Beaux-Arts,* 66–123.

39. Lampué, *Programmes des concours.*

40. Judgment of the academicians recorded in the Registre des Concours, 157.

41. See Vaudoyer and Baltard, *Grands prix d'architecture.* Pierre Baltard contracted with A.-L.-T. Vaudoyer in 1809 to continue the publication (begun in 1806) of winning Prix de Rome projects; editions appeared in 1818 and 1834: "Acte de Société entre Mr. Vaudoyer et Baltard, le 1er avril 1809," AN, 332 AP 1.

42. Van Zanten, "Architectural Composition," 219–23; Levine, "Architectural Legibility," 357–93; David Van Zanten, "The Beginnings of French Romantic Architecture and Félix Duban's Temple Protestant," in Searing, *In Search of Modern Architecture,* 64–84; Van Zanten, *Designing Paris,* 3–43; Bergdoll, *Léon Vaudoyer,* 75–108.

43. L.-P. Baltard, *Discours d'ouverture,* 5–6.

44. See Quatremère de Quincy, "Antique" and "Architecture," in *Dictionnaire historique,* vol. 1.

45. Laurent, *À propos de l'École,* 121–22.

46. [Tiburce Morisot], "Beaux-Arts: Concours pour le grand prix d'architecture," *La propriété* (ed. Tiburce Morisot) 1, no. 42 (1833): 1–3, quotation on 2. I thank David Van Zanten for sharing this review with me.

47. Timbal, "Baltard"; also Deconchy, "Baltard," 237.

48. V. Baltard, preface to *Villa Médicis.* See Daly, "Bibliographie," *RGA* 8 (1849): cols. 170–71.

49. Passport of Victor Baltard and Adéline [*sic*] Lequeux, issued in Lyon on 8 March 1834 and stamped with visa controls, AN, 332 AP 3.

50. Victor Baltard painted a small self-portrait of himself at this time; in the collection of the Baltard family.

51. Académie royale des Beaux-Arts, *Règlement pour les jeunes artistes pensionnaires du Roi,* AN, 332 AP 3. See Pinon and Amprimoz, *Envois de Rome,* 13–70.

52. Victor Baltard to the *ministre du commerce et travaux publics,* 25 November 1833, and ministerial report dated 23 December 1833, AN, F 21 608. See Pinon, *Baltard,* 114.

53. "Règlements pour les pensionnaires de l'Académie de France à Rome" (1846), in V. Baltard, *Villa Médicis,* 37–44.

54. Ten letters from Victor Baltard to Eugène Roger, 21 September 1834 to [November 1838], AN, 332 AP 3. Correspondence between Eugène Roger, J.-A.-D. Ingres, and the *ministre de l'intérieur,* 20 June 1835 to 29 May 1837, documents Roger's return to France in 1835–37 due to a severe pulmonary illness, AN, F 21 608.

55. Baltard to Roger, 19 February 1836.

56. Baltard to Roger, 2 August 1835.

57. Baltard to Roger, 19 February 1836.

58. Baltard to Roger, 1 May 1837.

59. Baltard to Roger, 10 July 1838. Baltard's indifference to Leveil was shared by Paul Lequeux, who criticized Leveil's 1836 *envoi* in a letter to Baltard of 20 September 1838, AN, 332 AP 3. Victor's alliances paralleled his father's: Constant-Dufeux and Garrez trained with Debret and Vaudoyer, friends of Pierre Baltard; Morey trained with Achille Leclère, a Percier student but Pierre Baltard's competitor; Leveil trained with Huyot, Pierre Baltard's nemesis at the École.

60. Vigne, *Ingres,* 200ff.

61. Amaury-Duval, *L'atelier d'Ingres,* 118–19. A student of Ingres's who traveled on his own to Italy in the autumn of 1834, Amaury-Duval was the son of the same Amaury Duval who collaborated with Pierre Baltard on *Paris et ses monuments.*

62. Ibid., 122.

63. Baltard to Roger, 2 August 1835.

64. Baltard to Roger, 19 February 1836.

65. E.-E. Viollet-le-Duc, *Lettres d'Italie;* see also ENSBA, *Voyage d'Italie.*

66. Eugène Viollet-le-Duc to Emmanuel Viollet-le-Duc, 28 November 1836, 27 December 1836, and 4 January 1837, in E.-E. Viollet-le-Duc, *Lettres d'Italie,* 200, 213, 217.

67. Letter of 28 November 1836, in ibid., 200–202.

68. Letters of 15 January and 26 March 1837, in ibid., 217, 271–72.

69. Letter of 26 March 1837, in ibid., 272.

70. Letter of 1 March 1837, in ibid., 256.

71. Letter of 26 March 1837, in ibid., 271; see the discussion of Morey's restoration of the Forum of Trajan in the letter of 28 November, in ibid., 200.

72. Victor Baltard recorded this course in notebooks, AN, 332 AP 3. See Pinon and Amprimoz, *Envois de Rome,* 95.

73. Baltard to Roger, 8 September 1837.

74. Amaury-Duval, *L'atelier d'Ingres,* 128.

75. Victor Baltard's passports, itineraries, and "Carnet de Voyage: Italie, [1834–]1835," in AN, 332 AP 3; additional loose-leaf sketches in AN, 332 AP 19 and 23, and in the collection of the Baltard family.

76. Baltard to Roger, 7 September 1836.

77. Ibid.

78. Recounted in letters from Victor Baltard to Pierre Baltard, 29 November and 23 December 1836; from Baltard to Roger, 29 December 1836; and a draft from Victor Baltard to the duc de Luynes, 24 December 1836 / 24 January 1837, AN, 332 AP 3.

79. Correspondence related to the book by Huillard-Bréholles, *Recherches sur les monuments,* is in AN, 332 AP 5. Albert, duc de Luynes, was an archaeologist and patron of the arts who charged Félix Duban in 1839 with restoring his seventeenth-century château at Dampierre, where Ingres was then asked to paint a mural cycle of the Ages of Man. See Thomas de Luynes, "Duban

à Dampierre," in Bellenger and Hamon, *Duban,* 150–55.

80. Sixteen sketches are in AN, 332 AP 19. An additional sketch, of the episcopal throne in the church of San Nicola in Bari, is in the collection of the Baltard family.

81. Mead, *Garnier's Paris Opéra,* 33.

82. Baltard to Roger, 7 September 1836.

83. See Amaury-Duval, *L'atelier d'Ingres,* 108–9; Vigne, *Ingres,* 214. Baltard's drawings were exhibited in the 1844 Salon: Daly, "Salon de 1844," *RGA* 5 (1844): col. 184.

84. Filloux, "La Stratonice de M. Ingres," *RGA* 1 (1840): cols. 554–56; Delaborde, *Ingres,* 219; Wildenstein, *Ingres,* cat. no. 232; Rosenblum, *Ingres,* 146; Vigne, *Ingres,* 225–28.

85. Baltard to Roger, 19 February 1836. See a letter from J.-A.-D. Ingres to Édouard Gatteaux, July 1840, cited in Delaborde, *Ingres,* 219.

86. Vitruvius, *Ten Books,* bk. 6, chap. 3; Gusman, *Pompei,* 287–89.

87. Victor Baltard's small sketchbook from 1836 is in AN, 332 AP 14; twenty-six loose-leaf pencil, ink, and watercolor sketches from 1836 of Pompeii, Herculaneum, and Pompeiian artifacts in Naples are in the collection of the Baltard family.

88. L.-P. Baltard, *Discours d'ouverture,* 6.

89. Amaury-Duval, *L'atelier d'Ingres,* 130.

90. See ENSBA, *Pompéi,* and Pinon and Amprimoz, *Envois de Rome,* 385–430, esp. 409–10.

91. Van Zanten, *Architectural Polychromy;* D. Schneider, *Hittorff;* Robin Middleton, "Hittorff's Polychrome Campaign," in Middleton, *Beaux-Arts,* 174–95; David Van Zanten, "Architectural Polychromy," in ibid., 196–215; Marie-François Billot, "Recherches aux XVIIIe et XIXe siècles sur la polychromie de l'architecture grecque," in ENSBA, *Paris, Rome, Athènes,* 61–125; Musée Carnavalet, *Hittorff.*

92. Levine, "Architectural Legibility," 357–93; Van Zanten, "Architectural Composition," 319–23.

93. Eugène Lequeux to Victor Baltard, 20 September 1838, AN, 332 AP 3.

94. Académie royale des Beaux-Arts, *Règlement pour les jeunes artistes pensionnaires du Roi,* art. 17.

95. One sheet from this *envoi* survives in the collection of the Baltard family, along with preparatory sketches.

96. Deconchy, "Baltard," 239. On the "Parallèle de tombeaux de diverses époques de Rome et ses environs," see Pinon, *Baltard,* 115.

97. V. Baltard, "Carnet de Voyage: Italie."

98. Académie des Beaux-Arts, "Rapport sur les ouvrages envoyées de Rome par les pensionnaires de l'Académie de France, pour l'année 1835," Archives de l'Académie de France, carton 46, as quoted in Pinon, *Baltard,* 115. Louis-Pierre Baltard also criticized these polychromatic details, as reported by Lequeux to Baltard: see Baltard to Roger, 1 May 1837.

99. Académie des Beaux-Arts, "Rapport sur les ouvrages . . . pour l'année 1836," Archives de l'Académie de France, carton 46, as quoted in Pinon, *Baltard,* 115.

100. Pinon, *Baltard,* 115–16.

101. Marie-Christine Hellman and Philippe Fraisse, "Architecture grecque et envois de Rome," in ENSBA, *Paris, Rome, Athènes,* 25–38.

102. Antoine-Chrysostome Quatremère de Quincy to the *ministre de l'intérieur,* 24 December 1835, AN, F 21 608, and Quatremère de Quincy to J.-A.-D. Ingres, 24 December 1835, Archives de l'Académie de France, carton 37, fol. 131, as cited in Pinon and Amprimoz, *Envois de Rome,* 262–63.

103. The rendered elevation is in the private collection of the Baltard family, along with two pencil drawings of the plan and elevation.

104. See Pinon and Ampromiz, *Envois de Rome,* 296–97.

105. Académie des Beaux-Arts, "Rapport sur les ouvrages . . . pour l'année 1837," Archives de l'Académie de France, carton 37, as quoted in Pinon, *Baltard,* 119.

106. Baltard to Roger, 1 May 1837.

107. The *envoi* is in the ENSBA archives.

108. Flaminio Vacca, *Memorie di varie antichità* (Rome, 1594); Giovanni Battista Piranesi, *Antichità romane* (Rome, 1756); Famiano Nardini, *Roma antica* (Rome, 1818); Luigi Canina, *Indicazione topografica di Roma antica* (Rome, 1831); Antonio Nibby, *Roma nell'anno 1838* (Rome, 1838 and 1839), whose content Baltard would have received in advance from Nibby's course in 1836–37.

109. See Vitruvius, *Ten Books,* bk. 5, chap. 8.

110. Académie des Beaux-Arts, "Rapport sur les ouvrages . . . pour l'année 1838," Archives de l'Académie de France, carton 37, as quoted in Pinon, *Baltard,* 121; Beulé, *Fouilles et découvertes,* 1:258–60; Nash, *Pictorial Dictionary,* 2:423–28.

111. Pinon and Amprimoz, *Envois de Rome,* 73.

112. Julien Guadet, "Mémoire: Forum de Trajan, 1867," as quoted in Annie Jacques, "Les architectes de l'Académie de France à Rome au XIXe siècle et l'apprentissage de l'archéologie," in ENSBA, *Roma Antiqua,* xxviii. See Pinon and Amprimoz, *Envois de Rome,* 89, 329–30.

113. Baltard to Roger, 1 May 1837.

114. Académie des Beaux-Arts, "Rapport sur les ouvrages . . . pour l'année 1838," as quoted in Pinon, *Baltard,* 121.

115. Quatremère de Quincy, "Restauration," in *Dictionnaire historique,* 2:375.

116. Quatremère de Quincy to Ingres, 24 December 1835.

117. Victor Baltard, "Mémoire: Théâtre de Pompée, 1838," ENSBA.

118. Vitruvius, *Ten Books,* bk. 1, chap. 1, on architectural expertise; bk. 3, chap. 1, on compositional principles; and bk. 6, chap. 9, on the alterations to those principles in practice.

119. Victor Baltard to Pierre Baltard, 29 November 1836, and an undated letter postmarked 1837, AN, 332 AP 3.

120. Undated, untitled, and unsigned project in AN, 332 AP 25.

121. Institut de France, *Séance publique . . . du samedi 5 octobre 1839,* 12.

122. Ibid.; Labrouste, "Travaux des élèves de l'école d'architecture de Paris, pendant l'année 1839," *RGA* 1 (1840): col. 59.

123. See the draft from Victor Baltard to the Académie des Beaux-Arts, 24 January 1863, AN, 332 AP 2.

124. Baltard opened the *atelier* with Lequeux in 1840 and ran it independently from 1847 until 1853; with ten to fifteen students a year, the studio trained several students who went on to municipal careers (including Ferdinand Deconchy, Gustave Huillard, Auguste Radigon, and Marcelin-Emmanuel Varcollier), though only one ever won a Prix de Rome: Gabriel-Auguste Ancelet (1851). See "École royale des Beaux-Arts: Section d'architecture; Résultats des jugements de 2ème classe; Commencé le 10 octobre 1831," AN, AJ 52 176; a ledger recording monthly attendance in the *atelier* from April 1844 to December 1848, and the "Règlement de l'atelier de Monsieur Baltard," 3 July 1846, AN, 332 AP 2; Daly, "École des Beaux-Arts: Note statistique sur la section d'architecture," *RGA* 10 (1852): cols. 301–3; letters from Gabriel-Auguste Ancelet to Victor Baltard, AN, 332 AP 13.

125. Puylaroque, "Pierre Baltard, architecte, peintre et graveur," 195–96; Pinon, *Baltard,* 95.

126. Daly, "Nouvelles et faits divers," *RGA* 3 (1842): cols. 42–43.

127. Pierre Baltard to Victor Baltard, 8 August 1840, in Puylaroque, "Pierre Baltard, peintre, architecte et graveur," 547.

128. Victor Baltard, "Théorie de l'architecture," 1841–45, AN, 332 AP 8. See Pinon, *Baltard,* 201–6.

129. Pinon, *Baltard,* 202.

130. Middleton and Baudoin-Matuszek, *Rondelet,* 298, 295–98.

131. Baltard's dismissal in favor of Blouet did not affect their friendship: Victor Baltard to [Abel] Blouet, n.d., Getty Research Institute, Special Collections: Victor Baltard, Letters no. 860596.

132. See Blanchot, *Sainte-Clotilde;* Courcel, *Sainte-Clotilde;* Brunel, *Dictionnaire des églises.*

133. L.-P. Baltard, *Introduction au cours . . . de l'année 1839,* 6ff.; L.-P. Baltard, *Introduction au cours . . . de l'année 1841,* 16.

134. L.-P. Baltard, *Introduction au cours . . . de l'année 1841,* 17–18, 27.

135. Ibid., 30–31.

136. Pierre Baltard, "Concours d'émulation: 8 décembre 1841; Église paroissiale," AN, AJ 52/128.

137. Daly, "Enseignement de l'architecture à l'École des Beaux-Arts," *RGA* 2 (1841): cols. 634–39; Daly, "Nouvelles et faits divers," *RGA* 2 (1842): cols. 42–43.

138. V. Baltard, "Théorie de l'architecture," 1ère cours de 1841–42, 1ère leçon.

139. Ibid., 1ère cours de 1841–42, 1ère leçon; 2ième cours de 1842 à 1843, 1ère leçon; and 3ième cours de 1843 à 1844, 2ième leçon.

140. L.-P. Baltard, *Introduction au cours . . . de l'année 1841,* 8; V. Baltard, "Théorie de l'architecture," 2ième cours, 1ère leçon.

141. V. Baltard, "Théorie de l'architecture," 1ère cours, 1ère leçon.

142. Ibid., 4ième cours de 1844 à 1845, 1ère leçon.

143. This was first formulated by Augustin-Charles d'Aviler, *Cours d'architecture* (Paris: Langlois, 1691). See Middleton, "Blondel and the Cours d'Architecture"; Fichet, *Théorie architecturale;* Szambien, *Symétrie, goût, caractère.*

144. V. Baltard, "Théorie de l'architecture," 2ième cours, 1ère leçon.

145. F. Blondel, *Cours d'architecture;* J.-F. Blondel, *Cours d'architecture,* vol. 1; Normand, *Nouveau parallèle.*

146. See Fichet, *Théorie architecturale,* 138–73, 183–255; Picon, *French Architects and Engineers,* 16–34.

147. After Blondel's death, Pierre Patte completed the projected third part of Blondel's *Cours,* on construction.

148. Durand, *Précis des leçons,* 1:30–32.

149. Quatremère de Quincy, "Architecture," in *Dictionnaire historique,* 1:93–101.

150. Levine, "Architectural Legibility"; Van Zanten, *Designing Paris,* 45–68; Bergdoll, *Léon Vaudoyer,* 109–40.

151. Léonce Reynaud, "Architecture," in Leroux and Reynaud, *Encyclopédie nouvelle,* 1:771. Victor Cousin laid out his theory of progress in lectures delivered at the Sorbonne in 1828–29 and published in the *Cours d'histoire de philosophie: Cours de 1829,* 2 vols. (Paris: Pichon et Didier, 1829); these ideas were

picked up by his follower Edgar Quinet and by the historian Jules Michelet. Reynaud and his circle adhered to the nonceremonial Saint-Simonianism defined by Hippolyte Carnot, *Exposition générale de la doctrine saint-simonienne,* 2 vols. (Paris: Le Globe, 1829–30), which broke with the sect espousing the utopian Saint-Simonian doctrine established by Prosper Enfantin in 1831. See Van Zanten, *Designing Paris,* 46, 60–61; Bergdoll, *Léon Vaudoyer,* 115.

152. Reynaud, "Architecture," 1:771.

153. Ibid., 1:778. In 1837, Léonce Reynaud's appointment as the professor of architecture at the École polytechnique gave him a forum in which to lecture on his ideas, and this led in 1850–58 to his *Traité d'architecture,* which replaced Durand's *Précis des leçons* as the standard architectural treatise in France during the second half of the nineteenth century.

154. V. Baltard, "Théorie de l'architecture," 1ère cours, 4ième–6ième leçons.

155. Ibid., 2ième cours, 7ième–12ième leçons.

156. Ibid., 6ième leçon.

157. Ibid., 10ième leçon.

158. Ibid., 9ième leçon.

159. Ibid., 3ième cours, 1ère leçon.

160. Ibid., 5ième cours de 1845 à 1846, Discours d'ouverture (1 décembre 1845).

161. Victor Baltard's *concours d'émulation* programs, February 1842 to January 1846, in "École des Beaux-Arts: Architecture 2ième Classe; Concours d'émulation, programmes 1831–1860," AN, AJ/52/128, and "École des Beaux-Arts: Architecture 1ère Classe; Concours d'émulation, programmes," AN, AJ 52 143. See Annie Jacques, "The Programmes of the Architectural Section of the École des Beaux-Arts," in Middleton, *Beaux-Arts,* 58–65; Michel Denès, "L'aménagement de Paris à travers les concours d'émulation de l'École des Beaux-Arts," in Bowie, *Modernité avant Haussmann,* 304–12.

162. Victor Baltard, "Concours d'émulation, 4 novembre 1844: Rendu; Une église paroisialle."

163. Baltard, "Théorie de l'architecture," 4ième cours, 8ième leçon.

164. Vaudoyer and Lenoir, "Études d'architecture," *Magasin pittoresque* 7 (1839): 123–26, 163–67, 196–99, 259–64, 334–36, 355–60; and 10 (1842): 121–28.

165. Quatremère de Quincy, "Architecture"; Reynaud, "Architecture"; Vaudoyer and Lenoir, "Études d'Architecture," *Magasin pittoresque* 9 (1841): 123–25.

166. See Middleton, "The Abbé Cordemoy and the Graeco-Gothic Ideal."

167. E.-E. Viollet-le-Duc, "De la construction des édifices religieux"; E.-E. Viollet-le-Duc, "De l'art étranger et l'art national"; Lassus, "De l'art et l'archéologie." See Mead, *Garnier's Paris Opéra,* 223–28.

168. Lassus, "De l'art et l'archéologie" (June 1845), 330.

169. Vaudoyer and Lenoir, "Études d'architecture," *Magasin pittoresque* 12 (1844): 262; Désiré Raoul-Rochette, "Considérations sur la question de savoir s'il est convenable, au XIXe siècle, de bâtir des églises en style gothique," in E.-E. Viollet-le-Duc, "Du style gothique," 326–33. Lassus, *Réaction de l'Académie.*

170. Raoul-Rochette, "Percier."

171. See Quatremère de Quincy, *Histoire.*

172. V. Baltard, *Augustin Caristie,* 18.

173. V. Baltard, *L'École de Percier,* 3.

174. Baltard and Gatteaux, *Galerie de la Reine,* 3. See Garnier, "Bibliographie: La Galerie de Diane."

175. The election is documented by a record of the results in AN, 332 AP 9, and by [Daly], "Académie des Beaux-Arts," *RGA* 20 (1862): col. 286.

176. Félix Duban to Victor Baltard, [February 1863], AN, 332 AP 9. Though the two architects were not close, Baltard had great respect for Duban's artistic skills: see V. Baltard, "Exposition d'une collection de dessins de Félix Duban," *RGA* 29 (1872): cols. 22–29.

177. See the draft from Victor Baltard to the Académie des Beaux-Arts, 24 January 1863, AN, 332 AP 2.

178. V. Baltard, *Augustin Caristie,* 9–10.

179. *Gazette des architectes et du bâtiment* 1 (1863): 192–97; Delaborde, *Académie des Beaux-Arts,* 310–19; Richard Chaffee, "The Teaching of

Architecture at the École des Beaux-Arts," in Drexler, in Drexler, *Architecture of the École des Beaux-Arts,* 97–105; Laurent, *À propos de l'École,* 124–33.

180. Directeur des Beaux-Arts to Victor Baltard, 2 March 1848, AN, 332 AP 8, appointing a commission "instituée pour l'examen des reformes à faire à l'organisation de l'École Française de Rome et de l'École des Beaux-Arts."

181. Notes by Victor Baltard of a meeting by the commission, AN, 332 AP 8.

182. Ingres, *Réponse au rapport;* Beulé, "L'École de Rome"; and Beulé, *Réponse de l'Académie des Beaux-Arts.*

183. "Règlement de l'École impériale et spéciale des Beaux-Arts," *Gazette des architectes et du bâtiment* 1 (1863–64): 274–76.

184. Victor Baltard to [J.-A.-D. Ingres], n.d., and copy of Ingres's *Réponse,* with annotations by Baltard, AN, 332 AP 8.

185. Draft from Victor Baltard to an unidentified colleague, 21 November 1863; "Note relative au décret du 13 novembre 1863 concernant l'organisation de l'École impériale des Beaux-Arts," AN, 332 AP 8.

186. Copy of a letter from Victor Baltard to the comte de Nieuwerkerke, November 1863, AN, 332 AP 8.

187. Victor Baltard, "Note relative à l'organisation de l'École des Beaux-Arts et au grand prix de Rome: Examen comparatif de l'état ancien, de l'état actuel; proposition pour l'avenir," AN, 332 AP 8.

188. Ibid., pp. 3–4.

189. Victor Baltard, "Vitruve," AN, 332 AP 9, pp. 2–3.

190. Ibid., p. 3.

191. Ibid., p. 10.

Chapter 3

1. Lavedan, *Nouvelle histoire;* Ballon, *Paris;* Ranum, *Paris.*

2. See Say, *Études sur l'administration;* Lazare, *Paris;* Camp, *Paris;* Merruau, *Souvenirs de l'Hôtel de Ville;* Pontich, *Administration de la ville;* Haussmann, *Mémoires;* Cilleuls, *Histoire de l'administration;* Rambuteau, *Mémoires;* Lanfant, *Conseil général de la Seine;* Barroux, *Département de la Seine;* Félix, *Régime administratif;* Tulard, *Paris*

3. Say, *Études sur l'administration,* vj.

4. Van Zanten, *Building Paris,* 46–73 and 198–202 passim.

5. Gourlier and Questel, *Bâtiments civils;* see note 2 above on municipal authors.

6. Biet et al., *Choix des édifices publics;* Narjoux, *Paris.*

7. See Weber, *Economy and Society,* 1:271–84, "Collegiality and the Division of Powers," and 2:956–1005, "Bureaucracy."

8. Gourlier and Questel, *Bâtiments civils,* 36–37.

9. Say, *Études sur l'administration,* 291–94.

10. Victor Baltard was twice president of the Société central des architectes, 1865–67 and 1871–73, when he kept its sights firmly fixed on the professional unity of its members: see V. Baltard, "Discours d'ouverture" and documents in AN, 332 AP 9.

11. Van Zanten, *Building Paris,* 129.

12. See Olsen, *City as a Work of Art;* Hall, *Planning Europe's Capital Cities.*

13. Loyer, *Paris,* 14.

14. Van Zanten, *Building Paris,* 122–24.

15. Mead, "Urban Contingency."

16. Ibid., 168.

17. See Habermas, *Structural Transformation.*

18. The *Almanach impérial/royal/ national* and Préfecture de la Seine, *Recueil des actes administratifs,* document the administrative structure and personnel during this period. Additional documentation on the Service d'architecture is in Baltard's papers, AN, 332 AP 4 and 13, and the Fonds Antoine Bailly, AS, V42 M1. See Anne-Marie Chatelet, "La conception haussmannienne du rôle des ingénieurs et architectes municipaux," in Cars and Pinon, *Paris-Haussmann,* 257–63; Van Zanten, *Building Paris,* 56–59; Claire Monod, "Les origines des services d'architecture du département de la Seine," in Bowie, *Modernité avant Haussmann,* 165–76.

19. Van Zanten, *Building Paris,* 48–65.

20. Claude de Rambuteau, Arrêté, 16 May 1836, AN, 332 AP 4.

21. Claude de Rambuteau, Arrêté, 30 November 1840, AS, V42 M1,

22. Louis-Antoine Garnier-Pagès (25 February–9 May 1848); Armand Marrast (9 May–19 July 1848); Ariste Trouvé-Chauvel (19 July–27 October 1848); and Adrien-Barnabe-Athanase Recurt (27 October–20 December 1848).

23. Préfecture de la Seine, *Recueil des actes administratifs* (1853).

24. Georges-Eugène Haussmann, Arrêté, 18 May 1854, AN, 332 AP 4.

25. Georges-Eugène Haussmann, Décret, 26 December 1854, in Lazare and Lazare, *Dictionnaire administratif,* 697–700. A related edict of 28 February 1856 subdivided the external Service of Public Works into three parts, each headed by an engineer: (1) the Service de la voie publique, charged with street sanitation, under Homberg; (2) the Service des eaux, charged with water and sewers, under Eugène Belgrand; and (3) the Service des promenades et plantations, charged with parks, promenades, and landscaping, under Adolphe Alphand. Edicts of 28 December 1856 and 31 January 1859 set up a Service du plan de Paris, headed by Eugène Deschamps and initially answering alongside the Service of Architectural Works to the fifth bureau: "Arrêtés d'organisation de 28 décembre 1856 et 31 janvier 1859," in Préfecture de la Seine, *Recueil des actes administratifs* (1860).

26. Haussmann, *Mémoires,* 2:222.

27. Ibid., 223.

28. Georges-Eugène Haussmann, Arrêté, 31 March 1860, AN, 332 AP 4; Préfecture de la Seine, *Recueil des actes administratifs* (1860); "Réorganisation du Service d'architecture du département de la Seine et de la ville de Paris," *Encyclopédie d'architecture* 10 (July 1860): cols. 97–103. A second edict, of 1 November, combined formerly separate internal offices and external services into the unified agencies of a Direction de la voirie de Paris, a Direction du Service municipal, and a Direction du Service d'architecture. A third edict, of 31 December, made their directors answer directly to the prefect: Georges-Eugène Haussmann, Arrêté, 31 December 1861, AN, 332 AP 4.

29. Missing were the bid and contract clerks (*vérificateurs*), who came after accountants on Rambuteau's original list, though they soon appeared on other inventories of service personnel.

30. Haussmann, *Mémoires,* 2:259–60.

31. Ibid., 259.

32. Georges-Eugène Haussmann, Arrêté, 15 August 1854, and Ampliation, 26 September 1854, AN, 332 AP 4; Haussmann, Arrêté, 31 March 1860.

33. Haussmann, Arrêté, 31 March 1860.

34. Haussmann, *Mémoires,* 2:256. Documents in AN, 332 AP 4, indicate that the number of district architects increased unevenly, starting in 1861, until the situation was regularized in prefectoral edicts of 31 January 1864 and 1 March 1865.

35. On such appointments, see a letter from J. Baudry, Direction du service d'architecture, 12 September 1863, AN, 332 AP 13.

36. Victor Baltard, Circulaire, 22 September 1865, in the Fonds Antoine Bailly, AS, V42 M1.

37. Nineteen letters, notes, and documents from Victor Baltard to Antoine Bailly, in the Fonds Bailly, AS, V42 M1.

38. Note concerning "un examen pour le grade de commis-piqueur dans le service des travaux d'architecture," 14 January 1865.

39. Haussmann, *Mémoires,* 2:258ff., 265–66, 278–79.

40. Ibid., 256–57.

41. See Narjoux, *Paris,* vols. 1 and 3.

42. Saint-Augustin (1860–68), Victor Baltard; La Trinité (1861–67), Saint-Ambroise (1863/65–76), and Saint-Joseph (1867–74), Théodore Ballu; Notre-Dame-de-la-Croix at Ménilmontant (1860/63–69), Louis-Jean-Antoine Heret; Saint-Pierre-de-Montrouge (1863–69), Émile Vaudremer; Saint-François-Xavier (1861/65–76), Louis-Adrien Lusson and François Uchard; Notre-Dame-des-Champs (1867–76), Léon Ginain; Synagogue, Rue des Tournelles (1867–76), Marcelin-Emmanuel Varcollier.

43. This undated and unlabeled sketch project is included among a series of preliminary sketches for Saint-Augustin in AN, 332 AP 4, though it remains unclear whether it was in fact a design for Saint-Augustin or for another church.

44. IIIe Arrondissement (1864–67), Victor Calliat and Eugène Chat; IVe Arrondissement (1862–67), Antoine Bailly; XIe Arrondissement (1862–65), Étienne-François Gancel; XIIIe Arrondissement (1867/73–77), Paul-Émile Bonnet; XVIe Arrondissement (1860s/75–77), Eugène Godeboeuf; XXe Arrondissement (1868–75), Léon Salleron.

45. On Haussmann's dismissal, see Cars and Pinon, *Paris-Haussmann,* 305–11; Jordan, *Transforming Paris,* 315–18. On Baltard's resignation, see Sédille, "Baltard," 495.

46. Léon Say, Arrêté, 30 June 1871, AN, 332 AP 4; "Service d'architecture du département de la Seine," *RGA* 28 (1870–71): cols. 180–85.

47. Haussmann, *Mémoires,* 2:223–24.

48. See Préfecture de la Seine, *Recueil des actes administratifs.*

49. See Félix, *Régime administratif,* 1:125ff.; Fleury and Tulard, *Almanach,* vol. 1.

50. Strong, *Art and Power,* 7–19.

51. Ibid., 22–35, 42–50.

52. Villefosse, *Nouvelle histoire.* See also Fleury and Tulard, *Almanach;* Ballon, *Paris,* 69–70; Barry Bergdoll, "Duban et les Fêtes de Juillet," in Bellenger and Hamon, *Duban,* 191–98; Bergdoll, "Metteur en scène des Fêtes de Juillet et de fastes du IIe Empire," in Hamon and MacCallum, *Visconti,* 142–60; Van Zanten, *Building Paris,* 74–121 and 204–11.

53. Villefosse, *Nouvelle histoire,* 79–87 and 172–76.

54. See Thomson, *Renaissance Paris,* 73–98; Dunlop, *Royal Palaces,* 97–114; Daufresne, *Louvre et Tuileries,* 19–78; Ballon, *Paris,* 15–56; Berger, *Palace of the Sun.*

55. On absolutism, see Ranum, *Paris.* On the royal squares, see Ballon, *Paris;* Cleary, *Place Royale.* See also Ziskin, "The Place de Nos Conquêtes"; Ziskin, *Place Vendôme;* Musée Carnavalet, *De la place Louis XV;* Christ, *Place des Victoires.*

56. Strong, *Art and Power,* 42–43.

57. Ziskin, *Place Vendôme,* 8.

58. Percier and Fontaine, *Description des cérémonies* (1808); Villefosse, *Nouvelle histoire,* 347–85.

59. Fouche, *Percier et Fontaine;* Biver, *Pierre Fontaine;* Szambien, *Rue des Colonnes.*

60. Van Zanten, *Building Paris,* 122–28.

61. Waquet, *Fêtes royales,* and Waquet, "Architecte des fêtes et cérémonies royales," in Musée Carnavalet, *Hittorff,* 27–39.

62. Van Zanten, *Designing Paris,* 203–5; Pierre Pinon, "La Bastille, place introuvable," in Pinon, *Traversées de Paris,* 81–84; Werner Szambien, "La Colonne de Juillet," in ibid., 85–89; Bergdoll, "Metteur en scène"; and Bergdoll, "Duban et les Fêtes de Juillet."

63. D. Schneider, *Hittorff,* 1:365–424; Musée Carnavalet, *De la place Louis XV,* 112–27; Jean-Marie Bruson, "La place de la Concorde," in Musée Carnavalet, *Hittorff,* 75–109.

64. Louis-Philippe, as quoted in D. Schneider, *Hittorff,* 1:386.

65. Ibid., 397–424.

66. See Van Zanten, *Building Paris,* 110; also Burton, *Blood in the City.*

67. Calliat, *Hôtel de Ville;* Vachon, *Hôtel de Ville.*

68. See Emmanuel Jacquin, "La réunion du Louvre aux Tuileries," in Hamon and MacCallum, *Visconti,* 220–47; David Van Zanten, "Visconti et le nouveau Louvre," in ibid., 248–53; Van Zanten, *Building Paris,* 74–121.

69. Baltard's work at the Hôtel de Ville is documented by projects and photographs, AN, 332 AP 2, 24, and 26; minutes of the Conseil général des bâtiments civils meetings dealing with the Hôtel de Ville in AN, F 21 2542/15 and 2542/19 (1851 and 1855); budget reports and edicts, 1851 to 1865, AS, V1 M2.

70. Jean-Jacques Berger, Arrêté, 4 November 1851, AS, V1 M2.

71. Jean-Baptiste-Cicéron Lesueur to Victor Baltard, 27 September 1854, AN, 332 AP 13.

72. This included completing the Galerie du Secrétaire Générale (1854), the Galerie de la Comptabilité (1854), and the Salle des Fêtes (1855), and building a new double staircase for the Hôtel de Ville library (1854); Baltard went on

to alter the prefect's private apartments (1856), build an iron-and-glass-roofed gallery for the "atelier des géomètres et de dessinateurs du plan de Paris," design eight monumental gaslit candelabra for the Place de l'Hôtel de Ville (1859), and build a new façade belfry (1863–69): documented by budget edicts, contracts, and bills in AS, V1 M2.

73. Construction of the iron-and-glass roof in 1854–55, of a plaster model by Gallois for the final design of the staircase in 1860, and of the permanent staircase in 1861–63 at a cost of 263,688 francs is documented by budget edicts, contracts, and bills in AS, V1 M2.

74. Conseil général des bâtiments civils, "Procès verbal de la séance du 21 mai 1855," AN, F 21 2542/19.

75. AN, 332 AP 24.

76. See Villefosse, *Nouvelle histoire,* 411–32.

77. Hôtel de Ville, *Fête donnée;* the original watercolors of this album, given to Queen Victoria, are preserved in the Royal Collection, Royal Library, Windsor Castle, England.

78. Ibid., 8–9.

79. Ibid., 9.

80. Hôtel de Ville, *Fêtes et cérémonies;* the original of this album, given to the empress Eugénie, was destroyed in the fire of the Tuileries Palace in 1871. Correspondence, budgets, edicts, and official reports documenting this ceremony are in AN, 332 AP 4.

81. Hôtel de Ville, *Fêtes et cérémonies,* 7.

82. Ibid., 8–9.

83. Ibid., 10.

84. The banquet is documented by a guest list for the imperial table, two seating charts, a plan of the Salle des Cariatides, with indications for table decorations, and a sketch of the banquet table with decorations, AN, 332 AP 26.

85. On the baptism of the Prince Impérial and role of religious ceremonies staged at Notre-Dame during the Second Empire in connecting Napoléon III to Napoléon I, see Boudon, *Paris, capitale religieuse,* 319–27.

86. Van Zanten, *Building Paris,* 205–11.

87. Documented by correspondence, a broadsheet published by Roger on the

"inauguration du boulevard du Prince Eugène," watercolor renderings by Baltard for the Place du Trône, a plate of the triumphal arch for the Place du Trône from *Paris architecte* (March 1865), and two Richebourg photographs of the Place du Trône, 5 December 1862—all in AN, 332 AP 4, 19, 26.

88. *Journal des débats* (December 1862), as quoted and translated in Van Zanten, *Building Paris,* 210.

89. See Ville de Paris, *Ledoux et Paris,* 110–28; Vidler, *Ledoux,* 211–35.

90. Documentation on Baltard's post as inspector for the Barrière du Trône is in AN, 332 AP 4.

91. See Anne Pingeot, "Les statues de la République," in Pinon, *Traversées de Paris,* 119–26.

92. Karl Baedeker, *Paris et ses environs* (Leipzig: Baedeker; Paris: Ollendorff, 1903), 258.

93. Van Zanten, *Building Paris,* 204–5.

94. Ibid., 207.

95. Karl Marx, as quoted by Robert Skidelsky, "What's Left of Marx," *New York Review of Books* 47 (16 November 2000), 25.

96. Lazare and Lazare, *Dictionnaire administratif;* Alphand, *Recueil des lettres patentes;* Hillairet, *Dictionnaire historique.* See Haussmann, *Mémoires,* 1:45–55; Van Zanten, *Building Paris,* 233–41.

97. The design and construction of this building is documented by minutes of the Conseil général des bâtiments civils for 16 August 1855, 5 May 1856, and 21 July 1856, AN, F 21 2542/19 and 2542/20; by budget edicts issued by Georges-Eugène Haussmann on 17 October 1855, 3 July 1856, 12 July 1856, 15 July 1856, and 30 August 1856, AS, V1 M2.

98. Narjoux, *Paris,* 1:20.

99. Daly, "Panorama du mouvement architectural," *RGA* 20 (1862): col. 279; Pinon, *Baltard,* 159, points out that these preceded Henri Labrouste's metal stacks for the National Library (1858–67).

100. Haussmann, *Mémoires,* 2:233–34.

101. "Faits divers," *Le moniteur universel,* 17 January 1858.

102. Daly, "Panorama du mouvement architectural," *RGA* 20 (1862): col. 226.

103. Conseil général des bâtiments civils, "Procès verbal de la séance du 10 août 1855," AN, F 21 2542/19. The *conseil* reiterated its objections when it next reviewed the project, on 21 July 1856.

104. See Mead, "Urban Contingency," 161–64, for a fuller discussion of this issue.

105. Conseil général des bâtiments civils, "Procès verbal du la séance du 31 janvier 1860," AN, F 21 1843; Daly, "Tribunal de Commerce," *RGA* 23 (1865): cols. 248–49.

106. Conseil général des bâtiments civils, "Procès verbal de la séance du 16 décembre 1859," AN, F 21 1843.

107. Davioud and Daly, *Théâtres de la place du Châtelet,* 6.

108. Ibid., 5–6.

109. Daly, "Tribunal de Commerce." See also Narjoux, *Paris,* vol. 1.

110. Haussmann, *Mémoires,* 2:276–79, 287–92.

111. Van Zanten, *Building Paris,* 239.

112. Ibid., 243.

113. Loyer, *Paris,* 231–41.

114. Ibid., 232.

115. Ibid., 240.

116. Van Zanten, *Building Paris,* 246.

117. From 1864 to 1868 Baltard had worked on a series of unrealized projects for the Hôtel de Ville of Amiens, documented by correspondence in AN, 332 AP 5. Baltard also designed but did not submit a competition project for the Paris Opéra in 1860–61, in the collection of the Baltard family.

118. Préfecture de la Seine, *Programme du concours;* Préfecture de la Seine, *État des services;* Préfecture de la Seine, *Compte rendu*—all in AN, 332 AP 4. See Daly, "Reconstruction de l'Hôtel de Ville de Paris," *RGA* 29 (1872): cols. 125–28; Daly, "Concours publics," *RGA* 29 (1872): cols. 182–84; Daly, "Édilité parisienne," *RGA* 29 (1872): col. 259; Daly, "Concours de l'Hôtel de Ville de Paris," *RGA* 30 (1873): cols. 24–37, 107–22; Pierre Vaisse, "L'Hôtel de Ville reconstruit," in Pinon, *Traversées de Paris,* 109–14.

119. Arnould, *Baltard,* 14–15.

120. Garnier, *Baltard,* 10.

121. Victor Baltard, draft of a letter, n.d.; when, however, Ballu wrote to Baltard, 24 March 1873, expressing the hope that the competition would not alter "nos bonnes et cordiales relations," Baltard underlined the phrase and added a skeptical question mark—both letters in AN, 332 AP 4.

122. Victor Baltard, "Projet de reconstruction de l'Hôtel de Ville de Paris: État des pièces remises à la préfecture de la Seine par le soussigné Victor Baltard"; V. Baltard, "Concours pour la reconstruction de l'Hôtel de Ville de Paris: Note explicative; Considérations générales; Paris 31 janvier 1873"; V. Baltard, "Concours pour la reconstruction de l'Hôtel de Ville de Paris: Devis descriptif"—all in AN, 332 AP 4. His competition project on thirteen sheets, 31 January 1873, is in the collection of the Baltard family, along with eleven plans, sections, and elevations published by the Préfecture de la Seine to document the surviving state of Godde and Lesueur's Hôtel de Ville.

123. Claude, "Reconstruction de l'Hôtel de Ville," *La petite presse,* 20 March 1873; Louis Auvray, "Concours pour la reconstruction de l'Hôtel de Ville de Paris," *Annales: Société libre des beaux-arts et Comité central des artistes* 26 (January–April 1873), 113–19—both in AN, 332 AP 4. See Garnier, *Baltard,* 9–12.

124. Daly, "Concours de l'Hôtel de Ville," cols. 119–22.

125. The ranking was (1) Ballu and Deperthes, (2) Rouyer, (3) Davioud, (4) Vaudremer, (5) Magne, (6) Constant Moyaux and Charles Lafforgue, (7) Roguet and Achille Menjot de Dammartin, (8) Baltard.

126. Rouyer is listed as a student of Hippolyte Lebas's in Penanrum, Roux, and Delaire, *Architectes élèves,* but is recorded as a student of Baltard's and Hector Lefuel's in 1850, in "École royale des Beaux-Arts: Section d'architecture; Résultats des jugements de 2ième classe; Commencé le 10 octobre 1831," AN, AJ 52 176.

Chapter 4

1. Neil Levine, "The Romantic Idea of Architectural Legibility," in Drexler, *Architecture of the* École des beaux-Arts, 332–33.

2. Garnier, *Baltard,* 4.

3. Administered since 1840 as an external district of the Préfecture de la Seine, Sceaux fell outside the ring of industrial and working-class suburbs that Haussmann annexed in 1860, but lay within easy reach of the city after a railroad line was inaugurated in 1846 between the Barrière d'Enfer and an embarkation platform in the Ferme de la Ménagerie, on the former site of Colbert's seventeenth-century château: Baltard began spending summers there in 1847, at first renting a house on the Rue Fontenay, until he bought a piece of property in four lots along the nearby Rue Bertron, where the estate of the Russian admiral Tchitchakoff had been put up for sale in the wake of the Crimean War. The property remains in the Baltard family, though both the gardens and the villa have been altered over the years. The villa is documented by twelve sketch plans, elevations, perspectives, and details in the collection of the Baltard family, and by Arnould, *Baltard,* 12–14. Baltard also designed extensive modifications and additions to Haussmann's château of Cestas south of Bordeaux in 1867–70; a local architect, H. Duphoit, supervised the work; designs, bills, and correspondence in AN, 332 AP 5; see Carmona, *Haussmann,* 487–88.

4. Later, Baltard moved to 10 Rue Garancière, behind Saint-Sulpice, also in the VIe Arrondissement.

5. V. Baltard, "Exposition d'une collection de dessins de Félix Duban," 23.

6. Garnier, *Baltard,* 9.

7. Timbal, "Baltard"; Arnould, *Baltard,* 7.

8. Daly, "Tombeau de Napoléon," *RGA* 1 (1840): cols. 375, 443; "Brochure," *RGA* 1 (1840), cols. 557–58; "De la nécessité de mettre au concours," *RGA* 2 (1841): cols. 39–42; "Monument de Napoléon," *RGA* 2 (1841): col. 471; "Exposition des projets," *RGA* 2 (1841): cols. 521–28, 571–81, 593–629; "Rapport de la commission," *RGA* 2 (1841): cols. 630–34; "Réclamation de M. Visconti," *RGA* 3 (1842): cols. 35–39; "Tombeau de l'Empereur Napoléon," *RGA* 4 (1843): cols. 179–83. Driskel, "Le tombeau de Napoléon," in Hamon and MacCallum, *Visconti,* 168–80; "Le tombeau

de Napoléon," in Bellenger and Hamon, *Duban,* 199–203; *As Befits a Legend.* See also Humbert, *Napoléon aux Invalides.*

9. Five drawings for the competition project and four drawings and one sketch for an alternate design are in collection of the Baltard family.

10. See Daly, *Des concours;* Mead, *Garnier's Paris Opéra,* 44–98.

11. Hygin-Auguste Cavé, as quoted in Daly, "Exposition des projets," col. 525.

12. Daly, "Rapport de la commission," col. 634.

13. Daly, "Exposition des projets," cols. 615, 619–27. After Visconti threatened a suit for defamation, Daly printed a letter from Cavé denying the accusations: Daly, "Réclamation de M. Visconti," *RGA* 3 (1842): cols. 35–39.

14. See David Van Zanten, "Visconti architecte-voyer," in Hamon and MacCallum, *Visconti,* 66–69, and Barry Bergdoll, "Metteur en scène des Fêtes de Juillet et des fastes du IIe Empire," in ibid., 142–60.

15. Driskel, *As Befits a Legend,* 15–16 and 127–28, picks up on Daly's reading of Visconti as an administrator. Delaborde, "Baltard," 800, notes that Baltard spoke favorably of Visconti's design to the end of his life.

16. See Driskel, *As Befits a Legend,* 133–38, who ignores Baltard's ties with Ingres and Fontaine.

17. Daly, "Exposition des projets," cols. 575–81.

18. Daly, "Rapport de la commission," cols. 631–32.

19. Draft of letter from Victor Baltard to an unidentified member of the competition committee, n.d., in the collection of the Baltard family.

20. Daly, "Exposition des projets," col. 627; see Daly, *Des concours.*

21. Neil Levine, "The Book and the Building: Hugo's Theory of Architecture and Labrouste's Bibliothèque Ste-Geneviève," in Middleton, *Beaux-Arts,* 138–73; Van Zanten, *Designing Paris,* 83–98.

22. Victor Baltard, as quoted in Daly, "Exposition des projets," cols. 615–16.

23. Daly, "Rapport de la commission," col. 631.

24. Garnier, *Baltard,* 4.

25. In the first group, only the tomb of Victor Cousin, carved in 1868 from two pieces of black Volvic stone, is securely documented by five letters from the contractor, Lardot, and the client, Jules Barthélemy Saint-Hilaire, to Victor Baltard, 1868, AN, 332 AP 5. The claim made here is that Baltard authored the other copies of the sarcophagus: the white limestone tomb of Jean-Baptiste Gruyer and his family, 1848; that of Eugène Delacroix, identical to Cousin's tomb in size, detailing, and execution in black Volvic stone; and that of Saint-Hilaire, who apparently ordered that Cousin's tomb be duplicated for himself. All tombs are in Père Lachaise Cemetery. It would be ironic if Baltard authored Delacroix's tomb, since the painter was famously contemptuous of the architect: see Pinon, *Baltard,* 134. On the sarcophagus, see Nash, *Pictorial Dictionary,* 2:352–55. The second group includes the tombs of the Gonin family, Florence, n.d., and of Léon Rostan, Montmartre Cemetery, Paris, 1866, documented by sketches in the collection of the Baltard family; the monument to Hippolyte Flandrin, with a bust by Eugène-André Oudiné, in Saint-Germain-des-Près, Paris, 1866; a plaster maquette of the 1848 competition project for the tomb of Monsignor Affre (the archbishop of Paris who became a martyr for both the Right and the Left after he was killed trying to pacify combatants in the Place de la Bastille on 25 June 1848), with sculpture by Jean-Auguste Barre, Musée Carnavalet, Paris; Baltard lost the competition to Auguste de Bay. The third group includes the tombs of the Plon family, n.d., Paris; Salvador Barbier, bust by Normand, Père Lachaise Cemetery, Paris, 1843; the Louis-Pierre Baltard family, Montparnasse Cemetery, Paris, 1846; the Lequeux family, Paris, 1855; Hippolyte Flandrin, bust by Eugène-André Oudiné, Père Lachaise Cemetery, 1865; J.-A.-D. Ingres, bust by Jean-Marie Bonnassieux, Père Lachaise Cemetery, 1867; Louis-James-Alfred Lefébure-Wéli, bust by Jean-Marie-Hyacinthe Chevalier, Père Lachaise Cemetery, 1873; the Paul Huillier family, Bagneux, 1873. Drawings in AN, 332 AP 5, and the collection of the Baltard family document the Plon,

Barbier, Baltard, Lequeux, Flandrin, and Ingres tombs; correspondence in AN, 332 AP 5, documents the Ingres tomb and another for Mademoiselle Sauvan, Père Lachaise Cemetery, 1868. Garnier, *Baltard,* 15, notes additional tombs: Xavier Sigalon, Rome, 1837; Boulanger, Paris, n.d.; Thomas, Paris, n.d.; Artaud, Paris, n.d.; Bernheim, Paris, n.d.; Forster, Paris, n.d.

26. Etlin, *Architecture of Death.*

27. Quatremère de Quincy, "Cimitière," "Sépulcre," and "Tombeau," in *Encyclopédie méthodique,* 1:678, 3:367 and 500. See Bergdoll, *Léon Vaudoyer,* 68–69.

28. Quatremère de Quincy, "Cimitière."

29. Quatremère de Quincy, "Tombeau."

30. Victor Baltard sketched such an altar in Pompeii: *Pompeïa, autel pour les sacrifices dans le temple d'Esculape,* n.d., drawing in the collection of the Baltard family. On Cousin, see Charlton, "Victor Cousin; Mead, *Garnier's Paris Opéra,* 204–7.

31. The same is true of the medievalizing Flandrin memorial in Saint-Germain-des-Près.

32. Bergdoll, *Léon Vaudoyer,* 90.

33. See Lazare and Lazare, *Dictionnaire administratif;* Alphand, *Recueil des lettres patentes;* Hillairet, *Dictionnaire historique.*

34. Documented by letters from Prefect Rambuteau to Victor Baltard, 27 April 1843; from Prefect Trouvé Chauvel to Baltard, 9 September 1848; from Baltard to Chauvel, 12 September 1848; and from Prefect Berger to Baltard, 27 January 1849; along with minutes of the Commission municipale, 5 January 1849, AN, 332 AP 4; five drawings recording two variants of the project, AN, 332 AP 26; Conseil général des bâtiments civils, "Procès verbal de la séance du 23 avril 1846," AN, F 21 2542/10 (1846).

35. This project is a precedent for Baltard's octagonal Temple Protestant of Nérac, designed in a competition in 1852; see Pinon, *Baltard,* 156–59.

36. Pinon, *Baltard,* 127, claims the Corps de Garde was never built, because Baltard petitioned for an indemnity in 1849, but the correspondence cited in

note 34 above documents the building's completion in 1848, and the Commission municipale minutes for 5 January 1849 distinguish between the executed project, for which Baltard was paid, and the alternative project, for which he was requesting the indemnity. The final, modest construction cost suggests, however, that the project was not realized as originally designed.

37. Lespès and Bertrand, *Paris,* 94.

38. Bergdoll, *Léon Vaudoyer,* 168–71.

39. Documented by administrative correspondence; government committee reports; reports by the Bâtiments civils; project reports, budgets, and plans; and monthly construction reports in AN, F 21 1674. Additional correspondence and project sketches are in AN, 332 AP 4 and 26. See also Conseil général des bâtiments civils, minutes of meetings on 3 February 1845, 9 September 1847, 14 March 1850, 13 January and 17 February 1851, AN, F 21 2542/9 (1845), 2542/11 (1847), 2542/14 (1850), and 2542/15 (1851); "Timbre Impérial," *Moniteur des architectes* 24 (1854), cols. 178–79; Daly, "Nouvelles et faits divers," *RGA* 7 (1847–48): cols. 3–4, and "Faits d'architecture parisienne," *RGA* 10 (1852): cols. 179–80.

40. Ministerial edict, 7 June 1841. See Lazare and Lazare, *Dictionnaire administratif,* on the their location at the Rue de la Paix.

41. Ministerial edict, 27 March 1844; committee report, 4 April 1844.

42. Paul Lelong, "Programme des constructions à élever sur les terrains appartenant à l'État dans le Domaine des Petis Pères et destinées à remplacer celles actuellement existant rue de la Paix et affectées au Timbre," n.d. (received 2 November 1844), AN, F 21 1674.

43. Achille Leclère, "Rapport fait au Conseil: Séance du 25 novembre 1844; Timbre Royal," and Conseil général des bâtiments civils, "Extrait du registre des délibérations: Séance du 28 novembre, 1844," AN, F 21 1674.

44. Paul Lelong, "Hôtel du Timbre Royal: Description du projet," 13 January 1845, AN, F 21 1674; façade elevation, longitudinal section, and plans, AN, 332 AP 26.

45. Achille Leclère, "Rapport fait au Conseil: Séance du 3 février 1845;

Timbre Royal," and "Rapport fait au Conseil: Séance du 6 février 1845; Construction des Bâtiments de la direction de l'Enregistrement et du Timbre," AN, F 21 1674.

46. Lazare and Lazare, *Dictionnaire administratif;* Alphand, *Recueil des lettres patentes;* Hillairet, *Dictionnaire historique.*

47. Paul Lelong, "Rapport mensuel sur la situation des travaux de l'Hôtel du Timbre," 4 September 1846, AN, F 21 1674.

48. Lemonnier de la Croix, "Rapport . . . sur la situation des travaux de l'Hôtel du Timbre," 3 October and 3 November 1846, AN, F 21 1674.

49. Sylvain Dumon to Victor Baltard, 14 November 1846, AN, 332 AP 4; Baltard defeated nine rivals: see Pinon, *Baltard,* 127.

50. François Guizot to Sylvain Dumon, 28 October 1846, AN, F 21 1674. Documentation on Baltard's post as inspector for the École normale is in AN, 332 AP 4.

51. Victor Baltard to Sylvain Dumon, 5 November 1846, and "Rapport sur l'augmentation de dépense occasionné par le mauvais état du sol en fondation," 7 January 1847, AN, 332 AP 4.

52. Project dated 30 December 1846 on five sheets; the site plan and elevation/section survive with a covering letter, Baltard to Dumon, 5 January 1847, AN, F 21 1674.

53. Charles Rohault de Fleury, "Direction générale de l'Enregistrement et des Domaines: Hôtel du Timbre," 27 February 1847, AN, F 21 1674.

54. Letter from Baltard to Dumon, 26 April 1847, with an accompanying "devis estimatif des ouvrages de diverses natures à exécuter pour suppléer l'insuffisance de surface," and three sets of schematic plans, indicating (1) the "projet de M. Paul Lelong," (2) the "premières modifications proposées par M. Baltard," and (3) the "nouvelles dispositions proposées par M. Baltard," AN, F 21 1674.

55. Letter from Victor Baltard to Hippolyte-Paul Jäyr, 6 February 1849, AN, F 21 1674.

56. Letter from Baltard to Jäyr, 28 June 1849, forwarded to the Ministère

de l'Intérieur, where the request to hire Oudiné and Jacquemart was approved in a letter from Charles Blanc to Baltard, 7 September 1849, AN F 21 1674.

57. Daly, "La Mairie du IIe arrondissement de Paris," *RGA* 11 (1853): col. 445.

58. Bergdoll, *Léon Vaudoyer,* 160–64.

59. The churches of Paris are catalogued in Préfecture de la Seine, *Inventaire général;* Brunel, *Dictionnaire des églises.* Surviving municipal records are preserved in AS, VM 32 Églises; an anonymous, untitled, and undated manuscript records Baltard's activities as the *inspecteur des beaux-arts,* AN, 332 AP 2. Baltard's biographers date his appointment as *inspecteur des beaux-arts* to 1842, but it is correctly recorded from 1840 until 1870 by the *Almanach* (1840–70) and Conseil municipal, *Rapport . . . sur la réorganisation du Service des Beaux-Arts,* 55–56, in AN, 332 AP 4. See Foucart, *Renouveau;* Van Zanten, *Building Paris,* 256–79; Pinon, *Baltard,* 133–53.

60. Notre-Dame-des-Blancs-Manteaux (IVe Arrondissement; 1858–63: modification); Notre-Dame-de-Lorette (IXe Arrondissement; 1854–58: maintenance); Notre-Dame-des-Victoires (IIe Arrondissement; 1855–58: modification); Saint-Denis-du-Saint-Sacrement (IIIe Arrondissement; 1856–57: maintenance); Sainte-Elisabeth (IIIe Arrondissement; 1841–63: decoration and modification); Saint-Étienne-du-Mont (Ve Arrondissement; 1856–64: modification, restoration, and decoration); Saint-Eustache (Ier Arrondissement; 1842–59: restoration and decoration); Saint-Germain-l'Auxerrois (Ier Arrondissement; 1840–58: restoration and decoration); Saint-Germain-des-Prés (VIe Arrondissement; 1842–65: restoration and decoration); Saint-Gervais-Saint-Protais (IVe Arrondissement; 1843–59: restoration, maintenance, and decoration); Saint-Jacques-du-Haut-Pas (Ve Arrondissement; 1850–55: modification and decoration); Saint-Jean-Saint-François (now Sainte-Croix-Saint-Jean, IIIe Arrondissement; 1853–60: modification and maintenance); Saint-Leu-Saint-Gilles (Ier Arrondissement;

1847–63: restoration, modification, and decoration); Saint-Louis-d'Antin (IXe Arrondissement; 1841–58: decoration and maintenance); Saint-Louis-en-l'Ile (IVe Arrondissement; 1841–43: decoration); Sainte-Marguerite (XIe Arrondissement; 1853–58: maintenance and restoration); Saint-Merry (IVe Arrondissement; 1840–45: decoration); Saint-Nicolas-des-Champs (IIIe Arrondissement; 1843–59: decoration and maintenance); Saint-Nicolas-du-Chardonnet (Ve Arrondissement; 1854–63: maintenance, restoration, decoration, and modification); Saint-Paul-Saint-Louis (IVe Arrondissement; 1852–60: restoration, decoration, and maintenance); Saint-Phillipe-du-Roule (VIIIe Arrondissement; 1852–59: modification, decoration, and maintenance); Saint-Roch (Ier Arrondissement; 1846–64: decoration); Saint-Sèverin (Ve Arrondissement; 1839–59: decoration and restoration); Saint-Sulpice (VIe Arrondissement; 1845–70: decoration); Saint-Thomas-d'Aquin (VIIe Arrondissement; 1841–51: decoration); Temple Protestant de Pentemont (VIIe Arrondissement; 1843–56: modification); Temple Protestant de l'Oratoire (Ier Arrondissement; 1854–55: modification).

61. See Pierre Pinon, "L'éventrement de vieux Paris," in Cars and Pinon, *Paris-Haussmann,* 126–34; Choay, *Invention,* 117ff.; Boyer, *City of Collective Memory;* O'Connell, "Afterlives of the Tour Saint-Jacques."

62. Boudon, *Paris, capitale religieuse,* 14–16 and passim. See also Cilleuls, *Histoire de l'administration,* vols. 1 and 2; Brunel, *Dictionnaire des églises,* 59–78. On the religious history of nineteenth-century France, see Dansette, *Religious History.*

63. Boudon, *Paris, capitale religieuse,* 195.

64. Ibid., 195–242.

65. Ibid., 306–12.

66. Cilleuls, *Histoire de l'administration;* Conseil municipal, *Rapport,* 49–61; Brunel, *Dictionnaire des églises.*

67. Conseil municipal, *Rapport,* 53.

68. In 1853, this office was reassigned to the Cabinet du préfet; in 1867, it moved to the Service d'architecture.

69. Leniaud, *Lassus,* 69–76; Leniaud, "La restauration des cathédrales," in Laroche, *Abadie,* 84–91; Van Zanten, *Building Paris,* 63–65.

70. Alain Erlande-Brandenburg, "Paris: La restauration de Notre Dame," in Foucart, *Viollet-le-Duc,* 61–64.

71. On Saint-Sulpice, see Pinon, *Baltard,* 155.

72. Gourlier and Questel, *Bâtiments civils;* Léon, *Vie des monuments;* Jean-Michel Leniaud, "Félix Duban, architecte de la Sainte-Chapelle," in Bellenger and Hamon, *Duban,* 71–77.

73. Léon, *Vie des monuments;* Bercé, *Premiers travaux;* Leniaud, *Lassus;* Françoise Bercé, "Les restaurations: Monuments historiques et 'églises de villages,'" in Laroche, *Abadie,* 72–74; Van Zanten, *Building Paris,* 61–63.

74. Leniaud, *Lassus,* 57–59.

75. Préfecture de la Seine, *Inventaire général,* vol. 1; Brunel, *Dictionnaire des églises;* AS, V17M 32; Conseil général des bâtiments civils, "Procès verbal de la séance du 27 mars 1856: Paris," and "Procès verbal de la séance du 10 avril 1856," AN, F 21 2542 20 (1856).

76. Sédille, "Baltard," 492. On Pierre Baltard at the Panthéon, see Bergdoll, *Panthéon,* 192–200.

77. Foucart, *Renouveau,* 80–82.

78. Documents in AN, 332 AP 2, include an anonymous and undated manuscript listing Baltard's programs of mural paintings for the churches of Paris.

79. Foucart, *Renouveau,* 53–62.

80. Georges Brunel, "La chapelle Saint-Jean à Saint-Sèverin (1839–41)," in Foucart and Foucart, *Flandrin,* 83–89. On Gatteaux's role in securing Baltard's appointment, see Timbal, "Baltard"; Deconchy, "Baltard," 241; Sédille, "Baltard," 487.

81. Fanier, "Peintures murales de Saint-Germain-des-Prés"; Gautier, "Peintures murales de M. Hippolyte Flandrin"; Bruno Horaist, "Saint-Germain-des-Prés," in Foucart and Foucart, *Flandrin,* 125–53.

82. Timbal, "Baltard"; Sédille, "Baltard," 487–88.

83. Foucart, *Renouveau,* 195–233.

84. Mead, *Garnier's Paris Opéra,* 175–93.

85. See Blanc, *Grammaire,* 622–26.

86. Victor Baltard, "Théorie de l'architecture," 4ième cours, 11ième leçon.

87. Victor Baltard, watercolor studies for Saint-Louis-en-l'Ile, 20 February 1841; Saint-Sèverin, 2 May 184[1]; and Saint-Louis d'Antin, 4 May [1841]—all in AN, 332 AP 26.

88. See Foucart, *Renouveau,* 15–51.

89. Germann, *Gothic Revival,* 135–50; Leniaud, *Lassus,* 38–41.

90. See Dansette, *Religious History,* vol. 1; Girard, *Nouvelle histoire,* 271–79; Boudon, *Paris, capitale religieuse,* passim.

91. Gautier, "Hippolyte Flandrin"; Beulé, *Éloge de M. Flandrin;* Bruno Foucart, "Saint Hippolyte Flandrin," in Foucart and Foucart, *Flandrin,* 35–36; Foucart, *Renouveau,* 49–50, 205–11.

92. Foucart, *Renouveau,* 1–8, 15–18.

93. Charlton, "Victor Cousin"; Mead, *Garnier's Paris Opéra,* 204–7.

94. The phrase "prudently eclectic" is from Foucart, *Renouveau,* 15.

95. Hittorff and Zanth, *Restitution du temple.* See Van Zanten, *Architectural Polychromy,* 29–52 and passim.

96. Jollivet, "De la peinture murale," and Merimée, "De la peinture murale et son emploi dans l'architecture moderne," *RGA* 8 (1849) and 9 (1851).

97. Ludovic Vitet, "Les monuments historiques du nord-ouest de la France: Extrait d'un rapport adressé au ministre de l'intérieur, en 1831," cited in Foucart, *Renouveau,* 54–55.

98. Gautier, "Revue des arts."

99. See Driskel, "The 'Gothic'"; Van Zanten, *Building Paris,* 261–62.

100. Schmit, *Nouveau manuel.*

101. Bills submitted in the 1850s by masons, painters, plasterers, and other contractors who readied the nave of Saint-Germain-des-Prés for Flandrin's murals document this preparatory work, AS, V19M 32.

102. Préfecture de la Seine, *Inventaire général,* vol. 1; Brunel, *Dictionnaire des églises;* AS, V13M 32; *Almanach* (1852–54); Daly, "Nouvelles et faits divers," *RGA* 9 (1851): col. 43, and 10 (1852): cols. 123, 179–80, and "Panorama du mouvement architectural du monde," *RGA* 20 (1862): 236; Gaudreau, *Notice descriptive et historique.*

103. Commission des monuments historiques, meetings of 13 May 1842,

6 January 1843, and 24 February 1843, in Bercé, *Premiers travaux,* 209, 230, 241; see Pinon, *Baltard,* 139.

104. Drawing in AN, 332 AP 26.

105. Claudius Lavergne, *Restauration de l'église Saint-Eustache: Mobilier, décoration, peinture murales* (Paris, 1856), as quoted in Pinon, *Baltard,* 138.

106. According to the manuscript cited in note 78 above, the commission went to Séchan, a painter of stage sets, against Baltard's wishes, on orders from Prefect Berger.

107. Victor Baltard, "Projet d'achèvement de la façade de l'église Saint-Eustache," AN, 332 AP 2; Daly, "Panorama du mouvement architectural du monde," *RGA* 20 (1862): col. 236.

108. See Jörn Garleff, "L'École des Beaux-Arts de Duban: La sublimation de l'antiquité à l'aube de l'historicisme," in Bellenger and Hamon, *Duban,* 47–61; Van Zanten, "Félix Duban."

109. Vaudoyer and Lenoir, "Études d'architecture," *Magasin pittoresque* 10–13 (1842–45); quotation from 11 (1843): 51.

110. Ibid., 12 (1844): 259; Bergdoll, *Léon Vaudoyer,* 168–71. On Vaudoyer's "historical philosophy of design," see Bergdoll, *Léon Vaudoyer,* 156 and 141–84 passim; also Van Zanten, *Designing Paris,* 98–111.

111. Préfecture de la Seine, *Inventaire général,* vol. 2; Brunel, *Dictionnaire des églises;* AS, V11M 32; *Almanach* (1856–58); Daly, "Panorama du mouvement architectural du monde," *RGA* 20 (1862): cols. 231–40.

112. Conseil général des bâtiments civils, "Procès verbal de la séance du 20 sept. 1859" AN, F 21 1843.

113. Choay, *Invention,* 12–13. See Riegel, "The Modern Cult of Monuments"; Lavin, *Quatremère de Quincy;* Murphy, *Memory and Modernity.*

114. Choay, *Invention,* 83.

115. See Barry Bergdoll, "A Matter of Time: Architects and Photographers in Second Empire France," in Daniel, *Baldus,* 99–119.

116. See Rice, *Parisian Views;* Jeanne Przyblyski, "Images de la modernité avant Haussmann," in Bowie, *Modernité avant Haussmann,* 56–81.

117. Choay, *Invention,* 87–108.

118. Baltard, "Théorie de l'architecture," 5e cours, discours d'ouverture.

119. Baltard, *Augustin Caristie,* 11.

120. Viollet-le-Duc, "Restauration," *Dictionnaire raisonné,* vol. 8. See Françoise Bercé, "Viollet-le-Duc et la restauration des édifices," in Foucart, *Viollet-le-Duc,* 50–58; Van Zanten, *Building Paris,* 257–60; Murphy, *Memory and Modernity.*

121. Although Baltard's aesthetic purpose should not be confused with Schmit's ideological agenda, Schmit had similarly argued in *Églises gothiques* that churches were to be appreciated as functioning religious institutions, not abstracted as documents of construction. See Van Zanten, *Building Paris,* 261.

122. Léon, *Vie des monuments,* 371–87; Murphy, *Memory and Modernity.*

123. Conseil général des bâtiments civils, "Procès verbal de la séance du 12 juin 1854/15 juin 1854," AN, F 21 2542 18 (1854); Lazare and Lazare, *Dictionnaire administratif;* Hillairet, *Dictionnaire historique;* Szambien, *Rue des Colonnes.*

124. Préfecture de la Seine, *Inventaire générale,* vol. 1; Brunel, *Dictionnaire des églises.*

125. Lazare and Lazare, *Dictionnaire administratif;* Alphand, *Recueil des lettres patentes;* Hillairet, *Dictionnaire historique.*

126. Cited by Pinon, *Baltard,* 148.

127. Préfecture de la Seine, *Inventaire général,* vol. 1; Brunel, *Dictionnaire des églises; Almanach* (1858–62); Daly, "Panorama du mouvement architectural du monde," *RGA* 20 (1862): col. 236. Starting in 1859, the church and its additions were decorated with murals, sculptures, and stained-glass windows. Budgeted at 826,000 francs, the alterations, additions, and decoration of Saint-Leu-Saint-Gilles are documented in AS, V33M 32.

128. Van Zanten, *Building Paris,* 271; Haussmann, *Mémoires,* 2:233.

129. Conseil général des bâtiments civils, "Procès verbal de la séance du 30 sept. 1857," AN, F 21 1843.

130. Ibid.

Chapter 5

1. See Baltard and Callet, *Halles centrales;* Camp, "Les Halles centrales,"

in *Paris,* 2:141–210; Merruau, *Souvenirs de l'Hôtel de Ville;* Pontich, *Administration de la ville;* Préfecture de la Seine, *Notes sur les abattoirs;* Cilleuls, *Histoire de l'administration;* Vigneau, *Halles centrales;* Rambuteau, *Mémoires;* Hugueney, "Halles centrales"; Léri, "Aspect administratif"; Boudon et al., *Système de l'architecture urbaine;* BHVP, *Baltard;* Lemoine, *Les Halles;* Moncan, *Baltard,* reprints Baltard and Callet, *Halles centrales,* and Camp, "Les Halles centrales." On Paris, see Lavedan, *Nouvelle histoire;* Sutcliffe, *Autumn of Central Paris;* Agulhon, *La ville de l'âge industriel;* Olsen, *City as a Work of Art;* Van Zanten, *Building Paris;* Bowie, *Modernité avant Haussmann;* Papayanis, *Planning Paris.*

2. Choay, *Modern City,* 7.

3. Lavedan, *Question du déplacement;* Sutcliffe, *Autumn of Central Paris,* 15–22; Lavedan, *Nouvelle histoire,* 398–411; Pierre Pinon, "Les conceptions urbaines au milieu du XIXe siècle," in Cars and Pinon, *Paris-Haussmann,* 44–50; Nicholas Papayanis, "L'émergence de l'urbanisme moderne à Paris," in Bowie, *Modernité avant Haussmann,* 82–94; Frédéric Monet, "Penser la ville en fouriériste: Les projets pour Paris de Perreymond," in ibid., 95–109; and Isabelle Backouche, "Projets urbains et mémoire du fleuve (1840–1853)," in ibid., 110–22; Papayanis, *Planning Paris,* passim.

4. Haussmann, *Mémoires,* 1:29. See Merruau, *Souvenirs de l'Hôtel de Ville,* 363–74; Morizet, *Du vieux Paris au Paris moderne,* 129–32; Lavedan, *Nouvelle histoire,* 318–23 and 413ff.; Pierre Pinon, "Le projet d'embellissement de Paris," in Cars and Pinon, *Paris-Haussmann,* 51–56; Van Zanten, *Building Paris,* 199–202.

5. Lenoir and Landry, "Théorie des villes"; Daly, "Travaux de Paris," *RGA* 20 (1862): col. 179.

6. Marcel Royancolo, "La production de la ville," in Agulhon, *La ville de l'âge industriel,* 77–117, and Françoise Choay, "Pensées sur la ville, arts de la ville," in ibid., 159–237.

7. On Jean-Christophe-Armand Husson (1809–1874), see Cilleuls, *Histoire de l'administration,* 2:170ff.

8. Husson, *Consommations,* 12, 42–43, 116, 124–25. See Claudin, *Paris,* for a comparable argument.

9. Husson, *Consommations,* 519.

10. Ibid., 118 and passim.

11. Loyer, *Paris.* As David Van Zanten noted to me, Loyer's study was preceded by that of Maurice Halbwachs, *La population et les tracés des voies à Paris depuis un siècle* (Paris: Presses Universitaires de France, 1928).

12. Cars and Pinon, *Paris-Haussmann;* Van Zanten, *Building Paris;* Papayanis, *Planning Paris.*

13. François Loyer, "Le regard des historiens sur la transformation de Paris au XIXe siècle," in Bowie, *Modernité avant Haussmann,* 9. On urbanism, see Choay, *Modern City;* Sutcliffe, *Towards the Planned City;* Hall, *Planning Europe's Capital Cities.* On urban history, see Briggs, *Victorian Cities;* Dyos, *Study of Urban History;* Fraser and Sutcliffe, *Pursuit of Urban History.*

14. Barrie Ratcliffe, "Visions et (ré)visions des dynamiques de la croissance urbaine dans le Paris de la première moitié du XIXe siècle," in Bowie, *Modernité avant Haussmann,* 41–55, argues that the population of Paris was stable in its pattern of growth (rather than marked by a dramatic increase over earlier periods), that the base of its manufacturing economy remained in workshops (instead of moving wholesale to large factories), and that there is little evidence for systematic working-class unrest in this period. See Harvey, *Paris,* 153–82, for a different view.

15. Boudon et al., *Système de l'architecture urbaine,* 1:56.

16. Lemoine, *Les Halles,* 6.

17. Van Zanten, *Building Paris,* 226, 230.

18. Van Zanten, "Paris Space," 189.

19. Baltard and Callet, *Halles centrales,* 9–11.

20. On the definition of the central market as a building type in the nineteenth century, see Tangires, *Public Markets and Civic Culture,* 185–89, and Tangires, *Public Markets,* 231–59.

21. See Bailly and Laurent, *La France des halles et marchés;* Tangires, *Public Markets and Civic Culture,* 35–47 passim.

22. Eugène Griffault, "Le Marché des Innocents," in Kock, *Nouveau tableau,* 2:25–38; Lazare and Lazare, *Dictionnaire administratif,* 399–403; Lemoine, *Les Halles,* 9–15.

23. Boudon et al., *Système de l'architecture urbaine;* Deming, *Halle au Blé.*

24. See Lemoine, *Les Halles,* 17–25.

25. See Préfecture de la Seine, *Recueil de règlements;* Pontich, *Administration de la ville,* 557ff.; Préfecture de la Seine, *Notes sur les abattoirs,* 46–51; Cilleuls, *Histoire de l'administration,* 1:22–25, 112–18.

26. Napoléon I, as quoted in Lazare and Lazare, *Dictionnaire administratif,* 401.

27. Alphand, *Recueil des lettres patentes.*

28. Lemoine, *Les Halles,* 51–55; Puylaroque, "Pierre Baltard, peintre, architecte et graveur," 124, 177–81.

29. Merruau, *Souvenirs de l'Hôtel de Ville,* 121–24, 192–98; Cilleuls, *Histoire de l'administration,* 1:22–25; Léri, "Aspect administratif."

30. Lemoine, *Les Halles,* 55.

31. Léri, "Aspect administratif," 175–76.

32. Pontich, *Administration de la ville,* 557ff.

33. Alphand, *Recueil des lettres patentes* and *Suppléments;* Souviron and Pontich, *Recueil annoté;* Lanfant, *Conseil général de la Seine;* Barroux, *Département de la Seine;* Félix, *Régime administratif;* Pronteau, *Notes biographiques.*

34. Rambuteau, *Mémoires,* 278, 291.

35. Merruau, *Souvenirs de l'Hôtel de Ville,* 124; Préfecture de la Seine, *Notes sur les abattoirs,* 51; Cilleuls, *Histoire de l'administration,* 2:14–17; Léri, "Aspect administratif," 186–87.

36. Lahure, *Études sur les Halles* (13 January 1837), as quoted in Lahure, *Nouveau projet d'agrandissement des Halles* (5 July 1842), in Préfecture du département de la Seine, *Documents à étudier* (Paris, 1842–43), document no. 2, in BHVP (no. 102 993).

37. See Lavedan, *Question du déplacement,* 31 n. 28.

38. Rambuteau, *Mémoires,* 373; Alphand, *Recueil des lettres patentes.*

39. Conseil municipal, "Délibération du 1er août 1839," in Daubanton, *Déplacement,* 1. See Lanquetin, *Question du déplacement,* in Lavedan, *Question du déplacement,* 63–64; Lanquetin, *La question du déplacement,* 2–3, in BHVP, *Projets pour la ville de Paris* (in-40 104 306).

40. Lanquetin, *Question du déplacement,* 63.

41. Conseil général, "Délibération du 28 octobre 1839," in Daubanton, *Déplacement,* 1–2.

42. Daubanton, *Déplacement,* 2.

43. The health issues would be addressed by a doctor, Henri Bayard, *Mémoire sur la topographie médicale du IVe arrondissement de Paris: Recherches historiques et statistiques sur les conditions hygiéniques des quartiers qui composent cet arrondissement* (Paris, 1842).

44. Lavedan, *Question du déplacement;* Papayanis, *Planning Paris.*

45. Lanquetin, *Question du déplacement,* 63.

46. Ibid., 65.

47. Ibid., 79.

48. Victor Grisart, "Projet de Halles générales à élever sur les terrains des Bernardins et du Cardinal Lemoine," AN, 332 AP 7.

49. Édouard Gatteaux, "Déplacement de Paris," May 1840, AN, 332 AP 6.

50. Chabrol-Chaméane, *Mémoire sur le déplacement,* BHVP.

51. Perignon, ["Rapport de la Sous-commission sur le déplacement de Paris,"] 1840, AN, 332 AP 6.

52. See Lanquetin, *La question du déplacement,* 6, and Papayanis, *Planning Paris,* 113, on a flurry of newspaper articles by A. Rabusson in the *Journal de Paris* (1839–41).

53. Perreymond, "Études sur la ville."

54. Ibid., *RGA* 3: col. 573.

55. Ibid., col. 574.

56. Ibid., *RGA* 4: cols. 413–29, 449–58.

57. Ibid., cols. 72–79.

58. Meynadier, *Paris sous le point de vue pittoresque,* 5.

59. Ibid., 32.

60. Ibid., 45–49.

61. Rambuteau, as quoted in Daubanton, *Déplacement,* 4.

62. Ibid., 5–6.

63. Claude de Rambuteau, ["Discours de M. le Préfet de la Seine, prononcé à la Chambre de commerce, Dec. 1846"], in Daly, "Faits divers," *RGA* 6 (1845–46): col. 523.

64. Say, *Études sur l'administration,* 25.

65. Marie, *De la décentralisation,* argued that the real displacement in Paris was of poor people being pushed outward to the periphery of the city by wealthy people in its center.

66. [Hourdequin], *Études sur les Halles* (Paris, 1 October 1840), in Préfecture du département de la Seine, *Documents à étudier,* document no. 5, and in Lavedan, *Question du déplacement,* 111–21.

67. In 1842, Hourdequin was convicted and sentenced to four years in prison for accepting a bribe of 15,000 francs from a real-estate company speculating in the property expropriations for the Rue de Rambuteau: Alphonse de Calonne, "Affaire Hourdequin," *RGA* 3 (1842): cols. 374–79.

68. Lanquetin, *Observations,* in Préfecture du département de la Seine, *Documents à étudier,* document no. 6, and in Lavedan, *Question du déplacement,* 123–36.

69. Lanquetin, *La question du déplacement.*

70. Lahure, *Étude de projet d'alignement de la grande Halle* (19 May 1841), as summarized in Lahure, *Nouveau projet d'agrandissement des halles* (5 July 1842).

71. Daniel, *Recherches et considérations relatives à la construction d'une grande Halle dans Paris* (Paris, 6 July 1842), in Préfecture du département de la Seine, *Documents à étudier,* document no. 3.

72. Claude de Rambuteau, "Arrêté portant institution de la Commission des Halles" (14 July 1842), in Préfecture du département de la Seine, *Documents à étudier,* document no. 1.

73. Claude de Rambuteau, "Allocation: Prononcé par M. le Comte de Rambuteau, préfet de la Seine, à l'ouverture de la première séance de la Commission des Halles" [1842], in Préfecture du département de la Seine, *Documents à étudier,* document no. 1.

74. Lavedan, *Question du déplacement,* 9–10.

75. Commission administrative des Halles, "Procès verbal du séance du 20 avril 1843," as quoted in Sous-commission administrative des Halles, *Rapport sur le système à adopter pour l'exécution du projet de construction des Halles centrales* (Paris, 7 May 1850), 59–52, in BHVP, *Rapport sur les Halles centrales* (in-40 102 991).

76. Daly, "Exposition annuelle d'architecture au Louvre," *RGA* 4 (1843): cols. 126, 162; "Grande halles érigées à Paris sur l'emplacement adopté par le Conseil municipal," *Journal des beaux-arts et de la littérature* (1843), 201–5, BHVP (no. 113 265). See Lemoine, *Les Halles,* chap. 7, n. 13, on whether this project was by Pierre Magne (1788–1871) or his son Auguste-Joseph Magne (1816–1886).

77. AN, 332 AP 7.

78. Daly, "Nouvelles et faits divers," *RGA* 1 (1840): col. 250; Lemoine, *L'architecture du fer,* 160.

79. Victor Baltard, "Halles centrales de Paris et marchés accessoires: Projet pour l'agrandissement des Halles et l'amélioration des marchés; Première partie" and "Projet d'ensemble pour l'agrandissement des Halles centrales et l'amélioration des marchés qui s'y rattachent," in the Fonds Baltard, BHVP, documents no. 2 and no. 1. Also documented in BHVP, *Baltard.*

80. See Lemoine, *Les Halles,* 74–76.

81. AN, 332 AP 7.

82. Gabriel Delessert, "Lettre de M. le Conseiller d'État, préfet de police, à M. le Préfet de la Seine, ayant pour objet la fixation des Halles centrales d'approvisionnement" (30 November 1843), in Préfecture du département de la Seine, *Documents à étudier,* document no. 7.

83. Lemoine, *Les Halles,* 73–74, attributes the collaboration between Delessert and Baltard to their shared Protestantism and to the fact that both attended the Collège Henri IV; given their difference in age, however, Delessert may simply have turned for technical assistance to the same young architect who was already working for him. On Delessert, see Tulard, *Préfecture de police,* 40–49. Baltard's papers include a related variant of the Delessert plan, delineated over a lot survey of the quarter, and a copy of the plan marked with annotations in the architect's hand: lot survey in the Fonds Baltard, BHVP, document no. 4; BHVP, *Baltard,* 37; copy of the Delessert plan in the private collection of the Baltard family. Victor Baltard, "Halles centrales d'approvisionnement: Avant-projet" [17 July 1844], in Commission municipale des Halles, *Agrandissement et construction des Halles,* called the Boutron Report, BHVP (no. 102 990), which documents the approval of this project in 1844–45.

84. Boutron Report, 8–9.

85. Ibid., 23.

86. Ibid., 25.

87. Ibid., 10.

88. Ibid. 97–102.

89. Claude de Rambuteau, Arrêté, 20 May 1845, in Préfecture de la Seine, *Recueil des actes administratifs.*

90. Hector Horeau, *Halles centrales de Paris* (Paris: author, [June 1845]), in BHVP, *Rapports sur les Halles centrales* (in-40 102 791). Horeau later misdated to August 1845 this brochure and the public inquest to which it responded. See letters from Horeau addressing his projects to various government officials, in AN, F 21 1463; Françoise Boudon, "Hector Horeau et les Halles centrales," in Boudon, Loyer, and Dufournet, *Horeau,* 152–59; Lemoine, *Les Halles,* passim.

91. Boudon, "Horeau," 153–54.

92. See Paul Dufournet, "Les étapes de l'existence," in Boudon, Loyer, and Dufournet, *Horeau,* 142–43. Pinon, *Baltard,* 171, claims the two were friends, though this is contradicted by documents discussed below.

93. Horeau, *Halles centrales,* with notations by Victor Baltard in italics, AN, 332 AP 7.

94. Victor Baltard, "Rapport à Monsieur le Préfet de la Seine sur le projet des halles proposé par M. Horeau en juin 1845," June 1845, AN, 332 AP 7.

95. Claude de Rambuteau, Arrêté, 4 August 1845, AN, 332 AP 7. Baltard, in Daly, "Chronique," *RGA* 27 (1869): col. 205, remembered that he only learned of this appointment several months later, suggesting improbably that Rambuteau's edict was kept from him, though the edict was found in his papers and he was already a municipal employee.

96. ENSBA, *Pompéi,* 115–27, 286.

97. Bowie, *Grandes gares,* 70–79.

98. Hillairet, *Dictionnaire historique,* 1:234; Loyer, *Paris,* 88.

99. Lemoine, *Les Halles,* 82.

100. Pinon, *Baltard,* 171, makes the same suggestion.

101. Correspondence and drafts of Baltard's memorandum of agreement with Callet's heirs about architectural fees, 18 August 1854, AN, 332 AP 7.

102. Daly, "Halles centrales," *RGA* 12 (1854): col. 25.

103. See a letter from Victor Baltard to Félix Callet, June 1848, AN, 332 AP 6.

104. Claude de Rambuteau, Arrêté, 18 August 1845, and letter to Victor Baltard, 18 August 1845, AN, 332 AP 6.

105. Baltard, Anger, and Husson, *Rapport sur les marchés,* 2, 32. See Schmiechen and Carls, *British Market Hall.*

106. Baltard, Anger, and Husson, *Rapport sur les marchés,* 37–38.

107. Conseil général des bâtiments civils, "Procès verbal de la séance du 9 février 1846/23 mars 1846," AN, F 21 2542/10 (1846).

108. Hector Horeau to Victor Baltard, 12 August 1846, AN, 332 AP 7.

109. Rambuteau, ["Discours . . . prononcé à la Chambre de commerce, Dec. 1846,"] col. 524.

110. Ordinance in Alphand, *Recueil des lettres patentes;* Rambuteau, *Mémoires,* 292–93. See Merruau, *Souvenirs de l'Hôtel de Ville,* 109–10.

111. Merruau, *Souvenirs de l'Hôtel de Ville,* 106–8, 132.

112. Claude de Rambuteau, "Programme des travaux à exécuter pour la construction des Halles centrales d'approvisionnement" (21 October 1847), in Préfecture du département de la Seine, *Documents à étudier,* document no. 8.

113. Ibid., 4–5. Horeau was silent in 1847, but the official program was attacked that year by a medical doctor named Tessereau, *Études hygiéniques,* in BHVP, *Halles centrales* (in-Fo. 10375). Responding to another cholera outbreak, Tessereau complained that broad sidewalks and rows of trees would do little to ameliorate the Halles (6–7): "the wholesale vending of vegetables will continue to be transacted in the street, and . . . the reduction of rubbish into a sort of infectious detritus, as a result of being crushed by the wheels of vehicles and either human feet or horses' hooves, will continue." He went on to to claim (11) that the resulting "miasmas . . . will spread through the air of the markets, making this air very unhealthy; then, pushed by breezes, these miasmas will carry their pernicious effects to a large part of the city." The doctor's concern for fresh air reflected the common wisdom that diseases like cholera bred in the narrow, dank, and dark streets of crowded districts like the fourth, from whence the infection spread like a cloud to wealthier and healthier parts of the city. Echoing Lanquetin, Tessereau advocated removing the markets from the center of Paris to a more peripheral location. See the earlier medical study by Henri Bayard cited in note 43 above.

114. "Plan d'ensemble du 48e N.9," AN, 332 AP 7, from Jacoubet, *Atlas général.*

115. Baltard and Callet, *Halles centrales,* 14.

116. Claude de Rambuteau to Victor Baltard and Félix Callet, 1 December 1847, AN, 332 AP 6. A second letter, from Chantelot, *chef de 2e bureau de la 4e division,* to Baltard and Callet, 1 March 1848, AN, 332 AP 6, denied their request to enlarge the perimeter of the Halles.

117. Victor Baltard and Félix Callet, "Halles centrales," 10 August 1848, with subsequent revisions, AS, Cartes et Plans 550. Victor Baltard and Félix Callet, draft of an untitled report to the préfet de la Seine, [15] June 1848; Victor Baltard, "Halles centrales de Paris: État comparatif de la dépense prévue par le devis définitif, établi à manière à ne pouvoir être excédé en aucun cas; et les aperçus accompagnant l'avant projet," AN, 332 AP 6.

118. Baltard and Callet, report of June 1848.

119. Lemoine, *Les Halles,* 92.

120. Baltard and Callet, report of June 1848.

121. Ibid.

122. Papayanis, *Planning Paris,* 203–13.

123. Merruau, *Souvenirs de l'Hôtel de Ville,* 165.

124. Ibid., 75–78; Alphand, *Recueil des lettres patentes.*

125. Alphand, *Recueil des lettres patentes.*

126. Adjudications recorded in *Recueil des actes administratifs* (1848–49); G. Pozier, géomètre de la ville de Paris, "Plan parcellaire des Halles centrales de Paris: Expropriation, 2e partie," June 1848, AN, 332 AP 6.

127. Draft of letter from Victor Baltard to Jean-Jacques Berger, 23 January 1849, AN, 332 AP 6.

128. Victor Baltard, "Halles centrales: Nouvelles études et explications d'après les observations de Monsieur le Préfet de Policea," 23 March 1849, AN, 332 AP 6, which responds to Rebillot's report of 19 February.

129. Victor Baltard, "Halles centrales: Proposition de rectification de l'alignement," 23 March 1849, AN, 332 AP 6.

130. Magne and Thibault, "Projets de modifications."

131. Horeau, with Callou and Lacasse, *Note sur un projet de Halles centrales;* Horeau, *Nouvelles Halles centrales.*

132. Hector Horeau, with Callou and Lacasse, to Lacrosse, *ministre des travaux-publics,* 2 October 1849, AN, F 21 1463.

133. Horeau, with Callou and Lacasse, *Note sur un projet de Halles centrales.*

134. Victor Baltard, "Halles centrales: Note supplémentaire," June 1849, AN, 332 AP 6.

135. Victor Baltard and Félix Callet, "Halles centrales: Demande d'autorisation pour l'exécution d'un modèle en relief des nouvelles constructions," 18 January 1850, AN, 332 AP 6, returned to Baltard with the notation "M. le Préfet n'autorisa pas."

136. "Les Halles de Paris," *Journal des travaux publics,* 19 August 1849; Louis Lazare, "Les Halles centrales," *La revue municipale,* 1 November 1849; [César Daly], "Galeries d'exposition des produits de l'industrie," *RGA* 7 (1849): cols. 91–94; "Des Halles centrales," *La ville de Paris,* 16 June 1850; Arnoux, "Halles centrales à élever à Paris."

137. Senard, *Halles centrales de Paris,* 3–4.

138. Ibid., 30–31, 41.

139. Ibid., 47–62.

140. Letter cited in Préfecture de la Seine, *Commission municipale de Paris: Séance du 11 juin 1851; Délibération; Les Halles centrales* (11 June 1851), in BHVP, *Rapports sur les Halles.*

141. Commission municipale (Comité spéciale des Halles), *Rapport sur l'emplacement des Halles centrales,* called the Tronchon Report, in BHVP, *Rapports sur les Halles.*

142. Jean-Jacques Berger, *Rapport sur l'emplacement des Halles centrales* (June 1850), in Commission municipale, *Rapport sur l'emplacement des Halles centrales,* 6.

143. Pierre Carlier, *Rapport adressé à la Commission municipale de Paris par M. le Préfet de Police, relativement aux besoins actuels des Halles sous le rapport de l'emplacement et de la circulation* (15 March 1851), 25–30, in BHVP, *Baltard* (in-Fo 10375).

144. Merruau, *Souvenirs de l'Hôtel de Ville,* 384.

145. "Discours de M. le Président de la République," in BHVP, *Baltard,* 15.

146. Commission municipale, *Rapport sur l'emplacement des Halles centrales,* 22.

147. Published in Fayet, *Véritables embellissements,* in AS, V1 M21.

148. Marie, *De la décentralisation.*

149. A. Chevalier, *Question des Halles.*

150. AN, 332 AP 7.

151. Grenet to Baltard, 19 April 1850. Draft of letter from Victor Baltard, [April 1850], AN, 332 AP 7. [Blondel et al.], *Halles centrales* (April 1850).

152. Sous-commission administrative des Halles, *Rapport sur le système à adopter pour l'exécution du projet de construction des Halles centrales* (7 May 1850), 49–60, in Commission municipale, *Rapport sur l'emplacement des Halles centrales,* 54.

153. Ibid., 56.

154. A. Lenoir, "Projet pour la construction des Halles centrales de Paris," 20 June 1850, AN, 332 AP 7.

155. *Journal des débats,* 23 June 1850. [Blondel et al.], *Halles centrales* (July 1850).

156. Langlois, *Consultation pour les propriétaires.*

157. Senard, *Halles centrales* (December 1850). [Blondel et al.], *Halles centrales* (January 1851).

158. Carlier, *Rapport adressé à la Commission municipale,* 30, 32–37.

159. Dupuit, *Rapport de l'ingénieur en chef directeur du service municipal sur le nivellement des voies publiques aux abords des nouvelles Halles centrales* (26 March 1851), in Commission municipale, *Rapport sur l'emplacement des Halles centrales,* 37–48. Bélanger to Horeau, 12 September 1850, in Senard, *Halles centrales* (December 1850), 29–34. Grenet wrote to Baltard, 10 February 1851, that Bélanger complained that Horeau had badgered him into supporting his project.

160. Commission municipale, *Rapport sur l'emplacement des Halles centrales,* 6.

161. Charles Duval, *Halles centrales de Paris* (Paris, 1851); Bordot, "Halles centrales de Paris," 24 April 1851; Régnier, "Halles centrales de Paris"; Paillet, "Le Louvre du peuple," 3 September 1851.

162. Pigeory, "Halles centrales."

163. Jean-Jacques Berger, memorandum of 22 May 1851, cited in Commission municipale, *Rapport sur l'emplacement des Halles centrales.*

164. Victor Baltard and Félix Callet, "Halles centrales," 10 June 1851, in the Fonds Baltard, BHVP; BHVP, *Baltard,* 37–39. Related drawings are in AS, Cartes et Plans 550, no. 18, and AN, 332 AP 7.

165. Grenet to Baltard, 6 July 1850 and 10 February 1851.

166. Lemoine, *Les Halles,* 115. See Delamarre, "Travaux de la ville de Paris: Halles centrales de Paris," *La patrie,* 9–10 June 1851.

167. Grenet to Baltard, 10 May 1851.

168. Commission municipale, *Rapport sur l'emplacement des Halles centrales,* 16–17.

169. Horeau, *Halles centrales: Contre-rapport,* in AS, V1 M21.

170. *Le siècle,* 20 June 1851.

171. Commission municipale, *Rapport sur l'emplacement des Halles centrales,* 16–17.

172. Merruau, *Souvenirs de l'Hôtel de Ville,* 421–22.

173. Conseil général des bâtiments civils, "Procès verbal de la séance du 28 juillet 1851," AN, F 21 2542 (1851).

174. Alphand, *Recueil des lettres patentes.*

175. Jean-Jacques Berger, *Formation du périmètre et des abords des Halles centrales* (August 1851), in BHVP, *Baltard.*

176. Victor Baltard and Félix Callet, "Halles centrales: Modification de l'axe principal," 22 September 1851, AN, 332 AP 6.

177. Lesobre, *Rapport fait à la Commission centrale des propriétaires et habitants du XIIe arrondissement, sur les Halles centrales au point de vue de l'intérêt général de Paris et des besoins particuliers à la rive gauche* (1851); *Enquête concernant la reconstruction des Halles centrales et l'amélioration des voies publiques aux abords de ce monument: Observations présentés par la Commission centrale des propriétaires et habitants des trois arrondissements de la rive gauche, Xe, XIe et XIIe* [August 1851], in BHVP, *Baltard.*

178. A.-F. Mauduit, *Observations sur divers travaux d'intérêt général projetés pour la ville de Paris* (1849–51), BHVP.

179. Berger, *Formation du périmètre.*

180. Merruau, *Souvenirs de l'Hôtel de Ville,* 442.

181. Alphand, *Recueil des lettres patentes.*

182. Victor Baltard, "Devis sommaire des travaux à exécuter," September 1851, AN, 332 AP 6.

183. Paillet, "Le Louvre du peuple," in BHVP, *Baltard.*

184. Pierre Joly to Victor Baltard, 22 September 1851, AN, 332 AP 7.

185. Four working drawings in AS, Cartes et Plans 550. See Daly, "Nouvelles de Paris," *RGA* 10 (1852): col. 424; *La presse,* 25 January 1853, in BHVP, *Baltard.*

186. Drawings in the Fonds Baltard, BHVP. Adjudication of bids documented in AN, 332 AP 6.

187. See the report by G.-E. Haussmann cited in note 209 below; Lemoine, *Les Halles,* 124.

188. *La presse,* 25 January 1853.

189. Daly, "Halles centrales," *RGA* 12 (1854): col. 25. Pavilion 2 was in fact intended for the sale of poultry, game, and cooked meats.

190. Ibid., cols. 25–27.

191. Lemoine, *Les Halles,* 122.

192. Victor Baltard to Napoléon III, [June 1853], AN, 332, AP 6.

193. Daly, "Halles centrales," *RGA,* 12 (1854): col. 25.

194. "Discours de M. le Président de la République," in BHVP, *Baltard,* 15.

195. Camp, *Paris,* 2:151.

196. Daly, "Halles de Paris," *RGA* 11 (1853): col. 224.

197. Jean-Jacques Berger to Victor Baltard and Félix Callet, 11 June 1853, AN, 332 AP 6.

198. Daly, "Halles centrales," *RGA* 12 (1854), and Auguste Husson, "Les Halles centrales de Paris," *Le siècle,* 5 August 1853. See Charles Duval, *Projet d'une Halle centrale* (Paris, 1853); Henry Roze and A. Roze, *Nouveau projet de Halles centrales dans la Cité* (Paris, June 1853); Maurice-Sidoine Storez, *Mémoire sur la construction des Halles de Paris* (Paris: Dupont, June 1853) and "Projet de reconstruction des Halles centrales de Paris," *La revue municipale,* 1 October 1853; Thorel and Chirade, "Halles centrales de la ville de Paris" (Paris, 1853), in BHVP, *Baltard.*

199. Lemoine, *Les Halles,* 126–27.

200. Bowie, *Grandes gares,* 62–63.

201. Daly, "Halles centrales," *RGA* 12 (1854): col. 21.

202. Victor Baltard and Félix Callet, "Halles centrales: Nouveau système de construction presque exclusivement en fer; Projet n. 1," 13 June 1853; "Halles centrales: Nouveau système de construction en fer avec piles en pierre; Projet n. 2," 13 June 1853; "Halles centrales: Nouveau système de construction mixte en pierre et en fer en utilisant le pavillon exécuté," 13 June 1853—all in the Fonds Baltard, BHVP; BHVP, *Baltard,* 37–39. Victor Baltard to Napoléon III, [June 1853], AN, 332, AP 6; BHVP, *Baltard,* 16–18. See also Baltard to Jean-Marie Piétry, [June 1853], and Victor Baltard and Félix Callet, "Halles centrales: État de la question au 13 juin 1853," AN, 332 AP 6.

203. Lemoine, *L'architecture du fer,* 22.

204. Lemoine, *Passages couverts.*

205. Victor Baltard to George-Eugène Haussmann, 5 July 1853, AN, 332 AP 6. Also Baltard and Callet, "Halles centrales: Changement du système de construction; Envoi des trois projets," 5 July 1853, AN, 332 AP 6; BHVP, *Baltard,* 19–20.

206. Jacques-Étienne-Marie de Cardaillac to George-Eugène Haussmann, 21 July 1853, AN, F 21 797.

207. Victor Baltard to Georges-Eugène Haussmann, 1 August 1853, AN, 332 AP 6; Victor Baltard and Félix Callet, "Halles centrales: Modifications proposées au pavillon n. 2," 13 August 1853, and "Halles centrales: Nouveau système de construction pour les pavillons 3, 6, 7," 13 August 1853, in the Fonds Baltard, BHVP.

208. Georges-Eugène Haussmann, Arrêté, 8 August 1853, AN, 332 AP 6.

209. Georges-Eugène Haussmann, "Mémoire présenté par M. le Préfet de la Seine à la Commission municipale," *La presse,* 1 and 10 September 1853, in BHVP, *Baltard.*

210. Casselle, *Commission des embellissements.* See Florence Bourillon, "À propos de la Commission des embellissements," in Bowie, *Modernité avant Haussmann,* 139–51; Papayanis, *Planning Paris,* 226–46.

211. Van Zanten, "Paris Space," 182–83.

212. Trémisot, head of the Second Division in the Prefecture of the Seine, to Victor Baltard, 9 October 1853, AN, 332 AP 6.

213. Victor Baltard and Félix Callet, "Projet des Halles centrales d'après le nouveau lotissement des pavillons," 19 October 1853, in the Fonds Baltard, BHVP; *Vue générale des Halles centrales de Paris projetées d'après un nouveau lotissement du terrain,* October 1853, AN, 332 AP 7.

214. Haussmann, *Mémoires,* 2:228.

215. Baltard and Callet, *Halles centrales,* 18.

216. News clipping dated 17 January 1854, in BHVP, *Baltard; Le siècle,* 5 February 1854.

217. Conseil général des bâtiments civils, "Procès verbal de la séance du 27 mars 1854," AN, F 21 1542/18 (1854).

218. Conseil général des bâtiments civils, "Procès verbal de la séance du 12 avril/13 avril 1854," AN, F 21 2542/18 (1854).

219. Haussmann, *Mémoires,* 2:230; see Lemoine, *Les Halles,* 153–55.

220. News clipping dated May 1854, in BHVP, *Baltard; Le moniteur universel,* 19 May 1854; Haussmann, *Mémoires,* 2:230.

221. Giedion, *Building in France,* 114.

222. Conseil général des bâtiments civils, "Procès verbal de la séance du 16 février/20 février 1854," AN, F 21 1252/18 (1854); Bronty, "Plan des abords des Halles centrales"; news clipping dated 21 March 1854, in BHVP, *Baltard;* Bordot, "Halles centrales de Paris," 15 May 1854; Alphand, *Recueil des lettres patentes.* David Van Zanten has found the original of this plan in the Archives nationales, F1a2000 87: see Van Zanten, "Paris Space," 186.

223. Conseil général des bâtiments civils, "Séance du 16 février 1854."

224. Conseil général des bâtiments civils, "Séance du 20 février 1854."

225. Ibid.

226. Haussmann, *Mémoires,* 1:29.

227. Alphand, *Recueil des lettres patentes;* Préfecture de la Seine, *Recueil de règlements.*

228. David Van Zanten, "Mais quand Haussmann est-il devenu moderne?" in Bowie, *Modernité avant Haussmann,* 152–64.

229. Casselle, *Commission des embellissements.*

230. See Cadoux, *Finances de la ville,* 45–73, 253–68; Pierre Pinon, "Entreprises et finances," in Cars and Pinon, *Paris-Haussmann,* 102–6; Harvey, *Paris,* 117–46.

231. Haussmann, *Mémoires,* 1:19–20.

232. Baltard and Callet, *Halles centrales,* 23. Surviving working drawings are in AS, Cartes et Plans 500–555.

233. Baltard and Callet, *Halles centrales,* 24.

234. Ibid., 14.

235. Ibid., 26.

236. See ibid. for a comparative analysis of average temperatures.

237. See Pontich, *Administration de la ville,* 557ff. When street sanitation and lighting (the "Petite Voirie") were transferred by imperial decree to Haussmann's control on 10 October 1859, the prefect seemed poised to get full control over all the public spaces of Paris, including its markets—until the minister of the interior, on 27 December, reaffirmed the jurisdiction of the

police to inspect all foodstuffs in the city: Préfecture de la Seine, *Règlements sur l'assainissement,* 13. The legal status quo did not change when the Commission municipale, on 11 January 1860, unilaterally invested the Prefecture of the Seine with responsibility for all the markets of Paris: Cilleuls, *Histoire de l'administration,* 2:213, 292–301; Félix, *Régime administratif,* 1:203–7.

238. See Baltard and Callet, *Halles centrales,* 20; Camp, *Paris,* 2:160–89; Vigneau, *Halles centrales.*

239. V. Baltard, *Complément,* in Moncan, *Baltard,* 139–40.

240. Le Corbusier, *Vers une architecture,* 107.

241. Contractors are named on the relevant working drawings; see Lemoine, *Les Halles,* 163–64.

242. Dallemagne's firm was later joined by the firm of Texier and Petit, which carried out the brickwork of the exterior screens for each pavilion.

243. Halles construction office:

1852–53
Baltard et Callet, *architectes;*
Gabriel Veugny, *inspecteur;*
Alphone-Joseph Hugé, Henri-Martin Moutard, *sous-inspecteurs;*
Fayard, Gabriel Davioud, Arthur-Stanislas Diet, *conducteurs.*

1854
Baltard et Callet, *architectes;*
Veugny, *inspecteur;*
Émile Vaudremer, *sous-inspecteur.*

1855–59
Baltard, *architecte;*
Veugny, Touchard, *inspecteurs;*
Augustin-Joseph Pappert, Charles-Gustave-Marie Huillard, David de Penanrum, *sous-inspecteurs;*
Fayard, Chanoinat, Zerling, *conducteurs.*
Note: Huillard promoted to *inspecteur* in 1857.

1860–64
Baltard, *architecte;*
Veugny, Touchard, Huillard, *inspecteurs;*
Pappert, Penanrum, *sous-inspecteurs.*

1865–70
Baltard, *architecte;*

Huillard, *inspecteur ordinaire;*
Touchard, *inspecteur;*
Pappert, *sous-inspecteur.*

1871–74
Auguste-Albain Radigon, *architecte.*

244. Baltard and Callet, *Halles centrales,* 27. Pierre Joly was seconded by his son-in-law, César Jolly, an engineer.

245. The pavilions are identified here by their final numbering.

246. Tourettes, "Halles centrales"; Sauterion, "Halles centrales"; Préfecture de la Seine, *Notes sur les abattoirs.*

247. Préfecture de la Seine, *Notes sur les abattoirs.*

248. Brame and Flachat, "Chemin de fer" (1853). See Daly, "Chemin de fer," *RGA* 12 (1854): cols. 58–60, 63–64.

249. Édouard Brame to Victor Baltard, 27 January 1845 to 2 April 1854, AN, 332 AP 7. Tourettes, "Halles centrales."

250. Papayanis, *Planning Paris,* 219–20. A victim of its own technical complexity, this precocious underground system prefigured Fulgence Bienvenue's Metropolitan (1898): see Lavedan, *Nouvelle histoire,* 501–20.

251. George-Eugène Haussmann to Victor Baltard, and Arrêté, 14 December 1857, AN, 332 AP 7.

252. Commission des Halles, "Résumé des procès-verbaux de ses séances depuis le 22 décembre 1857 jusqu'au 12 janvier 1858," AN, 332 AP 7.

253. Baltard and Callet, *Halles centrales,* 29.

254. Cadoux, *Finances de la ville,* 50–52.

255. Pontich, *Administration de la ville,* 37ff.

256. News clipping dated May 1859, in BHVP, *Baltard;* Conseil général des bâtiments civils, "Procès verbal de la séance du 19 août/21 octobre 1859," AN, F 21 1843; Victor Baltard, "Note relative à l'avis du Conseil des bâtiments civils concernant le nouveau projet d'agrandissement du périmètre des Halles centrales du côté de la Halle au Blé," AN, 332 AP 6.

257. Alphand, *Recueil des lettres patentes.*

258. Camp, *Paris,* 2:152.

259. Préfecture de la Seine, *Notes sur les abattoirs;* Georges-Eugène Haussmann, Arrêté, 26 October 1864, AS, V1 M21.

260. Lemoine, *Les Halles,* 205.

261. Baltard and Callet, *Halles centrales,* 19.

262. [Victor Baltard], "Dépenses à faire pour l'achèvement des halles, suivant le nouveau projet consistant dans l'extension du périmètre jusqu'à la Halle au Blé," AN, 332 AP 7.

263. Baltard and Callet, *Halles centrales,* 29.

264. Ibid., 29. See Cadoux, *Finances de la ville,* 52; Lemoine, *Les Halles,* 168–70.

265. Marché de Temple, 3e Arrondissement, 1863–65/partly demolished 1905, Jules de Mérindol; Abattoirs de la Villette, 19e, 1863–67, Jules de Mérindol under Louis-Adolphe Janvier; Marché Saint-Honoré, 1er, 1864–65/demolished 1958, Jules de Mérindol; Marché de Grenelle, 15e, 1865/demolished; Marché Saint-Maur-Saint-Germain, 6e, 1866/demolished, Louis Dainville; Marché de l'Europe, 8e, 1866/demolished 1970; Marché Saint-Quentin, 10e, 1866; Marché de Montrouge, 14e, 1866/demolished 1932; Marché Saint-Didier, 16e, 1867; Marché de Belleville, 20e, 1867/demolished; Marché d'Auteuil, 16e, 1867/demolished; Marché des Batignolles, 18e, 1867/demolished 1975; Marché de la Place d'Italie, 13e, 1867/demolished 1965, Henry Dubois; Marché Necker, 15e, 1868/demolished 1910; Marché des Ternes, 17e, 1868/demolished 1970; Marché Secrétan, 19e, 1868, attributed to Victor Baltard; Marché de Montmartre, 18é, 1868; Marché Voltaire, 11e, 1870. See César Daly, "Le Marché Saint-Maur-Saint-Germain," *RGA* 25 (1867): cols. 76–79; Narjoux, *Paris,* vol. 2; V. Baltard, *Complément à la Monographie;* Chemetov and Marrey, *Architectures à Paris.*

266. Préfecture de la Seine, *Notes sur les abattoirs.*

267. Victor Baltard and Gustave Huillard, "Marché du Temple: Avant Projet," 15 November 1858, and "Marché du Temple: Projet de reconstruction," 16 April 1860, AN, 332 AP 24. In 1870,

Baltard also designed a customhouse in cast and wrought iron for Callao, Peru; see correspondence and Baltard's preliminary project, "Construction d'un établissement de douane: Description sommaire," AN, 332 AP 26; additional correspondence in AN, 332 AP 2.

268. E.-E. Viollet-le-Duc, *Entretiens,* 2:318–51, and atlas, pl. XXXVI.

269. Levine, *Modern Architecture,* 164.

270. Fournier, "Halles centrales." See also Tourettes, "Halles centrales"; Sauterion, "Halles centrales"; Lazare, "Grandes halles de Paris."

271. [Daly], "Halles centrales," *RGA* 14 (1857): cols. 103–4.

272. E.-E. Viollet-le-Duc, *Entretiens,* 1:323, 2:46–47, 60–61.

273. Garnier, "L'architecture en fer"; also Garnier, *À travers les arts,* 75–77.

274. Garnier, "L'architecture en fer," 322.

275. Garnier, *Baltard,* 7.

276. Sirodot and Poitevin, "Halles centrales." The photolithographic reproduction was taken from a collodion negative.

277. Sirodot and Fortier, "Escalier de l'aile de François Ier." See Sylvain Bellenger and Marie Cécile Forest, "Le château de Blois abandonné et redécouvert par l'histoire," in Bellenger and Hamon, *Duban,* 79–89.

278. Sirodot and Fortier, "Escalier de l'aile de François Ier," col. 215. Barry Bergdoll, "Duban et la photographie," in Bellenger and Hamon, *Duban,* 228–32, observes that Duban made pathbreaking use of daguerreotypes commissioned from Hippolyte Bayard to assist him in his restoration.

279. See Thézy, *Marville.*

280. Haussmann, *Mémoires,* 1:28; see Thézy, *Marville,* 31–32.

281. Zola, *Ventre de Paris,* 474.

282. Ibid., 585.

283. Ibid., 451.

284. Ibid., 388, 394, 477.

285. Ibid., 473.

Chapter 6

1. See Préfecture de la Seine, *Inventaire général,* vol. 2; AN, 332 AP 4, 13, 26; Conseil général des bâtiments civils, "Procès verbal de la séance du 31 jan.

1860: St. Augustin," AN, F 21 1843; *Almanach* (1862–69); Daly, "Panorama du mouvement architectural du monde," *RGA* 20 (1862): col. 239, and 14 (1866): col. 262; E.-L. Viollet-le-Duc, "Saint-Augustin"; Bouchet, "L'église Saint-Augustin"; "Église St.-Augustin à Paris," *Nouvelles annales de la construction* 18 (August 1872), pls. 33–35; Narjoux, *Paris,* 3:4–7; Aimard, "Vie et oeuvre de Victor Baltard"; Pinon, *Baltard,* 191–99.

2. Building chronology:

1854: imperial decree of 14 March orders opening of the Boulevard des Malesherbes in two sections between the Place de la Madeleine and the Parc Monceau

1859: Baltard is commissioned to design the new church of Saint-Augustin, replacing a temporary church built in 1850

1860: design approved by the Conseil des bâtiments civils in January; site excavated and foundations begun

1861: Boulevard des Malesherbes inaugurated 14 August; active construction begins in September

1862–67: artists commissioned to decorate the church

1865: structure of the church completed; in situ execution and installation of decoration begins

1868: church inaugurated 28 May

1871–72: church is restored and its decoration cleaned and restored after the dome is damaged by shells during the Siege of Paris in 1870–71

On the complicated planning history of the Boulevard de Malesherbes, see Lazare and Lazare, *Dictionnaire administratif;* Alphand, *Recueil des lettres patentes;* Hillairet, *Dictionnaire historique.*

3. Victor Baltard, "Rapport au préfet de la Seine sur la construction de l'église Saint-Augustin," 7 December 1859, as quoted in Aimard, "Vie et oeuvre de Victor Baltard," 53; Lemoine, *L'architecture du fer,* 264–68. Haussmann, *Mémoires,* 2:232, discusses Baltard's decision to eliminate the need for buttresses by using an iron vaulting structure.

4. Eight church projects in AN, 332 AP 4 and 26; Pinon, *Baltard,* 199

n. 942, cites other projects in AN, F 21 1868.

5. Léonce Reynaud, "Architecture," in Leroux and Reynaud, *Encyclopédie nouvelle,* 1:778.

6. Works of painting: Paul-Jean Étienne Balze (1862/64, façade, enameled volcanic stone); Jean-Louis Bézard (1862, dome, pasted canvas); William-Adolphe Bouguereau (1862/64, transept vaults, pasted canvas); Pierre-Nicolas Brisset (1862, Chapelle de la Vierge, pasted canvas); Alexandre Denuelle (1867, ornamental painting); Diogène-Ulysse-Napoléon Maillart (1870/74, nave, easel paintings); Émile Signol (1862, dome pendentives, pasted canvas). Works of sculpture: Eugène Aizelin (1867, right transept, plaster statues); Jean Bonnassieux (1862, left-side façade, stone relief); Louis Brian (1863, left-side façade, stone statue); Eugène-Cyrile Brunet (1862, nave, stone statue); Albert-Ernest Carrier-Belleuse (1862, right-side façade, stone group with candelabra); Jules-Pierre Cavelier (1862/63, main façade, stone statues); Louis-Léopold Chambard (1862, left-side façade, stone statues); Pierre-Joseph Chardigny (1862, right-side façade, stone statue); Charles Cordier (1862, left-side façade, stone group with candelabra); Louis Desprez (1862, right-side façade, stone statue); Amédée-Donatien Doublemard (1867, right transept, plaster statues); Vital-Gabriel Dubray (1867, left transept, stone statue); Jean-Baptiste-Eugène Farochon (1862/63, left-side façade, stone statues); François-Ambroise-Germain Gilbert (1862, right transept, stone relief); Théodore-Charles Gruyère (1862/63, right-side façade, stone statues); Claude Guillaume (1867, left transept, plaster statues); Henri-Alfred Jacquemart (1862, main façade, stone statues); Léon-Louis-Nicolas Jaley (1862, Chapelle de la Vierge, marble group); François Jouffroy (1862, main façade, stone relief); Edmond-Victor Leharivel-Durocher (1862, Chapelle de la Vierge, stone statue); Alfred-Adolphe-Édouard Le Père (1862, main façade, stone reliefs); Eugène-Louis Lequesne (1862, right-side façade, stone reliefs); Jacques-Léonard Maillet (1867, Chapelle de la Vierge, plaster statue); Henri-Charles

Maniglier (1867, left transept, plaster statues); Aimé Millet (1862, right transept, stone relief); Mathurin Moreau (1863, main façade, plaster models for galvanized bronze reliefs); Auguste-Louis-Marie Ottin (1862, right-side façade, stone statue); Aimé-Napoléon Perrey (1862, Chapelle de la Vierge, stone statue); Alexandre Schoenewerck (1862, left transept, stone relief); Louis Schroeder (1862, main façade, stone statues; nave and crossing, plaster models for cast-iron angels); Taluet (1862, nave, stone statue); Pierre Travaux (1862, left transept, stone relief). Works of stained glass: Prosper Lafaye (1863, façade rose window); Claudius Lavergne (1862, Chapelle de la Vierge); Lusson (1865, chapels); Charles-Laurent Maréchal (1862, nave windows); Paul-Charles Nicot (1865, chapels); Eugène-Stanislas Oudinot (1865, triforium).

7. Pinon, *Baltard,* 195.

8. Le Corbusier to Auguste Perret, 14 December 1915, in Le Corbusier, *Lettres à Perret,* 152.

9. Van Zanten, *Sullivan's City,* 3.

10. Ibid., 9–12.

11. Two more Neo-Gothic churches were built in the 1850s, Saint-Jean-Baptiste-de-Belleville (1854–59) by Jean-Baptiste Lassus and Saint-Bernard (1858–61) by Auguste-Joseph Magne.

12. Though the decoration was noted by Daly, "Panorama du mouvement architectural du monde," *RGA* 20 (1862): col. 239.

13. Alphonse de Gisors, report of 31 January 1860, AN, F 21 1868, as quoted in Pinon, *Baltard,* 194–95; Conseil général des bâtiments civils, "Procès verbal de la séance du 31 jan. 1860."

14. Ballu, *Monographie.*

15. Vaudremer, *Monographie;* Thomine, *Vaudremer,* 83–96.

16. Conseil général des bâtiments civils, "Procès verbal de la séance du 31 jan. 1860." Pinon, *Baltard,* 195, notes, however, that Alphonse de Gisors recognized the advantages of Baltard's iron structure, explaining the *conseil*'s final approval.

17. E.-L. Viollet-le-Duc, "Saint-Augustin."

18. Bouchet, "L'église Saint-Augustin"; Delaborde, "Baltard," 805–6.

19. Sédille, "Baltard," 494.

20. Garnier, *Baltard,* 5.

21. Ibid.

22. Ibid., 4.

23. Lemoine, *L'architecture du fer,* 173.

24. Dainville, "Projet d'église paroissiale."

25. Sédille, "Baltard," 494.

26. See [Daly], "Église Saint-Eugène," *RGA* 13 (1855): cols. 82–83, and 14 (1857): col. 100; Delbrouck, *Saint-Eugène.*

27. L.-A. Boileau, *Nouvelle forme architecturale.* See also, by L.-A. Boileau, *Débat sur l'application du métal, Le fer, Histoire critique.*

28. Lance, "Nouvelle forme architecturale"; M. Chevalier, "Exposition universelle"; E.-E. Viollet-le-Duc, "Lettre à M. Adolphe Lance"; L.-A. Boileau, "Lettre à M. Adolphe Lance"; E.-E. Viollet-le-Duc, "Réplique à la réponse de M. Boileau."

29. Lance, "Nouvelle forme architecturale," cols. 27–28.

30. M. Chevalier, "Exposition universelle," 2.

31. E.-E. Viollet-le-Duc, "Lettre à M. Adolphe Lance," cols. 83–86.

32. Ibid., 87. E.-E. Viollet-le-Duc, *Entretiens,* 2:93 and 53–103 passim, demonstrated this integrated system in his 1864 project for an auditorium, which supported masonry vaults on cast-iron ribs and columns, while his student Anatole de Baudot analogously, if less radically, set masonry vaults on thin iron columns in his Gothicizing design for the church of Saint-Lubin in Rambouillet (1865–69).

33. Léonce Reynaud, "Architecture," in Leroux and Reynaud, *Encyclopédie nouvelle,* 1:777.

34. See Venturi, Scott Brown, and Izenour, *Learning from Las Vegas,* 87ff.; also Christopher Mead, "Introduction: The Meaning of 'Both-And' in Venturi's Architecture," in Mead, *Venturi,* 3–6.

35. See Marrey, *Grands magasins,* 68–83.

36. Louis-Charles Boileau *fils,* "Les magasins au Bon Marché," *Encyclopédie d'architecture* (1876): 120, as excerpted in Marrey, *Paris sous verre,* 207–9.

37. See L.-C. Boileau, "Le rationalisme gothique et la raison classique."

38. L.-C. Boileau, in Marrey, *Paris sous verre,* 207–9.

39. See Mead, *Garnier's Paris Opéra,* 113 and nn. 37–38.

40. Sédille, *Ballu;* Van Zanten, *Building Paris,* 278–79.

41. See Boudon, Loyer, and Dufournet, *Horeau,* 89–95.

42. Zola, *Ventre de Paris,* 394.

43. Colin Rowe and Fred Koetter have considered this difference between the traditional city and modernist city at length in *Collage City,* 50–83.

Epilogue

1. Van Zanten, *Building Paris,* 230; Pinon, *Baltard,* 209.

2. Giedion, *Building in France,* 101.

3. Alfred Gotthold Meyer, with Wilhelm Freiherr von Tettau, *Eisenbauten: Ihre Geschichte und Aesthetik* (Esslingen: Paul Neff, 1907), 81–94.

4. Giedion, *Building in France,* 152.

5. Ibid., 89.

6. Benjamin, *Arcades Project,* 465. See also Walter Benjamin, *Paris, capitale du XIXe siècle: Le livre des passages,* trans. Jean Lacoste (Paris: Cerf, 1997), 482. Notes from Giedion, *Building in France,* occur throughout Benjamin's text, as do notes from Meyer's *Eisenbauten;* on the specific parallel between Giedion's architectural history and Benjamin's social history of nineteenth-century Paris, see Benjamin, *Arcades Project,* 458–59. Sokratis Georgiadis, introduction to Giedion, *Building in France,* 53, documents correspondence between Giedion and Benjamin.

7. Benjamin, *Arcades Project,* 26.

8. Ibid., 151. Benjamin also identified the nineteenth century as a "prehistory" to the present, ibid., 410.

9. Ibid., 23.

10. See Cassirer, *Philosophy of the Enlightenment,* esp. 3–92, 234–74. See also Barbara Stafford, *Voyage into Substance: Art, Science, Nature, and the Illustrated Travel Account, 1760–1840* (Cambridge, Mass.: MIT Press, 1984), 46–52.

11. See Starobinski, *Rousseau.*

12. Jean Jacques Rousseau, "Second Dialogue: Du naturel de Jean Jacques, et de ses habitudes," *Oeuvres complètes de J. J. Rousseau* (Paris: Armand-Aubrée, 1829), 13:241.

13. See Rabinow, *French Modern,* 17–19, on this shift from a world in which, for Louis XIV and his court, appearance was being "to the world of modernity, in which representations ceased to provide a reliable grid for the knowledge of things." See also Habermas, *Structural Transformation.*

14. See Christian Eych, "Enigmes de la transparence," in Marrey, *Paris sous verre,* 153.

15. See David Van Zanten, "Architectural Composition at the École des Beaux-Arts from Charles Percier to Charles Garnier," in Drexler, *Architecture of the École des Beaux-Arts,* 115–30.

16. Durand, *Précis des leçons,* 1:19. On the history and various meanings of "character," see Egbert, *The Beaux-Arts Tradition,* 121–38; Szambien, *Symétrie, gout, caractère,* 174–99; Vidler, *The Writing of the Walls,* 146–64; Mead, *Garnier's Paris Opéra,* 111–13; Lavin, *Quatremère de Quincy,* 126–47. See Picon, *French Architects and Engineers,* 76–78, 270–74, and passim, on the application

to architecture of Rousseau's ideal of transparency, interpreted as a speaking language of architecture.

17. L.–A. Hardy, *RGA* 43 (1887): col. 244, as quoted and translated in Van Zanten, *Designing Paris,* 225.

18. Trélat, *Le Sitellarium,* 33.

19. L.-C. Boileau, in Marrey, *Paris sous verre,* 207–9.

20. See Isobel Armstrong, "Transparency: Towards a Poetics of Glass in the Nineteenth Century," in *Cultural Babbage: Technology, Time, and Invention,* ed. Francis Spufford and Jenny Uglow (London: Faber and Faber, 1996), 123–48.

21. See Kahlmaier and Sartory, *Houses of Glass.* Rohault de Fleury's Grandes Serres in the Jardin des Plantes in Paris (1834–36) introduced the greenhouse to France as a form of public architecture.

22. See Considérant, *Description d'un phalanstère.*

23. See Geist, *Arcades;* Lemoine, *Passages couverts.*

24. Benjamin, *Arcades Project,* 421.

25. Walter Benjamin, "Paris, Capital of the Nineteenth Century," in *Reflections* (New York: Schocken Books, 1986), 148.

26. See Habermas, *Structural Transformation.*

27. Préfecture de la Seine, *Notes sur les abattoirs.*

28. Rossi, *Architecture of the City,* 57.

29. Ibid., 29.

30. Ibid., 57–58.

31. Ibid., 146.

32. Vidler, "Third Typology," 2.

33. Ibid., 3.

34. Ibid., 2. On the city as a work of art, see Rossi, *Architecture of the City,* 32–35.

35. Ville de Paris, *Paris–Les Halles.*

36. Jean Nouvel, "Des jardins, des halles, des places, des équipements . . . ," in *Paris–Les Halles,* 50.

37. Victor Baltard, "Vitruve," AN, 332 AP 9, p. 10.

Abadie, Paul. *Institut de France, Académie des Beaux-Arts: Notice sur M. Gilbert.* Paris: Firmin-Didot, 1876.

Académie royale des Beaux-Arts. *Règlement pour les jeunes artistes pensionnaires du Roi.* Paris: Bureau des Beaux-Arts, 1821.

Agulhon, Maurice, ed. *La ville de l'âge industriel: Le cycle haussmannien.* Vol. 4 of *Histoire de la France urbaine,* edited by Georges Duby. Paris: Seuil, 1983.

Aimard, Emilienne Nelly. "Vie et oeuvre de Victor Baltard (1805–1874), Saint-Augustin." Mémoire de maîtrise d'histoire de l'art, Université de Paris I, 1971.

Alphand, Adolphe, with A[drien] Deville and [Émile] Hocherau. *Recueil des lettres patentes, ordonnances royales, décrets et arrêtes préfectoraux concernant les voies publiques.* Paris: Ville de Paris, 1886. *Suppléments* of 1889 and 1902.

Amaury-Duval, [Eugène-Emmanuel]. *L'atelier d'Ingres.* Paris: G. Crès et Cie., 1924. (First published 1878.)

Arnould, Louis. *Victor Baltard, 1805–1874.* Le Puy-en-Velay: Imprimerie "La Haute-Loire," 1939.

Arnoux, J. J. "Halles centrales à élever à Paris." *La patrie,* 26 October, 3 November, 26 November 1850.

Aunay, Alfred d'. "Victor Baltard." *Le Figaro,* 15 January 1874.

Auzas, Pierre-Marie. *Eugène Viollet-le-Duc.* Paris: Caisse Nationale des Monuments Historiques et des Sites, 1979.

Bachelier, Jean-Jacques. *Discours sur l'utilité des Écoles élémentaires en faveur des arts mécaniques: Prononcé à l'ouverture de l'École gratuite de dessin.* Paris, 1766.

Bailly, Gilles-Henri, and Philippe Laurent. *La France des halles et marchés.* Toulouse: Éditions Privat, 1998.

Ballon, Hillary. *The Paris of Henri IV: Architecture and Urbanism.* New York: Architectural History Foundation; Cambridge, Mass.: MIT Press, 1991.

Ballu, Théodore. *Monographie de l'église de la Sainte Trinité, construit par la ville de Paris.* Paris: Dupuis, 1868.

Baltard, Louis-Pierre. *Architectonographie des prisons; ou, Parallèle des divers systèmes de distribution dont les prisons sont susceptible, selon le nombre et la nature de leur population, l'étendue et la forme des terrains.* Paris: author, 1829.

———. *École royale des Beaux-Arts: Discours d'ouverture du cours de théorie de l'architecture.* Paris: Crapelet, [1831].

———. *École royale des Beaux-Arts: Introduction au cours de théorie d'architecture de l'année 1839.* Paris: Crapelet, 1839.

———. *École royale des Beaux-Arts: Introduction au cours de théorie d'architecture de l'année 1841; Aperçu sur le bon goût dans les ouvrages d'art et d'architecture.* Paris: Crapelet, 1841.

Baltard, Victor. *Complément à la Monographie des Halles centrales de Paris.* Paris: Ducher, 1873.

———. "Discours d'ouverture." *Annales de la Société centrale des architectes français* 1 (1874): 2–12.

———. "Exposition d'une collection de dessins de Félix Duban." *Revue générale de l'architecture* 29 (1872): cols. 22–29.

———. *Institut de France, Académie des Beaux-Arts: Compte rendu de l'ouvrage intitulé la Galatie et la Bithynie exploration archéologique par Georges Perrot, Edmond Guillaume et Jules Delbet.* Paris: Firmin-Didot, 1873. (Also published as "Exploration archéologique de la Galatie et la Bithynie, par MM. Georges Perrot, Edmond Guillaume et Jules Delbert." *Revue générale de l'architecture* 31 [1874]: cols. 235–38.)

———. *Institut de France, Académie des Beaux-Arts: Compte rendu des travaux pendant l'exercice 1870, par M. Baltard, président.* Paris: Firmin-Didot, 1870.

———. *Institut de France, Académie des Beaux-Arts: Discours de M. Baltard, président de l'Académie, prononcé aux funérailles de M. Schnetz.* Paris: Firmin-Didot, 1870.

———. *Institut de France, Académie des Beaux-Arts: Discours prononcé aux funérailles de M. M.-F. Jäy, architecte.* Paris: Firmin-Didot, 1871.

———. *Institut de France, Académie des Beaux-Arts: Hommage rendu à Félix Duban au nom de la Société centrale des architectes.* Paris: Firmin-Didot, 1871. (Also published as "Discours prononcé au nom de la Société centrale des architectes." In César Daly, "Funérailles de Félix Duban." *Revue générale de l'architecture* 28 [1871]: cols. 199–224, 212–24.)

———. *Institut de France, Académie des Beaux-Arts: Notice sur la vie et les ouvrages d'Augustin Caristie; Lue dans la séance du 14 mai 1870.* Paris: Firmin-Didot, 1870.

———. *Institut de France: De la peinture sur verre; Lu dans la séance publique annuelle des cinq académies le 16 août 1864.* Paris: Firmin-Didot, 1864.

———. *Institut de France: L'École de Percier; Lu dans la séance publique annuelle de l'Académie des Beaux-Arts du 15 novembre 1873.* Paris: Firmin-Didot, 1873.

———. *Institut de France: Séance publique annuelle des cinq académies du samedi 13 août 1870, par M. Baltard, président.* Paris: Firmin-Didot, 1870.

———. *Organisation des ouvriers de bâtiment au point de vue moral et matériel: Rapport présenté au Conseil et à l'assemblée générale de la Société centrale des architectes français.* Paris: Société centrale des architectes, 1872.

———. *Villa Médicis à Rome: Dessinée, mesurée, publiée et accompagnée d'un texte historique et explicatif par Victor Baltard, architecte, ex-pensionnaire de l'Académie de France.* Paris: author, 1847.

Baltard, Victor, Anger, and Armand Husson. *Rapport sur les marchés publics en Angleterre, en Belgique, en Hollande et en Allemagne.* Paris: Préfecture de la Seine, 1846.

Baltard, Victor, Charles-Ernest Beulé, and Louis Duc. *Institut de France, Académie des Beaux-Arts: Discours prononcés aux funérailles de M. Vaudoyer.* Paris: Firmin-Didot, 1872.

Baltard, Victor, and Félix Callet. *Monographie des Halles centrales de Paris construites sous le règne de Napoléon III et sous l'administration de M. le Baron Haussmann.* Paris: Morel, 1863.

Baltard, Victor, and Gabriel Davioud. "Circulaire de la Société centrale des architectes." *Revue générale de l'architecture* 29 (1872): col. 271.

Baltard, Victor, and Édouard Gatteaux, eds. *Galerie de la reine dite de Diane à Fontainebleau, peinte par Ambroise Dubois en MDC sous le règne de Henri IV: Publiée par E. Gatteaux et V. Baltard d'après les dessins de L. P. Baltard et de C. Percier.* Paris: authors, 1858.

Barroux, Marrius. *Le département de la Seine et de la ville de Paris.* Paris, 1910.

Bellenger, Sylvain, and Françoise Hamon, eds. *Félix Duban, 1798–1870: Les couleurs de l'architecte.* Paris: Gallimard/ Electa, 1996.

Benjamin, Walter. *The Arcades Project.* Translated by Howard Eiland and Kevin McLaughlin. Cambridge, Mass.: Belknap Press of Harvard University Press, 1999.

Bercé, Françoise. *Les premiers travaux de la Commission des monuments historiques.* Paris: Picard, 1979.

Bergdoll, Barry. *European Architecture, 1750–1890.* Oxford: Oxford University Press, 2000.

———. *Léon Vaudoyer: Historicism in the Age of Industry.* New York: Architectural History Foundation; Cambridge, Mass.: MIT Press, 1994.

———, ed. *Le Panthéon: Symbole des révolutions.* Paris: Picard, with the Centre Canadien d'Architecture and the Caisse Nationale des Monuments Historiques et des Sites, 1989.

———, ed. *Les Vaudoyer: Une dynastie d'architectes.* Dossiers du Musée d'Orsay, 45. Paris: Reunion des musées nationaux, 1991.

Berger, Robert. *The Palace of the Sun: The Louvre of Louis XIV.* University Park: Pennsylvania State University Press, 1993.

Beulé, Charles-Ernest. "L'École de Rome au dix-neuvième siècle." *Revue des deux mondes* 48 (December 1863): 916–38.

———. *Fouilles et découvertes.* 2 vols. Paris: Didier, 1873.

———. *Institut de France, Académie des Beaux-Arts: Éloge de M. Flandrin; Lu dans la séance du 19 novembre 1864.* Paris: Firmin-Didot, 1864.

———. *Institut de France: Réponse de l'Académie des Beaux-Arts à S. É. le Ministre de la Maison de l'Empereur et des Beaux-Arts.* Paris: Firmin-Didot, 1864.

Bibliothèque historique de la ville de Paris. *Victor Baltard: Projets inédits pour les Halles centrales.* Edited by Maria Deurberque. Paris: Ville de Paris, 1978.

Biet, Jean-Marie-Dieudonné, Charles Gourlier, Edme-Jean-Louis Grillon, and Jean-Jacques Tardieu. *Choix des édifices publics projetés et construits en France depuis le commencement du XIXe siècle.* 3 vols. Paris: Colas, 1825–50.

Biver, Marie-Louise. *Pierre Fontaine: Premier architecte de l'Empereur.* Paris: Plon, 1964.

Blanc, Charles. *Les artistes de mon temps.* Paris: Firmin-Didot, 1876.

———. *Grammaire des arts du dessin.* 2nd ed. Paris: Renouard, 1870. (First published 1867.)

Blanchot, Auguste. *Église Sainte-Clotilde de Paris.* Paris: Librairie archéologique d'Alphonse Pringuet, n.d.

[Blondel et al.]. *Halles centrales d'approvisionnement: A messieurs les membres de la Commission municipale de Paris; Nouvelles observations présentées par les intéressés à l'achèvement du projet approuvé en 1845.* Paris: Jousset, July 1850.

———. *Halles centrales d'approvisionnement: Examen comparatif de projet de l'administration approuvé en 1845 et du projet de M. Horeau; Réponse au mémoire de M. Senard.* Paris: Jousset, 30 April 1850.

———. *Halles centrales d'approvisionnement: Réponse au nouveau mémoire publié par M. Senard, et la lettre de M. Bélanger, ingénieur, à M. Hector Horeau, architecte, sur la question du nivellement.* Paris: Jousset, January 1851.

Blondel, François. *Cours d'architecture enseigné dans l'Académie royale d'architecture.* 2 vols. Paris: Auboin et Clouzier, 1675–83.

Blondel, Jacques-François. *Cours d'architecture, ou Traité de la décoration, distribution et construction des bâtiments.* 6 vols. Paris: Desaint, 1771–77.

Blouet, Guillaume-Abel, with Amable Ravoisié, Achille Poirot, Félix Trézel, and Frédéric de Tournay. *Expédition scientifique de Morée, ordonnée par le gouvernement français: Architecture, sculpture, inscriptions et vues.* 3 vols. Paris: Firmin-Didot, 1831–38.

———. *Supplément au Traité théorique et pratique de l'art de bâtir de Jean Rondelet.* 2 vols. Paris: Firmin-Didot, 1847–48.

Boileau, Louis-Auguste. *Débat sur l'application du métal; à la construction des églises.* Paris: Bonaventure et Ducessois, 1855.

———. *Le fer, principal élément constructif de la nouvelle architecture.* Paris: author, 1871.

———. *Histoire critique de l'invention en architecture.* Paris: Dunod, 1886.

———. "Lettre à M. Adolphe Lance à propos de celle adressée à M. Adolphe Lance par M. Viollet-le-Duc." *Encyclopédie d'architecture* 5 (1855): cols. 100–105.

———. *Nouvelle forme architecturale.* Paris: Gide et Baudry, 1853.

Boileau, Louis-Charles. "Le rationalisme gothique et la raison classique." *L'architecture* 2 (1889): 589–95; 3 (1890): 13–15, 65–68, 109–11.

Bordot, J. "Halles centrales de Paris." *Journal des travaux publics,* 24 April 1851; 15 May 1854.

Bouchet, Jules. "Les nouveaux monuments de Paris: L'église Saint-Augustin." *Revue générale de l'architecture* 27 (1869): cols. 84–88.

———. "Les nouveaux monuments de Paris: Sanctae Trinitati, par M. Ballu, architecte de la ville." *Revue générale de l'architecture* 24 (1866): cols. 160–62; 26 (1868): cols. 121–25.

Boudon, Françoise, André Chastel, Hélène Couzy, and Françoise Hamon. *Système de l'architecture urbaine: Le quartier des Halles à Paris.* 2 vols. Paris: CNRS, 1977.

Boudon, Françoise, François Loyer, and Paul Dufournet. *Hector Horeau 1801–1872.* Paris: Centre d'études et de recherches architecturales, 1979.

Boudon, Jacques-Olivier. *Paris, capitale religieuse sous le Second Empire.* Paris: Éditions du Cerf, 2001.

Bowie, Karen, ed. *Les grandes gares parisiennes du XIXe siècle.* Paris: Délégation à l'action artistique de la ville de Paris, 1987.

———, ed. *La modernité avant Haussmann: Formes de l'espace urbain à Paris, 1801–1853.* Paris: Éditions Recherches, 2001.

Boyer, M. Christine. *The City of Collective Memory: Its Historical Imagery and Architectural Entertainments.* Cambridge, Mass.: MIT Press, 1994.

Braham, Allan. *The Architecture of the French Enlightenment.* Berkeley and Los Angeles: University of California Press, 1980.

Brame, Édouard, and Eugène Flachat. "Chemin de fer de jonction des Halles centrales avec le chemin de ceinture." *Revue municipale,* 16 December 1853.

———. "Chemin de fer des Halles à Paris." *Nouvelles annales de la construction* (1855): pls. 39–40.

Briggs, Asa. *Victorian Cities.* Foreword by Andrew Lees and Lynn Hollen Lees. Rev. ed. Berkeley and Los Angeles: University of California Press, 1993. (First published 1963.)

Bronty, C. "Plan des abords des Halles centrales." *Revue municipale,* 1 March 1854.

Brunel, Georges, with Marie-Laure Deschamps-Bourgeon and Yves Gagneux. *Dictionnaire des églises de Paris.* Paris: Hervas, 1995.

Burton, Richard. *Blood in the City: Violence and Revelation in Paris, 1789–1945.* Ithaca: Cornell University Press, 2001.

Cadoux, Gaston. *Les finances de la ville de Paris de 1798 à 1900.* Paris: Berger-Levrault, 1900.

Calliat, Victor. *Hôtel de Ville, mesuré, dessiné, gravé et publié par Victor Calliat.* 2nd ed. Paris: author, 1856. (First published 1844.)

Camp, Maxime du. *Paris: Ses organes, ses fonctions et sa vie dans la seconde moitié du XIXe siècle.* 6 vols. Paris: Hachette, 1869–75.

Carmona, Michel. *Haussmann.* Paris: Fayard, 2000.

Cars, Jean des. *Haussmann: La gloire du Second Empire.* Paris: Perrin, 1988.

Cars, Jean des, and Pierre Pinon, eds. *Paris-Haussmann.* Paris: Picard, 1991.

Casselle, Pierre, ed. *Commission des embellissements de Paris: Rapport à l'empereur Napoléon III.* Cahiers de la Rotonde 23. Paris: Rotunde de la Villette, 2000.

Cassirer, Ernst. *The Philosophy of the Enlightenment.* Princeton: Princeton University Press, 1951.

Chabrol-Chaméane, Ernest de. *Mémoire sur le déplacement de la population dans Paris et su les moyens d'y remédier, présenté par les trois arrondissements de la rive gauche de la Seine (10e, 11e, 12e) à la Commission établie près de la ministère de l'intérieur.* Paris, 1840.

Chapman, J. M., and Brian Chapman. *The Life and Times of Baron Haussmann: Paris in the Second Empire.* London: Weidenfeld and Nicolson, 1957.

Charlton, D. G. "Victor Cousin and the French Romantics." *French Studies* 27, no. 4 (1963): 311–21.

Charton, Édouard, ed. *Dictionnaire des professions, ou Guide pour le choix d'un état.* 3rd ed. Paris: author, 1880. (First published 1842.)

Chemetov, Paul, and Bernard Marrey. *Architectures à Paris, 1848–1914.* Paris: Dunod, 1980.

Chevalier, Auguste. *Question des Halles, à mes collègues: Réflexions sur la décentralisation et le division des Halles.* Paris, 25 December 1850. (Reprinted in *La revue municipale,* 16 January, 1 February, 1 June 1851.)

Chevalier, Louis. *L'assassinat de Paris.* Paris: Éditions Ivrea, 1997. (First published 1977.)

Chevalier, Michel. "Exposition universelle: Le fer et la fonte employés dans les constructions monumentales." *Journal des débats et des décrets,* 1 June 1855.

Choay, Françoise. *The Invention of the Historic Monument.* Translated by L. M. O'Connell. Cambridge: Cambridge University Press, 2001.

———. *The Modern City: Planning in the 19th Century.* Translated by Marguerite Hugo and George Collins. New York: George Braziller, 1969.

Christ, Yvan, et al. *La place des Victoires et ses abords.* Paris: Délégation à l'action artistique de la ville de Paris, 1983.

Cilleuls, Alfred des. *Histoire de l'administration parisien au XIXe siècle.* 3 vols. Paris: H. Campion, 1900.

Claudin, Gustave. *Paris.* Paris: E. Dentu, 1862.

Cleary, Richard. *The Place Royale and Urban Design in the Ancien Régime.* Cambridge: Cambridge University Press, 1999.

Commission municipale (Comité spéciale des Halles). *Rapport sur l'emplacement des Halles centrales.* Paris: Préfecture de la Seine, June 1851.

Commission municipale des Halles. *Agrandissement et construction des Halles centrales d'approvisionnement:*

Rapport fait au Conseil municipal dans sa séance du 28 février 1845, au nom d'une commission composée de MM. Lafaulotte; Boutron, rapporteur; Lahure, président; Say, Michau, Lanquetin, Pellassy de l'Ousle, Grillon et Galis. Paris: Ville de Paris, 1845.

Conseil municipal de Paris. *Rapport au nom de la 4e Commission sur la réorganisation du Service des Beaux-Arts et des musées de la ville de Paris.* Paris: Préfecture de la Seine, 1903.

Considérant, Victor. *Description d'un phalanstère et considérations sur l'architectonique.* Paris: Librairie sociétaire, 1840.

———. "Note sur les intérêts généraux de la ville de Paris, et spécialement du dixième arrondissement." *Revue générale de l'architecture* 4 (1844): cols. 22–29.

Corbin, Alain. *The Foul and the Fragrant: Odor and the French Social Imagination.* Cambridge, Mass.: Harvard University Press, 1986.

Courajod, Louis. *L'École royale des élèves protégés, précédée d'une étude sur le caractère de l'enseignement de l'art français aux différentes époques de son histoire, et suivie des documents sur l'École royale gratuite de dessin.* Paris: Dumoulin, 1874.

Courcel, Robert de. *La basilique de Sainte-Clotilde.* [Paris: Archevêché de Paris], 1957.

Cousin, Victor. *Du vrai, du beau et du bien.* Paris: Didier, 1853.

Dainville, Édouard. "Projet d'église paroissiale (concours de construction générale—École roy. des B. Arts–2e classe), par M. Dainville, élève de M. Constant Dufeux." *Revue générale de l'architecture* 7 (1847–48): pl. 19.

Daly, César. "Bibliographie: Villa Médicis." *Revue générale de l'architecture* 8 (1849): cols. 170–71.

———. "Brochure sur la nécessité de mettre au concours le monument de Napoléon: Critiques de l'emplacement projeté." *Revue générale de l'architecture* 1 (1840): cols. 557–58.

———. "Chemin de fer de jonction des Halles centrales avec le chemin de fer de ceinture de Paris" *Revue générale de l'architecture* 21 (1854): cols. 58–60, 63–64.

———. "Chronique: Une lettre de M. Baltard, architecte en chef de la ville de Paris." *Revue générale de l'architecture* 27 (1869): cols. 205–20.

———. "Concours de l'Hôtel de Ville de Paris." *Revue générale de l'architecture* 30 (1873): cols. 24–37, 107–22.

———. *Des concours pour les monuments publics dans le passé, le présent et l'avenir.* Paris: A. Morel, 1861.

———. "Concours publics: Programme d'un concours pour la reconstruction de l'Hôtel de Ville de Paris." *Revue générale de l'architecture* 29 (1872): cols. 182–84.

———. "De la nécessité de mettre au concours le monument de Napoléon." *Revue générale de l'architecture* 2 (1841): cols. 39–42.

———. "École des Beaux-Arts: Note statistique sur la section d'architecture." *Revue générale de l'architecture* 10 (1852): cols. 301–3.

———. "Édilité parisienne: Édifices municipaux." *Revue générale de l'architecture* 29 (1872): col. 259.

———. "Enseignement de l'architecture à l'École des Beaux-Arts." *Revue générale de l'architecture* 2 (1841): cols. 634–39.

———. "Exposition des projets de tombeau pour Napoléon." *Revue générale de l'architecture* 2 (1841): cols. 521–28, 571–81, 593–629.

———. "Halles centrales de Paris." *Revue générale de l'architecture* 12 (1854): cols. 5–34.

———. "La Mairie du IIIe arrondissement de Paris (M. A. Girard, architecte)." *Revue générale de l'architecture* 11 (1853): cols. 441–48.

———. "Monument de Napoléon." *Revue générale de l'architecture* 2 (1841): col. 47.

———. "Notices nécrologiques: MM. Vaudoyer et Baltard." *Revue générale de l'architecture* 6 (1845–1846): cols. 547–52.

———. "Nouvelles de Paris: Halles de Paris." *Revue générale de l'architecture* 11 (1853): col. 224.

———. "Nouvelles et faits divers." *Revue générale de l'architecture* 3 (1842): cols. 42–43.

[———]. "Nouvelles et faits divers . . . : Édifices religieux; Église Saint-Eugène." *Revue générale de l'architecture* 13 (1855): cols. 82–83; 14 (1857): col. 100.

[———]. "Nouvelles et faits divers . . . : Halles centrales." *Revue générale de l'architecture* 14 (1857): cols. 103–4.

———. "Panorama du mouvement architectural du monde accompli dans ces dernières années: France; Travaux de Paris." *Revue générale de l'architecture* 20 (1862): cols. 30–33, 112–32, 164–200, 219–40, 271–86.

———. "Rapport de la commission chargée d'examiner les projets de mausolée pour Napoléon." *Revue générale de l'architecture* 2 (1841): cols. 630–34.

———. "Réclamation de M. Visconti." *Revue générale de l'architecture* 3 (1842): cols. 35–39.

———. "Reconstruction de l'Hôtel de Ville de Paris." *Revue générale de l'architecture* 29 (1872): cols. 125–28.

———. "Salon de 1844." *Revue générale de l'architecture* 5 (1844): col. 184.

———. "Tombeau de l'empereur Napoléon." *Revue générale de l'architecture* 4 (1843): cols. 179–83.

———. "Tombeau de Napoléon." *Revue générale de l'architecture* 1 (1840): cols. 375, 443.

———. "Tribunal de Commerce de Paris, par M. A. N. Bailly, architecte du gouvernement." *Revue générale de l'architecture* 23 (1865): cols. 248–54.

Daniel, Malcolm. *The Photographs of Edouard Baldus.* New York: Metropolitan Museum of Art; Montreal: Canadian Centre for Architecture, 1994.

Dansette, Adrien. *Religious History of Modern France.* Translated by John Dingle. 2 vols. Freiburg: Herder; Edinburgh: Nelson, 1961.

Daubanton, L.-J. M. *Du déplacement de la population de Paris.* Paris: Carilian-Goeury, 1843.

Daufresne, Jean-Claude. *Louvre et Tuileries: Architectures de papier.* Paris: Pierre Mardaga, 1987.

Davioud, Gabriel, and César Daly. *Les théâtres de la place du Châtelet: Théâtre du Châtelet; Théâtre-Lyrique.* Paris: Ducher, [1865].

Deconchy, [Jean]-Ferdinand. "Notice sur la vie et les oeuvres de Victor Baltard." *Annales de la Société centrale des architectes* 1 (1874): 235–46.

Delaborde, Henri. *L'Académie des Beaux-Arts depuis la fondation de l'Institut de France.* Paris: Plon, Nourrit et Cie., 1891.

———"Architectes contemporains: Victor Baltard." *Revue des deux mondes,* 3rd ser., 2 (April 1874): 788–811.

———. *Ingres, sa vie, ses travaux, sa doctrine.* Paris: Plon, 1870.

Delbrouck. *L'église Saint-Eugène à Paris.* Paris: H. Lebrun et Cie., 1856.

Deming, Mark. *La Halle au Blé de Paris, 1762–1813.* Brussels: Archives d'architecture moderne, 1984.

Drexler, Arthur, ed. *The Architecture of the École des Beaux-Arts.* New York: Museum of Modern Art, 1977.

Driskel, Michael Paul. *As Befits a Legend: Building a Tomb for Napoleon, 1840–1861.* Kent: Kent State University Press, 1993.

———. "The 'Gothic,' the Revolution, and the Abyss: Jean-Philippe Schmit's Aesthetic Authority." *Art History* 3 (June 1990): 195–211.

Dunlop, Ian. *Royal Palaces of France.* New York: W. W. Norton, 1985.

Durand, Jean-Nicolas-Louis. *Précis des leçons d'architecture données à l'École polytechnique.* 2 vols. Rev. ed. Paris: Firmin-Didot, 1823–25. (Originally published 1802–5.)

Dyos, H. J., ed. *The Study of Urban History.* New York: St. Martin's Press, 1968.

École nationale supérieure des Beaux-Arts. *Paris, Rome, Athènes: Le voyage en Grèce des architectes français aux XIXe et XXe siècles.* Edited by M.-C. Hellmann and P. Fraise. Paris: École nationale supérieure des Beaux-Arts, 1982.

———. *Pompéi: Travaux et envois des architectes français au XIXe siècle.* Naples: Gaetano Macchiaroli and École française de Rome, 1980.

———. *Le voyage d'Italie d'Eugène Viollet-le-Duc, 1836–37.* Edited by G. Viollet-le-Duc and J.-J. Aillagon. Florence: Centro Di, 1980.

École nationale supérieure des Beaux-Arts, with Académie de France à Rome and École française de Rome. *Roma Antiqua: Envois des architectes français (1788–1924); Forum, Colisée, Palatin.* Rome: Académie de France, 1985.

Egbert, Donald Drew. *The Beaux-Arts Tradition in French Architecture.* Edited by David Van Zanten. Princeton: Princeton University Press, 1980.

Etlin, Richard. *The Architecture of Death: The Transformation of the Cemetery in Eighteenth-Century Paris.* Cambridge, Mass.: MIT Press, 1984.

———. *Symbolic Space: French Enlightenment Architecture and Its Legacy.* Chicago: University of Chicago Press, 1994.

Evenson, Norma. "The Assassination of Les Halles." *Journal of the Society of Architectural Historians* 32, no. 4 (1973): 308–15.

———. *Paris: A Century of Change, 1878–1978.* New Haven: Yale University Press, 1979.

Fanier, A. de. "Peintures murales de Saint-Germain-des-Près, par M. Hippolyte Flandrin." *L'artiste* (1846): 205–6.

Fayet, E. *Les véritables embellissements du plus beau centre de Paris, comprenant les Halles centrales, le Louvre, ses abords, sur et y compris la moitié du Pont-Neuf; le Carrousel et les Galeries neuves entre les deux Palais pour les exhibitions des beaux-arts et de l'industrie; le commencement de la rue pour aller sur l'axe du Louvre à l'Hôtel de Ville et au-delà.* Paris: Saintin, 1850.

Félix, Maurice. *Le régime administratif du département de la Seine et de la ville de Paris.* 3 vols. 3rd ed. Paris, 1946.

Fichet, Françoise, ed. *La théorie architecturale à l'âge classique.* Paris: Pierre Mardaga, 1979.

Filloux, A. "La Stratonice de M. Ingres." *Revue générale de l'architecture* 1 (1840): cols. 554–56.

Fleury, Michel, and Jean Tulard. *Almanach de Paris.* 2 vols. Paris: Encyclopaedia Universalis, 1990.

Foucart, Bruno. "Architecture carcérale et architectes fonctionnalistes en France au XIXe siècle." *Revue de l'art,* no. 32 (1976): 37–56.

———. *Le renouveau de la peinture religieuse en France (1800–1860).* Paris: Arthéna, 1987.

———, ed. *Viollet-le-Duc.* Paris: Réunion des musées nationaux, 1980.

Foucart, Bruno, and Jacques Foucart, eds. *Hippolyte, Auguste et Paul Flandrin: Une fraternité picturale au XIXe siècle.* Paris: Réunion des musées nationaux, 1984.

Fouche, Maurice. *Percier et Fontaine.* Paris: Henri Laurens, n.d.

Fournier, Édouard. "Les Halles centrales." *L'illustration* 30 (1857): 138.

Fraser, Derek, and Anthony Sutcliffe, eds. *The Pursuit of Urban History.* London: Edward Arnold, 1983.

Garnier, Charles. "L'architecture en fer." *Le Musée des sciences* 1 (February 1857): 321–23.

———. *À travers les arts.* Paris: Hachette, 1869.

———. "Bibliographie: La Galerie de Diane, à Fontainebleau, par MM. Baltard et Gatteaux; et la Villa Médicis, par M. V. Baltard." *Revue générale de l'architecture* 16 (1858): cols. 187–89.

———. *Institut de France, Académie des Beaux-Arts: Notice sur Victor Baltard; Lu dans la séance du 30 mai 1874.* Paris: Firmin-Didot, 1874.

Garnier, Charles, and A[uguste] Ammann. *L'habitation humaine.* Paris: Hachette, 1892.

Gaudreau. *Notice descriptive et historique sur l'église et la paroisse Saint-Eustache de Paris.* Paris, 1855.

Gautier, Théophile. "Hippolyte Flandrin." *Le moniteur universel,* 24 July 1864.

———. "Peintures murales de M. Hippolyte Flandrin à Saint-Germain-des-Près." *L'artiste* (1862): 29–32.

———. "Revue des arts: Tableaux et styles de décoration dans les édifices publics de Paris." *Revue des deux mondes* 28 (1 September 1841): 791–807, 803–7.

Geist, Johann Friedrich. *Arcades: The History of a Building Type.* Translated by Jane O. Newman and John H. Smith. Cambridge, Mass.: MIT Press, 1983.

Germann, Georg. *Gothic Revival in Europe and Britain: Sources, Influences, and Ideas.* Cambridge, Mass: MIT Press, 1972.

Giedion, Sigfried. *Building in France, Building in Iron, Building in Ferroconcrete.* Translated by J. Duncan Berry. Introduction by Sokratis Georgiadis. Santa Monica: Getty Center, 1995. (German original first published 1928.)

———. *Space, Time, and Architecture: The Growth of a New Tradition.* 5th ed. Cambridge, Mass.: Harvard University Press, 1967. (First published 1941.)

Girard, Louis. *Nouvelle histoire de Paris: La Deuxième République et le Second Empire, 1848–1870.* Paris: Hachette, 1981.

———. *La politique des travaux publics sous le Second Empire.* Paris: Colin, 1952.

Gopnik, Adam. *Paris to the Moon.* New York: Random House, 2000.

Gourlier, Charles, and Charles-Auguste Questel. *Notice historique sur le Service des travaux des bâtiments civils à Paris et dans les départements.* 2nd ed. Paris: Colas, 1886. (First published 1848.)

Grunchec, Phillipe. *Les concours des Prix de Rome, 1797–1863: La peinture à l'École des Beaux-Arts.* 2 vols. Paris: École nationale supérieure des Beaux-Arts, 1986.

Guadet, Julien. *Éléments et théorie de l'architecture.* 4 vols. Paris: Librairie de la construction moderne, [1904].

Guédy, Henry. *L'enseignement à l'École nationale et spéciale des Beaux-Arts.* Paris: Aulnier, [1899].

Gusman, Pierre. *Pompei: La ville, les moeurs, les arts.* Paris: Gaillard, 1906.

Habermas, Jürgen. *The Structural Transformation of the Public Sphere: An Inquiry into a Category of Bourgeois Society.* Translated by T. Burger. Cambridge, Mass.: MIT Press, 1989. (German original first published 1962.)

Hall, Thomas. *Planning Europe's Capital Cities: Aspects of Nineteenth-Century Urban Development.* London: Spon, 1997.

Hamon, Françoise, and Charles MacCallum, eds. *Louis Visconti, 1791–1853.* Paris: Délégation à l'action artistique de la ville de Paris, 1991.

Harvey, David. *Paris, Capital of Modernity.* New York: Routledge, 2003.

Haussmann, Georges-Eugène. *Mémoires.* 2 vols. Paris: Guy Durier, 1979. (First published 1890–93.)

Hautecoeur, Louis. *Histoire de l'architecture classique en France.* 7 vols. Paris: Picard, 1943–57.

Hillairet, Jacques. *Dictionnaire historique des rues de Paris.* 2 vols. 8th ed. Paris: Éditions de Minuit, 1985.

Hitchcock, Henry-Russell. *Architecture: Nineteenth and Twentieth Centuries.* Penguin: Baltimore, 1958.

Hittorff, Jacques-Ignace, and Ludwig Zanth. *Restitution du temple d'Empédocle à Sélinonte, ou l'Architecture polychrome chez les grecs.* 2 vols. Paris: Firmin-Didot, 1851.

Horeau, Hector. *Examen critique du projet d'agrandissement de construction des Halles centrales d'approvisionnement pour la ville de Paris, soumis à l'enquête publique en août [sic] 1845.* Paris: author, October 1845.

———. *Halles centrales: Contre-rapport et comparaison entre le projet amendé et le projet Horeau.* Paris: author, July 1851.

———. *Nouvelles Halles centrales de Paris.* Paris: author, September 1849. (Also published in *Revue générale de l'architecture* 8 [1849]: cols. 152–60.)

———. *Nouvelles observations sur le projet d'agrandissement et de construction des Halles centrales d'approvisionnement pour la ville de Paris, soumis à l'enquête publique en août 1845: Suite d'un examen critique publié en octobre 1845.* Paris: author, April 1846.

Horeau, Hector, with G. Callou and Lacasse. *Note sur un projet de Halles centrales, proposé pour la ville de Paris, et présenté à M. le Préfet de la Seine; par MM. Horeau, architecte, G. Callou et Lacasse, entrepreneurs des travaux publics.* Paris: author, July 1849.

Hôtel de Ville de Paris. *Fête donnée en l'honneur de S. M. B. la Reine Victoria.* Paris: Charles de Mourgues Frères, [1856].

———. *Fêtes et cérémonies à l'occasion de la naissance et du baptême de Son Altesse le Prince Impérial.* Paris: Charles de Mourgues Frères, 1860.

Hugo, Victor. *Notre-Dame de Paris.* Edited by Marius-François Guyard. Paris: Garnier, 1976. (Originally published in 1832.)

Hugueney, Jeanne. "Les Halles centrales de Paris au XIXe siècle." *La vie urbaine,* April–June 1968, 81–130

Huillard-Bréholles, Adolphe, with Victor Baltard. *Recherches sur les monuments et l'histoire des Normands et de la Maison de Souabe dans l'Italie méridionale, publiée par les soins de M. le Duc de Luynes, membre de l'Académie des inscriptions et des belles lettres.* Paris, 1844.

Humbert, Jean Marcel, ed. *Napoléon aux Invalides: 1840, le retour des cendres.* Paris: Musée de l'Armée and Fondation Napoléon, 1990.

Husson, Armand. *Les consommations de Paris.* 2nd ed. Paris: Guillaumin, 1875. (First published 1856.)

Ingres, Jean-Auguste-Dominique. *Réponse au rapport sur l'École impériale des Beaux-Arts.* Paris: Didier, 1863.

Institut de France. *Séance publique de l'Académie royale des Beaux-Arts, du samedi 5 octobre 1839.* Paris: Firmin-Didot, 1839.

Jacoubet, Théodore. *Atlas général de la ville de Paris, ses faubourgs et ses monuments.* Paris: Hocq, 1836

Jacques, Annie. *La carrière de l'architecte au XIXe siècle.* Paris: Réunion des musées nationaux, 1986.

Jäy, [Adolphe-]F[rançois-]M[arie]. *Résumé des leçons de construction faites à l'École spéciale et impériale des beaux-arts jusqu'en 1864.* Paris: E. Thunot, [1864].

Jollivet, Pierre-Jules. "De la peinture murale." *Revue générale de l'architecture* 8 (1849): cols. 73–80, 129–41, 194–99, 242–50, 313–18, 383–97; 9 (1851): cols. 28–35, 55–64, 121–29, 173–81.

Jordan, David P. *Transforming Paris: The Life and Labors of Baron Haussmann.* New York: Free Press, 1995.

Kahlmaier, Georg, and Barna von Sartory. *Houses of Glass: A Nineteenth-Century Building Type.* Cambridge, Mass.: MIT Press, 1986.

Kalnein, Wend Von. *Architecture in France in the Eighteenth Century.* New Haven: Yale University Press, 1995.

Kock, Charles Paul de. *La grande ville, nouveau tableau de Paris.* 2 vols. Paris: Bureau central des publications nouvelles, 1842.

Kostof, Spiro, ed. *The Architect: Chapters in the History of the Profession.* New York: Oxford University Press, 1977.

Labrouste, Henri. "Mélanges: Nouvelles; Travaux des élèves de l'école d'architecture de Paris, pendant l'année 1839." *Revue générale de l'architecture* 1 (1840): cols. 58–60.

Lampué, Pierre. *Programmes des concours d'architecture pour le Grand Prix de Rome.* Paris: Durenne, 1881.

Lance, Adolphe. *Abel Blouet, architecte, membre de l'Institut: Sa vie et ses travaux.* Paris: Bance, 1854.

———. "Nouvelle forme architecturale: Composée par M. Boileau, architecte." *Encyclopédie d'architecture* 4 (1854): cols. 24–28.

Lanfant, Henri. *Conseil général de la Seine (1791–1902): Lois, décrets, rapports officiels et documents divers relatifs à l'organisation et aux attributions de l'assemblée départementale.* Paris: Ville de Paris, [1902].

Langlois, J[acques]. *Consultation pour les propriétaires et les commerçants du quartier des Halles centrales.* Paris: Cosson, August 1850.

Lanquetin, Jacques-Séraphin. *Observations sur un travail de l'administration municipale de Paris, intitulé Études sur les Halles.* Paris, 20 March 1841.

———. *La question du déplacement de la population: État des études sur cette question; À mes collègues du Conseil municipal de Paris.* Paris, 15 April 1842.

———. *Question du déplacement de Paris: Opinion d'un membre de la Commission ministérielle chargé d'examiner cette question.* Paris, 30 April 1840.

Large, Pierre-François. *Des Halles au Forum: Métamorphoses au coeur de Paris.* Paris: Éditions L'Harmattan, 1992.

Laroche, Claude, ed. *Paul Abadie, architecte, 1812–1884.* Paris: Réunion des musées nationaux, 1988.

Lassus, Jean-Baptiste. "De l'art et l'archéologie." *Annales archéologiques* 2 (February 1845): 69–77, (April 1845): 197–204, (June 1845): 329–35.

———. *Réaction de l'Académie des Beaux-Arts contre l'art gothique.* Paris: Didron, 1846.

Laurent, Jeanne. *À propos de l'École des Beaux-Arts.* Paris: École nationale supérieure des Beaux-Arts, 1987.

Lavedan, Pierre. *Nouvelle histoire de Paris: Histoire de l'urbanisme à Paris.* Paris: Hachette, 1975.

———. *La question du déplacement de Paris et du transfert des Halles au Conseil municipal sous la Monarchie de Juillet.* Paris: Ville de Paris, 1969.

Lavin, Sylvia. *Quatremère de Quincy and the Invention of a Modern Language of Architecture.* Cambridge. Mass.: MIT Press, 1992.

Lazare, Félix, and Louis Lazare. *Dictionnaire administratif et historique des rues et monuments de Paris.* 2nd ed. Paris: author, 1855. (Originally published 1844.)

Lazare, Louis. "Les grandes halles de Paris." *La revue municipale,* no. 239 (20 August 1857): 65–68; no. 240 (18 September 1857): 73–75.

———. *Paris: Son administration ancienne et moderne; Études historiques et administratives.* Paris: author, 1856.

Le Corbusier. *Lettres à Auguste Perret.* Edited by Marie Jeanne Dumont. Paris: Éditions du Linteau, 2002.

———. *Vers une architecture.* Rev. ed. Paris: Arthaud, 1977. (Originally published 1923.)

Lefebvre, Henri. *The Production of Space.* Translated by Donald Nicholson-Smith. Oxford: Blackwell, 1991. (French original first published 1974.)

Lemoine, Bertrand. *L'architecture du fer: France, XIXe siècle.* Paris: Champ Vallon, 1986.

———. *Architecture in France, 1800–1900.* Translated by Alexandra Bonfante-Warren. New York: Abrams, 1998.

———. *Les Halles de Paris.* Paris: L'Equerre, 1980.

———. *Les passages couvertes en France.* Paris: Délégation à l'action artistique de la ville de Paris, 1990.

Leniaud, Jean-Michel. *Charles Garnier.* Paris: Monum / Éditions du patrimoine, 2003.

———. *Jean-Baptiste Lassus (1807–1857), ou Le temps retrouvé des cathédrales.* Geneva: Droz, 1980.

Lenoir, Albert, and Pierre Landry. "Théorie des villes: Comment les villes sont formées." *Revue générale de l'architecture* 12 (1854): cols. 292–98.

Léon, Paul. *La vie des monuments français.* Paris: Picard, 1951.

Léri, Jean-Marc. "Aspect administratif de la construction des marchés de la ville de Paris, 1800–1850." *Bulletin de la Société de l'histoire de Paris* (1976–77): 171–90.

Leroux, Pierre, and Jean Reynaud, eds. *Encyclopédie nouvelle.* 8 vols. Paris: Charles Gosselin, 1834–41.

Lespès, Léo, and Charles Bertrand. *Paris-album historique et monumentale en vingt arrondissements.* Paris: Bertrand, 1860; facsimile, Nîmes: Lacour, 1991.

Levine, Neil. *Modern Architecture: Representation and Reality.* New Haven: Yale University Press, 2009.

Loyer, François. *Paris XIXe siècle: L'immeuble et la rue.* Paris: Hazan, 1987.

Magne, Auguste. "Nécrologie [Victor Baltard]." *Revue générale de l'architecture* 31 (1874): cols. 86–88.

Magne, Auguste, and Thibault. "Projets de modifications à apporter aux plans précédemment adoptés pour l'érection des grandes halles." *Revue municipale,* 1 September 1848.

Malo, Léon. "Correspondance à Monsieur le rédacteur en chef du *Génie civil* [Eugène Flachat]." *Le Génie civil* 17 (October 1890): 397–99

Marie, Léon. *De la décentralisation des Halles de Paris.* Paris: E. Thunot, 1850.

Marrey, Bernard. *Les grands magasins des origines à 1939.* Paris: Picard, 1979.

Marrey, Bernard, with Jacques Ferrier. *Paris sous verre: La ville et ses reflets.* Paris: Picard / Pavillon de l'Arsenal, 1997.

Mead, Christopher, ed. *The Architecture of Robert Venturi.* Albuquerque: University of New Mexico Press, 1989.

———. *Charles Garnier's Paris Opéra: Architectural Empathy and the Renaissance of French Classicism.* New York: Architectural History Foundation; Cambridge, Mass.: MIT Press, 1991.

———. Review of *La modernité avant Haussmann. Journal of the Society of Architectural Historians* 61 (March 2002): 106–8.

———. "Urban Contingency and the Problem of Representation in Second Empire Paris." *Journal of the Society of Architectural Historians* 54 (June 1995): 138–74.

Mercier, Louis-Sébastien. *Panorama of Paris.* Edited by Jeremy Popkin. Translated by Helen Simpson and Jeremy Popkin. University Park: Pennsylvania State University Press, 1999.

———. *Le tableau de Paris.* Edited by Jeffry Kaplow. Paris: Éditions la Découverte, 1989. (Originally published 1781–88.)

Merimée, Prosper. "De la peinture murale et son emploi dans l'architecture moderne." *Revue générale de l'architecture* 9 (1851): cols. 258–73, 327–37.

Merruau, Charles. *Souvenirs de l'Hôtel de Ville de Paris, 1848–1852.* Paris: Plon, 1875.

Meynadier, Hippolyte. *Paris sous le point de vue pittoresque et monumental, ou Éléments d'un plan général d'ensemble de ses travaux d'art et d'utilité publique.* Paris: Dauvin et Fontaine, 1843.

Michel, Christian. *Les Halles: La renaissance d'un quartier, 1966–1988.* Paris: Masson, 1988.

Middleton, Robin. "The Abbé Cordemoy and the Graeco-Gothic Ideal: A Prelude to Romantic Rationalism." *Journal of the Warburg and Courtauld Institutes* 25 (1962): 278–320; 26 (1963): 90–123.

———, ed. *The Beaux-Arts and Nineteenth-Century French Architecture.* Cambridge, Mass.: MIT Press, 1982.

———. "Jacques-François Blondel and the Cours d'Architecture." *Journal of the Society of Architectural Historians* 18 (1959): 140–48.

Middleton, Robin, and Marie-Noëlle Baudoin-Matuszek. *Jean Rondelet: The Architect as Technician.* New Haven: Yale University Press, 2007.

Middleton, Robin, and David Watkin. *Neoclassical and Nineteenth Century Architecture.* New York: Abrams, 1980.

Moncan, Patrice de, ed. *Baltard, les Halles de Paris.* Paris: Éditions de l'Observatoire, 1994.

Morizet, André. *Du vieux Paris au Paris moderne: Haussmann et ses prédécesseurs.* Paris: Hachette, 1932.

Muntz, Eugène. *Guide de l'École nationale des Beaux-Arts.* Paris: Quantin, [1889].

Murphy, Kevin. *Memory and Modernity: Viollet-le-Duc at Vézelay.* University Park: Pennsylvania State University Press, 2000.

Musée Carnavalet. *De la place Louis XV à la place de la Concorde.* Paris: Musées de la ville de Paris, 1982.

———. *Hittorff, 1792–1867: Un architecte du XIXe siècle.* Edited by Thomas von Joest and Claudine de Vaulchier. Paris: Musées de la ville de Paris, 1986.

Narjoux, Félix. *Paris: Monuments élevés par la ville, 1850–1880.* 4 vols. Paris: Morel, 1880–83.

Nash, Ernest. *Pictorial Dictionary of Ancient Rome.* 2 vols. New York: Praeger, 1962.

Normand, Charles. *Nouveau parallèle des ordres d'architecture des Grecs, des Romains, et des auteurs modernes.* Paris: Firmin-Didot, 1819.

O'Connell, Lauren. "Afterlives of the Tour Saint-Jacques: Plotting the Perceptual History of an Urban Fragment." *Journal of the Society of Architectural Historians* 60, no. 4 (2001): 450–73.

Olsen, Donald. *The City as a Work of Art: London, Paris, Vienna.* New Haven: Yale University Press, 1986.

Paillet, Léon. "Le Louvre du peuple." *La patrie,* 2–3 September 1851.

Papayanis, Nicholas. *Planning Paris Before Haussmann.* Baltimore: Johns Hopkins University Press, 2004.

Penanrum, David de, Louis-François Roux, and Edmond Delaire. *Les architectes élèves de l'École des Beaux-Arts.* 2nd ed. Paris: Librairie de la construction moderne, 1907. (Originally published 1895.)

Percier, Charles, and Pierre Fontaine. *Description des cérémonies, et des fêtes, qui ont eu lieu pour le couronnement de L.L. MM Napoléon, empereur des Français et roi d'Italie, et Joséphine, son auguste épouse.* Paris: Leblanc, 1808.

———. *Description des cérémonies, et des fêtes, qui ont eu lieu pour le mariage de S.M. l'empereur Napoléon avec S. A. L. Mme l'archiduchesse Marie-Louise d'Autriche.* Paris: Didot, 1810.

———. *Palais, maisons, et autre édifices modernes, dessinés à Rome.* Paris: authors, 1798.

———. *Résidences de souverains: Parallèle entre plusieurs résidences de souverains de France, d'Allemagne, de Suède, de Russie, d'Espagne et d'Italie.* Paris: authors, 1833.

Pérouse de Montclos, Jean-Marie. *Concours de l'Académie royale d'architecture au XVIIIe siècle.* Paris: Berger-Levrault / École nationale supérieure des Beaux-Arts, 1984.

Perrault, Claude. *Ordonnance of the Five Kinds of Columns After the Method of the Ancients.* Translated by I. K. McEwen. Introduction by Alberto Pérez-Gomèz. Santa Monica: Getty Center, 1993. (French original first published 1683.)

Perreymond, A. "Études sur la ville de Paris." *Revue générale de l'architecture* 3 (1842): cols. 540–54, 570–79; 4 (1843):

cols. 25–37, 72–79, 79–78, 413–29, 449–58, 458–64, 464–69, 517–28.

Peters, Tom. *Building the Nineteenth Century.* Cambridge, Mass.: MIT Press, 1996.

Picon, Antoine. *French Architects and Engineers in the Age of Enlightenment.* Translated by Martin Thom. Cambridge: Cambridge University Press, 1992.

Pigeory, Félix. "Les Halles centrales." *Revue des beaux-arts,* 15 May 1851, 149–52; 1 June 1851, 171–75; 15 June 1851, 187–90; 1 July 1851, 201–5.

Pinkney, David. *Napoleon III and the Rebuilding of Paris.* Princeton: Princeton University Press, 1958.

Pinon, Pierre. *Louis-Pierre et Victor Baltard.* Paris: Monum / Éditions du patrimoine, 2005.

———, ed. *Les traversées de Paris: Deux siècles de révolutions dans la ville.* Paris: Éditions du Moniteur, 1989.

Pinon, Pierre, and François-Xavier Amprimoz. *Les envois de Rome (1778–1968): Architecture et archéologie.* Rome: École française de Rome, 1988.

Polonceau, Camille. "Pratique: Notice sur un nouveau système de charpente en bois et en fer." *Revue générale de l'architecture* 1 (1840): cols. 27–32.

Pontich, Henri de, under the direction of Maurice Block. *Administration de la ville de Paris et du département de la Seine.* Paris: Guillaumin, 1884.

Préfecture de la Seine. *Compte rendu des opérations du jury chargé de juger le concours ouvert pour la reconstruction de l'Hôtel de Ville de Paris.* Paris: Ville de Paris, 1873.

———. *État des services à installer dans l'Hôtel de Ville reconstruit: Annexe au programme de concours.* Paris: Ville de Paris, 1872.

———. *Inventaire générale des oeuvres d'art appartenant à la ville de Paris, dressé par le Service des Beaux-Arts.* 4 vols. Paris: Ville de Paris, 1878–86.

———. *Notes sur les abattoirs, entrepots, halles, marchés et établissements divers concourant à l'approvisionnement de Paris.* Paris: Ville de Paris, 1889.

———. *Programme du concours pour la reconstruction de l'Hôtel de Ville de Paris.* Paris: Ville de Paris, 1872.

———. *Recueil de règlements sur l'assainissement.* Paris: Ville de Paris, 1872.

———. *Recueil des actes administratifs de la préfecture du département de la Seine.* 9 vols. Paris: Paul Dupont, 1844–76.

Pronteau, Jeanne. "Construction et aménagement des nouveaux quartiers de Paris, 1820–1826." *Histoire des entreprises* 2 (1958): 8–32.

———. [Ville de Paris. Commission des travaux historiques.] *Notes biographiques sur les membres des assemblées municipales parisiennes et des conseils généraux de la Seine de 1800 à nos jours: Première partie, 1800–1871.* Paris: Ville de Paris, [1958].

Puylaroque, Thérèse de. "Pierre Baltard, peintre, architecte et graveur, 1764–1846; biographie raisonnée et catalogue sommaire." Thèse de 3e cycle, Université de Paris 1, 1981.

———. "Pierre Baltard, peintre et dessinateur (1764–1846)." *Bulletin de la Société de l'histoire de l'art français, année 1976* (1978): 331–39.

Quatremère de Quincy, Antoine-Chrysostome. *Dictionnaire historique de l'architecture.* 2 vols. Paris: Leclère, 1832.

———. *Encyclopédie méthodique: Architecture.* 3 vols. Paris: Pancoucke, 1788–1825.

———. *Histoire de la vie et des ouvrages des plus célèbres architectes du XIe siècle jusqu'à la fin du XVIIIe.* 2 vols. Paris: Renouard, 1830.

Rabinow, Paul. *French Modern: Norms and Forms of the Social Environment.* Chicago: University of Chicago Press, 1995.

Rabreau, Daniel, ed. *Gabriel Davioud, architecte (1824–1881).* Paris: Délégation à l'action artistique de la ville de Paris, 1981.

Rambuteau, Claude de. *Mémoires du Comte de Rambuteau, publiées par son petit-fils.* Paris: Calman-Lévy, 1905.

Ranum, Orest. *Paris in the Age of Absolutism.* Rev. ed. University Park: Pennsylvania State University Press, 2002.

Raoul-Rochette, Désiré. "Percier: Sa vie et ses ouvrages." *Revue des deux mondes* 24 (1840): 246–68.

Régnier, Jacomy. "Halles centrales de Paris." *Journal des travaux publics,* 8 May 1851.

Reynaud, Léonce. *Traité d'architecture.* 2 vols. Paris: Carlian-Goeury et Dalmont, 1850–58.

Rice, Shelley. *Parisian Views.* Cambridge, Mass.: MIT Press, 1997.

Riegel, Alois. "The Modern Cult of Monuments: Its Character and Its Origins." Translated by Kurt Foster and Diane Ghirardo. *Oppositions* 25 (Fall 1982): 21–50.

Romane-Musculus, Paul. "La famille de l'architecte Victor Baltard." *Bulletin de la Société de l'histoire du protestantisme français* 117 (1971): 643–46.

Rosenblum, Robert. *Ingres.* New York: Abrams, [1967].

Rossi, Aldo. *The Architecture of the City.* Translated by Diane Ghirardo and Joan Ockman. Introduction by Peter Eisenman. Cambridge, Mass.: MIT Press, 1981. (Italian original first published 1966.)

Rowe, Colin, and Fred Koetter. *Collage City.* Cambridge, Mass.: MIT Press, 1978.

Rowlands, Thomas. "Quatremère de Quincy: The Formative Years, 1785–1795." Ph.D. diss., Northwestern University, 1987.

Rybczynski, Witold. *City Life: Urban Expectations in a New World.* New York: Scribner, 1995.

Sadler, Simon. *The Situationist City.* Cambridge, Mass.: MIT Press, 1998.

Saint, Andrew. *The Image of the Architect.* New Haven: Yale University Press, 1983.

Sauterion. "Les Halles centrales." *Le spectateur,* 17 October 1857.

Say, Horace. *Études sur l'administration de la ville de Paris et du département de la Seine.* Paris: Guillaumin, 1846.

Schmiechen, James, and Kenneth Carls. *The British Market Hall: A Social and Architectural History.* New Haven: Yale University Press, 1999.

Schmit, Jean-Philippe. *Les églises gothiques.* Paris: Angé, 1837.

———. *Nouveau manuel complet de l'architecte des monuments religieux, ou Traité d'application pratique de l'archéologie chrétienne à la construction, à l'entretien, à la restauration et à la décoration des églises.* 2nd ed. Paris: Roret, 1859. (First published 1845.)

Schneider, Donald David. *The Works and Doctrine of Jacques Ignace Hittorff (1792–1867): Structural Innovation and Formal Expression in French Architecture, 1810–67.* New York: Garland, 1977.

Schneider, Réné. *Quatremère de Quincy et son intervention dans les arts.* Paris: Hachette, 1910.

Searing, Helen, ed. *In Search of Modern Architecture: A Tribute to Henry-Russell Hitchcock.* New York: Architectural History Foundation; Cambridge, Mass.: MIT Press, 1982.

Sédille, Paul. *Théodore Ballu, architecte (1817–1885).* Paris: Chaix, 1886.

———. "Victor Baltard, architecte." *Gazette des beaux-arts* 9 (May 1874): 485–96.

Sédille, Paul, et al. *Annales de la Société centrale des architectes français* 1 (1874).

Semper, Gottfried. *The Four Elements of Architecture and Other Writings.* Translated by Harry Francis Malgrave and Wolfgang Hermann. Cambridge: Cambridge University Press, 1989.

Senard, Antoine-Marie-Jules. *Halles centrales: Réponse de M. Senard aux mémoires publiés par les intéressés au projet de 1845, suivie d'une lettre de M. Bélanger, ingénieur, à M. Hector Horeau, architecte, sur la question du nivellement.* Paris, December 1850.

———. *Halles centrales de Paris: De l'état actuel des Halles; des divers plans proposées, et spécialement du projet Horeau; de la convenance et de la justice du concours demande à l'état.* Paris: Brière, [April 1850].

Sirodot, Henri, and François-Alphonse Fortier. "Escalier de l'aile de François Ier au Château de Blois: Vue photographique." *Revue générale de l'architecture* 14 (1856): cols. 213–16 and pl. 21.

Sirodot, Henri, and Alphonse Poitevin. "Les Halles centrales à Paris: Vue du pavillon sud-ouest pendant le montage." *Revue générale de l'architecture* 14 (1856): cols. 367–70 and pl. 61.

Souviron, Alfred, and Henri de Pontich. *Recueil annoté des lois et décrets sur l'administration communale et départementale comprenant les textes spéciaux à l'administration de la ville de Paris et du département de la Seine.* Paris, 1893.

Starobinski, Jean. *Jean–Jacques Rousseau: Transparency and Obstruction.* Chicago: University of Chicago Press, 1988.

Steiner, Frances. *French Iron Architecture.* Ann Arbor: UMI Research Press, 1984.

Strong, Roy. *Art and Power: Renaissance Festivals, 1450–1650.* Rev. ed. Berkeley and Los Angeles: University of California Press, 1984.

Sutcliffe, Anthony. *The Autumn of Central Paris: The Defeat of Town Planning, 1850–1970.* London: Edward Arnold, 1970.

———. *Paris: An Architectural History.* New Haven: Yale University Press, 1993.

———. *Towards the Planned City: Germany, Britain, the United States, and France, 1780–1914.* New York: St. Martin's Press, 1981.

Szambien, Werner. *De la rue des Colonnes à la rue de Rivoli.* Paris: Délégation à l'action artistique de la ville de Paris, 1992.

———. *Jean-Nicolas-Louis Durand 1760–1834: De l'imitation à la norme.* Paris: Picard, 1984.

———. *Le musée d'architecture.* Paris: Picard, 1988.

———. *Symétrie, goût, caractère: Théorie et terminologie de l'architecture à l'âge classique, 1550–1800.* Paris: Picard, 1986.

Tangires, Helen. *Public Markets.* New York: W. W. Norton, in association with the Library of Congress, 2008.

———. *Public Markets and Civic Culture in Nineteenth-Century America.* Baltimore: Johns Hopkins University Press, 2003.

Tessereau, Docteur. *Études hygiéniques sur les Halles centrales de Paris.* Paris: author, 1847.

Texier, Edmond. *Tableau de Paris.* 2 vols. Paris: Paulin et le Chevalier, 1852–53.

Thézy, Marie de. *Marville, Paris.* Paris: Hazan, 1994.

Thomine, Alice. *Emile Vaudremer, 1829–1914: La rigueur de l'architecture publique.* Paris: Picard, 2004.

Thomson, David. *Renaissance Paris: Architecture and Growth, 1475–1600.* Berkeley and Los Angeles: University of California Press, 1984.

Thuillier, Guy. *La vie quotidienne dans les ministères au XIXe siècle.* Paris: Hachette, 1976.

Timbal, Charles. "Victor Baltard." *Le Français,* 19 January 1874.

Tourettes, A. "Les Halles centrales." *La patrie,* 28 July 1857.

Trélat, Émile. *Le Sitellarium: Étude de composition architecturale.* Paris: author, [1871].

Tulard, Jean. *Paris et son administration (1800–1830).* Paris: Ville de Paris, 1976.

———. *La Préfecture de police sous la Monarchie de Juillet.* Paris: Ville de Paris, 1964.

Vachon, Marius. *L'Ancien Hôtel de Ville de Paris, 1533–1871.* Paris: Quantin, 1882.

Valence, Georges. *Haussmann le grand.* Paris: Flammarion, 2000.

Van Zanten, David. *Architectural Polychromy in the 1830s.* New York: Garland, 1977.

———. *Building Paris: Architectural Institutions and the Transformation of the French Capitol, 1830–1870.* Cambridge: Cambridge University Press, 1994.

———. *Designing Paris: The Architecture of Duban, Labrouste, Duc, and Vaudoyer.* Cambridge, Mass.: MIT Press, 1987.

———. "Félix Duban and the Buildings of the École des Beaux-Arts, 1832–1840." *Journal of the Society of Architectural Historians* 37 (1978): 161–74.

———. *Sullivan's City: The Meaning of Ornament for Louis Sullivan.* New York: W. W. Norton, 2000.

———. "Paris Space: What Might Have Constituted Hauss-manization." In *Manifestoes and Transformations in the Early Modernist City,* edited by Christian Hermansen Cordua, 179–210. Farnham, Surrey: Ashgate, 2010.

Vaudoyer, Antoine-Laurent-Thomas, and Louis-Pierre Baltard. *Grands prix d'architecture: Projets couronnés par l'Académie des Beaux-Arts royale en France.* Paris: authors, 1818 and 1834.

Vaudoyer, Léon, and Albert Lenoir. "Études d'architecture en France." *Magasin pittoresque* 7–20 (1839–52).

Vaudremer, Émile. *Monographie de l'église de Saint-Pierre de Montrouge.* Paris: author, 1874.

Vauthier, P. "Conférences nationales de la Société centrale des architectes." *Revue générale de l'architecture* 30 (1873): cols. 127–33.

Venturi, Robert. *Complexity and Contradiction in Architecture.* Introduction by Vincent Scully. New York: Museum of Modern Art, in association with the Graham Foundation for Advanced Studies in the Fine Arts, 1966.

Venturi, Robert, Denise Scott Brown, and Steven Izenour. *Learning from Las Vegas.* Rev. ed. Cambridge, Mass.: MIT Press, 1977. (First published 1972.)

Vidler, Anthony. *The Architectural Uncanny: Essays in the Modern Unhomely.* Cambridge, Mass.: MIT Press, 1992.

———. *Claude-Nicolas Ledoux.* Cambridge, Mass.: MIT Press, 1990.

———. "The Third Typology." *Oppositions* 7 (Winter 1976): 1–4.

———. *The Writing of the Walls.* Princeton: Princeton Architectural Press, 1987.

Vigne, Georges. *Ingres.* Translated by John Goodman. New York: Abbeville Press, 1995.

Vigneau, Jules. *Les Halles centrales de Paris autrefois et aujourd'hui.* Paris: E. Durny, 1903.

Ville de Paris. *Ledoux et Paris.* Cahiers de la Rotonde, 3. Paris: Rotonde de la Villette, 1979.

———. *Paris–Les Halles: Concours 2004.* Paris: Moniteur, 2004.

Villefosse, René Héron de. *Nouvelle histoire de Paris: Solennités, fêtes, et réjouissances parisiennes.* Paris: Hachette, 1980.

Viollet-le-Duc, Eugène-Emmanuel. "De la construction des édifices religieux en France depuis le commencement du christianisme jusqu'au XVIe siècle." *Annales archéologiques* 1 (1844): 179–86.

———. "De l'art étranger et l'art national." *Annales archéologiques* 2 (1845): 303–8.

———. *Dictionnaire raisonné de l'architecture française du XIe au XVIe siècle.* 10 vols. Paris: A. Morel, 1858–68.

———. "Du style gothique au XIXe siècle." *Annales archéologiques* 4 (1846): 325–53.

———. *Entretiens sur l'architecture.* 2 vols. Paris: A. Morel et Cie., 1863–72.

———. *The Foundations of Architecture: Selections from the Dictionnaire raisonné.* Translated by Kenneth Whitehead. Introduction by Barry Bergdoll. New York: Braziller, 1990.

———. *Habitations modernes.* 2 vols. Paris: A. Morel, 1875–77.

———. *Histoire d'un hôtel de ville et d'une cathédrale.* Paris: Hetzel, 1878.

———. "Lettre à M. Adolphe Lance en réponse à un article de M. Michel Chevalier." *Encyclopédie d'architecture* 5 (1855): cols. 81–87.

———. *Lettres d'Italie, 1836–1837.* Edited by Geneviève Viollet-le-Duc. Paris: Léonce Laget, 1971.

———. "Réplique à la réponse de M. Boileau." *Encyclopédie d'architecture* 5 (1855): cols. 105–10.

Viollet-le-Duc, Eugène-Louis. "Saint-Augustin." *Gazette des architectes et du bâtiment* 6 (1868): 1–4.

Vitruvius. *Ten Books on Architecture.* Translated and edited by Ingrid Rowland and Thomas Noble Howe. Cambridge: Cambridge University Press, 1999.

Waquet, Françoise. *Les fêtes royales sous la Restauration, ou l'Ancien Régime retrouvé.* Geneva: Droz, 1981.

Weber, Max. *Economy and Society: An Outline of Interpretative Sociology.* Translated and edited by Guenther Roth and Claus Wittich. 2 vols. Berkeley and Los Angeles: University of California Press, 1978.

Wildenstein, George. *Ingres.* 2nd ed. New York: Phaidon, 1956.

Woods, Mary. *From Craft to Profession: The Practice of Architecture in Nineteenth-Century America.* Berkeley and Los Angeles: University of California Press, 1999.

Ziskin, Rochelle. "The Place de Nos Conquêtes and the Unraveling of the Myth of Louis XIV." *Art Bulletin* 76 (March 1994): 147–62.

———. *The Place Vendôme: Architecture and Social Mobility in Eighteenth-Century Paris.* Cambridge: Cambridge University Press, 1999.

Zola, Émile. *Le ventre de Paris.* Paris: Seuil, 1987. (First published 1873 as vol. 1 in the series *Les Rougon-Macquart.*)